A FIRE IN HIS SOUL

A FIRE IN HIS SOUL

VAN GOGH, PARIS, AND THE MAKING OF AN ARTIST

MILES J. UNGER

PEGASUS BOOKS
NEW YORK LONDON

A FIRE IN HIS SOUL

Pegasus Books, Ltd.
148 West 37th Street, 13th Floor
New York, NY 10018

First Pegasus Books cloth edition March 2025

Interior design by Maria Fernandez

Library of Congress Cataloging-in-Publication Data is available.

ISBN: 978-1-63936-845-7

10 9 8 7 6 5 4 3 2 1

Printed in the United States of America
Distributed by Simon & Schuster
www.pegasusbooks.com

For Jody, as always.

You feel emptiness where there could be friendship and high and serious affections, and you feel a terrible discouragement gnawing at your psychic energy itself, and fate seems able to put a barrier against the instincts for affection, or a tide of revulsion that overcomes you. And then you say, How long, O Lord! Well, then, what can I say; does what goes on inside show on the outside? Someone has a great fire in his soul and nobody ever comes to warm themselves at it, and passersby see nothing but a little smoke at the top of the chimney and then go on their way. So now what are we to do [to] keep this fire alive inside . . .

—Vincent to Theo van Gogh, June 24, 1880

Contents

Introduction: The Isolated One xi

1: Two Brothers 1

2: The Country of Paintings 49

3: The Lure of Paris 105

4: L'Oeuvre 157

5: The Painter of Modern Life 225

6: Messiah of a New Art 291

7: The Student 341

8: The Shop Around the Corner 381

9: Outcasts 425

10: *Japonaiserie* Forever 475

11: Artists of the *Petit Boulevard* 525

Epilogue: Four Days 585

Appendix: When Was Van Gogh at Cormon's Studio? 593

Acknowledgments 597

Bibliography 599

Endnotes 611

Index 633

The Isolated One

"You know, what makes the prison disappear is every deep, serious attachment. To be friends, to be brothers, to love; that opens the prison through sovereign power, through a most powerful spell. But he who doesn't have that remains in death. But where sympathy springs up again, life springs up again."

—Vincent to Theo van Gogh

I n January 1890, six months before Vincent van Gogh's death, the critic Albert Aurier published a landmark article on the artist in the pages of the *Mercure de France.* Titled "Les Isolés" ("The Isolated Ones"), the piece introduced him to the public as a saintly hermit, shunned by a society too materialistic and out of touch with the spiritual dimension of the universe to appreciate his unique gift. Van Gogh's genius, according to Aurier, could only flourish in solitude, far from the shallow vulgarians that made up the civilized world in general, and Paris in particular.

Van Gogh wasn't pleased. He was particularly troubled by Aurier's description of him as a man apart, an *isolé.* Rather than following his own singular muse—or worse, listening to the voices inside his

head—he insisted he made his art in conversation with his contemporaries. "Thank you very much for your article in the *Mercure de France*, which greatly surprised me," he wrote to the author the following month. "However, I feel ill at ease when I reflect that what you say should be applied to others rather than to me."[1] Van Gogh went on to list a number of painters more deserving of acclaim, including his friend "Paul Gauguin, with whom I worked for a few months in Arles, and whom, besides, I already knew in Paris."[2]

Rejecting Aurier's label, Van Gogh summoned a group of colleagues, both real and imagined, to show that he was part of a larger movement. For all his difficulties fitting in, he had a profound need to *belong*, to find acceptance among his peers and love among family and friends. Calling him an isolé, Aurier defined him by the most miserable aspect of his existence.

The truth is that Van Gogh had already spent far too long in the wilderness to want to take up residence there. Ten years earlier, at one of the lowest points in his life, he'd written his brother Theo:

> You know, what makes the prison disappear is every deep, serious attachment. To be friends, to be brothers, to love; that opens the prison through sovereign power, through a most powerful spell. But he who doesn't have that remains in death. But where sympathy springs up again, life springs up again.[3]

Now Aurier was raising the walls his art was intended to tear down. Responding to the critic's claim that he was "so far removed from the milieu of our pitiful contemporary art,"[4] Van Gogh cited precedents and sought out kindred spirits. He vented his frustration in a letter he wrote to his mother in Holland: "I was saddened by [the article] when

I read it because it's so exaggerated; it's not like that—precisely what sustains me in my work is the feeling that there are several people who are doing exactly the same as I, and so why an article about me and not about those 6 or 7 others etc.?"[5]*

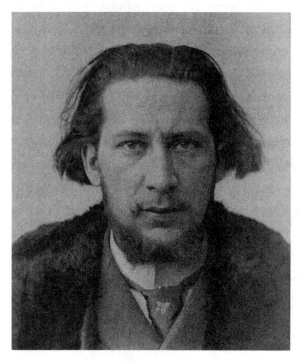

Albert Aurier

Equally distressing was the critic's facile approach to his mental illness. Unfortunately, Aurier's tribute had come at just the wrong time. Van Gogh's already difficult life had recently spun completely out of

* Van Gogh compares Aurier's article to one written by a fellow Dutchman, Joseph Isaacson, in which he praises the artist in very similar terms. In August of 1889, as part of his Paris letters, for *De Portefeuille. Kunst- en Letterbode*, Isaacson wrote: "I know of one, a single pioneer; he wrestles alone in the grand night; his name, Vincent, is for posterity."

control, which meant that recognition arrived when he could least make use of it, and in a form calculated to wound his already wounded soul. Since May 1889 he'd been confined to the psychiatric hospital Saint-Paul de Mausole in Saint-Rémy, following a series of breakdowns so shattering that they denied him the solace he'd always found in work. How easy it was for the critic to wax poetic about "a brain at the boiling point, pouring down its lava unchecked into all the ravines of art, a terrible maddened genius"![6] To Van Gogh these were afflictions to be overcome, not the source of his creativity.

It's not that Van Gogh didn't recognize something of himself in the critic's description. The public airing of his troubles was made more painful by the fact that the words cut painfully close to the bone. As he wrote to his sister Wil, citing his own unhappy experience, "many painters die or go mad from despair, or become paralyzed in their production because nobody loves them personally."[7] The isolation Aurier claimed as a mark of his originality was in fact a calamity that snuffed out the spark of inspiration.

So he pushed back—gently, not wishing to offend an influential critic who'd taken an interest in his work—explaining that his art was not the result of any mental aberration but rather part of a *shared* project, one that was rationally conceived and pursued in partnership with like-minded artists.

Despite Van Gogh's objections, however, the story of the solitary genius, driven into exile and to the brink of madness by an uncomprehending world, was too good to discard. Art, modern art in particular, needed heroes, men and women whose alienation from society was the sign of their integrity, prophets who, again in Aurier's words, were "too simple and too subtle for the contemporary bourgeois mind."[8]

Six months after "Les Isolés" appeared in print, Van Gogh was dead from a self-inflicted gunshot wound, confirming his role as a martyr to

a sacred cause.* Over the years, while some resisted the temptation to turn his life into a tale of tragedy and redemption, most followed Aurier's lead. Paradoxically, he became famous for being completely ignored, embodying the myth of the artist as outcast, his genius ratified by society's disdain. Typical of the hagiography that emerged in the wake of his suicide was an essay by the Dutch psychiatrist Frederik van Eeden. Van Eeden was a man of science and well acquainted with the van Gogh family, having taken his brother Theo under his care. He should have known better than to turn man into myth, but even he succumbed to the seductive narrative. "Was he not one of the noble and immortal race which the common people call madmen," van Eeden asked, "but which men among us consider sort of saints?"[9]

In the decades that followed, as Van Gogh's fame grew to dimensions he could never have dreamed of, he remained fixed in the popular imagination largely in the terms in which he was first introduced in the *Mercure de France.* He was the incarnation of the solitary genius, the purity of his vision guaranteed by the distance he put between himself and the cosmopolitan centers that devoured innocence and rewarded superficiality. Throughout his life he suffered from neglect, misunderstanding, and even hostility, but in death he suffered an equally insidious form of erasure as a troubled man was resurrected as a secular saint, a man of sorrows, his life a sacrament and his suicide a sacrifice to redeem our corrupt age. Even the paintings, for all their familiarity, have been bled of substance, their quirkiness, wild

* The exact circumstances of Van Gogh's death have never been clear. Vincent himself, staggering into the inn where he had a room, told the proprietor, "I have wounded myself," and that version of events has been generally accepted. But no gun was ever found, and in the thirty hours between his injury and death he provided no further insight as to whether it had been accidental or intentional. What is certain is that the tragic circumstances of his death contributed to the mystique that grew up around him.

brilliance, and assertive presence diminished as they metamorphize into precious relics preserved behind glass in the temple of the museum, or are reduced to pale ghosts through endless reproduction on tote bags and coffee mugs. Some eighty years after Aurier's article, one can still hear echoes in Don McLean's song "Vincent":

> *You took your life, as lovers often do*
> *But I could've told you, Vincent*
> *This world was never meant for*
> *One as beautiful as you.*

This romanticized version of the man and antiseptic image of the art rob the story of much of its fascination. Rather than deprive the tale of its beauty, Van Gogh's failings make his ultimate triumph that much more remarkable, even transcendent. Just as he pushed back on the version of himself offered up by Aurier in the pages of the *Mercure de France*, he would have rejected the caricature presented by Don McLean and numerous Hollywood biopics. Certainly those who knew him in the flesh—friends and family who had to contend with a far more egotistical and abrasive character—would have laughed at such a sentimental rewriting of history. It's simply not true that his master-pieces emerged effortlessly from a holy innocent whose only sin was an unrequited love for humanity. Rather they were the result of a titanic struggle, with his own demons, with his divided nature, and with the world at large, whose embrace he so desperately craved but with which he was constantly at war.

The popular version of Van Gogh's life not only distorts his character and the nature of his art. Crucially, it ignores the cultural forces that shaped him, the uniquely creative world he inhabited in the last years of his life and that determined his aesthetic choices, the colleagues with

whom he shared his ideas and techniques, contemporaries who urged him to take his art in new directions and against whom he measured his own achievement. The fact that Aurier's article appeared in a leading Parisian journal of the avant-garde undermines its own thesis. Far from being shunned by the spiritually deficient society in which he found himself, Van Gogh had landed in the one place that could recognize, and even celebrate, a man of his eccentric gifts, nurturing a genius that would otherwise have withered in fallow ground. He was not, as Aurier claimed, a man out of step with his times, but a man perfectly in tune with an era in which marginal and extreme characters were cherished as the authentic representatives of the neurotic fin de siècle.

The story of how Vincent van Gogh made himself into an artist of towering genius is as improbable as any in the history of art. It begins with a painter of no particular skill or obvious gifts, a provincial rube clinging stubbornly to outmoded ideas, and chronicles his remarkable transformation over the course of two short years into one of history's great visionaries. It was not, as legend would have it, a process that took place on some lonely heath or provincial village, but in the heart of the world's most cosmopolitan and culturally adventurous city; a transformation, moreover, that depended as much on interactions with his fellow artists as on his own internal resources.

Building the narrative around the two crucial years Van Gogh spent in Paris reveals a character unfamiliar to most readers. The man we meet is not the lonely hermit of Aurier's narrative, but someone in deep conversation with his peers. Rather than an isolé, he's eager to surround himself with fellow travelers, knowing difficult journeys are more easily made in good company. This company—brilliant, quarrelsome, more adept at backstabbing than productive collaboration—catalyzed

changes in his art, sparking his creative breakthrough, and allowing his latent brilliance to burst forth.

Only by meeting up with Van Gogh in the French capital can we hope to solve the riddle of his remarkable career. The city was both an ordeal and a crucible from which he emerged emotionally shattered but artistically reborn. Here he took his art in directions he hadn't even known existed before he arrived.

Paris, and specifically the Parisian avant-garde, provided him with the means to convey ideas and feelings he had no means of realizing on his own. He had come to the city with little appreciation for the revolutions taking place in art and literature, and with rather limited goals, to improve his technique and perhaps earn his living as a portraitist or commercial illustrator. What he found instead was a community of artists as contemptuous as he was of the superficial work that grabbed most of the headlines and earned most of the money, anxious to explore the far reaches of the human psyche and to invent new expressive forms that would speak to the anxieties of this most creative and deracinated age. This radical approach played to Van Gogh's strengths and even made virtues of his deficits. In Paris, in dialogue with new comrades, he absorbed a new artistic language and embraced a new approach that unleashed his creative potential.

That's not to say the popular image of Van Gogh as a misfit is inaccurate. Even (or especially) in Paris he had difficulty accommodating himself to the demands of polite society. He was made of rough edges and sharp elbows, incapable of conformity, no matter how desperately he longed for acceptance. The traits that made it difficult for him to form lasting relationships were painfully exposed by the sociability required of city dwellers, and its hectic pace proved a constant irritant to his raw-nerved constitution. "Deep in his heart there was such a great longing for sympathy, for kindness and friendship," recalled his

sister-in-law Jo Bonger, "and though his difficult character generally prevented him from finding this and left him isolated in life, yet he always kept on longing for somebody with whom he could live and work."[10]

These contradictory impulses warped his life and shaped his art. His paintings are distinctive, individualistic, often awkward, as aggressive as he was in the flesh. At the same time they summon with infinite longing a viewer willing to accept him as he is, with all his peculiarities, for all his faults. He is both assertive and tender, pugnacious and ingratiating. He puts up formidable barriers only to disarm us with his vulnerability and the sincerity with which he invites us to share his world with him.

The same dynamic played out in his relationships with his peers. Much as Van Gogh craved colleagues from whom he could learn and with whom he could share his thoughts, he was too eccentric a personality and too undisciplined a talent to fit comfortably within any movement. And much as he demanded respect and sympathetic understanding, he was too opinionated, too much his own man, to march in lockstep. No one could ever mistake one of his paintings for the work of any of his contemporaries; there are not, as he claims, "6 or 7" making work in a similar vein that history has simply missed. And many of the models he cites—the academic Ernest Meissonier and eccentric Adolphe Monticelli—are comparative mediocrities. He downplayed his own idiosyncrasies in part because he failed to recognize them and in part because to acknowledge them would be to admit the extent to which he was in fact the isolé Aurier believed him to be.

The community Van Gogh summoned to rebut the critic was very real. He'd even coined a name for this fellowship, dubbing his comrades "the artists of the Petit Boulevard" to distinguish these up-and-comers

from the already established Impressionists, the artists of the Grand Boulevard. They were a ragtag group on the far fringes of the Parisian art world, individuals of real talent and vision who dared to challenge the status quo and strike out in new directions. In the last decade and a half of the 19th century, it was these aesthetic pioneers who helped set the course of modern art.

Paris was their home base. Most were full-time residents of the city, but even if, like Van Gogh, they ultimately chose to live elsewhere—Cézanne, painting masterpieces in Aix-en-Provence, not far from Arles, was typical of the breed; Gauguin, who eventually made his way to Tahiti, was more extreme—it was Paris that fed their ambition and provided the only context in which their art made sense.

It's true that by the time Aurier became aware of him Van Gogh was no longer a resident of Paris. But in labeling Van Gogh an isolé, the critic ignored the web of connections that continued to bind him to the French capital. Even when he put a 500-mile buffer between himself and the city that almost destroyed him, he had no desire to cut himself off from the community he found there. Far from it. Van Gogh never felt more connected than when he was physically distant. After all, it was in Paris that he'd come into his own as an artist. And it was in Paris that, for the first time in his life, he'd found partners who took their mission as seriously as he did, collaborators from whom he could learn and who, in turn, could learn from him.

He described his comrades affectionately as "poor souls who live in coffee houses, lodge in cheap inns, live from one day to the next"[11] and very much wished to be included among their number. Even after he'd settled in Arles, he stressed the "tie [that] binds me to the French painters whom people call the Impressionists" and the fact that "I know many of them personally and like them."[12] His brother—an art dealer who managed one of the premier galleries in the city—continued to

keep him informed about the latest developments, and he remained in close contact with his former colleagues, exchanging paintings and participating in the debates that raged in the cafés of Montmartre via letters shuttling back and forth from the capital to Arles and back again. In short, he remained very much a Parisian artist, and to the extent that he *was* isolated, that was something to be endured rather than celebrated.

Tagging along after Van Gogh as he strides down the boulevards of the bustling metropolis, peering over his shoulder as he sets up his easel on the banks of the Seine and on the steep slopes of Montmartre—or as he devours the paintings on view in the museums and salons with his ravenous gaze—we can see a remarkable transformation taking place. At first he's hesitant, almost bewildered by the rich feast set before him, by turns disoriented and defiant as he confronts work that conforms to none of his notions of what art should be. We watch as he struggles to make sense of it all, trying on different artistic guises until, finally, he assimilates these disparate influences and arrives at a synthesis distinctly and powerfully his own.

In the two years Van Gogh lived in Paris, his art underwent a metamorphosis perhaps as rapid and surprising as any in the history of art. Crucially, the experience changed not only the way he made art but the way he thought about it, the purposes it served, and the means to achieve them. From an artist steeped in the past, he made himself into one fully committed to the future. He arrived as a provincial, clinging to an old-fashioned approach that even Theo knew was hopelessly out of date. By the time he left, he was one of the leaders of the avant-garde who shared the revolutionary impulses of the younger generation. The process was wrenching, forcing him to reimagine the role of the artist and even the meaning of art itself. It is a tribute to Van Gogh's remarkable drive that he emerged from this difficult time emotionally bruised

but professionally accomplished, desperate to escape but carrying in his battered luggage the tools he needed not only to survive but to thrive as a painter of genius.

The story of Van Gogh's artistic coming of age involves a remarkable synergy between a man with his own obsessions and unusual perspective and the most creative city in the world—a world that was, crucially, undergoing its own cultural upheaval at the very moment he arrived. The metropolis Van Gogh encountered was a battlefield in which progressive Impressionists assailed the conservative Academics while defending themselves against sniping from radical Symbolists, where Synthetists skirmished with Divisionists, where rebels proudly styled themselves Incohérents or Decadents, monarchists took up arms against anarchists, and strident nationalists prepared to resist the rising tide of the Socialist International. It was a world of temporary alliances and long-running feuds, where ideas were lethal weapons and no faction could ever hope for a decisive victory. However much Van Gogh himself deplored the combative spirit he found there, he quickly joined his comrades on the front lines, ready, as he said, to "play my part in a battle"[13] against the reactionaries and know-nothings who stood in the way of progress.

Unlike the more familiar tale involving the artist alone with his thoughts or pouring his heart out in letters to his brother, this one involves a large supporting cast—from the brilliant, sardonic Toulouse-Lautrec to the professorial Paul Signac, the cerebral Émile Bernard, and the domineering, charismatic Paul Gauguin. And always there's his brother Theo, not only his guardian angel and sole confidant but also his vital link to the Parisian art world, without whom Vincent would never have been allowed inside the charmed circle.

Not only did the provincial Dutchman learn from his more
sophisticated colleagues, but they too learned from him, particularly
as he grew more confident in his powers and found his own voice.
The future of modern art was largely determined in these crucial
years in Paris, when the various movements that would dominate
the 20th century emerged from the generation that had grown up
in the wake of the Impressionist revolution. It was a drama to which
Van Gogh not only had a front row seat, but in which—to the sur-
prise of many, including himself—he jumped on stage and shifted
the course of the action.

The image of Van Gogh as a lonely dreamer, first presented in the
Mercure de France, is not so much false as incomplete. The hermitlike
aspect of his nature coexisted with another, equally powerful, that
craved companionship and sympathetic understanding. Early in his
career as a painter, he explained to Theo what allowed him to persevere
in the face of almost insuperable obstacles:

> I want to reach the point where people say of my work,
> that man feels deeply and that man feels subtly. Despite my
> so-called coarseness—you understand—perhaps precisely
> because of it. It seems pretentious to talk like this now, but
> that's why I want to push on.
>
> What am I in the eyes of most people? A nonentity or
> an oddity or a disagreeable person—someone who has and
> will have no position in society, in short a little lower than
> the lowest.
>
> Very well—assuming that everything is indeed like that,
> then through my work I'd like to show what there is in the
> heart of such an oddity, such a nobody.

This is my ambition, which is based less on resentment than on love in spite of everything, based more on a feeling of serenity than on passion.

Even though I'm often in a mess, inside me there's still a calm, pure harmony and music.[14]

This need for connection is at the core of Van Gogh's artistic mission. What he found so heartbreaking in Aurier's portrayal of him was the suggestion that his struggle to connect had landed him just where he started, alone in the world, those cords tying him to his fellow man frayed beyond repair.

Van Gogh had to prove Aurier wrong. An artist, at least as he understood it, was the exact opposite of an isolé. Indeed, it was his almost sacramental faith in art and its power to tear down walls that moved him to take up painting in the first place. In the summer of 1880, having struggled through a dark period in which he'd managed to alienate most of his friends and family—and in which he'd lost the religious faith that once sustained him—he reached out to Theo, the one person still willing to give him a sympathetic hearing. His letter, a long, heartfelt cri de coeur, is filled with anguish but also relieved by faint glimmers of hope:

You feel emptiness where there could be friendship and high and serious affections, and you feel a terrible discouragement gnawing at your psychic energy itself, and fate seems able to put a barrier against the instincts for affection, or a tide of revulsion that overcomes you. And then you say, How long, O Lord! Well, then, what can I say; does what goes on inside show on the outside? Someone has a great fire in his soul and nobody ever comes to warm themselves at it,

and passersby see nothing but a little smoke at the top of the chimney and then go on their way. So now what are we to do [to] keep this fire alive inside.[15]

The answer turned out to be—become an artist! From this moment he made it his life's work to reveal the fire that blazed within him, to allow "what goes on inside show on the outside." Painting, like his earlier passion for preaching the gospel, involved establishing a bond between one human being and another. It made no more sense to paint in isolation than it did to preach the word of God to the trees; each activity involved striking a spark capable of leaping across the divide and kindling a flame in another heart.

By the winter of 1886, Van Gogh was as far from his goal as ever. He'd been laboring at his craft for more than five years with little to show for his efforts. His drawings remained clumsy, his paintings murky and unappealing. He was unable to sell a single drawing, much less support himself through his art. He was plagued by doubt, and even the loyal Theo was losing patience. After a string of discouraging setbacks, he faced the prospect of another failure and another winter alone.

Paris, Theo's home for the past seven years, offered him the only path forward. Here Vincent's younger brother had risen to a position of respect and responsibility, while he was going in the opposite direction. Might not some of that success rub off on him? Theo could not only provide emotional and financial support, but he was well connected to the city's vibrant art community and could ease Vincent into circles that would otherwise be closed to someone of his limited abilities.

Paris held out hope—perhaps Vincent's last—of a new beginning. Practical considerations may have been the immediate precipitating factor, but the psychological imperative was at least as compelling. After years of self-directed toil, Van Gogh longed to rub shoulders with

other artists and art lovers, to be among fellow strivers and to prove to them—and to himself and to Theo—that he belonged to the sacred brotherhood. Thus far he'd been working almost entirely on his own and with little formal instruction, and thus far the world had greeted his efforts with derision. Paris would be different. Surely among the thousands who made their careers, and sometimes their livings, plying the brush, the pen, or the chisel, there would be at least one or two congenial souls who would take him under their wings and lead him to the promised land.

Only a few months earlier, he'd written to Theo: "I desire nothing other than to live deep in the country and to paint peasant life."[16] The decision to plunge instead into the frenetic heart of Europe's most cosmopolitan city was an admission that he needed to find another way. It was the desperate gamble of a desperate man.

Vincent van Gogh arrived in Paris on a cold February morning in 1886, stepping onto the platform of the Gare du Nord, where he braced himself against the onrushing crowd. He was exhausted, broke, and beaten down. But he was not without hope. Here, he believed, was a chance for redemption, a chance to reveal to the world that the fire, long hidden from view, still burned within.

1

Two Brothers

"I adored him more than anything imaginable, & we were extremely close to one another for several years."
—Theo van Gogh

"Like everyone else, I have need of relationships of friendship or affection or trusting companionship, and am not like a street pump or lamp-post, whether of stone or iron, so that I can't do without them without perceiving an emptiness and feeling their lack."
—Vincent to Theo

Theo van Gogh was at his gallery on the boulevard Montmartre when a messenger arrived with a note from his brother—a few hastily scrawled lines announcing his arrival in Paris:

My dear Theo,

Don't be cross with me that I've come all of a sudden. I've thought about it so much and I think we'll save time this way. Will be at the Louvre from midday, or earlier if you like. A reply, please, to let me know when you could

come to the Salle Carrée. As for expenses, I repeat, it comes to the same thing. I have some money left, that goes without saying, and I want to talk to you before spending anything. We'll sort things out, you'll see. So get there as soon as possible.[1]

How like Vincent! To hide his plans until it was too late to do anything about it and then dismiss any objections with an airy "we'll sort things out."

Theo's heart sank. Vincent in Paris meant his well-ordered life was about to be thrown into turmoil. And by giving him no advance warning, he'd made sure to maximize the disruption.

Still, if the timing was awkward the move itself didn't come as a complete shock. Over the years they'd discussed the possibility of living together, though each of them had misgivings. Once inseparable, their lifestyles had diverged to such an extent that setting up a joint household would demand concessions neither was willing to make.

But over the past few weeks, Vincent's tone had changed. Three months after arriving in Antwerp—in one of those impulsive moves that characterized his peripatetic existence—he was struggling, lonely, in poor health, and unable to make progress in his art. The monthly allowance Theo sent him and that was his sole means of support should have been more than adequate for his needs, but with his extravagant spending on art supplies, models, and prints to decorate his walls he barely had enough left over to feed himself.

The worse life got in Antwerp, the more Paris beckoned. Visions of fraternal bliss filled Vincent's head. He pictured strolls with his younger brother along the boulevards deep in conversation—an urban reprise of the walks they used to take through the fields of their boyhood home—followed by tours of the city's museums, where they

could explore their shared passion for beautiful things, a meeting of minds and hearts too long deferred. Moving to Paris was not only the fulfillment of a lifelong dream but, he now insisted, eminently practical as well. To prove his point, he filled his letters from Antwerp with half-baked schemes for making a little money by setting up a portrait studio or selling his drawings to the city's many illustrated magazines.

But just as Vincent warmed to the idea, Theo pulled back. Over the past few weeks, he'd done everything he could to put him off, hoping to at least postpone the move until he was better prepared to receive him. For every point Theo raised in favor of delay, Vincent countered with five demonstrating why it made sense to seize the moment. "Let's not delay or get involved in long-winded discussions,"[2] he urged, pushing his latest plan with a vehemence that unnerved his more cautious younger brother.

It's not that Theo didn't see advantages in having Vincent close at hand, where he could keep an eye on him. In fact he'd been the first one to suggest the move over five years earlier, when Vincent was just starting out as an artist and could profit from the unparalleled opportunities to learn his trade.[3] But now was simply the wrong time. First of all, Theo was short of money; sales at the gallery had been slow, and his employers registered their disappointment by decreasing his annual bonus. And in any case his apartment on the Rue de Laval was too small. Living on top of each other would make an already difficult situation almost impossible.

What he couldn't tell him was that even at a distance he found his brother exhausting. Vincent's tendency to quarrel about anything and everything, his unpredictable moods, veering from elation to despair and back again seemingly at random, took a toll even when their only form of communication was through the letters that poured forth from his pen in an endless stream.

For the fastidious Theo, Vincent's chaotic habits and questionable hygiene were another hurdle. The thought of living under the same roof—something they'd not done since the older brother left home at the age of sixteen—filled Theo with dread. Once his lease was up in June, he told him, they could think about renting a bigger place together. Then Vincent could set up his own studio, an arrangement that would allow him to work in peace and spare Theo the disorder that seemed to follow him wherever he went.

Hoping to forestall him, Theo proposed an alternate plan: Why not return to the family home for a few months, which would save money and allow him time to make the necessary arrangements? In Nuenen—a rural village located in southern Holland, the region known as Brabant, where both of them had grown up—he'd have plenty of time and space to work on his painting, surrounded by the rustic countryside, which was far more congenial to him than city life. This way he'd also be able to help out their recently widowed mother. She would soon be moving to Breda, and Vincent could make himself useful packing up the family home. Coming to Paris without first laying the groundwork and setting some ground rules was a recipe for disaster.

Vincent disagreed. "I definitely need to tell you that it would reassure me greatly if you were to approve my coming to Paris much earlier than June or July if need be," he shot back on February 11, after Theo vetoed the move.* "The more I think about it, the more desirable this appears to me."[4] Against Theo's sensible advice, Vincent unleashed a volley of counterarguments. He brushed aside Theo's suggestion that he help their mother, pointing out that she could easily hire a couple of local

* We have to infer most of Theo's arguments from Vincent's responses since we don't have the latter's originals. This is usually the case when dealing with their voluminous correspondence, since Theo saved almost everything Vincent wrote while Vincent was a far more careless custodian of his brother's memory.

workers to pack up the house. In any case, he was barely on speaking terms with her and his oldest sister and couldn't bear the thought of months having to face their icy disapproval.

Vincent went on to attack his brother for his stinginess, dismissing his worries about money as shortsighted: "I don't think that you can reasonably ask me to go back to the country for the sake of perhaps 50 francs a month less, when the whole stretch of years ahead is so closely related to the associations I have to establish in town, either here in Antwerp or later in Paris."[5] Ignoring his own spendthrift ways, he crunched the numbers, proving that living together would actually reduce expenditures.[6] Throughout this discussion Vincent (implausibly) portrayed himself as the more practical one. "I'm beginning to object more and more to your imagining yourself to be a financier and thinking the exact opposite of me,"[7] he snapped. As always, he claimed his greatest extravagances were actually sound investments, repeating in various iterations the old adage about wisdom when it came to pennies and folly when it came to pounds. "Don't take it amiss of me if I also calculate what's possible and impossible for once,"[8] he lectured Theo without a trace of irony

Most of all, he insisted, the demands of his art made it necessary to make the move immediately: "Of course all my attention is concentrated on gaining what I want to gain. Namely a clear field to make a career. Namely to find my feet instead of going under. . . . I've already told you that there's no reason to go and work in the country again for the first year—that it's infinitely better for the whole future if I draw plaster casts and nudes in town."[9]

Drawing from plaster casts and hiring nude models so that he could perfect his skill in rendering the human form were all part of a scheme guaranteed to pay dividends in the near future. Portraits provided the surest route to financial security, he explained.[10] Any delay now would

simply put off the moment when he could expect some return on the outlay he'd already made. To Vincent, Theo's resistance was not only ungenerous but foolish.

Still fuming, Theo set out for the Louvre. This sprawling Baroque palace, formerly the home of kings, was now home to the world's greatest collection of artworks, a monument to the imperial reach and cultural preeminence of the French nation.

Much as he loved his older brother, Theo wasn't looking forward to this reunion. The tone of Vincent's note had been conciliatory, even apologetic, but Theo had enough experience of his brother's mercurial temper to know that contrition was usually the prelude to defiance, promises to do better followed by a return to the same destructive pattern. They'd last seen each other in July, during a visit to Nuenen in the company of his friend Andries (Dries) Bonger. It had not gone well. Then, Theo had scolded Vincent for his profligate ways, to which Vincent responded by claiming that Theo was pleading poverty just for the pleasure of watching him grovel. After his brother left, Vincent, terrified he might be cut off, had tried to patch things up. He penned a letter dripping with pathos in which he compared himself to "a little vessel which you have in tow" and begged him not to sever "the tow-rope [to] my little craft."[11]

The battle over money flared up again in the following months, with Vincent desperate to emancipate himself but unable to cut the purse strings. Seething with resentment, he threw Theo's generosity back in his face, accusing him of wanting to control his life. "I do not want to get embroiled in a second series of quarrels," he growled, "of the kind I had with Father I, with Father II—Father II being yourself. One is enough."[12] There was no reason to expect that living together would change the dynamic: rage followed by remorse then back again in an

endless cycle, an emotional rollercoaster ridden by anyone who tried
to draw close to the temperamental artist.

Vincent had tried to soften the blow of his unannounced arrival by
choosing for their rendezvous a place that held deep emotional reso-
nance for them both. If the *grand tradition* in art had a holy of holies,
a shrine where the highest achievements in painting were treated like
divine relics, it was the grand Salon Carré of the Louvre. This magnifi-
cent gilded hall was home to many of the world's greatest masterpieces,
including the *Mona Lisa*, Rembrandt's *Holy Family*, and Veronese's vast
Marriage at Cana. "I wish that we could spend a few days together in
the Louvre and could just talk,"[13] Vincent had written a few weeks
earlier. Here he could remind Theo of the bond they shared as art
lovers, offering a vision of a life pursuing a common goal. This had
always been his fondest dream: a collaboration of equals rather than a
relationship of dependence, a true partnership based on mutual affec-
tion and shared ideals. In Paris, that dream might actually come true.

Theo knew better. None of Vincent's dreams were realizable, and
none of them came cheap. The more soaring his rhetoric the more
quickly he squandered his money, without the slightest thought for
how hard Theo worked to earn it. His sense of entitlement was galling,
as was his penchant for indulging in emotional blackmail. "Am I less
than your creditors?" Vincent had demanded a month earlier, after
Theo urged him to stick to a budget:

> Who should wait, *they* or *I*??? . . . And do you have any
> notion *how heavy* the burdens that the work demands every
> day are for me, how hard to get models, how expensive
> the things needed for painting? Do you realize that it's
> sometimes almost literally impossible for me to keep going?
> And that I *must* paint, that too much depends on pressing

on with the work here with assurance *immediately* and WITHOUT HESITATION? A few weaknesses could make me fall in a way from which I wouldn't recover for a long time. My situation is perilous on all sides and can only be won by working on determinedly.[14]

That Theo continued to support his brother in the face of this ingratitude revealed the strong sense of obligation to family that had been drilled into him from an early age. But there was more to it than that. In those rare moments of calm, when he was able to look past his brother's inconsiderate behavior, he still had faith in Vincent's star. Yes, that faith was tested almost every day, often dimmed by anger at Vincent's manipulative ways and frustration at his stubborn refusal to take sensible steps to advance his career. But deep down he still clung to this belief, which sustained him at his darkest moments. It was a belief that had been there from the earliest days of his youth, when he would listen worshipfully as his older brother held forth on his latest passion, his words tumbling out in a brilliant cascade that both confused and delighted the boy. Even now, through all the trials and heartbreaks, the disappointments and near disasters, it was vital to his own sense of well-being to keep that faith alive.

Theo was prepared for the worst, but catching sight of his brother across the crowded hall still gave him a shock. Vincent stood with his back to him, all alone, subjecting the painting that had caught his eye to a probing inspection, oblivious to everything else. He made a striking contrast to the other visitors, dressed in their Sunday finery, a gaunt figure from another world. In his paint-spattered overcoat, worn boots, and fur cap bedraggled by years of exposure to wind and rain, he was

described by one museum visitor as looking like "a drowned tomcat."[15] He ignored the stares and whispers of his neighbors, who gave him a wide berth, disconcerted as much by the intensity of his gaze as by the oddness of his clothes.

More concerning to Theo was the physical toll the last few months had taken. Thin to the point of emaciation, with hollow cheeks covered by a stubble of red beard, his eyes sunk deep in dark sockets, Vincent was a picture of suffering and neglect. He'd already provided his brother with a preview. In a bid for sympathy, and in an attempt to extract concessions, his letters from Antwerp chronicled every digestive trouble, every rotten tooth and psychological trauma he'd endured. But seeing Vincent here in the ravaged flesh drove home once more the agonizing cost of his struggles with himself and with the world.

As they embraced, intractable quarrels were temporarily forgotten. There were likely tears, a testament to the fraternal bond often strained but never broken, of a love that made every slight or disappointment that much more painful, that dragged down as much as it lifted up, but that would survive every test and emerge stronger. To the casual observer they must have seemed an odd couple. The physical resemblance was pronounced, but so were the contrasts, a subtle play of theme and variation that suggested kinship but also vast differences in personality and circumstance. Both had the same high forehead, prominent cheekbones, and close-set eyes—green in the older brother, pale blue in the younger. Though not yet thirty-three, Vincent's face was already heavily creased, exhibiting the wear not only of his four additional years but of physical and emotional hardship; Theo still possessed a softness that made him seem even younger than he was, a youth just arriving into full manhood. Vincent's coarse hair was cropped short in bristly

spikes, his beard ill-cut with a reddish hue he often exaggerated in his self-portraits for expressive effect, while Theo's hair and sparse mustache were finer and shaded to pale blond. Both were of medium height, but while Vincent, even in his reduced state, projected a certain rugged vigor, Theo appeared almost frail. When she met Vincent for the first time a few months before his death, his sister-in-law remembered him as "of medium height, rather broad-shouldered [giving] the impression of being rather strong and sturdy."[16] Her husband Theo was "more delicately built and his features more refined."[17]

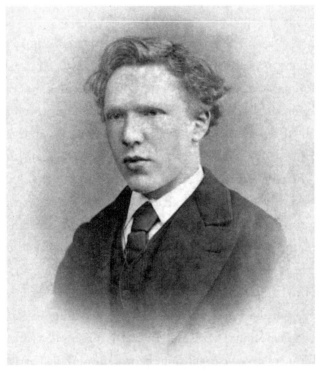

Vincent van Gogh, age 19

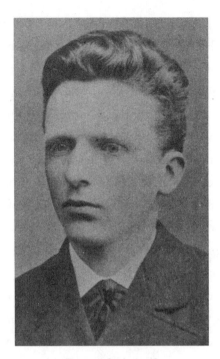

Theo van Gogh age 18

Contrasts in manner were even more striking. In a crowded room or on a city street, Vincent radiated a ferocious vitality, his focus on whatever had caught his attention so intense that he temporarily shut out everything else. His indifference to how others viewed him, his defiance of convention, instinctively caused strangers to avoid him. Theo, by contrast, was keenly aware of how he appeared in others' eyes and calibrated his look accordingly. Over the six years he'd lived in Paris, he'd adapted to its rhythms. Loyal service to his firm had lifted him into a position of responsibility, and a slow rise in income allowed him to dress the part. Like any practiced boulevardier, his instinct was to conform, to become just one more elegant face in the elegant crowd, the better to observe his neighbors with ironic detachment. His well-tailored suit and silk cravat constituted the uniform of

a successful businessman, someone whose job it was to put customers at their ease and create a pleasant, but not memorable, impression. Like many fundamentally shy people, he glided frictionlessly through his cosmopolitan habitat, while Vincent, always girded for battle, demanded more of the passerby than he would willingly give.

A closer look would have revealed affinities lying just beneath the surface—a certain wariness, a hypersensitivity or vulnerability, which caused one brother to assume a pose of studied savoir faire while the other, with less ability to dissimulate, was always on his guard, as if expecting a sudden attack. No doubt these affinities would have been more evident were it not for a family dynamic that pulled them in opposite directions. As the older brother strayed further from a conventional path, the younger was forced to hew more closely to the straight and narrow. Vincent's wayward course closed off options for Theo. Left to his own devices, there's little doubt Theo would have enjoyed a more bohemian lifestyle, perhaps even becoming a painter like his older brother. As it was, Vincent had already staked out that territory, and the stresses this placed on the rest of the family trapped Theo into a life that was not necessarily congenial to his sensitive nature. With each passing year Theo was saddled with more responsibility, while Vincent followed his errant course with scant regard for how this impacted those closest to him. It was a situation that bred resentment, particularly when Vincent, biting the hand that fed him, sneered at Theo's bourgeois pretensions, refusing to acknowledge that it was his own irresponsibility that condemned his younger brother to a life of drudgery. Their embrace was more a wrestler's clench than a tender hug, as painful as it was close. The coming months would strain their relationship to the breaking point and change them both in ways they could not have predicted.

From their earliest days Vincent and Theo's parents impressed on them and their siblings a strong sense of duty inherited from their Protestant forebears—toward God, toward society, toward each other—though the harsh Calvinism of former generations had yielded to the more worldly form typical of the enlightened 19th century. *Degelijkheid*, the Dutch called it, a solidity that marked anyone who possessed it as a good citizen, perhaps even touched by divine grace. Bourgeois decorum played a central role in this Protestant creed, as important as metaphysics, perhaps more so since how one comported oneself in this world was the outward manifestation of how one was likely to fare in the next. In Theo the requirement to pursue respectability at any cost instilled habits of obedience; in Vincent it was met by an instinct for rebellion.

For this particular branch of the van Gogh clan, the need to present a solid front was made more urgent by the recognition that their status rested on shaky foundations. Each member of the family was drilled in the virtues of showing a brave face to the world, whatever went on behind closed doors and in the even more inaccessible reaches of the heart. "Duty above all other things,"[18] their mother preached, a stoic doctrine that made few concessions to weakness, whether of the mind or of the flesh.*

The ethic of conformity was deeply ingrained in Vincent and Theo's parents, Anna Carbentus and Theodorus (Dorus) van Gogh, both of whom were born into families that embodied, at least on the surface, the ideal of worldly success and the stolid virtues of the Dutch upper middle class. Anna's father, Willem Carbentus, prospered as "Royal

* Anna's fear of scandal was no doubt fueled by secrets in her own family. The eminently respectable Willem died of an unspecified "mental disease," while at least two of her siblings also suffered from similar afflictions. In typical fashion, knowledge of these tragedies was closely held by the immediate family. [See Naifeh and Smith, 16]

Bookbinder" in The Hague, while Dorus's father, Reverend Vincent van Gogh, rose in the hierarchy of the Reformed Dutch Church to become a leader in the "Society for Prosperity,"[19] tasked with preaching the Protestant gospel to the Catholic South. Both Anna and Dorus grew up in large houses, attended by servants and surrounded by material plenty, memories of which continued to shape their view of the good life even as the present strayed further from that ideal. Vincent would later sneer at what he called his "family perhaps not entirely devoid of prejudices and other similarly honourable and fashionable qualities,"[20] determined to find more enduring principles upon which to build a life.

Dorus was the only one of the elder Vincent van Gogh's six sons to follow him into the ministry, but despite this evidence of filial devotion there was always a faint whiff of failure about him, as if he did not quite live up to the standard set by the father. Or by his older siblings, including Johannes, who rose to the rank of rear admiral in the Dutch navy, and Vincent (known as Cent), who made a fortune in the expanding business of selling art prints to the prospering middle class. Dorus, by contrast, was forced to scrape by on the meager salary of a humble country parson. "We have no money," Anna sighed, adding hopefully, "but we still have a good name."[21]

A diffident, dignified, and somewhat introverted man, Dorus did not possess the ambition or oratorical skill needed to reach the heights scaled by his father. As a preacher he was earnest rather than inspiring, a man of sober virtues, appreciated by his flock for his fundamental decency rather than his leadership. The modesty of his abilities was reflected in the fact that three years after graduating from the University of Utrecht the best position he could find was a posting to the out-of-the-way Zundert, a village in the heavily Catholic region of Holland near the Belgian border known as the Brabant.

Anna Carbentus exchanged the large house in The Hague for the rustic parsonage in Zundert shortly after her wedding in May 1851, settling with her new husband into the tidy two-story house on the town square, close by the small brick church where Dorus mounted the pulpit each Sunday to deliver his halting sermons. Here Vincent was born on March 30, 1853, followed two years later by Anna, and in May of 1857 by Theo.*

For the van Gogh children, memories of those days formed an ideal against which later realities were compared and usually found wanting. "Their childhood was full of the poetry of Brabant country life," wrote Theo's wife, Jo:

> They grew up among the wheatfields, the heath and the pine forests, in that peculiar sphere of a village parsonage, the charm of which stayed with them all their lives. It was not perhaps the best training to fit them for the hard struggle that awaited them both; they were still so very young when they had to go out into the world, and during the years following, with what bitter melancholy and inexpressible homesickness did they long for the sweet home in the little village on the heath."[22]

Vincent in particular recalled his childhood home with a sometimes unbearable yearning, the familiar landscape of southern Holland

* There were six children, excluding a child (also named Vincent) who was stillborn a year before the artist: Vincent, 1853; Anna (1855); Theo (1857); Elisabeth (Lies) 1859; Willemina (Wil), 1862; Cornelis (Cor), 1867. Some biographers have made much of the psychological trauma caused by bearing the name of a deceased sibling, but there is no evidence that the second Vincent's psyche was damaged by what was, after all, a rather common occurrence in those days.

forming a kind of talisman of love and belonging, a lost paradise that for the rest of his short life he could summon with almost photographic clarity. "Memories of times past came back to me," Vincent wrote to Theo many years after he'd left the family home, "including how often we walked with Pa to Rijsbergen and so on in the last days of February and heard the lark above the black fields with young green wheat, the shimmering blue sky with white clouds above—and then the paved road with the beech trees—O Jerusalem Jerusalem! or rather Zundert O Zundert!"[23] Conflating his childhood home with the Holy Land, he invested this simple scene with an emotional intensity we find in many of his paintings, where an ordinary rustic landscape can become the site of cosmic drama.

His sister Lies (Elisabeth) struck a similarly aching note when she described her "free, unhampered existence," playing in the garden with her brothers and sisters. "Back of the children stood the house," she recalled of one emblematic day, "while stretching out before them as far as the eye could see, lay the fields of rye until lost in a pale gray line on the horizon. There were meadows and the fruit farms . . . through which a small Brabant stream was gliding under a near-by gleaming white bridge."[24]

But even Lies, for all her loyalty to her family and worshipful attitude toward her oldest brother, could not entirely conceal the fact that trouble crept early into this Eden. "Brother and sister were strangers to him," she wrote of the seventeen-year-old Vincent, "as well as his own youth." When the rest of them romped in the yard, Vincent rarely joined them: "Without a greeting the brother passed by, out of the garden gate, through the meadows, along the path that led to the stream."[25] Ignoring the boisterous laughter of his younger siblings, "he sought solitude, not the companionship of his family."[26] Alone among the woods and streams, the teenage Vincent withdrew into a

world of his own making, a stranger even in the intimate circle of their Zundert home.

In some biographies Vincent's parents are cast in the role of villains: cold, unbending, unable to provide the nurturing environment their gifted son required. Here in embryo is the myth, later elaborated by the critic Aurier, of a sensitive soul forced into exile by an indifferent world. The truth is that while Anna and Dorus had rather rigid views, they strived to create a loving home for their six children, including Vincent, who ultimately pushed them beyond their limited capacities. Elisabeth paints a pious, sentimental portrait of her parents, describing them as an "honored couple" living "in undisturbed married felicity spinning threads of love and loyalty around the hearts of their neighbors."[27] She ignores the darker shades. Both Anna and Dorus suffered from periodic bouts of depression, which they fought by hewing tightly to the path of duty and through strict adherence to convention. By suppressing the outward expression of inner turmoil, they believed, those demons would lose their power. "Learn the normal life more and more," their mother urged her children.[28] This willful neglect of the gloomy regions of the human soul gave them little empathy for the excesses of their oldest child. Visitors to the parsonage described him as "a queer one" with "a difficult temper,"[29] eccentricities that perplexed and embarrassed his parents, who put a premium on conformity. Still, given the expectations of their class and the conventions of the age, they did their best to save him from torments of his own making.

Though Vincent could be withdrawn or even hostile in the presence of his family, he also had a desperate need to be wrapped in the warm embrace of those who knew him best, conflicting emotions that led to endless strife. One searing memory involved being sent away from home at the age of eleven to attend school in Zevenbergen, a town twelve miles to the north of Zundert. As always when recalling an

emotional scene, he painted it in precise colors, unrequited longing
calling forth his most vivid images:

> It was an autumn day and I stood on the front steps of
> Mr. Provily's school, watching the carriage drive away that
> Pa and Ma rode home in.
>
> One could see that yellow carriage in the distance on
> the long road—wet after the rain, with thin trees on either
> side—running through the meadows. The gray sky above
> it all was reflected in the puddles. And around a fort-
> night later I was standing one evening in a corner of the
> playground when they came to tell me that someone was
> asking after me, and I knew who it was and a moment later
> I flung my arms round Father's neck.[30]

This heartbreaking image of the homesick boy standing alone in
the corner of the playground is perhaps Van Gogh's most authentic
self-portrait; the image of the tearful embrace is equally poignant.
Tragically, these longed-for reunions never matched the idyll he con-
jured in his imagination, leading to disappointment and resentment
and leaving a void that he would ultimately fill by creating another,
better reality in his art.

From the beginning Theo was seen in the family as Vincent's tem-
peramental opposite, a ray of hope to pierce the dark pall so often cast
by his older brother. "A friendly soul from the moment he was born,"[31]
his sister recalled, he was warmhearted, eager to please, and naturally
sociable. Four years Vincent's junior, and thus exactly the right age to fall
under his spell, the younger brother at first idolized the older. "I adored
him more than anything imaginable," Theo remembered of these early
days, "& we were extremely close to one another for several years."[32]

Vincent, for his part, found in Theo the receptive audience he craved. Still too young to form independent judgments, Theo would hang on his every word. Vincent's first enthusiasm, which he imparted not only to Theo but to his other siblings, was an intense love of nature, manifested in his obsessive collecting of specimens: of beetles, butterflies, birds' nests, and all manner of unsightly debris that he dragged into the house, much to the dismay of his mother, who prided herself on her tidiness. A few years later this obsession with beauty was transferred to the world of art, manifested in an equally obsessive collecting of prints—an inexpensive medium that allowed him to indulge his hoarding instincts. He conveyed these passions to his admiring younger brother, though in Theo they never took on the manic dimensions they did in Vincent. "He took me under his wing when I was just starting out," Theo recalled, "& it is to him that I owe my love of art."[33]

To everyone else Vincent appeared odd, ill-mannered, and lacking any sense of proportion. Even the tactful Lies was forced to admit he "never felt any need for society" and "was a stranger to her laws and her convention!"[34] Whatever topic grabbed his fancy he pursued with fanatical devotion, contemptuously dismissing those who didn't share his obsession of the moment. These characteristics, already apparent to his own family, were even more glaring when he was among strangers. At the Willem II school in Tilburg, which he began attending when he was thirteen, he was described as aloof, argumentative, occasionally erupting in anger but more often avoiding the other children altogether. In a preview of his Parisian journey less than two decades later, the fourteen-year-old showed up one evening unannounced on the doorstep of the Zundert parsonage, having walked out of school to make the thirty-mile journey on foot.

As on that later occasion, Vincent's unexpected arrival was deliberately disruptive, or at least made without regard for how it might impact those around him. Imposing himself and his eccentric habits on his family, he threw their cherished routines into chaos. Anna and Dorus, acutely aware of their position as role models to the small Protestant community, suffered the shame he brought upon the entire family. How could the minister lecture his parishioners on the virtues of obedience when he could not even command it in his own son?

While at boarding school in Tilburg, Vincent dreamt of home, but at home he kept ever more to himself. His normal sullenness increased with the knowledge that he'd disappointed his parents. Unwilling to face their reproaches, he holed up in his room with his books or took long walks in the countryside, feelings of shame increasing his tendency to withdraw into himself.

At first Theo's easygoing nature helped reduce the friction between Vincent and his parents. He was a natural peacemaker, his eagerness to smooth things over a balm to a family sorely in need of relief. But by the time Vincent left school—for good, as it turned out—the difference in their characters began to work to the older brother's disadvantage, inviting comparisons by which he could only lose. As worry increased over Vincent's aimless existence, Anna and Dorus began to place more of their hopes in their second son. "Dear Theo," they wrote to him a few years later, as he was taking his first steps up the ladder of success, "remain the pride and joy of the parents who are being shaken so often . . . It's a ray of sunshine in these uneasy days."[35] This tendency to measure one son against the other began early and grew more pronounced with every misstep on Vincent's part and every triumph of Theo's. As Vincent floundered their parents heaped praise on the second son.

The realization that he wasn't the favored child stoked Vincent's sense of grievance. He punished his parents for their betrayal by

digging in and lashing out, which merely confirmed his status as the black sheep. Differences in temperament led to misunderstanding, misunderstanding to anger, and anger to defiance, a destructive spiral that no one wanted but from which they all seemed helpless to extricate themselves. Perhaps the root of the conflict was simply that Vincent experienced the world with an intensity, both positive and negative, that ran against the grain of his parents' Dutch reserve. His vehemence frightened them, reminding them of dark corners of their own psyches better left unexamined.

As the difficult child grew into the moody adolescent, the strain began to take on the contours of an ideological battle. Dorus and Anna's disapproval of his unconventional habits made him aware of their narrow-mindedness. Vincent felt things deeply; they preferred to dwell on appearance. He couldn't help but speak his mind, while they found virtue in reticence. All the things that seemed to him good and true—the beauties of nature and art, the world of feeling he discovered in the sentimental literature of the age—his parents regarded with suspicion, at least when indulged in with the excess to which he was prone. If moderation was their god, he worshipped at a savage altar, practicing a creed that promised ecstasy and suffering in equal measure.

Anna admonished her children: "Make your paths even and straight"[36]—an impossible demand for her oldest son. Whenever he lurched too far in one direction, he compensated by lurching too far in the other. The middle of the road was the one place he never occupied. Swings in mood and sudden reversals of plan and even of values kept everyone off balance, not least himself. Having defied his parents, he then internalized their disappointment, wallowing in feelings of guilt and self-reproach. This was itself a form of rebellion since such navel-gazing was frowned upon as an unhealthy indulgence. Still, no matter how troubled the waters, Vincent felt more at home in these murky

depths than in the chilly atmosphere of the parsonage, where so much was left unsaid.

For almost a year and a half, Vincent idled while Anna and Dorus fretted. It was during these months that he picked up what he called his "more or less irresistible passion for books,"[37] which allowed him to expand his imaginative life even as the real one was closing in. "Books and reality and art are the same kind of thing for me," he once confessed."[38] Among his favorite authors were Harriet Beecher Stowe, Charles Dickens, and Victor Hugo, novelists whose ability to tug at the heartstrings offered a rebuke to his parents' stoicism and whose sympathy for the unfortunate—Uncle Tom, Oliver Twist, Jean Valjean—struck a chord with someone who increasingly came to identify as one of them.

Desperate to find Vincent some occupation that might cure his malaise, Anna and Dorus turned to Uncle Cent. Dorus's older brother was a wealthy businessman and pillar of the community. A man of refined tastes and broad horizons, with homes in The Hague, Paris, and nearby Princenhage—since 1867 a Knight of the Order of the Oak Crown, an honor conferred on him by King Willem III—he was a role model in the parsonage, where material success was valued almost as highly as moral rectitude. While Dorus had followed his father's profession, it was Cent who carried on the van Gogh tradition of worldly success. Despite the differences in their circumstances, intimacy between the brothers was encouraged by the fact that Cent was married to Anna's younger sister Cornelia. When Cent and Cornelia were at home in Princenhage, frequent visits back and forth drew the families close; the childless couple took an almost parental interest in their various nieces and nephews. Thus it was only natural that in the current crisis Uncle Cent would step in to set his nephew back on course. In July of 1869 he offered Vincent a position

as a junior apprentice in The Hague branch of his international art publishing firm, Goupil & Cie.*

Later that month Vincent departed Zundert to make the fifty-mile journey to The Hague, where he took up lodgings at the home of Willem and Dina Roos at Lange Beestenmarkt 32, just south of Goupil's main gallery on the stately Plaats. At first, the move seemed to do him good. He threw himself into his new career with enthusiasm, finding in his change of address and prospects the fresh start he required. Whatever explanation his parents sought for his recent idleness, sloth was never Vincent's problem. Once he'd set his mind to something, he committed himself fully, overwhelming any doubts by driving himself to the point of exhaustion.

Vincent would later describe these years as "a miserable time,"[39] but to his family he initially projected confidence, hoping to make amends for his recent transgressions through a show of diligence. Working at Goupil's introduced Van Gogh to a new world of beauty that consoled him for the lost beauty of the Brabant countryside. Surrounded by both prints and original paintings, he discovered the joys of nature seen through the eyes and transcribed by the hand of the artist. He plunged into this new world with his typical gusto, replacing his collection of bugs and birds' nests with prints of his favorite artists. As always, he was a tireless proselytizer for his passion of the moment, once again finding in the impressionable Theo the perfect disciple. It didn't take long for Vincent to form strong opinions that he expected Theo to share, explaining which paintings he found particularly beautiful, and which were not worth his time. "Go to the museum as often as you can," he instructed, for "it is good to know the old painters."[40]

* In 1861, Cent went into partnership with the Parisian art dealer Adolphe Goupil, creating one of the most successful international firms working in the exploding market for art reproductions.

He was thrilled when, in December 1872, Uncle Cent found Theo a similar position in the Brussels branch, though the fact that the fifteen-year-old was taken out of school and sent to work was a sign of the family's continuing financial struggles. "I'm so glad that both of us are now in the same line of business, and in the same firm," Vincent wrote,[41] adding in the next letter: "It's such a fine firm, the longer one is part of it the more enthusiastic one becomes."[42] When in January 1873 he received a raise—from forty to fifty guilders a month—he was quick to inform Theo, boasting, "I now hope to be entirely self-supporting."[43] This sign of favor came just in time. His family's strained budget was stretched even further when Vincent was drafted into the Dutch army and Dorus was forced to pay the 625 florins needed to buy a substitute. Vincent, for all his recent truculence, was anxious to prove himself worthy of the sacrifice.

It was during his years in The Hague that Vincent and Theo began their correspondence, perhaps the most revelatory, infuriating, and ultimately moving account of an artist's life ever penned. These letters provide a record of someone always teetering on the edge of a precipice, in which brief moments of stability are followed by long stretches when their author struggles to find purchase on the crumbling ledge. They are filled with profound insights and appalling delusions, human kindness and petty spite. They offer a view of a life close up, a treasure trove of mundane details that provide the gritty texture of his day-to-day existence. He complains, he makes excuses for his bad behavior, he lashes out in angry diatribes. But just when the less appealing aspects of his character threaten to drag us down into the well of self-pity he's dug, he lifts his eyes to scan far horizons. A vast panorama opens up and, should we choose to follow our somewhat eccentric guide, we embark on a journey across the treacherous landscape of the human soul.

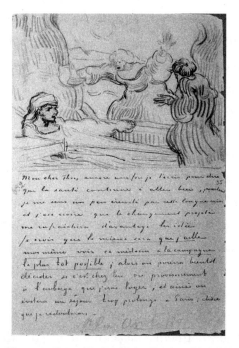

Letter from Vincent to Theo with sketch after Rembrandt's *Raising of Lazarus*

Over the course of seventeen years and running to over 700 letters—
the vast majority, 650, from Vincent to Theo, while fewer than 50 of
Theo's letters to Vincent remain*—the brothers chronicle the details
of their now separate lives, an indication of how closely intertwined

* Among his other siblings, Wil was his favorite correspondent with twenty-one
extant letters. Twelve letters survive to his mother and five to his father. Though
far fewer in number, Vincent's letters to his fellow artists are equally revealing.
Among these, the largest number are addressed to his friend from Brussels,
Anthon van Rappard (fifty-eight). Of the artists he knew in Paris, twenty-two
survive to Emile Bernard and only six to Paul Gauguin. But it's dangerous to
draw firm conclusions from this incomplete record. For instance, the fact that far
more letters exist from Vincent to Emile Bernard than to Paul Gauguin may well
reflect the former's somewhat worshipful attitude. By contrast, Vincent preserved
sixteen letters from Gauguin, while none survive from Bernard. Vincent was
a far less careful steward of his younger brother's letters than Theo was of his,
which skews the record and warps our understanding.

they still are despite the miles that lie between them. They discuss their present difficulties and distant dreams, share their mutual passions and hash out their aesthetic disagreements. They quarrel, often bitterly, about money, about family, about the paths they've chosen in life. But sooner or later they take up the pen once more—sometimes grudgingly, at others to express genuine remorse—unwilling to sever the connection that nourished them both and without which neither of them could survive.

For all their revelatory power, these letters must be used with caution. Vincent is the most unreliable of narrators, with as great a capacity for self-deception as for insight, someone whose views of the world were warped by turbulent emotions that veered suddenly from one extreme to another. But the very fact that Vincent was incapable of providing an objective account is itself revealing, for it is the distorting lens of emotions he could not control that makes his art so powerful. For Vincent no landscape is merely a collection of facts, any more than a portrait is a dispassionate record of appearance. Everything is viewed through the prism of his strange but compelling personality, colored by love or hate, incandescent joy or black despair.

In The Hague Vincent was introduced to the world of art, not yet as a practitioner himself but as an expert in other people's work. Working for Goupil & Cie he familiarized himself with old masters and the recent popular successes at the salons of Paris and his native land, spotting the latest trends and attuned to the fluctuations of the market. Poring over dozens of works each day—both reproductions and originals—he trained his eye and cultivated his taste.

At Goupil's he was able to sample a large variety of prints and paintings, but not everything emerging from the studios of the French capital was included in their stock. In particular, the work of

the Impressionists—the latest provocateurs scandalizing the Parisian art world—was conspicuously absent. Headquartered in Paris on the fashionable Place de l'Opéra, Goupil & Cie favored the work of artists who'd already achieved popular success at the Salon over more experimental art with an uncertain market. There was even a so-called *Goupil School,* which included such crowd-pleasers as Jean-Léon Gérôme, Ary Scheffer, and William-Adolphe Bouguereau, the same academic stalwarts under attack by the Impressionist malcontents. Uncle Cent and his French partner, Adolphe Goupil, made their money catering to the prevailing taste, not anticipating it, and certainly not by going out on a limb to push radical new forms. By the time a painting was hung in a gilt frame on their walls, or sent out for reproduction using one of the many photographic techniques that were just beginning to revolutionize the mass market for art, it had already received the stamp of critical approval and legions of admirers among the buying public.

Still, Goupil's was not entirely immune to changes that were transforming the Parisian art world, even if change came slowly and with an eye toward the market rather than out of conviction. Among the works gaining in popularity were landscapes by the so-called Barbizon painters:[*] Jean-François Millet, Charles-François Daubigny, Camille Corot, and others, whose charming scenes of rural France, once derided by traditionalists, had finally entered the mainstream. These painters had inspired similar movements across Europe, including in Holland, where the Hague School was just beginning to find favor with the critics and buying public. Also known as the "gray school" for their muted views of the Dutch landscape, these local pioneers adopted some of the innovations of the Barbizon painters and their Impressionist

[*] The movement took its name from the village of Barbizon, on the outskirts of the forest of Fontainebleau not far from Paris. These innovative plein-air painters are often seen as the precursors of the more radical Impressionists.

successors, but in a toned-down form pleasing to conservative eyes. Vincent absorbed all these visual riches, storing them away in his capacious memory, where they offered him guidance when he finally took up the brush himself.

Goupil & Cie showroom, The Hague

His years working at Goupil taught him other lessons as well, many of them negative. Here, amid the upholstered sofas, tasseled curtains, and ornate wallpaper of the gallery on the Plaats, artworks were treated as decorative trifles to adorn an elegant townhouse, not vessels of the human spirit touching the deepest chords of our shared humanity. Even worse, as far as he was concerned, they were traded as commodities, multiplied in thousands of inferior copies, their value measured in florins and francs and fluctuating with every speculative bubble. For the rest of his life, Vincent would have a love/hate relationship with the art world, sometimes hoping to use his expertise to cash in, at others angrily rejecting its shallowness and corruption. As yet he

had no concept of the radical innovations coming out of Paris, where a new generation of aesthetic rebels was challenging the Establishment and ushering in the modern era. It was only when he moved to the city in 1886 that he began to absorb the lessons of the Impressionists and their disciples, joining that ragtag brotherhood loosely referred to as the avant-garde.

Burying himself in this exciting new world of art could not disguise the fact that he was floundering. He tried to put on a brave face for his family, but the reality of his life in The Hague was grim. The homesickness he'd suffered in Zevenbergen and later in Tilburg redoubled in the uncongenial urban setting. When he wasn't in the store on the Plaats, he kept to his room at the boardinghouse, reading deep into the night, rarely mingling with the other guests. In his loneliness he turned to the prostitutes who plied their trade nearby in the narrow alleyways of the Geest, the beginning of a lifelong habit in which paid companionship substituted for the real relationships that continued to elude him.

Word of his peccadillos soon reached his father, who admonished him to "tear his heart away from sin."[44] Vincent blamed his boss, the *gérant* Hermanus Gijsbertus Tersteeg (known as H.G.), for tattling on him. Years later Vincent was still seething. "He said things about me which contributed not a little toward putting me in a bad light,"[45] he told Theo.

This handsome, cultured young man, eight years Van Gogh's senior, was to play a prominent role in the artist's life, first as mentor and later as antagonist. Charming and at ease in society in ways Vincent envied but could not emulate, he eventually came to stand for all that was wrong with the fashionable world where art was traded as just one more consumer good, an embodiment of superficiality whose aesthetic

judgments, Vincent sneered, coincided exactly with the price tag a work of art fetched in the market.

Vincent's grudge against Tersteeg involved a mix of ideological disapproval and personal resentment. When he first arrived in The Hague, H. G. Tersteeg was tasked not only with initiating the teenager into the mysteries of buying and selling art but, equally important, keeping an eye on the boss's nephew while he was away from home. Vincent certainly came to regard him as a spy, accusing him of "unsympathetic, schoolmasterly, unfeeling and indiscreet meddling in my most intimate and private affairs."[46]

Struggles in his personal life soon bled into his work. Behind the scenes, in the stockrooms where Goupil's vast inventory was managed, Vincent's enthusiasm and retentive visual memory made him a valued employee. But in the plush public galleries where well-heeled clients browsed works shown off in golden frames, his lack of social graces and brusque dismissal of anyone whose tastes differed from his were a liability. A report from his brief stint in the Paris branch (in 1874) reveals the nature of the problem: "He could not handle customers with tact, but insisted on imposing his own opinions on them, to their disgust and rage. Parisian ladies complained of the manners of 'ce Hollandais rustre' [that Dutch boor], who dared question their taste."[47]

Uncle Cent and his fellow directors made every effort to retain his services, despite his obvious unsuitability. After consulting with his parents, in March 1873 Uncle Cent decided to send Vincent to Goupil's London branch where, significantly, he would not be required to interact with the public. "Goupil has no gallery in London," Vincent explained to Theo, "they only supply the trade."[48]

It was a miserable prospect for the homesick twenty-year-old. Vincent already found the hectic pace of The Hague a strain on his nerves. How much more abrasive would he find life in Europe's largest

city, one, moreover, where his imperfect command of the language was likely to add to his sense of isolation. But he could hardly refuse. Still determined to be the dutiful son and aware of how much his family had sacrificed on his behalf, he set out with a heavy heart. Passing through Paris—"too large, too confused"[49] were his first impressions—he stayed only long enough to visit the annual Salon and tour the galleries of the Louvre before setting off across the Channel, arriving in the English capital on May 19, 1873.

Vincent's transfer to London accelerated his alienation from his family and their bourgeois values, and from society in general. He couldn't help feeling he was being exiled to some distant place where he wouldn't prove an embarrassment to his wealthy and well-connected uncle or a burden to his family. According to Jo Bonger, the time he spent in London marked the true break in Vincent's life, the moment he went from a moody but relatively normal young man to a troubled adult incapable of making his way in the world. "There, without any family life," she wrote, "he grew more and more silent and depressed."[50]

In his loneliness he formed an inappropriate attachment to his landlady's daughter, Eugenie Loyer, who at the time was engaged to another man. Writing to Theo in August 1874, their mother only hints at the trouble: "Vincent will also not have had it easy at the Loyerses'—I'm glad he's no longer there, there were too many secrets there and no family like ordinary people, but he will surely have been disappointed by them and his illusions will not have been realized—real life is different from what one imagines."[51]

Neither Vincent nor his family recorded the details of the relationship that Jo called his "his first great sorrow,"[52] but if it resembled most of his subsequent liaisons it existed largely in his own head. His sister Anna, who had a front-row seat since she'd moved in with her brother while seeking a position as a governess in England, observed sourly:

"I believe that he has illusions about people and judges people before he knows them, and then when he finds out what they're really like and they don't live up to the opinion he formed of them prematurely, he's so disappointed that he throws them away like a bouquet of wilted flowers."[53] Vincent's faulty judgments about the people in his life (both good and bad) are a constant theme among those who knew him best, explaining perhaps the power of his portraits, rendered with a hypnotic intensity that reveals less about the sitter than about the man who painted them.

In the wake of this disappointment, disgusted with the vanities of this world and with his own weakness, Vincent found his way to the Metropolitan Tabernacle, located a few blocks from his boardinghouse. Here, surrounded by hundreds of his fellow worshippers, he listened spellbound as the charismatic Baptist preacher Charles Haddon Spurgeon urged them to feel Christ "to be near of kin to you. . . . bone of your bone flesh of your flesh."[54] Spurgeon's populist Christianity largely dispensed with forms, rituals, and even theology, encouraging an intimate one-on-one relationship with the Savior. How different this was from the dour Christianity of Vincent's father! It was full of warmth and passion, appealing directly to the heart while disdaining reason. This hopeful message was tailor-made to appeal to a lonely young man far from home. Cut adrift from his family, incapable of forming lasting friendships, he found a sense of belonging in the expectant crowds at the Tabernacle and consolation in the joyful words pouring forth from the pulpit.

Only a year earlier, when Dorus admonished him to "tear his heart away from sin," Vincent had responded by feeding a religious tract his father sent him, page by page, into the fire. Now he made one of those sudden reversals that mark his life. He embraced Dorus's piety, though in a form that was alien to the father's reserved, cerebral nature. Vincent

plunged in heedlessly, both body and soul, his newfound commitment to his God filling the void left by his failures in other walks of life. He poured out his convictions in letters to Theo. "To act on the world one must die to oneself," he proclaimed:

> The people that makes itself the missionary of a religious thought has no other country henceforth than that thought.
>
> Man is not placed on the earth merely to be happy; nor is he placed here merely to be honest, he is here to accomplish great things through society, to arrive at nobleness, and to outgrow the vulgarity in which the existence of almost all individuals drags on.[55]

Over the next months and years, Vincent bombarded his family with almost daily sermons, homilies, philosophical digressions, and pious observations, obsessively filling his letters with long passages from Scripture. Theo, as always, bore the brunt of his furious attention, as Vincent proselytized for his latest enthusiasm. "You should also go to church every Sunday if you can," he urged, "even if it isn't so very beautiful; do that, you won't regret it."[56] One of his sisters summed up the reaction of the family, or at least the younger generation, to Vincent's latest mania: "His religion makes him absolutely dull and unsociable."[57]

For his parents the change was more unnerving, suggesting a loss of balance, perhaps even a slide into the insanity that ran like a dark stream through the generations of van Goghs and Carbentuses. He grew dangerously thin, and his performance at work continued to suffer. In October 1874, Vincent was transferred temporarily to the Paris branch, but even the French capital's unparalleled artistic riches could not distract him from the word of God. In his letters, reports on his favorite artists—Millet, Jules Breton, Corot, and other Barbizon

painters—compete for space with pious observations. Just as he'd taken Theo's artistic education in hand, now he turned to the far greater task of saving his soul. "Let us trust in God with all our heart and lean not unto our own understanding. God's will and not ours,"[58] he admonished. He even begged him to discard (as he had) those modern novels and histories they both loved but that might turn his eyes from heaven. "Read no more Michelet or any other book (except the Bible) until we've seen each other again at Christmas,"[59] he instructed.*

Vincent's contempt for Goupil's clientele only grew as he came to equate lapses in taste with moral failings. By the time he visited his family over Christmas break in 1875, it was clear to everyone what would come next.** "I almost think that Vincent had better leave Goupil within two or three months," Dorus wrote to Theo: "there is so much good in him, yet it may be necessary for him to change his position. He is certainly not happy."[60] Though Dorus seemed to think—or wanted Theo to believe—the decision was Vincent's, the truth is that he was asked to leave. Vincent admitted as much some years later, recalling: "[They] just told me, 'You are an honest and hardworking employee but you set a bad example to the others.'"[61] Out of consideration for his brother, if not for his nephew, whom he now regarded as beyond the pale, Uncle Cent kept him on until April, easing the shock and allowing him time to plan for the future.

* Jules Michelet was a radical French historian, the scourge of political and religious conservatives. When Vincent later rejected organized religion, he returned to Michelet. Later, whenever Vincent wished to provoke his father, he ostentatiously carried around a volume of his work. He inscribed his drawing *Sorrow* with a quotation from Michelet: "How can there be on earth a woman alone."

** This was not in Zundert but Helvoirt, where the family had moved in 1871. Over the course of his peripatetic career, Dorus was transferred every few years to another town in the Catholic South. In 1875 the family moved to Etten, and in 1882 to Nuenen.

Though by then he'd come to despise everything Goupil's stood for, Vincent was humiliated. His failure was made all the more painful when contrasted with his younger brother's continued success in the family-run firm. In the fall of 1873, a few months after Vincent moved to London, Theo was transferred from Brussels to The Hague, taking over his brother's former position in a symbolic replacement that only drove home their diverging fortunes. Working under his former boss, *gérant* H. G. Tersteeg, Theo excelled in the aspects of the business that had proved so difficult for Vincent to master. "How happy and grateful we are that you take pleasure in your work," Dorus wrote him. "If only V. had that too! His outlook on life does tend to be a bit too morbid."[62]

For Anna and Dorus, Vincent's struggles were not only painful to watch but a reminder of their own tenuous hold on respectability. As the older brother continued to struggle, the younger was cast in the role of savior. They called Theo "the crowning glory of their old age."[63] More ominously, Dorus compared their story to that of Jacob and Esau, in which the younger son usurps the rightful place of the older.[64] When they were younger, Vincent had set the pace and Theo happily tagged along, captivated by his older brother's brilliance and swept along by the intensity of his convictions. Now, though Vincent still tried to dominate his younger brother, haranguing him from afar on matters both religious and aesthetic, Theo's conventional success allowed him to at least hold his own, even to push back when Vincent tried to bully him. Their relationship became, if not exactly one of equals, a more evenly matched contest of wills, each bringing to the battle different strengths and strongly held convictions.

With his expulsion from Goupil's, Vincent strayed permanently from the path his parents had mapped out for him, moving further with

each passing year from the status of middle-class respectability they'd set as the goal for each of their children. His journey in search of a purpose in life initially took him back to England, where he found a position as a lowly teacher's assistant in a small boys' school, in the village of Ramsgate, on the southeast coast. A few months later he took a similar position in the London suburb of Isleworth, tutoring, his sister recalled, "scholars belong[ing] to the very lowest class of small London shopkeeper."[65] This marked a steep decline in his standard of living. He was now marooned on the very margins of society, barely able to feed and clothe himself. At first he resented this descent down the social ladder; he would soon come to accept and later to embrace his outsider status.

Vincent knew what a disappointment he was to his parents, but he still craved their love and approval. A prodigal in search of a way home, he sought consolation in faith. "We've often parted from each other already," he wrote as he set out once more into exile, "though this time there was more sorrow than before, on both sides, but courage as well, from the firmer faith in, and greater need for, blessing."[66] One passage from the Bible spoke to him with particular poignancy, and he often quoted it: "sorrowful, yet always rejoicing"[*67]—words that offered him consolation as he embarked on his own tortuous pilgrimage and that helped him navigate both the highs and lows he encountered along the way.

Religion sustained him far from home, the one anchor in a life otherwise adrift. In an effort to live out his faith, he tried his hand at preaching, delivering sermons at the Wesleyan Methodist Church in Richmond. "When I stood in the pulpit I felt like someone emerging

* "As sorrowful yet always rejoicing; as poor yet making many rich, as having nothing and yet possessing all things." [2 Corinthians 6:10]

from a dark, underground vault into the friendly daylight,"[68] he exalted, hinting at a renewed purpose. But his enthusiasm proved short-lived. Despite his obvious sincerity he had no ability to communicate with his flock, hampered by his broken English, convoluted reasoning, and halting delivery.

He returned to Holland in January 1877, having found neither joy nor fulfillment far from home. Painfully aware of his own shortcomings and wracked by guilt, he still hoped for redemption: "O Theo, Theo, old boy, if only it might happen to me and that deluge of downcastness about everything which I undertook and failed at, that torrent of reproaches I've heard and felt, if it might be taken away from me and if I might be given the opportunity and the strength and the love required to develop and to persevere and to stand firm in that for which my Father and I would offer the Lord such heartfelt thanks."[69]

Deliberately conflating his heavenly and earthly father, he was determined to win them both at once. In May he moved to Amsterdam, intending to follow in Dorus's footsteps by preparing for a career as a minister in the Reformed Dutch Church. He marked his return by lodging with his uncle, the eminent Admiral Jan van Gogh, who, according to his sister, "had taken in this strange nephew only to please [Vincent's] parents."[70]

Vincent threw himself into his studies with his usual passion. In order to prepare for the necessary exams, he hired the services of a Jewish scholar, Dr. Maurits Mendes da Costa, who gave him lessons in Latin and Greek, subjecting himself to punishing rigors in an effort to master the uncongenial material. His teacher recalled his strange habits:

> Whenever Vincent felt that his thoughts had strayed further than they should, he took a cudgel to bed with him and belabored his back with it; and whenever he was convinced

that he had forfeited the privilege of passing the night in his bed, he slunk out of the house unobserved at night, and then, when he came back and found the door double-locked, was forced to go and lie on the floor of a little wooden shed, without bed or blanket. He preferred to do this in winter, so that the punishment, which I am disposed to think arose from mental masochism, might be more severe.[71]

But no amount of suffering could make up for his lack of feeling for the material. The warmth he'd felt listening to the sermons of Charles Spurgeon, or in preaching the word of God to workers in the humble Richmond church, congealed in contact with the arid intellectuality of his theological lessons. Vincent's Christianity was a gospel of humility and poverty, not of propriety and plenty, fueled as much by the searing portraits of injustice in novels by George Eliot and Charles Dickens as the Bible. "It always strikes me that when we see the image of indescribable and unutterable desolation," he wrote, "of loneliness, of poverty and misery, the end of all things or their extreme—then rises in our mind the thought of God."[72] Seeking something that spoke to his heart, he was drawn to the sermons of the popular preachers who plied their trade in Amsterdam's slums. Under their influence Vincent changed course once more, deciding to take up the humble profession of Bible teacher to the poor. "A Catechist!" Dorus groaned. "That does not put bread on the table."[73] For his mother it was the loss of status that hurt most. "What a prospect for his honor—and ours!"[74] she despaired.

Dorus had more than the usual reasons to fret about the irresponsibility of his oldest child. For years now the family dynamic seemed to have fallen into a pattern that, while less than ideal,

at least appeared manageable: As one brother struggled, the other thrived. While Vincent lurched from one thing to another, Theo rose steadily up the ladder of promotion, reflecting credit on his parents and bringing much-needed stability (as well as income) to a family always on the brink. As a counterweight to Vincent's deviations from social norms, Anna and Dorus could depend on Theo to do what was expected of him.

Or so they thought. The truth was that Theo was more like Vincent than they knew. He had an unconventional streak that he could rarely indulge since Vincent already occupied that territory. But occasionally the stress of responsibility grew too much, and Theo lashed out unexpectedly.

The crisis burst into view in May of 1877. For some time Theo had been sexually intimate with "a girl from a lower class."[75] He may well have gotten her pregnant; in any event he announced that he intended to marry her. Appalled and frightened, his parents struck back. "Such a relationship is so wretched and loathsome," his father scolded, his fear of being ostracized provoking unusual venom, "because it lacks any moral foundation and is based on material interest, combined with sensual desire. A man, a young man, a young man of good family as you are, you would be throwing yourself away if you let yourself be tempted again to enter into a relationship that you cannot expect to be a happy one."[76] His mother was equally scathing: "Your love is based on sensuality, and you must open your eyes to the danger in order to flee it all the more forcefully."[77]

Theo was stung. While Vincent was accustomed to his parents' reproaches, it was a new experience for him, and he was shaken to the core. He wrote to Vincent in a despairing mood: "I should really like to get away from everything, I'm the cause of everything and only make others sad, I alone have caused all this misery to myself and others."[78]

For a time he even contemplated giving up his career as an art dealer and becoming a painter. But after a few miserable days wrestling with his conscience he relented, agreeing to break things off with his mistress and remain at Goupil's. Later, Vincent would dredge up this incident to accuse Theo of moral cowardice. It's certainly true that he lacked his older brother's ruthlessness, his capacity to live without regard to the feelings of others. It's also true that without Theo's strong sense of duty Vincent would never have been free to pursue his dreams.

By now it was clear to everyone that Vincent's attempt to join the ministry had failed. Bowing to the inevitable, in July 1878 Dorus accompanied his son to Brussels, using his connections in the church to enroll him (provisionally) in a school that trained young men to become evangelists to the poor. It was a big step down in terms of prestige and financial security, but at least it offered Vincent the chance of fulfilling work that played to his strengths. "One is not even required to complete the training before competing for a place and position as an Evangelist," he explained to Theo. "What is required is the talent to give easy, warmhearted, and popular lectures or speeches to the people, better short and to the point than long and learned. . . . more consideration is given to one's suitability for practical work and one's natural faith."[79]

But even this low bar proved too high for Vincent to clear. After a tempestuous three months in which he managed to pick fights with his fellow students as well as his teachers, he was refused a permanent spot. His parents were in despair. "We have not told anyone about this," they wrote to Theo. "What is going to happen?"[80]

The answer, when it came, only confirmed their worst fears: Vincent's evangelical fervor would take him as far from bourgeois respectability as it was possible to go. "Experience has taught us that those who work in darkness, in the heart of the earth like the mine-workers in

the black coal-mines, among others, are very moved by the message of the gospel and also believe it," he wrote to Theo, justifying his actions. "In the south of Belgium, in Hainaut, from around the area of Mons to the French borders and even extending far beyond them, there is a region called the Borinage, where there is one of those populations of labourers who work in the many coal-mines. I found this and other things about them in a geography book."[81]

In December Vincent left Brussels, heading for the blighted "black country" of the coal mines, where everything was coated in soot and the people were stooped from the grinding toil of their profession. Here he found a world that conformed to the darkness he carried around with him wherever he went. Here at last was a place he might fit in. He no longer wished to ascend the pulpit, like his father, and dispense wisdom from on high. Rather he would walk among his flock, an outcast among outcasts. Surely in this desolate place he'd not be rejected; among the poorest of the poor his shabby clothes and awkward manner would not set him apart but rather mark him as a kindred spirit. Here among society's most abject he would find his true purpose. Here he would be reborn.

Shortly after he arrived in the Borinage, Van Gogh received an appointment as a lay preacher, tasked with giving Bible readings and nursing the sick in the mining town of Wasmes.* He set out to live as one with the poor sufferers, dispensing material and spiritual comfort. After months shuffling through arid tracts, this blasted land seemed fertile ground for the useful work he longed to do.

Initial reports were encouraging; for a while, even his parents seemed reconciled. "It's a wonderfully heartening idea that he now

* The sponsoring organization was the Belgian Evangelization Committee of the Association of Churches.

has a steady position, which could lead to better things,"[82] his mother wrote in January. Dorus chimed in: "He seems to work with success and ambition."[83] Vincent himself felt liberated, embracing the land and the people, whom he felt he knew already from the sentimental portraits he found in books by Eliot, Stowe, and Dickens depicting the downtrodden as God's favored creatures.

Vincent was determined to share his neighbors' hardships, not only their suffering but also their peril: "I went on a very interesting excursion not long ago," he reported proudly to Theo:

> I spent 6 hours in a mine. In one of the oldest and most dangerous mines in the area no less, called Marcasse. This mine has a bad name because many die in it, whether going down or coming up, or by suffocation or gas exploding, or because of water in the ground, or because of old passageways caving in and so on. It's a sombre place, and at first sight everything around it has something dismal and deathly about it. The workers there are usually people, emaciated and pale owing to fever, who look exhausted and haggard, weather-beaten and prematurely old, the women generally sallow and withered. All around the mine are poor miners' dwellings with a couple of dead trees, completely black from the smoke, and thorn-hedges, dung-heaps and rubbish dumps, mountains of unusable coal &c.[84]

Empathy was essential for someone in his position, but as always he took things too far, less interested in lifting up his flock than in joining them in misery. The locals reported his strange behavior to his supervisors in Brussels; their misgivings eventually reached his parents' ears. "If he doesn't conform and adhere to the conventions, as requested, he

cannot be [re]appointed," his mother fretted. "If he would just get a grip on himself for once, how much could still be put to rights. Poor chap, what a difficult, young life with so little fulfilment and so much deprivation, what will become of him?"[85]

The truth is that Vincent had gone to the Borinage not merely to make himself useful but as a form of self-punishment, a continuation of the scourging his teacher Mendes da Costa had witnessed. Vincent was drawn to the pain of his neighbors, never more at peace than when enduring pain himself. Suffering, he believed, sanctified the sufferer. Life's victims belonged to a higher order, possessing more natural nobility than the fashionable ladies with whom he'd tussled in Goupil's grand salon.

Unfortunately that love wasn't reciprocated. The locals knew that only a fool would live like them if he had any other choice. Finding his simple room "too luxurious," Vincent moved into an abandoned thatch-roofed hut, where he slept on a hard wooden palette; his clothes went from shabby to tattered, and he rarely washed. But instead of accepting him as one of their own, the villagers called him *fou*, mad. The growing chorus of complaints prompted a visit from an inspector, Reverend Rochedieu, who scolded him for what he called his "regrettable excess of missionary zeal."[86]

In February Dorus, warned of his son's descent, made the journey to the black country, where he found Vincent "lying on a straw-filled sack, and looking appallingly weak and emaciated."[87] But he couldn't persuade him to return home. Even after the Association of Churches refused to renew his contract, Vincent was determined to stick it out. The further he fell from grace, the more fiercely he clung to his martyrdom.

Vincent's failures put added pressure on Theo. Now, as his parents never ceased to remind him, there was no room for error. His salary,

part of which he sent home each month, was a necessary supplement to Dorus's meager income. Even more important, his success sustained their morale when Vincent threatened to drag them down: "What sadness . . . !" they wrote. "What pains, which we have felt day and night over him. We are tired and almost despondent—even though we remain firm in our faith and that he is a child in God's provenance. . . . And we again give you the assurance that we need you and that you are our crown and joy."[88]

Theo redoubled his efforts, and his diligence was noticed by his bosses. The contrast with his older brother could not have been more stark: At the very same moment Vincent was crawling about in the darkness of the Marcasse mine, Theo was enjoying himself in the City of Light, where he'd been sent to represent Goupil's at the prestigious World Exposition. And while Vincent appeared to have reached a dead end, Theo's latest triumph was merely an audition for greater things to come. "Everyone who knows you thinks you deserve it," his parents crowed, "and we all agree this appears to be very good for your future. It will certainly be a great opportunity to make yourself known."[89]

In August 1880 Theo assumed the disagreeable task of talking some sense into his brother. At his parents' urging he took the train to the small town of Cuesmes, where Vincent was lodging with a miner turned evangelical preacher, Edouard Joseph Francq. He arrived on Sunday, August 10, and as they often did when they were together, they took a walk. Passing by huddled buildings of soot-stained brick, they made their way into the countryside with its piles of smoking slag, women bent under their heavy loads, and miners, as black as the earth beneath which they toiled, shouldering their picks and shovels. To Theo's skeptical eye it appeared to be a

blighted land, while Vincent insisted the scenery was "picturesque" and the inhabitants the embodiment of simple virtues.

But the old routine failed to rekindle the old camaraderie. Vincent was no longer a god in Theo's eyes, nor was he the eager disciple. Vincent had fallen in his esteem, so far in fact that he couldn't hide his disgust at what he'd become. As they walked Theo began to lecture his older brother on his responsibilities, to their parents, to the world, to himself. He was a burden, selfishly pursuing his own mad dreams while putting them all through hell. Theo accused him of "idling," an accusation Vincent vehemently denied, pointing out that no one worked harder or suffered more for his calling. Still, he couldn't deny that he was a drain on the family budget, a shortfall Theo was forced to meet by dipping into his own inadequate salary. Worse, Theo chided, was the way he dragged the van Gogh name through the mud. Standing in for Dorus and Anna, Theo channeled their hurt, urging Vincent to come back into the fold. On a more constructive note, he suggested possible careers for which he might be better suited: bookkeeper, lithographer for greeting cards, even, as his sister suggested, baker.

Theo left the same day. The following morning, Vincent began a long letter, rehashing their argument and searching for the words that failed him in the heat of the moment. Replaying it in his head, he's more sad than angry. He sounds weary and a bit lost, unwilling to accept his family's harsh verdict but forced to admit he's made some bad choices. "It's better that we feel something for each other rather than behave like corpses toward one another," he tells him. He confesses his loneliness and his fear that he'll find himself completely cut off from human society: "Like everyone else, I have need of relationships of friendship or affection or trusting companionship, and am

not like a street pump or lamp-post, whether of stone or iron, so that I can't do without them without perceiving an emptiness and feeling their lack."[90] Even so, he can't hide his irritation at being lectured by his younger brother:

> I've heard such talks before, many, in fact, and often. Plans for improvement and change and raising the spirits—and yet, don't let it anger you, I'm a little afraid of them—also because I sometimes acted upon them and ended up rather disappointed. . . . For such experiences are pretty drastic for me. The damage, the sorrow, the heart's regretfulness is too great for both of us not to have learned the hard way. . . . Improvement in my life—should I not desire it or should I not be in need of improvement? I really want to improve. But it's precisely because I yearn for it that I'm afraid of remedies that are worse than the disease.[91]

Having unburdened himself, Vincent put down his pen. Contemplating the wreckage of his young life, he was consumed by remorse. Theo's visit both lifted him up and cast him down, temporarily relieving the loneliness that gnawed at him out here in the black country but also reminding him how far he had fallen in the estimation of those he loved most. As always he was torn by conflicting impulses, to lash out and to fall on his knees and beg forgiveness, caught between defiance and guilt. And as always in his darkest moments, home beckoned like a beautiful, impossible dream.

When it came to his brother, the relationship seemed broken, perhaps beyond repair. Seeing Theo in his well-tailored suit, so out of place in the rustic countryside, it was clear to Vincent he'd become "one of them," the picture of shallow respectability that was becoming ever

more repugnant to his ardent soul. It was infuriating that the boy who once hung on his every word now felt entitled to deliver lectures and reprimands. Vincent took his revenge the only way he knew how: For almost a year he cut Theo out of his life.

The next time he wrote to Theo, both of them were in a far different place: the younger brother was living the life of a successful man about town in Paris, while the older had finally found his calling.*

* The gap in their correspondence lasted from August 1879 to June 1880. The only comparably fallow period is the two years Vincent was in Paris, but then only because the two brothers were living together.

2

The Country of Paintings

"I feel homesick for the country of paintings."
—Vincent van Gogh

On June 24, 1880, after almost a year of silence, Vincent reached out to his brother. "My dear Theo," he began: "It's with some reluctance that I write to you, not having done so for so long, and that for many a reason. Up to a certain point you've become a stranger to me, and I too am one to you, perhaps more than you think; perhaps it would be better for us not to go on this way."[1]

Beyond his desire to repair a relationship that had once meant so much to him, Vincent had a more practical reason for renewing their correspondence: "It's possible that I wouldn't even have written to you now if it weren't that I'm under the obligation, the necessity, of writing to you. . . . I learned at Etten that you had sent fifty francs for me; well, I accepted them. Certainly reluctantly, certainly with a rather melancholy feeling, but I'm in some sort of impasse or mess; what else can one do?"[2]

Obligation, necessity—these cold, businesslike terms now intruded on an attachment once based on mutual affection and a shared outlook

on life. Fifty francs changed everything, particularly after the initial installment was followed by others, becoming in time a regular allowance.* The transaction bound them more tightly, but not as equals. "If I've come down in the world," he wrote with a touch of bitterness, "you, on the other hand, have gone up."[3] A dynamic of patronage and dependence would breed resentment on both sides. And while it hurt Vincent's pride to have to rely on his younger brother's generosity, Theo harbored doubts of his own. In offering to support his brother wasn't he simply enabling his folly? They'd both been raised on an ethic of hard work, self-reliance, and self-discipline. Accepting charity was an admission of weakness; dispensing it was an endorsement of vice.

Theo's initial contribution coincided with a crisis that almost tore the van Gogh family apart. For years Dorus had watched helplessly as his oldest son stumbled from one catastrophe to another, sinking lower with each reverse until his health and even his life were at risk. Along the way he'd tried both encouragement and gentle admonishment, but nothing he said could turn Vincent from his self-destructive course. Instead of listening to reason, he responded to his father's lectures by heaping scorn on his middle-class values.

In the Borinage he'd carried this rejection to an extreme, denying himself every material comfort, restricting his diet to dry bread, boiled potatoes, and chestnuts roasted by vendors on the street corner,[4] neglecting those outward signs of respectability that to his parents were

* A letter from April 1881 reveals that Theo had been providing regular support for some time: "I heard from Pa that you've already been sending me money without my knowing it, and in doing so are effectively helping me to get along. For this accept my heartfelt thanks. I have every confidence that you won't regret it; in this way I'm learning a handicraft, and although I'll certainly not grow rich by it, at least I'll earn the 100 francs a month necessary to support myself once I'm surer of myself as a draftsman and find steady work." [Letter 164, April 2, 1881]

a sign of God's favor. As if these daily austerities weren't sufficiently rigorous, early in March 1880 he embarked on a bizarre pilgrimage, a fifty-mile journey, largely on foot, in ragged clothes and split boots, to Courrières, in northern France, where the painter Jules Breton had his studio. "I wandered and wandered forever like a tramp," he recalled, "without finding either rest or food or covering anywhere."[5] Like so many of his journeys, this one ended in failure: Having reached his destination, he turned away, too unsure of himself to risk a meeting with an artistic hero.

This via dolorosa proved too much even for Vincent. A few days later he retreated to Etten (where the family had moved in October 1875), no doubt anticipating one of those tearful reunions that were the reward for all his lonely suffering. This time Dorus wasn't going along. Seeing the prodigal on his doorstep filled him with dismay. Filthy, ragged, and dangerously thin, Vincent had not only slipped out of polite society but seemed determined to drive himself into an early grave. Under the circumstances, kindness seemed a form of cruelty and cruelty a gift. Sometime in March or April, Dorus approached a legal expert and asked him to draw up a "certificate of insanity" that would allow him to commit Vincent to the lunatic asylum in the town of Geel.*

For Vincent this was the ultimate betrayal. Because he was an adult—he'd just turned twenty-seven—Dorus had little leverage and Vincent managed to fight successfully for his freedom. But it was a hard-won victory, leaving scars on both sides. Vincent often dredged

* Given the lack of letters from Vincent during these months, the exact sequence of events is hard to pin down. But it's likely that Dorus's attempt to have his son committed occurred between March and May of that year, while he was home in Etten. Geel was an enlightened establishment in which inmates lived in regular houses and were given work as a form of therapy.

up that terrible time, particularly when Theo scolded him for being too hard on their parents. "*I refuse to accept* that a father is right who curses his son and (think of last year) wants to send him to a madhouse (which I naturally opposed with all my might),"[6] he seethed. "Pa and Ma have always passed for such gentle, quiet people, so kindly and good. But how can I reconcile that with this morning's scene or that matter of Geel last year?"[7]

In the end, Dorus's heavy-handed tactics only drove his son further away. Vincent stormed out of the parsonage and returned to the Borinage, preferring the lonely freedom of the black country to the suffocating supervision of home. The rupture wasn't permanent—Vincent was too addicted to emotional turbulence, the endless cycle of love and betrayal, to cut his family out of his life—but it was a wound that never fully healed.

Van Gogh was not the same man who'd set out for the black country a year and a half before, filled with missionary zeal. Then, he'd assumed that, possessing nothing, the natives would be grateful for his attention. When he discovered they were no more tolerant of his peculiarities than the fine ladies and gentlemen of The Hague or Paris, he grew disillusioned, if not entirely cynical.

Taking a room with a miner named Charles Decrucq in Cuesmes, he approached his neighbors more warily. Rather than walk among them to share the Good Word, he stood aside and observed them as they went about their daily rounds. The blasted landscape still seemed picturesque and the inhabitants full of character, but instead of carrying a Bible when he walked the streets of the village he now carried charcoal and paper. "The miners and the weavers are something of a race apart from other workmen and tradesmen," he observed, "and I have a great fellow-feeling for them and would count myself

happy if I could draw them one day."⁸ He still viewed them through the sentimental lens of painters like Jean-François Millet and Jules Breton—or writers like George Eliot and Charles Dickens—but he found it easier to believe in their nobility when he didn't have to talk to them or involve himself in their daily struggles. On the outside looking in—this was far more congenial to his nature than intimate encounters, where his awkward manner and strange tics got in the way of normal human interactions.

Miners in the Snow, 1880, Cuesmes

A few years earlier Van Gogh had proclaimed: "Woe is me if I don't preach the gospel."⁹ But as he turned against organized religion—not only the tepid homilies preached by his father, but also

the red-hot evangelical fervor of Spurgeon and his ilk—he found that art could fill the void. He discarded the Gospels but kept his faith. "You mustn't think that I'm rejecting this or that," he assured Theo: "in my unbelief I'm a believer."[10]

In fact he'd always viewed art in spiritual terms and religion in terms of pictures. Trying to summon the manner of a preacher he particularly admired in Amsterdam, he observed: "It is as if he paints, and his work is at the same time high and noble art."[11] He found it easy enough to dispense with Scripture when the best paintings spoke truths equally profound: "Try to understand the last word of what the great artists, the serious masters, say in their masterpieces; there will be God in it. Someone has written or said it in a book, someone in a painting."[12]

Of course Van Gogh's decision to exchange the role of preacher for that of the artist was the key turning point of his life, but in many ways it reflected continuity rather than rupture. Indeed, both professions had deep roots in the Carbentus and van Gogh families. The religious strain was represented by Vincent's father and paternal grandfather, while Anna's father made his fortune in the craft of book-binding. In addition, both Uncle Cent and Uncle Cor prospered as art dealers, a profession carried on in the younger generation by Theo. There was even a fine artist in the family. Anton Mauve, a cousin by marriage, was a successful painter, one of the leaders of the Hague School and an example, should Vincent need one, of a close relative making a comfortable living from his art.

The decision didn't come in a blinding flash. It built slowly, inexorably, over the course of a few weeks in the summer of 1880. In fact it barely seemed like a decision at all. Rather, it had the quality of a gradual enlightenment: a recognition of something he'd always felt,

as well as an admission that he had few options left. In many ways it was a spiritual homecoming.

When Van Gogh returned to the black country in the summer of 1880, he arrived with no occupation or direction in life, having failed at everything he'd attempted, his illusions shattered and his passions unrequited. He showed up in the grim little town of Cuesmes hoping to take stock, to see where he'd gone wrong, and what he might yet salvage from the wreckage. He compared the process to a bird molting, hiding himself away until he was ready to return to the world renewed.

But he didn't undergo this transformation entirely alone. His need to reflect on his life, both past and future, was perhaps the most compelling reason to reconnect with Theo. He'd reached an impasse and required a sympathetic soul with whom he could share his innermost thoughts. His letter of June 1880 marks the point at which Theo became not only his financial backer but also his therapist, perhaps even his priest. "I, for one, am a man of passions, capable of and liable to do rather foolish things for which I sometimes feel rather sorry," he confessed. "I do often find myself speaking or acting somewhat too quickly when it would be better to wait more patiently. . . . Now that being so, what's to be done, must one consider oneself a dangerous man, incapable of anything at all? I don't think so. But it's a matter of trying by every means to turn even these passions to good account."[13] For the rest of Vincent's life, Theo would be the almost exclusive custodian of his ideas, expressed in both words and images, a role he occasionally resented but that he always carried out with loyalty that was rarely repaid in kind.

It was at this critical moment that Vincent wrote his heartbreaking letter to Theo in which he conjured the searing image of a man with "a

great fire in his soul" ignored by the passersby, and asks what can be
done to keep the flame alive. A few years earlier he'd plunged down
a new road, certain it would lead him to the Promised Land. Now
hopelessly lost, he was groping about in the darkness in an attempt
to discover the purpose he needed to keep him going. "My torment
is none other than this, what could I be good for, couldn't I serve and
be useful in some way?"[14] It's telling that the metaphor that leaps to
his mind is the creation of an artwork, from first draft to finished
masterpiece:

> It's true that I've lost several people's trust, it's true that my
> financial affairs are in a sorry state, it's true that the future's
> not a little dark, it's true that I could have done better, it's
> true that just in terms of earning my living I've lost time . . .
> But what's your ultimate goal, you'll say. That goal will
> become clearer, will take shape slowly and surely, as the
> croquis becomes a sketch and the sketch a painting, as one
> works more seriously, as one digs deeper into the originally
> vague idea, the first fugitive, passing thought, [until] it
> becomes firm.[15]

Contemplating the disasters of recent years, he recalled a happier
time, before he'd been marked out as a failure: "When I was in dif-
ferent surroundings, in surroundings of paintings and works of art,
you well know that I then took a violent passion for those surround-
ings that went as far as enthusiasm. And I don't repent it, and now,
far from the country again, I often feel homesick for the country of
paintings."[16]

The country of paintings! How far he'd strayed from that first love,
and how he longed to find his way back.

At the very same moment, and with nothing else to do, he picked up his pencil and paper. At first his drawings—crude and derivative yet possessing a vigor that, if only in retrospect, hints at greatness to come—were simply a new way to relate to the world, a means of uncovering its manifold secrets while holding it at arms' length. Shut out of the normal human intimacy he craved, he found a substitute in the world of words—in the novels he devoured and the letters he wrote—and images in which he invested the emotional energy that had no other outlet.

By August 1880, Van Gogh's image-making became more pur-poseful, more urgent, more focused. He started to hound his brother for reproductions of famous artworks, particularly of paintings by Jean-François Millet, which he hoped to copy in order to raise his own standards. From the beginning he treated this project as a team effort. In fact he saw it as a way to restore their damaged friendship: "It's because I think you'd prefer to see me doing something good than doing nothing at all that I'm writing to you on this subject, and perhaps it would be a reason why good understanding and friendship might be reestablished between the two of us, and we might perhaps be useful to one another."[17] Unlike his religious mania, which tore them apart, art was something they had in common, a shared love that would unite them in fraternal accord.

Vincent always claimed it was actually Theo who planted the idea of becoming an artist in his head. Two years later he recalled Theo's decisive role: "I remember very well that when you spoke to me back then about my becoming a painter, I thought it very inappropriate and wouldn't hear of it."[18] Whenever Theo expressed frustration at his slow progress or strange choices, Vincent would point out that since Theo was the one to set the plan in motion he was obliged to see it through to the end.

If true, Theo was merely pushing on a door that Vincent was holding firmly ajar. Vincent's letter of June 1880 had already dropped plenty of hints as to where his thoughts were turning. It's not clear at this point whether Theo believed his brother would make a career of it, or whether he was just hoping he'd find something to occupy his mind and direct his energies, to release him from the morbid, self-defeating pattern he was stuck in. If Vincent took to it with his usual gusto, he might eventually acquire skills that would make him self-sufficient. Perhaps someday he'd even find happiness within his reach. In the meantime, Theo could take comfort in the fact that he seemed to have a renewed purpose in life.

Whatever the long-term prospects of Vincent's new career path, in the short run it added to Theo's burdens. His initial involvement didn't absolve him of further responsibility. Quite the opposite. In his solipsistic way, Vincent turned his generosity into a commitment, both to him and to the joint venture he believed they'd undertaken. Obligation tended to flow in only one direction. The fact that Vincent was completely dependent on Theo's largesse didn't stop him from doing exactly as he pleased. He was more than willing to take his brother's money but refused to submit to his guidance, leaving Theo with all the responsibility while Vincent claimed all the power.

One way Theo tried to exert some measure of control was by inviting Vincent to move in with him. Paris and art were always closely associated in both brothers' minds—as indeed they were for most aspiring painters. A stay in the French capital was almost required for anyone wishing to perfect his craft or to make a name for himself. What Theo didn't say was that in Paris he could keep an eye on him and, hopefully, rein in his worst excesses. Which is precisely why Vincent declined the offer. He still valued his independence too much to place himself under Theo's direct supervision,

but from this point on he kept the offer in his back pocket, ready to play that card should need arise.*

Vincent launched himself into this new vocation with his usual heedless enthusiasm. "I'll pick up my pencil that I put down in my great discouragement," he said, "and I'll get back to drawing, and from then on, it seems to me, everything has changed for me."[19] Soon he was deluging his brother with demands, for materials, for reproductions of paintings he could copy, and rushing about the countryside sketching the local inhabitants. He asked Theo to send him instruction books, particularly Charles Bargue's two-part course on drawing figures, *Exercices au Fusain* (*Charcoal Exercises*), and Armand Cassagne's *Guide de l'alphabet du Dessin* (*A Guide to the ABCs of Drawing*), which provided instruction on the difficult science of perspective. This work, in particular, helped convince him that the skills necessary to become an artist were within reach. "What made me stop doubting," he recalled, "is that I read a clearly written book on perspective, Cassagne, *Guide de l'Abc du Dessin* [*sic*], and a week later drew an interior of a little kitchen, with stove, chair and table and window in their place and on their legs, whereas it used to seem to me downright witchcraft or coincidence that one had *depth* and proper perspective in a drawing."[20] Over the next months he plodded through the lessons like a dutiful schoolboy.** As he had when cramming for the exams to qualify him for the ministry, he believed all obstacles could be overcome through hard labor. However much he despised his parents' narrow-minded Calvinism, he internalized their gospel of hard work, believing, as they did, that honest toil would be rewarded in heaven.

* See Letter 158, Sept. 24, 1880. His ostensible reason for declining was a shortage of funds.

** Many of his early drawings, particularly his copies of works by the old masters, are exercises taken from these books.

Seated Nude after Charles Bargue, 1881

Just as Theo had hoped, Vincent was filled with renewed purpose. He'd discovered what he was good for, how to "serve and be useful in some way." And having found his purpose, he started to heal, psychologically as well as physically. As Jo Bonger put it in a somewhat optimistic account: "At last he had found his work and his mental equilibrium was restored; he no longer doubted himself, and however difficult or hard his life became, the inner serenity, the conviction of having found his own calling, never deserted him again."[21] The truth is that while inner serenity would always elude him, once he decided to become an artist he never looked back.

In October Vincent finally moved out of the coal miner's hut in Cuesmes, heading for Brussels, where he took a room in a small lodging house on the Boulevard du Midi. The change of address marked another one of those abrupt reversals that characterize his life. Over the previous few years he'd drifted (or fallen) out of society, but now

he was anxious to rejoin the community of men. Art gave him a way to come in from the cold, more confident, now that he had finally found a profession that matched his talents, in his right to take his place among his fellow citizens.

Van Gogh took a number of steps to demonstrate dedication to his new profession, including enrolling in a drawing course at the Académie Royale des Beaux-Arts.* This was a surprising choice. Vincent was a nonconformist in art, just as he was when pursuing his religious studies. He had nothing but contempt for those polished academics who turned out vapid confections to hang on the walls of wealthy patrons—exactly the trivial fare that was Goupil's stock-in-trade. Instead, he gravitated to outsiders (at least as he conceived them) like Millet and Breton, artists with *soul* who depicted the same downtrodden peasants and workers whose noble suffering had first drawn him to the Borinage.** Even before he'd decided to become a painter himself, Millet's work had spoken to him on a spiritual level. "There was a sale here of drawings by Millet," he wrote to Theo from Paris in 1875: "I don't know whether I've already written to you about it. When I entered the room in Hôtel Drouot*** where they were exhibited, I felt something akin to: Put off thy shoes from off thy feet, for the place whereon thou standest is holy ground."[22] If by the 1880s this taste was no longer radical, from his provincial perch these mud-caked pioneers still carried a whiff of rebellion. Of the still more

* Theo had put him in touch with a successful landscape painter, Willem Roelofs. He recommended Vincent practice his drawing from life and from plaster casts before entering the Academy.

** By the 1880s, these former outsiders were now very much part of the mainstream. Official recognition came in 1855 with their representation in the Exposition Universelle.

*** The Hôtel Drouot was Paris's main auction house for art. The line "Put off thy shoes . . ." is from Exodus.

radical Impressionists currently upsetting the status quo in Paris he had little knowledge and less interest. Nonetheless he was instinctively radical, regarding the art establishment with the same scorn he felt for the pharisees who'd thwarted his efforts to become a minister: "You must know that it's the same with evangelists as with artists," he told Theo. "There's an old, often detestable, tyrannical academic school, the abomination of desolation."[23]

But despite his tendency to divide the world between us and them, good vs. evil, Vincent was perfectly capable of turning on a dime, finding something of value in what he had just dismissed with contempt. This was certainly true of the Academy,* which he often derided as a sink of moral and aesthetic corruption but occasionally embraced as a storehouse of useful knowledge and tricks of the trade from which he might profit. Enrolling at the Brussels institution reflected his need to show Theo and his parents that he took his new profession seriously. Art, at least at this early stage of his career, was not a tormented pilgrimage of the kind that would ultimately be associated with his tragic life, but a skill to be mastered by diligent application and by following a prescribed course. "In Paris there are many draftsmen who earn 10 or 15 francs a day," he wrote to his parents, demonstrating a practical attitude he knew they'd appreciate, "and in London and elsewhere just as much or even more, but one can't achieve this all at once . . . should I gradually begin to earn some money, that wouldn't be disagreeable at all."[24]

He attempted to reassure them in other ways as well, reporting his purchase of "a pair of trousers and a jacket secondhand . . . [that] turned out so well that I bought another jacket and another pair of trousers from the same man."[25] To allay Theo's concerns, he confirmed he was

* Many western European capitals had an academy modeled on the Académie des Beaux-Arts in Paris, which for centuries set the standard for quality in painting and sculpture.

looking after his health and going to the public baths two or three times a week. Rejecting the punitive zeal of the Borinage, he now embraced the discipline of hard work and clean living.

But Vincent's reformation was not entirely convincing, neither to himself nor to his family, who'd been through too many similar conversions to feel certain of his salvation. It's not even clear whether he ever attended classes at the Académie, and there is no evidence in his work that he followed the exercises of drawing from plaster casts that were part of the normal curriculum.

Keenly aware that he'd started late and was far behind his peers, Van Gogh sought out more experienced artists. "How is one supposed to learn to draw unless someone shows you?" he asked. "With the best will in the world one cannot succeed without also coming into and remaining in contact with artists who are already further along."[26] But no matter how many times he resolved to follow a conventional course of instruction, his natural rebelliousness made it impossible for him to accept any guidance. This dysfunctional dynamic was only resolved in Paris when he joined a community of artists as instinctively transgressive as he was, with whom he could interact with as a respected colleague rather than obey as a humble apprentice.

A sympathetic, if troubling, picture emerges from the one friend he made during his months in Brussels. Theo had met Anthon van Rappard in Paris, where he'd gone to train in the studio Jean-Léon Gérôme, a crowd-pleasing star of the Salon as well as a favorite at Goupil's. Theo no doubt encouraged the relationship between Vincent and Rappard, hoping he would provide companionship and prove a stabilizing influence. His instincts were sound, though at first blush they were an unlikely pair. Rappard, five years younger than Vincent, was his opposite in almost every way, an aristocratic young dandy with polished manners and an easygoing personality. For a time he acted

as a sounding board for Vincent's ideas, someone with whom he could talk shop and who provided him that sense of collegiality he craved.

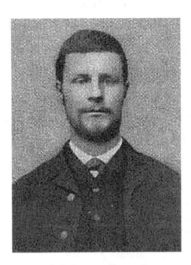

8. Anthon van Rappard

Rappard was the first real artist Van Gogh could call a friend, and it set the pattern for the more consequential relationships he would form in Paris. Vincent invested an enormous amount of emotional energy in this budding friendship, interpreting Rappard's affability as a profound meeting of minds and insisting he'd found his artistic soulmate. Over time, as it became clear that Rappard had a very different temperament and very different goals, Vincent tried to remake him in his own image. When Rappard told him he intended to study at the Académie himself, Vincent unleashed his scorn: "You don't belong there in my opinion, and as regards the 'technical competence' you hope to gain at the Academy, you will, I fear, end up being deceived. . . . those academics you worry about aren't worth tuppence . . . I don't want to hear another syllable or utter another syllable about the whole academy ever again. It isn't worth the bother."[27]

For all Vincent's overbearing manner, Rappard was impressed by his passion—so different from his own ingratiating approach—and willing to put up with his opinionated rants for the sake of the raw genius he thought he detected. Between 1881 and 1885, when there was a final rupture, Vincent wrote over sixty letters to his new friend, who served Theo well by providing another outlet for the obsessions that crowded his brother's brain and relieving him of some of the pressure of being his sole confidant. Years later, when Van Gogh was vaulting to posthumous fame, Rappard penned a vivid tribute to the man he'd come to know in Brussels, revealing both the trials and the rewards that came with calling oneself Vincent van Gogh's friend:

> Whoever had witnessed this wrestling, struggling, and sorrowful existence could not but feel sympathy for the man who demanded so much of himself that it ruined body and mind. He belonged to the breed that produces the great artists. . . . Whenever in the future I shall remember that time . . . the characteristic figure of Vincent will appear to me in such a melancholy but clear light, the struggling and wrestling, fanatic, gloomy Vincent, who used to flare up so often and was so irritable, but who still deserved friendship and admiration for his noble mind and high artistic qualities.[28]

In February 1881, in a move that was to have important consequences for Vincent's future, Theo was appointed director of Goupil's satellite gallery at 19 Boulevard Montmartre. Theo was pleased by this sign of his boss's confidence and reveled in his freedom to choose the art he bought and displayed on the gallery walls. Unlike the grand establishment on the Place de l'Opéra, the small space in Montmartre was

a venue for work that did not require the stamp of approval from the establishment. Here, within the limits set by his conservative masters, Theo could take risks and indulge his own tastes. His appetite for less conventional fare developed slowly as he gained confidence, until he transformed his gallery into one of the city's most exciting venues for the exhibition of new work.

In April, Vincent abruptly left Brussels and moved back into the family home in Etten. For a time Anna and Dorus were cautiously optimistic. A fragile peace reigned in the parsonage. Vincent appeared healthier to them and less agitated. He worked hard and seemed determined to make a success of his new career. They were thrilled when Rappard paid a visit in June; this was exactly the kind of man they thought their son should consort with, a model of the gentleman artist they hoped he'd become.

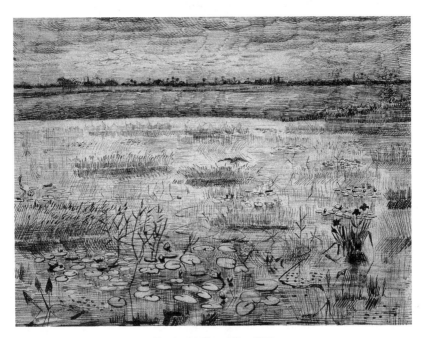

Marsh with Water Lilies, 1881

Freed from having to look after his own daily needs, Vincent began to make strides as an artist. Setting out each morning with a sketch pad, pens, and pencils, he and his friend searched out picturesque scenery, particularly drawn to the marshes surrounding the parsonage, which Van Gogh rendered in fine lines, filling the paper with nervous, repetitive hatchings that anticipate the hypnotic swirls of his mature painting. Thus far, however, he'd not attempted the more difficult medium of working in oils. Despite the fact that his lessons at the Académie in Brussels had gone nowhere, he still followed the academic program espoused there and in similar institutions across Europe and the Americas, in which the student was required to master the art of drawing before picking up the brush.

One of his most ambitious works from this period—a carefully conceived work of art rather than an exercise—is the drawing *The Bearers of Burden.** Taken from his life among the coal miners of the Borinage, it reflects Van Gogh's conviction that art should tell a story and convey a message. Like the novels of Dickens, George Eliot, and Harriet Beecher Stowe—or the "black and whites" he hoarded from publications like *The Graphic* and *Illustrated London News***—this was art with a social conscience. It was, in effect, a continuation of his missionary work in another medium, preaching the gospel in images that dignified the work and sanctified the lives of the downtrodden.

* The unusual attention Van Gogh lavished on this work is reflected in the variety of media he employed, including pencil, ink, and opaque watercolor. It's also unusual in his oeuvre for not being done from life but from memory or imagination. Despite some awkwardness in the rendering of the figures, it has the quality of a statement piece or manifesto, much like his *Potato Eaters* a few years hence.

** Van Gogh had over 1,400 images from these British publications in his collection.

Bearers of Burden, 1881

Though he was making progress in his art and appeared to have pulled his life together, the calm of these months couldn't last. Vincent's unstable personality meant every swing of the pendulum in one direction required a swing, often more drastic, in the other. Despite recent efforts to show himself as an upstanding member of society, he continued to seethe over the way he'd been treated. The more he conformed to his parents' expectations, the more he felt the need to lash out, as if the bonds of love had to be tested until at last, under unbearable stress, they snapped.

Four years earlier, when he was living in Amsterdam, he'd been a frequent guest of his uncle Johannes Stricker. Johannes, married to Anna's sister Wilhelmina Carbentus, was a minister like Dorus and provided his nephew moral guidance and material support during that difficult

period. Vincent remembered fondly the evenings spent in the minister's house. He was particularly taken with his adult daughter Cornelia (known as Kee), who at the time was married to a sickly husband and mother to a young son. To a lonely young man adrift in an unfriendly city, Kee appeared a paragon of maternal virtues. "They love each other truly," he wrote of the couple. "When one sees them side by side in the evening, in the kindly lamplight of their little living room, quite close to the bedroom of their boy, who wakes up every now and then and asks his mother for something, it is an idyll."[29] Contemplating this vision of domestic bliss, he made invidious comparisons with his own family, discovering in Kee a tenderness he felt was lacking in his own mother.

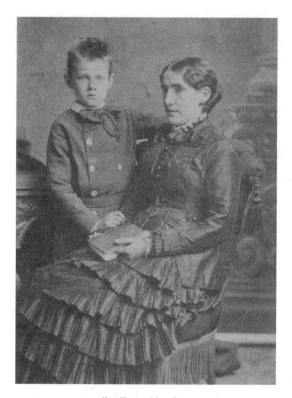

Kee Vos and her Son

In the summer of 1881, following the death of her husband, Kee and her son visited the parsonage in Etten. She and Vincent took long walks in the countryside, where she impressed him with her intelligence and depth of feeling. Vincent now fell madly in love; before the month was out he'd proposed marriage. Her response, which Vincent repeated obsessively in letters to Theo, was an emphatic "no, nay never,"[30] after which she fled back home to Amsterdam.

That should have been the end of it, but Vincent refused to take no for an answer. Months later he was still obsessed. For him, Kee had become the "she and no other"[31] in his life. "By now you understand that I mean to leave no stone unturned in my endeavours to bring me closer to her,"[32] he warned Theo. Since he couldn't blame his failure on the woman he adored, he attacked their mutual relatives, spinning paranoid fantasies of secret conspiracies meant to ruin his happiness. It's true that both families were firmly opposed to the match; they pointed out that Vincent had no prospect of supporting himself, much less a widow and her child. The main obstacle, however, remained Kee herself. Vincent simply ignored her feelings, focusing his wrath on "the elders" meddling in his affairs. He elevated this family quarrel into an epic clash of civilizations where his enemies were not simply wrongheaded but represented the desiccated remains of an oppressive patriarchy, too prejudiced, too cold, and too timid to appreciate a love that transcended all. As both sides dug in, the atmosphere in the parsonage turned toxic. Vincent retaliated for what he considered his parents' disloyalty by refusing to utter a word in their presence, in order, he told Theo, "to make them feel what it would be like if ties really were broken."[33] Dorus responded to this childish behavior by threatening to kick him out of the house.

Matters came to a head late in November when Vincent, having talked Theo into providing him the necessary funds, traveled to

Amsterdam to make one final attempt to win Kee over. When he arrived at the Stricker residence, Johannes told him she was not at home. Vincent grew increasingly agitated, accusing his uncle of lying. Then, as he reported to Theo: "I put my fingers in the flame of the lamp and said, let me see her for as long as I hold my hand in the flame. But they blew the lamp out, I believe, and said, you shall not see her."[34]

Vincent felt no remorse or embarrassment over this bizarre behavior, even recounting the scene with a touch of pride. He was so wrapped up in his own concerns, so convinced of his own rectitude, that he couldn't imagine his brother, or anyone else, seeing the matter differently. Had he had more psychological insight, he'd have realized Theo would side with the despised elders, but his brother, like Kee herself, was simply missing from his narrative, obliterated by the white heat of his passion.

This incident was a grim premonition of that more famous act of self-mutilation in 1888 when, following a quarrel with Paul Gauguin, Van Gogh cut off part of his left ear. For Vincent, the penalty for pain inflicted was always more pain. His solipsism prevented him from distinguishing where the self ended and the outside world began. The object of his affections was not loved for herself—as a woman with her own independent existence—but as an icon of the impossible virtues he assigned to her. Everyone and everything was a prop in the great melodrama of his life, tossed this way and that as he stormed across the stage. At times Vincent appeared to recognize his own patholo-gies, but more often he was bewildered, unable to understand why he'd been shunned when all he wanted was to love and be loved. "I refuse to believe, Theo," he wrote, "that I'm such a monster of rudeness or incivility as to deserve to be cut off from society."[35]

Van Gogh's misreading of people, his tendency to invest more in them emotionally than they could ever repay, suggests a way into his art. In painting a landscape, a portrait, a still life of flowers, or even an

old pair of shoes, he filled his subject with life, with himself, projecting his intense emotional response onto even the most mundane fact. For him, to want something was to achieve it. Despite plenty of evidence to the contrary, he couldn't imagine a world in which he would be denied his heart's desire. Kee must ultimately submit to his will; the mysteries of art must ultimately fall to his prolonged assault. In these mutually tangled and interconnected realms, Vincent believed he could bend reality to conform to his feelings, the objective facts counting for little when subjected to the relentless onslaught of his need.

Vincent's frustrated courtship of Kee confirmed his contempt for the bourgeois values of his family. Back at the parsonage in Etten, he goaded his father by flaunting radical, anticlerical views. When he wasn't giving him the silent treatment, he was quoting from the pages of the godless Michelet and the equally suspect Victor Hugo. During Christmas 1881, he capped off his belligerent campaign by refusing to attend church, after which Dorus banished him from the house. Stung by this latest betrayal, Vincent subjected his father to a torrent of abuse before storming out the door. "Was I *too* angry, *too* violent?" he asked rhetorically.[36] To which Theo supplied a sharp rebuke: "What the devil made you so childish and so shameless as to contrive in this way to make Pa and Ma's life miserable and nearly impossible?"[37]

Before the New Year, Vincent was back in The Hague, the city where he'd first been introduced to the "country of paintings" while working at his uncle's firm. Dorus, hoping to ease the pain of their latest separation, offered to send him money to set himself up. Vincent refused. Insisting he must now make himself completely independent of his father, he demanded Theo make up the difference. In his current bitter mood, he was inclined to bite the hand that fed him, contrasting his selfless feelings for Kee with Theo's soulless existence. He addressed him facetiously as "O man of business!"[38] and insisted that

a life in pursuit of love and beauty was infinitely better than one spent grubbing after riches and worldly success. Love sanctified his existence even as practicalities threatened to drag him into the mire. "Not that you or I actually bow down to that 'Mister Mammon' and serve him," he admitted, "but he does make it amazingly difficult for you and me at times. Me through poverty lasting many years, you through a high salary. Those two things have this in common, that they are temptations to bow to the power of money."[39] He failed to see the irony that it was only Theo's diligence that allowed him to pursue a higher calling.

Setting up his studio in the suburb of Schenkweg, Vincent purchased new furniture, new supplies, and even new clothes, all of which he expected Theo to pay for. He deployed an argument he would trot out whenever Theo rebuked him for extravagance, claiming the more he spends now the sooner he'll be able to pay him back with earnings from his art: "Listen, you know it all, my expenses will be slightly higher than they were in Etten, but let's put our shoulders to the wheel. M[auve] gives me much hope that I'll soon be earning something. And now that I'm in my own studio, it will most probably make a not unfavorable impression on some people who until now have thought that I'm merely dabbling, idling, or loafing about."[40]

The man he most need to convince he wasn't simply "loafing about" was Theo, and during those first weeks in The Hague Vincent did everything he could to demonstrate his seriousness. One of the main reasons he returned to the city was to study painting with his cousin by marriage, Anton Mauve, already a leading light of the Hague School. Mauve's atmospheric, silver-toned paintings of the northern landscape had recently found favor with the public in Europe and America as an acceptable alternative to the more unsettling innovations of the French Impressionists. Even more than Rappard, Mauve was the kind of artist Dorus and Anna could approve of, not only cultured but commercially successful.

Anton Mauve

After working on his own for so long, Vincent was grateful for his cousin's guidance. "Mauve's sympathy was like water to a parched plant to me,"[41] he gushed. For some time Theo had been urging his brother to try his hand at oil painting, especially landscape, a genre he knew appealed to the public and for which Vincent's love of nature should have given him an instinctive feel. But thus far he'd been reluctant, intimidated by the hurdles of mastering a new medium. Now, after years of toiling in black and white, Vincent was finally ready to plunge into the world of color.

His first paintings, made under the watchful eye of his cousin, exhibit none of the pyrotechnic brilliance of his later work. They are rather plodding efforts, still lifes deploying a somber chiaroscuro in which forms are modeled through contrasts of light and shade.* [see color plate 1]

* Vincent had visited The Hague at the end of November, following the disastrous trip to Amsterdam. At that time, Mauve had already begun instructing him in still life painting. *Still Life with an Earthenware Pot and Clogs*, perhaps Van Gogh's earliest extant painting, dates from this time.

Well into his career, this artist famous for his incandescent palette
continued to insist: "Expressing the form—I think—works best
with an almost monochrome color scheme."[42] In these early exercises
Van Gogh shows no awareness of the new ideas that were transforming
the Paris art world, instead working his way through an antiquated
tradition just as the Impressionists were sweeping it away. Even Mauve's
toned-down Impressionism left little mark since it was ill suited to
Van Gogh's far more heavy-handed approach.

Another sign Van Gogh was determined to make himself into a
solid citizen was that he renewed his acquaintance with his former
boss, H. G. Tersteeg; he even managed to sell him a drawing for the
small sum of ten guilders.[43] Mauve and Tersteeg represented art as a
respectable and commercially viable enterprise, the world long inhab-
ited by Uncle Cent and by Theo himself. As long as Vincent remained
on their good side, and they on his, there was every reason to believe
he'd regained his footing.

But like earlier attempts to achieve conventional success, this one
ended in disaster. The break with Tersteeg came first, prompted by
the gérant's contemptuous dismissal of his efforts and accusations that
he was mooching off his brother. "It's sometimes unbearable to have
Tersteeg forever saying to me 'you should start thinking about earning
your bread,'" he groused to Theo. "I find that such a loathsome expres-
sion that I have trouble keeping my temper. I work as hard as I can
and don't spare myself, so I'm worth my bread, and people shouldn't
reproach me if I haven't yet been able to sell anything."[44]

The break with Mauve, following soon after, was particularly painful
since he'd initially shown him so much kindness. "I was so shaken by
Mauve's forsaking me,"[45] Vincent confessed, acknowledging he was
partly responsible for the break. "It is too difficult for you to guide me,"
he'd told Mauve, "and it is too difficult for me to be guided by you if

you require strict obedience."[46] A major source of strife was Vincent's insistence on working from the live model in defiance of Mauve's explicit instructions. "Once," Vincent recalled, "he spoke to me about drawing from plaster casts in a tone that even the worst teacher at the academy wouldn't have used, and I held my peace, but at home I got so angry about it that I threw the poor plaster mouldings into the coal-scuttle, broken. And I thought: I'll draw from plaster casts when you lot become whole and white again and there are no longer any hands and feet of living people to draw."[47]

Vincent's rage suggests his teacher had found a sore spot. Indeed, the battle over hiring models went far deeper than Vincent would admit, or probably even knew. Mauve's rejection of Vincent's approach threatened his artistic mission, which involved gaining some measure of control over a world he otherwise found bewildering. Prowling the working-class neighborhoods of The Hague, particularly the red-light district of Geest, Van Gogh enticed poor laborers and prostitutes back into his studio with the promise of a few guilders. Even at such a pittance, they cost him far more than he could afford.* Many of his quarrels with Theo were sparked by his obsessive hiring of this supporting cast, but no matter how many times his brother rebuked him, he refused to give up this extravagance. Dressing his guests in costumes that he also purchased at great expense, he created an artificial community, one that, unlike the world outside, succumbed to his will. The obsessiveness with which he constructed this make-believe world is suggested by a letter he wrote to Theo in which he detailed what he required "in order to dress the models for my drawings":

* Pleading poverty, Vincent demanded an increase from 100 to 150 francs a month, which would have been about one half of Theo's base salary. But Theo made bonuses as well, bringing his monthly average (in 1884) to 912 francs. [See letter 479, note 2] Theo sent money as well to his parents.

For instance, a Brabant blue smock, the gray linen suit that the miners wear and their leather hat, then a straw hat and clogs, a fisherman's outfit of brown fustian and a sou'wester. And certainly also that suit of black or brown corduroy which is very picturesque and distinctive—and then a red flannel shirt or undervest. And also a few women's costumes, for instance that of the Kempen and from the neighbourhood of Antwerp with the Brabant bonnet and, for instance, those of Blankenberg, Scheveningen, or Katwijk.[48]

Here he sounds less like an artist than someone staging an amateur theatrical production! Though Vincent tried to demonstrate his frugality by pointing out everything was purchased secondhand, Theo grew increasingly alarmed at the expenses he was racking up.

As for the models themselves, he boasted of "making those I want to pose for me do so, wherever I want them, and as long as I want them"[49] and confessed: "If only one had to deal with people only inside the studio! . . . But personally I cannot get on well with people outside of it, and cannot get them to do anything."[50] Loneliness, then, as much as artistic scruple caused him to defy his teacher: "Tomorrow two children are coming to visit whom I must amuse and draw at the same time. I want some life in my studio."[51] Here, moving his guests about like dolls in a dollhouse, he found the society that eluded him in the wider world.*

* Vincent complained of the high prices he was forced to pay in The Hague. In Etten, he'd been able to hire models for 20–30 cents, while in Schenkweg he was forced to pay 1.5–2 guilders, four or five times as much. In September 1882, he found a cheaper alternative when he discovered the pensioners at the Dutch Reformed Old People's Home. One old man in particular caught his fancy, and he drew him on numerous occasions and in varied garb.

Vincent's compulsion to purchase relationships he could not acquire through normal human interactions led him back into dangerous territory. Always on the lookout for models with character and longing for female companionship, Vincent hired a pregnant prostitute by the name of Clasina Maria Hoornik, known as Sien. She soon made the transition from model to mistress, further jeopardizing his faltering bid for respectability.

Sien in a White Bonnet, 1882

The fact that Sien already had a daughter, four-year-old Maria, and was also expecting increased her appeal in Vincent's eyes. As with Kee, he discovered—or projected—a maternal warmth around which he could build a new, ersatz family. The birth of her son,

Willem, in July 1882 completed his makeshift household, which he doted on, tenderly sketching the mother and the infant in his cradle: "I can't look at the last piece of furniture without emotion, for it's a strong and powerful emotion that grips a person when one has sat beside the woman one loves with a child in the cradle near her. And even if it was a hospital where she lay and I sat with her, it's always that eternal poetry of Christmas night with the baby in the manger as the old Dutch painters conceived of it, and Millet and Breton—that light in the darkness—a brightness in the midst of a dark night."[52]

Neither Sien's rough manner nor her ravaged form could rob him of his illusions. To Theo he admitted that she was "ugly . . . wasted"; he said her speech was poor and that many would find her habits "repellent."[53] But ultimately he insisted, "To me she's beautiful, and I find in her exactly what I need. Life has given her a drubbing, and sorrow and adversity have left their mark on her—now I can make use of it."[54]

This phrase, "now I can make use of it," is telling. Van Gogh was attracted to suffering because it allowed him to enter the lives of others, lives from which he was otherwise excluded. He was always far more comfortable with broken people than successful men like Tersteeg, with "superficially civilized manners . . . smart clothes";[55] men, that is, of his own class who looked down on him and knew just how far he'd fallen from his proper station. His sympathy lay with the down-and-out, the destitute and the meek, particularly when they were dependent on whatever favors he could bestow from his brother's generous allowance.* While Tersteeg sneered and Mauve sniffed, his models were grateful for what they could get. "They're poor people

* The most famous instance, of course, came when Theo agreed to fund Gauguin's residence in Arles, at Van Gogh's "yellow house." Unfortunately, despite his dependence on Theo's generosity, Gauguin proved a less than accommodating roommate.

and, I must say, invaluably willing," he explained. Sien, at least for the first few months of their relationship, was "a tame dove,"[56] willing to do his bidding in return for room and board. "Perhaps it's true that I don't have the ability to mix with people who are keen on etiquette," he said, "but on the other hand I perhaps have more feeling for poor or simple folk."[57] Social awkwardness was ultimately raised to an ethical and aesthetic principle, leading him to announce grandly, "I want to make figures from the people for the people."[58]

The most lasting fruit of his liaison with Sien Hoornik was the famous drawing *Sorrow*, depicting her nude body, with sagging breasts and swollen belly, her head buried in her arms so that she's stripped of all individuality. In case its message wasn't immediately apparent, Van Gogh inscribed the word *Sorrow* in English along the bottom, transforming his mistress into an anonymous symbol of resignation and suffering.[*] Reducing the contours of Sien's body to a few simple lines that convey a universal theme, Van Gogh overcame the clumsiness typical of his figure drawing. In the process, he anticipated the mood and methods of Symbolism, the movement that would catalyze profound transformations in his art four years later when he arrived in Paris.

Vincent managed to keep his relationship secret for months. He only revealed Sien's existence in May, by which time he'd decided to marry her. Theo was outraged. She was nothing but a con artist, he insisted, taking advantage of his naïveté.[59] He warned him their father might try again to make him a ward of the court, to which Vincent responded by recounting a story of someone who, deprived of his liberty by his family, smashed his guardian's brains in with a poker.[60]

[*] The surprising use of the English word is probably related to his interest in English illustrated magazines, which he collected obsessively in these years. He even hoped that when his own skills improved he might be hired by one of these publications.

Sorrow, 1882

To be fair, most of his arguments were more uplifting. He rhapso-
dized about a love capable of conquering every earthly difficulty and
defended himself by reminding Theo of his own amorous escapades:
"If I remember rightly, you were acquainted with a girl from a lower
class and you loved her and had slept with her."[61] Vincent's arguments
grew more confident when he learned that Theo was caught up in another
romantic entanglement, this time with a woman named Marie, to whom

he'd also just proposed marriage. From being antagonists they became, at least in Vincent's mind, coconspirators, seekers of true love in a world that valued only material things. In a dig at their minister-father he claimed that *they* were the true Christians, their illicit affairs really acts of charity: "To you and to me there appeared on the cold, cruel pavement a sad, pitiful woman's figure, and neither you nor I passed it by—we both stopped and followed the human impulse of our hearts."[62]

Arguments over lifestyle choices were mirrored in disagreements over artistic direction, with Theo once more on the side of convention while Vincent preferred to follow his errant heart. As manager of a prestigious Parisian gallery, Theo knew exactly what pleased the public and was continually urging his brother to make concessions to popular taste. He suggested concentrating on painting rather than drawing, adopting a lighter palette and a lighter touch and offering scenic vistas rather than portrait heads and figures. Most of all he demanded proof of "progress in a direction that is reasonable."[63]

But Vincent refused to bow to the demands of either his brother or the marketplace. "The duty of the painter is to study nature in depth and to use all his intelligence, to put his feelings into his work so that it becomes comprehensible to others," he pronounced. "But working with an eye to salability isn't exactly the right way in my view, but rather is cheating art lovers."[64] Even so, he recognized the need for artistic growth: "It goes without saying that the studies must become more beautiful—and that certainly they have their shortcomings too—but I believe that even in these first ones you'll already see that there's something of the open air in them, something that proves I have a feeling for nature and the heart of a painter."[65]

His painter's heart inevitably led him to those on society's margins, the laborers he came across on his daily rambles and with whom he felt a kinship lacking with members of his own class. One in particular

struck his fancy. "I have drawn the digger in 12 different poses and am still looking for better ones," he informed Rappard. "He is a marvelously fine model, a true veteran digger."[66] The digger is an Everyman, not a particular individual with whom he'd inevitably quarrel. Starved of intimacy, Vincent discovered a connection with strangers, men and women whose anonymity allowed him to remake them in his own image.

The Digger, 1882

On Theo's advice he tried his hand at watercolor, though he had difficulty mastering the delicate medium, which didn't really suit his vehement personality. He also started making oil studies directly from nature, hauling his gear to the beach at Scheveningen, where he painted two small seascapes—exactly the sort of subject that Mauve had made famous and that Theo saw as a more marketable alternative to his figure studies. Despite the similar subject matter, nothing could be further from his cousin's pleasant light-filled vistas than these crudely daubed canvases. [see color plate 2] Lacking Mauve's deft touch, Van Gogh trowels on pigment made even crustier by the large quantities of sand that blew into the wet paint; instead of shimmering sunlight, he captures nature at its most extreme, a view of howling storm and billowing sea that threatens to engulf the puny figures who huddle along the shoreline. Recalling his self-punishing treks in the Borinage, his Scheveningen outing was a battle with the elements where "the wind was so strong that I could barely stay on my feet and barely see through the clouds of sand."[67]

Throughout his time in The Hague, Vincent cycled through periods of giddy optimism, when he was convinced that success was just around the corner, followed by periods of despair when he saw no way forward. These moods were exacerbated by his increasing dependence on his younger brother, as he cycled back and forth between an exaggerated sense of entitlement and gnawing feelings of guilt. "In order for me to succeed," he wrote in the spring of 1882, "you'll have to help me a bit . . . I'd be willing and daring enough to embark on this undertaking if I could count on 150 francs a month for another year."[68*] When that year passed and he was still no closer to his goal, feelings

* Those 150 francs represented about one half of Theo's monthly salary at the time, though he also earned commissions.

of remorse overcame him: "I'm terribly sorry that I make life difficult for you—perhaps it will clear up by itself—but if you're faltering, tell me plainly. In that case I would rather give up everything than make you carry a heavier burden than you can bear."[69]

Frustrations with his art were compounded by troubles at home. The idyll of domestic bliss he'd built up in his imagination inevitably gave way to a more sordid reality. "She's too weak in spirit and will-power in particular to continue on a proper course,"[70] he told Theo, accusing Sien of scheming with her mother to return to the life she'd led before they met. His final verdict was harsh: "a whore, already marked by the pox, already withered and aged, already mother of 2 children—oh—she isn't a *good* woman, all right."[71]

By the fall of 1883 he'd had enough. Unable to view Sien any longer in the role of victim and himself in the role of her savior, the basis for their ad hoc ménage disappeared.

As old illusions died, new horizons beckoned.

He'd first learned of Drenthe from Rappard, who'd visited this region of peat moors in northeast Holland in search of peace and picturesque motifs. To Van Gogh, disgusted with life in the city, where his shabby clothes and strange manner set him apart, the remote countryside offered respite from his current woes. Rappard's description evoked the landscape of his lost childhood. "I imagine it as being like North Brabant *when I was young*, about 20 years ago," he told his friend, recalling those happy days in the Zundert parsonage. "I remember as a boy seeing the heath and the small farmhouses, the looms and the spinning wheels . . . Well, what will remain in me is something of the austere poetry of the true heathland. And it seems that the true heath still exists in Drenthe just as it used to in Brabant."[72]

Throughout his life Van Gogh was drawn to remote locales, though not to seek the isolation that the critic Albert Aurier claimed was his natural state. In fact Vincent conceived of Drenthe, as he later conceived of Arles, as a place where, freed from the demands and expenses of civilization, like-minded pilgrims could congregate in monastic brotherhood. Even before he'd set foot on the waterlogged moors, he was dreaming of an outpost on the heath: "Once there [in Drenthe], I believe I would stay for good in the heathland and the peat districts, where more and more painters are coming, and in time a kind of painters' colony might develop."[73] This image had enormous appeal for Van Gogh: the crew of a storm-tossed boat, the family drawn up around the hearth or at the kitchen table—islands of warmth and companionship in an otherwise hostile world.

On September 11, 1883, Van Gogh boarded the train for the hamlet of Hoogeveen in the province of Drenthe. It was one more leap into the void, wrenching him from the bosom of a family that, however inadequate, provided him with at least a semblance of normal life. As in the earlier voyages to England or the Borinage, the journey to Drenthe was a pilgrimage in search of a promised land forever out of reach.

Van Gogh's initial reports were filled with ecstatic descriptions of his new surroundings, his mood no doubt lifted by relief at having escaped his latest domestic hell. Among the moors he focused almost exclusively on depicting the landscape, though his gloomy vistas were nothing like the pleasant, light-filled canvases gracing the walls of Theo's Paris gallery. Van Gogh's Drenthe is a twilight realm, relieved only by faint glimmers of the dying sun or a glimpse of a glowing hearth seen through a narrow window. His touch is still clumsy, but his eye is educated. He views the moors through the eyes of other artists: the stormy skies remind him of Georges Michel's views of the mills of Montmartre, the huts "dark as a cave" recall the work of certain English

artists, the sunset "a particular painting by Jules Dupré," and every-thing is tinged by "the melancholy which things in general have . . . as in Millet's drawings."[74] The images he created here—a few oils and watercolors, along with numerous drawings in pen and ink wash—are filled with loss and longing: gnarled roots desperately clawing the mud flats, squat huts huddled on a lonely moor. When he includes figures they are peasants—rarely standing erect but stooped above the land they work with unremitting toil, silhouetted against a sulfurous sky. He invests inanimate objects with human individuality, while men and women are anonymous, sprouting from the muck like stunted trees.

Landscape with Bog, 1883

As often happened, the elation brought on by a change of scene quickly dissipated. Once more, he was overwhelmed by loneliness. "I'm

at a point where I need credit, trust, and some warmth, and you see there's no trust in me," he wrote to Theo two weeks after he arrived. "You're an exception to this, but precisely because everything falls on you it makes it even more apparent how dismal everything is in my case." The monotony and isolation were becoming oppressive. "It's been pouring with rain incessantly for several days," he complained, "[and] I increasingly see how I'm actually stuck here."[75]

Van Gogh was jolted out of his funk in mid-October when Theo confided he was having difficulties of his own. Nothing revived Vincent's spirits more quickly than someone else's troubles. Not only did it take his mind off his own, but it lifted him out of the morass of self-analysis and self-pity into which he'd sunk. In the case of his brother, he had the added satisfaction of getting a bit of his own back. For years Theo had soared while he sank; Theo was the favored child, he the prodigal. Now with Theo struggling, the roles were reversed.

Theo's troubles were caused by his bosses at Goupil & Cie, whom Vincent referred to sneeringly as "the gentlemen."[76] Earnings at the Boulevard Montmartre gallery had been disappointing, and the upcoming sale of the firm put greater pressure on the bottom line.* Weighed down by his responsibilities, unappreciated by his employers, Theo expressed a desire to "just disappear."[77] He was unhappy enough to contemplate, if only briefly, the possibility of starting life anew in America.

Vincent interpreted his brother's frustrations at work as part of a deeper spiritual crisis. Recalling his own difficulties with these same gentlemen, he saw in Theo's struggle proof of their underlying affinity.

* The plan was to sell the venerable firm to Léon Boussod, Adolphe Goupil's partner, and René Valadon, Boussod's son-in-law. After 1884, when the sale was finalized, the company was henceforth known as Boussod & Valadon, though Parisians still often referred to it as Goupil's.

If, over the years, he suffered from nerves and was thought mad, his brother must be experiencing a similar unraveling. He saw an opportunity to recover an intimacy that time and circumstance had strained. Rather than flee to America, Vincent proposed an even less practical alternative. "I still see that repeated occurrence in the history of art of the phenomenon of two brothers who are painters,"[78] he wrote, urging Theo to come join him on the heath.

For the next weeks Vincent fixated on this fantasy of a shared life of material poverty and spiritual riches, a recreation of that lost brotherhood of Zundert: "I've already thought so very often that it must be so almighty pleasant to work together, and both could be so productive for the very reason that one supports the other and many melancholy times disappear."[79] He made up detailed budgets, proving they could live on credit for two years, by which time they'd certainly be earning handsomely from their art. Rather than listen with a sympathetic ear and providing constructive suggestions, he leapt to his own conclusions, insisting that Theo couldn't possibly patch things up with his bosses and that the only thing left to do was to make a drastic course correction—one that happens to coincide with his own deepest desires. He conjured this new idyll in a passage of mournful poetry, built around his favorite image of the welcoming hearth, a refuge of warmth and light in a turbulent world. "Come on, old chap," he sang his siren song, "come and paint with me on the heath, in the potato field, come and walk with me behind the plough and the shepherd—come and stare into the fire with me—just let the storm that blows across the heath blow through you."[80]

Theo had no intention of joining Vincent on the heath, or anywhere else for that matter. Like many working stiffs, he occasionally had daydreams in which he threw it all away to enjoy a life free of responsibility. And like most of his colleagues, after blowing off a bit

of steam he willingly (if not happily) returned to the daily grind. Once again Vincent's hopes had run ahead of reality. He was not what one would call a "good listener"; he imposed his own reality, projecting his own hopes and fears, on his correspondent. When Theo made it clear he'd not be joining him on the heath, Vincent felt betrayed, suggesting darkly that "some ambiguity is beginning to creep into our relationship, which began by being sincere, by mutually understanding and respecting each other."[81]

He conceded the fault wasn't Theo's alone. His brother was a victim of the world he inhabited, not only the firm of Goupil's, which debased art with commerce, but the "poison in the Paris atmosphere"[82] that turned the honest man deceitful as he spent his life seeking material advantage. He accused him of becoming "a Parisian through and through—analytical, steely, 'knowing' as they call it."[83] Rummaging about in Theo's life for other villains, Vincent discovered one closer to home in Theo's mistress Marie, whom he speculated might be another Lady Macbeth.[84] Months earlier Vincent had seen in his brother's illicit love a mirror of his own tragic affairs; now he made invidious comparisons between his feelings for the unfortunate Sien and Theo's for the conniving Marie, one an example of Christian charity, the other a tryst with the devil.

In his anger, Vincent announced his intention to emancipate himself from the corrupt bargain he'd struck—one of many such manifestos that Theo learned to view with skepticism. He began by acknowledging the crucial role Theo had played to this point: "If your support was indispensable until today, I believe that in future I, at least, must work on bringing about a change in this." He continued:

> Make no mistake—there has perhaps—no CERTAINLY—been
> a crisis both at home and in my own life when I really

believe that all our lives were, as it were, literally *saved* by you—ruin averted by the support and protection that we got from you—for me, in particular, it was critical. If I've now reached a point where, when I stand before an object or a figure, I feel within myself clearly, distinctly, without hesitation the power to draw it—not render it perfectly but definitely in its general structure and proportion, very well, it was *essential*, absolutely ESSENTIAL to reach this point, and if I've reached it, it has been chiefly because your support was a hedge or fence between a hostile world and me, and I had the peace I needed to think almost exclusively about drawing, and my thoughts weren't snuffed out by fatally overwhelming material worries.[85]

But, Vincent concludes, he will refuse to accept his charity any longer if it means tying Theo to a dead-end job: "I'm so decidedly against it, I so decidedly warn you: the art trade will betray you in the end—that I want no part in forcing you to make such a decision by needing help myself. And although I hope that we'd remain just as good friends and always feel that we're brothers, I repeat, it is my intention to refuse your financial help as soon as you bind yourself to G & Cie *permanently*."[86]

This bold stance was undercut by his outrage when the monthly installment arrived late, an attitude that infuriated Theo, who pointed out Vincent's inconsistency of claiming the moral high ground while simultaneously complaining of being shortchanged. In a letter filled with sarcasm, he suggested that Vincent's threat to reject his allowance could only mean he's feeling "flush." To which Vincent responded by accusing Theo of deliberately setting him up for failure:

All this keeping me *very hard up* all the time—to put it *mildly*. Add to this that singular torture . . . loneliness, and you really will no longer be *able* to think that there's any possibility of my feeling "flush" for the time being—or that I felt it then.

I say loneliness and not even in peace—but *that* loneliness which a painter in an isolated region encounters when every Tom, Dick, and Harry takes him to be a madman—a murderer—a vagabond &c. &c.[87]

Vincent had one more arrow in his quiver, and he took this opportunity to unleash it. "Things *can't* remain as they are at present," he rumbled. "I have to find a way out."[88] The only solution was to move back in with their parents—the very crisis Theo's generosity had been intended to avert.

A few months earlier the family had relocated to the town of Nuenen, the latest stop in Dorus's meandering journey through southern Holland in search of souls to save. In early December, Vincent left for this village in North Brabant, setting out "on a stormy afternoon with rain, with snow [which] cheered me up no end, or rather my feelings were so in sympathy with nature that it calmed me down more than anything else."[89] As always, Vincent found in physical suffering a remedy for more intractable maladies of the spirit.

Hoping to head off disaster, Theo tried once more to lure his brother to Paris, this time with the solid prospect of a job at the illustrated magazine *Le Moniteur Universel*. But Vincent, though he'd often spoken of one day supporting himself in just such a position, rejected the offer. Reviving an age-old trope, he condemned the city as a den of iniquity that enticed young men and women (including, perhaps, Theo himself) to their doom through the empty promise of material rewards. The art

trade in particular was corrupt, and Theo's continued participation a sign of weakness, or worse.

Vincent arrived in Nuenen on December 5, 1883. Instead of basking in the usual tearful reunion, Vincent challenged his father the moment he walked in the door, demanding an apology for having thrown him out two years earlier. Dorus refused to admit he'd been in the wrong, setting the stage for a yearslong cold war between father and son in which their physical proximity only increased their emotional distance.

Though it was clear they wouldn't be able to resolve past disagreements, Dorus and Anna thought they might at least achieve a modus vivendi by accepting their oldest son as he was. "We are undertaking this experiment with real confidence," they wrote in a cautiously optimistic note to Theo shortly after Vincent's return, "and we intend to leave him perfectly free in his peculiarities of dress etc. . . . There is simply no changing the fact that he is eccentric."[90]

Vincent, however, preferred hot conflict to tepid civility. While he deigned to reside beneath the parental roof, he had no intention of playing by their rules. In fact he went out of his way to offend their bourgeois sensibilities, which in his mind stood for emotional and moral bankruptcy. He discovered in his father "a certain steely hardness and icy coldness . . . that grates like dry sand, glass or tin"[91] and compared his parents' grudging tolerance unfavorably to Rappard's family, which opened its home to their artist son without reservation.

For all his combativeness, Vincent was filled with self-doubt. Long grievance-filled rants were interrupted from time to time by moments of clarity, when it dawned on him that he might be his own worst enemy. "Perhaps I sometimes appear as insensitive as a wild pig during the day in everyday life," he admitted, "and I can readily understand that people find *me* coarse. When I was younger I used to think much

more than now that the problem lay in coincidences or little things or misunderstandings that were groundless. But as I get older I draw back from that more and more, and I see deeper grounds."[92]

But it never took him long to depart those deeper grounds for the more familiar territory of rancor and self-pity. He decried his father's "minister's vanity" and lumped him in with his uncles, Cor and Cent, prosperous businessmen who represented the crass, commercial side of life. He challenged his brother as well: "are you a 'Van Gogh' too?" If the answer is yes, he warns him, "I would keep silent about it, but our paths would diverge too greatly for me to be able to continue regarding the financial tie advisable, as it stands now."[93]

That January, distressed by what he considered Theo's coolness toward him, Vincent completely reversed course. Rather than refuse his allowance, he decided to rebrand their relationship as a mutually beneficial business partnership. "Now I have a proposal to make for the future," he wrote to Theo, in a tone that suggests a completely reasonable transaction. "Let me send you my work and you take what you want from it, but I insist that I may consider the money I would receive from you after March as money I've earned." He did, however, make one concession: "I don't mind at all if it's not as much at first as I've been receiving up to now."[94] Practically, this changed nothing—Vincent was already shipping much of his work to Theo in order to demonstrate his progress—but a turn of phrase transformed a parasitic into a symbiotic relationship. Henceforth Vincent would produce goods in exchange for his stipend—conveniently ignoring the fact that there were no paying customers through whom he could recoup his losses.

Recognizing the proposal for what it was, a fiction that allowed Vincent to maintain a shred of self-respect, Theo held his tongue; he also shrugged off the frequent insults launched at him and at their relatives, hoping to avoid another explosion. "You have *never yet* sold *a*

single thing of mine," Vincent groused, "—not for a lot or a little—and IN FACT HAVEN'T TRIED TO YET,"[95] to which Theo could only respond that he'd "not yet made enough progress."[96]

Despite the chilly atmosphere of the parsonage, it was in Nuenen that Van Gogh began to paint in earnest.* He'd made a start in The Hague and continued to improve his skills in Drenthe, but it was only in his parents' home that working in oils became his chief occupation. Without the expense of room and board, more of Theo's allowance could go toward supplies. Dorus and Anna did their part. Barely scraping by themselves, they paid to have a woodstove installed in the small laundry room so that it could serve as a studio in winter.** In short, free from the demands of making it on his own, he could concentrate his time and effort mastering this difficult medium—one more reminder that Van Gogh's solitary pilgrimage was enabled by sacrifices made by friends and family.

Vincent's belligerence found its way into his art, as if his dependence on his family for material sustenance demanded that he assert his independence in other areas. The subjects he chose to paint were a deliberate challenge to his parents' class consciousness and his heavy-handed approach a rebuke to his brother's more refined sensibility. In these dark, clotted paintings he turned his gaze on Nuenen's despised proletariat, the weavers (mostly Catholic) living in squalid huts on the outskirts of town, earning a pittance from their monotonous toil—exactly the sort that Anna and Dorus instructed their children to avoid. If Vincent felt out of place among the lace and polished

* In March of 1885, Vincent told his brother: "I've devoted myself almost exclusively to *painting* for more than a whole year." [Letter 485, March 9, 1885]

** Vincent found this studio inadequate to his needs. In May 1884, he rented a larger studio nearby. Much to his parents' dismay, his new landlord was sacristan of the local Catholic church.

mahogany of the family home, he was in his element in these dark and foul-smelling huts. [see color plate 3] He communed with society's outcasts as he had in the Borinage, though once again he tended to regard their suffering as inevitable and ennobling rather than as an outrage requiring real solutions.

He wallowed in misery, both human and meteorological, finding comfort in the fact that the outside world mirrored his inner climate: "I've hardly ever begun a year that had a gloomier aspect in a gloomier mood, and so I don't expect a future of success, but—a future of struggle. It's dismal outdoors—the fields a marble of clods of black earth and some snow, usually a few days of fog and mud in between—the red sun in the evening and in the morning—crows, shriveled grass, and withered, rotting vegetation, black bushes, and the branches of the poplars and willows vicious as wire against the dismal sky."[97] His art followed along the same path, progressing from dark to darker, ignoring Theo's recommendation to lighten his palette, to please rather than to edify. Though both brothers shared a taste for the painters of the Barbizon School, Theo gravitated toward Corot's silver-toned landscapes while Vincent was drawn to Millet's sentimental tableaux of noble peasants, paintings with an almost theological message of the meek and the earth they are to inherit.*

A truce was called in the family feud when, in January 1884, Anna stumbled while getting out of a train carriage and broke her femur. The change in Vincent was instantaneous. From the surly son bent on punishing his parents for past misdeeds, he became a paragon of

* Neither Millet nor Corot was a typical member of the group that congregated in the village of Barbizon, near the forest of Fontainebleau, in the mid–19th century. Corot was a full generation older, an inspiration rather than a colleague, while Millet's interest in the human figure set him apart. The school was best represented by pure landscape painters like Théodore Rousseau, Charles-François Daubigny, and Narcisse Virgilio Díaz.

filial devotion, cooking, cleaning, and tending to her every need; on sunny days he would even carry Anna into the garden in a portable chair he'd devised. Dorus was happily surprised, calling his behavior in these trying times exemplary. Vincent, too, welcomed the armistice, exhausted by battles where no victory was possible. "I was glad to be at home in the circumstances," he reported to an anxious Theo back in Paris, "and the fact of the accident naturally having pushed some questions (on which I have a considerable difference of opinion with Pa and Ma) entirely into the background—it's all going pretty well between us, and it may mean that I'll stay more and longer in Nuenen than I originally imagined could be the case."[98] In an effort to please, he put aside the grim scenes of the weavers at home and made some lovely drawings in pen and pencil of the vicarage garden his mother loved so well. Dorus basked in the unfamiliar glow of domestic harmony: "Don't you think those pen drawings of Vincent's are beautiful?"[99] he asked Theo, grateful at last to have something positive to point to.

Pollard Birches, 1884

But the pause in hostilities was only temporary. Once more the crisis was precipitated by a sexual indiscretion on Vincent's part. A frequent visitor to the parsonage during Anna's convalescence was a forty-four-year-old "spinster" named Margot Begemann, the daughter of Nuenen's leading Protestant family. She had shared nursing duties with Vincent during Anna's six-month convalescence, and the two had become friendly. Unlike most of the respectable residents of the village, Margot was not put off by his eccentricities. She discovered a tenderness beneath the gruff exterior, a side of Vincent that was fully on display during these trying times.

An inexperienced middle-aged woman, she fell hopelessly in love. It's unclear how much encouragement Vincent gave her, but once the scandal spilled into public view he acted in his typically contrarian way. Her family vented their fury not only on him, but also on his parents, calling him "a degenerate son of the minister . . . who fancies himself a painter."[100] He responded by lashing out at the same petty bourgeois conventions that had frustrated his courting of Kee Voss. He fed off their scorn, upping the ante when he saw everyone was arrayed against him: "I will marry her . . . I want to marry her. I *must* marry her,"[101] he proclaimed.

To keep Margot out of Vincent's clutches, her family decided to pack her off to Utrecht. Vincent recounted what happened next in a letter to Theo, written a few days after the incident:

> She had often said to me when we were taking a quiet walk or something, "I wish I could die now"—I'd never paid attention to it. One morning . . . she fell to the ground. I still only thought it was a little weakness. But it got worse and worse. Cramps, she lost the power of speech and mumbled all sorts of only half-comprehensible things, collapsed with

all sorts of convulsions, cramps, etc. It was different from a nervous fit although it was very like one, and I was suddenly suspicious and said—have you taken something by any chance? She screamed "Yes!"[102]

Margot had ingested strychnine. Vincent probably saved her life by inducing her to vomit up the poison, but his quick thinking on this occasion did nothing to redeem him in the eyes of the townsfolk.* Shunned by his neighbors, he prowled the streets of the village with a menacing air, at war with everyone and everything.

Vincent was used to being treated as an outcast, but it was unfamiliar territory for his parents. "Because of Vincent and Margot, our relationship with the people has changed," Dorus sighed. "They don't come by to see us because they don't want to run into him,"[103] Anna wrote to Theo: "[It] is a great privation for me, but it is not your mother's way to complain."[104] The toxic mood in the parsonage was recorded by Rappard, who paid a visit in October, where he witnessed violent quarrels between father and son, one of which ended with Vincent threatening his father with a carving knife.[105]

To relieve the unbearable tension, Vincent often slept at the studio he'd rented close by on the Kerkstraat, where—again in a spirit of angry defiance—he adopted those habits of self-mortification that signaled his unhappiness both with himself and with the world at large. Alone in his rooms, "adjoining the coal hole, sewers, and dung pit,"[106] as he

* "Well, I acted boldly. She wanted me to swear I'd never tell anyone about it—I said, fine, I'll swear anything you want, but on condition that you vomit that stuff up straightaway—stick your finger down your throat until you vomit, otherwise I'll call the others. Anyway, you understand the rest. The vomiting only half worked and I went with her to her brother Louis, and told Louis, and got him to give her an emetic, and I went straight to Eindhoven." [Letter 456, Sept. 16, 1884]

described them, he spent his nights in the filthy attic, though he had a far more pleasant space downstairs. "To have slept anywhere else would have been pampering himself,"[107] his landlady remembered.

One occasional visitor—a local businessman and amateur painter, named Anton Kerssemakers, who'd agreed to take painting lessons with him—left a description of Van Gogh's studio: "A great heap of ashes around the stove, which had never known a brush or stove polish, a small number of chairs with frayed cane bottoms, a cupboard with at least thirty different bird's nests, all kinds of mosses and plants brought along from the moor, some stuffed birds, a spool, a spinning wheel, a complete set of farm tools, old caps and hats, coarse bonnets and hoods, wooden shoes, etc., etc."[108]

Kerssemakers also left a description of the man himself: "In those days he was starving like a true Bohemian, and more than once it happened that he did not see meat (for the purpose of eating) for six weeks on end, always just dry bread with a chunk of cheese."[109] On one outing, when Kerssemakers offered him ham and butter, Vincent turned him down, saying "that would be coddling myself too much." One luxury he did permit himself was a flask full of brandy, which he took on all his painting excursions and that "he would not have looked to do without,"[110] hinting at problems that would reach crisis levels in Paris.*

Vincent's truculence threatened to destroy the one crucial relationship in his life. In August, Theo reduced his allowance from 150 to 100 francs, citing financial worries as well as a lack of progress

* Dorus wrote to Theo: "Wil[lemien] was very worried by the feeling that he sometimes seemed to have been drinking. She found drink in a field flask of his and this agitated her greatly and she wrote to Anna about it so that she could tell you." [Letter 464, note 1, Oct. 2, 1884] But the family concluded it was not a serious problem at this time.

on Vincent's part. Always prone to conflating self-interest with principle, Vincent conjured hostile armies arrayed against him, marching under the banner of bourgeois respectability. He accused Theo of trying to "deliberately to get rid of me"[111] and demanded he choose sides, something his brother refused to do, particularly when it became clear that Vincent had assigned their parents to the enemy camp. At one point Theo admitted that he'd become "mistrustful,"[112] a rebuke Vincent regarded as a sign of irreconcilable differences. "You're in an elevated position," he said, throwing Theo's success back in his face, "that's no reason to be mistrustful of someone who's in a lowly position, as I am—where I also intend to stay."[113] He no longer regarded Theo as the soulmate of his youth but as "one of them," a respectable gentleman like Tersteeg who cared more about maintaining his station in polite society than about truth and beauty. "Please don't think that I don't *want* to remain good friends," Vincent concludes, "but here it's in the nature of the thing that it's not *possible*; even if one were to try it, it still wouldn't work."[114]

They "relapse into cold decency."[115] Vincent accuses Theo of not believing in him, of fobbing him off with vague possibilities of future sales. "Perhaps later, once you have expressed yourself more clearly,"[116] Theo tells him, a vote of little confidence that Vincent regards as a betrayal of their pact. Vincent shoots back: "Speaking bluntly—I think that you've been too neutral toward me the last *1½* or two years, and I wish above all for more *warmth*, and the friendship was too cool and not animated enough for me."[117] In a strange twist of logic, he blames Theo's material support for the emotional poverty of his existence. "Personally you're of *no use whatsoever* to me, nor I to you. . . . You can't give me *a wife*, you can't give me *a child*, you can't give me *work*. Money—yes. But what good is it to me if I have to do without the rest?"[118]

Overspending as always—on supplies and models, though certainly not on creature comforts—Vincent resorted to a form of blackmail. Noting the hostile mood in the parsonage, he urged Theo to "do your best to make it rather easier for me financially, I believe that then there would be a real chance of keeping the *peace* later, albeit it far from *concord*."[119]

When Theo proposed sending the extra fifty francs a month directly to Dorus in return for his room and board, Vincent retaliated by making another threat. As far as his lukewarm charity goes, "you can count me out. And while, without words, without sympathy, I've received the money very regularly but very coolly each month, I have—*kept working*—but—increasingly realizing that a moment could come when we each go our own way instead of the same way together."[120] He was determined to cut the umbilical cord—but not quite yet. He talked of moving to Antwerp or some other city and finding someone willing to take a risk on his work, "some dealer or other, however much of a cheapjack—[who] gives me board and, even if it's a tiny attic, lodgings, and some paint, [and] I'll sell myself with great pleasure."[121]

When this failed to extract any concessions, he tried another tack. "I don't think that you'll approve of my coming to Paris," he wrote in December, "but what can I do about it? You flatly refuse to look after my interests—very well—but I can't just leave it at that. I wouldn't have thought of it if you had written less decidedly that it was beneath you, but now—well, now—I can take no notice of you."[122]

Raising the possibility of a move to Paris at this point was less a constructive proposal than a threat to bring the psychodrama of the parsonage to Theo's doorstep, but it suggests that Vincent's thoughts were already turning in that direction. Frustrated by his situation at home, he saw opportunities in the French capital. He was not yet ready to abandon the rustic enclave of Nuenen, but Paris was where

his "interests" lay—interests he might be forced to look after in person if Theo refused to do his part. In some sense he was already a Parisian artist, conceiving his work in terms of what would be acceptable there, wondering where he might fit in. It will be another year before Vincent takes the plunge, but throughout the next turbulent months the challenge and the promise of the City of Light will never be far from his thoughts.

3

The Lure of Paris

*"I shan't be asking you whether you approve or disapprove
of anything I do or don't do—I won't be embarrassed and,
if I feel like going to Paris, for instance, I shan't ask you
whether or not you object."*
—Vincent to Theo van Gogh, Dec. 6, 1884

Paris loomed large in the mind of any ambitious artist. It was a capstone to an aesthetic education, a mountain to climb, a rite of passage. Even those like Millet who wore their contempt for the city as a badge of honor built their careers there, knowing that fashionable Parisians who would never dream of actually setting foot in a barn would pay handsomely for images of sturdy peasants and rosy-cheeked milkmaids. Here one could find the best of the old *and* the new. Paris was a treasure house, overflowing with monuments of past greatness, as well as the center of art as a living practice.

In many neighborhoods, from Montmartre and Batignolles in the north to the Latin Quarter and Montparnasse to the south, upper floors with large north-facing windows still mark the studios where painters and sculptors once toiled, usually in obscurity but always in hope. The

vast population included professionals of every stripe and status: a few Salon stars with international reputations and fat bank accounts, an untold number of hacks catering to the whims and pocketbooks of the burgeoning middle class, and scruffy provocateurs who lived for scandal and thrived on outrage.

They came in the thousands, attracted by the unmatched opportunities to learn the trade, by enrolling at the world-famous École des Beaux-Arts or in one of the many independent ateliers, where the rules were a bit more relaxed but the training every bit as rigorous. At the very least, a monthslong stay in Paris meant that you were up on the latest trends; it was a mark of sophistication you could turn to profit back home. Even if you had no intention of making it your permanent home, it was necessary to test yourself in this most competitive arena, to see if you measured up and how much you still had to learn. Some stayed only weeks, leaving with renewed inspiration, while others retreated as fast as they could for calmer waters. Just as many were seduced and remained a lifetime. It was no different for Vincent van Gogh. His journey would inevitably take him to Paris. If not now, then someday.

The truth is that Van Gogh was deeply conflicted about Paris. He'd spent almost a year there—from May 1875 through April 1876—but at a time in his life when he was least able to appreciate what it had to offer. With his career at Goupil's grinding to its sorry conclusion and plunged in the depths of religious mania, the city's cultural riches left him cold, its pleasures passed him by. "Too large, too confused," he'd pronounced on his first visit, and familiarity didn't necessarily increase its appeal. For a time his loneliness was eased by the arrival of his friend Harry Gladwell, whom he'd met in London and who shared his pious bent, but either alone or in company he was out of step with the joyful, hedonistic spirit of the city. His sister-in-law said he

preferred "his 'cabin' in Montmartre where, morning and evening, he read the Bible with his young friend Harry Gladwell, [to being out] among the worldly Parisian public."[1] Despite unequaled opportunities to indulge his love of painting, he made no attempt to connect with the city's diverse community of artists, too consumed by his own obsessions to make note of the momentous changes taking place around him.*

But from the summer of 1880, when he took up his new calling, Paris took center stage, in his thoughts if not in fact. The prospect of living with Theo appealed to him, at least in theory, particularly during those periods when he felt most isolated. "The thing that attracts me most about Paris," he wrote from Drenthe, "that would be of most use in my progress, is actually being with you, having that friction of ideas with someone who knows what a painting is, who understands the reasonableness of the quest. I think Paris is all right because you're in Paris, and if consequently I were less alone I would get on faster, *even* there."[2] Sometimes he talked of moving there as a practical matter, as the means to acquire the skills necessary to start earning a living; sometimes its allure was more aspirational, a distant goal to be approached only after he was accomplished enough to make his own mark. It served as both a spur to his ambition and a safety valve in case he wore out his welcome closer to home.

Vincent and Theo danced around the issue for years. It would be mentioned first by one and then the other, usually tentatively and with many caveats, each hoping his brother wouldn't pursue the matter since they both suspected that life together might prove unbearable. In 1883, when he was dragging his easel about the moors of Drenthe, it had been Theo urging him to come back to civilization and Vincent who

* The famous Salon des Refusés that made Édouard Manet a hero to the younger generation had taken place a decade earlier, in 1863. The first Impressionist Exhibition was held between April and May 1874.

balked, suggesting instead that Theo come join him on the heath. The calculus shifted over time, pros and cons taking on different weights depending on the nature of their latest quarrel or the balance in Theo's bank account. By late 1884—Vincent having stumbled from crisis to crisis, changing addresses as he fled one impossible situation only to find himself mired in another equally bleak—the city where his brother already enjoyed independence and material comfort seemed to offer refuge from the storms of life. "If I feel like going to Paris," he warned Theo, "I shan't ask you whether or not you object."[3]

The prospect of Paris always looked brighter when things were dark at home. Since the scandal involving Margot Begemann, the rift between Vincent and his parents had grown into a yawning chasm; the residents of Nuenen were now openly hostile, providing a kind of negative pressure that forced Vincent to consider other options. The difficulties of his domestic situation were compounded by disagreements with Theo over the direction of his art. He still favored dark canvases of peasant subjects, bleak visions of grinding poverty, clumsily rendered, with little commercial appeal and showing little awareness of recent trends. Vincent's complaints that his brother wasn't doing anything to promote his work in Paris were met by Theo's exasperation with his stubborn refusal to deviate from his chosen path.

But even as Vincent's art appeared to have fossilized, the man was changing. He was experiencing an internal revolution, one that was largely invisible but that would erupt in the radical innovations of his Paris years. In battles with his father, he honed his worldview, his hatred for the suffocating *degelijkheid* of his parents giving him a new conception of who he was and what he stood for. His thinking on art, on politics—his attitude toward the modern world in general—underwent a crucial transformation, a change reflected in his taste in literature

as he moved away from the tear-soaked tales of Dickens, Hugo, and Harriet Beecher Stowe, toward the incisive portraits of urban life in the novels of de Maupassant, the Goncourt brothers, and, above all, Émile Zola. These "modern" novelists shared the social consciousness of their predecessors, but they couched their critique in a more objective form. Zola was as much journalist as novelist, his writings an accumulation of facts all the more devastating for the dispassionate way they were presented. As he wrote in his preface to *L'Assommoir*, he intended it to be "the first novel about the common people which does not tell lies but has the authentic smell of the people," adding, "my characters are not bad, but only ignorant and spoilt by the environment of grinding toil and poverty in which they live."[4] A few years earlier, Vincent had urged his brother to destroy such books in order to fix his eyes on heaven, but now he embraced their godless creed. As he steeped himself in tales of Parisian life, low and high, the city became ever more the focus of his thoughts. It was there, in the French capital, where the great drama of modern civilization was playing out, and it was there that, more and more, he saw his own future taking shape.

The trials of recent years had hardened Van Gogh. He still identified with the less fortunate, but now his love for humanity took on a sharper edge. His two disastrous courtships caused him to despise those who'd denied him his happiness and to lash out against anything that smacked of hypocrisy. At home he provoked his father by carrying around books by radical or anticlerical authors, provoking accusations from Dorus that he was trying to "infect him with his French fallacies."[5] Vincent's evangelical fervor was replaced by an instinctive socialism—not a systematic program but rather an emotional identification with society's outcasts and an increasing alienation from the class into which he was born. "The working man against the bourgeois," he rumbled, "is as justified as the third estate against the other two a hundred years ago."[6]

Unable to accept responsibility for family quarrels, he rebranded personal antagonisms as ideological disagreements. His fights with Theo over money became skirmishes in the endless war between the haves and have-nots, a matter of principle rather than self-interest: "I'm on one side, you on the other of a certain barricade that may no longer be visible *in the form of paving-stones*,"* he told him, "but which still definitely exists and persists in society."[7] Who were those on the wrong side of the barricade? "They were people, as I see it, like, say, Pa and Grandfather old Goupil . . . people in short who look almighty respectable—profound—serious—yet if one looks at them a bit sharply and at close quarters, there's something lugubrious, dull, even feeble about them, to such a degree that they make one sick."[8] Would Theo make his stand with the "mediocrities,"[9] or would he join him as a crusader for Truth and Beauty?

This line of argument, originating in petty slights, would have profound consequences for Van Gogh's art—in particular for his decision to go to Paris and to throw his lot in with the avant-garde. Previously he tended to think of France (Theo's world) exclusively in terms of the superficiality of modern life; it was glitz and glamour, all those empty vanities he couldn't stand. But now he discovered another aspect of the City of Light and of the modernity with which it was so closely associated, one that was radical, socially conscious, subversive, as disdainful of high society as he was. The more estranged he was from his family, the more he saw their straitlaced *degelijkheid* as the root of all his troubles, the more he was attracted to this other world. In a dialectic

* Van Gogh is referring here to the Revolution of 1848, which overthrew the government of King Louis Philippe and ushered in the Second Republic. It was fought largely in Paris, with the revolutionaries erecting barriers made of paving stones. The "third estate" mentioned above is a reference to the French Revolution of 1789.

worthy of Marx himself, he began to see modern capitalist society not simply as the oppressor of the common man, but as the creative engine constructing a new and better world—a revolution of the mind as well as in social arrangements. "One feels instinctively that a tremendous amount is changing, and everything will change," he opined. "We're in the last quarter of a century that will end with another colossal revolution . . . but the next generations will be able to breathe more freely."[10] For the rest of his life this hope that modernity might usher in a new world in which creativity was rewarded and social justice achieved vied with his earlier, more romantic view of the countryside, and the peasant who worked the land, as the source of all virtue. It's a contradiction he never fully resolved, one that drew him to the city and then to the countryside again, a back and forth that reflected his own profound ambivalence.

His attitude toward the art trade also evolved: from his first days as a junior clerk in his uncle's firm in The Hague, where he cultivated his connoisseur's eye, to his current situation in the village of Nuenen where, from afar, he railed against the vapid productions of the Academy and the Salon. Frustrated in his attempts to achieve conventional success, he took comfort in the failures of those who came before him and who also struggled for recognition. Art, he proclaimed, was a sacred mission and could not be measured in guilders and francs—a concept completely foreign to men like Tersteeg and his colleagues at Goupil's. Even his mother was unwittingly drawn into the conflict, deposited on the wrong side of the barricade: "Ma simply cannot comprehend that painting is *a faith* and that it brings with it *the duty* to pay no heed to public opinion—and that in it one conquers by *perseverance* and not by *giving in*."[11]

As Van Gogh embraced (at least rhetorically) the excitement of modern city life, he strived to find a connection between the artists he admired who extolled the simple life of the countryside and the Parisian

novelists whom he saw increasingly as ideological soulmates. He found the link in an imperative that was at the heart of his own struggles: sexual freedom. Cursing the puritanism—"the damned icy coldness"[12] he called it—preached at home, which had denied him his own physical and emotional fulfillment, he embraced the hedonism he discovered in modern fiction. "I mentioned a difference between Mouret and what I should want, and yet the parallels," he tells Theo, citing the lecherous hero of Zola's *Au Bonheur des Dames*: "Look here. Mouret worships the modern Parisian woman—very well. But Millet, Breton, worship the *peasant woman* WITH THE SAME PASSION. These two passions are ONE AND THE SAME."[13] The sturdy country girls of Millet and the coquettes of Zola—unlike Kee Voss and Margot Begemann—are *available*, not cloistered by repressive morality. He quotes Mouret approvingly: "I want her, I'll have her! . . . to create—to struggle against facts, *vanquish them or be vanquished by them*, all human joy and health are THERE!' . . . I PREFER TO DIE OF PASSION THAN TO DIE OF BOREDOM!."[14] He urged this seize-the-day approach on Theo, as well as himself: "If you aren't an artist in *painting*, be an artist as a *dealer*, just like Mouret."[15]

Thwarted in both his professional and love life, Van Gogh found an all-purpose villain in a "conventional morality [which] is all BACK-TO-FRONT."[16] None of this is particularly original. The association of art, bohemianism, and sexual license is an old one, and Van Gogh was actually rather late to the game. He knew the conduct that had earned him universal condemnation in the village of Nuenen would have gone unnoticed in Montmartre or the Latin Quarter, where promiscuity was the rule, models often doubled as prostitutes, and every artist was expected to keep at least one mistress. This world, to which Vincent was introduced in the paperback novels he devoured, seemed ever more appealing as the allure of the country life congealed under the frigid stares of his neighbors. "I want in any event to have a bit of

city life," he confided to Theo, "a bit of a change of scene, since I've been either in Drenthe or here in Nuenen for a full year and more. . . . You once said to me that I would always be isolated. I don't believe it—you're decidedly mistaken in my character."[17] He yearned for comrades, for physical and spiritual companionship, all those things his oh-so-proper family had denied him.

In imagining his potential audience, Vincent already thought of himself as a Parisian artist, with Theo acting as his agent on the ground. It was a role Theo was uncomfortable playing, particularly since Vincent's art was still unformed. "Perhaps later, once you have expressed yourself more clearly,"[18] Theo told him, trying inject a little realism into the conversation. Rather than accepting this as sensible advice from someone who knew the market well, Vincent charged him with disloyalty. (This despite the fact that most of what he shipped off to Paris he himself dismissed as "studies" or "mere scratches.") "When one sends you something or one asks, please, try to find an opening with the illustrated magazines so that I can earn something extra," he complained, "one hears no more about it and *you don't lift a finger*."[19]

Vincent didn't care that he was putting his brother in an awkward position. Theo had his reputation to think of and was sensitive to the accusations of nepotism that would be leveled against him if he showed his brother's work to his bosses, particularly since he knew it didn't come close to meeting Goupil's standard. As an expert in contemporary French painting, he could see not only that Vincent lacked technical proficiency, but that his approach was decidedly old-fashioned, even naïve. The truth is that no matter how well-read Vincent was or how closely he followed the goings-on in Paris, he was a country bumpkin sounding off about things he knew only at second or third hand. As with so many autodidacts, his passionate convictions

rested on spotty knowledge. Occasionally he admitted the depths of his ignorance—pleading with Theo to provide him with more up-to-date information—but more often he lectured his art-dealer brother, pontificating on the ups and downs of the art business and on aesthetic and technical matters about which Theo was far better informed.

At this point Van Gogh liked to think of himself as a rebel, but he was actually fighting battles that had been waged and won three decades earlier. His artistic heroes—Millet, Breton, and Daubigny—were no longer outsiders banging on the doors of the Academy demanding to be let in. Rather, they were painters whose works graced many a fashionable drawing room and fetched high prices in the galleries and the auction houses. In fact the Barbizon painters were among the best sellers at Goupils & Cie, a firm Vincent dismissed as a pillar of the establishment. When he proudly declared himself to be a "peasant painter," he was not, as he imagined, thumbing his nose at the respectable elements of society, but validating the middle-class taste for sentimental images of country life.

Jules Breton, *The Friends*, 1873

Initially it was Theo who pointed Vincent in the direction of modern art and Vincent who had to be dragged kicking and screaming into this new world. A term that began to find its way into Theo's letters around this time was *Impressionism*—itself no longer quite the latest rage but, after a decade of struggle, a movement that was just beginning to enjoy commercial and critical success. At first Vincent resisted Theo's gentle nudging. "To me Millet, not Manet, is that essential modern painter who opened the horizon to many,"[20] Vincent wrote in reference to the man the Impressionists themselves regarded as their mentor. In these early days of Vincent's career as a painter, Theo was the progressive and his brother the reactionary, insisting that *"since Millet* we have sunk very low—the word decadence, now whispered or pronounced in veiled terms."[21] [see color plate 4]

But cracks were beginning to show in his stubborn resistance. Could one be a fan of Zola—an early champion of Manet in particular—without also taking on board the new art? If the novelist's unsparing portraits of city life were so compelling, surely his painter friends, who turned their perceptive eyes on many of the same scenes, were worth taking another look at. Still, he wasn't ready to throw over old heroes for new. "There's a school—I believe—of—Impressionists," he wrote in April 1885. "But I don't know much about it. I do know, though, who the original and actual people are around whom—as around an axle—the peasant and landscape painters will revolve. Delacroix, Millet, Corot, and the rest."[22]

For their battle over what he called "the *light* paintings of the present day,"[23] Vincent came armed with what he considered the most up-to-date weapons. He quoted extensively from treatises he had recently acquired on color theory, by Eugène Fromentin and especially Charles Blanc, whose *Grammar of Painting and Engraving* and *The Artists of*

My Time became his new aesthetic bible.* Following Blanc's lead, he discovered a new god to place alongside Millet in the pantheon: the great French Romantic painter Eugène Delacroix (1798–1863), whose technique of enlivening his compositions with flecks of pure and contrasting color had provoked the ire of an earlier generation reared on classical formulas. Reading Théophile Silvestre's article on Delacroix, Van Gogh could barely contain his excitement, writing to Rappard: "These words struck me, for the whole article pointed out how in his paintings the MOOD *of colors and tone was at one with the meaning.* The contrast of colors, breaking, reciprocal effect from black to white, from yellow to violet, from orange to blue, from red to green."[24] Here Van Gogh anticipated in writing the chromatic brilliance of his mature work; what he actually produced in terms of paint on canvas still lagged far behind. [see color plate 5]

Van Gogh seized on Blanc's thesis that an artist's use of color could be boiled down to a few simple rules. It was a comforting thought for someone struggling as he was to master the fundamentals of his craft. "These rudiments, developed by modern scholars," Vincent wrote, quoting Blanc, "have led to the notion of certain laws, which form a luminous theory of colours—a theory that E. Delacroix mastered scientifically and thoroughly, after having instinctively known it."[25] For the next few months, Vincent bombarded Theo with long passages on color theory, as he'd once barraged him with passages from Scripture, explaining the basics of primaries, complementaries, and what Blanc termed "broken tones,"[26] made by mixing complementaries in different proportions.

* Blanc, in turn, derived much of his theory from the work of Michel Eugène Chevreul (1786–1889). Chevreul was a major influence on Neo-Impressionists like Georges Seurat and Paul Signac.

He began to free himself from the old-fashioned notion that objects possessed an inherent hue—referred to as their "local color"—that remains unchanging under varied circumstances. Modern color theory, by contrast, stresses that our perception of color shifts depending on the time of day, the intensity of light, atmospheric conditions, and even the subjective experience of the viewer. Indeed color is not a *fact*, but rather a *perception*, realized only in the eye of the beholder. Understanding this allowed the artist to explore a far greater range of optical phenomena, opening new possibilities as nature was observed en plein air, rather than recreated in the studio.

To Vincent these ideas came as a revelation, but for Theo they weren't particularly novel or controversial. Living in Paris, he'd been able to study the work of the Impressionists, whose revolutionary canvases were predicated in large part on just these discoveries. In any case, the paintings he was receiving in crates sent from Nuenen didn't match this newfound obsession. They were the same old images of weavers in their "poor, smoke-blackened cottage[s],"[27] an occasional landscape, equally bleak, and a series of "heads," studies of the local residents in which Vincent pursued his obsession with painting the figure. Despite hailing Blanc and Delacroix as prophets of the gospel of true color, Vincent continued to fight a rearguard action in favor of the old, heavy chiaroscuro in various shades of brown and gray. "It has bothered me FOR A LONG TIME, Theo, that some of the painters nowadays are taking from us the bistre and the bitumen,"[28] he said, referring to shades of brown and tarry black that the Impressionists had already consigned to the dustbin of history. How this lined up with Blanc's rules of complementaries he didn't say, concern over inconsistency never proving a barrier to his dogmatic pronouncements.

Even as Vincent struggled to bring more light and air into his paintings, the atmosphere in the parsonage was growing more toxic. "We are doing our best to restore him to calm, which is the most important thing," Dorus reported. "But his outlook on life and his ways are so different from ours, that it's questionable whether living together in the same place can continue in the long run."[29] Fearing he'd be thrown out again, Vincent dug in. "I *cannot* give up the studio yet," he protested, "and they can't in any event demand of me that I leave the village."[30] The memory of his loneliness in Drenthe was still fresh in his mind, and he dreaded the prospect of yet another period of exile. For all his contempt for his parents and their petty bourgeois ways, he was terrified of abandonment. Independence was a pipe dream and the prospect of permanent separation a nightmare.

In fact it was too late. Father and son were locked in mortal combat fueled by mutual incomprehension. "My father was a stickler for the proper form," his daughter Wil (Willemina) recalled, "and [Vincent] never concerned himself with all that; naturally that often caused clashes, and neither of the parties readily forgot words that were spoken in anger."[31] Love, in the absence of forgiveness, was not enough. Neither would yield; neither was able to break free.

There were plenty of warning signs, but no one seemed to know how to avert disaster—least of all Dorus himself. "You'll be the death of me,"[32] he'd cried out after one particularly violent confrontation. Over the years some version of this phrase often came to his lips as Vincent found relief from his own pain by inflicting it on those closest to him. His sister Anna had a front-row seat to this grim drama. "I saw and noticed a great deal that was bad," she recalled. "He gave in to all his desires, and spared nothing and no one. How Pa must have suffered."[33]

Theo received Vincent's telegram early on the morning of March 27, 1885. It read simply: SUDDEN DEATH, COME, VAN GOGH.[34] Realizing this was insufficient, Vincent sent another an hour and a half later with a crucial clarification: OUR FATHER FATAL STROKE, COME, BUT IT IS OVER.[35]

Theo immediately set out for Nuenen, accompanied as far as the train station by his friend Andries Bonger. "Never have I taken a friend to the Gare du Nord in more melancholy circumstances than on Friday of last week," Andries reported to his family back in Holland. "My friend Van Gogh had heard the news that morning that his father had suffered a sudden stroke and died. He had received a letter from him just the day before in which he said he was perfectly well. Van Gogh himself is not very strong; so you can understand the state he was in when he left."[36]

Death had come so suddenly there had been no time to prepare. "Pa went out in the morning healthy and in the evening he came home and as he came in the door he collapsed without giving any further sign of life,"[37] Wil recalled. The sense of shock was still palpable when Theo arrived at the parsonage the next day. Grief brought the family together, but other emotions pushed them apart. Anna, saying aloud what many were thinking, blamed Vincent for bringing his sixty-two-year-old father's life to an untimely end. He'd exhausted him with worry, goading the old man, exploiting all his weak spots, and playing on his conflicted emotions, until he could take no more. Others were less harsh, but no one denied that stress inflicted by his oldest son contributed to the stroke that killed him.

For the younger son, Dorus's death meant the loss of a cherished mentor. To Theo, he had been the embodiment of simple virtues, of piety, kindness, and rectitude. Over the years, as Theo had been forced to take on more parental responsibility, he sometimes resented the burden placed on him too soon, but he never blamed his father for his

plight. He was, after all, the favored son. The day before he died, Dorus had written to thank him "for always thinking of us and making our life sweeter by his attention and his comforting words."[38] These kind expressions now served to remind Theo of all he'd lost.

It was more complicated for Vincent. Accounts of his behavior in the days leading up to the funeral (which took place on March 30, his thirty-second birthday) suggest he'd retreated into a defensive shell. They depict him as withdrawn, standing apart from the rest of his family. To one mourner overcome by emotion he observed cynically: "Dying is hard, but living is harder still."[39] His mother, wrapped up in her own sorrow, was distant, while Anna made no attempt to conceal her hostility. Returning to the parsonage to care for their mother, she made it clear that Vincent was no longer welcome in the house. Anna wasn't the only one who wanted him gone. "As a result of many unpleasant discussions with other members of the family," Jo Bonger recounted, "he resolved no longer to live at the vicarage."[40] In May, he packed up his things and moved into his studio on the Kerkstraat, where he nursed his wounds and brooded on the injustices he suffered.

Though Vincent must have been on the scene only minutes after his father's collapse, he left no account of his death—an unusual omission for this most confessional and self-analytic of men. Instead, he worked out his feelings in his art, where Dorus's ghost occasionally seems to hover just outside the frame. A few months after the funeral, he painted, at Theo's suggestion, the ruined church tower and the graveyard where his father was buried. Presiding over the gloomy scene are the circling crows that would feature ominously in the far more famous painting he created in the last days of his life. If this is a coded reference to his deceased father—and surely a depiction of his grave so soon after his tragic passing was freighted with meaning—it's less a tribute than a continuation of their quarrels

from this life into the next. Titling the work *The Old Church Tower at Nuenen (The Peasants' Churchyard)*, he placed the minister in the company of people he had considered beneath him all his life. Vincent used the note he sent to his brother accompanying the painting to take another swipe at everything Dorus stood for: "This ruin says to me how a faith and religion mouldered away, although it was solidly founded—how, though, the life and death of the peasants is and will always be the same, springing up and withering regularly like the grass and the flowers that grow there in that churchyard."[41]

The Old Church Tower at Nuenen (The Peasants' Churchyard), 1885

He memorialized their bitter clash of worldviews a few months later in a painting titled *Still Life with Bible* [see color plate 6] Dominating the composition is his father's personal Bible, opened to the Book of

Isaiah, chapter 53, which contains the famous lines: "He is despised and rejected of men; a man of sorrows, and acquainted with grief." Given Vincent's tendency to view himself as a martyr, he no doubt meant this as a self-portrait, while the snuffed candle represents his departed father. Another layer of meaning is suggested by the second book, a cheap paperback edition of *Joie de Vivre*, Émile Zola's jaundiced portrait of contemporary Parisian life that represented the modern viewpoint—socially conscious, sexually adventurous, secular, progressive—that Dorus and his reactionary colleagues feared but that Vincent now embraced as his own. Created shortly before his own departure for Paris, the painting offered a meditation on his past even as it pointed him toward his future.

The day after his father's funeral, Theo returned to Paris, carrying with him a crate of Vincent's paintings and drawings. Worn down by his constant carping—and perhaps detecting a glimmer of progress—Theo had finally agreed to show his studies to a select few colleagues. For the most part he avoided the high-end galleries, including Goupil & Cie, instead approaching fellow artists whom he expected would be more forgiving of Vincent's less-than-polished efforts, and small-time dealers more willing to take a chance on an unknown. The one exception was Paul Durand-Ruel, the dealer who'd made the Impressionists famous, but the great man declined the drawings without comment.

Theo was able to report at least one mildly positive response. It came from Arsène Portier, an admittedly marginal player whom Theo described as "more of an enthusiast than a salesman."[42] And even his praise was something short of a ringing endorsement. He claimed to have "detected personality"[43] in his work, the sort of remark one makes while searching for something nice to say.

Still it was a start, and Theo was happy to be able to pass along a bit of good news. Since he knew his brother was likely to read too much into it, he tried to tamp down expectations, pointing out that Portier was not actually in a position to purchase anything. But after so many disappointments Vincent was overjoyed. He was soon building castles in the air and spinning out countless unrealizable plans, convinced he'd made the longed-for breakthrough. Reenergized, he returned to the studio with confidence in his work and a growing conviction that his future lay in Paris.

But if Theo hoped Portier's encouragement would induce his brother to produce work that the Parisian public might actually want to buy, he was soon disappointed. Vincent took his remark about *personality* as confirmation that he was already on the right track. Instead of heeding Theo's advice about lightening his palette and painting more appealing subjects, he vowed "more and more to be myself,"[44] doubling down on those very qualities that made his work a tough sale.

Anton Kerssemakers was the first to see exactly what Vincent meant by being more himself when he showed him his latest effort, "a picture done in very dark colours, with a hanging lamp over the table, around which a peasant family is sitting and eating steaming potatoes out of a dish."[45]

Ironically, given how out of step with current taste it was, *The Potato Eaters* was the first major work Van Gogh made specifically with Paris in mind. [see color plate 7] More ambitious and carefully plotted than anything he'd ever before attempted, he saw it as a manifesto in which he staked out his turf as a "peasant painter" in the tradition of Millet, Dupré, and Breton.

The idea to paint a definitive statement of his artistic principles had originated in a testy exchange with Theo. In February, his brother had suggested submitting a painting to the jury for the upcoming Salon,

an offer that Vincent was reluctant to accept but couldn't ignore. A year earlier, in March of 1884, Theo had made a similar proposal, asking whether Vincent might be willing to subject a work of his choosing to the harsh judgment of the jury. At a the time, Vincent had rejected the idea out of hand, assuming it was just a rhetorical device aimed at forcing him to admit his technical shortcomings. "I think it's silly of you to give your opinion of how the Salon jury would judge my work," he grumbled, "when *I've never uttered a syllable to you about sending anything to the Salon*."[46]

When Theo renewed the offer, Vincent had to give it serious consideration. After all, he'd been complaining about Theo's half-hearted efforts on his behalf, and he worried that Theo would regard another refusal as proof his more cautious approach had been right all along. In the end, he excused himself on the grounds that he had nothing ready,[47] but the need to demonstrate he was making strides led him to contemplate the kind of grand performance that would make the cognoscenti sit up and take notice.

The truth is he'd often expressed his scorn for the Paris Salon, that great bazaar of middlebrow culture. "When I see in the Salon issue," he said after receiving one of the catalogs Theo regularly sent to keep him abreast of the latest, "so many paintings which are impeccably drawn and painted in terms of technique, if one will, many of them bore me stiff all the same, because they don't make me feel or think anything, because they've evidently been made without a certain passionateness."[48]

The Potato Eaters, Vincent's response to Theo's challenge, was the opposite of a typical Salon production in almost every way, except, that is, for its underlying premise, that the best way to grab the public's attention was through a large-scale figural composition. *His* peasant painting would be a rebuke to all those "perfumed" scenes of prettified rustics that had long been a staple of the exhibition, marking him out as an artist of integrity and high ideals. It was also a final act of

defiance toward his now departed father as he lifted up the very people his parents feared would drag him down.

Vincent began sketching ideas early in April 1885, including a "scratch" of the composition he included with the letter dated the ninth of the month. Since his days in the Schenkweg studio in The Hague, where he arranged costumed models like so many dolls, he'd dreamed of making large, well-populated compositions. Despite his disdain for the Academy, his notion of what constituted "important" art followed traditional lines. Paintings that showed a mastery of the human form, that choreographed a large cast of characters, were touchstones of academic practice. These were the kind of works that grabbed the attention of the public and swept up all the prizes. Thus far his efforts along these lines had been sporadic and mostly inept, but now the prospect of placing his work before the Parisian public allowed him to act out his fantasy of a miniature universe over which he exercised complete control.

letter with sketch of the *Potato Eaters*

This large-scale work followed traditional lines in other ways as well. A humble repast of humble folk was by now a well-worn, even trite, image. Its origins lay in Baroque religious imagery, particularly in scenes of Christ dining with his apostles at Emmaus—most memorably depicted by masters like Rembrandt and Caravaggio—as well as in satirical rustic vignettes by artists like Pieter Bruegel and Adriaen Brouwer. Even shorn of overtly religious references, such images retained their sacramental quality. According to his friend Émile Bernard, both Van Gogh and Millet shared a "biblical love of the earth and its workers."[49] The theme surged in popularity in the latter half of the 19th century as city-dwelling Victorians indulged in pleasant daydreams of country life. Perhaps the closest model for Van Gogh was Jozef Israëls's immensely popular *The Frugal Meal* (1876), which shows a mother and father with their three young children gathered for supper in a rustic abode. In playing his own variation on this hoary theme, Vincent was clinging to a formula that was already passé, tearfully sentimental even as Manet and his Impressionist disciples affected a detached, neutral approach to contemporary life.

For Vincent the image also had roots closer to home. Ever since his return to Nuenen, he'd sought out the poorest members of the community, preferring the company of these workers (mostly Catholic) to those of his own tribe. Among his most reliable models were members of the sprawling De Groot–Van Rooijen clan, who lived in convivial squalor in a hut just down the street from the parsonage. By demonstrating that these simple peasants were worthy of our attention and our sympathy, Vincent was taking a political stand, while simultaneously taking a swipe at his own family. Their furnishings may be ramshackle, their manners rough, and their fare meager, but the warmth of their shared meal stands in contrast to the frigid atmosphere in the Van Gogh household, where propriety reigned.

Rembrandt, *Supper at Emmaus*, 1648

Israels, *The Frugal Meal*, c. 1880

Vincent began with "father Millet," as he now called him, an artist who, when he depicted one of his sturdy rustics, painted him "with the soil he sows."[50] Defending himself in advance against detractors who would call his painting crude, Van Gogh insisted it would be "a REAL PEASANT PAINTING" and scoffed at "anyone who would rather see insipidly pretty peasants."[51]

As always, the fight was personal. Just as he thumbed his nose at those who would condemn his dirty clothes and rough manners, so he dismissed anyone who sneered at his Brabant yokels. He identified with his subjects, shared their uncouth habits and plain-spoken virtues; a rejection of his painting was a rejection of *him*. "If a peasant painting smells of bacon, smoke, potato steam—fine—that's not unhealthy—if a stable smells of manure—very well, that's what a stable's for—if the field has an odor of ripe wheat or potatoes or—of guano and manure—that's really healthy—particularly for city folk. *They get something useful* out of paintings like this. But a peasant painting mustn't become perfumed."[52]

With so much riding on this one work, he suppressed his normal impetuousness, laboring diligently and working out the composition in multiple studies; he even made a lithograph of the composition that he sent to Theo for distribution among his Paris acquaintances. In other words, he set out very deliberately to craft a "masterpiece." It was, he confessed, "a tremendous struggle,"[53] one in which he second-guessed every decision, working and reworking every passage until the paint accreted in sedimentary layers.

Unfortunately, his labor wasn't necessarily rewarded. The extent to which he fretted over every element revealed doubts that he could carry it off. Not only did he have difficulty rendering the human form convincingly, but color became an increasingly intractable problem. Wedded to the dramatic chiaroscuro he loved in the old masters, Van Gogh chose to depict these simple folk at their evening meal, the

dark "cave" illuminated by an overhead lantern. But by now he was a convert to Blanc's color theories, an approach thoroughly at odds with the "bistre and bitumen" he'd relied on in the past. His solution was idiosyncratic, to say the least. Noting that a whole host of "broken tones" could be achieved by the mixing of complementaries, he managed to deploy the same theories the Impressionists used to create their shimmering light-filled canvases to conjure a scene of impenetrable gloom. Close inspection of the painting reveals an array of subtle color contrasts—a gray-green next to a gray-pink in the bonnet of the woman seated on the left, for instance, or deep blue shadows in the rendering of the hands—but the overall effect is that of mud.* Later in Paris, when he was able to study the work of the Impressionists and their successors firsthand, these initial experiments would pay off in works of stunning brilliance, but for the time being his efforts to master scientific color theory yielded only paradoxical results.

Vincent was clearly worried about how the painting would be received in Paris. On May 6, he packed it up and shipped it to Theo, but not before preparing the ground by offering copious descriptions, explanations, apologies, theoretical and ideological justifications, as well as instructions on how to care for it and what frame to use (gold or copper) in order to bring out the richness of the colors.

Vincent anxiously awaited his brother's verdict. When it came it was something of a mixed bag, though Vincent was positively giddy—at least at first. Anton Kerssemakers recalled that after receiving Theo's letter Vincent rushed over "very animated to tell me that his brother had written very favourably about it," and that "of course he was overjoyed by this: he had written, he said, that when he looked at the painting '*he*

* The overall greenish hue of the painting today is largely the result of discoloration due to his use of cheap colors and multiple layers mixed with copious amounts of medium.

could hear the clatter of the sitters' clogs.' [54] Like Portier's earlier observation that the work had *personality,* Theo's comment highlighted the painting's obvious sincerity in order to gloss over its technical shortcomings. To their mother, Theo sent an even more upbeat report: "Several people saw his work, either at my place or Mr. Portier's and the painters, in particular, think it's very promising. Some of them find a great deal of beauty in it, precisely because his characters are so true."[55] However he concluded with a note of caution: "As far as sales are concerned, even well-known painters are not finding it easy at the moment. So it is that much harder to sell something by an unknown who has only been working for a few years. Still, it will happen."[56]

In subsequent letters to Vincent, Theo combined cautious praise with equally cautious advice, pointing out some awkwardness in the drawing and expressing concerns about the overall dark tonality—to which Vincent responded (for once) in equally measured tones. He agreed there were flaws in rendering the figures but assured him that with further practice those imperfections would disappear. He also promised to lighten his palette, though he continued to defend tonal painting against the moderns' use of a uniformly light palette. "One of the most wonderful things accomplished by painters this century has been: to paint DARKNESS that is nevertheless COLOR."[57] He again dismissed the Impressionists who "regard every effect against a strong and coloured light, every shadow, as heresy."[58] For Van Gogh, like many of the reactionary critics of the Impressionists, tonal painting was serious painting, building on a centuries-old tradition, and figure painting the summit of an artist's ambition. The effort to capture the brilliance of real sunlight, by contrast, was a cheap trick only meant to please the eye. "As to whether we've already heard the last of *Impressionism,*" he wrote to Theo, "I always imagine that many newcomers may still emerge in figure painting, in particular, and I'm

beginning to think it increasingly desirable in a difficult time like the present that one should seek one's salvation precisely by going deeper into *high* art. For there is relatively higher and lower—*people* are more than the rest, and for that matter a whole lot harder to paint, too."[59]

Thus while the aesthetic rebels were demonstrating how *surface*, when observed with a keenly analytic eye, could capture the kaleidoscopic energy of modern life, Van Gogh, even in Paris, shared the academic prejudice in favor of figure painting and could never quite convince himself that their atmospheric landscapes were anything more than pleasant fluff. In fact, there's more to his insistence on sticking with the figure than mere stubbornness. Van Gogh needed his paintings to strike an emotional chord, something he only felt he could achieve through narratives filled with pathos. Impressionism's more objective approach never spoke to him in quite the same way, though he would need to absorb its lessons before he discovered how he could achieve the same emotional charge by painting pure landscapes in vivid color.

In its awkward forms and contrary aims, *The Potato Eaters* testifies to Van Gogh's deep ambivalence toward Paris and all it stood for. It is *countrified*, defiantly so and in a way that only makes sense for an urban audience, for whom it's thrown down as a kind of challenge. Made specifically with the annual Salon in mind, intended to take sides in the debates that raged in the capital, packed off to be examined by Theo and his sophisticated colleagues, it was nonetheless wildly out of place. It was a country bumpkin crashing an elegant soiree, tramping about in muddy boots, and scattering the slippered ladies in terror. Had Theo actually submitted it to the Salon jury, it would have been rejected out of hand. Unlike the popular images of peasant life by painters like Jozef Israëls, Jules Breton, or Léon Augustin Lhermitte—a particular

favorite of Theo's whom he urged Vincent to study—it was a laughably clumsy effort, redolent not so much of bacon and manure as of ignorance and amateurishness.

Vincent's eye was too well educated for him not to perceive the difference between his crude "masterpiece" and the slick depictions of peasant life by the painters he admired. He alternated between bluster, in which he defended inadequacy as authenticity, and apologies for its technical shortcomings. "I know myself that there are flaws in it,"[60] he wrote while anxiously awaiting the verdict of Poiret and Serret: "When you speak to them, just tell them that it may very well be that I draw back from the present copper and green soap-like tones, but that this drawing back will, *I hope*, be TWOFOLD, namely that I hope to paint some in a lighter spectrum, more flesh and blood—but equally am searching for something that's *even more* green soap and coppery."[61]

After his initial elation, Van Gogh began to beat a tactical retreat. If *The Potato Eaters* was meant as an audition for a role on the Paris stage, he recognized at some level that he'd not made the cut. "I myself have criticisms of it, and more serious ones than theirs,"[62] he admitted. And if the problems were evident, so was the solution: "I can sometimes very much long to see the Louvre and the Luxembourg once again, and that sooner or later I really should study the technique and colour of Millet, Delacroix, Corot and others," he wrote plaintively, adding: "There's absolutely no immediate hurry, though, to my mind; the more I work the more benefit I'll derive from it *if* it can happen sometime. It's just that one needs *both* nature *and* paintings."[63]

His uncertainty involved not only where he should live, but what kind of painter he should be. At times he seemed resigned to staying in Brabant, where he would not only paint the peasants, but live as one:

I think it by no means unlikely that I'll stay here for the rest of my life, too. After all, I desire nothing other than to live deep in the country and to paint peasant life.

I feel that I can create a place for myself here, and so I'll quietly keep my hand to my plough and cut my furrow. I believe that you thought differently about it, and that you would perhaps rather see me take another course as regards where I live.

But I sometimes think that you have more idea of what people can do in the city, yet on the other hand I feel more *at home* in the country. [64]

Most of all, he vowed to persevere: "All the same, it will still take me a great deal of effort before I imprint my paintings in people's heads. Meanwhile, I have no intention whatsoever of allowing myself to be discouraged." [65]

That resolution was tested from an unexpected source. Van Gogh had sent Rappard one of the early lithographs of the composition, and his scathing comments were based on this admittedly less-than-perfect reproduction: "You can do better than this—fortunately," Rappard wrote with brutal honesty, no doubt paying him back for all the lectures he'd been forced to endure from his less proficient friend,

but why, then, observe and treat everything so superficially? Why not study the movements? *Now* they're posing. That coquettish little hand of that woman at the back, how untrue! And what connection is there between the coffeepot, the table, and the hand lying on top of the handle? What's that pot doing, for that matter; it isn't standing, it isn't being held, but what then? And why may that man on

the right not have a knee or a belly or lungs? Or are they in his back? And why must his arm be a meter too short? And why must he lack half of his nose? And why must the woman on the left have a sort of little pipe stem with a cube on it for a nose?

And with such a manner of working you dare to invoke the names of Millet and Breton? Come on! Art is too important, it seems to me, to be treated so cavalierly.[66]

Van Gogh's first response was to return the letter without comment. Then, finding silence emotionally unsatisfying, he demanded a retraction. When Rappard failed to show sufficient remorse, he indulged in paranoid fantasies, accusing him of panning his work in order to curry favor with his nemesis, H. G. Tersteeg. Over the course of the summer, he waged a retaliatory campaign, filling page after page with angry screeds, marshaling a host of artists and writers to repel his attack. By August, Rappard was exhausted, simply leaving Vincent's letters unanswered. In what would turn out to be his final missive, Van Gogh, perhaps sensing what was coming, offered an eloquent apologia for himself as a man and as an artist:

Take whichever study or drawing of mine you like, even the one I'd point out to you myself with relative equanimity. And—there'll be mistakes both in the drawing and in the colour or tone that a REALIST *wouldn't readily make.* Certain inaccuracies of which I'm convinced myself, which if need be I myself will sometimes point out more severely than other people. Inaccuracies sometimes, or imperfections.

And yet I believe that—*even if I keep producing work* in which people, if they want to look at it precisely from

that angle and with that aim, can find *faults*—it will have a certain life of its own and *raison d'être* that will overwhelm those faults—in the eyes of those who appreciate character and *mulling things over in their minds*. And with all my faults, people *won't* find it as easy to overwhelm me as they think. I know too well what aim I have in view, I'm too absolutely and utterly convinced that I am, after all, on the right path—when I want to paint what I feel and feel what I paint—to worry too much about what people say of me.[67]

The truth is that Van Gogh was far more wounded than he was willing to admit, and far less certain of the direction he was taking. But he was determined to carry on, pursuing his chosen course in the face of discouragement and even despair. Improbably, this moving response has been vindicated by history—improbably because in this particular argument Rappard is completely in the right. The drawing of *The Potato Eaters* is clumsy, the narrative forced, the modeling inconsistent, and the whole unconvincing. And yet, as Vincent points out, it has "a certain life of its own." Years later, he still regarded it as a kind of touchstone, a work that, however flawed, captured something of his essence.[*] As soon as he learned to harness that vital energy, discovering novel means of expression capable of conveying the passions of his raging heart—"to paint what I feel and feel what I paint"—this latent power would burst forth in works of brilliant originality.

[*] "What I think of my own work is that the painting of the peasants eating potatoes [. . .] is—*après tout*—the best I have ever done," he wrote in 1887. [*Paintings of Vincent van Gogh*, vol. 1, 144] From time to time, he expressed ambivalence about the direction he took in Paris and wondered if he should return to the chiaroscuro of his earlier work.

In *The Potato Eaters*, Van Gogh offers a highly sentimentalized view of life in a small village, where poverty is redeemed by the simple values of hearth and home. The reality he encountered every day was far different. Many of his studies—though not the final canvas, which was largely done from memory—were made during long hours spent in the De Groot cottage on Kerkstraat. In late August it was discovered that the unmarried twenty-nine-year-old Gordina de Groot was pregnant. Most of the villagers leapt to the conclusion that Vincent was the father, and given the scandal with Margot Begemann the accusation was certainly plausible. His admiration for Zola's womanizing antihero Mouret suggests his exploitive sexuality, particularly when it came to women of the lower classes. And, indeed, there wasn't much distance between treating models as props and treating them as property. Vincent angrily denied the charge, but even Anton Kerssemakers credited local rumors that Gordina was, as he coyly put it, "his Dulcinea."[68]

Whatever the truth, Gordina's misfortune confirmed Van Gogh's status as the town pariah. Now, not only did he have to put up with the usual hostile stares and rude comments, but the priests instructed their parishioners to have nothing to do with him, cutting him off from the models that were always crucial to his sense of himself as an artist. The fact that Gordina was a Catholic and he the son of the Protestant minister turned a personal matter into a sectarian feud. "This last fortnight I've had a great deal of trouble with the reverend gentlemen of the priesthood," he informed Theo, who must have been annoyed to have yet another crisis dumped in his lap, "who gave me to understand—of course with the best of intentions and, no less than others, believing that it was their duty

to interfere—I shouldn't be too familiar with people beneath my station."[69]

The immediate result was a forced return to still life painting, which he'd first attempted under the watchful eye of Anton Mauve. These images of humble objects—potatoes, apples, birds' nests—are peasant paintings minus the peasants. Just as in the Drenthe he'd depicted his rustics like plants sprouting from the mud, so he conceived of his rustic neighbors as little more than beasts of the field. "I had finished all the heads and even finished them with great care," he explained, "but I quickly repainted them without mercy, and the colour they're painted now *is something like the colour of a really dusty potato, unpeeled of course.*"[70] This anthropomorphic confusion is a rich vein that runs through both his early and mature work, merging human and natural elements into a vital, animistic whole.

Basket with Apples, 1885

Early in October, Van Gogh boarded a train to make the seventy-five-mile trip to Amsterdam. His destination was the newly opened Rijksmuseum, built to house the nation's treasures of Dutch and Flemish art. For a while now Vincent had been complaining of a lack of examples he could learn from, this handicap driven home by criticism of *The Potato Eaters*. A trip to Amsterdam and the Rijksmuseum would cure him, at least temporarily, of his cultural homesickness.

He was joined on this trip by his student Kerssemakers, who left a vivid portrait of his teacher in the midst of the urban bustle: "When I came into this waiting room I saw quite a crowd of people of all sorts, railway guards, workmen, travelers, and so on and so forth, gathered near the front windows of the waiting room, and there he was sitting, surrounded by this mob, in all tranquility, dressed in his shaggy ulster and his inevitable fur cap, industriously making a few little city views (he had taken a small tin paintbox with him) without paying the slightest attention to the loud disrespectful observations and critical remarks of the esteemed (?) public."[71] At the museum, he cut an equally odd figure:

He spent the longest time in front of [Rembrandt's] *The Jewish Bride*: I could not tear him away from the spot; he went and sat down there at his ease, while I myself went on to look at some other things. "You will find me here when you come back," he told me. When I came back after a pretty long while and asked him whether we should not get a move on, he gave me a surprised look and said, "Would you believe it—and I honestly mean what I say—I should be happy to give ten years of my life if I could go on sitting

here in front of this picture for a fortnight, with only a crust
of dry bread for food?"[72]

Early in his artistic career Van Gogh asserted: "I've had very little
conversation with painters lately. I felt none the worse for that. It
isn't the language of painters one ought to listen to but the language
of nature."[73] But after years of frustration, he realized that progress
would require renewing his citizenship in the "country of paintings."
The three-day trip to Amsterdam and the transformative experience
of wandering the galleries of the Rijksmuseum helped catalyze yet
another momentous change in Van Gogh's life. Only recently he
had assured Theo he planned to make a life among the peasants of
Brabant; now he felt compelled to return to the city, walk the crowded
streets, and observe the varied scene, to soak up the culture that
only an urban center could provide. Standing before masterpieces
by Rembrandt, Hals, Rubens, and other masters of the Dutch and
Flemish golden age, he realized how much he was missing. "When
I escaped to Amsterdam for a few days, I was really delighted to see
paintings once again. For it's sometimes damned hard to be entirely
away from paintings and the world of painters and not to see anything
by other people. Since then, I've had quite a yearning to get back into
it, at least for a while."[74]

City life might not have been quite so appealing had he not burned
all his bridges at home, the final insult administered by the priests who
forbade their parishioners to pose for him. For the moment, Paris was
off limits, Theo having made it clear he was not prepared to receive
him. In desperate need of a change of scene, Van Gogh opted instead
for the bustling Belgian port of Antwerp. "I have to choose between a
studio without work here, and work without a studio there," he wrote
on the eve of his move. "I took the latter. And with pleasure that's

actually so great that it feels to me like a return from exile. After all, I've been out of the world of painting altogether for a long time."[75] The truth, which he concealed from Theo, was that he intended Antwerp as the prelude to a more permanent relocation. "To be accepted in Paris one must have worked somewhere else before,"[76] he noted. Even more direct evidence for his plans comes from Anton Kerssemakers, who recalled that Vincent stopped by to announce that Antwerp was merely the first stop on a voyage that would eventually lead him to France.[77]

Van Gogh's impulsive zigzag from country to city and back again reflected not only his restless nature and certainty that a change of address would cure his current ills. It spoke as well to his confusion over what kind of artist he wished to be. Was he a "peasant painter," chronicling the timeless verities of the fields? Or should he fashion himself into something more modern, a Zola of the brush capturing the ever-changing cityscape? It turns out, of course, that this was a false choice: He would ultimately find a way to express eternal truths while being *of* or even *ahead* of his time. But before he could resolve the contradictions at the heart of his artistic journey, he would have to go to Paris.

Vincent arrived in Antwerp on November 24, 1885, renting a room at Lange Beeldekensstraat 194. The apartment's main drawback was that there was no separate studio. On the plus side, it was a short walk to the crowded port filled with seedy bars and brothels, and he took full advantage of these opportunities. After the monotony of Nuenen, the commotion of a busy seaport both fascinated and overwhelmed: "I can't tell you how delighted I still am that I came to Antwerp. And how much there is to observe here for me, who has been out of things for so long. How much good it does me—much as I love the peasants and countryside—to observe a city again. How the bringing together

of extremes gives me new ideas—extremes, the countryside as a whole and the bustle here. I really needed it."[78]

In an instant he took off his peasant smock and wooden clogs and reinvented himself as an urban flaneur. From Millet, "peasant painter," he transformed himself into Mouret, predatory hedonist roaming the streets in search of amorous adventure. He was no longer bound to his subject through sympathy and shared experience. He had become a voyeur, viewing the scene with a hungry, even cynical eye:

> Through the window of a very elegant English inn one will look out on the filthiest mud and on a ship where such delightful wares as hides and buffalo horns are being unloaded by monstrous docker types or foreign sailors; by the window, looking at this or at something else, stands a very fair, very delicate English girl. . . . There'll be Flemish sailors with exaggeratedly ruddy faces, with broad shoulders, powerful and robust, and Antwerp through and through, standing eating mussels and drinking beer, and making a great deal of noise and commotion about it. Contrast—there goes a tiny little figure in black, with her small hands pressed against her body, slipping soundlessly along the gray walls. In a frame of jet-black hair, a little oval face, brown? Orange yellow? I don't know.
>
> She raises her eyelids momentarily and looks with a slanting glance out of a pair of jet-black eyes. It's a Chinese girl, mysterious, quiet as a mouse, small, like a bedbug by nature.[79]

His new mode of life demanded a new approach to painting. In the hours he'd spent in the Rijksmuseum, he'd been struck by the way these

old masters had worked with a dash he could only envy.* After ago-
nizing for months over *The Potato Eaters*, going over every passage mul-
tiple times in an effort to get it right, their apparent spontaneity came
as a revelation, a promise of liberation from the unrewarding drudgery
he'd just endured. "What particularly struck me when I saw the old
Dutch paintings again is that they *were usually painted quickly*," he told
Theo. "That these great masters like Hals, Rembrandt, Ruisdael—so
many others—as far as possible just put it straight down—and didn't
come back to it so very much. . . . Paint in one go, as far as possible
in one go."[80]

Painting quickly! How much better this suited his impulsive nature
than the more premeditated approach he'd deployed before. Such an
approach also made it easier to incorporate the lessons of Delacroix,
in which rapidly applied strokes of pure color blended only in the eye,
a practice carried to an extreme by the Impressionists. This painterly
technique—sometimes referred to as *alla prima* (at once)—was already
centuries old, but it felt of the moment, allowing the artist to capture
the accelerating pace of modern life with a sharp eye and a nimble hand.

The old masters—Frans Hals in particular—also inspired Van Gogh
to revive a project near to his heart: to paint portraits, particularly
of young women. "I find a power and vitality in those common girls
and fellows which, to express them in their singular character, would
have to be done with a firm brushstroke, with a simple technique.[81]
For Van Gogh, the relationship between artist and his model involved
dynamics of power and sexuality. "The women's figures I see among

* Another associated term, coined by Swiss art historian Heinrich Wölfflin, is
malerisch (painterly), as opposed to linear. In painting in this more direct manner,
where the individual brushstrokes show, Van Gogh was following in the footsteps
of artists like the Venetian masters Titian and Tintoretto, Baroque masters like
Rembrandt and Hals. More recently Delacroix and then the Impressionists had
raised the banner of the *malerisch* camp.

the people here make an enormous impression on me," he confessed, "far more to paint them than to have them, although I'd actually really like both."[82] Reviving the habits that got him into trouble first in The Hague and then in Nuenen, he frequented the dance halls and brothels in search of not only subjects but companionship.

Frans Hals, *The Gypsy Girl*, c. 1625

Either way, these liaisons cost money. Theo, feeling increasingly pinched by his brother's spendthrift ways, tried in vain to rein him in. "We have no money," he protested, "there is nothing doing. I tell you no."[83] But Vincent doubled down, invoking the overriding imperatives

of his art and contrasting Theo's pettiness with his own martyrdom. "When I receive money," he wrote in a tone calculated to provoke, "my greatest hunger, even if I've fasted, isn't for food, but is even stronger for painting—and I set out hunting models right away, and I carry on until it's gone."[84]

Responding to Theo's calls to cut costs, he splurged on more expensive paints—cobalt blue, cadmium red, emerald green, insisting: "It's false economy to do without them, those colors."*[85] This, too, was in keeping with his new artistic persona as he focused on producing attractive, well-made paintings rather than works that pushed a social agenda.

In order to keep the money flowing, Vincent knew he had to do more than invoke art as a higher calling. He had to convince Theo he was making an investment that would pay dividends in the near future. "I found six art dealers' addresses,"[86] he reported, taking full advantage of the opportunities the cosmopolitan city offered. Noting the brisk work done by the local photography studios, he calculated that as soon as he acquired a knack for achieving a fair likeness he'd be able to market his services to attractive young ladies seeking flattering portraits to hang in their places of business:

> I must also try to make some acquaintances among the girls, which is *no easy task* with a purse with little in it, I can assure you; one is by no means doing it for one's pleasure. But it's not the effort that I find daunting. Only, I believe that you've become all too, all too accustomed to thinking it perfectly all right for me always to be neglected, that you

* For instance, Père Tanguy, Van Gogh's main paint supplier in Paris, sold cobalt blue for four times the price of the common Prussian blue. Cobalt was both purer and more stable.

all too readily forget that for so many years I haven't had what's due to me.

And that the desire I have to expand my affairs is good not just for me, but for you too, because it's only by this means that we can earn.[87]

For all his happy talk of lucrative opportunities, this was simply money down the drain; no paying customers ever materialized. He did manage to entice at least one beauty into his studio, a chorus girl from the Scala café concert, a dance hall modeled on the Folies Bergère in Paris, but he simply gave her the painting in exchange for agreeing to pose. This striking profile of a young woman with jet-black hair and a bright red bow reveals a newfound freedom as he captures her likeness in a few strokes laid on with all the dash of Frans Hals, if not quite his impeccable control. [see color plate 8] Gone is the slowly accreting geology of *The Potato Eaters*; banished too is its stygian gloom. As his brush quickens, his palette brightens. "In the woman's portrait I have brought lighter tones into the flesh, white tinted with carmine, vermilion, yellow, and a light background of gray-yellow, from which the fact is separated only by the black hair. Lilac tones in the dress."[88] If this was not exactly what Theo had in mind when he urged his brother to bring more light and air into his painting, it was a step in the right direction.

How easily Van Gogh discards the sentimentality of the earlier works! How carelessly he must have worn those peasant smocks and wooden clogs to have tossed them aside so easily. He's taken on a completely new identity, an objective chronicler of contemporary mores, a connoisseur of female beauty like Mouret. How could someone so moved by the rustic denizens sharing their frugal meal now be captivated by this raven-haired charmer? "Almost no one knows that

the secret of beautiful work is to a large extent good faith and sincere feeling,"[89] he once proclaimed, channeling the moral certainty of a preacher. But now all that goes by the wayside. One moment he's Dr. Jekyll, filled with compassion for suffering humanity; in the next Mr. Hyde, lecherous, predatory, self-serving.

Van Gogh was still in search of his authentic self, lurching from one thing to another, desperate to find a place where he might win acceptance, where he might belong. In the past he had "considered art more sacred, more than now,"[90] he confessed a couple of years later with a tinge of regret for lost illusions. Here we see an artist as uncertain as the man, caught between contradictory methods and faithful to no particular school. The one constant is the vehemence with which he latched onto each thing in turn, the heat of his passion in no way tempered by his inconsistency. As his Parisian friend Émile Bernard would later note, everything he touched he invested with "a sense of life's intensity"[91]—as true when he was painting a family of peasants at their dinner table as a still life of the muddy boots they wore.

Vincent adopted a new artistic persona largely to make himself and his art more acceptable to Theo. He was reinventing himself for the Paris market, at least as he perceived it. Even before leaving Nuenen—but following his revelatory trip to the Rijksmuseum—he was beginning to make concessions. "Lighten up!" had been Theo's motto all along, and Vincent now did his best to comply. "Presently my palette is thawing, and the bleakness of the earliest beginnings has gone," he insisted as early as October.[92] As evidence of his change of heart, he offered works like *Autumn Landscape with Four Trees* [see color plate 9], whose muted palette is relieved by passages of more vivid color and enlivened by looser handling. If the effect is still more Barbizon than Impressionist, in both approach and subject matter it was a sign he'd gotten the message.

The three months Van Gogh spent in Antwerp, like the six months he spent in Brussels, were a period of rehabilitation. In 1880, the sins he needed to atone for involved excesses in the Borinage so extreme that his father tried to have him committed. Five years later in Nuenen, a similar crisis demanded similar efforts to repair the damage. In each case Vincent went out of his way to demonstrate his practical side, purchasing new clothes and taking concrete steps to earn money from his art, either as a commercial illustrator or a hack portraitist. "This much is certain, I want to be seen," he assured Theo, even if it meant stooping to painting "signboards and decoration."[93] Despite Van Gogh's reputation as an artist of deeply held convictions—convictions so uncompromising they condemned him to a life of poverty and neglect—he was in fact tactically flexible, as ready to abandon his ideals for the sake of easy money as to climb on his high horse to preach the sacred calling of his art. With a little more facility and a more ingratiating personality, it's unlikely he would ever have achieved the greatness that necessity thrust upon him.

Following the pattern he'd set in Brussels, Vincent enrolled at the Royal Academy of Visual Arts, participating in the life drawing class taught by Charles Verlat, as well as an evening course with Frans Vinck, where students drew from plaster casts of ancient sculptures. Given past quarrels with Mauve and Rappard, Van Gogh's willingness to submit to the rigors of a traditional course of study seems a bit hypocritical. Mostly he was doing it for Theo's benefit, to demonstrate he was taking his responsibilities seriously. This interpretation is bolstered by the fact that he seems to have exaggerated his connection to the school. There's no indication he was ever officially enrolled at the Academy, which would have required passing a preliminary exam. It's likely he simply crashed the more prestigious life drawing course, as suggested in an account by a fellow student: "Van Gogh burst into the Academy like a

bomb, and his clothes—a blue stockman's smock and a fur cap—and his furious manner of painting and drawing caused a sensation."[94]

Once again his promise to toe the line was undone by his refusal to buckle under. "I actually find all the drawings I see there hopelessly bad," he told Theo, "and fundamentally wrong. And I know that mine are totally different—time will just have to tell who's right."[95] He returned to the subject a few days later: "It's strange that when I compare my study with those of other people, it has almost nothing in common with them. Theirs have more or less *the same colour as the flesh*—and so look very accurate from close to—but if one steps back a bit, it becomes painful and flat to look at—all that pink and delicate yellow, etc., etc., soft in itself, produces a hard effect. The way I do it, from close to it's greenish red, yellow-gray, white, black and a lot of neutral, and mostly colours one can't put a name to."[96] In these passages one can still hear echoes of Blanc's principles of complementaries and "broken tones," though on the evidence of the paintings he created in these months, theory continued to outpace practice.

Van Gogh's most distinctive quality as an artist at this point in his career is not his actual achievement but his personality, which, on the evidence of the paintings themselves, is defiant, pugilistic, opinionated, and, admittedly, not terribly coherent. With very little professional training under his belt, and few artistic successes to point to, Van Gogh exhibited that independence of mind that will serve him so well when he forges an artistic identity of his own. One can feel him fumbling about, seeking the right tools and expressive language to say what's in his heart, but his disdain for conformity, his faith that there is something more than mere technical competence, points to intellectual immaturity but also at greatness to come.

In the meantime he was locked in the same old quarrels with his brother over money and life choices. Vincent accused Theo of skimping on his allowance and, even worse, on emotional support:

> Do you realize that it's sometimes almost literally impossible for me to keep going? And that I *must* paint, that too much depends on pressing on with the work here with assurance *immediately* and WITHOUT HESITATION? A few weaknesses could make me fall in a way from which I wouldn't recover for a long time. My situation is perilous on all sides and can only be won by working on determinedly. The paint bill weighs on me like lead and yet I must *go forward*!!! . . . Oh, if only I could make you understand how much more satisfaction you could have for yourself, how much more of a friend you would be to me—if, instead of the inflexible and cold neglect, and keeping me at a distance—think about last summer and previous summers!—you might at last come to the realization that *this* isn't the way. Always to be in a state of exile, always hanging by a thread, always half measures. [97]

For Theo, whose salary no longer stretched far enough to support his brother in the manner to which he felt entitled (not to mention his mother and siblings back in Nuenen), the solution was obvious: Vincent should leave Antwerp and return to the family home, where he might actually live within his means. But for Vincent there were too many ghosts in Holland. The thought of returning to his family, of having to endure their pregnant silences and reproachful stares, filled him with dread. He called his mother and siblings "the family stranger than strangers" and confessed that "the estrangement drove me mad." [98]

In an effort to extract another fifty francs a month, he brought up the much discussed and long deferred possibility of moving to Paris. "I might perhaps go further afield rather than go back to Holland before I've worked in a studio for a while," he wrote in early January 1886. "And that further afield—might possibly be Paris, without hesitation."[99] He returned to the topic a few days later: "So just let me scratch around, and for heaven's sake don't lose heart or weaken. I don't think that you can reasonably ask me to go back to the country for the sake of perhaps fifty francs a month less, when the whole stretch of years ahead is so closely related to the associations I have to establish in town, either here in Antwerp or later in Paris."[100]

If anyone was in danger of losing heart it was Vincent. He'd arrived in Antwerp with high hopes, but as always the initial euphoria brought on by a change of scene dissipated as he confronted the same old problems he thought he'd left behind. As his difficulties mounted, he lost his Mouret-like swagger. Instead of projecting confidence, his letters begin to chronicle a tale of woe. "I really do notice that I've been at a very low ebb,"[101] he admitted in early February. The money was never enough, and if Theo ever managed to send him a little extra, it went to hiring models and purchasing supplies. He smoked heavily to quell the pangs of an empty stomach and filled his flask with cognac to steady his jangled nerves. He had little to spare for food or other necessities.

Deprivation, along with his need for female companionship, contributed to the inevitable breakdown. In early February, Vincent was treated for syphilis. He'd already been hospitalized once for venereal disease—in the summer of 1881 while Sien was giving birth to her son—though in that case it was gonorrhea that laid him low. Syphilis was more dangerous, and treatment in those days before antibiotics, more unpleasant. He paid numerous visits to a Dr. Amadeus Cavenaille, who seems to have prescribed mercury—taken either in

pill form or in fumigations—a toxic metal that damaged the patient as much as the disease.

Vincent didn't reveal the underlying cause of his ills—not wanting to give his brother any more excuse to lecture him about his lifestyle—but he shared his gruesome symptoms. A chronically upset stomach, excessive salivation, and tooth loss made daily life a struggle. "I'm most definitely literally exhausted and overworked," he admitted. "It's *total* debilitation."[102]

Once again he'd reached an impasse. The enthusiasm he felt on arriving in Antwerp, his delight in the varied scene and exotic faces, vanished over the course of the unforgiving winter. His attempts to make a human connection ran up against the usual incomprehension. Even his fellow artists didn't know what to make of this strange character: "He came rushing in like a bull in a china shop and spread his roll of studies out all over the floor," recalled one fellow student:

> Everyone crowded around the newly arrived Dutchman, who gave more of an impression of an itinerant oil-cloth dealer, unrolling and unfolding at a flea market his marked-down samples of easily folded tablecloths. . . . Indeed, what a funny spectacle! And what an effect it had! The majority of the young chaps laughed their heads off. Soon, the news that a wild man had surfaced spread like wildfire throughout the building, and people looked on Vincent as if he were a rare specimen from the "human wonders" collection in a traveling circus.[103]

The laughter hurt. For all his bluster, Vincent never learned to shrug off this kind of abuse. "I also have to tell you that although I still go there," he confided to Theo, "it's often insupportable for me, the

carping of the fellows at the academy, for it has proved that they're still spiteful."[104] Loneliness took a toll, affecting not only his health but the thing he cared about most—his work: "When I compare myself with the other fellows, there's something much too stiff about me, as if I'd been *in prison for 10 years*. And that's a matter whose cause lies in the fact that for 10 years or so I've had a both difficult and turbulent time, and worry and sorrow and no friends. That will change, though, as my work gets better and one can do something and knows something. Which, I say, we're on track to establishing really solidly."[105]

One of Van Gogh's strengths was that no matter how bad things got he always imagined something better just around the corner. He rarely succumbed to despair, at least not for long, living his life in chiaroscuro with the darks merely making the lights shine forth more brightly. This current crisis would also pass, if only he could restore his health, fix up his appearance, work a little harder and with more focus. He realized he hadn't achieved much lately—his latest project to paint portraits of the local beauties had come to nothing—but he was now more confident in his abilities. When one of his teachers gave him a word of encouragement, he excitedly passed it along to Theo, crowing that even the exacting Verlat had "seen good things in his work."[106]

He admitted there had been detours along the way, but now he believed he was on the right track: "If I'd known beforehand what I've found out here about opportunities to work in a studio in town, I'd have done it sooner."[107] One more year of drawing, he insisted, and he'd be ready to take on the world. One more year studying with a teacher, working with a model, and drawing from plaster casts, and he'd be ready to spread his wings. Or, on a more down-to-earth note, one more year and he'd begin to earn his keep, either as a commercial illustrator or a portraitist.

His only thought was to get to Paris as soon as possible. "Now—since I *must* make progress and since I'm also ill—all I can do is ask you to approve my staying here until I go to Paris, and let me go to Paris at any rate not later than when the course here ends, 31 March."*[108] Lonely and worn out, he dreamed of a happy reunion with Theo that would restore him to health in both mind and body.

Theo didn't respond with an outright refusal, always a dangerous tactic with his brother. He was troubled by Vincent's account of his suffering, though he was also acutely aware how much he'd brought it upon himself. All he could do is put him off. The lease on his apartment would be up at the end of June, which would allow him time to find them a larger place. To ease his disappointment Theo even encouraged his scheme—which he surely knew was far-fetched—to set himself up as a painter of society portraits. In the new, larger apartment, he pointed out, there will be room for "a rather good studio where one can receive people if need be."[109]

At first Vincent was encouraged by Theo's attitude. "I'm really glad that you like my plan to come to Paris," he wrote on February 6:

> I believe it will help me make progress and at the same time that, if I didn't go, I might easily get into a mess, keep moving around in the same circle too much, persist in the same mistakes. . . . For the rest, I have to tell you the same about me as you write about yourself—*I'll disappoint you.*
>
> And even so, this is the way to combine forces. And even so, much greater understanding of each other can follow from it."[110]

* He's referring to the course at the Academy.

The only difficulty was what to do in the meantime. Theo insisted that Vincent return to Nuenen, since Antwerp was not only draining his bank account but taking a terrible toll on his health. Vincent disagreed. "To go back to Brabant is actually a detour," he grumbled, "and I'll lose time and money on it. Why can't I go straight from here to Paris whenever you like, and carry on working here until I go?"[111]

The truth was that even Vincent had his doubts. Now that the prospect of living together was more than theoretical, he saw all sorts of potential difficulties. "Setting up a studio together may perhaps be *very good*—but we have to be able to stick it out and—we really have to know what we're doing and what we want, and once we set it up a degree of self-confidence is needed, left, after all, after whole series of lost illusions."[112] He longed for a reunion with Theo in Paris but was realistic enough to know it could end badly. "We'll see whether we can get on together—I hope so—but if it didn't work, then we'd know something more definite about it if we'd had that provisional trial for a few months first."[113]

The negotiations dragged on for weeks. The prospect of living together forced them to test the strength of their relationship, each wondering whether it could withstand the added strain. They dredged up the past, rehashed the same old arguments. Rather than draw them closer together, the negotiations pushed them further apart. As Vincent grew more insistent, Theo dug in. "Your letter disappoints me since you don't accede to my request," Vincent wrote on February 22, "because I still continue to believe so strongly that the reasons which I gave you in my last letter for preferring to come even sooner were justified. But since I don't want to argue about that, after all, I just wanted to ask you to reconsider it again."[114]

Theo *wouldn't* reconsider. Faced with what he perceived as his brother's intransigence, Vincent simply took matters into his own

hands. Five days later, with the rent overdue and creditors pounding on his door, he skipped town. He arrived in Paris the following morning, joining the expectant throng crowding the platform of the Gare du Nord. Like many of his fellow travelers, he'd come here to reinvent himself, to open a new chapter in his life. In the course of writing it, Vincent van Gogh would not only transform his own narrative but, in the space of a few short years, inscribe his name in the history books.

4

L'Oeuvre

"It was there that everybody was laughing loudest and longest: in front of his picture. 'There!' cried the trium-phant Jory. 'How's that for success?'... 'We're launched, no doubt about it. The papers will be full of us tomorrow!'"
—Émile Zola, *L'Oeuvre*

The first installment of Émile Zola's *L'Oeuvre* appeared in the Paris daily *Gil Blas* on December 23, 1885. Over the course of the next four months, an additional seventy-nine installments would appear in its pages before the novel finally concluded in March 1886. Van Gogh made sure to get his hands on the opening chapter as soon as it was available. As he prepared to leave Antwerp, hoping to join the world Zola was describing, he offered Theo his thoughts: "I think that this novel will do some good if it sinks in a little in the art world. I thought the excerpt that I read was very realistic."[1]

The artists of Paris on whom Zola had focused his keen journalist's eye had a somewhat different take. To them the novel felt like a slap in the face, especially to those who thought they saw themselves thinly disguised as characters in its pages. Paul Cézanne, Zola's childhood

friend, was particularly outraged, convinced the book's flawed protagonist, Claude Lantier, had been based on him. He thanked Zola politely for the copy he'd sent and never spoke to him again. But even those on less intimate terms with the author were stung by his portrayal. Claude Monet responded on behalf of his fellow Impressionists: "I have just read it and I am worried and upset, I admit. You were purposely careful to have none of your characters resemble any one of us, but, in spite of that, I am afraid lest our enemies among the public and the press identify Manet or ourselves with failures, which is not what you have in mind, I cannot believe it. . . . I am afraid that, just as we are about to meet with success, our enemies may make use of your book to overwhelm us."[2]

It wouldn't have been so bad had this unflattering account come from one of the usual suspects, one of those reactionary critics whose attacks they'd come to expect. But this was friendly fire. For two decades, Zola had been a stalwart champion of the avant-garde, taking on the establishment and defending the new art in polemical articles in the city's leading cultural journals. Now it seemed their most effective spokesman had gone over to the enemy.

*L'Oeuvre** is the story of the painter Claude Lantier and his doomed effort to create the definitive modern masterpiece. While Lantier resembles Cézanne in some particulars—his friend Sandoz is clearly meant to represent the author himself—his place as the leader of a movement comes closer to that of Édouard Manet.** The novel follows Lantier and his band of bohemian rebels as they challenge the

* Usually translated into English as *The Masterpiece*, though it literally means either "The Work" or "The Body of Work."

** Van Gogh himself believed Lantier was based on Édouard Manet [See letter 562, Feb. 11, 1886]. In reality, Lantier is a composite, part Manet, part Cézanne, and part generic Impressionist. As Monet realized, Zola had deliberately avoided comparisons with one particular artist.

Academy, struggling to invent an artistic language that could speak to a new age. Lantier is the leader of the "Open-Air School," modeled on the movement initiated by Manet and carried forward by his younger Impressionist colleagues. Zola had stood with Manet in the face of withering attacks; he then went on to deploy his pugilistic skills to defend his disciples. But with *L'Oeuvre*, he seemed to have lost faith. Yes, he still sympathized with their ideals, but he takes them to task for the gap he perceives between their ambition and their actual achievement: "Since the 'Salon des Refusés" the Open-Air School had developed considerably and its influence was being felt more and more. Unfortunately, its efforts lacked cohesion; its new recruits turned out little more than sketches and were easily satisfied with impressions tossed off on the spur of the moment. What was needed was the man of genius whose work would be the living image of their theories. What a fortress to storm, they said, and what a victory to win! To conquer the public, open a new period, create a new art!"[3] In Zola's telling that genius had yet to appear. The promise of modernism was still unrealized—perhaps it was unrealizable.

For those flesh-and-blood artists fighting for recognition, Zola's defection was a cruel blow. Perhaps, some of them rationalized, he was never really what he seemed. For all his courage in standing up to the reactionaries, his criticism always lacked depth. He celebrated Manet and his followers when their work seemed to conform to the spare realism he was pursuing in literature, but his understanding of what they were actually up to was rather limited. He couldn't see that the "sketchiness" that he took as a lack of resolution *was* the resolution. The "spur of the moment" was exactly what mattered, evoking the sensory overload of being immersed in nature. His insistence that

* See below.

the new art failed to live up to its promise simply meant that it failed to follow slavishly his own agenda. In short, their pictorial experiments ceased to interest him, as soon they departed from the *naturalism* he insisted was the only legitimate form of modernist expression.

Van Gogh's initial take on Zola's work is telling. Judging the writer's criticisms "realistic," he assumed he was echoing his own conviction that the modern school had lost its way. It's unlikely he fully grasped Zola's intent, particularly since when he wrote to Theo he'd only read the first installment. And it's certainly true that he would ultimately develop along lines diametrically at odds with Zola's more realistic outlook. (In fact, Zola reserves his most savage criticism for Lantier's turn from realism to Symbolism, the very path Van Gogh would soon embark upon.) But on the eve of setting out for Paris, he was encouraged that such a formidable intellect shared his own misgivings about the latest artistic fads. Thus he arrived in Paris with a rather superior attitude, assuming Zola's takedown mirrored his own views.

The anger of progressive artists and critics—one editor described the novel as filled with "pitiful ravings"[4]—was fueled in part by the sneaking suspicion that his critique wasn't entirely off the mark. There was a sense that the avant-garde *was* in crisis. Manet had died in 1883, and the younger generation of Impressionists no longer shared the unity of purpose they once possessed. Just as these former *enfants terribles* were beginning to achieve a measure of respect, they were at something of a loss over what should come next. The heroic battles were in the past, and the future was both wide open and unnervingly unformed. "Now we need something else," Zola's fictional painter cries out. "Just exactly what I don't really know!"[5] In 1886, in Paris, how many artists secretly shared his doubt?

The controversy that erupted over Zola's *L'Oeuvre* was a peculiarly Parisian phenomenon. Here in the French capital, art was as much about polemic as it was about the actual nuts and bolts of picture-making. "To paint," insisted Camille Pissarro, "it is absolutely necessary to live in Paris, so as to keep up with ideas."[6] The city's cultural community was energized by debate and thrived on controversy. One might even say it couldn't survive without it.

Other cities in Europe and America—London, Berlin, New York—had vibrant art scenes (though none could compete with Paris in terms of the sheer volume of work being produced and put in front of an eager audience).* More important than numbers, however, was the dynamism it projected, derived from the certainty that art was not merely an ornament to life but life itself. Here painting, sculpture, and literature were treated as serious business, and the health of the cultural sector was carefully monitored by the authorities since it was deemed essential to the health of the nation as a whole. Given the stakes, it's not surprising that the field was contested and that the perennial struggle between tradition and innovation was bound up with larger political debates. In the hundred years preceding Van Gogh's arrival in Paris, France had been rocked time and again by revolution and counter-revolution, periods of dazzling opportunity alternating with periods of retrenchment. The cultural battles paralleled this tumultuous history in only slightly less sanguinary form.

The contest was not confined to the museums and galleries. It spilled out onto the street, where it was taken up in cafés and literary salons, engaging both the written and spoken word. Modernism was argumentative, unthinkable without the larger intellectual context that

* In 1886, Paris had a population of just under 2.5 million. London's was just over 3 million, and New York City under 1 million.

sustained it and the mass media that publicized it. Taking a stand for or against the latest innovation went a long way toward defining one's social and political identity. It was difficult, if not impossible, to be a radical when it came to art and a reactionary in politics—and vice versa. Debates focused on abstruse aesthetic matters were often proxies for wider discontents, giving them an urgency out of all proportion to the apparent stakes.

All of which helps explain why Paris was flooded with periodicals covering every aspect of the visual arts, as well as countless pamphlets, catalogs, books, and essays, along with the mass-circulation newspapers that devoted large sections to reporting on the latest exhibitions. Some, like *Le Figaro*—home to Manet's nemesis Albert Wolff—were well established and read by millions, while others were fly-by-night publications that closed almost as soon as they were announced with great fanfare and high hopes. Controversy was the lifeblood of the city's cultural existence. "A newspaper is simply a battleground," proclaims the journalist Sandoz. "A man has to live, and to live he has to fight. The Press, whatever one thinks of it, and however much you may dislike working for it, is a power to be reckoned with, an invincible weapon in the hands of a chap who has the courage of his convictions."[7] In short, he concludes, the press offered a "new literature for the coming century of science and democracy!"[8]

In typically Parisian fashion, allegiances were proclaimed by where one chose to eat and drink. Each of the factions that sprang up in what often seemed like a war of all against all claimed a particular café or tavern as its home base. Paradoxically, quarrelsomeness actually enforced a group mentality as cultural soulmates sought safety in numbers: Realists gathered at the Brasserie des Martyrs; Manet and his gang at the Café Guerbois; the Impressionists at the Café de la Nouvelle Athènes, while Symbolists scribbled manifestos on

the tables of the Brasserie Gambrinus. The general public chose sides with the passion of sports fans, cheering for their favorites and heckling their rivals, identifying the latest school emerging in the annual Salon, anointing heroes and villains, trading in gossip and delving into the theories that lay behind each mark of the brush or scratch of the pen.

Van Gogh was not particularly well-versed in these debates when he arrived in the city. He was far more conversant with the art of the past than of the present, far more invested in what was hanging on the walls of the Louvre and the Luxembourg than in what was being conjured in the studios of Montmartre or the Montparnasse. Rubens and Rembrandt, Millet and Delacroix, were the names he summoned in his arguments with Theo and Rappard, not Manet, Monet, or Degas. When he did venture to weigh in on the current state of affairs, his pronouncements had an element of naïveté.

The biggest gap in his knowledge involved that subset of living artists who were sometimes referred to as the avant-garde, a rather elastic term that implied little more than an eagerness to defy convention.* Theo himself, though he'd come around to Impressionism, wasn't much help as a guide to the radical fringes of the Parisian art world. More up to date than Vincent, he was still risk averse, reflecting both his own cautious nature and the conservative aesthetic of Goupil & Cie. The materials he'd been forwarding from Paris, and from which Vincent had formed his picture of the Parisian scene, were mostly issues of the popular illustrated

* The first use of the term in a cultural sense goes back at least as far as 1825 when, in his essay "L'artiste, le savant et l'industriel," the mathematician and social reformer Olinde Rodrigues called on artists to "serve as [the people's] avant-garde." By midcentury the term was in common use to define those cultural practitioners who pushed the boundaries of accepted practice.

journals—like *Le Courrier Français* and *La Vie Populaire*[9]—catalogs from the annual Salons, and articles from the mainstream press; notably absent were those with smaller circulations, but dedicated readers, where new trends were announced.* Thus, Van Gogh's basis for judging Zola's depiction of the Paris art world as "realistic" was limited at best, based largely on ignorance and distorted by his own preconceived ideas. He would not find it easy to move beyond the prejudices he brought with him from the North. Van Gogh was nothing if not dogmatic, certain of his convictions up to the very moment he changed them for others equally strongly held. Over the next two years, the French capital would offer him a crash course in the most radical art, opening his eyes and his heart to new possibilities and transforming him from a provincial rube into one of the most original practitioners of the age.

By the winter of 1885–86, the Parisian art world had fallen into a predictable pattern. Nearly a quarter-century earlier, a band of revolutionaries had launched an assault on the bastions of the French artistic establishment. The old guard had not yet conceded defeat, nor had they relinquished their dominant position in the institutions that doled out honors and lucrative commissions. But after a decades-long campaign, the former revolutionaries were no longer relegated to the far fringes of the French art world; they had advanced within striking distance of the centers of power and were sufficiently well armed to challenge the status quo on something like equal terms. But as they inched forward,

* The shift in interest from English to French illustrated journals parallels his shift in interest from writers like Dickens to writers like Zola and the Goncourt brothers. The British journals tended to publish images of a sentimental or moralizing tone; the French were more neutral, in keeping with the "modern" aesthetic.

reaching for respectability and (crucially) financial security, there was a growing unease among the ranks, a sense they lacked direction and the unity of purpose that once bound young idealists together in a desperate cause. Now that the thrill of that initial revolt had receded, many asked: What next?

Zola did not set his novel at the end of the era—the moment in which he was actually writing—but at the beginning, as if the opening act of the revolution contained within itself the seeds of its own failure. The action revolves around the famous Salon des Refusés of 1863, an event often identified with the birth of modernism and the avant-garde. "Here there was a scent of battle in the air," Zola recalled of that seminal event, "a spirited battle fought with zest at crack of dawn, when the bugles sound and you face the foe convinced you will defeat him before nightfall."[10] Now, looking back, he mourned a squandered opportunity, a moment of liberation that failed to live up to its initial promise.

In the spring of 1863 many, including Zola himself, believed that the stony grip of tradition was loosening and a new age of progress opening up. But as chronicled in the pages of *L'Oeuvre*, the new age was stillborn; Lantier's attempts to build something lasting on the rubble of the old foundations ends in despair and suicide.

The Salon des Refusés, the Salon of the Rejected, was a quintessentially Parisian paradox. For two centuries leading up to this watershed event, the annual (sometimes biennial) Paris Salon was the world's premiere exhibition of contemporary art. Drawing hundreds of thousands to its month-and-a-half-long run each spring, it was meant to appeal not so much to connoisseurs and arts professionals as to the public at large.* In fact this was its purpose:

* In the 1880s, average attendance was about 300,000.

to put the highest cultural achievements before the widest pos-
sible audience, raising not only the aesthetic but even the moral
standards of the population and demonstrating French leadership
in the cultural realm.

For most of this period, the Salon was actually sponsored by the
government,* specifically the Académie des Beaux-Arts, an agency
within the Institut Nationale des Sciences et des Arts tasked with
upholding the highest standards of excellence in the visual arts. The
Salon reflected official taste and reinforced official ideology. Its juries
consisted of the most distinguished painters and sculptors in the realm,
many of them on the government payroll as members of the Institut.
Above all, the Salon was a self-congratulatory spectacle demonstrating
the cultural preeminence of *La Patrie*.

In fact, a "Salon of the rejected" was a contradiction in terms. It
was a failure of consensus within a system operating on the premise
that consensus was not only possible, but necessary. At best it was
an admission that placing the official seal of approval on certain
paintings and sculptures while denying it to others was an exercise
in subjective imprecision; at worst, a completely misguided attempt
to impose a rigid set of values on a form of human activity resistant to
such distinctions. The fact that it was the government passing judg-
ment meant that the process was inherently political, with the usual
horse-trading, favoritism, and corrupt bargaining that the term
implies. This would have mattered less if admission into the Salon
had been simply a point of pride. But for many, it was the difference

* In 1881, after repeated controversies, the government officially withdrew its
sponsorship and ceded responsibility to the independent Société des Artistes
Français. But the Salon continued to have the status of an officially sanctioned
event, at least in the public's mind.

between success and ruin. Since it was almost impossible to sell a work stamped on the back with the dreaded *R*, one's livelihood depended on the jury's verdict. Even an artist like Pierre-Auguste Renoir, who made his career fighting against the system, couldn't hold himself completely aloof, grumbling: "There are in Paris scarcely fifteen art-lovers capable of admiring a painting without Salon approval . . . there are eighty thousand who will not buy even an inch of canvas if the painter is not in the Salon."[11]

The Salon des Refusés represented not a failure of the system, so much as the logical outcome of contradictions that had been present at its birth. The fact that Paris grew into the center of radical artistic practice—incubator of the avant-garde and, thus, of modernism itself—was the result of a centuries-long project to turn the city into a bastion of conservative aesthetic values. Just as the political revolutions of 1789, 1830, and 1848 involved violent outbursts against regimes too rigid to evolve by peaceful means, so the character of the artist-as-rebel was forged in battle with a system that was both all-encompassing and unable to adapt to a rapidly changing world.

In a sense, the Salon and the Academy were victims of their own success; their heavy-handed efforts at control nourished a revolutionary cadre bent on their destruction. The system originated during the reign of Louis XIV and his chief minister, Cardinal Mazarin, who founded the Royal Academy of Painting and Sculpture in 1648 as part of an effort to centralize and rationalize French cultural production and place it more firmly under the control (and at the service) of the crown. One of the key components was a school to train artists worthy of royal patronage, the famous École des Beaux-Arts, which Mazarin placed under the direction of the king's court painter, Charles Le Brun.

Cardinal Mazarin, 1658

One of Mazarin's goals had been to demolish the medieval guild system. Before the cardinal's innovations, aspiring artists apprenticed to a recognized master; they belonged to an ancient craft tradition in which skills were passed down from generation to generation. Crucially, this meant that paintings and sculptures were produced without regard to any overarching artistic principle, depending instead on the skill of the individual craftsman and capricious tastes of the patron. Mazarin replaced this haphazard process with one regulated by a centralized arts bureaucracy. Quality was ensured through exacting admissions standards and a rigorous training program; an

official style was encouraged through competitions in which prizes were awarded to those students who most skillfully set forth the dominant ideology. To ensure that artists directed their efforts toward glorifying king and country, as well as elucidating the central tenets of the Christian faith, the Academy established a clear hierarchy in which history painting—heroic tales set in the distant past, battle scenes chronicling the triumph of French arms, or uplifting religious narratives—was held up as the pinnacle of artistic achievement, while landscape, portraiture, and other genres were relegated to lower rungs. So pervasive and enduring were the standards promulgated in Paris that even Van Gogh couldn't entirely free himself from their tyranny. The academies he attended in Brussels and Antwerp were both modeled on the Paris original, and when he told Theo he needed to spend a year drawing from plaster casts, he was following the pedagogy laid down by Le Brun and his successors.

For the artists themselves, the cardinal was offering a devil's bargain: Painters and sculptors gained prestige as well as security under the bureaucratic umbrella, but at the cost of their freedom. Plucked from the ranks of humble artisans, they joined the company of poets, scholars, and other intellectuals who worked with their minds rather than their hands.* But they had a new master to answer to. Fine arts were now deemed matters of state, too important to the French nation to be left to the artists themselves.

From the outset it was clear that the Academy and the École couldn't perform their edifying function unless and until they put their products before the public. The first large-scale Salon, held in the Louvre Palace in 1699, proved an immediate hit with Parisians, who flocked

* In the early years there were ongoing battles between the older guilds and the government-run system. But over the centuries, the power of the central government prevailed.

in large numbers to see these high-minded, impeccably crafted works that, they were assured, represented the pinnacle of artistic achievement. The spectacle was perhaps a bit more democratic than its creators intended. "What an abominable crowd!" complained one early–19th century observer. "Porters, street-hawkers, valets! A swarm of children, jostling, crying, stepping on one's toes!"[12]

In 1748, the pool of eligible artists expanded with the creation of the jury system, which allowed any painter, sculptor, or architect who could withstand their stern verdict to put their work on display. As public interest rose and the number of works on view multiplied, enterprising printers did a brisk business putting out cheap *livrets* or guidebooks to help visitors navigate the confusion. Inevitably, these pamphlets pitted the writer's judgment against the jurors' as they directed their readers toward the most notable works and steered them away from those deemed unworthy of their time.

Thus was born the art critic, the thoughtful man (or occasional woman) who took it upon himself to educate the public on the right way to look at and feel about the work in front of them. If aesthetics was a form of moral discourse, as the Academy insisted, then it was incumbent upon those of elevated taste and upstanding character to enlighten the public and lead them on the path of virtue. From the beginning, aesthetics and ethics were intertwined. One of the first modern critics was La Font de Saint-Yenne, who urged his readers to reject the Rococo fripperies of artists like François Boucher and Jean-Honoré Fragonard in favor of the sober classicism of Nicolas Poussin. His 1747 pamphlet *Reflections on Some Causes of the Current State of Painting in France* contrasts the good sense of the common citizen to the specious hyper-refinement of official tastemakers: "It is only in the mouths of those firm and equitable men who compose the Public . . . that we can find the language of truth."[13]

Jean-Honoré Fragonard, *The Swing*, 1767

Thus, the Academy and Salon that were intended to reinforce the power of the state actually worked to challenge it. Insisting that art was both an ethical and political practice meant that it was contested territory, allowing those unhappy with the current regime to disguise their critique as mere differences of taste. Art was no longer simply the business of the patron (an individual or institution) who paid for the work, but also "the public," an amorphous, essentially ungovernable mass of citizens who felt they had a right to opine on such matters.

The members of the Academy and the jurors of the Salon now had to compete for influence with journalists and provocateurs whose agenda was often diametrically opposed to theirs. La Font's writing actually contains a subtly subversive message—one echoed by many of his successors, including the philosophe Denis Diderot. By confirming the wisdom of crowds, he promoted a democracy of taste with dangerous implications in the political arena. A public that felt free to diverge from the official line when it came to aesthetic matters might exhibit independence in other areas as well. In the years leading up to the Revolution of 1789, debates about the direction of art substituted for debates on more dangerous topics. A critic from this fraught time captures this democratizing process. The Salon, he writes, is

> a vast theater where neither rank, favor, nor wealth can preserve a place for bad taste. . . . Paris comes alive, all classes of citizens come to pack the Salon. The public, natural judge of the fine arts, already renders its verdict on the merits of the pictures which two years of labor have brought forth. . . . [A]bove all the good faith of the majority, arrive finally to produce a judgment all the more equitable in that the greatest liberty has presided there.[14]

The unintended consequence of Mazarin's innovations was that by placing the fine arts under the control of the central government he created a public that felt empowered to comment upon, even to criticize, its decisions.

The Salon of 1857

The power of art to shape public discourse was spectacularly dem-
onstrated when Jacques-Louis David exhibited his *Oath of the Horatii*
at the Salon of 1785 [see color plate 10] to universal acclaim. David,
a winner of the coveted Prix de Rome—the top honor granted to a
student at the École des Beaux-Arts—depicted a scene from ancient
Roman history that celebrated heroic self-sacrifice in service to the
nation. Though its subject was firmly within the Academic tradi-
tion, its pared-down forms and "manly" austerity were widely seen as
a rebuke to those fussy, "effeminate" costume dramas favored by the
court and the pampered aristocracy. Four years later, when revolution
finally came, David was hailed as a prophet announcing the dawn of

a new egalitarian age. When the king was overthrown, the artist confirmed his radicalism by joining Robespierre as a member of the Jacobin Club and participating enthusiastically in the Reign of Terror. As chief propagandist for the radical regime, David worked to abolish the Royal Academy, which had become a hated symbol of the former regime and its elitist tendencies.

With the restoration of the monarchy in 1814, the Academy (now renamed the Académie de peinture et de sculpture) and École des Beaux-Arts again took up their role as defenders of traditional French culture. In an age of reaction, these institutions provided essential ballast for the ship of state, promoting stability in increasingly turbulent seas. But the *public*—Mazarin's unruly stepchild—remained, their passions stirred by an increasingly powerful press that passed judgment on every Salon and thrived on controversy rather than consensus.

In the early decades of the 19th century, the main battles were fought between the Neoclassical school—epitomized by Jean-Auguste-Dominique Ingres (1780–1867)—and the Romantics, whose acknowledged leader was Eugène Delacroix. Classicism remained the house style of the establishment (despite the fact that the arch-classicist David had voted to guillotine the king) while the Romantics appealed to progressives. Delacroix made his allegiance clear with the painting *Liberty Leading the People* [see color plate 11], an allegorical celebration of the Revolution of 1830 that once again succeeded in toppling a king. It's no surprise that an instinctive revolutionary like Van Gogh would take Delacroix as one of his heroes; when he asked Theo which side of the barricades he was on, he likely had this painting in mind.

Jean-Auguste-Dominique Ingres, *Grande Odalisque*, 1814

If classicism, with its appeal to timeless truths, was well suited to promoting a conservative ideology, Romanticism proved less useful as a vehicle for a radical social agenda. Inherently individualistic, appealing to the subconscious and attracted to the neurotic and the perverse, it was inward-turning rather than public-facing. It could be subversive to the extent that it encouraged people to consult their own consciences rather than pledge allegiance to the state, but it was too idiosyncratic to pose a real threat to the status quo. In any case, the reactionaries soon found a more formidable opponent upon which to train their weapons: the Realists, and their charismatic leader, Gustave Courbet (1819–1877).

Fortunately, Courbet was not one to wilt under fire. A man of enormous self-confidence, even arrogance, his faith in himself was justified by his unmatched technical ability and brilliant showmanship. He was, first of all, a superb manipulator of paint on canvas, evoking the softness of nude flesh or the subtle play of light and shade in a forest

glade with a deft touch and irrepressible brio. His skills won him early acclaim, and even a gold medal at the Salon of 1849 for his *After Dinner at Ornans*—a genre scene, based on life in his native village, whose evocation of simple rustic virtues bears more than a passing resemblance to Van Gogh's *Potato Eaters*.

But early success did not encourage him to play by the rules. Courbet flouted the academic order, in which scenes of peasant life were modest in scale and heavy on charm, paintings that, in other words, confirmed the natural order of the world. His massive *A Burial at Ornans*, painted the following year, turned the official hierarchy on its head. Once more he chose to focus on a scene of country life, but now he conceived it on the vast scale (more than ten by twenty feet) usually reserved for important historical or religious dramas. When conservative critics detected a whiff of socialism, Courbet didn't deny it, boasting that he was "not only a socialist, but furthermore democratic and republican, in a word a partisan of all revolution and above all a realist, a sincere friend of the true truth."[15] His reputation as a dangerous radical was cemented when Emperor Napoleon III threatened to slash one of his offensive paintings with a whip.

Courbet, *A Burial at Ornans*, 1850

This put the selection committee in an awkward position. As the winner of a medal in a previous Salon, Courbet should have been ruled *hors concours*, that is, admitted automatically, without having to subject himself to their verdict. At the Exposition Universelle of 1855,* showcasing the finest achievements in French art and industry, the jury got around this technicality by accepting only minor works while rejecting two of his large-scale masterpieces, *A Burial at Ornans* and another vast canvas titled *The Studio: A Real Allegory of the Last Seven Years of My Life*. Courbet reacted to this snub by constructing at his own expense a small structure near the exhibition grounds, charging the public a small fee for the privilege of viewing paintings the official jury had rejected. As if this weren't cheeky enough, he gave this ramshackle structure the pretentious name The Pavilion of Realism. Delacroix, in a symbolic passing of the torch to a new generation, paid homage to the younger man. "There alone for nearly an hour," he recalled. "I discovered a masterpiece in his rejected picture [*The Studio*]. I couldn't tear myself away from it. They have refused, there, one of the most extraordinary works of our time."[16]

Commercially, the Pavilion was an utter failure, but as a piece of self-promotion it was a glorious success. In a wider sense, it marked an important milestone in the evolution of the avant-garde as a kind of permanent opposition. Reviled by the old guard, Courbet was lionized by the new, a symbol of resistance to authority both cultural and political. His status as the pied piper of French art was confirmed in 1861 when a group of students at the École des Beaux-Arts, unhappy

* The Exposition Universelle of 1855 was one of numerous world's fairs staged in Paris throughout the century to demonstrate French cultural and economic preeminence. These spectacles placed equal weight on the arts and technology. Among the most famous were the Exposition of 1889 on the centennial of the Revolution, which gave us the Eiffel Tower, and in 1900, which first drew Picasso to Paris.

at the hidebound methods of their professors, walked out of their class-rooms and prevailed upon Courbet to open up his own private studio, where they might learn at the feet of a true master.

At the same time, though in a less confrontational manner, another group of artists was challenging the hegemony of the Academic system. Known collectively as the Barbizon School—named for the village near the forest of Fontainebleau where they worked—these landscapists were pioneering the technique of plein-air painting.* Packing up their gear and heading out into the countryside—making use of innovations like premixed colors in aluminum tubes and portable easels, and taking advantage of the ease of travel provided by the rapidly expanding rail system—they revolutionized the art of landscape painting by working on the spot, observing directly the ever-shifting play of sunlight and atmosphere, which they translated into images of deceptive simplicity and charm.**

Unlike Courbet, Charles-François Daubigny (1817–1878), Théodore Rousseau (1812–1867), and Narcisse Virgilio Díaz (1807–1876), to name a few of the most accomplished representatives, were not self-proclaimed revolutionaries, but rather sensitive artists pursuing their own vision within existing institutions. True, their unpretentious landscapes were relegated to second-class status in the Salon, but they earned respect and achieved solid, if not spectacular, careers without resorting to attention-grabbing stunts. Ultimately, however, these painters did as much to undermine the Academy as Courbet with his frontal assault. In time, the growing Parisian middle class would find

* They were sometimes referred to as the "school of 1830," identifying them with that revolutionary year. [See *Durand-Ruel*, x] Jean-Baptiste-Camille Corot, another hero of Van Gogh's, was among the first to live and paint there.

** Unlike their Impressionist disciples, the Barbizon painters tended to complete the finished canvas in the studio. But they carried the direct observation of natural phenomena to new levels.

these unassuming views of country life far more congenial than the *grands machines* favored by the Academy, and their pioneering work painting out of doors would pave the way for the greater provocations of the Impressionists to come.

Charles-Francois Daubigny, *Washerwomen on the Banks of the Seine*, 1860

Jean-François Millet, Van Gogh's artistic hero, was generally grouped with his fellow residents of Barbizon. Unlike his colleagues, however, Millet concentrated on painting the human figure. Usually these were peasants in a rural setting, treated with sentimentality that can seem saccharine to 21st-century viewers but that appealed to his contemporaries, who felt reassured that these rustics, rather than plotting violent revolution, were filled with piety and contented with their lot. [see color plate 4] A contemporary English guidebook summed up his appeal, urging its readers to seek out the work of this master "whose commendable object is to cast a pleasing poetic halo around the simple annals of humble and domestic life."[17]

At midcentury, the centralized bureaucracy put in place by Cardinal
Mazarin and Charles Le Brun remained largely intact, having
survived the political upheavals in which France swung from mon-
archy to republic then back again, suffering two more revolutions in
1830 and 1848, before returning once more to autocratic rule under
Bonaparte's nephew, Emperor Napoleon III. Despite the political
instability, these were decades of rapid growth and disorienting
social change in which a rising middle class claimed an ever larger
share of the economy and ever greater influence in cultural matters.
Their buying power transformed the landscape of sensibility, molding
the worlds of high fashion, gastronomy, and fine arts to their taste.
While generally deferential to whatever authority held power at the
moment, they had different priorities and predilections from their
aristocratic forebears. They generally preferred finely crafted kitsch
to edifying sermons, paintings that told stories to ones that made
heavy demands on their intellect. Even as the academic system beat
off various challenges from within and without, it was accepted
by the vast majority of Parisians and by the rest of the world that
looked to Paris for guidance when it came to art and fashion.
Hundreds of thousands continued to flock to the annual Salon, now
held beneath the spacious vaults of the Palais de l'Industrie.* They
came to be entertained and, by and large, the Salon obliged.

But stresses were beginning to build just below the surface,
opening up fissures in the apparently solid foundations laid down
by the ministers of Louis XIV. The government—particularly after
1848, when it fell to the machinations of Louis Napoleon—kept
a nervous eye on cultural developments, knowing its prestige was

* This replaced the much smaller Salon Carré of the Louvre. Built for Exposition
Universelle of 1855, it was also known as the Palais des Champs-Élysées.

tied to Paris's continued reputation as a center of artistic excellence. Uncertain of its own legitimacy, the regime marginalized anyone with the temerity to challenge the official line. Under Napoleon's director general of museums and superintendent of fine arts, Count de Nieuwekerke, the Salons grew even more restrictive and more set in their ways.

The public at large hardly noticed, content with a profusion of eye-catching fare, but for many of the producers themselves—the students at the École and those attending the growing number of private studios springing up around the city—pedagogical methods and ideologies established during the reign of the Sun King no longer claimed their allegiance or sparked their interest. Perhaps at no other time in history were so many well-crafted works of art made to so little purpose as in Paris in the first half of the 19th century. History painting remained the prestige category at the Salon, though served up on a less heroic scale. Instead of morality tales promoting piety and patriotism, they were reduced to costume dramas where anecdote and archeological accuracy mattered more than moral uplift. Jacques-Louis David had already predicted this decline: "I hear the antique praised on every side but when I try to find it applied, I discover that it never is. All these gods, all the heroes, will be replaced by chevaliers, by troubadours singing beneath the windows of their lady-loves, at the foot of medieval towers."[18]

It's not simply that scenes of ancient Greece and Rome were replaced by a fascination with medieval and Renaissance history. The "troubadour style," which had its heyday in the first half of the century, repackaged David's morality tales as nostalgia. History painting became little more than escapism as Parisians, disoriented by a city that was changing before their eyes and shifting beneath their feet, lost themselves in pleasant dreams of yesteryear. One British journalist

noted in 1862: "So long as Parisians are amused, there is less probability of their thoughts dwelling on political slavery."[19] The most popular and highly compensated artist in the world at midcentury was Ernest Meissonnier, a painter who specialized in small-scale genre scenes packed with detail and humorous incident, but unburdened by any hint of a deeper message.

Ernest Meissonier, *The Stop at the Inn*, 1863

If Parisians wished to withdraw into a comforting past, it was largely because the present felt so uncertain. Rocked by decades of political turmoil and military catastrophe, the old patriotic cries rang hollow; it was hard to rally around the flag when that flag (revolutionary tricolor, Bourbon white, or Communard red) kept changing. Even the streets they walked along and the neighborhoods they'd grown up in were becoming unrecognizable. Starting in 1853, Louis Napoleon's prefect of the Seine, Baron Georges-Eugène Haussmann, began a massive urban renewal project in the heart of the city, blasting through warrens of narrow, winding streets that dated from the Middle Ages to open up grand boulevards lined by elegant apartment

buildings. By 1870, the year of Louis Napoleon's downfall, the cost of *les grands travaux* (the great works) had risen to 2.5 billion francs. Included in the price tag were the 17,000 gas streetlamps lining the boulevards, along with 46,000 newly planted trees.[20] The human cost, less easy to quantify, included the 27,000 buildings razed and the 350,000 residents (mostly poor) displaced from the city center and forced out to the suburbs.[21]

Charles Marville, *Boulevard Haussmann*, 1853–70

Part of Haussmann's task was simply to make the city easier to control. (In the Revolution of 1848, alleyways had been rendered impassable by insurrectionists throwing up rubble barriers to block government forces from moving freely about the city.) But military considerations were only part of a larger imperative: to transform Paris into a thoroughly modern city, sweeping away the random accretion of centuries to turn it into a model of rationality. Straight lines replaced aimless meanders; uniformity overcame randomness; broad vistas appeared where crumbling tenements had blocked out light

and air; and green oases like the newly designed Bois de Boulogne, the Tuileries, and the Jardin du Luxembourg sprang up amid vast cobblestone deserts.

Not everyone was happy with Haussmann's "improvements," in which charm was sacrificed for the sake of order, and quaintness for clarity. Victor Hugo—a vocal opponent of Louis Napoleon who spent the years of his reign in exile—deplored the destruction of the medieval city he'd portrayed so lovingly in the novel *Notre-Dame de Paris*. Charles Baudelaire dedicated a poem to the great novelist in which he mourned:

> *Old Paris is no more (the shape of a city*
> *Changes faster, alas! than the heart of any mortal man.)* [22]

For those who loved Old Paris, rationality equaled sterility. The journalist Alfred Delvau described the new buildings lining Haussmann's boulevards as "cold, colorless, as regular as barracks and sad as prisons in the middle of streets aligned like infantrymen . . . lamentable in their regularity." [23]

Inside these cookie-cutter apartments lived the professionals and entrepreneurs driving the new money economy. Rapid growth and material plenty raised millions into the middle class but also fostered anxiety as age-old certainties were undermined by doubtful possibilities. Many rural areas were depopulated when their younger and more ambitious residents emigrated to the city, straining an urban infrastructure ill equipped to absorb the influx and upsetting longstanding social networks. These dislocations were chronicled by Zola in his twenty-volume series of novels tracing the fate of the Rougon-Macquart family as they navigated the roiling currents of the age.* Among

* The series subtitle is "A natural and social history of a family under the Second Empire."

the victims of these forces is Nana, the prostitute whose rise from streetwalker to high-class courtesan can be seen as an emblem of the tawdry, get-ahead-at-any-price mentality of Napoleon's Second Empire.

The advent of a large middle class with money to spend and opinions to share transformed the way art was made and consumed. Instead of producing a painting on commission for a particular client, artists now had to consider the taste of a vast but unpredictable buying public, subject to the winds of fashion and swayed by influential journalists. These shifts in the realm of "high culture" paralleled shifts in the retail industry, where mom-and-pop operations providing bespoke goods to individual customers were put out of business by new department stores. These vast emporiums sold mass-produced goods to the masses, stoking a self-perpetuating cycle of desire and fulfillment. The most successful of these new businesses was the Bon Marché, which opened its doors in 1869. To one dazzled customer it appeared "a gigantic fairy extravaganza in a music hall."[24]

Zola charts the rise of the department stores in his novel *Au Bonheur des Dames* (*The Ladies' Delight*), where the owner, the lecherous Mouret, devours the old-fashioned drapers' shops unable to compete with the "avalanche of cheap goods . . . the bait at the doorway, the bargains which halted the customer as she went past."[25]* Like the prostitute Nana, Mouret is an expert in the art of seduction, and, like the prostitute, his business model depends on turning once intimate relationships into anonymous transactions.

The cultural architecture put in place by Le Brun and Mazarin was singularly ill equipped to adapt to this changing world. Faced with

* Zola's use of the gendered pronoun "she" is deliberate. This new consumer economy was fueled largely by women, whose influence on popular culture grew along with their buying power.

rapid economic and demographic shifts—as well as a crisis of legitimacy brought about by periodic changes in government—the Academy clung ever more tightly to the glories of the past. For many, it was enough to provide a sense of security in an age when so much else was undergoing dizzying change. But as the gap between the official language of art and the world the artists actually inhabited continued to widen, and as the teaching at the École fossilized into repetitive exercises promoting skill at the expense of creativity, many of those who actually made the works the public came to see were growing restless. The student revolt of 1861, when many marched out of the École to seek enlightenment from that dangerous prophet, Gustave Courbet, was only the first faint rumble of a coming storm.

Two years later the storm burst.

In 1863, the always fraught selection process for the Salon proved particularly contentious. Over 4,000 paintings were rejected by a selection committee dominated by a cabal of reactionary professors from the École des Beaux-Arts.* This time, rather than submit meekly to their verdict, the offended artists took the unprecedented step of petitioning the Count de Nieuwekerke. Much to everyone's surprise, the emperor (whose own taste in art was decidedly conventional) decided to address their concerns, perhaps fearing that the protests, if ignored, might spill out into the wider political arena. "Numerous complaints have reached the ear of the Emperor on the subject of works of art which have been refused by the Salon jury," read the official announcement in *Le Moniteur Universel*. "His majesty, wishing to

* That year the dominant figure on the jury was Émile Signol, a professor at the École des Beaux-Arts who specialized in elaborate paintings of historical scenes.

let the public judge the legitimacy of these complaints, has decided that the rejected works of art are to be exhibited in another part of the Palais des Champs-Élysées."[26]

Predictably, this exhibition of also-rans was a hit with Parisians, not so much because they wished to expand their aesthetic horizons, but because controversy was good entertainment. Among the 366 painters included in the exhibition, one was singled out as the worst of the worst, and one painting in particular became the target of the public's derision.

Édouard Manet's *Le Déjeuner sur L'Herbe* (Luncheon on the Grass)* [see color plate 12] is a strange hybrid in which traditional elements are presented with a distinctly modern flair. Following the time-honored academic tradition, Manet borrowed heavily from the past. His depiction of an alfresco meal with clothed and naked figures was modeled on a famous composition by the Renaissance master Giorgione; the pose of one of the male figures was filched from another Renaissance master, the great Raphael himself, an artist often held up as the paragon of the academic style. But Manet treated these borrowed elements in an entirely new way, as if he'd embraced the rules of the game only to flout them.

Manet was, in fact, an unlikely revolutionary. He came from a wealthy, upper-middle-class family—his father was a judge, his mother the daughter of a diplomat—and his small inheritance gave him the luxury of ignoring the critics, at least for a time. With the exception of his radical approach to painting, he was the model of the Parisian gentleman, a flaneur, fond of nice clothes, fine food, and sparkling conversation, which he indulged in at his favorite café in the Batignolles neighborhood, just to the west of Montmartre.

* It was originally titled *Le Bain*, "The Bath."

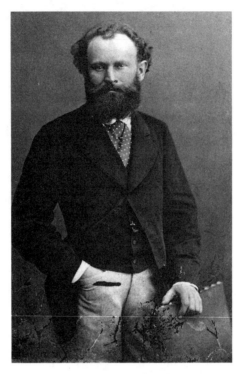

Edouard Manet, c. 1870

Somewhat reserved, he never sought notoriety, wishing only to be granted the freedom to follow his artistic conscience. According to his friend, the poet and critic Charles Baudelaire, "Manet has great talent, a talent which will stand the test of time. But he has a weak character."[27] The temperamental opposite of Courbet, he never felt comfortable as the standard-bearer of revolt. Agreeing only reluctantly to show in such uncouth company, he was unprepared for the outrage that greeted his painting. "He seems to me crushed and stunned by shock," Baudelaire reported. The artist Zacharie Astruc explained his friend's dilemma: "M. Manet has never desired to protest. On the contrary, it is against him, who did not expect it, that there has been protest, because there exists a traditional teaching . . . because those brought

up on such principles do not admit any others."[28] Even after finding himself the target of public abuse, he wouldn't fully reject the system that had so spectacularly rejected him.

Even as a painter Manet was in many ways a traditionalist, grounding his revolutionary approach in historic precedent. He developed his more gestural manner by studying Dutch and Spanish art, particularly the work of Baroque masters Frans Hals—whose work made such an impact on Van Gogh during his visit to the Rijksmuseum—and the Spaniard Diego Velázquez. In fact, he'd already employed the pictorial shorthand that caused such an uproar with *Déjeuner*, even winning mild acclaim for his vigorous approach. In 1861 his *Spanish Guitar Player* had not only been accepted by the Salon jury but won an "honorable mention," suggesting he was about to embark on a respectable career within the academic fold. It was only when this bold technique was employed on a grander scale, to depict a subject many deemed scandalous, that the radicalism of his vision became apparent.

There is, in fact, something provocative about the painting, an in-your-face cockiness that the artist was perhaps not even aware of himself. Rather than concealing the passage of his hand beneath translucent veils of shadow, he attacked the canvas with a loaded brush, an approach that could at first glance appear slapdash but that allowed him to retain the purity of his hues and a feeling of immediacy, as if the composition hadn't been carefully worked out in advance but he'd stumbled upon the scene and caught his subjects unawares.

The works dominating the official Salon, by contrast, loudly proclaimed the monthslong effort that went into their creation. Impeccably drawn and thoroughly researched to give historical scenes an archeological plausibility, these murky canvases bore the weight of centuries. "It was one long succession of gold frames filled with shadow," Zola wrote of the Salon of 1863, "black, ungraceful shapes, of Classical

Antiquity, historical subjects, genre paintings, landscapes, each one thoroughly soaked in the train-oil of convention. Every picture oozed unfailing mediocrity; every one showed the same dingy, muddy quality typical of anemic, degenerate art doing its best to put on a good face."[29]

To eyes accustomed to this academic manner, Manet's painting seemed not only garish but poorly made. Of course his spontaneity was more apparent than real; it required enormous discipline and years of honing his craft to pull off a work of such effortlessness. Most viewers, however, couldn't perceive this rarest of skills and believed instead that he was pulling their leg.

If the *way* Manet painted gave offense, so did the *what*. Dressing the male picnickers in black frock coats and gray trousers rather than in period costumes, he relocated the improbable vignette from the safe confines of a mythological never-never land to a Parisian park, where its sexual charge was far more problematic. The greatest affront was given by the nude woman at the center of the canvas—a portrait of the model Victorine Meurent—who, rather than coyly playing her part in the charade, stares back at the viewer with a brashness bordering on insolence. Combined with Manet's vigorous brushwork, orchestrated clashes of color and form—see, for instance, the brilliant still life in the foreground whose only purpose is to allow us to revel in the sumptuous hues and bravura technique—she announces a new era, one in which a painting can no longer be considered a window onto a make-believe world but an object that boldly, even rudely, asserts its physical existence as an object in our world.

Déjeuner sur L'Herbe is like one of those plays that pierces the third wall and forces the audience to participate in the action. Victorine Meurent is an actor turning to address the audience, challenging us not to take what's happening on stage at face value. We can't con-template her world from a safe distance because the actors refuse to

behave themselves. In the end, the process of constructing an illusion, rather than the illusion itself, is the subject of Manet's unsettling masterpiece.

The uproar over the Salon des Refusés revealed a profound shift in the way the public consumed art. In the late 18th century, radical critics like La Font de Saint-Yenne praised the common sense of the common man, enlisting them in his battle with the ancien régime and praising them as the source of renewal. Now that same public provided a brake on innovation. The radical art of the late 19th century would make an enemy of common sense, forging ahead and daring the public to follow. Most refused. If the Parisian public came to mock *Le Déjeuner*, it's because the artist seemed to be mocking them, serving up a parody of a *grand machine* and forcing them out of their comfort zone.

Alexandre Cabanel, *The Birth of Venus*, 1863

It's hard for us now to see why *Le Déjeuner* provoked such outrage. To 21st-century eyes, jaded by over 150 years spent assimilating far

more radical assaults on traditional forms, its departures from academic orthodoxy seem tame. As for accusations of indecency, Manet's painting seems far less provocative than erotic fantasies by such stalwarts of the Academy as Jean-Léon Gérôme, Alexandre Cabanel, and Adolphe Bouguereau that were deemed perfectly acceptable. Manet's real offense was that he refused to hide behind the fiction that *his* nude was a Venus or an Ariadne, that she was anything other than a Parisian street girl, unembarrassed by her nakedness and confronting our voyeuristic interest with a sassy grin of her own. If the emperor regretted giving Manet a platform from which to assault standards of good taste, he merely compounded his initial error by declaring his painting "immodest,"[30] guaranteeing its author a notoriety he never sought.

In Zola's *L'Oeuvre*—written two decades later, after the routine had become familiar—the mockery aimed at Lantier's painting was not a sign that he'd failed but rather proof that he'd struck a blow for the future: "It was there that everybody was laughing loudest and longest: in front of his picture. 'There!' cried the triumphant Jory. 'How's that for success?' . . . 'We're launched, no doubt about it. The papers will be full of us tomorrow!'"[31]

To be in the papers, to be talked about, to be proclaimed the leader of a new movement—this became the goal of any ambitious artist refusing to submit to the suffocating regimen of the Academy. The Salon des Refusés established this dynamic once and for all, opening up an avenue to fame (if not necessarily fortune) by stirring up controversy, challenging the status quo, and grabbing the attention of the press, which liked nothing more than a good fight. The rejected artist could now wear the infamous *R* as a badge of honor identifying him as a member of a confraternity known as the avant-garde, a brotherhood that consisted of professional outsiders who defined themselves

in opposition to the powers that be, thriving on outrage and drawing nourishment from the bracing oxygen of defiance.

Zola's character, the critic Jory, puts a cynical spin on it, but the artists themselves were usually motivated less by a thirst for publicity than sincere conviction; most suffered for their intransigence. Still, if they were destined to struggle, Manet's celebrity demonstrated that exclusion from the sacred halls of the Salon was not necessarily a death sentence. In fact, it could be the basis of another kind of career, one that was less secure than that of an academic painter but that brought rewards of its own.

Manet, *Olympia*, 1865

How this worked in practice was demonstrated two years after the Salon des Refusés, when Manet found himself once more at the center of controversy with his painting *Olympia*. This time it was Titian's *Venus of Urbino* that got the distinctive Manet makeover, as he

reimagined the mythological scene in a contemporary Parisian context. And once again traditionalists were appalled at his gall in transforming the Roman goddess of love (an encore performance by Victorine) into a Parisian courtesan. Responding to this latest affront, the influential critic for *Le Figaro*, Albert Wolff, chose to attack what he thought was its greatest vulnerability, using the words of the former bad boy of French art, Gustave Courbet, to take down the latest provocateur: "It is flat, it is not modelled. It is like a card game Queen of spades getting out of a bath."[32]

But now Manet's defenders were ready, returning fire as soon as the critics launched their salvos. Among those manning the barricades was the young journalist and aspiring novelist Émile Zola. Writing in the pages of *L'Evénement*, he declared: "It is impossible—impossible I say—that M. Manet will not have his day of triumph, that he will not crush the timid mediocrities that surround him."[33] The beleaguered artist, grateful for Zola's support, showed his appreciation by painting the author's portrait. [see color plate 13]

By now Manet was, if not quite famous, at least talked about. But notoriety didn't necessarily bring material rewards. Despite a handful of ardent defenders and the celebrity that came from being singled out as a threat to public order, the prospect of earning a decent living from his art was still a long way off. When, in 1867, Manet once again put his art on display at a private gallery, it generated plenty of invective, but few sales. "A few artists and several art lovers came to study them with interest," recalled one visitor, "but the press, the cartoonists, and the entire public hounded their maker."[34] Manet's career, blazing a trail followed by countless avant-garde artists to come, was one in which the price of originality was a continual financial struggle. And while Manet's inheritance spared him some of the hardships faced by many

of his colleagues, even he found the constant struggle draining. Toward the end of his life, he wrote with wistful humor to the critic Albert Wolff: "I shouldn't mind reading, while I'm still alive, the splendid article you will write about me once I'm dead."[35]

It's tempting to turn this contest into a morality tale in which an avant-garde too pure to concern itself with material matters took on a world of academic art corrupted by money and driven by commercial considerations. In fact, the world of radical art had its own distinctive economy. For both artists and dealers, the risks of defiance were great but the potential rewards even greater.

A new theme begins to emerge in the critical writing of the time, one that will become a key component of modernism and give the art of the last 150 years an inexorable forward momentum: the notion of aesthetic *progress*, an awareness that the despised radicals of the past are often perfectly acceptable to audiences of the present, and are likely to be proclaimed masters in the near future. Even Van Gogh's old nemesis, H. G. Tersteeg—not known as an aesthetic risk-taker—urged his colleagues to keep an open mind: "Never denounce a movement in the arts . . . [for] what you denounce today, in ten years may make you kneel."[36] In a similar vein, the critic Theodore Duret, writing in 1870, observed: "Only yesterday, Courbet was ridiculed, yet now people outdo themselves in praising him . . . but then, his work has become a familiar sight, one has got used to him . . . we shall therefore pause in front of the canvases of M. Manet . . . we are surrounded by a crowd and immediately become aware that the good public . . . here mocks our original artist precisely because of his originality and invention."[37]

This notion of artistic progress is closely tied to a modern economy based on markets, investments, and speculation. The belief

that value necessarily increases, that an initial outlay by a savvy investor can lead to big payoffs in the future, begins to permeate conversations about art. The language of investment is not merely metaphorical: Zola and his progressive colleagues often couched their aesthetic prognostications in monetary terms. "In fifty years [Manet's paintings] will sell for fifteen or twenty times more than now," Zola wrote in his review of the Salon of 1866, "and certain other pictures now valued at forty thousand francs will not be worth fifty."[38] While this kind of thinking was anathema to stalwarts of the *Institut* who trafficked in eternal truths, it was second nature to the bankers, stockbrokers, and businessmen who made up an increasingly large share of the market for luxury goods, including paintings and sculptures. Debates over artistic merit became investment opportunities, the imperative to buy low and sell high creating a dynamic all its own. The fear of missing out on the next big thing will spur speculative bubbles, driving the pace of innova-tion and placing a premium on novelty. A few decades later, after the pattern had had time to set in, we find this attitude expressed in its most vulgar form in a sign over the door of one of Picasso's earliest Parisian dealers. It read: SPECULATORS! BUY ART! WHAT YOU PAY 200 FRANCS FOR TODAY WILL BE WORTH 10,000 FRANCS IN TEN YEARS' TIME. YOU'LL FIND YOUNG ARTISTS AT THE CLOVIS SAGOT GALLERY.[39] Now in the twenty-first century, after more than 150 years of avant-garde provocation followed by market success, this expectation is so ingrained as to seem like the natural order of things.

The fact that crass terms borrowed from the stock exchange were now used to assign artistic value was a natural consequence of shifts in the business of art making and art dealing. Despite the still dominant position of the Salon in shaping the conversation,

the Parisian art world was becoming increasingly diversified and commercialized. Private dealers played a growing role. Many of them merely rubber-stamped the judgments of the official Salon, but a few were willing to buck the conventional wisdom. Though many had gotten their start selling old masters on the international market centered in Paris, some began to deal in contemporary work, where the demand was less certain but potential profits higher. Signing a contract with a rising Salon star could be lucrative for both parties, particularly as new technologies for reproduction allowed the gallery to sell multiple copies of a popular painting at a price the average citizen could afford. This was the model employed to such good effect by Adolphe Goupil, who opened his Paris establishment in 1850. He and his Dutch partner, Cent van Gogh, took advantage of technologies like photogravure and lithography to disseminate reproductions of works by the artists they kept on retainer. By 1874, the year Vincent worked at the flagship store on the Place de l'Opéra, Goupil was stocking originals alongside prints, thus catering to both ends of the market.

Private dealers were not necessarily more open to innovation than the selection committee of the official Salon. Goupil and his partners didn't anticipate the market. Instead, they catered to it, tapping into the vast new opportunities afforded by marketing their wares to the growing middle class. Their biggest sellers were artists like Gérôme and Bouguereau, the same crowd-pleasers claiming the top prizes at the Salon. This was the great age of middlebrow culture as the newly prosperous bourgeoisie aped the manners of the old aristocracy, but in watered-down form and without quite the same budget. The great caricaturist Honoré Daumier often poked gentle fun at this new breed of patron with more enthusiasm than money.

Honoré Daumier, *The Print Collector*, c. 1860

The growth of the private market, and the education of a discerning public to which it catered, was necessarily in tension with the state-sponsored system. The Institut Nationale des Sciences et des Arts, the Académie des Beaux-Arts, Institut, and the École des Beaux-Arts had succeeded in turning Paris into the center of the international art world, but at the cost of creating a vast new infrastructure of cultural production and reception that would ultimately challenge its hegemony. At the time

of the Salon des Refusés, artists were just beginning to seek alternative outlets for their work in commercial venues, and the rules of the game were not entirely clear. In fact it's likely that the hostile reception Manet received was in part triggered by the fact that he had been given a one-man show at the gallery of Louis Martinet; the Salon's harsh treatment may have been an effort to punish him for this attempt to upstage them. The truth, as Astruc pointed out, was that he had few other options, particularly once it became clear that the jury would never relent: "Since 1861, M. Manet has been exhibiting or attempting to exhibit. This year he decided to offer directly to the public a collection of his works. . . . To exhibit is the vital question . . . for the artist, because it happens that after several examinations people become familiar with what surprised them and, if you will, shocked them.'"[40] On one level, the emergence of modernism involved the replacement of a system in which Church and State were the chief sources of patronage by one in which that role was taken up by the more flexible private sector.

Zola captures this new world in the character of Naudet, a dealer who treats art as nothing more than a product to pump and dump:

> He was turned out like a gentleman, perfectly groomed and polished, complete with fancy jacket and jeweled tie-pin and all that goes with them, hired carriage, stall at the Opera, table at Bignon's, and he made a point of being seen in all the right sort of places. In business he was a speculator, a gambler, and heartily indifferent to good painting. He had a flair for spotting success, that was all; he could tell which artist it would pay him to boost, not the one who showed promise of becoming a great and much-discussed painter, but the one whose specious talent, plus a certain amount of superficial daring, was soon going to be at a premium

in the collectors' market. And he changed completely the tenor of that market by ceasing to cater for the old type of collector who knew a good picture when he saw one, and dealing only with the wealthier amateur who knew nothing about art, who bought a picture as he might have bought stocks and shares, out of sheer vanity or in the hope that it would increase in value.[41]

If Naudet represents the cynical hack out to make a quick buck, Paul Durand-Ruel, "dealer to the Impressionists," was a new kind of warrior on the cultural battlefield. Like Naudet, he was a man of business, a speculator, but, unlike his fictional counterpart, he had real passion for the goods he sold and a real commitment to the men and women whose careers he nurtured. Toward the end of his life, Monet paid tribute to the man who believed in him when no one else would: "Without Durand-Ruel we would have died of hunger, all us Impressionists. We owe him everything. He was stubborn and relentless, risking bankruptcy a dozen times in order to support us. The critics dragged us through the mud, yet it was even worse for him! They would write, 'Those people are crazy, but the most insane of all is a dealer who buys their work!'"[42]

Durand-Ruel was as much a visionary as a businessman, and his profits, such as they were, came from playing the long game and placing a bet on the future.* Paul's father, like many early art dealers, got into the still rudimentary business through the back door. Durand-Ruel senior owned a stationery shop on the Rue de la Paix, just north of the Place Vendôme. Over the years, he added to his core business by

* Durand-Ruel was the one established dealer Theo approached with Vincent's drawings. For all his famed powers of discernment, the gallerist showed no interest in his work.

dealing in a few blue-chip artists like the great English landscape
painter John Constable (1776–1837) and the great French Romantics
Eugène Delacroix and Théodore Géricault. His son preferred to
purchase art that had not yet found a secure market, hoping, like an
investor scoping out promising start-ups, to use his discerning eye
to turn a profit. After seeing a display of the Barbizon painters at
the Exposition Universelle of 1855, he began trading in the work
of these pioneer landscapists, prospering as they gradually found
acceptance and their works fetched higher prices. It was as a dealer in
Barbizon painters, rather than Impressionism, that Van Gogh knew
him. It's telling that when he paid a visit to Durand-Ruel's shop in
1876, he only thought to mention works by Millet and Dupré, while
ignoring those by Monet, Degas, and Renoir.[43]

Pierre-Auguste Renoir, *Portrait of Paul Durand-Ruel*, c. 1910

Durand-Ruel's involvement with the future Impressionists began, surprisingly, not in Paris but London, during one of those political upheavals that plagued 19th-century France and drove many of its most creative figures abroad. In July 1870, Emperor Napoleon III decided the time had come to push back on the rising Prussian state—led by its ambitious chancellor, Otto von Bismarck—precipitating a war he assumed would win him the glory once enjoyed by his illustrious uncle. But the nephew, it turned out, had inherited the older man's ambition but not his military genius. In early September, German forces routed the French army at the Battle of Sedan, capturing the emperor and toppling his regime. The Government of National Defense, formed in the wake of this disaster, proved no more capable of holding off the German army than its predecessor. Paris was quickly surrounded by the German army, which began lobbing artillery shells into the city center while national forces made ineffectual efforts to come to its relief. Manet, who had courageously remained behind to serve in the National Guard, reported in November: "They are starting to die of hunger here . . . there are now cat, dog, and rat butchers in Paris. We no longer eat anything but horse meat when we can get it."[44] In January, the shattered, half-starved city surrendered.

Paris's agony did not end with its capitulation. Over the course of the siege, much of the population, particularly in Montmartre, Belleville, and other working-class districts, had become radicalized. National humiliation at the hands of the Germans exacerbated preexisting social tensions; defeat delegitimized a central government that had managed to deliver only misery. Seizing control from the forces of the newly constituted National Assembly of the French Republic, radical elements of the National Guard and the Central Committee formed the

so-called Paris Commune. During the two months of its existence, the Commune—the first "dictatorship of the proletariat" according to Karl Marx and Friedrich Engels—put in place a broad program of social and economic reforms, including an end to the death penalty, the separation of Church and State, and the abolition of child labor.

In addition to pushing through progressive reforms, the radicals engaged in petty acts of violence and vandalism, taking their wrath out on such symbols of repression as the Tuileries Palace—former residence of kings—and the Hôtel de Ville, burning them both to the ground. But measured by their capacity for mayhem, the Communards could not match the central government. The standoff ended in *La Semaine Sanglante* (The Bloody Week) in May 1871, when the ragtag forces of the Commune were defeated by the regular French army. From May 21st to 28th, between 10,000 and 20,000 Parisians died in the street fighting and the reprisals that followed, while large swaths of the city center were left a smoky ruin.

Artists, conservative and progressive alike, suffered along with their neighbors. Meissonnier and Manet both depicted those terrible days, their artistic differences washed away in the flood of their shared grief. And while reactions to the events of 1870–71 tended to fall along predictable lines—avant-garde artists generally supporting the Communards, while those who worked within the academic system favored the National Assembly—the truth is that most were too wrapped up in their own concerns to take an active role in politics. Even a committed anarchist like Camille Pissarro found it expedient to decamp to London.*

* Born on the island of St. Thomas in what was then the Danish West Indies, Pissarro's Danish citizenship made him ineligible to serve in the French army.

Manet, *Civil War*, 1871

Like Pissarro, Durand-Ruel had relocated to the English capital, assuming it would be easier to conduct business in a city that wasn't under constant shelling or in the grip of civil war. Here he made the acquaintance of this disciple of Camille Corot and another young artist intent on pursuing the Barbizon tradition of working *en plein air*, a thirty-one-year-old painter by the name of Claude Monet. Durand-Ruel opened his gallery to his young compatriots, placing their work alongside those by the more established "school of 1830." By 1872, both he and his fellow exiles were back on French soil. Despite the recent trauma, the capital was recovering quickly. "Everybody is returning to Paris," Manet observed: "besides, it's impossible to live anywhere else."[45] Reopening his gallery on the Rue Laffitte, Durand-Ruel continued to show the work of the artists he'd met in London, along with a number of their like-minded colleagues.

Durand-Ruel initially assumed the public would have no trouble assimilating these painters following in the footsteps of Corot,

Daubigny, Diaz, and the rest of the Barbizon cohort. He would soon learn better. In his memoirs he would recall the struggle of those early days:

> I naïvely thought that my firm's renown and the reputation I had acquired by being one of the first to recognize the talent of the great masters of 1830 would help me to convince others of the merits of my new friends without too much difficulty. . . . I owned a considerable number of their paintings, so alongside the finest works by the masters of 1830 adorning my galleries, I exhibited sets of pictures by Manet, Degas, Puvis de Chavannes,* Claude Monet, Renoir, Sisley, Pissarro, and Mademoiselle Berthe Morisot. People called it a crime. . . . My fellow dealers, as blind as the public, resented all my efforts to get clients to accept such pictures, which they felt completely clashed with everything they sold themselves and which featured in every collection. Even dealers who might possibly have acknowledged certain qualities criticized me for overstepping my role, which traditionally involved selling what is desired rather than doing battle with public taste in order to force it to accept what it does not understand. Obviously, that end of trade is easier and more lucrative, but it suits a merchant in fashion accessories or dry goods, which is neither interesting nor honest—for very often fashionable works, which command enormous prices, have no artistic value and deflate to nothing at some point. Everyone

* Puvis de Chavannes was an artist of a far different stripe than the Barbizon painters and the Impressionists. Straddling the line between the Academy and the avant-garde, he will later be claimed by the Symbolists.

agreed that I had gone mad and lost all sense of taste. All my clients were quickly alienated from me, because many collectors are unsure of themselves and can be shaken by the slightest criticism.[46]

At first, Durand-Ruel's new friends didn't identify as members of a coherent movement. Most were admirers, if not followers, of Édouard Manet; many of them gathered about the great man each evening as he took his ease at the Café Guerbois, and later at the Nouvelle Athènes.* And most of them, with the exception of Edgar Degas, focused on landscape, building on the Barbizon tradition of plein-air painting. Still, it would take the shock of universal condemnation to forge a distinctive sense of identity.

In general, these younger artists were even more committed to painting outdoors than their predecessors, transforming everyday scenes into shimmering tapestries of light and color. Equally important, they had come of age in the wake of the Salon des Refusés and saw an alternative to the usual career path that led through the École des Beaux-Arts and culminated in gold medals being draped around their necks at the annual Salon.** They weren't necessarily opposed, at least at this early stage, to exhibiting in that circus-like spectacle of middlebrow culture, and many of them managed have an occasional painting placed on the crowded walls of the Palais de l'Industrie. But they had a healthy skepticism of the system and knew they'd always be thought of as second-class citizens. After all, they'd seen how the academy marginalized their artistic masters and ridiculed their hero

* Among the Impressionists, Morisot was closest to Manet. She ultimately married his younger brother, Eugène.

** Of the core Impressionists, Pissarro was actually two years older than Manet, and Degas was two years younger. All the rest were almost a decade younger.

Manet. And in the decade since, the selection committee had grown if anything more intolerant of innovation. Durand-Ruel offered these painters something they desperately needed: a venue where they could put their work directly before the public, without having to appease the gatekeepers of the Salon.

In Zola's fictional account it is a time of limitless possibility:

> The moment was most propitious, [Lantier] thought, for the success of an artist with courage enough to strike a note of sincerity and originality amid the general collapse of the old schools. . . . Delacroix had died without pupils; Courbet was being followed merely by a few clumsy imitators; the masterpieces they left behind in their turn were going to be nothing more than museum pieces, dimmed with age, examples of period art. It seemed a simple matter to forecast the formula which would crystallize out of the work of the younger painters from the burst of blazing sunshine, the limpid dawn that was breaking in so many recent paintings, through the growing influence of the Open-Air School. There was no denying now that the light-colored pictures which had been the laughingstock of the "Salon des Refusés" were now quietly working on a number of artists, lightening a great many palettes. Nobody would admit it yet, but the ball was rolling, and the tendency was becoming more and more obvious at every Salon.[47]

In the real world, these pioneers would face a long struggle for respect and financial security. Durand-Ruel could exhibit their work, but he couldn't force the public to buy. Manet had already discovered

that it was next to impossible to make a living outside the academic system, since few collectors were willing to pay for a work without the imprimatur of the selection committee. When, as was almost inevitable, Durand-Ruel began to run into financial difficulties, his stable of young artists realized they required a new strategy to get themselves noticed. Plotting the way forward in late-night sessions at the Café Guerbois, they conceived a new kind of artistic association, based as much on financial expedience as a shared aesthetic.

The thirty or so artists showing their work at the studio of the photographer Nadar* in April of 1874 were a somewhat uneven bunch, with little to unite them beyond a certain frustration with the Salon and a pressing financial need. Calling themselves the *Société anonyme cooperative des artistes, peintres, sculpteurs, graveurs, etc.* (The anonymous cooperative society of painters, sculptors, printmakers, etc.), most had experienced at least some difficulties with the official venues and chafed at having to submit themselves to their increasingly reactionary ideology. There was an independence of spirit, a willingness to push the boundaries, but not yet a clear sense of where that experimental impulse would lead them.

It was disappointing that Manet, their patron saint, was unwilling to participate. He preferred to improve the system from within and believed that the correct strategy was to force their way into the Salon rather than hold themselves apart.

For all their divisions and mixed motives, there *was* something radical in the project. Pooling their scant resources and exhibiting as a group on one of Paris's main commercial thoroughfares—the Boulevard des Capucines, near the Opéra—they were, whether

* Nadar (Gaspard-Félix Tournachon) was a pioneer balloonist and photographer, combining his two passions in some of the first aerial views of Paris, or any city. During the siege, his balloons delivered mail to and from the isolated city.

they intended it or not, striking a blow against the entire academic structure put in place by Cardinal Mazarin. Like Courbet's Pavilion of Realism, the exhibition offered an implicit rebuke to the notion that the selection committee possessed a monopoly on wisdom. Appealing directly to the public, these artists bound themselves to the world of commerce, trusting the verdict of the market rather than the cultural gatekeepers.

Unfortunately, the market at this stage was no more discerning than the Academy. The great majority of middle-class Parisians were aesthetically conservative, too insecure in their own taste to see virtues where a selection committee found none. The crowds, egged on by the establishment press, came as they had to the Salon des Refusés a decade earlier, and with much the same idea in mind—that bad art was good entertainment. Durand-Ruel recalled the chaotic scene:

> The public flooded in, but with the obvious intention of finding everything dreadful. People wanted to amuse themselves at the expense of the ridiculous artists about whom they had heard. Unable to assess the serious qualities of such new works, so different in appearance from the ones they were accustomed to seeing, they viewed the exhibitors as presumptuous ignoramuses seeking attention through eccentricity. Mirth, contempt, and even indignation redoubled, and was openly heard in clubs, studios, salons, and even theaters, where these wonderful artists were mocked.[48]

Of course even mockery could be useful. As Jory pointed out when Lantier's painting suffered a similar indignity, attracting even a hostile

crowd put you on the map. The show generated few sales—the participants all lost money on the project—but it succeeded in bringing them to the attention of the public. Crucially, the experience of being under attack from all sides, an advance guard deep inside enemy territory, gave them a sense of solidarity, transforming a motley crew of diverse talents into a cohesive movement.

The skeptical press even found a name for them. They called them *Impressionists,* borrowing the term from one of the paintings on view: Monet's *Impression, Sunrise.** [see color plate 14] Though it was initially used in derision, the artists soon appropriated it for themselves, realizing it provided a group identity they'd failed to achieve on their own. The term *impression* implied a lack of finish, a superficiality, anathema to the academic painter, for whom precise draftsmanship and high finish were goals to be realized only after long years of practice. This new brand of painting seemed slapdash, unformed. Writing of Monet, Albert Wolff complained: "[he] paints as if from an express train."[49] What cheek to take a mere sketch, frame it, slap it on the wall, and expect the public to applaud!

In fact, the kind of work they were doing was not entirely unprecedented. Artists, particularly landscape painters, had long made quick notations out of doors, which they later used as the basis for more elaborate compositions in the studio. Studies by John Constable—a source of inspiration for Delacroix—look a lot like Impressionist paintings, not only the loose brushwork that merely suggests rather than fully describes, but also in the way they conjure evanescent effects of light and atmosphere. In the past, such sketches had been regarded as mere exercises, not legitimate works of art in their own right. By

* The name first appeared in the title of a review by Louis Leroy in the satirical journal *Le Charivari* on April 25, 1874, titled "The Exhibition of the Impressionists."

proposing their first thoughts, their initial *impressions*, as worthy of close study, Monet and his colleagues were overturning the traditional hierarchies that accorded the highest status to works that demonstrated the greatest technical skill and demanded the greatest amount of labor. In an Impressionist landscape, it's the sensitivity of the artist's *perception* that matters, her ability to capture infinitesimal shifts in light and atmosphere, rather than the amount of detail she can cram onto a single canvas.

Impressionism, in a sense, is the ultimate form of realism, an attempt to convey our initial sensory encounter—the flickering patterns of light and dark, hues that shift from moment to moment—before we've had a chance to refine, organize, and synthesize that raw data into a plausible model of the world that exists only in our minds. Monet once said that he wished he'd been born blind and regained his sight only later in life so that his perception wouldn't be corrupted by what he knew.[50] Manet, asked to explain the goals of his younger colleagues, put it this way: "That's what people don't understand yet. . . . That one doesn't paint a landscape, a seascape, a figure; one paints the effect of a time of day on a landscape, a seascape, or a figure."[51]

Such an approach is the logical conclusion of painting *en plein air*, the technique pioneered by the previous generation of landscape painters.* It's obvious to any artist who sets up an easel in a field or on the edge of a forest that no tree, lake, or mountain range looks the same for any extended period; its appearance transforms

* As always, Degas is the odd man out. While most of the Impressionists painted landscapes outdoors, Degas preferred to depict interiors, a dance studio or concert hall. While most preferred to dissolve solid forms in hazy atmosphere that blurred contours, Degas was a brilliant draftsman. What he shared with his colleagues was a commitment to painting the everyday world around him, the Paris that he knew and was to him the center of the universe.

dramatically every moment from dawn to dusk, from a misty spring morning to a summer afternoon as the storm clouds gather and then break. The more the artist tries to fix a moment in time, the less the objects themselves seem fixed. Zola explained their approach in an article for the *European Herald* in 1879: "The impressionists have introduced open-air painting, the study of shifting effects in nature depending on the innumerable variations of weather and the time of day. . . . Breaking light down into its constituent parts, studying the effects of air movement, the shading of color, the random variations of light and shadow, all the optical phenomena which make a vista so changing and so difficult to render."[52] Next to a landscape by a Barbizon painter—not to mention one by Sisley, Pissarro, or Monet—a landscape by a great 17th-century master like Nicolas Poussin will reveal itself to be an artificial construct, evenly lit, logically laid out, a fragment of conceptual architecture in the mind of God. In painting the light that reflected off things and refracted through things rather than the things themselves, the Impressionists reimagined the world as pure experience.

The Impressionists differed from their academic counterparts as well in the kinds of subjects they chose to depict. Like their Barbizon forebears, they found beauty in the mundane: a quiet country lane, a field of poppies with a farmhouse in the distance, a shady park along the Seine, even one of Baron Haussmann's boulevards seen from an apartment window where the people are reduced to little blobs of color. A busy street in Paris, they proclaimed, offered more drama, more pictorial interest, than Hector and Achilles facing off before the walls of Troy.

The shorthand Pissarro and his colleagues used to indicate form, far more fragmented than anything Manet dared to employ in *Déjeuner sur L'Herbe* or *Olympia,* was perfectly suited to the fast-paced and

ever-changing urban scene.* The *what* of painting became the *how* of painting, with a premium placed on incisive observation. Manet's Victorine Meurent with her brassy stare had broken down the third wall between the fictive space of the painting and that occupied by the viewer; now the Impressionists urged their fellow Parisians to exit the theater altogether, to accompany them on their daily rounds and to see familiar haunts with fresh eyes. Unfortunately, the vast majority simply weren't ready. Dragged into the blazing sunshine, most Parisians quickly retreated back into the darkness, where they could lose themselves in gossamer dreams of enchanted lands.

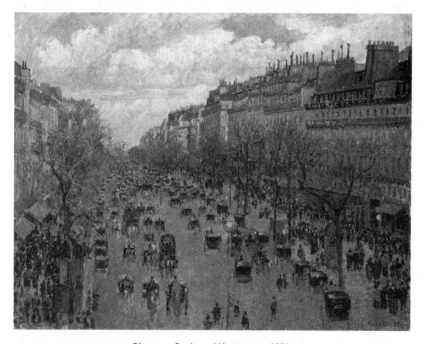

Pissarro, *Boulevard Montmartre*, 1891

* By the late 1870s, artistic influence was flowing in the opposite direction, and Manet began to take his cues from his younger colleagues. But Manet never went as far as the Impressionists in dissolving form in light.

With the exhibition at Nadar's studio in April 1874, the Impressionist movement was, as Jory would say, *launched*. Repeating the stunt in subsequent years—there were eight Impressionist exhibitions in all between 1874 and 1886, when clashing personalities and disparate goals finally put an end to group exhibitions—the Impressionists carved out a distinctive niche within the Parisian art world. The public and the critics remained skeptical at best—Wolff dismissed the second Impressionist exhibition, held in the spring of 1876 at Durand-Ruel's gallery, as "five or six lunatics, one of whom is a woman"[53]—but that didn't necessarily matter. The woman in question, Berthe Morisot, was actually heartened by the response, remarking: "Anyway, we are being discussed, and we are all so proud of that we are all very happy."[54]

Morisot, like her future brother-in-law Manet, was a woman of independent means and could afford to take the long view; for others, like Pissarro, Sisley, Monet, and Renoir, it wasn't so easy to shrug off scathing reviews that discouraged sales and drove down prices. "Often when I lacked basic necessities myself," Durand-Ruel recalled of these early days, "I borrowed at steep interest rates in order to rescue an artist from poverty, to prevent him from starving to death or seeing his studio and furniture sold by the bailiffs."[55]

The public would come around, but only slowly. Durand-Ruel was able to cultivate a small and dedicated following for his artists, but prices remained pitifully low for a decade after their initial exhibition. In the meantime, the dealer devised creative ways to support his stable of artists, including by paying them a small stipend regardless of how many works sold.

The real turnaround began early in 1886, when Durand-Ruel crossed the Atlantic to try his luck in the American market. That March, he

introduced the Impressionists to a New York audience in an exhibition titled *Works in Oil and Pastel by the Impressionists of Paris.* "The show drew crowds of the curious," he recorded, "and unlike what happened in Paris, it triggered no fuss or stupid comments and sparked no protest. Press coverage was unanimously favorable and many articles of praise appeared in all the papers in New York and all large cities in the United States. Art lovers and the general public came not to laugh, but to find out about the notorious paintings that had created such a stir in Paris."[56] He concluded: "My success on the other side of the Atlantic had a significant repercussion in France. The same people who either had not dared to buy a Manet, Renoir, or Monet, or pay only a few hundred francs for them, now resolved to pay as much as the Americans. So little by little prices increased, as did the number of collectors."[57] Once again, Morisot's insight was vindicated: being talked about was all that mattered, and notoriety would, sooner or later, translate into material success.

It's ironic that Durand-Ruel first showed the Impressionists in London and made his great breakthrough in New York, for Impressionism was a quintessentially Parisian movement. Unloved stepchild of the French Academy, born on the battlefield of competing schools that gave the city its unique position as the world's cultural capital, greeted by shrieks of horror, Impressionism created its own set of possibilities, its own reality. The arguments were loud enough to be heard on the far side of the Atlantic, spurring a curiosity in the less jaded American audience that initially came to see what all the fuss was about and then came to appreciate the work on its own merits. In fact, Americans had always been skeptical of the pretentious kind of history painting that to conservative Frenchmen was the pinnacle of serious art; their native traditions favored landscape and genre scenes, making the Impressionist focus on daily life easier to assimilate.

But if America could embrace Impressionism, it could not invent it. Modern art was born in Paris in large part because it was so hotly contested, the avant-garde forged in battle with the establishment into a highly motivated cadre determined to take on and, ultimately, to topple the old regime.

By the time Vincent van Gogh arrived in the city, the battle for Impressionism had largely been won, though the victors were not yet ready to celebrate and their foes not yet willing to surrender.* Theo was something of a bellwether. Cautious by nature, he was cut from a different cloth than Durand-Ruel. He was temperamentally incapable of risking everything for the sake of an artistic revolution—and wouldn't have lasted long at Goupil's had he been—but he had a sensitive eye and a curious mind. From the beginning of his tenure at Goupil's, he had promoted the School of 1830 as well as their Dutch counterparts, Anton Mauve and the Hague School painters. The fact that while Vincent was still up North Theo urged him to study the Impressionists shows they were no longer regarded as the lunatic fringe. Nor was his support for the new art merely rhetorical. In April 1885 he purchased his first Impressionist work on behalf of his firm, a landscape by Claude Monet, a clear signal that such art was becoming respectable.[58] As Zola himself noted, the Open-Air school was even having an impact at the Salon, where many painters were loosening their brushwork

* The continuing resistance of the old guard is revealed in the outrage generated in 1894 when Gustave Caillebotte bequeathed his magnificent collection of Impressionist works to the Luxembourg Museum. The Institut de France and the Académie des Beaux-Arts lodged formal protests calling the bequest "an offense to the dignity of our school" that would create "a strange confusion [in the public's mind] between what is worthy of being admired and what deserves strong disapproval." [Tucker, *Monet in the Nineties*, 236]

and brightening their palettes. Even as the Impressionists themselves struggled, their ideas were seeping into the mainstream in watered-down form.

They'd been so successful, in fact, that the sense of common purpose was beginning to fray. No longer a beleaguered outpost in enemy territory, they were mid-career artists just beginning to win a degree of acceptance and enjoy a bit of material comfort. Tensions were emerging between those now making a decent living—Monet, Renoir, Degas—and others—Pissarro, Sisley—who were still struggling to make ends meet.

Even more damaging to the sense of common purpose was a feeling that the plein-air movement itself had run its course. Even Monet, the purest of Impressionists, was going in new directions, still dedicated to exploring the infinitely beguiling play of light and atmosphere on form, but in a way that was both more inward-looking and more monumental. Renoir, too, was rethinking the basis of his art, returning to the human figure that Impressionism had largely abandoned and seeking to give his work an old-master polish.

And just as these stalwarts were starting to waver, a new generation was coming up for whom the Impressionist revolution was old news—not the end of the journey, but a gateway opening onto new territory undreamed of by the Impressionists themselves. The Eighth Impressionist Exhibition, held above the restaurant the Maison Dorée on the Rue Lafitte from May 15–June 15, 1886, would be the last; the band was breaking up so that the members could pursue solo careers.

Zola captures the anxieties of this moment in Lantier's struggles to bring forth the masterpiece that will validate the new school:

> Such is the effort of creation that goes into the work of art! Such was the agonizing effort he had to make, the

blood and tears it cost him to create living flesh, to pro-
duce the breath of life! Everlastingly struggling with the
Real, and being repeatedly conquered, like Jacob fighting
with the Angel! He threw himself body and soul into the
impossible task of putting all nature on one canvas and
exhausted himself in the end by the relentless tension of his
aching muscles, without ever bringing forth the expected
work of genius.[59]

As Cézanne and Monet pointed out in their critique of *L'Oeuvre*,
Lantier's struggles were more a reflection of Zola's own frustrations
than a valid criticism of the current state of affairs. Still, even they
recognized that the Parisian art world was changing, though neither
could yet articulate exactly where these changes would lead them. In
fact Zola was perhaps more attuned to the shift in the wind than the
artists themselves. But rather than welcome what he saw looming
over the horizon, he was appalled. To someone who had dedicated his
life to the Naturalist cause and who claimed, first, Manet and, later,
the Impressionists as comrades in arms, the current state of affairs
was alarming. On the one hand he chided the Impressionists for not
having delivered on their initial promise to create an art that captured
the essence of modern life. Even worse, some of them had aban-
doned naturalism altogether, turning their backs on the just-the-facts
approach he favored in his own writing to pursue wild chimeras that
dredged up the worst aspects of a moribund tradition. His alter ego
Sandoz delivers the eulogy for his friend Lantier, and for the modernist
project as Zola conceived it: "The century has been a failure. Hearts are
tortured with pessimism and brains clouded with mysticism for, try as
we might to put imagination to flight with the cold light of science, we
have the supernatural once more in arms against us and the whole

world of legend in revolt, bent on enslaving us again in our moment of fatigue and uncertainty."[60]

The novelist could feel the future slipping from his grasp, the "cold science" of his prose challenged by deluded mystics, his faith in progress through reason undermined by pessimists intent on binding humanity once more in chains of superstition. An ominous note had sounded a year earlier with the publication of Joris-Karl Huysmans's *A Rebours* (*Against the Grain*). A morbid chronicle of depravity, neurosis, and introspection, the novel was a betrayal of everything Zola stood for, one made all the more bitter coming as it did from a former disciple. Now the artists of the avant-garde seemed to have fallen under a similar spell. If *A Rebours* announced the world to come then, as Sandoz mourned, the century really was a failure. *L'Oeuvre* ends on a despairing note as the fanfare of 1863 devolves into the dying wail of fin de siècle decadence.

How much did Van Gogh share Zola's view? Initially, at least, he took the author's side against the avant-garde, proclaiming his novel "realistic" and opining that it would knock some sense into the radicals who'd strayed from the true gospel of Millet and Delacroix. But over the next four months, as he read the remaining installments, he should have realized that Zola's critique of modern art differed significantly from his own. This must have been glaringly obvious when he came to the passages where Zola ridicules Lantier's latest mania, one that must have had uncomfortable echoes of own obsessions. "His latest misfortune had been to be led astray by his fast-developing theory of complementary colors,"[61] Zola sneered, a dig so sharp and so precise that even Van Gogh could not have missed it.

He might have heard a more troubling echo of his own life in Zola's account of Lantier's descent into madness. Like the fictional painter,

Van Gogh was well acquainted with blood and tears, with the never-ending struggle to bring nature to life on canvas. He was equally familiar with the pendulum swing of elation and despair. And while he couldn't have known that, four years later, he too would take his own life, he might have found in Lantier's fate a grim premonition of his own psychotic break.

It's perhaps surprising, then, that Van Gogh never seems to have lost his initial enthusiasm for the novel and its author. He never acknowledged the extent to which his art evolved in exactly the direction Sandoz warned of, toward the mystical and imaginary. In part, this is because Zola's naturalistic approach still allowed room for the artist's distinctive voice. On numerous occasions Van Gogh quoted approvingly Zola's famous dictum, set forth in an 1883 article on Manet titled "Mes Haines" ("My Hatreds"): "A work of art is a corner of creation seen through a temperament."[62] Zola, no matter how wedded to objective reporting, recognized the role of the artist in shaping it according to his own nature, a loophole that allowed Van Gogh to reproduce the facts of the world he experienced without fear that his own personality would be erased.

As always, his goal was to produce art in which "honest human feeling is expressed,"[63] while staying in close contact with reality. He remained devoted not only to Zola himself, but to his quest for an art based on observation. Later, he often chided his Parisian colleagues for abandoning reality and indulging their taste for religious mumbo jumbo, rarely admitting how far his own work diverged from the Naturalism Zola espoused.* Even after he'd left Paris for Arles, he

* One of the few works Van Gogh painted entirely from his imagination was his *Memory of the Garden at Etten* (1888), made while he was living with Gauguin in Arles and under that artist's influence. He did not find the experiment a success and soon returned to his normal method of painting what he saw in front of him.

was still fighting the good fight on behalf of his literary hero. "Having come to France," he explained to Emile Bernard, "I have, perhaps better than many Frenchmen themselves, felt Delacroix and Zola, for whom my sincere and frank admiration is boundless. . . . Zola and Balzac, as painters of a society, of reality as a whole, arouse rare artistic emotions in those who love them, for the very reason that they embrace the whole epoch that they paint."[64]

In the end, Van Gogh found it easier to label himself a disciple of Zola than to acknowledge the pathological element in his own art. It's not that he didn't recognize the danger; it was precisely because he knew how easily he could slip into delusion that he clung so fiercely to the world of solid, reassuring fact. He set out the frightening alternative in a letter to Theo, written in the last year of his life, after a devastating series of psychotic breakdowns had confined him to the asylum in Saint-Remy: "I'm astonished that with the modern ideas I have, I being such an ardent admirer of Zola, of De Goncourt and of artistic things which I feel so much, I have crises like a superstitious person would have, and that mixed-up, atrocious religious ideas come to me such as I never had in my head in the north."[65] Van Gogh clings to Zola—and that other realist writer, Edmond de Goncourt—in order to combat the irrational element in his nature that he recognized but that represented for him a descent into darkness.

He returned to this theme in the letter he wrote to Albert Aurier in which he scolded the critic for defining him by his illness. However much others might appreciate his visionary quality—"a brain at the boiling point, pouring down its lava unchecked into all the ravines of art"—the prospect of losing contact with reality terrified him. "Aurier's article would encourage me, if I dared let myself go, to risk emerging from reality more and making a kind of tonal music with colour," he explained to Theo. "But the truth is so dear to me, *trying*

to *create something true* also, anyway I think, I think I still prefer to be a shoemaker than to be a musician, with colours. In any event, trying to remain true is perhaps a remedy to combat the illness that still continues to worry me."[66] Zola and his Naturalist colleagues represented a healthier approach, the artist he wished to be rather than the one he was. This unresolvable tension, of course, lies at the heart of his achievement, a tug-of-war between the dispassionate observer and the pathological visionary, the journalist who documents and the paranoid-obsessive for whom even the most banal scene is freighted with hidden menace.

Even before his psychotic episodes began in Arles, the specter of mental illness loomed over him. From the moors in Drenthe, Vincent confessed to a lifelong struggle: "People said that I was going mad; I myself felt that I wasn't, if only because I felt my own malady very deep inside myself and tried to get over it again. I made all sorts of forlorn attempts that led to nothing, so be it, but because of that idée fixe of getting back to a normal position I never confused my own desperate doings, scrambling and squirmings with I myself. At least I always felt 'let me just do something, be somewhere, it *must* get better, I'll get over it, let me have the patience to recover.'"[67] For someone who wrestled with such demons, Zola's plodding approach promised a safe harbor in the storm.

Van Gogh's trip to Paris was in many ways a pilgrimage to Zola's city, to the cradle of modernity the writer chronicled in his novels. He'd put away, at least for the time being, his peasant clogs and straw hat and brushed the dust of Nuenen from his smock. Already in Antwerp he'd begun to reinvent himself as an urban flaneur, a consumer, like Zola's Mouret, of urban pleasures, a collector of salacious anecdotes, acute observer of contemporary mores, an insatiable compiler of facts. He plunged into this role in his first letters from the city, where he

painted Theo a vivid word picture of his new surroundings, a densely textured portrait of the busy seaport in which he proclaimed his affinity for urban life, and that he hoped to capture with his restless brush. By coming to Paris, rather than returning to Nuenen as Theo urged, he was renewing his commitment to making himself an artist Zola could be proud of. If this was a delusion, if he would always be closer to the doomed Lantier than to his well-adjusted creator, it was one he clung to with the desperation of a drowning man.

5

The Painter of Modern Life

"The crowd is his element as the air is that of birds and water of fishes. His passion and his profession are to become one flesh with the crowd. For the perfect flaneur, for the passionate spectator, it is an immense joy to set up house in the heart of the multitude, amid the ebb and flow of movement, in the midst of the fugitive and the infinite."

—Charles Baudelaire,
"The Painter of Modern Life"

"I think that it's something to know Paris well—that if, once there, you become a Parisian through and through—analytical, steely, and what they call shrewd."
—Vincent to Theo, letter 481, Jan. 30, 1885

At the time of Vincent's arrival in Paris, Theo was living on Rue Laval,* in a mixed part of town on the honky-tonk border between the working-class 9th arrondissement and the still rustic Butte Montmartre. Vincent was already familiar with the neighborhood. In

* At number 25, in what is now the Rue Victor Massé.

1878, when Theo first moved to the city, Vincent shared his observations on the area, which was only a few blocks from where he'd stayed four years earlier:

> It's really a nice neighborhood where you live. If one roams the streets there, whether in the morning or evening, or walks in the direction of Montmartre, one is struck by many workshops and many rooms that recall "a cooper" or *The Seamstresses* or other paintings by E. Frere* and it does one good sometimes to see such things, which are simple, as one occasionally sees a good many people who for various reasons have strayed a long way from everything that is natural, thereby throwing away their true and inner lives, and also many who are rooted in misery and loathsome things, because in the evening and at night one sees all manner of those dark figures walking about, both men and women, who personify, as it were, the terror of the night, and whose misery must be classified among the things that have no name in any language.[1]

Eight years later Vincent was no longer inclined to moralize about the differences between the good simple folk and those who personified the "terror of the night." Nor for that matter was Theo. Like his brother, Theo indulged from time to time in the illicit pleasures the city had to offer. His apartment was strategically located, a fifteen-minute walk from his gallery on the Boulevard Montmartre and just around the corner from the cabarets, seedy taverns, and nightspots that clung

* Pierre Edouard Frère (1819–1886) was a French painter of sentimental genre scenes of the kind that appealed to Vincent in those days.

to the foot of the Butte*—an ideal perch from which an unattached young man might explore the seductive urban landscape.

The apartment itself was small, suitable for a bachelor but cramped for two, particularly when one of them was a painter with chaotic habits and no sense of personal boundaries. It had been more than fifteen years since the brothers shared an attic room in the Zunderdt parsonage, and over that time they'd moved in opposite directions. The older, by his own admission, had grown somewhat savage. He'd suffered years of self-inflicted hardship that inured him to squalor, while the younger slipped into the life of an upwardly mobile young professional, fastidious in his habits and jealous of his independence.

By the time Vincent showed up, Theo had been living in Paris for more than six years. Over that time he'd accommodated himself (if not always happily) to life in the bustling metropolis. Despite being overworked and often feeling underappreciated, he'd climbed the professional ladder at Goupil & Cie (since 1884 renamed Boussod, Valadon & Cie).** His bosses thought enough of his abilities that in 1881 they tapped him to run the new satellite gallery on the Boulevard Montmartre, doubling his salary to 300 francs a month, plus 7.5 percent commission on sales.***

Even with this raise, Theo had difficulty meeting his financial obligations, which included supporting not only Vincent but the rest of his family back in Holland. Paris was expensive. "I find living in

* The Butte (mound or hill) was how Parisians often referred to Montmartre, the neighborhood that rose at the northern edge of the city.

** When old Goupil retired he handed control to his partner, Léon Boussod, and his son-in-law René Valadon. Most people continued to refer to the venerable firm by its original name.

*** For much of this period, Theo was sending 100–150 f. a month to Vincent, which was up to half his salary.

Paris is much dearer than in Antwerp," Vincent grumbled to the
English painter Horace Mann Livens, an acquaintance from the Royal
Academy, "and not knowing what your circumstances are I dare not say
Come over to Paris, without warning you that it costs one dearer than
Antwerp and that if poor, one has to suffer many things."[2]

Theo age 30

Fortunately, Theo didn't have to rely solely on his earnings for his
pleasures. As an employee of the most prestigious art dealership in the
city, he was often wined and dined by rich clients seeking his advice
on their collections. His job didn't end when he locked up the gallery
for the evening. Both his income and his standing with his employers
depended as much on the relationships he cultivated after hours as sales
made on the premises. He'd mastered those personal skills his brother

so obviously lacked but that were essential to success in the art busi-
ness: knowing how to put people at their ease, nudging them in the
desired direction without bludgeoning them with his own opinions.
Not quite in the league of Zola's unscrupulous dealer Naudet, with his
carriage and box at the opera, Theo still enjoyed frequent nights out,
attending a circuit of candlelight soirées and receptions, and spent "days
off" promenading in the fashionable gardens of the Tuileries, where a
chance encounter might land him a new client.

Those who knew Theo described him as personable, though some-
what reserved, an engaging conversationalist and companion for an
evening out. But there was another side to him, one that showed
perhaps deeper affinities with his troubled brother than he cared to
admit. Despite a busy social life, he had few close friends; he was one
of these people who had many superficial relationships but found it dif-
ficult to forge deeper connections. Like Vincent, his need for heartfelt
companionship often led to disappointment. "I dislike mixing with
just anyone and find it absurd to say that people turn out better than
expected after a while and that everyone has his good qualities," he
wrote to his sister Lies. "There's an enormous difference between that
and being a misanthrope, because I find that on the contrary there
are people whom I love very much and who are so good and special
that I feel myself so small compared to them that I have difficulty
mixing with them and above all to take the first step to becoming
intimate with them."[3]

Unlike his older brother, Theo remained close to his family, but
they were far away and he'd found no adequate replacement in Paris.
A series of intense but unsuitable love affairs only made him miser-
able, provoking scolding lectures from his parents and rebukes from
his bosses, who expected their employees to uphold the honor of the
company name. Vincent was the only one to encourage Theo's amorous

adventures, partly out of sympathy but also in order to enlist him in his ongoing battle with those he believed had deprived him of his own happiness. He exploited his brother's weakness, using Theo's mistakes to distract from his own and to challenge his status as the lone black sheep in the family. Whenever Theo tried to distance himself from the excesses of his older brother, Vincent was quick to remind him that they shared more than the van Gogh name.

"Life here is above all so lonely," Theo confessed to his sister. "There's no family life, and so mixing with others is no more than with a few acquaintances and beyond that with people in the line of business. Can you understand that it's sometimes difficult never to mix with anyone other than men who talk about business, with artists who are generally having a difficult time themselves, but never to know the intimate life with wife or children of the same class? You can hardly imagine the great loneliness there can be in a big city. Now, you will say: have you no hope, then, that that will change? Yes, but in the meantime it's rough. Perhaps you can't understand how it is that there are no folk with whom I mix, but remember that people here are busy from morning till night, and then don't feel that the day is long enough to do what has to be done."[4]

For all his outward geniality, Theo was prone to depression, which he did his best to conceal behind an impassive facade. Like his parents, he regarded any weakness of mind or body as something close to sin, a fault to be wrestled into submission and put away where no one would find it. "Melancholy can be harmful," his father warned him soon after he'd left the parental home, "and to indulge in melancholy does not help to produce energy. My dear Theo! . . . I see that recently your liveliness has diminished, your cheerfulness is no longer what it was before."[5]

Theo mostly managed to keep the darkness at bay—one difficult child in the family was enough! But he wasn't always successful,

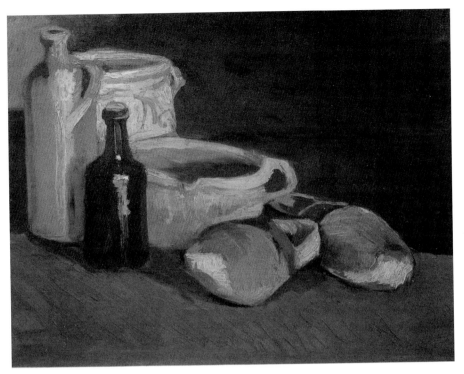

Figure 1. *Still Life with Earthenware Pot and Clogs*, 1881

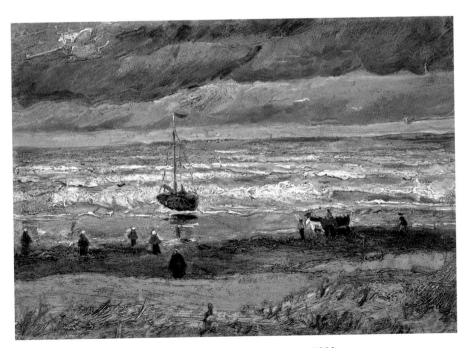

Figure 2. *The Beach at Scheveningen*, 1882

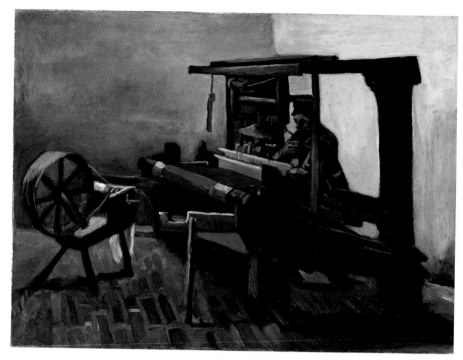

Figure 3. *The Weaver*, 1884

Figure 4. Jean-François Millet, *The Angelus*, 1859

Figure 5. Eugene Delacroix, *Women of Algiers*, 1834 (detail)

Figure 6. *Still life with Bible*, 1885

Figure 7. *The Potato Eaters*, 1885

Figure 8. *Portrait of a Woman with Red Ribbon*, 1885

Figure 9. *Autumn Landscape with Four Trees*, 1885

Figure 10. Jacques-Louis David, *Oath of the Horatii*, 1785

Figure 11. Eugene Delacroix, *Liberty Leading the People*, 1830

Figure 12. Edouard Manet, *Dejeuner sur l'herbe*, 1863

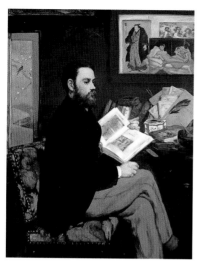

Figure 13. Edouard Manet, *Portrait of Émile Zola*, 1868

Figure 14. Claude Monet, *Impression, Sunrise*, 1874

Figure 15. *Butte de Montmartre*, 1886

Figure 16. Edouard Manet,
Vase with Peonies, 1864

Figure 17. *Bottle with Peonies and*
Forget-Me-Nots, 1886

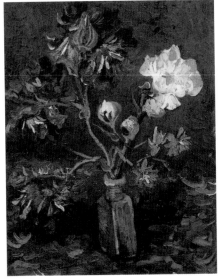

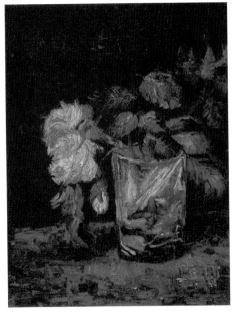

Figure 18. *Glass with Yellow Roses*, 1886

plunging into periods of despondency that put strains on his life and interfered with his work. The poet Gustave Kahn, who got to know Theo as a frequent visitor to the gallery, left a description of the manager that reveals someone more at home with the creative than the business side of the job, which helps explain some of the tensions with his bosses: "Theo van Gogh was pale, blond, and so melancholy that he seemed to carry canvases as beggars hold their wooden bowls," Kahn recalled. "He expressed his beliefs about the worth of art unenergetically, and thus ineffectively. He had no gift at all for sales patter. But that dealer was an excellent critic, and thanks to his love for and knowledge about art, he engaged with discussions with painters and writers."[6]

Before Vincent moved in, Theo's one close companion in Paris was his compatriot Andries (Dries) Bonger, whom he'd met at the Dutch Club, a gathering spot for expats. Here, surrounded by familiar faces and soothed by the sound of his native tongue, he could find relief for an hour or two from the stress of life in a foreign city. The rather prim Dries found Theo a bit too "Parisian" for his strict moral code, but he prized his intelligence and general decency. "The longer one gets to know him," he wrote to his parents in Amsterdam, "the more one learns to appreciate his fine mind. He is always entertaining company"[7]

A recurring theme in Dries's letters home is Theo's uncertain health. Even at the best of times he gave an impression of frailty, and when the press of events threatened to overwhelm him he succumbed to mysterious ailments whose symptoms were, at least in part, psychosomatic. When Theo learned of his father's sudden death, it was Dries who accompanied him to the train station, worrying about the impact the devastating news would have on him since, as he explained, he "was not very strong."

Accounts by Dries and others reveal someone who worked hard to present himself as a successful man about town. But when no one

was looking, he almost broke beneath the burdens heaped upon him. Theo's future wife—Dries's younger sister Jo—traced these difficulties, and Vincent's as well, to his earliest youth, suggesting the little village on the heath "was not perhaps the best training to fit them for the hard struggle that awaited them both."[8] The brothers responded to the trauma of exile from the Zunderdt paradise according to their very different temperaments: While Vincent raged against the injustice of his expulsion, Theo faced his loss with stoic endurance.

Vincent hoped that moving to Paris would allow them to rekindle their former intimacy, but neither brother really believed in the possibility of recapturing the old magic. If Vincent wondered whether "we can get on together," Theo harbored even fewer illusions. They'd not lived under the same roof since Vincent left Zunderdt for The Hague at the age of sixteen, and the closeness they'd once felt had been damaged countless times by Vincent's erratic, inconsiderate behavior. Catching sight of his brother across the crowded Salon Carré of the Louvre that February morning dredged up all that painful history. But there was no possibility of turning him away. Family first was the van Gogh creed, one that Theo, if not Vincent, strived to live up to. As the two of them set out for the Rue Laval, Theo prepared to assume once more the already familiar role of his brother's keeper.

"Of all that Theo did for his brother," wrote his future wife, "there was perhaps nothing that entailed a greater sacrifice than his having endured living with him for two years."[9] That sacrifice was made easier by the fact that, somewhere at the back of his mind and deep within his soul, he still had faith in Vincent's star. As a child he'd fallen under his brother's spell, dazzled by his brilliance and captivated by his passion. Over the years that faith had been sorely tested. But no matter how frustrated he was by Vincent's pigheaded ways, Theo never

entirely outgrew the worshipful image he'd formed in his earliest days. Even in the face of numerous disappointments, he could never shake the belief that Vincent was a man apart, not bound by the rules that governed mere mortals.

Within the family, Theo was often cast in the role of Vincent's champion. The previous summer he'd written to his mother: "I do so hope that Vincent will settle down eventually. One *cannot* expect him to become altogether like an ordinary person, but the best thing is just to let him do as he wants, and perhaps see the good in him."[10] To his sister Lies he opened up more fully: "He is one of those people who has seen the world up close and has withdrawn from it. Now we shall have to wait and see whether he proves to be a genius. I believe he is, and I am not the only one. . . . Once his work is good he will be a great man."[11]

Theo didn't minimize the difficulties. "As far as success is concerned he will probably suffer from the same fate as Heijerdahl,"* he mused, "appreciated by a few, but not understood by the public at large."[12] In the face of repeated disappointments, he longed for reassurance, hungry for any crumb of praise that might confirm that his efforts were not in vain:

> I showed his work again to an old painter (Serret's his name) who has seen and experienced a great deal in his life and has a good heart and a clear head. He told me that he could see in his work that it was done by someone who had been working for a relatively short time, but he found a great deal that is good in it. He even said that if he kept on working

* Hans Heyerdahl (1857–1913) was a Norwegian painter with whom both van Gogh brothers were quite taken. History has not validated Theo's verdict.

and could manage to work out his idea, he held out the prospect that he would surpass Millet, who as you know was one of the greatest painters that ever was, in expression. But speaking of success with the public, he thought that that would go slowly, very slowly. But, he went on, if it might please him, tell him that he has *my* sympathy entirely. So we must wait and see, and if he produces good work, which great men think is good and admirable, try to forgive him his peculiarities in everyday life. I regard the money I give him as payment for his work and as such he earns it. Perhaps it will take a long time, but one day it will be valuable, only I wish it was soon so that people would regard him in a different light from the way they do now.[13]

While his faith often wavered, it never broke, sustaining him through the many trials to come.

Predictably, adjusting to life together in a cramped apartment proved difficult. When they were apart they sparred long distance; now suffocating proximity drew sharper contrasts between their lifestyles and outlooks. After six years in Paris, Theo was used to his independence, living either on his own or with his lover of the moment. (His latest mistress was a woman he referred to simply as S.) Relations with his bosses were often strained, but here too he enjoyed a certain amount of freedom. At the Boulevard Montmartre satellite, the partners weren't always breathing down his neck, no matter how much they might still be looking over his shoulders. Reserved in manner, well turned out in his fedora, walking stick, and silk cravat, Theo recoiled instinctively from the chaos Vincent always brought with him.

Vincent, for his part, was determined to show Theo he'd pulled his life together. But even at his most accommodating he was a nightmare of a roommate, with no capacity to adapt to, or even understand, anyone else's needs. From his teenage years, he'd veered back and forth between fraught domestic situations and periods of extreme isolation that were equally painful and even less sustainable. His yearning for a communion of souls was so intense, and so one-sided, that it inevitably pushed away the object of his affection, driving him once more into the wilderness, where he raged against fate and agonized over his own shortcomings. And while his quarrels with Theo never reached the destructive fury of the life-and-death struggles with his father, many of the same patterns emerged and made domestic harmony impossible.

From Theo's point of view, the one advantage of having Vincent nearby was that he could keep a closer eye on him. In Nuenen and then in Antwerp, Vincent's life had spun ever more out of control, a situation he'd done nothing to hide. In fact he used his troubles to force Theo's hand. Responding to the younger brother's suggestion that he return to the family home, Vincent wrote: "But where the issue is—to take better care of oneself—well in Brabant I'd wear myself out again taking models, the same old story would start all over again, and it doesn't seem to me that any good could come of it. That way—we'd be straying from the path. So please give me permission to come sooner if need be. In fact I'd say right away, if need be."[14]

The recitation of his woes may have been part of Vincent's strategy to play on Theo's sympathy, but that didn't make them any less real. The struggles of recent months had taken a severe toll. Malnourishment and excessive consumption of alcohol and tobacco weakened him to the point that the symptoms of the syphilis he'd contracted earlier returned with a vengeance. He'd lost many teeth, either from the disease itself or the mercury fumigations prescribed by his doctor. His manic

expenditures on painting supplies left him little for food; an empty
wallet along with a chronically upset stomach and difficulty chewing
contributed to further weight loss in a continual downward spiral. All
of this undermined not only his health but his self-confidence, so that
the man who moved into the apartment on the Rue Laval seemed
frighteningly diminished.

But a change of address always came with a promise of renewal.
Paris, with Theo acting as his guardian angel, offered him a chance
to turn his life around, and he was determined to make the most of
it. Vincent tried to present himself in a more conventional manner,
purchasing a few new suits of clothes and otherwise attending to his
physical appearance. He dressed for success in the hope that the reality
would soon follow. In the Brabant, painting the peasants meant living
like them. Now, in order to paint Parisians, he also needed to look,
and act, the part.

New clothes, new dentures, a few pounds added to his bony frame:
Vincent's Parisian transformation may have been superficial, but for the
van Goghs outward appearance had almost magical powers to reform
the inner man. Clothes in particular were a stand-in for deeper issues.
In 1883, following a visit Theo paid him in The Hague, Vincent pushed
back on his criticism:

> As regards one or two things that you said to me when you
> left, I hope you won't forget that one or two things about my
> clothes &c. are somewhat exaggerated. . . . This year I've
> been completely outside any kind of social circle, so to speak.
> And in truth haven't bothered about clothes. . . . Theo,
> again—I don't entirely understand it, and think it has gone
> rather too far when both you and Pa feel ashamed to walk a
> little with me. For my part I'll keep away, though my heart

yearns to be together. . . . henceforth I would like us never again to discuss the question of conventions or clothes when we see each other. . . . A few friends I'll have later will, believe me, take me as I am. I think you'll understand this letter, and understand that it isn't a case of me getting angry when something is said to me about clothes.[15]

Here Vincent urged Theo to look beneath mere appearances to see the inner man. But at other times he showed himself to be equally invested in the language of self-presentation, internalizing the van Gogh code of conduct and equating a change of wardrobe with a more vital transformation. Periods in which he descended into squalor were always followed by periods in which he strived to conform to bourgeois expectations; shabby clothes were a sign he was in a rebellious mood, a new suit a sign that he wished to come in from the cold and rejoin society. After his calamitous sojourn in the Borinage, one of his first tasks upon arriving in Brussels was to furnish himself with new clothes (bought secondhand), including two jackets and two pairs of trousers. He was so proud of them and so anxious to show his parents he was back on track that he even enclosed a swatch of the fabric along with the letter announcing his purchases.[16]

In Antwerp he once again reached for respectability. "I'll have to do something about my clothes," he insisted, "because I've been wearing mine for two years and they've suffered, particularly recently. If it were just a 40-franc suit, say, it would be good enough. . . . Try, as I asked you, to send 50 francs, then I can get by till the end of the month and would buy myself a new pair of trousers and waistcoat at once, and the jacket in February."[17]

Such changes were not merely cosmetic: They were professional, even spiritual. Like an actor taking on a new role, he changed his costume

to mark his changed persona. A few new suits were all it took to turn himself from a peasant painter into a chronicler of urban life. Back in Nuenen he'd drawn a distinction between country and city life, mapping a moral geography of heart and mind in which Theo was placed (at least provisionally) on the wrong side of the barricade:

> I think that it's *something* to know Paris well—that if, once there, you become a Parisian through and through—analytical, steely, and what they call shrewd—I don't want to be so petty-minded as to condemn it. I'm not like that. Be a Parisian, remain one—that's fine, if it's what you want.
>
> There are various things in the world that are *great*—the sea with the fishermen—the furrows and the peasants—the mines and the colliers.
>
> *And likewise I think* the pavements of Paris and the people who know their Paris well *are also great*.[18]

Now he too aspired to be a Parisian, inside and out, to become shrewd, steely, in order to document the great drama of the streets with a reporter's analytical eye. He embraced the coldness he once deplored, adopting the pose of knowing cynicism typical of a city dweller. Instead of muddy fields, the pavements of Paris would be his beat, a change that was as much a matter of ethics as geography.

This was the great project he embarked upon when he abandoned the backwater of Nuenen for the bustling port of Antwerp and then for even more cosmopolitan Paris. A few months after arriving, he wrote to a friend back in Antwerp: "What is to be gained [in Paris] is PROGRESS and, what the deuce, that it is to be found here I dare ascertain. Anyone who has a solid position elsewhere, let him stay where he is but for adventurers as myself I think they lose nothing in risking

more."[19] As someone who knew him in Paris put it: "Though he had no success selling any of his work, there is no doubt he had at last come to an environment in which he could expand."[20]

If Van Gogh was determined to remake himself into a chronicler of the urban scene, an Émile Zola of the paintbrush, he already had the perfect roadmap. In 1863, the year of the Salon des Refusés, the poet Charles Baudelaire published a seminal essay titled "The Painter of Modern Life,"* in which he set forth his ideal of a contemporary artist.

What were the attributes of Baudelaire's paradigmatic figure? "Observer, philosopher, flaneur," he answered, "he is the painter of the passing moment and of all the suggestions of eternity that it contains."[21] He continued: "The crowd is his element, as the air is that of birds and water of fishes. His passion and his profession are to become one flesh with the crowd. For the perfect flaneur, for the passionate spectator, it is an immense joy to set up house in the heart of the multitude, amid the ebb and flow of movement, in the midst of the fugitive and the infinite."[22]

Baudelaire understood that capturing the kaleidoscopic urban scene demanded a new artistic language, more abbreviated, more detached. "For the sketch of manners, the depiction of bourgeois life and the pageant of fashion, the technical means that is the most expeditious and the least costly will obviously be the best. . . . but in trivial life, in the daily metamorphosis of external things, there is a rapidity of movement which calls for an equal speed of execution from the artist."[23]

* Van Gogh almost certainly knew the essay, though he never mentions it in his letters. It was very much in the air, and by the time he came to Paris the ideas had become commonplace. In general, he was not a fan of Baudelaire, telling Émile Bernard (who was): "How I prefer Daumier to that gentleman!" [Letter 822, to Bernard, Nov. 26, 1889]

Van Gogh had already sensed some of this in Antwerp, where he immediately applied his discovery of the *alla prima* painting technique in the work of Frans Hals to the portraits of cabaret singers and prostitutes who embodied the casual relationships fostered by city life. He anticipated the new sights that would greet him in the French capital, anxious to replace timeless vistas with the ever-changing spectacle of the modern urban center. In addition to a quick eye, he wanted to cultivate a cool, perhaps even callous, attitude toward his subjects, free from the moralizing sentimentality of his Nuenen studies. To be a flaneur, a boulevardier, this was his new ambition, to be reborn as a thoroughly urban creature, collector of varied experiences.

It was a commitment that involved a change not only in the way he presented himself to the world, but in his self-conception. Van Gogh forgot for the moment his war against bourgeois propriety. Indeed he was eager to adopt the manners and mores of the class into which he'd been born. Arriving in the City of Light, he was prepared to leap across the barricade and join Theo on the other side, a nattily attired man on the road to success.

And, at least according to Theo's report, his initial efforts paid off. "You would not recognize Vincent, he has changed so much," he wrote to his mother, "and it strikes other people more than it does me. He has undergone a major operation in his mouth, for he had lost almost all his teeth through the bad condition of his stomach. The doctor says that he has now quite recovered his health."[24]

The improvement wasn't only physical: "He makes great progress in his work, and has begun to have some success. He is in much better spirits than before and many people here like him. . . . If we can continue to live together like this, I think the most difficult period is past, and he will find his way."[25]

If Theo's tale sounds too good to be true, that's because it was. It's surely significant that he waited four months to write home, holding back until he could be certain the experiment wouldn't end in disaster. His family was desperate for good news and so, in typical Van Gogh fashion, he put the best possible spin on things, dealing with problems by simply wishing them away.

A more reliable account of these early days comes from Dries Bonger. In a letter to his family, written shortly after Vincent's arrival, he didn't hide his disapproval or his worry that Vincent's presence would disturb his friend's already fragile peace of mind: "Theo's brother is here for good, he is staying for at least three years to take a course of painting at Cormon's studio.* If I am not mistaken, I mentioned to you last summer what a strange life his brother was leading. He has no manners whatsoever. He is at loggerheads with everyone. It really is a heavy burden for Theo to bear."[26] A few months later he added: "Theo still looks terrible; he looks awfully haggard. The poor fellow has a lot of worries. On top of that, his brother is still making life difficult for him, and accuses him of all sorts of things of which he's completely blameless."[27]

No doubt a twinge of jealousy colors Dries's reports—Vincent was monopolizing Theo's time and disrupting the companionable routine they'd established—but the grim picture he paints was eventually confirmed by Theo himself. Dries reported he no longer saw much of his friend since the brothers "are now having their meals together in their neighborhood."[28]

It's not surprising that Theo rarely included Dries in these outings. Vincent tended to occupy all the psychic space, leaving little room for anyone else. Even when they were living apart, Theo had been his main

* See below.

confidant, his sounding board for thoughts on sex and art, politics, literature, religion, and history. Now, leaning over a stein of beer or a bowl of stew at one of the inexpensive brasseries or beer gardens of Montmartre they frequented, Vincent harangued his younger brother. Years of pent-up obsessions poured out in an unstoppable torrent, leaving Theo overwhelmed and exhausted. Whether because Theo was embarrassed by Vincent or simply wished to spare his friend the ordeal, in these early days he evidently preferred to keep Dries and Vincent apart.

Any possibility that Theo might have constructed a rich and varied social life in Paris vanished with Vincent's arrival. "When the first excitement of all the new attractions in Paris had passed," Jo Bonger recorded, "Vincent soon fell back into his old irritability."[29]

The truth is that Theo never felt more isolated in the foreign capital than when he was sharing a few cramped rooms with his brother. His upbeat letter to his mother was at the very least an example of selective reporting, perhaps more a case of self-deception than deliberate falsehood.

And, to be fair, there *were* tangible improvements, not only in Vincent's appearance but in his behavior, as he tried to adjust to his new circumstances. Dining out regularly with Theo, he began to put on weight. With his newly trimmed beard, new teeth, and new clothes, the two brothers could set out for a night on the town without anyone remarking on the contrast.

One of the venues they frequented was Bataille's restaurant on the Rue des Abbesses, a five-minute walk from their apartment. Offering plentiful food at reasonable prices served in long, narrow rooms, the establishment of *le père et la mére* Bataille made up in boisterous conviviality for what it lacked in elegance. Like many eateries in the vicinity of Montmartre, it catered to bohemian types; over the front

door the proprietors inscribed ENTRÉE DES ARTISTES. One of the locals enjoying their hospitality was a young art student at the nearby studio of Cormon by the name of Henri de Toulouse-Lautrec.

Lucien Pissarro, *Vincent and Theo*, 1887

Bataille's was in fact a step down from Theo's usual haunts. One of the many ways his brother's presence changed his life was that the dandified Theo was now forced to mingle with a rougher, more ill-mannered crowd. Vincent, even in the reformed version he presented in Paris, was more at home in seedier dives, among "the people" with whom he identified. So Theo adjusted, anxious to avoid anything that might set off one of his tirades. The diners at Bataille's and similar establishments were not the Salon stars that made up Boussod & Valadon's stock-in-trade and with whom Theo was accustomed to socializing, but more marginal types still struggling to gain a foothold within the existing system or revolutionaries bent on tearing it down.

This descent down the social ladder may have felt like just another sacrifice he was forced to make for Vincent's sake, but it would bear fruit in the coming years, eventually encouraging him to open his mind to new approaches and to take greater risks in his professional life. The impact was not immediate or dramatic, but his center of gravity was shifting subtly under the weight of Vincent's outsized personality, opening up new possibilities for both of them.

For Vincent, the new routine marked a step toward stability and inclusion. In places like Madame Bataille's, he first came in contact with the bohemian world of Parisian artists, acclimating himself to its customs and manners even before he was welcomed into the community. In Brussels, The Hague, or Antwerp he'd been an isolated figure; his efforts to connect with his fellow artists, first through Mauve and later through Rappard, had all ended badly. He'd quarreled with would-be mentors and had been ridiculed by fellow students at the various academies or drawing clubs he'd attended. In the more permissive atmosphere of Paris, he didn't stand out quite as much. More cosmopolitan, more tolerant, more adventurous, the French capital cultivated a diversity of manners and ideology. Decades of avant-garde agitation and official retreat fostered a culture that rewarded creative opposition and looked on deviations from norms as a sign of potential genius. In Paris, Vincent van Gogh was not an instant pariah, but rather one of those eccentrics who might yet contribute to the aesthetic discourse. If he was still on the outside looking in, he was at least knocking on the door.

It was always likely Van Gogh would end up here sooner or later. Like many talented misfits, he dreamed of a place where his flaws would not define him, where his appetites were not denied him. He devoured the amorous adventures of Octave Mouret in Zola's *Au Bonheur des Dames* and

Georges Duroy in Guy de Maupassant's *Bel-Ami*—both of whom treated Paris as their personal playground—and asked himself: Why not me?

While many were attracted by the free air of Paris, Van Gogh had more reason than most to seek out its liberating atmosphere. The pathologies that excluded him from normal human intercourse drew him to the libertine city and, ultimately, propelled him into the arms of the avant-garde—an outlaw subculture that suited his desperado's heart. At war with convention, alienated from his parents and the bourgeois values they espoused, he wandered the earth in search of a place where he might belong, where he'd be able to satisfy his urges, and where he'd be accepted on his own terms. This applied as much to his art as to his lifestyle. In fact the two were intimately linked. Both were reckless, rebellious, libidinous, and driven by an excess of passion. Both demanded tolerance, sympathy, the patience to dig deep and discover the warmth hidden beneath a bristling exterior.

Thwarted desire, often illicit or at least inappropriate, acted as both a disruptive force and a creative catalyst, turning Van Gogh into a restless wanderer. The hunger for physical and emotional contact drove a wedge between him and his family as he struggled to escape the grip of respectability's dead hand and release into something real, something closer to the heart (or the loins), more nourishing to the soul. "I'll look for a woman," he'd seethed following his disastrous courtship of his cousin, "I cannot, I will not, I may not live without love. I'm only human, and a human with passions at that, I need a woman or I'll freeze or turn to stone, or anyway be overwhelmed." His frustrations caused him to lash out against the strict code of his Calvinist forebears: "But all that drivel about good and evil, morality and immorality, I actually care so little about it. For truly, it's impossible for me always to know what is good, what is evil, what is moral, what is immoral. Morality or immorality coincidentally brings me to K.V."[30]

From the beginning, Van Gogh's artistic journey was wrapped up in his pursuit of sexual and emotional fulfillment. Artists, as everyone knew, were inherently disreputable, more often flouting than observing the rules. In their world he might recreate the bonds of affection he'd been denied under the parental roof. When his attempt to start a substitute family with the former prostitute Sien Hoornik failed, Van Gogh longed for what he called "the days of the Bohème."[31] According to Felix Pyat, who had coined the term *Bohemian* a few decades earlier, the scruffy young residents of that blessed land lived by "other ideas and other behavior [which] isolates them from the world, makes them alien and bizarre, puts them outside the law, beyond the reaches of society. They are the Bohemians of today."[32] No wonder the idea of lighting out for this wild frontier appealed to Vincent! In The Hague his unusual domestic arrangements made him an outcast, but in the more accommodating world of Bohemia "a painter's family and studio like mine would be nothing unusual."[33] His longing for freedom only increased in Nuenen, where supervision of his sex life proved even more restrictive. Scandals with Margot Begemann and Gordina de Groot brought down the wrath of the village elders and scathing disapproval of his parents. Feeling suffocated in that provincial backwater, he fled to Antwerp, where the women of the seaport were not so well protected.

Of course the libidinous heart of *la vie bohème* was in Paris, specifically in the Latin Quarter, Batignolles, and Montmartre, where the loose, louche lifestyle associated with students, poets, and painters was proverbial. The Naturalist novels of Zola and the Goncourt brothers had already offered him a preview of that more liberal society, where sex was readily available (paid for or freely given) and the morality police were scarce. In the European capital of vice, even eminently respectable artists enjoyed a degree of freedom in their private lives.

These more casual, more mercenary, interactions would compensate him for the satisfactions he was unable to obtain by other means. "I've grown fond of those women who are condemned and despised and cursed by clergymen,"[34] he proclaimed defiantly. Relocating to the city that stood for modernity and for license—the two being more or less synonymous—involved a new self-conception and coincided with a new direction in his art. To become "a painter of modern life" meant adopting a certain attitude toward one's fellow human beings: ironic, detached, cynical. Inevitably, it meant ignoring approved outlets for sexual release and finding gratification instead in encounters with strangers, turning an indulgent eye on weakness (particularly one's own), and relishing the human comedy. Just as his romantic fantasies of family life involving Kee Voss corresponded to his ambition to become a peasant painter, Mouret, the sexually rapacious hero of *Au Bonheur des Dames*, presided over this new phase.

Thus, this change of address involved not only a change in appearance, in the way he presented himself to the world and the way he wished to be perceived, but a transformation of the inner man. He had started out as a minister preaching the gospel before adopting the secular (and socialist) gospel of poverty as a peasant painter. From a sentimentalist in muddy clogs, shedding tears for those he rendered with such loving care, he transformed himself once more, into an urban boulevardier, a cynic in a frock coat and fedora, casting a jaundiced eye on the passersby. He'd now committed himself to the cause of modernity, in literature and, by implication, in art, which had replaced the old-time religion as a force for human progress. The old gospel must make way for the new—a point he'd already made in the still life he painted shortly after his father's death, in which Dorus's Bible has been set aside for Zola's well-thumbed novel. It was too soon to tell if this latest reinvention, brought on by amorous and

spiritual disillusionment, would prove more lasting than the earlier
ones. After all, it was easier to change one's wardrobe or one's reading
list than to change one's heart.

Over the preceding years, Vincent had offered many different ratio-
nales for coming to Paris: to find employment at one of the city's
many illustrated magazines or as a freelance commercial artist; to
set himself up as a portraitist; to continue his study of the human
figure by enrolling in a studio or drawing from plaster casts; to come
to grips with recent art, specifically Impressionism; to complete his
evolution from a peasant painter of rustic scenes into a chronicler of
the contemporary urban landscape in the spirit of Émile Zola. In most
of these scenarios, Vincent still regarded himself as a student with a
lot to learn. "I'm setting myself in advance, out of my own conviction,
the requirement of spending at least a year in Paris mainly drawing
from the nude and plaster casts," he wrote to Theo a few weeks before
setting out. "For the rest, let's do whatsoever our hand finds to do in
the way of painting, if an effect out of doors strikes us or we happen
to have a good model &c."[35]

Despite the confident tone he struck in his letters from Antwerp, he
got off to a slow start. The meager output of those first months doesn't
suggest someone who knew where he wanted to go and how to get
there. Of course much of his time and energy was taken up with the
painful course of oral surgery and by the larger project of restoring his
health. Perhaps more importantly, the cramped quarters on the Rue
Laval made working at home difficult, and cold winter days made
painting outdoors equally problematic.

But it's also clear that Vincent felt somewhat disoriented. Reinventing
himself from a painter of timeless rustic scenes à la Millet to a painter
of modern life in the spirit of Zola, and in the style of Manet, couldn't

happen overnight. Paris was huge and overwhelming, a constant assault on his sensitive nerves. And no matter how much he aspired to this new role, the love-'em-and-leave-'em insouciance of Octave Mouret didn't suit his passionate nature. He lacked the boulevardier's sense of irony, the rake's cruel indifference. To "set up house in the heart of the multitude, amid the ebb and flow of movement, in the midst of the fugitive and the infinite," as Baudelaire recommended, demanded a detachment he could never achieve. Works from these early months have a tentativeness that shows how much difficulty he had coming to terms with his new role. He wouldn't really hit his stride until he discovered another way, one that did not depend on a dichotomy between country and city, heart and mind, forcing him to choose between a vanished past or a soulless future.

A couple of unusual drawings from this period suggest he hoped to find work as an illustrator while he perfected his skills as a fine artist. This was not a new ambition. In 1885 he'd urged Theo: "Try to talk to someone at *Le Chat Noir*,* and ask them whether they want a scratch of those potato eaters and, if so, what size, because it makes no difference to me."[36] The fact that he believed his clumsy rustics might appeal to a magazine that trafficked in clever takedowns of society types shows just how out of touch he still was with the mood of Paris.

In Antwerp he'd stressed the importance of "being seen," even if that meant painting signboards and decoration; in Paris opportunities for commercial work were vastly greater. Many an artist who'd yet to make a splash at the Salon still earned a respectable income working for one of the city's many illustrated magazines, or in the burgeoning field of poster design.

* *Le Chat Noir* was a satiric journal put out by the cabaret of the same name. Toulouse-Lautrec was one of many talented artists who supplied the illustrations.

Indeed, the dynamic of the avant-garde often depended on the creative interchange between commercial and fine art. Poster design was a particularly promising medium, not only for making money but for artistic expression. In the hands of masters like Toulouse-Lautrec, Adolphe Willette, Alphonse Mucha, and Théophile Steinlen—the first two being patrons of the Bataille restaurant—posters were no longer simply hack work but original creations in their own right. Taking advantage of the relatively new medium of lithography—whose ease of drawing and affinity for bold, eye-catching colors encouraged the invention of novel forms—artists were enlivening Haussmann's monotonous grid with striking images in vivid hues. Through this "art for the masses" even Parisians who never set foot in a museum or gallery were exposed to some of the most innovative designs by some of the most creative visual artists.

Vincent's own efforts at commercial illustration were crude and half-hearted. They lacked the daring that characterized Lautrec's groundbreaking designs or the delightful intricacy of Mucha's Art Nouveau confections. One was a sample menu for an unidentified restaurant, featuring *"Cervelle Beurre noir," "veau marengo,"* and *"gateau de riz au Kirsch."** Providing a decorative border to these rather upscale offerings, Van Gogh sketched in a scene of promenaders in a Parisian park, the kind of pleasant suburban scene that had long been a staple of the Impressionists.

More curious is a drawing in pen, pencil, and colored washes showing a woman walking her dog. Its subtitle, "A La Vilette," comes from the verses Van Gogh inscribed at the bottom, which are taken from a song by the popular cabaret singer Aristide Bruant. While the Bruant original chronicles the life of a pimp, Vincent changed the sex and profession of the protagonist:

* Brains in black butter, veal Marengo, and rice cake with Kirsch.

De son métier elle ne faisait rien.
Le soir elle balladait son chien a la Villette. (A job? She didn't
have one. She walked her dog each evening to La Villette.)[37]

This is a character study, or rather a caricature, an urban grotesque
reminiscent of Honoré Daumier, though without the latter's deft
draftsmanship and ability to capture the essence of a familiar type with
a few well-chosen lines. Van Gogh often exaggerates, but usually for
expressive rather than comic effect. He evidently concluded his talents
lay elsewhere, since he never repeated this experiment in humorous
social commentary.

Most of the art Van Gogh produced during his first few months in
Paris consists of sketches he made in the city's streets and parks
in pencil and black chalk. Some concentrate on the topography;
others are rapid studies of typical urban types: promenaders out for
an evening stroll, couples embracing, a man taking his ease on a park
bench. This is a world of strangers, observed with the detachment of
Baudelaire's flaneur. Even when human figures predominate, they
remain anonymous, people about whom nothing is known and who
make no claims on our emotions. One is reminded of Zola's descrip-
tion of central Paris in *L'Oeuvre*: "The avenue was filled with a double
stream of traffic, rolling on like twin rivers, with eddies and waves of
moving carriages tipped like foam with the sparkle of a lamp-glass or
the glint of a polished panel down to the Place de la Concorde with
its enormous pavements and roadways like big, broad lakes, crossed in
every direction by the flash of wheels, peopled by black specks which
were really human beings."[38] Unlike the weavers of Nuenen, they are
not emblematic figures ennobled by their backbreaking labor. In fact
they are barely there at all, merely ghosts flitting by and leaving only
the faintest trace in the retina.

Terrace of the Tuileries, 1886

Taking on the subject matter of the Impressionists and borrowing their technique of rendering a scene in a few rapid strokes that merely suggest rather than depict, Van Gogh makes his first tentative steps in the direction of the new art. This was modern art, an art of the city: cool, disengaged, based on perception rather than deep human sympathy. The imperative to align his art with recent trends was not simply, or even largely, aesthetic: Theo knew that people were much more likely to purchase lighthearted renderings of the leisure activities in which they were engaged on a daily basis than heavy-handed works intended to reform the world. He'd tried to explain this before, but Vincent had stubbornly pursued his own course. Now, these modest efforts show that he'd changed his mind, or at least his tactics. He'd come to Paris eager to please, desperate to show Theo he was making progress, that there was hope he'd soon start to earn his keep.

Among the few paintings firmly dated to Vincent's first months in Paris are three portraits, experiments in a genre he hoped would soon offer him a lucrative outlet. Each is rendered in the same dark tonalities characteristic of his Nuenen period, though, as in *The Potato Eaters* and related works, the gloom is relieved by subtle contrasts of

complementaries—reddish tints in the shadows of the faces, a cool green in the backgrounds.[39] Two are portraits of Parisian ladies, one sporting a jaunty hat, the other elegant gloves on her crossed hands. These works are unusual in Van Gogh's oeuvre in that they depict solidly middle-class ladies rather than prostitutes or peasants, inhabitants of Theo's world rather than Vincent's.

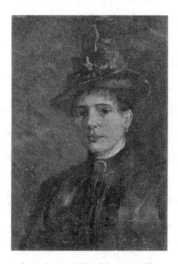

Portrait of a Lady with a Hat, 1886

Like the satiric drawing *A La Villette*, these bourgeois portraits were a dead end. No paying clients ever materialized. And no wonder! These paintings are neither stylish nor flattering, precisely the wrong advertisement for someone wishing to set himself up as a society portraitist. In fact they are something of a step backward, with none of brio of the likenesses he made in Antwerp of prostitutes and showgirls. Perhaps intimidated by their respectability, Van Gogh had opted for sobriety over flair, squeezing the life out of his sitters in an effort to capture an accurate likeness.

Also detrimental to Vincent's career as a budding portraitist was his habit of closing in on his subjects like a hunter stalking his prey. "Models didn't want to pose for him in Paris,"[40] Theo recalled. The most important skill a portraitist must cultivate is that of putting his subjects at ease, allowing them the space to reveal their true selves. Vincent, intense and overbearing, simply made people uncomfortable. For him, the relationship between the artist and his model was all about power and control; it was *his* needs that mattered, his demands that had to be met. "Do you understand that I'm not angry with the human race because they think I'm this or that," he grumbled to his sister Wil: "I freely admit in advance that they're absolutely right, but it saddens me that I don't have enough power to get what I want to pose for me, where I want and for as long or as short as I want."[41] This power dynamic had a sexually predatory aspect, as he revealed in the envious way he spoke of the fashionable Charles Joshua Chaplin,* "who paints the portraits of the most beautiful women in Paris mightily well, ladies in boudoirs dressed or undressed."[42] For Vincent, to paint someone was to possess her, body and soul, a bargain few—with the notable exception of Sien Hoornik—were willing to make.

The third painting in this series is a self-portrait, unremarkable except for the fact that it was the first in what would become one of the most characteristic and moving themes in his art. Van Gogh would go on to paint at least thirty-six self-portraits, twenty-five of them dating from his two years in Paris.**

* Charles Joshua Chaplin (1825–1891) was a popular academic landscape and portrait painter. He specialized in erotic seminude depictions of attractive young ladies.

** While this is his first surviving self-portrait, it's likely not his first attempt. Recently, an X-ray study of *Head of a Peasant Woman* (Gordina de Groot) from Nuenen revealed what is likely a self-portrait underneath.

This initial attempt at rendering his own features is not particularly compelling. *Self-Portrait with a Pipe*, like the two contemporaneous portraits of women, is little more than an exercise and one that barely rises to the level of technical competence. Van Gogh depicts himself in the same murky hues, though he takes advantage of his red hair and beard to inject a little color into the otherwise drab composition. He seems constrained by his need to show that he belongs to the same social station as his two sitters, an unconvincing bit of playacting that precludes probing for something deeper. Dressed in a coat with lapels, a waistcoat, and a white collar with a blue tie, he is the picture of the respectable man about town—the society portraitist he hoped he might one day become. Only a certain intensity in his gaze—an almost crazed look about the eyes—hints at something else bubbling beneath the conventional exterior.

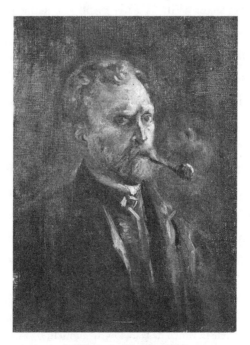

Self-Portrait with a Pipe, 1886

Van Gogh's apparent compulsion to render his own features was partly just a matter of convenience; he was always his most reliable subject, available even when he'd managed to scare everyone else away. But it was more than that. As his letters reveal, Van Gogh was relentlessly self-regarding and self-analytical. Whether rehashing his past failures or rehearsing future triumphs, nothing absorbed him as much as himself. He tended to view reality through the distorting lens of his own obsessions; nothing was as real as his own feelings, everything else fading to insignificance in the glare of his self-regard. Depicting his own features allowed him to capture not only the man he feared he might become, but also the one he aspired to be—a kind of magical thinking in which to picture something was to make it so. His self-portraits allowed him to don a whole series of costumes, to play a variety of different roles, substituting for the one he found most difficult to get right. As he once told his sister Wil: "To my mind the same person supplies material for very diverse portraits."[43] It's no coincidence that the bulk of his self-portraits date from his time in Paris, for these were years in which he was searching for his identity, both as an artist and as a man.* For much of his career, no time was as productive, or as revelatory, as time spent gazing in the mirror.

In June the brothers made the long-awaited move to a larger apartment. Their new home was located on the third floor of a recently constructed building faced in gleaming limestone, featuring an arched entranceway and spacious vestibule complete with a concierge to greet visitors and keep out the riffraff.** In back there was an elegant courtyard, filled in

* Van Gogh also painted a number of self-portraits in the fall and winter of 1888–1889, around the time of his psychotic breakdown when he cut off his ear—another time in which he feared losing himself.

** There is some dispute as to the exact floor, but I've chosen to follow Jo's lead.

spring and summer with an array of flowers. Dries reported the news to his family: "Have I already told you that Van Gogh has moved to Montmartre. They now have a large, spacious apartment (by Parisian standards, anyway) and their own household. They now have an excellent kitchen-maid."[44]

54 rue Lepic

The kitchen maid soon disappeared—Theo apparently decided she was an unnecessary extravagance—but in almost every way their new home was a distinct improvement on the old. It was airier and roomier and included a separate bedroom where Vincent could paint in peace.

If this was not quite "a good studio where one can receive people if need be,"[45] which they'd discussed while Vincent was still in Antwerp, at least it allowed him to close the door on the mess of rags, discarded paint tubes, and half-finished canvases that otherwise tended to spill into Theo's space.

The apartment came with the latest amenities—gas heat and light, a tin tub, and two faucets with running water—as well as upscale touches like parquet floors laid out in a herringbone pattern and mantlepieces carved from black marble.[46] "The new apartment on the third floor had three rather large rooms, a small room and a kitchen," said Jo, basing her description on her husband's recollections. "The living room was comfortable and cozy with Theo's beautiful old cabinet, a sofa, and a big stove, for both the brothers were very sensitive to the cold. Next to that was Theo's bedroom. Vincent slept in the small room and behind that was the studio, an ordinary-sized room with one not very large window."[47]

The apartment's best feature, however, had nothing to do with the furnishings or amenities. Located on a steeply sloping street rising to the heights of the Butte Montmartre, the building took full advantage of its elevated site. "As you may know," Theo wrote to a friend in Holland, "I am living with my brother Vincent, who is studying painting with unflagging enthusiasm. Since he needs a fair bit of space for his work we are living in quite a large apartment in Montmartre (54 rue Lepic) which, as you know, is a suburb of Paris built on the side of a hill. The remarkable thing about our flat is that we have a magnificent view from the windows overlooking the city, with the hill of Meudon, St Cloud etc. on the horizon: and a piece of sky above that's almost as vast as when one stands on the dunes."[48]

Completed four years earlier, no. 54 and its immediate neighbors were part of a building boom transforming this once rustic enclave.

Below and to the south lay the vast urban sprawl of the city that had largely succumbed to Baron Haussmann's need for order; rising to the north was the crest of the Butte, whose rocky heights continued to resist the rationalizing mania that had overtaken much of the city over the course of the past half century. Just beyond the bend paved streets gave way to unnavigable staircases leading to winding paths of dirt and cobblestone, and apartment blocks made way for rustic cottages and dilapidated lean-tos. Here on the "hill of martyrs," which rose some 300 feet above the city below, a few ancient monasteries survived, a reminder of the religious communities that had once made their home here. There were fewer traces of more recent history, since these had been deliberately suppressed. It was here that, a mere decade and a half earlier, the bloody Paris Commune had been born, and it was here, too, that it perished in blood.

Montmartre, even after its incorporation into Paris proper as the 18th arrondissement in 1860, remained something of a world apart. Below was the realm of commerce and high art, of the Louvre, the École des Beaux-Arts, the *Opéra*, and the *Bourse;* above a warren of squatters' shacks and tenements, overgrown quarries and kitchen gardens, seedy taverns and dark alleyways where Apaches—lawless bandits of legend—lurked, ready to pounce on visitors from the lowlands who'd been drawn to these heights by its dangerous allure.

Recently discovered by developers capitalizing on its bohemian appeal, Montmartre was home to a vibrant counterculture. "In this bizarre land swarmed a host of colorful artists, writers, painters, musicians, sculptors, architects," wrote Félicien Champsaur four years before the van Gogh brothers arrived, "a few with their own places but most in furnished lodgings, surrounded by the workers of Montmartre . . . sprouting up all over the place, like weeds. Montmartre was home to every kind of artist."[49]

In a pattern familiar in the 21st century, cheap rents attracted artists, which in turn attracted those seeking commercial opportunities. In the late 19th century, this was still a distinctly Parisian phenomenon. Other great metropolises boasted lively artist's quarters, marginal districts where painters and sculptors (mostly young and poor) wallowed in picturesque squalor. But none managed to commodify this as successfully as the French capital. "Paris has long enjoyed the reputation of being the most cosmopolitan city in Europe," noted a popular guidebook of the era, "where the artist, the scholar, the merchant, and the votary of pleasure alike find the most abundant scope for their pursuits."[50] Numerous establishments rose up along the borderlands between the valley and the Butte itself, exploiting middle-class fascination with low-class entertainment. Slumming in the *caf' concs** and *cabarets artistiques*, bankers and lawyers, accompanied by either their wives or mistresses, relieved the drudgery of their daily lives with a little risqué entertainment and distinguished themselves from their squarer colleagues by their willingness to take risks and laugh at themselves. At Rodolphe Salis's famous cabaret Le Chat Noir (on the Rue Victor Massé), the waiters dressed in the green-and-gold livery of the Académie Français and treated their guests "like pimps and whores."[51] The singer Aristide Bruant, an alumnus of Salis's cabaret, went into business on his own at Le Mirliton (on the Boulevard Rochechouart), where he made an art form out of insulting his audience:

> Well, boys, look who's here—one of our leading burglars,
> the eminent M'sieur A coming to spend some of the swag
> from his last sale of the blue sky. And a new lady with

* A *caf' conc*, or café-concert, was a combination café and theater. They were also
known as *cafés-chantants*.

him—another to whom coronets are more kind than hearts!
Well, well, the jails are full of honester people. But there is
a just providence that looks after things. One of these days
they will be pinning the Legion of Honor on him, and we
shall be avenged.[52]

Vincent and Theo's new apartment was within walking distance of
both the Chat Noir and Le Mirliton, as well as the popular dance hall Le
Moulin de la Galette, on the summit of the Butte. Countless nearby tav-
erns, cafés, and cabarets—including the infamous Cabaret des Assassins*—
catered to a variety of tastes, providing entertainment that went from the
suggestive to the downright obscene. There was even a circus close by,
the Cirque Fernando at 63 Boulevard Rochechouart, popular with artists
like Degas, Seurat, and Toulouse-Lautrec, who found inspiration in the
novel poses of the acrobats and equestriennes.**

The immediate neighborhood of No. 54 Rue Lepic reflected the
van Gogh brothers' paradoxical social standing, with one foot in the world
of bohemia and the other in the respectable world of commerce. The
development of the lower slopes of Montmartre was spurred by
the same social dynamic that drew well-heeled customers to the caba-
rets, exploiting the same sordid glamour and repackaging it in a form
that didn't require anyone to sacrifice their usual comforts. In a sense,

* It was later known as the Lapin Agile, becoming famous in the early 20th century
 as a favorite hangout of Picasso and his gang.
** In addition to the Cirque Fernando, Paris had two other indoor circuses: the
 Cirque d'Hiver on the Boulevard du Temple and the Nouveau Cirque on the
 Rue Saint-Honoré. The Cirque Fernando was succeeded by the Cirque Medrano,
 which would become one of Picasso's favorite hangouts when he moved to Mont-
 martre in 1903 and inspired many of his Rose Period masterpieces. Le Moulin
 Rouge, made famous by Toulouse-Lautrec's posters advertising the performers,
 didn't open until 1889, a year after Vincent left Paris.

the developers were taking advantage of the same trends as progressive dealers like Durand-Ruel, discovering opportunities in the unstable margins between old and new, tradition and innovation.

Moving in with Theo, Vincent adopted his brother's bourgeois lifestyle. The apartment was no ramshackle tenement of the kind that many struggling artists were forced to inhabit; it had none of the picturesque chaos of the Bateau Lavoir, which Picasso would make famous a generation later, and it was a major step up from the squalor to which Vincent had become accustomed. And if this was Montmartre, it was the part of Montmartre that was well on its way to becoming gentrified. It offered a bohemian vibe but with the rough edges filed off. And if it seemed a little stuffy for the rebellious Vincent, there's no indication he felt confined. The truth is that it suited his new conception of himself as a man about town, an artist with a frock coat, tugging thoughtfully on his pipe while he contemplated the world with wry amusement.

Though Van Gogh has become the poster child for the outsider artist, alienated from society and condemned to poverty by an uncomprehending public, in Paris at least he led a comfortably middle-class existence, experiencing far less hardship than artists like Pissarro, Sisley, and even Monet were forced to endure at the outset of their careers. Even at low points like the Borinage and Drenthe, his deprivations were self-imposed and could be relieved at any time by availing himself of the safety net provided by his father and younger brother. While they lived apart, the allowance Theo provided was more than sufficient to keep body and soul together; during the two years they lived together in Paris, Vincent never suffered material want. His troubles, which were real enough, came from other sources and were not so easily addressed.

Moving into their new apartment in June allowed Vincent to return to painting, which he'd neglected in the cramped quarters on the Rue Laval. He marked the occasion with a quick sketch of the view outside his studio window. There's nothing particularly charming about this scene of chimneys and slate rooftops, relieved by bits of greenery, but it serves as a memento of the happy event. Having fully recovered his health and with a dedicated studio of his own, he could now begin in earnest the project that had brought him to Paris.

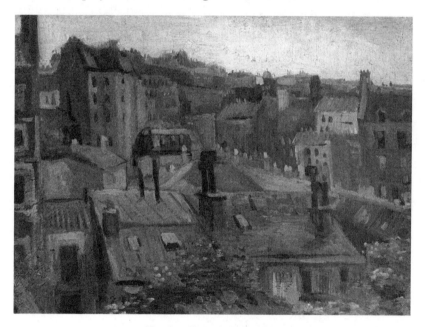

View from Vincent's Studio, 1886

The neighborhood hugging the lower slopes of Montmartre, along the Boulevard de Clichy and the Place Pigalle, catered to artists, and Van Gogh was able to purchase everything he needed from among the numerous local merchants stocking a wide variety of supplies to suit a wide range of budgets. In Antwerp he'd often splurged on the highest quality materials, forestalling Theo's inevitable criticism by

declaring, "The most expensive is still sometimes the cheapest."[53] Now, he generally settled for lower-grade paints and supports. Not only did he want to avoid antagonizing Theo, but he acknowledged that he was producing studies rather than finished products intended for sale. Indeed, living with his brother had not solved all his financial woes since Theo kept a close eye on his expenditures, itemizing them (much to Vincent's chagrin) in detailed ledgers. *View from Vincent's Studio* and a number of other works from the summer of 1886 were painted on *carton*, pre-primed pieces of cardboard that he purchased from the color merchant Pignel-Dupont, located at 17 Rue Lepic, for the low price of 65 centimes. These cheap, lightweight supports allowed him to experiment freely and were perfect for a quick sketch dashed off *en plein air.*

Vincent was energized not only by the change of address but by the change in season. The long nights and harsh winters of the North had always depressed him, urging him south to seek the sun.** Now, taking advantage of the fine summer weather, he packed up his easel and palette, his paint box and rags, and set out to explore the picturesque byways and spectacular views of the Butte. "Here he first painted his immediate surroundings," his sister-in-law recorded, "the view from the studio window, the Moulin de la Galette viewed from every side, the window of Madame Bataille's small restaurant where he had his meals, little landscapes of Montmartre, which at that time was still quite countrified—all painted in a soft, tender tone like that of Mauve."[54]

* Other suppliers include Rey et Perrod and Tasset et L'Hôte. In the fall of 1886, Van Gogh began frequenting the shop of Père Tanguy, who became his most important supplier and a good friend. [See below.]

** Among his many psychological problems, Van Gogh likely suffered from seasonal affective disorder (SAD). Many of his worst moments, including the crisis of December 1888 when he cut off his ear, came in the depths of winter. His longing for the heat of the South may well be an expression of this debilitating condition.

Van Gogh began painting Montmartre even before the move itself—perhaps inspired by house-hunting expeditions in the vicinity. One of his first oil landscapes from Paris is a view of a rural lane that, to judge from the blossoms on the apple tree, was made in late April or early May. Rapidly executed on cardboard, *Path in Montmartre*, like the drawings of the Tuileries and Jardin du Luxembourg, was a study rather than a finished work of art, a rudimentary attempt at the kind of picturesque scene that might appeal to the tourist market. Dashed off in a single session, it was an effort to train both his eye and his hand in the unfamiliar mode of depicting the varied urban scene.

Most of the paintings from Vincent's first months in Paris can be thought of this way: experimental, tentative, made with an eye to the low-end market rather than the Salon. Later, he explained his approach to Theo: "Shortly after I came to Paris I said to you that before I had two hundred canvases I wouldn't be able to do anything. What would appear to some people to be working too fast is in reality completely the ordinary run of things, the normal state of regular production, considering that a painter must work really just as hard as a shoemaker, for example."[55] These works are small, unpretentious, and deliberately superficial. They carry none of the moral weight of his *Potato Eaters* or even of his studies of the weavers and peasants of Nuenen. Those works were not simply documents but sermons on paper and canvas, tributes to the laborers' ceaseless toil that reflected his attachment to simple souls he believed were sanctified by work. Insofar as these early Paris views bespeak any ambition at all, it is to transform himself into a dispassionate chronicler of modern life, a journalist recording the passing scene without passing judgment. He is no longer the preacher deeply invested in the lives of his subjects, but a boulevardier treating the strangers against whom he brushes merely as decorative props to enliven his chosen vista.

If Van Gogh was determined to modernize his subject matter, he struggled to follow Theo's recommendation to lighten his palette in the manner of the Impressionists. In *View from Vincent's Studio* and *Path in Montmartre*, he incorporated the color theories of Charles Blanc based on complementary and "broken" colors. But, as in his paintings from Nuenen, he still only managed to achieve an overall effect of mud and murk. It would require more time and effort before he was able to free himself from the tonal approach he'd learned studying the works of the old masters.

Early that summer he hauled his gear to the far side of the Butte, to the southern slopes still untouched by developers. Here, less than a five-minute walk from his apartment, was a rural landscape consisting of green pastures complete with grazing sheep, interrupted by rock quarries, and dotted with garden sheds. [see color plate 15] This was familiar turf for Van Gogh, a rustic vista that seemed as far removed from the congested bustle of Paris as the fields of Brabant. In depicting this simple countryside, he reverted to a familiar style as well—the muted tones of Barbizon painters like Corot, Daubigny, Millet, and his cousin Anton Mauve. The nervous energy that characterized his drawings of the boulevards and parks of the city proper congeals into solid forms, painted with stripped-down, almost geometric brush-strokes that mimic the chunkiness of the rocky soil. There is a serenity to these scenes, as if Vincent was relieved to escape the commotion of the downtown and plant his easel on terra firma.

There's also an element of nostalgia as Van Gogh clings to something he knew was fast slipping away. Of all the spots in Paris he could have painted, this was the one that most evoked an earlier age. His approach, too, was old-fashioned. Reduced to broad bands of grassy hillside and wide sky, these paintings recall not only the Barbizon painters he admired but the great Dutch landscapists of the 17th century like Jacob Ruisdael and Aelbert Cuyp. Silhouetted against the sky are the

sails of the Blute-Fin, Radet, and Poivre windmills, a sight that surely reminded Vincent of his native Holland. Here in Paris, however, the windmills were little more than decoration. They were charming holdovers from a vanished past repackaged for tourists making their way to the summit of the Butte for a little rest and relaxation. The three windmills formed part of the entertainment complex of the Moulin de La Galette, a popular destination for working-class Parisians as well as artists like Renoir who memorably captured happy couples twirling in dappled sunshine.

At first glance, these picturesque scenes seem to undercut Van Gogh's mission to reinvent himself as a painter of modern life, but there was nothing more modern, more cosmopolitan, than the compulsion to escape the city and head for the nearest spot of greenery. Even as the center grew more congested and the countryside receded, Parisians flocked to accessible watering holes along the Seine, favorite haunts for the Impressionists, as well as seeking the fresher air of Montmartre's heights. These suburban locales were not symbols of timeless truth like the fields where Millet's peasants toiled, but sites of contemporary leisure—a concept foreign to the Barbizon master, who would no doubt have dismissed such scenes as trivial.* In painting the various byways of Montmartre, Van Gogh was emulating his Impressionist colleagues, offering up pleasant scenes that recorded bourgeois Paris's serious pursuit of recreation.

He had this same market in mind when, later that summer, he climbed to the summit of the Butte. Taking up a position next to the Moulin de la Galette that he'd recently painted from below, he saw the vast expanse of the city laid out beneath his feet. Like his view

* In the 19th century, leisure was a politically fraught subject. The right of the working classes to time off was proclaimed during the Paris Commune of 1871. In 1880, Paul Lafargue wrote an influential essay titled "The Right to Laziness."

out his studio window, these panoramas of the Paris skyline are composed in "broken tones," muted blues, greens, and pinks, contributing to an overall impression of overcast skies and shrouded distances. He deploys this reserved palette, which still owes something to Mauve's silver-toned Impressionism, to capture Paris's famously misty light. The Symbolist poet Marcel Schwob, recalling his own hike up to the summit, describes the very scene Van Gogh rendered, "the lake of fog in which swims the City of Light. Here and there, in the gaps, one vaguely sees Notre-Dame, the Panthéon, the Invalides, the Trocadéro."[56]

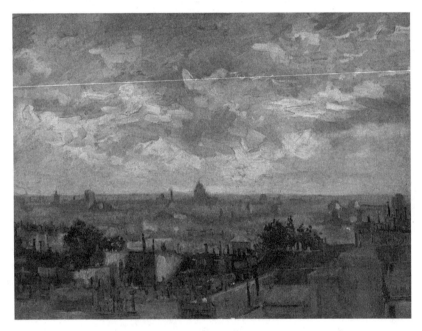

View of Paris, 1886

These panoramas are unusual, even unique, in Van Gogh's oeuvre and confirm the experimental nature of these early Parisian works as he tried out various techniques to see which ones suited his temperament and the market. In any case, he soon abandoned this approach,

no doubt concluding that atmospheric effects were not really his main interest. He would ultimately learn a great deal from his Impressionist contemporaries, but he never acquired the knack of capturing those fleeting effects of light and air that were the stock-in-trade of Monet, Pissarro, & co.

Along with the usual paraphernalia of the open-air painter, Van Gogh carried another piece of equipment on his rambles through Montmartre: a homemade perspective frame. This was often little more than a wooden stretcher across which he tacked wires laid out in a "Union Jack" pattern.* Peering through this grid allowed him to set down the main contours of the scene, usually in the form of a quick underdrawing in pencil or made with a tapered brush and thinned-out paint.

Letter with Drawing of Perspective Frame

* As early as 1882 he had one built to his specifications with the aid of a car-
 penter and a blacksmith. It was based on one described by the great Renais-
 sance painter Albrecht Dürer. Over the course of his career, he would try out
 a number of different variations. In Paris, he used a variety of different devices
 in a variety of different sizes, as can be seen through X-rays of various paintings
 where the traces still remain.

Vincent regarded this humble device as a key tool in his struggle to reconstruct the forms of the world on canvas. Perspective—a system for creating the illusion of a three-dimensional space on a two-dimensional surface—had for him almost magical properties. Indeed, it was only when he'd mastered the lessons on perspective he'd found in a book that he became convinced he could actually become an artist, likening it to a kind of "witchcraft."* For someone who lacked natural facility or an accurate eye, the perspective frame kept him from straying too far from reality. "It makes it possible to compare the proportions of objects close at hand with those on a plane further away," he explained to Theo, "in cases where construction according to the rules of perspective isn't feasible. Which, if you do it *by eye*, will always come out wrong, unless you're very experienced and skilled."[57]

This plodding, almost naïve, approach to rendering what was in front of him distinguished Van Gogh from most of his contemporaries in the avant-garde. Later, when he had begun to associate with innovators like Paul Gauguin and Émile Bernard, he continued to argue strenuously for his more realistic approach, grounded in a careful study of what was right before his eyes, rather than their preferred method of conjuring fantasies from their imaginations. Even in his most visionary works—those hypnotic landscapes from the last months of his life—the scenes he painted were rooted in fact, anchoring even his wildest flights of fancy to this earth.

Van Gogh's problem wasn't a *lack* of imagination but a surfeit, a tenuous grip on reality that he desperately needed to strengthen through the discipline of his art. It was a balance he sought early on and toward which he strived all his career: "Two things that remain eternally true and complement each other, in my view are:

* See Vincent to Theo van Gogh, April 2, 1882

don't snuff out your inspiration and power of imagination, don't
become a slave to the model; and, the other, take a model and study
it, for otherwise your inspiration won't take on material form."[58] Even
after careful measurement he had difficulty controlling his wayward
hand. He tended to exaggerate, to overemphasize, his forms warping
under the intensity of his gaze and the heaviness of his touch. He
realized this and did everything he could to master reality, knowing
that everything he produced would be stamped with his distinctive
personality. As he explained to Theo near the end of his life, he
wanted to be a shoemaker rather than a musician, to stick to the here-and-
now rather than fly off into airy abstractions from which he might
never return. Now as he stood on the summit of the Butte, all Paris
was encompassed in the organizing grid of his perspective frame,
each landmark in its proper place, and all he surveyed lay within
his control.

Even as Vincent was taking advantage of the fine summer weather to
depict the great outdoors, he was also making use of the studio on the
Rue Lepic to pursue tabletop experiments in a more controlled environ-
ment. As he'd explained to Theo in laying out his plans, his course of
study demanded "at least a year in Paris mainly drawing from the nude
and plaster casts." The impetus to improve his rendering of the human
form grew out of his experiences at the Royal Academy of Visual Arts
in Antwerp, where he'd been relegated to Frans Vinck's evening course
drawing from plaster casts after his teachers judged him insufficiently
skilled for the life-drawing course.* Here, as in similar classrooms all
across Europe and America, students improved the dexterity of their

* According to Vincent himself, he had attended Charles Verlat's life-drawing
course, but there's no evidence he was officially enrolled. [See letter 553]

hands and the accuracy of their eyes by carefully rendering the statues' idealized contours in pencil or charcoal on paper. It was hoped that by reproducing these exemplars of excellence, budding artists would also elevate their taste. By the time they were ready to tackle the more difficult subject of the live model, they presumably had a thorough understanding of proportion and anatomy, as well as a vision of what the human body *ought* to look like, however far short of perfection were the actual examples in front of them.

Of course Van Gogh's willingness to submit to this academic regimen was a complete reversal of his former disdain, which he'd articulated only the year before when he raked Rappard over the coals for relying on exactly the same training. "Does one learn it from the *plaster statue copiers* and at the *art academy?*" he'd asked his friend rhetorically, before answering with a resounding: "I believe: *not.*"[59]

Still, while Van Gogh now conceded the value of academic training, he made it clear he would pursue it in his own way. In Antwerp, as in Brussels, he found himself at odds with both his teachers and his fellow students. "I have to say that I think it's very good to draw plaster casts," he explained to Theo, "particularly for doing peasant figures, for instance, but not, please, as it's usually done! I actually find all the drawings I see there hopelessly bad—and fundamentally wrong. And I know that mine are totally different—time will just have to tell who's right. Damn it, *not one of them* has any feeling for what a classical statue is."[60] He'd shown up at the Academy in Antwerp with only rudimentary skills but an autodidact's dogmatic certainty. He had strong (if inconsistent) opinions, taking what he wanted from the books he read and rejecting anything that didn't reinforce his firmly held beliefs. Rather than adhering to the classical formula, in which contour was paramount, Van Gogh preferred a more robust approach

that emphasized internal volume. He gave his preferences an histori-
cally questionable pedigree. "The Greeks don't start from the outline,"
he lectured Theo,

> they start from the centers, from the cores. Géricault took
> that from Gros,* who took it from the Greeks, but Géricault
> himself wished to take it from the Greeks, too, and he
> studied them for that very thing—afterward Delacroix did
> the same as Géricault.
>
> This question—Millet draws like that too—more than
> anyone else—is perhaps the root of all figure painting—is
> extremely closely related to modelling by drawing directly
> with a brush—conceived totally differently from Bou-
> guereau and others, who lack interior modeling, are *flat*
> compared with Géricault and Delacroix, and who don't go
> beyond the paint.[61]

Modeling by drawing directly with the brush—this was the goal
he now set himself. It was a robust way of working that suited his
vehement personality. As he once told Rappard, what he valued most
in art was "manly strength, truth, loyalty, honesty,"[62] qualities he
saw in the work of painters like Rubens and Delacroix. This direct
approach is what gave their figures mass, a physical presence that

* Antoine-Jean Gros (1771–1835) and Théodore Géricault (1791–1824) were
pioneers of the emerging Romantic movement. In citing Gros, Géricault,
and Delacroix, Van Gogh was throwing in his lot with these traditional
opponents of the Neo-Classicists, whose champions were Jacques-Louis
David and Jean-August-Dominique Ingres. The lines between the two war-
ring camps were not always clear; Gros and Ingres, for instance, were both
pupils of David's.

distinguished them from the more precise, cold-blooded ideal pursued by arch-classicists like Ingres and Bouguereau. It also drew him closer to the Impressionists, who likewise eliminated precise contours in order to bathe their forms in light and atmosphere. "Do not define too closely the outline of things," advised Camille Pissarro: "it is the brush stroke of the right value and color which should produce the drawing."[63]

While painting from a live model was always Van Gogh's preferred method, working with plaster casts was considerably more convenient and cheaper. Small-scale replicas were a staple of the artist's atelier, available at the same shops where Van Gogh purchased his other supplies. Seven of the eleven plaster casts known to be part of the van Gogh brothers' collection survive, including a torso of an ancient Venus, a horse (based on the bronze statue of Marcus Aurelius in Rome), and a reproduction of Michelangelo's *Young Slave*.

The series of studies Van Gogh painted in the summer of 1886 reflect his anticlassical classicism. Painting rapidly with a loaded brush, Van Gogh strives to give his forms a sculptural solidity. The elegant proportions of the originals succumb to his vigorous exaggerations. Rather than line, he emphasizes mass—aggressively, insistently—as he works outward from the core. Often, the pasty strokes of paint follow the volumes of the figure, as if he's modeling in clay. Striated marks of the brush rather than light and shadow give these forms heft, allowing him to abandon the murky chiaroscuro of his earlier work. There is the same forcefulness, the same impatience, he exhibited in some of his Antwerp portraits painted under the spell of Rubens and Frans Hals. The thick, buttery pigment gives the surface an almost tactile quality, one that in his mature works reinforces their assertive presence.

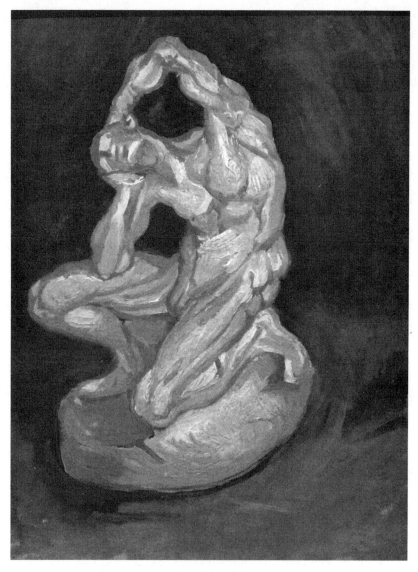

Plaster Cast, 1886

Despite their crusted surfaces, these paintings are lighter, more colorful than those that preceded them, as if he's finally heeding Theo's

advice to make his work more modern. In Antwerp he'd discovered the virtues of cobalt blue, "a divine colour" perfect "for putting space around things."[64] In these studies, though he opts for the less expensive Prussian blue and French ultramarine,[65] he's striving for the same airy effect, contrasting the cream-and-pearl hues of the statues with the cool tones of the background. However tentative, experimental, they're miles away from his muddy canvases of Nuenen. In their bold (if reductive) palette and directness, these simple exercises point the way to the future.

At the same time, Van Gogh set himself another (and intimately related) task: exploring the mysteries of color, not only to reproduce the reality he saw in front of him but as a means of organizing the two-dimensional surface of his canvas in a coherent and visually satisfying way.

"He is painting flowers mostly, mainly in order to make his next paintings more colourful,"[66] Theo reported to the family in Holland. Essentially, these floral still lifes posed the opposite problem from the studies of plaster casts, as if he was diligently following his own "how-to" course for becoming a painter. With the earlier series, the simplified palette allowed Vincent to study form in the absence of color; in the second, which he embarked upon almost immediately after the first, he explored the interaction of vivid hues without the need to bother too much about creating an illusion of the third dimension.

Crucially, Van Gogh had already begun to see form and color not as separate elements, but as one and the same thing. It was an insight that went back to his October 1885 visit to the Rijksmuseum. Shortly after that eye-opening experience, he wrote to Theo: "A great lesson that the old Dutch masters teach, it seems to me, is this: to regard drawing and colour as one."[67] He returned to that theme in Paris, writing to

the English painter Horace Mann Livens: "So as we said at the time in COLOR seeking life, the true drawing is modeling with color."[68]

In contrast to the more traditional academic practice—based on sound drawing, where the artist first established the outlines of the objects to be painted before filling them in with the appropriate local hues—Van Gogh was seeking more immediacy as form emerged naturally from strokes of saturated color applied with a loaded brush. It was an approach favored by Rubens and Hals and later by Eugène Delacroix.* Instead of the slick finish produced by Salon painters like Gérôme and Bouguereau, in which the picture plane seemed to disappear, opening a window onto a fictive world beyond, these artists favored a dynamic surface in which brushstrokes, laid on thickly, traced the passage of the artist's hand. The illusion, such as it was, existed in tension with the palpable physical reality of the painting itself.

For Van Gogh, as for Delacroix before him, this had the advantage of allowing him to deploy his colors at their full intensity, rather than adulterating or "breaking" them by mixing complementaries to produce intermediate neutral tones. Flowers offered the perfect subject for testing his new theories, since their bright petals could easily be rendered in bold dabs and slashes of vivid hue. In order to isolate the problem of color, he stuck to a rigid, and admittedly rather unimaginative, format: a vase of cut flowers placed on a table in his studio and viewed against a largely monochrome background. This simple formula

* The great Swiss art historian Heinrich Wölfflin (1864–1945) termed such painters *malerisch*, painterly, as opposed to linear. One can draw a throughline from Renaissance Venetian painters like Titian and Tintoretto to Baroque masters like Rembrandt, Hals, and Rubens, to the Romantics like Géricault and Delacroix, and finally to the Impressionists and Van Gogh himself.

allowed him to try out different arrangements, setting up jarring contrasts and orchestrating visually striking harmonies.*

By this point Van Gogh had spent years wrestling with the issue. At the beginning of his career, he thought mainly in terms of black and white, and more in terms of the *what* of an artwork than the *how*. But once he began painting, in the summer of 1883, he could no longer ignore the problem of color. It took another year before he discovered the writings of Charles Blanc—and through him the work of Eugène Delacroix. Now armed with theory, he could proceed with confidence, knowing his choices were backed by science. Of course putting theory into practice was easier said than done. Initially, his bold pronouncements were rarely matched by actual results as he worked and reworked Blanc's complementaries into darker and dingier tones.

At this stage of his career, Van Gogh's intellectual development far outstripped his technical ability. Much of what he learned about modern art he learned in books and magazines, and while he talked a good game his paintings still smacked of amateurism. "COLOR EXPRESSES SOMETHING IN ITSELF," he trumpeted from the wilds of Nuenen,"[69] words that could have come out of the mouth of the most radical member of the French avant-garde. To Theo, who'd been urging him to adopt a bolder palette, this must have seemed mere bluster. Still, if it hardly reflected his current production, it offered a

* The chronology of these canvases can be established simply by determining which flowers were in bloom at the time. Peonies, poppies, and cornflowers bloom in spring and early summer, while hollyhocks, gladioli, and Chinese asters emerge later in the summer. Theo used this network of suppliers as evidence that Vincent was making valuable connections in Paris, telling his mother: "He also has acquaintances from whom he receives a beautiful delivery of flowers every week which can serve him as a model." [Concordance, documentation, Theo to Anna, August 1886] These works, like the depictions of local Montmartre tourist spots, had the added benefit of providing a potential commercial outlet for the financially struggling artist.

prophecy of what was to come. He'd already made the leap from using color as a means of more faithfully describing the world he *saw* to using color to express the world he *felt*. If Vincent was able to radically transform his art in Paris, it's because he'd already made the journey in his mind.

After he arrived in the city, the issue of color took on a renewed urgency. His interest may have been sparked by an opportunity to view a painting by Delacroix up close when he and Theo attended an auction at the Hôtel Drouot in June. This is the only recorded instance during these early months in Paris when Theo allowed Vincent to share in his work, an exception that reflected his belief that his brother would profit from the experience. Otherwise, he seemed determined to cordon off his professional life from Vincent's intrusive presence. There's no record, in fact, that Vincent ever set foot in Boussod & Valadon during his stay in Paris. It's likely he dropped by from time to time at the branch on the Boulevard Montmartre, but he avoided the flagship store on the Place de l'Opéra. His humiliating dismissal a decade earlier still rankled, and Theo, for his part, had reason to worry Vincent might embarrass him in front of his bosses.

Inviting Vincent to accompany him to the Hôtel Drouot, Theo hoped he might benefit from seeing examples of high-quality works by old and contemporary masters. After all, such opportunities were the main reason he'd relocated to Paris. At this point in their relationship, Theo was far more sophisticated about contemporary art and took it upon himself to nudge his brother in the right direction. Professionally, he'd just begun (cautiously) to dip his toe into the market for Impressionist work, taking advantage of the relative freedom his bosses afforded him at the Boulevard Montmartre to move into this more speculative arena. As early as 1884 he'd sold a painting by Camille Pissarro for the low price of 150 francs, and the following year single

works by Alfred Sisley, Auguste Renoir, and Claude Monet, each to the collector Victor Desfossés.*

Two paintings Van Gogh saw at the Hôtel Drouot auction made a lasting impact on his own work. The first was Delacroix's *Christ Asleep during a Tempest*. Painted with the great Romantic's usual brio, the biblical scene is built around the red/green polarities, a play of complementaries that adds to the sense of the storm's crackling energy. Two years later, in a letter to Émile Bernard, he still recalled the work in detail: "Christ's boat—I'm talking about the blue and green sketch with touches of purple and red and a little lemon yellow for the halo, the aureole," adding crucially that the effect was not descriptive but "speaks a symbolic language through colour itself."[70]

While Delacroix's biblical scene lingered in his memory, foreshadowing the anti-naturalist turn his work would soon take, a flower still life by Manet had a more immediate impact. Only a couple of years earlier he'd insisted, "Millet, not Manet, is that essential modern painter who opened the horizon to many." Now, having embraced the *alla prima* methods of Frans Hals, he gained a renewed appreciation for Manet's command of rapid brushwork and his capacity to convey an enormous amount with a few deft touches. The play of complementaries in *Vase with Peonies* [see color plate 16] is far more subtle than in the Delacroix—pale pinks and slate greens, rather than the acid hues of the storm-tossed boat—but all the more effective, demonstrating that Charles Blanc's rules were capable of infinite elaboration.

* Theo eliminated any risk to the firm by handling the work only after he'd found a certain buyer, rather than by purchasing it "on spec" and hoping he could unload it for a profit at some future date. Thus Goupil & Cie could dabble in this more speculative market without putting up any of their own capital.

Van Gogh drew an explicit connection between his favorite theorist and his flower studies in his letter to Livens:* "White and rose roses, yellow chrysanthemums—seeking oppositions of blue with orange, red and green, yellow and violet, seeking THE BROKEN AND NEUTRAL TONES to harmonise brutal extremes. Trying to render intense COLOUR and not a GRAY harmony."[71]

He calls these works "gymnastics"[72] and "color studies,"[73] emphasizing their experimental nature. Dries Bonger, who stayed at the Rue Lepic apartment for a few weeks while Theo was away in Holland, had a chance to observe Vincent's work. "The ensemble of flower pieces is very gay and colourful," he wrote to Theo. "Some, though, are flat, but I just can't persuade him of that. He keeps replying: but I wanted to get this or that colour contrast into it. As if I gave a damn what he *wanted* to do!"[74] Theory, at least according to Dries, had run ahead of practice, his ambitions thwarted by his still rudimentary skills.

Vincent explained his method in a letter he wrote to his sister Wil a few months before leaving Paris for Arles: "Last year I painted almost nothing but flowers to accustom myself to a colour other than gray, that's to say pink, soft or bright green, light blue, violet, yellow, orange, fine red."[75] The lessons he learned could be applied to other subjects as well, not only landscapes but even portraits, as he explained to Livens: "I lately did two heads which I dare say are better in light and colour than those I did before."[76]

The early works in the series—he made around 35–40 flower still lifes in the summer of 1886 alone—stick to this program. As he painted with rapid strokes of the brush and with relatively saturated hues, one can sense him trying to reverse engineer the lessons of Manet's little

* This letter is often dated to the fall of 1886, but, for a variety of reasons, it likely dates from the following year. Since the letter is crucial for establishing the chronology of Van Gogh's life in Paris, it will be discussed in greater detail below.

gem. His most explicit homage is his *Bottle with Peonies and Forget-Me-Nots* [see color plate 17], where purple and yellow blossoms play off a gray/green background—a quiet tone poem that eschews obvious effects in favor of quieter harmonies. A comparison with Manet's still life, however, demonstrates how far he still had to go before he could match the Frenchman's sure touch and sophisticated feel for subtle variations in hue and tone. Viewed side by side, Van Gogh's brushwork appears clunky, his colors less successfully integrated into a convincing whole. Still, the lesson was vital, leading him, as his sister-in-law put it, "to renew his palette under the influence of the French plein-air painters, such as Monet, Sisley, Pissarro, etc."[77]

The fact is that Manet excelled in exactly those areas where Van Gogh fell short. Manet was the consummate boulevardier with top hat and cane, his life marked by grace and subtle humor. "The country has charms only for those who are not obliged to stay there,"[78] he scoffed, while Van Gogh was more comfortable roaming the fields and forests. As a painter Manet was equally debonair, casting a knowing eye on all he surveyed and chronicling the sophisticated world to which he belonged with an indulgent smile. Such subtleties were lost on Van Gogh. His gifts, which he would unleash soon enough, were of the opposite nature: vehement where Manet was reserved, rough rather than polished. He was a visionary who set his sights on distant horizons while the Frenchman was fully invested in the here and now. The lessons Manet could teach were important in catalyzing changes already taking place, but, like the Impressionists whose influence would soon come to the fore, Manet was not the prophet Vincent was seeking. However much Van Gogh strived to make himself into a flaneur, he always lacked the necessary objectivity, his nerves too raw and his needs too insistent for him to blend into the crowd like a benevolent stranger.

Just then he discovered another artist, one whose tormented life and equally tortured canvases touched him far more deeply than the suave Frenchman's ever could. Van Gogh first came across the work of Adolphe Monticelli in June of 1886 at the gallery of Joseph Delarebeyrette and immediately recognized him as a kindred spirit. Theo, too, was smitten by the eccentric Provençal and would soon purchase his work for his own gallery and private collection.

Much to his regret, Van Gogh never had a chance to meet his artistic hero. The sixty-one-year-old painter had already departed from Paris by the time Vincent arrived. Later that June he died in Marseilles under mysterious circumstances—some said of alcohol poisoning, others of suicide. He was, in fact, the kind of marginal figure who appealed to Van Gogh, a man who, like himself, had learned how to transform his pain into art.

For the rest of his life, Van Gogh would cite Monticelli as a major source of inspiration. In his letter to Albert Aurier, written a few months before his death, he blunted the critic's effusive praise by pointing him toward his model: "I feel ill at ease when I reflect that what you say should be applied to others rather than to me. For example, to Monticelli above all."[79] In fact part of Van Gogh's motivation for heading south to Arles was to retrace the doomed artist's steps. He originally contemplated continuing on to Marseilles, where he hoped to corner the market on the works of someone he considered an underappreciated genius. "I myself think about Monticelli a great deal down here," Vincent wrote to his sister from Arles. "He was a strong man—a little, even very, cracked—dreaming of sunshine and love and gaiety, but always frustrated by poverty, a colorist's extremely refined taste, a man of rare breeding, carrying on the best ancient traditions.

He died in Marseilles, rather sadly and probably after going through a real Gethsemane. Ah well, I myself am sure that I'll carry him on here as if I were his son or his brother."[80]

Monticelli was in many ways a strange choice of mentor. Though he'd painted alongside some of the Barbizon painters, he wasn't affiliated with any particular school, and he had no real disciples (excluding Van Gogh himself). He and the young Paul Cézanne had been friends during the 1860s, but the innovations of recent decades had largely passed him by. And while he didn't march with the Impressionists, he was no more comfortable in the Academy, pursuing his idiosyncratic vision without regard to the debates that were roiling the Parisian art world.* His art is difficult to classify, with elements that look to the past and others that seem to presage the future. Above all, he was out of step with his times.

Van Gogh clearly identified with this artist, whose struggles must have seemed ominously familiar and whose tragic fate foretold his own. He appreciated his independent spirit and the manic intensity with which he applied his pigments, as if the wooden panels on which he liked to paint were the enemy and had to be beaten into submission. So violent was his assault, and so encrusted the surfaces these battles produced, that imagery itself often dissolved in the conflagration.

Theo, perhaps too late, saw Vincent's obsession as unhealthy, writing to Jo after his brother's breakdown: "Sadly enough, many painters have gone insane yet nevertheless started to produce true art.

* In fact one of his favorite subjects was the *fête galante*, a scene of aristocrats frolicking in an idealized landscape, a staple of such 17th-century Rococo painters as Antoine Watteau and Jean-Honoré Fragonard. Manet's *Déjeuner sur L'Herbe* was essentially a fête galante reimagined for the late 19th century. Monticelli's versions seem more like period pieces.

Some have been cured, but not all. Vincent calls himself Monticelli's follower and Monticelli is precisely someone who was unhinged for years and who died like that. Genius roams along such mysterious paths in the mind that a spell of dizziness can bring it hurtling down from its heights."[81]

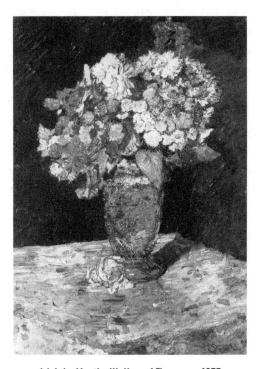

Adolphe Monticelli, *Vase of Flowers*, c. 1875

Monticelli's influence is evident in a number of the flower still lifes Van Gogh painted in the summer of 1886. A typical example is *Glass with Yellow Roses*. [see color plate 18] Compared to *Bottle with Peonies and Forget-Me-Nots*, where tonal variations are relatively muted, here Van Gogh has opted for a strong contrast between the dark, neutral background and the yellow blossoms—like fireworks bursting in a

night sky. Also reminiscent of Monticelli's approach is the thickly impastoed brushwork. Instead of a Manet-like fluidity, the strokes pile up in clotted mounds, turning parts (particularly the petals of the roses themselves) into a kind of corrugated relief. These works are as tactile as they are optical; to the extent that Van Gogh is able to summon the presence of the flowers he depicts, it's through the physical force of the pigment on canvas rather than illusionistic suggestion.

In some ways these Monticelli-inspired works can seem like a regression as Van Gogh discarded the more atmospheric mode he'd been working toward in Paris in favor of an old-fashioned tonal approach inspired by old masters like Rembrandt and Caravaggio. For Van Gogh, it was a relief to return to this kind of painting, which recalls the potatoes, apples, and birds' nests he painted at the end of his stay in Nuenen. Like those earlier works, these are earthy, literal, their realism material rather than visual. This was painting completely after his own heart, of the kind he felt in his bones. Here was the nourishing stuff of life, troweled onto the canvas in meaty dollops. Monticelli gave him permission to paint in the way that came most naturally to him: directly, vigorously, without the mediation of *technique* or visual trickery.

To paint honestly, Van Gogh believed, one had to live honestly. His goal, he confided in Theo at the beginning of his artistic career, was to leave behind something "in which an honest human feeling is expressed."[82] This is what he found in Monticelli's work. Like his hero, Van Gogh felt himself misunderstood as people confused his sincerity for clumsiness, his passion for violence. The honest man had no need for craft (in either sense of the word!). As he had when courting Kee Voss or preaching to the miners of the Borinage, he assumed that the direct approach was the best, for it was the only one that allowed him to speak the truths of an overflowing heart without dissimulation.

Thus during the spring and summer of 1886, Van Gogh was being pulled in opposite directions: toward a more modern style embodied in the work of Manet and his Impressionist disciples; and, on the other hand, toward more congenial modes, falling back on the dramatic chiaroscuro of *The Potato Eaters* and the Nuenen still lifes. For a time Van Gogh believed Monticelli's eccentric blend of old and new offered him a way out of his dilemma, but that too would prove to be a dead end.

Despite Vincent's many false starts, Theo appreciated how hard he was working, his willingness to try new approaches, and his openness to new ideas. He no longer clung as fiercely to his old favorites as he had before moving to Paris. If he'd yet to find his way, that too would surely come—hopefully sooner rather than later.

Theo's letter to his family that summer certainly paints too rosy a picture of Vincent's situation. It's less an objective assessment than an anticipation of better times just around the corner. "He is also much more cheerful than before," Theo told his mother, "and he goes down well with the people here. To give you an example, hardly a day passes without him being invited to visit the studios of painters of repute, or people come to him."[83] Citing his "tremendous progress" and insisting "that he is starting to make a success of it," he was still forced to admit "he hasn't yet sold any paintings for money, but exchanges his work for other paintings."

While the lack of sales was disappointing, the connections he was making did provide one tangible benefit: "In this way we're building up a fine collection, which is also worth something of course." Again, Theo exaggerated. The exchanges that can be dated to late 1886 and early 1887 involved only very minor artists, including the obscure American Impressionist Frank Boggs, and two classmates at Cormon's,

a Spaniard named Cristóbal de Antonio and someone named Fabian.[*]
Attempts to exchange his work with more established artists like
Charles Angrand, a recent convert to the Divisionist cause, were
rejected out of hand.

Most important: "There is a picture dealer who has already taken
four of his paintings in this way and has promised to hold an exhibi-
tion of his work next year."[84] This was likely Arsène Portier, a so-
called courtier dealer, that is a broker who dealt out of his private
residence rather than a storefront gallery. "A little old man suffering
from a chronic stomach condition,"[85] as one contemporary described
him, Portier was already well known to Theo. He'd been among
those he called on to give their opinion of Vincent's lithograph of
Potato Eaters the year before; it was his cautiously positive comment
that it had "personality" that had sent Vincent into such raptures
and accelerated his plans to come to Paris. Portier was a bit of an
eccentric, a marginal figure who'd been among the first to exhibit
works by the Impressionists before, as he put it, "being crowded out
by Durand-Ruel."[86] After missing out on the Impressionist boom, he
continued to dabble in a small way with promising artists who'd yet
to find major representation. He was exactly the kind of dealer who
might have taken a chance on a still unproven talent like Van Gogh.
It's unclear whether his supposed interest reflected his belief in
Vincent's latent talent or was merely a gesture to please a colleague;
and, in the end, the promise of an exhibition never came to anything.
It also didn't hurt that M. Portier was their downstairs neighbor at
no. 54 rue Lepic.

[*] Two paintings by Boggs were found in the collection of the van Gogh brothers,
 River Estuary with Lighthouse and *Ships on the Thames*, both of them dedicated
 to Vincent. Even these modest transactions may have been made primarily as a
 way of currying favor with Theo.

In short, Theo could convince himself that Vincent was taking the steps needed to build a career. "If we can keep this up," he concluded with a line calculated to lift his mother's spirits, "then I think that his difficult period will be behind him and that he will go on to find his feet."[87]

6

Messiah of a New Art

*"This Messiah of a new art, or this cold-blooded mystifier,
is Monsieur Georges Seurat."*

—*L'Art Moderne*

*"I told him, it's as necessary now to pass through Impres-
sionism properly as it once was to go through a Paris studio."*

—Van Gogh, 1888

By the time Van Gogh began to grapple with the lessons of Impres-
sionism, the movement itself was imploding, undermined from
within by petty jealousies and larger philosophical differences. For
more than a decade, these rebels had laid siege to the bastions of power,
but now that they'd begun to breach the walls they lost the esprit de
corps that once bound them together. This lack of conviction within
the vanguard of French art wasn't an isolated phenomenon. Rather, it
was a symptom of a more widespread malaise, a cluster of pathological
symptoms involving neurosis, melancholy, and anxiety grouped under
the catch-all phrase fin de siècle. "We're living in a bad season," Zola
warned, "with the century coming to an end and everything in a process
of demolition."[1]

Impressionism, for all its subversive reputation, was an art for a confident age, an art of literal and figurative sunshine. Depicting the world of ordinary experience, of untroubled domesticity, crowded boulevards, and rural country lanes, it allowed middle-class Parisians to see their lives reflected and affirmed, a vision of progress and plenty that validated their comfortable, complacent existence. In many ways it was the culmination of 19th-century positivism, an extension of Courbet's realist project to bring art back down to earth, stripping it of Neoclassical claptrap and Romantic histrionics. This project, writ large, placed its faith in science and technological progress, fueled by the promise that a deeper understanding of the laws underpinning the physical world would yield better outcomes for mankind.

But Impressionism, like technology itself, contained the seeds of its own destruction. When these plein-air painters hauled their easels out into the bright sunlight, they discovered that reflection and refraction dissolved the apparently solid ground on which Courbet and his followers had taken their stand, demonstrating that the more precisely one parsed reality—taking into account the ever-shifting flow of momentary perceptions—the more that reality slipped through one's fingers.* Indeed, objectivity when carried to its logical extreme merely reinforced radical subjectivity, since how the world looked depended on who was doing the looking, and exactly when and where. Even Zola, chief exponent of the Naturalist cause, often succumbed to despair. "It was inevitable," his alter ego Sandoz mourns at the end of *L'Oeuvre*: "All our activity, our boastfulness about our knowledge was bound to lead us back again to doubt. The present century has cast so much

* There's an obvious parallel with contemporary developments in physics. The more precisely one measures apparently solid matter, the more insubstantial it appears.

light on so many things, but it was bound to end under the threat of another wave of darkness."[2]

If the artistic rebels who for more than a decade had taken on the forces of reaction now turned on each other, what hope was there for progress in other areas? The art historian André Michel captured the prevailing mood, writing in the year before Van Gogh arrived in Paris: "The present hour is obscure and troubled. . . . How can one prevent oneself from having serious misgivings in front of the disarray in our contemporary artistic standards and aesthetics, where every system is at the same time attacked and defended."[3]

Viewed from ground level—in the cafés and ateliers of Paris in 1886—the quarrels seemed somewhat less high-minded, more a clash of egos than of principle. The Impressionists themselves had not shown together as a group for four years, and it was even longer since they'd presented a unified front to the world. Much of the blame went to the prickly Edgar Degas, who insisted on dictating conditions to his colleagues and, worse, promoting his own gaggle of disciples at the expense of the old guard. "On Degas's side . . . the tendency has been getting worse and worse," Paul Gauguin complained to his mentor Pissarro: "each year another impressionist has left and been replaced by nullities and pupils of the École [des Beaux-Arts]. Two more years and you will be left alone in the midst of these schemers of the worst kind. . . . Despite all my goodwill I cannot continue to serve as buffoon for M. Raffaëlli and company."[4]*

* Perhaps his most unpopular rule was that those wishing to show with the Impressionists could not also submit their work to the annual Salon, a particularly onerous requirement for artists like Monet and Renoir who hoped to join the ranks of those more respectable (and highly compensated) artists. Jean-François Raffaëlli specialized in sentimental pictures of the urban proletariat. Some considered him the urban Millet; both van Gogh brothers were fans.

Among those put off by Degas's high-handed ways was Claude
Monet, considered by many the heart and soul of the movement.
He'd sat out the fifth and sixth exhibitions (in 1880 and 1881) and
threatened to boycott the seventh the following year. "Now for this
exhibition," he wrote to Paul Durand-Ruel, "I must tell you that
my ideas on the subject are very definite. At the point where we are
now, an exhibition must either be extremely well done or not take
place at all, and it is totally necessary that we be *among ourselves*,
that no stain be allowed to compromise our success. Is it possible to
hold such an exhibition this year? I know that it is not possible
since certain persons are already involved; thus to my great regret,
I absolutely refuse to take part under these conditions."[5] Renoir,
his old comrade in arms, also balked, though his objections rested
on somewhat different grounds. Less concerned with projecting an
aesthetically unified front, he worried that, just as the group was
beginning to find acceptance, a minority of troublemakers threat-
ened to bring them all into disrepute: "To exhibit with Pissarro,
Gauguin, and Guillaumin would be like showing my work with
some socialistic group. . . . The public doesn't like what smells of
revolution, and I have no wish, at my age, to be a revolutionary."
He ended this screed with an antisemitic jab: "To remain with the
Jew Pissarro, that would be the revolution."[6]

Back in 1882, Monet and Renoir had succeeded in banishing Degas
and his acolytes. The Seventh Impressionist Exhibition of that year
ended up as the most purely "Impressionist" of all, built around a core
of plein-air painters sharing a common approach and subject matter.
But now, four years later, the tables were turned: once again Degas had
seized control and both Monet and Renoir were out.

The Eighth (and what would prove to be the last) Impressionist
exhibition did finally open on May 15, but just barely and only after

months of bitter clashes. Held in cramped rooms above the popular restaurant La Maison Dorée, the show took place in an atmosphere of bruised feelings and mutual recrimination. Even Berthe Morisot, who'd done more than anyone to salvage something from the wreckage, grumbled at "Degas's perversity"[7] and dubbed the whole enterprise "a complete fiasco."[8]

The fracturing of the Impressionist movement involved more than what Morisot termed "conflicts of vanity,"[9] which were often a proxy for more fundamental disagreements. Real issues were at stake, both material and aesthetic. On the one hand, Impressionism had grown more focused, evolving from a loose association of artists banding together for mutual support to an aesthetically coherent movement centered around plein-air painting and the depiction of scenes from contemporary life. A recognizable Impressionist technique had evolved as well, featuring speedy execution ("sloppy" in the eyes of their critics) and visible brushstrokes well suited to rendering momentary configurations and the shifting play of light and shadow. But just as the movement was claiming its artistic identity, the inclusion of more academic or figure-based painters (among them Degas himself) threatened to dilute their message. As Monet grumbled, "our little temple has become a dull schoolroom whose doors are open to any dauber."[10]

Economic factors played a role as well. Even modest success, unevenly distributed, undermined the group ethic. As early as 1883, Durand-Ruel launched one-man shows of Monet, Renoir, Pissarro, and Sisley, which violated the group's collective spirit but which, he insisted, "attracted public attention and helped to change many people's minds about them."[11] And if prices remained depressingly low in Paris itself, the dealer's American venture, launched in March 1886, opened up a lucrative market for his vast stock of Impressionist paintings, promising

better days ahead for the more prominent names but also opening up a gulf between the haves and the have-nots.

Still, much had been achieved in the twelve years since the first Impressionist exhibition. The painters, though still largely denied honors in the Salon itself, had rendered those traditional markers of success obsolete, demonstrating that it was possible to have a successful career without adhering to the academic formula. Monet and Renoir had even returned to the official Salon, a sign that they were no longer regarded, and no longer regarded themselves, as subversives. And, in a phenomenon noted by Zola in *L'Oeuvre*, the plein-air painters were shaping practice within the Salon, where many prospered by deploying what was called the *juste-milieu* (the happy medium), a compromise between the precision of the traditional academic style and the more open brushwork of Impressionism.*

At the same time, Durand-Ruel had been joined by a handful of other gallerists in cultivating a buying public and, equally important, a sympathetic press. The steady encroachment of the commercial market undermined the authority of the official gatekeepers, and while many collectors continued to rely on the imprimatur of the Salon jury, others preferred to demonstrate their independence of mind by investing in the new art.

By the mid-1880s the more established Impressionists were less interested in stirring the pot than in securing what they'd won. No longer *enfants terribles*, most were approaching middle age. They were responsible for wives (or mistresses), along with assorted children, legitimate and not.** Monet, nearing fifty, was living with his longtime mistress,

* Among the practitioners of the juste-milieu was Fernand Cormon, teacher of
 both Toulouse-Lautrec and (shortly) Van Gogh himself.
** The major female Impressionists, Berthe Morisot and Mary Cassatt, were women
 of independent means, which allowed them the freedom to make it in what was
 still a man's world. Morisot was married to Édouard Manet's younger brother
 Eugène and had a daughter, Julie.

Alice Hoschedé, and supporting her six children, as well as two of his own from a previous marriage. When it came to marketing his work, loyalty counted for less than ensuring he could meet his domestic obligations. In 1885 he broke with Paul Durand-Ruel, convinced his old dealer wasn't doing enough to promote him. Instead, he signed on with the more upscale Georges Petit, whose opulent gallery on the Rue de Sèze was frequented by such luminaries of French society as the Comtesse de Greffulhe and Robert de Montesquiou, model for the Baron de Charlus in Marcel Proust's *À la Recherche du Temps Perdu*. The defection of major Impressionists to a gallery described by Émile Zola as "the department store of painting"[12] reflected their growing commercial appeal. Soon, the even more established Boussod & Valadon would move into this market, with their young *gérant* Theo van Gogh leading the way.

Despite these signs of progress, many Impressionists continued to struggle financially. Camille Pissarro—one of the original gang and the only artist to show in all eight group exhibitions—railed against the market and society at large. A Jew and a confirmed anarchist, he could never hope (nor did he have any desire) to join the ranks of polite society. But his intransigence came with a cost. He was forced to beg and borrow to feed his family and was only able to participate in the 1886 exhibition when Berthe Morisot and her husband Eugène Manet agreed to defray his expenses. The following year, faced with what he called "complete disaster,"[13] he too abandoned his old friend Durand-Ruel in favor of the security Boussod's offered.

Pissarro's struggles were not unique; in fact they were more the rule than the exception. The once-booming market in contemporary art had gone bust, victim of a worldwide recession that began in 1882 following the collapse of the Union Générale des Banques. Four years on and

prices were still depressed, particularly for luxury goods like paintings. (The prospects for sculptors were even worse.) "Times are bad, that is certain,"[14] Morisot observed in 1884. Two years later Pissarro grumbled: "Things must be very bad . . . Everything is at a standstill."[15]

The economic slowdown contributed to a widespread belief that society was fundamentally broken. Lack of opportunity contributed to the growth of political radicalism: on the left not only socialism but anarchism (soon to erupt into violent terrorism); on the right, a rise in Gallic nationalism.* Many artists were attracted to radical causes, seeing in their own predicament a sign of deeper rot.** Paul Signac, like many of his colleagues, believed art could transform the world for the better. "Justice in sociology," he wrote in 1891, "harmony in art: the same thing."[16] As their own livelihoods were threatened by retrenchment, they questioned the basic tenets of their craft and sought new modes for putting their work before the public.

Even the unworldly Van Gogh took note of the adverse conditions, writing from Antwerp: "The longer I'm in town the more I become convinced that the business crisis is not at an end, that the trade in paintings, above all, is being terribly threatened and has already been affected."[17] Typically, he saw the economic catastrophe largely in terms of what it meant to him personally, using the dire

* A wave of anarchist terror began in 1886 with an attack in the stock exchange by a radical who threw acid at the traders and fired shots from a revolver. The most famous anarchist outrage was the 1894 Café Terminus bombing by Émile Henry, which targeted ordinary citizens rather than government officials. On the right, discontent led to the rise of the nationalist General Ernest Boulanger, who in 1889 almost managed to topple the Third Republic and replace it with a military dictatorship.

** Camille Pissarro, for instance, identified as an anarchist, as did the critic Félix Fénéon. Edgar Degas was one of the few artists espousing right-wing causes.

situation in what he called "the big houses" like Boussod's to pro-
mote his pet project of launching a joint venture with his brother.
The current slowdown, he insisted, meant Theo could no longer count
on his employers: "I'm not misstating the case when I dare assert that
your own situation is also more or less critical—critical enough,
at any rate, to make it advisable to seek *renewal*." Specifically, his
plan involved "setting up a studio in Paris" while Theo established
himself as an independent dealer, handling Vincent's painting
(something he could never do at Boussod's) along with the work
of other deserving artists. Since Vincent still required a year of
study with a reputable master, that gave Theo plenty of time to
figure things out. "During that period," Vincent admonished, "you
take another really good look at the business, and the opportuni-
ties. And then—I believe—we can chance it."[18] Of course this
was just another of Vincent's pipe dreams, unrealistic obsession
masquerading as rational analysis. Theo often contemplated setting
up on his own, but he knew better than to plan around his erratic
brother. As always, Vincent deployed plausible rationales to arrive
at implausible solutions.

Far-fetched as this scheme was, it offers an important insight into
Van Gogh's psychology. Despite Albert Aurier's claim that he was an
isolé, Van Gogh was in fact an instinctive, almost fanatical, joiner. His
answer to every problem in the world was collaboration; his deepest
desire was to participate in something larger than himself, to be linked
to his fellow strivers in some great cause. Disaster always brought out
the best in him. Someone else's tragedy interrupted the self-destructive
cycle, allowing him a way back into the lives of others from which in
better times he felt excluded. He was attracted to broken souls and
impoverished lives, the sight of their suffering prompting fantasies of
rescue and redemption.

Even the death of a stranger could forge the emotional connections he craved.* In 1877, while in Amsterdam studying for the ministry, he witnessed the drowning of a young boy. That night he visited the grieving family, seduced by the touching scene he recorded for his brother:

> In the evening I went back to see the people, it was then already dark in the house, the little body lay so still on a bed in a side room, he was such a sweet little boy. There was great sorrow, that child was the light of that house, as it were, and that light had now been put out. Even though coarse people express their grief in a coarse way and without dignity, as the mother did, among others, still, one feels a great deal in such a house of mourning, and the impression stayed with me the whole evening when I took a walk."[19]

A pool of light in the darkness, the guttering flame in the untended hearth: these images haunted him, a chiaroscuro that revealed both his loneliness and his desperate need for communion.

The same dynamic played out within his family. In 1884, when his mother broke her hip, Vincent was instantly transformed into the doting son. Nursing her back to health temporarily repaired the breach that had opened up with his parents. The year before, while painting in Drenthe, he had seized on Theo's difficulties at work to propose a

* One of his earliest drawings was prompted by one such tragedy: "My dear Theo, I'm sending you herewith a small drawing. I made it last Sunday, the morning a daughter (13 years old) of my landlady died. It's a view of Streatham Common, a large, grass-covered area with oak trees and broom. It had rained in the night, and the ground was soggy here and there and the young spring grass fresh and green." [Letter 32, April 1875] The following year he hiked six hours to be with the grieving family of Harry Gladwell, whose sister had died suddenly.

partnership on the heath. All his torments disappeared in moments of crisis as the outer world seemed suddenly to line up with the inner, providing at least the illusion of shared emotional space.

The latest economic crisis was ripe with possibility as he latched onto the larger catastrophe to conjure improbable partnerships and communal arrangements. The status quo, he argued, is untenable. "If one analyzes from close up," he wrote, "one sees that the greatest and most energetic people of the century have always worked *against the grain*, and with them working was always through personal initiative."[20] Working against the grain did not mean going it alone. Far from it. Given the collapse of the market, it was incumbent upon the pro-ducers (i.e., the artists themselves) to take control of their own destiny: "Painters increasingly prefer personal initiative and are circumventing the dealers and managing their own affairs—and even doing harm to the big houses where they can."[21] He would return to this notion time and again over the course of the next two years, culminating in his effort, launched during his final months in Paris, to organize his colleagues in the avant-garde into a self-supporting artists' cooperative. Arranging group exhibitions and proposing various joint business ventures, he hoped to realize his dream of a community in which, freed from the burden of having to grub for a living, all worked selflessly toward a common goal. For Van Gogh the answer to every problem was pulling together—a degree of solidarity that, much to his disappointment, the Parisian avant-garde rarely achieved.

In the meantime, Vincent continued to pursue his artistic education. He visited the Impressionist exhibition at the Maison Dorée—probably more than once. No doubt he also stopped by the Georges Petit Gallery, where he would have seen the works of Monet, Renoir, and other Impressionists at the rather pompously titled *Expositions Internationales*.

He was aware of their internal squabbles, but *"not* being one of the club,"[22] as he explained to his friend Livens, these meant little to him. The fact that in his letters from Paris he mentions only two works by major Impressionists—a Monet landscape and a Degas nude, both of which he admired—shows that he'd not yet chosen sides.*

He later admitted how much trouble he had coming to grips with this unfamiliar mode of painting. He'd come to Paris skeptical of Impressionism and was still underwhelmed. In the summer of 1888, long after he'd assimilated their lessons and even moved beyond them, Vincent recalled his initial reaction. "[P]eople have heard of the Impressionists, they have great expectations of them," he wrote to his sister Wil, "and when they see them for the first time they're bitterly, bitterly disappointed and find them careless, ugly, badly painted, badly drawn, bad in colour, everything that's miserable. That was my first impression, too, when I came to Paris with the ideas of Mauve and Israels and other clever painters. And when there's an exhibition in Paris of Impressionists alone, I believe a host of visitors come back from it bitterly disappointed and even indignant."[23]

Crucially, however, he persevered. Expediency, if nothing else, demanded he change with the times. If he wanted to make himself into a modern painter and, critically, if he wished to keep Theo on his side, he needed to remake his art in light of current practice. But for all the strides he made, the evidence suggests he was never entirely reconciled to the Impressionist cause. We can see him absorbing the lessons of the new school in paintings made *en plein air* as well as in the controlled environment of his studio. (Van Gogh's studies of plaster casts may reflect his admiration for Degas's pastel nudes, since

* By contrast, when he visited the official Salon in May, he found twenty-one works worthy of note, diligently recording them in his sketch pad.

the way he uses the marks of the brush to delineate form resembles Degas's technique of using parallel marks of the chalk to "sculpt" the masses of the female form.) But even as he assimilated Impressionist techniques and an Impressionist palette, it's clear that he was never entirely at home in their world.* "What I think about my own work," he wrote to his sister from Paris, "is that the painting of the peasants eating potatoes that I did in Nuenen is after all the best thing I did."[24] This tension between the artist he felt he was and the artist he thought he ought to be played out in the first half of 1886, leading to work that was tentative, experimental, and, as his subsequent creative breakthrough will reveal, transitional.

The truth is that Van Gogh was not an instinctive Impressionist. No matter how hard he tried, he could never be a painter of light, conjuring shimmering veils and capturing fleeting moments. Nor would he succeed in remaking himself into an urban flaneur, recording the passing scene in all its glorious variety. Whether he was fully aware of it himself, he was after something else, something eternal, subjects that went straight to the heart, like his portraits of the redeemed prostitute Sien Hoornik, a Mary Magdalene who existed only in his imagination, or the humble de Groot family, whose simple meal is treated with the reverence of holy sacrament. Tackling Impressionism proved to be a liberating experience. It helped him break the shackles that bound him to the art of the past, but it could never lead him to the Promised Land.

———————

* Determining Van Gogh's attitude toward Impressionism is complicated by the fact that he used the term rather loosely: sometimes to describe the work of Monet, Renoir, Degas, et al.; at other times as synonymous with the progressive movement in art, a movement in which he was an enthusiastic participant.

Fortunately, alternatives were beginning to emerge on the scene, new directions that would offer a more fruitful direction in Van Gogh's development. For a time, Monticelli's expressive intensity, as well as his old-fashioned tenebrism, offered an alternative to what seemed the bland superficialities of Impressionism. But the Provençal artist had removed himself from the scene. His premature death would turn him into a legendary martyr, but not an effective prophet of the new age. Still, the following he inspired among certain Parisian artists points to a larger discontent with what Gauguin would soon call "the low-vaulted ceiling"[25] of Impressionism. There was a hunger for something deeper, an inchoate longing for something that would probe beneath the surface of life and touch the mystic chords of our shared humanity.

Some of that soul searching took place within the Impressionist movement itself. The clashes among the leading practitioners reflected a general sense of frustration, of promises unfulfilled. The movement had run its course and something more was needed, though there was no agreement as to what that might be. Zola, an early booster of both Manet and the Impressionists, did not conceal his disappointment. In *Le Naturalisme au Salon* he wrote:

> The great misfortune is that not one artist of this group has achieved a powerful and definitive realization of the formula which they all employ fragmentarily in their works. . . . They are all forerunners, the man of genius is not yet born. It is easy to see what they are aiming at, you agree right is on their side; but you look in vain for the masterpiece which will carry the day and command universal respect. That is why the struggle of the Impressionists is not yet over; they

are not yet up to the task they have set themselves, they stammer and cannot find the right word.[26]

Monet was appalled when Zola's *L'Oeuvre* appeared, but changes in his own work show that he knew he'd reached the limits of his previous approach and required new sources of stimulation. Sometimes he traveled far afield in search of inspiration, to the Mediterranean or Atlantic coasts, to Venice; or he retreated to his house at Giverny, where he developed a language that was both increasingly precise and increasingly subjective. In the magnificent series from late in his career—poplars, haystacks, cathedrals, and finally the inexhaustible visual riches of his own garden—the subject is no longer the familiar landscape of rural France but time itself, the drama of Creation making and remaking itself in each instant of perception.

Renoir and Pissarro were also in the grips of midlife crises, doubting their talent and seeking ways to reinvigorate their art, the former by attaching himself to the classical tradition of Raphael and Ingres, while the latter sought to freshen his painting by latching onto a younger generation to revitalize a craft that had begun to seem stale. The sense of inadequacy and exhaustion was pervasive. Gauguin, a former stockbroker who'd learned to paint under the tutelage of the generous Camille Pissarro and who'd exhibited at every Impressionist group exhibition since 1879, was among those restless souls. His search for something deeper would ultimately take him far from Paris: to rustic Brittany, then on to the Caribbean, and finally to the South Seas, where he would fulfill his genius even as he confronted poverty, disease and, ultimately, death.

But it wasn't necessary to travel thousands of miles to shake things up. In fact the artist who, more than any other, signaled the dawn of the new artistic age deliberately chose the most mundane, near-at-hand

subject imaginable—a scene of Parisians relaxing on a Sunday after-noon in one of the popular watering holes along the Seine that had long been a staple of Impressionist repertoire. Even more provocatively, he launched his revolution at the very same exhibition at the Maison Dorée where the Impressionists were making one last bid for relevance.

Georges Seurat

Georges Seurat was a former student at the École des Beaux-Arts who'd studied under a pupil of the arch-classicist Ingres before falling under the spell of, first, Delacroix and then the Impressionists. At twenty-six, he was a full generation younger than the founders of the movement, and while he shared their ambition to investigate (and

then to reproduce) how light was actually processed in the eye, he was unhappy with what he considered their ad hoc, unscientific approach. Like many in his generation, he took Impressionism as his starting point only to leap beyond, regarding it as an important innovation that had outlived its usefulness. As his most ardent proselytizer, Paul Signac, put it: "Our formula is certain, demonstrable, our paintings are logical and no longer done haphazardly."[27] Their inclusion in the Eighth Impressionist Exhibition—at the invitation of Pissarro, who'd been captivated by these novel methods—was bitterly resented by the older generation and one of the factors leading to the movement's final collapse.

While critics dismissed the work of the Impressionists as "sloppy" and "unrigorous," Seurat was among the most methodical artists in history, a painter who fervently believed that masterpieces could (and must!) be built on unswerving principles and according to objectively verifiable rules. Reserved, even secretive, his quiet certainty gave him a magnetism that drew others to him. The poet and critic Gustave Kahn described him at a gathering: "He was silent in larger groups of people; with a few proven friends he spoke freely of his art, about his aims, about technical volitions. The emotion which penetrated him then was hinted at by a light redness along his jaws; he spoke very literarily and breathlessly."[28]

Like Van Gogh and his older Impressionist colleagues, Seurat incorporated the latest discoveries in optics and color theory into his art. But he was far more systematic, seeing them not as merely aids in transcribing what he saw onto canvas but as the very heart of his artistic enterprise. He studied not only the writings of Charles Blanc (Van Gogh's favorite) but also Michel Chevreul, and the American Ogden Rood, searching for those principles that would remove art from the realm of the subjective and place it on a par with scientific

truth.* He was particularly taken with Chevreul's "law of simultaneous contrast of colors," which explained how, in natural daylight, adjacent hues interact with one another, inflecting their neighbors with complementary contrasts. As set down by Seurat's follower Lucien Pissarro (Camille's son): "According to the law of contrast a color achieves its maximum intensity when brought close to its complementary. But while two complementaries enhance each other through juxtaposition, they destroy each other when mixed."[29]

Seurat used these principles as the basis for a new kind of painting he called *chromoluminism*. The public quickly attached other labels to the nascent movement, as if its radical nature could not be captured in a single term: Divisionism, Pointillism, or the more generic Neo-Impressionism. By whatever name, it involved the application of tiny dots of pure color, a painstaking process that eliminated any element of spontaneity. The intuitive, impromptu look of Impressionism congealed in canvases characterized by chilly precision. Rather than mixing pigments on the palette—the "broken colors" Van Gogh derived from Charles Blanc—the artist achieved varied tones by placing dots of prismatic color side by side in precisely calibrated ratios so that they mixed in the eye of the viewer. According to theory, at least, this generated a far more vibrant, more "real" experience of light than traditional methods. The movement's most eloquent spokesman, journalist Félix Fénéon, describes the experience of standing before Seurat's monumental *A Sunday Afternoon on the Island of la Grande Jatte*:

> If, in the *Grande-Jatte* of M. Seurat, one considers, for example, a few square centimeters of apparently uniform

* Ogden Rood's *Modern Chromatics* was published in America in 1879. It was translated into French in 1881, under the title *Théorie scientifique des couleurs*, and soon became a handbook of the Divisionist painters.

tone, one will discover that it is made up of a swirl of tiny dots, which together constitute that tone. That shaded lawn: the spots, for the most part, provide the local color of the grass; others, tinted orange, are scattered about, capture the barely perceptible effect of the sunlight; additional purple strokes are complementary to the green; strokes of cyan blue, generated by the proximity of the grass to the sunlight, gather toward the line of demarcation and become progressively rarefied.[30]

Thus, in theory at least, all the colors perceived in nature could be expressed through the precise juxtaposition of primary and secondary hues. For a man of Seurat's disciplined cast of mind, however, it wasn't enough to determine the colors he deployed according to irrefutable laws; every aspect of the composition should be subject to the same rigorous treatment. "If, with the experience of art," he wrote, "I have been able to find scientifically the law of pictorial color, can I not discover an equally logical, scientific, and pictorial system to compose harmoniously the lines of a picture just as I can compose its colors?"[31]

He found what he was seeking in the work of Charles Henry, a professor at the Sorbonne, who believed mathematical laws were key to the artist's craft. Henry propounded his *esthetique scientifique* in a series of lectures at the university in 1885 well attended by members of the avant-garde. In works like *Théorie des directions* (*Theory of Lines*) and *Introduction a une esthetique scientifique* (*Introduction to a Scientific Aesthetic*), Henry tried to place not only the visual but the psychological experience of an artwork on a sound scientific basis. Lines slanting up or down, he claimed, can induce positive or negative responses, while certain colors (pink and yellow) encourage positive feelings and green, blue, and violet the opposite. Seurat put these theories into practice in

two demonstration pieces: *Parade de Cirque* (1888), with cool, muted colors and dominant horizontals, and *The Circus* (1891), with its warm oranges and reds and insistently upward sweeping lines.* So seductive were these ideas, and so universal the desire to remove the chance element of creativity, that even Gauguin, an artist who otherwise demonstrated little sympathy for rationalism, succumbed. "There are lines that are noble, deceitful, etc.," he wrote to his friend Schuffenecker: "the straight line renders infinity, the curve limits creation. . . . There are noble tones, others that are common, harmonies that are quiet, consoling, others that excite by their boldness."[32]

Seurat, *The Circus*, 1890–1

* Seurat died tragically in 1891 at the age of thirty-one, leaving the latter painting unfinished in his studio.

While revolutionary in one sense, this approach was also an updated version of the Academic formula that presumed masterpieces could be cranked out by the correct application of objective rules. In this latest iteration those laws derived from science rather than ancient models, but the impulse was similar: to rescue art from emotion and instinct and place it on a firmer foundation. As Henry set forth in a series of articles titled "Phenomena of Vision" (1880): "one must look at nature with the eyes of the mind and not merely with the eyes of the body. . . . Despite their absolute character, rules do not hamper the spontaneity of invention or execution. Science delivers from every form of uncertainty."[33] How this would have appalled a Romantic painter like Delacroix, or his later Expressionist heirs! What room was there in this cold philosophy for dreams and visions, for plumbing the unlit regions of the soul? Of course this pendulum swing was nothing new, only the latest episode in the eternal battle between heart and mind that fuels creative innovation.

The work Seurat presented as the "manifesto" of his new method was the monumental *A Sunday Afternoon on the Island of la Grande Jatte.* [see color plate 19] When it first went on display at the Eighth Impressionist Exhibition, it provoked the kind of nervous laughter that once greeted Manet's *Déjeuner sur L'Herbe.* Even those who'd embraced the Impressionists had difficulty assimilating this radical approach, one that seemed to adopt some of their technical innovations (and subject matter) only to repudiate their spirit. After visiting the Maison Dorée, the Paris correspondent for the avant-garde Belgian periodical *L'Art Moderne* singled out "that odd fellow because of whom, in this exhibition of intransigents the intransigents themselves battle each other, some praising him beyond measure, others criticizing him pitilessly. This Messiah of a new art, or this cold-blooded mystifier, is Monsieur Georges Seurat."[34]

The correspondent also noted the confusion stirred up by this controversial work: "Judging him only on the immense canvas which he calls *A Sunday Afternoon on La Grande Jatte* . . . one might not take him seriously. The figures are wooden, the composition has a geometrical aspect."[35] But, in the end, he gives the artist his due: "A hoax? We do not think so. A few landscapes painted by the same technique . . . reveal an artistic nature singularly gifted at isolating the elements of phenomena in order to express in them, by a simple but brilliant combination of means, the most complicated and intense effects. We accept M. Georges Seurat as a sincere, observant painter who the future will classify."[36]

One of the defects of the new approach, which critics were quick to point out, was that it tended to produce nearly identical canvases, robbing artists of their individuality. For some, like Camille Pissarro, this was a positive advantage. Introduced to Seurat through his son Lucien, he found renewal in the young man's certainty. He quickly abandoned the haphazard brushwork of his earlier style for the Pointillist dot, creating landscapes according to formulas that released him from his own doubts.

Seurat's revolution was not merely one of technique. In almost every way it represented a repudiation of the movement from which it sprang. The art of Seurat and his followers was not, as Camille Pissarro seemed to believe, merely an extension of Impressionism. In the process of pushing their optical investigations to the logical extreme, they conjured something completely new. Fénéon clarified their divergent aims in an article for *L'Art Moderne* from May 1887: "The spectacle of the sky, of water, of greenery varies from instant to instant, according to the original Impressionists. To seize one of these fugitive appearances on the canvas was their goal. Thus the necessity arose of capturing a landscape in a single sitting, and a propensity for making nature

grimace to prove that the moment was indeed unique and would never be seen again." By contrast, Seurat and his Neoimpressionist colleagues "synthesize the landscape in a definitive aspect which perpetuates the sensation. . . . In their scenes with figures, there is the same aversion to the accidental and transitory. . . . To them objective reality is simply a theme for the creation of a superior, sublimated reality in which their personality is transformed."[37]

This "superior, sublimated reality" was far removed from the workaday world the Impressionist artist inhabited; it involved an escape into the realm of artifice that the previous generation had so vehemently rejected. Seurat and his followers were so clearly out of step with their older colleagues, and so in sync with each other, that at the Maison Dorée they were confined to a separate room. Each group staked out its own territory, neither seeing any profit in engaging in dialogue. Seurat's vast "manifestation" had turned everything on its head, consigning the once edgy works of Monet, Renoir, Degas, and co. to history as he boldly staked his claim to the future.

A month after its debut at the Eighth Impressionist Exhibition, *A Sunday Afternoon on the Island of La Grande Jatte* went on display at the newly founded Salon des Indépendants, where it continued to be the focus of lively debate.* So great was its disruptive power that when it was shown the following year in Brussels, at the avant-garde exhibition organized by *Les Vingt* (the XX), the event was hailed by supporters as *L'année de la Grande Jatte* and condemned by conservative politicians who rose up to denounce this threat to national order.

* The first Salon des Indépendants was held in December of 1884 at the Pavillon de la Ville de Paris in the Champs-Élysées, with 138 participants, including both Seurat and Signac. Conceived as a counterweight to the increasingly reactionary official version, the Indépendants had no jury and was therefore open to any artist. For many innovative artists this was a godsend, while others preferred not to exhibit side by side with amateurs and incompetents.

In retrospect, it's clear that Seurat's monumental canvas marked a cultural watershed, one of those rare works—like David's *Oath of the Horatii* or Manet's *Déjeuner Sur L'Herbe*—that signals the end of one age and the beginning of another. For some it heralded a brave new world in which art finally took its rightful place alongside science: incontrovertible, self-evident, *true*. Others attacked it for the very same reasons, complaining that Seurat and his acolytes ignored the qualities that allowed art to express the deepest longing of the human soul. Many more were simply baffled, unsure what to make of an art that looked so different from everything that preceded it, that defied the orthodoxies of both the Academy and the avant-garde. The most difficult position to maintain, at least for anyone claiming to care about the fate of contemporary culture, was one of indifference.

Like any messiah worth his salt, Seurat gathered around him a gaggle of eager disciples. His message was compelling and the formula (at least in theory) straightforward. Anyone with sufficient discipline, patience, and skill could fashion a respectable Pointillist landscape. The Pissarros, father and son, were early converts, along with the precocious Paul Signac and a host of minor followers who preached the gospel with varying degrees of conviction. Even those who didn't necessarily consider themselves adherents of the new creed discussed their ideas, in cafés, in independent studios, even in the École des Beaux-Arts itself.

A typical incident occurred in the studio of Fernand Cormon, where a headstrong eighteen-year-old named Émile Bernard managed to throw the classroom into disarray by proclaiming the gospel of true color. (His most provocative act was to replace the neutral drop cloth that normally served as background for the nude model with one featuring stripes of vivid color.) Cormon expelled his disruptive pupil, but

not before the infection had spread. By the time of his forced departure, Bernard's prank had stirred up his classmates to such an extent that the master, feeling he was losing control, was forced temporarily to close the studio.

Leaving nothing to chance, Seurat offered clear guidance as to how his work should be understood. "They see poetry in what I have done," he said. "No, I apply my method and that is all there is to it."[38] Pissarro also toed the party line, referring patronizingly to Monet and Renoir as "romantics," comparing them unfavorably to the young "scientific impressionists."[39]

Still, and much to Seurat's chagrin, more imaginative souls claimed to find poetry in the results. And indeed, his scenes are so carefully composed, so attentive to the abstract quality of line, the careful orchestration of hue against hue, that they call to mind the most refined Alexandrine verse or frozen music. Seurat inadvertently invited such poetic associations, seeking, as Gustave Kahn explains, "to compare the progress of his art with those of the sonic arts, very preoccupied with finding a fundamental unity in his efforts and those of poets and musicians."[40] Painstakingly distilled from reality, his paintings have a preternatural sense of calm, evoking a dreamlike revery that seems infinitely far removed from our daily lives.* Even Félix Fénéon, the young critic who was among the first to champion the new school and to explain its technical underpinnings, described Seurat's paintings as "hieratic," comparing the artist to a "modernizing Puvis [de Chavannes]."[41]

* Perhaps the closest analogy would be the art of the great Renaissance master Piero della Francesca, whose rigorous pursuit of a scientific basis for his art also led to images of dreamlike perfection.

At first glance, the comparison to Puvis de Chavannes (1824–1898) seems far-fetched. While Seurat rooted his paintings firmly in the here and now, depicting contemporary Parisians out for a Sunday stroll or factories along the Seine, Puvis preferred to set his in a never-never land populated with nymphs cavorting around classical temples. Seurat considered himself a clinical observer of optical phenomena; Puvis was unabashedly sentimental. Seurat turned his back on academic formulas, while Puvis remained firmly within that tradition.

Puvis de Chavannes, *Sacred Grove*, c. 1884

But for all these differences, their art converged in surprising ways. Both rejected the spontaneity of Impressionism, fashioning compositions as harmoniously arranged as a landscape by Nicolas Poussin by synthesizing numerous studies and preparatory drawings. In many ways the spirit of the Academy has returned through the back door. Realism gives way to idealism; order is imposed on chaos.

Despite all the props and costumes that wouldn't have felt out of place in a historical canvas by David, Puvis managed to attract many followers in the younger generation. Gauguin was an ardent admirer.

His monumental *Where Do We Come From? What Are We? Where Are We Going?* is basically a remake of Puvis's *Sacred Grove* with an exotic South Seas twist.

Van Gogh was an admirer as well. He was deeply moved by the retrospective of the artist's work at Durand-Ruel's gallery in November 1887 and often described the paintings he'd seen there in glowing terms. After abandoning urban Paris for rustic Arles, he rhapsodized whenever he came across a motif that reminded him of the master's work. Even in Auvers, where he spent the last months of his life, the suburban landscape reminded him of the master. "There's a lot of well-being in the air," he wrote hopefully to his sister-in-law. "I see or think I see a calm there à la Puvis de Chavannes, no factories, but beautiful greenery in abundance and in good order."[42]

Above all, both painters sought an underlying order, believing that art should be elevated above everyday life rather than share in its messy contingency. There's an artifice to *La Grande Jatte*—which Fénéon calls hieratic—that transforms a casual outing into a sacred ritual, as if these figures had stepped out of an ancient frieze to take their leisure on the banks of the Seine. Seurat's bourgeois and working-class Parisians are arranged as carefully, as unnaturally, as Puvis's gods and goddesses. Even those myriad dots in which the Pointillists claimed they had distilled the warmth of natural light manage, through their mind-numbing discipline, to freeze everything in place. Unlike the typical Impressionist, completing a painting at breakneck speed during a couple of outdoor sessions, racing against the movements of the sun, the Pointillist did most of his work in the studio, building the image piece by piece, dot by dot, logically, according to a preconceived plan. Everything was rigorously plotted; nothing was left to chance. There's no more atmosphere in a painting by Seurat or Signac than in a mural by Puvis. While Monet, Morisot, Sisley, and co. strived to capture

the evanescent moment, Seurat's tableaux are as far removed from the bustle of the modern city as one of Puvis's sacred groves.

The collapse of Impressionism as the leading vehicle of the avant-garde opened up possibilities that Van Gogh would be quick to seize. His arrival in Paris came during a moment of profound cultural change, one that happened to align with latent tendencies in his own work and that would ultimately catalyze his own transformation. If he started as a caterpillar and ended up a butterfly, no one was more surprised than he, since the artist he'd become was not something he could even imagine at the outset of his Parisian journey.

Like most of the artists who laid the foundations of the new art in the years to come, Van Gogh came to modernism through Impressionism. Seurat, Cézanne, Toulouse-Lautrec, and Gauguin, to name the most prominent, all did their apprenticeships before moving on, picking out threads from which they wove their own brilliantly original tapestries. Van Gogh went through a similar, if accelerated, process. He appreciated the vital role these experiences played in his development, while also admitting their limitations. In August of 1888, while discussing the development of another young artist, he recalled his own Parisian journey: "At the moment he's doing timid Impressionism, but very much by the rules, very exact. And I told him that it was the best thing he could do, although he would lose 2 years on it perhaps, delaying his originality, but after all, I told him, it's as necessary now to pass through Impressionism properly as it once was to go through a Paris studio."[43]

What Van Gogh didn't say, perhaps because he was too close to it to know himself, was what awaited this young artist on the other side.*

* The artist in question was Eugène Boch, a Belgian poet and painter. He was the subject of one of Van Gogh's most moving portraits.

Van Gogh would come to regard his apprenticeship in Impressionism as a rite of passage, a stop along the journey but not the destination. Even as he attempted to remake himself into a boulevardier, chronicler of urban manners and suburban vistas, the landscape was shifting beneath his feet. Van Gogh would shift along with it.

The truth is that Impressionism's contribution to modernism was as much structural as stylistic. Crucially, the decade-long struggle between La Société anonyme coopérative des artistes peintres, sculpteurs et graveurs and the official Salon had opened up new opportunities, new systems of distribution; it had altered the media landscape and transformed expectations of what art should be and whom it should address. Perhaps most importantly, it established the avant-garde as a permanent feature of the art world, operating outside official channels, bound by no rules, recognizing no overarching authority but its own internal logic.

This dynamic was given institutional form in the summer of 1884 with the founding of the Société des Artistes Indépendants. Intended to provide an alternative to both the official venue *and* the commercial galleries, it was, in effect, a permanent Salon des Refusés. With no jury, its annual exhibition was open to any artist willing to pay the semiannual membership fee of 1.25 francs, and a nominal exhibition charge. There were 402 artists in the inaugural exhibition, including George Seurat, whose monumental *Bathers at Asnières* foreshadowed the even more radical innovations of *A Sunday Afternoon on the Island of La Grande Jatte* two years later. Over time, the Independent Salon provided exposure for many talented artists unwelcome in the hallowed halls of the official venue—Seurat, Signac, Odilon Redon, and Van Gogh himself—along with countless mediocrities.* Crucially, it gave a formal

* Some artists, like Paul Gauguin, refused to show there, not wanting to be exhibited alongside amateurs and hacks.

structure to the dialectic of modern art in which the ongoing battle between the old and new guards stimulated creative innovation.

Henceforth modernism would be rebellious, pugnaciously forward-looking, victory going to those who pushed ahead, rather than to those who lagged behind. Like all revolutionaries, the Impressionists devoured their own, radicalism generating its own momentum and condemning the previous generation to obsolescence. Almost by accident, Van Gogh would get caught up in this generational battle. Forced to choose sides, he aligned himself with the radicals, among those he would memorably dub the artists of *le petit boulevard*. Here, on the far fringes of the Parisian art world, he discovered exactly the right constellation of characters, influences, and ideas to nourish his own unique talents.

The publication of Zola's *L'Oeuvre,* the last stand of the Impressionist old guard at the Maison Dorée, and Seurat's "manifesto" all signaled the arrival of a new cultural age; even the vogue for Puvis's escapist fantasies pointed to the future. "In painting as in literature a moment came . . . when we had enough and too much of realism," recalled the critic Téodor de Wyzewa. "We were struck by a thirst for dreams, for poetry . . . And it was then we attached ourselves to the poetic art of Puvis de Chavannes."[44]

If 1886 was a moment of crisis, it was also a moment of opportunity. Over the course of the next few years, Paris would prove to be, as it had in July 1789, the birthplace of revolution. This time the upheaval was not political but cultural, a profound rupture in modes of thought and expression that, while less violent, was equally disorienting to those who lived through it. Among poets and novelists, painters, and sculptors, the most sensitive were alive to new possibilities, certain the old ways were played out and that a new age was dawning for the human spirit.

The hunger for something new was not confined to the world of the visual arts. To those who'd come of age in the years since the traumatic suppression of the Paris Commune, neither the forces of revolution nor the forces of reaction felt like viable alternatives: the first were agents of chaos, the second the feeble heirs of a discredited regime. "A new generation, having come to manhood, wished to take its place in the sun," proclaimed the poet Ernest Raynaud:

> It met with the opinionated hostility of its elders. All the newspapers, all the reviews were systematically closed to it. This was due to a disparity of mood and an extraordinary incompatibility of ideas. One would have said that the disasters of 1870 had dug a deep division between fathers and sons. The French soul had become transformed. The frivolous generations of the Empire, smitten with bawdy humor and fol-de-rols, were succeeded by a generation that was serious, concentrated, and sad. . . . There was no possible compromise. The new-comers, too proud to buy the place which had been refused them with degradation and servility, too much in a hurry to take their place in a queue . . . resolved to march into battle with their own arms, created willy-nilly. They opened fire. Too bad for those facing them![45]

Many believed that art was the key to building a better world. "A day will come," wrote Félix Fénéon, "when art will be part of the life of ordinary men . . . when it does the artist won't look down at the worker from his celluloid collar: the two of them will be a single one. But to achieve this the Revolution must get up steam and we must build a completely anarchist civilization."[46]

Despite Raynaud's martial language and Fénéon's revolutionary fervor, the belligerence of the new generation was at once less political and more profound: a questioning not so much of basic institutions (which were too hopelessly corrupt to be worth bothering about) but of meaning itself. As in the days of the Romantic movement, when the horrors of war and revolution had caused a generation of artists and poets to turn inward, there was a sense that any revolution worthy of the name would involve less a public reckoning than a turning inward, a renewal not of the body but of the spirit.

That September, the poet Jean Moréas came up with a new term to describe the new sensibility: *Symbolism.* In an article for *Le Figaro* titled "Literature: Manifesto of Symbolism," he declared that the goal of these aesthetic innovators was to "clothe the idea in sensible form."[47] Moréas and those he spoke for took their stand against realism, naturalism, or any other aesthetic movement that clung to the material world. Rather than build their works, like Zola, around a relentless accumulation of facts, Symbolists built theirs around subjective states. Some went so far as to claim that the world "out there" didn't exist at all, but was merely a projection of the psyche. It was the task of the poet or painter to bring that truer but less immediately apparent reality to life.*

Gustave Kahn fleshed out Moréas' conception in an article for *L'Evenement*: "The essential goal of our art is to objectify the subjective (the exteriorization of the Idea) instead of subjectifying the objective (nature seen through a temperament)."**[48] Impressionism's insistent focus on the mundane no longer sufficed: "For the subject matter of the

* There has been lively scholarly debate over the years as to whether Symbolism is a term that should be confined to literature or that can be applied to the visual arts as well. Though the term originated among Parisian writers and poets, its spirit pervades the work of painters, sculptors, and even composers during the last years of the 19th century.

** This is Zola's phrase.

works, weary of the quotidian, of the elbowing and necessity of the con-
temporary, we want to be able to place the development of the symbol
in any epoch or even in dreamland (*the dream being indistinguishable
from life*)."[49] When reality was so disappointing, the only alternative
was to live inside the mind. For the artist Odilon Redon, Symbolism was
about "putting the logic of the visible at the service of the invisible,"
adding, "nothing in art is done through the will alone, everything is
done by docile submission to the arrival of the unconscious."[50] Émile
Bernard, looking back on the movement to which he'd contributed in
his younger days, explained: Symbolism did not paint things, but 'the
idea of things.'"[51]

Unlike many fellow Symbolists, Kahn himself didn't reject modern
science. He insisted that radical subjectivity was entirely compatible
with the latest discoveries, allowing him to conscript not only the
Impressionists but Seurat and his fellow Divisionists to the Symbolist
cause: "This is a literary adherence to scientific theories constructed by
induction and controlled by the experiments of M. Charles Henry . . .
These theories are founded on the purely idealistic philosophical
principle that causes us to reject the utter reality of matter and only
admit the existence of the world of representation."[52] When fact gives
way to perception, as in an Impressionist painting, the boundary
between the objective and the subjective becomes porous.

And indeed, some rejected the notion that Symbolism was a repudia-
tion of Impressionism. The Symbolist writer Paul Adam, reviewing the
Maison Dorée exhibition, claimed the painters "pursue the subjectivity
of perception to its most abstract formulation, thereby objectifying it
as pure phenomenon."[53] Albert Aurier, the poet and critic who first
discovered Van Gogh's original genius, even found a spiritual dimen-
sion in the work of the arch-Impressionist Claude Monet, describing
him as "mystic heliotheist."[54] In this formulation, the Symbolist retreat

into subjectivity merely extended the Impressionist insight that we apprehend the world not by establishing solid facts but through insubstantial perceptions. Zola's formulation that "a work of art is a corner of creation seen through a temperament" has been stood on its head, or at least its polarities reversed, so that one's inner state, the distorting lens of the temperament, undermines any attempt to assert objective truth.

Still, Gustave Kahn's mission to establish a more rational basis for the new literature and art put him at odds with the majority of his Symbolist colleagues, who saw science and technology as enemies, antithetical to the spiritual renewal they were seeking. Albert Aurier crowed that the "omnipotence of scientific observation and deduction of the 19th century was at last proven puerile."[55] Among those he ultimately recruited to the antirationalist cause was the peculiar Dutchman whose recent psychotic breakdown merely proved his bona fides. "[Van Gogh] is almost always, a Symbolist," he insisted in his seminal 1890 article, "who feels the continual need to clothe his ideas in precise, ponderable, tangible forms, in intensely sensual and material exteriors."[56] In Aurier's formulation, Van Gogh's mental instability, his tenuous hold on reality, made him an instinctive Symbolist, "a dreamer, a fanatical believer, a devourer of beautiful Utopias, living on ideas and dreams."[57]

Zola, deploring the very same tendencies Aurier celebrated, agreed that the new art represented a flight from reality and rejection of science. It was a product, he insisted, of nothing more than childish disappointment. "We have been promised too much and led to expect too much, including the conquest and the explanation of everything," sighs his alter ego Sandoz. "We're resentful because, in a matter of a hundred years, science hasn't given us absolute certitude and perfect happiness."[58] For Zola and his fellow realists, Symbolism represented an unforgivable turning away from the world.

Perhaps the most painful defection, at least as far as Zola was con-
cerned, was that of his former disciple Joris-Karl Huysmans, whose
1884 novel *A Rebours* was a repudiation of everything his master
stood for.* Huysmans recalled with perverse pride the howls of out-
rage that followed its publication: "*A Rebours* fell like a meteorite on
to the literary fairground and there was utter stupefaction and rage,
the press went wild; never had it raved through so many articles."[59]

For Zola, the purpose of literature was to confront the reader with
the unvarnished truth, to depict the world in all its brutal, grubby
reality. He was a reformer, politically and socially active. He regarded
writing as tool of social progress.** Huysmans rejected all that. His
hero Jean des Esseintes is a jaded aristocrat who retreats into his own
world of obscure pleasures: "Once more he was toying with the idea
of becoming a recluse, of living in some hushed retreat where the tur-
moil of life would be muffled—as in those streets covered with straw
to prevent any sound from reaching invalids."[60] Rather than actively
engaging in the world, des Esseintes embraces the futility of dreams.
"It is only the impossible, the unachievable that arouses desire,"[61] des
Esseintes confesses.

Zola had seen this coming and wasn't about to give up without a
fight. In notes for his novel *Joie de Vivre,* published the year before *A
Rebours,* he sketched out the character of Lazare, whose disillusionment
with the modern world resembles des Eissentes': "The important thing,
the very basis of Lazare, is to make him into a pessimist, someone sick
of our new science . . . an intelligent nature that knows something
about our times, goes along with scientific discovery, has touched on

* The title, literally *Backward,* is often rendered in English as *Against the Grain* or
 Against Nature.
** It's no coincidence that he would be the most courageous defender of Alfred
 Dreyfus, the Jewish army captain falsely accused of treason.

experimental method, has read our literature, but denies it all by a kind of bewilderment."[62]

As with most seismic shifts in the cultural landscape, the Symbolist earthquake had been preceded by years of ominous shakes and rumblings. An antirationalist, antimaterialist strain was evident in French culture even before Moréas's Symbolist Manifesto, embodied in the writing of Charles Baudelaire and Stéphane Mallarmé. Asked by Kahn to define poetry, Mallarmé responded: "Poetry is the expression, in human language brought back to its essential rhythm, of the mysterious sense of existence: thus it endows our existence with authenticity and constitutes the sole spiritual task."[63] Another Symbolist forerunner was the playwright Auguste Villiers de l'Isle-Adam, a habitué of the Brasserie des Martyrs along with Gustave Courbet and the young Claude Monet. A fragment of dialogue from his 1865 drama Elën captures this irrational undercurrent: "Samuel: 'Science will not suffice. Sooner or later you will end by coming to your knees.' Goetz: 'Before what?' Samuel: 'Before the darkness!'"[64]

Of course the twilight battle between mind and heart, rational clarity and emotional mystery, is a perennial theme in Western culture, with one or the other dominating for a period before the inevitable reaction sets in. Early in the 19th century, it had taken the form of the clash between the Neoclassicists and the Romantics, before both were driven from the field by the rising Realists. Each constitutes the suppressed undercurrent of the other, only awaiting a propitious moment to reemerge and claim the stage for a few years before the pendulum changes direction once more.

A Rebours was as much a manifesto as Seurat's Sunday Afternoon or Moréas' "Literature: Manifesto of Symbolism." Closeted with his own neurotic thoughts, surrounded by objects that mirror his obsessions,

Huysmans's protagonist cuts himself off from the world and from the
bourgeois materialism he despises. Narrative itself is a victim of his
perverse obsessions. Huysmans, an art critic as well as a novelist, used
the book as a vehicle to promote his own aesthetic views and favored
artists. Among those he championed were two eccentrics who, like
Puvis, did not fit comfortably in either the academic or modernist camp:
Gustave Moreau (1826–1898) and Odilon Redon (1840–1916). In one
particular painting by Moreau, des Eissentes "realized the superhuman
and exotic Salome of his dreams . . . the symbolic deity of indestruc-
tible lust, the goddess of immortal Hysteria, of accursed Beauty."[65] He
finds Redon's charcoal drawings equally compelling, one featuring "a
frightful spider revealing a human face in its body. . . . Figures whose
simian shapes, heavy jaws, beetling eyebrows, retreating foreheads and
flat skulls recalled the ancestral heads of the first quaternary periods,
when inarticulate man still devoured fruits and seeds."[66]

Odilon Redon, *Smiling Spider*, 1887

Though des Eissentes' estate in Fontenay lay on the outskirts of Paris, it was worlds away from the crowded boulevards and marketplaces Zola chronicled in such scrupulous detail. In fact one didn't need to leave Paris at all to withdraw into the lonely self, as Baudelaire demonstrated in *Les Fleurs du Mal,* one of the foundational texts of the Symbolist era:

> *Paris changes! but nothing in my melancholy*
> *Has moved! new palaces, scaffolding, apartment blocks,*
> *Old neighborhoods, for me all became allegory,*
> *And my cherished memories heavier than stones.*[67]

Huysmans goes further than Baudelaire. Baudelaire remained engaged with the world and with Paris in particular, as much a man of the city as Zola himself. For Huysmans's antihero, by contrast, complete removal from everyday life is the precondition of self-discovery. The art with which des Eissentes surrounds himself sets its sights on distant shores, nightmare visions, and mythical Shangri-las.* Introspective, neurotic, even solipsistic, des Eissentes barely moves a limb as he takes us on a journey through the tortured psyche, shutting his door and drawing the blinds the better to explore the landscape of his dreams.

Huysmans represents an extreme version of this fin de siècle crisis of confidence, which, like most such moments, came in response to larger social and economic forces. The financial collapse of 1882 and the worldwide recession that followed shook people's faith that the future would be better than the past. The retreat from Courbet's realist (or Zola's Naturalist) project reflected skepticism of the ever-onward-ever-upward ethic of the modern world, a vision mocked by

* Curiously, drawings by Redon were included in the final Impressionist Exhibition, one more sign that the movement had lost all internal coherence.

persistent inequality exacerbated by economic collapse. Constricted horizons induced feelings of anxiety or ennui. In a time of uncertainty, Puvis's restful glades and Redon's bizarre fantasies offered a refuge from the disruptive power of modern technology and the destructive fury of modern capitalism.

Of course not everyone succumbed to such pessimism. Many agreed with Zola that the current mood predicted cultural and even moral decline. The German Max Nordau, who spent much of the 1880s prowling the cafés and cabarets of Paris, thought he detected the signs of a pervasive sickness: "The physician, especially if he has devoted himself to the special study of nervous and physical diseases, recognizes at a glance, in the fin de siècle disposition, in the tendencies of contemporary art and poetry, in the life and conduct of the men who write mystic, symbolic and 'decadent' works, and the attitude taken by their admirers in the tastes and aesthetic instincts of fashionable society, the confluence of two well-defined conditions of disease, with which he is quite familiar, viz. degeneration (degeneracy) and hysteria, of which the minor stages are designated as neurasthenia."[68]

Others viewed the rejection of science, of progress, of materialism, not as a sign of decline but of *renewal*. The positive agenda of the new art and literature was to recover a spiritual dimension its adherents believed had been lost in the blind pursuit of gain. For the Catholic pseudo-prophet and occult novelist known as Sâr Péladan (1858–1918), founder of the Salon de la Rose + Croix[*], the purpose was "to

[*] Between 1892 and 1897, Sâr Péladan (aka Joséphin Péladan) organized a series of art exhibitions to promote his mystical and esoteric views. Émile Bernard was among the many artists attracted for a time by his eccentric views. As he turned toward his Catholic faith, Bernard turned slowly away from the modernist art he pioneered as a young man.

restore the cult of the IDEAL in all its splendor, with TRADITION as its base and BEAUTY as its means . . . To ruin realism, reform Latin taste and create a school of idealist art."[69] The work of art, he claimed, "is more an operation of the soul than of the hand . . ."[70]

Péladan was a devout, if unconventional, Catholic, and his philosophy had a reactionary tinge. He hoped to restore what had been lost, to return to the faith mankind practiced before we worshipped the false god of material progress. His reference to "Latin taste" reflected a right-wing nationalist strain that ran through parts of the avant-garde and the country as a whole and that attempted to purge French culture of "Teutonic influences" like the music of Wagner and the philosophy of Schopenhauer. Jean Moréas would ultimately turn in this jingoistic direction and reject his earlier work, as a cofounder of the so-called École romane, which sought to "reaffirm the Greco-Latin principles . . . [and] restore the Gallic chain that had been broken by the romantics and their Parnassian, Naturalist, and Symbolist descendants."[71]

Even those turned off by Péladan's mumbo jumbo and regressive Catholicism shared his belief that to overcome the alienation of modern life we had to return to a simpler time. In Victorian England, this impulse found expression in the Arts and Crafts movement, which sought to revive the old craft traditions gutted by mass production; and the Pre-Raphaelite Brotherhood, which hoped to revive the naïve simplicity of the arts before the innovations of the High Renaissance. Puvis de Chavannes's art was animated by many of the same impulses, but perhaps the best example of this primitivizing tendency in French art was the painting and sculpture of Paul Gauguin. Like many of his generation, Gauguin had come to maturity in the Impressionist movement, brought into the fold by Pissarro; and, like many of his younger colleagues, he grew

impatient with what he saw as its limited horizons, its embrace of superficialities. By 1886, if not earlier, he was seeking something deeper, something that nourished the soul as well as the eye. His spiritual journey would take him first to rustic Brittany, where he was captivated by the peasants' naïve piety; it would take on greater urgency in tropical Martinique, and finally take him to the even more remote South Seas, where he hoped to discover a paradise uncorrupted by the modern world.

During his first months in Paris, Van Gogh seemed to have little interest in these epochal shifts and bitter controversies. He'd barely begun his self-directed apprenticeship in Impressionism and was as yet too unsophisticated to understand what was at stake. Pursuing his own lonely course, haunting the margins of the art world but not yet part of it, he kept a wary eye on things, alternating between bouts of dogmatic certainty and paralyzing insecurity.

Given his determination to profit from his renewed citizenship in "the country of paintings," he must have spent considerable time perusing the Neoimpressionist room at the Maison Dorée. He was certainly aware from conversations with Theo that these works were considered by many to be the next great thing and were generating heated debate in progressive circles. But in the spring and summer of 1886, Vincent himself gave no indication he cared about or understood what Seurat and his followers were up to. The evidence from his contemporaneous paintings suggests that these revolutionary works barely registered in his consciousness, which is all the more striking since there were significant points of contact between his own work and that of the Divisionists.

In fact Divisionism flowed logically from the writings of color theorists like Charles Blanc, but Vincent had still not entirely freed

himself from the tonal mode he'd taught himself as a neophyte artist.*
Seurat's innovations would eventually transform his own practice, but
only the following year, after he'd had a chance to acclimatize himself
to the new art and, significantly, only *after* he befriended Paul Signac,
the messiah's most ardent disciple. Later, he would anoint Seurat the
leader of a new wave he dubbed the artists of the *petit boulevard*, but
for now he resisted his charms.

He was even less in sympathy with the literary Symbolism of poets
like Baudelaire, Mallarmé, Verlaine, and Rimbaud. In fact he was never
particularly attracted to their work, which must have struck him as
precious and obscure. Though he was a voracious reader, these poets,
among the most important writers of the day, barely merit a mention
in his letters. By contrast, he discussed at great length socially engaged
writers like Harriet Beecher Stowe, George Eliot, and Charles Dickens,
and, later, Parisian Naturalists like Zola, the Goncourt brothers, and
Maupassant. The *literary* avant-garde, as opposed to the radical
painters, left him cold.** To the extent that he was, as Aurier claimed,
a Symbolist through and through, it was of a more robust, more full-
blooded variety, suspicious of fantasy and animated by things that
throbbed with the pulse of life. He was attracted to stories with human
warmth, tales that tugged at the heartstrings and that could keep him
company in the long, lonely hours of the night, not abstruse intellectual
puzzles. Later, when he became friendly with artists like Gauguin and
Bernard, he often rebuked them for their flights into literary fantasy,

* It would be interesting to know what Van Gogh made of Seurat's equally inno-
 vative black-and-white drawings. Using conte crayon on heavily grained paper,
 Seurat was able to achieve some of the shimmering, luminescent effects of his
 works in oil paint, without the use of color.
** He does claim "an unbounded admiration" for Huysmans but mentions him
 far less frequently than his other favorites. [See letter 804, to Willemien,
 Nov. 19, 1889]

insisting that no matter how far one traveled from reality, the work of art must be rooted in the here and now.

It's not particularly surprising that Van Gogh didn't immediately respond to the work of Seurat and his disciples. Since announcing his intention to become an artist six years earlier, he'd always been a step or two behind, a provincial learning about the latest innovations largely from magazine articles or from conversations with his brother. He stubbornly clung to old models—Rembrandt, Delacroix, Millet—writing elaborate justifications for his choices that struck the more sophisticated Theo as naïve. Coming to Paris was a shock to his system. He had difficulty enough reconciling himself to the novelties of the older Impressionists without having to accept their rebellious stepchildren.

Perhaps most important, Seurat was temperamentally Van Gogh's opposite in almost every way: cerebral where Vincent was passionate; cool where he burned with unquenchable desires; disciplined where he was impulsive; calculating rather than instinctive. Neither the Impressionists' fascination with capturing subtle nuances of light and atmosphere nor the Pointillists' monastic discipline, was particularly congenial to his nature. Over the course of his stay in Paris, each would provide crucial guidance on his journey of self-discovery—liberating him from bad habits he'd acquired, and forcing him to see in novel ways—but these were merely stepping stones along a road that would lead him into uncharted territory.

Throughout the spring and summer of 1886, Van Gogh remained on the periphery of the Parisian art world, an observer rather than a participant. Even living with his art-dealer brother, he'd not yet found a way into the community of artists; he was unable (perhaps unwilling) to establish even those tenuous connections he'd managed in Brussels, The Hague, and Antwerp.

That doesn't mean he was entirely wasting his time. When he wasn't carting his easel and perspective frame around the Butte de Montmartre, he trained his eye and stimulated his mind by making the rounds of the city's world-class museums—including the Louvre, where he continued to draw inspiration from the old masters, and the newly reopened Luxembourg, where modern masterpieces were on display. He paid frequent visits to the various salons, including the official version at the Palais de l'Industrie and the newly created Salon des Indépendants, whose second Exposition was held that summer, as well as Georges Petit's gallery, featuring shows of both Renoir and Monet.

Through Theo he kept abreast of the commercial side of things, noting which artists found favor with the public, whose prices were rising and whose were sinking, all the while imagining new arrangements that would free the producers from exploitation by the capitalist market. Equally important, he acclimatized himself to bohemian Paris, familiarizing himself with its rhythms and manners in settings like Madame Bataille's restaurant on the Rue des Abesses.

In August Theo traveled to Holland to visit his family in Breda, near the Belgian border, where they'd been living since March. He also paid a visit to the family of his friend Dries Bonger in Amsterdam. "He was in raptures over his stay with you,"[72] Dries reported after Theo's return. One member of the Bonger family in particular had caught Theo's eye—Dries's twenty-three-year-old sister Jo, though their interaction seems to have been brief and, at least according to Jo, casual.*

Time spent with Jo, however, was a rare bright spot in what was otherwise a difficult period in Theo's life. Indeed, leaving Paris had

* This was actually their second encounter. They had met briefly on his previous
 visit in the summer of 1885.

felt more like an escape than a vacation. For some time now he'd been carrying on one of those passionate, unsuitable relationships to which he was prone, this time with a woman simply known as S. By spring matters had deteriorated to the point that he felt compelled to break it off. But, worried about the woman's emotional stability, he delayed the painful decision. He set out for Holland in early August with the issue still unresolved, leaving it to Vincent and to Dries (who moved into the Rue Lepic apartment while he was away) to sort things out.

Given the young woman's apparently fragile state, Vincent urged Theo not to do anything to push her over the edge: "That you don't belong with S. nor S. with you is absolutely certain, it seems to me. And that it has to be finished, too—but how? It's a good thing for you to be prepared that the affair perhaps *cannot* be ended in the way you suggest, because by rushing her you could simply either provoke her to suicide or send her mad, and the effect of that on you would be tragic, of course, and could shatter you forever."[73] Vincent proposed a simpler solution. "An amicable arrangement which is virtually self-evident is that you pass her on to me," he suggested, implying he was willing to make this noble sacrifice for the sake of domestic tranquility. "This much is certain, if both you and she were willing to accept it, then I'm prepared to take S. over from you, preferably, though, *without* marrying her, but if it works out better then *even with* a marriage of convenience."[74]

In the end this drastic solution wasn't needed. The prospect of exchanging the debonair Theo for his gruff, disheveled brother apparently didn't appeal to S., and she simply disappeared from the scene. But the incident reveals something about Vincent's awkward human interactions, his predatory attitude toward women in particular, exacerbated by frustrated sexual needs he could only satisfy through coercive arrangements. Even in an age when women were treated as

weak-willed creatures who needed a man to take control of their lives, Vincent's assumption that S. would accept being handed from brother to brother seems callous.

For a time after S. departed, life at 54 Rue Lepic settled into a pleasant routine. Theo even felt confident enough of Vincent to invite Dries along on their nightly outings. Theo's friend had apparently learned to appreciate Vincent's finer qualities during the weeks they lived together, acknowledging that a keen intelligence lay below the rough exterior. Throughout the late summer of 1886 and into the fall, the three men usually dined together, apparently quite happily. "I now go to eat with [Theo] Van Gogh every evening as a permanent thing," Dries reported. "It does take up a lot of time, since he lives in Montmartre, and the evenings are now taken up altogether, but it's more pleasant for us both. The three of us always have plenty to talk about."[75]

During these months Van Gogh discovered a new subject for his still lifes: his own work shoes, which he depicted with his usual obsessiveness, in pairs or in multiples, in various combinations. Unlike the vases of flowers he'd been painting throughout the summer, these humble objects are inherently expressive, even human. They sit side by side companionably, or face off like old, quarreling couples. Misshapen, scuffed, spattered, they are, in a sense, self-portraits, standing in for their absent owner, intimately tied to his body and scarred by his labors. An acquaintance recalled how Van Gogh came to own at least one of these pairs: "At the flea market he'd bought an old pair of clumsy, bulky shoes—peddler's shoes—but clean and freshly shined. They were fine old clonkers, but unexceptional. He put them on one afternoon when it rained and went for a walk along the old city walls. Spotted with mud, they had become interesting."[76]

Pair of Shoes, 1886

This attraction to the old, the battered, things with a history—preferably rough—was characteristic of the way Van Gogh looked at the world. It applied to people as well as things, like the ravaged prostitute Sien Hoornik. "To me she's beautiful," he rhapsodized, "and I find in her exactly what I need. Life has given her a drubbing, and sorrow and adversity have left their mark on her—now I can make use of it."

The still lifes with shoes recall his Nuenen paintings, not only due to their earth-toned palette but also in terms of their subject matter, which is deliberately grubby—not the patent leather shoes of a boulevardier tripping lightly along the more fashionable thoroughfares, but of a day laborer whose bulky footwear roots him to the pavement. These humble objects proclaim a man who relates to the world physically,

with bone and muscle, not with his mind and with his eyes. Heavily impastoed, the paintings have the physicality of the things they represent. Van Gogh has forgotten for the moment the lessons of Manet and the Impressionists, returning to an earlier, more comfortable mode, where paint has a material rather than an optical relationship to the things represented.

For Van Gogh, clothing, particularly shoes, always conveyed deeper meanings. He noted approvingly that Millet didn't care for the "fine shoes and life of a gentleman,"[77] but instead went about in the wooden clogs of a peasant, seeing in his choice of footwear proof of his great and simple soul. He defended his own lifestyle in similar terms. "So what I hope not to forget is that," he told Theo, "'it's a question of going around in clogs', that is of being content as regards food, drink, clothes, sleep, with what the peasants are content with."[78] Theo, too, when he wished to flatter his brother, used these peasant shoes as a sign of authenticity, remarking on *The Potato Eaters* that "*he could hear the clatter of the sitters' clogs.*"

The shoes Van Gogh painted in the fall of 1886 are not peasant clogs but laborer's boots, markers of their owner's working-class status. By depicting these practical items, he once again seems to be staking out new territory. When he first came to Paris in February, he'd purchased a few new suits that, along with the repairs he made to his teeth, signaled his determination to rejoin the middle class. It was part of his larger quest to refashion himself into a painter of modern life. But the role of boulevardier was never a good fit. He soon grew uncomfortable in fancy clothes, squirming like a child in his Sunday best.

By the autumn of 1886 he'd reverted to his old truculent ways, not only clomping around in a workman's mud-spattered boots but donning the characteristic proletarian blue smock, which he wore while posing for the dark, brooding *Self-Portrait as a Painter* he painted that

November. He no longer portrayed himself as the society portraitist, ready to receive his fashionable clients, but as a man alone with his thoughts. This is not the convivial dinner companion Dries noted a few months earlier, but an awkward loner, more inclined to turn in upon himself, where his thoughts spiraled round and round in futile circles.

Self-Portrait as a Painter, 1886

Once more the changing seasons took a toll. Any lightness he'd achieved faded with the summer sun, bright colors submerged once more in sooty hues. Jo noted that "when the first excitement of all the new attractions in Paris had passed, Vincent soon fell back into his old irritability." He'd come to the French capital desperate to show Theo he was a changed man, but he was unable to sustain that easygoing attitude for long. With the coming of the gloomy weather, he reverted to his old ways, picking fights and railing at the world. With both brothers forced indoors, the Rue Lepic apartment felt claustrophobic. His painting grew less expansive, more turgid, as the walls closed in, his mess simultaneously spreading outward from the studio in

concentric waves, encroaching ever more on their shared space. What little consideration Vincent had managed to muster during the early months of living together vanished, and Theo once more had reason to regret his decision to allow his brother to stay with him.

Fortunately, just as things were reaching a crisis, Vincent's circumstances changed. Early that fall he found a new outlet for his art, one that got him out of the house and out of Theo's hair. Even more importantly, perhaps, it rekindled his enthusiasm for his work, reenergizing him in a season when he was otherwise likely to feel down in the dumps. Crucially, it put him into contact with other artists, providing him with the human connection he craved and that provided a necessary catalyst for his artistic growth.

For the first time since he left Antwerp, Vincent was a student again.

1

The Student

"It is as if there were two persons in him—one marvel-
ously gifted, delicate, and tender, the other egotistical and
hard-hearted! They present themselves in turn, so that
one hears him talk first in one way, then in the other,
and this always with arguments which are now all for,
now all against the same point. It is a pity that he is his
own enemy, for he makes life hard not only for others but
also for himself.
> —Theo van Gogh to Willemien van Gogh

Early in the fall of 1886, Van Gogh enrolled at the studio of Fer-
nand Cormon, an independent atelier located at 104 Boulevard
de Clichy, a five-minute walk from the Rue Lepic apartment.*
With this step Vincent suddenly plunged into the very heart of the
Parisian art world.

* The dates Van Gogh attended Cormon's studio have been the subject of
heated debate. There are three possibilities: that he enrolled almost as soon
as he arrived and quit after a few months; that he attended classes in the
spring and continued in the fall; that his time at Cormon's was confined to
the fall of 1886. The evidence points overwhelmingly to the third alternative.
For a fuller discussion of the issues involved, see Appendix A.

The studio, in fact, was one of the most prestigious and sought-after in the city. In the competition for attracting top students, Cormon's star had been on the rise since the beginning of the decade. He'd created a sensation at the Salon of 1880 with his vast biblical panorama *Cain Fleeing with his Family*, which was so popular it created its own short-lived vogue for prehistoric subjects. In 1884 he was named to the Salon jury, which increased his appeal to prospective students since he was now in a position to reward his favorites. More important for Vincent's purposes, he was an exponent of the so-called *juste-milieu*, that middle ground between Impressionist looseness and academic precision. Presiding benignly over a studio that combined technical rigor with a relaxed atmosphere, Cormon must have seemed a master perfectly matched to Vincent's needs.

Van Gogh knew of Cormon before he'd even arrived in Paris, having heard tales of the studio from George Breitner, an acquaintance from The Hague who'd spent a month at his atelier in 1884. During Vincent's time in Antwerp, the possibility of learning at the feet of this particular master grew into something of an obsession. As often happened, he seems to have taken a few casual anecdotes, out of context, and used them to build elaborate castles in the air.

At first he name-dropped Cormon as a way to convince his brother he was serious about pursuing his studies. Theo had been urging him to go to Nuenen, and Vincent needed counterarguments. He'd stagnate in that backwater, he insisted. It was urgent that he go instead to Paris, where there were ample opportunities to hone his craft. "Of course all my attention is concentrated on gaining what I want to gain. Namely a clear field to make a career."[1] Cormon, whatever his actual pedagogical virtues, was a name around which he could construct a plausible Parisian narrative. Let him enroll in classes with a respected master, and he'll no longer be an amateur with few prospects for

earning a living, but rather a student acquiring the skills he needs to pursue his trade. In the weeks preceding his move, the opportunity to study with Cormon grew from a mere possibility to a fait accompli, one, he insisted, that would put him firmly on the road to success.

From Theo's point of view, Vincent's suggestion was not entirely unwelcome since it armed him with one more reason to propose a delay. Wait until June, he advised, by which time he'd be able to arrange things with the studio as well as find a larger apartment more suited to their needs. Vincent was thrilled. "The fact that you yourself now actually propose the plan of going to Cormon is something that gives me immense pleasure," he wrote at the beginning of February.[2] As always he heard only what he wanted to hear, ignoring Theo's admonition to move cautiously and tearing off at his usual breakneck pace.

By proposing to study with Cormon, Vincent was pursuing the course he'd set for himself when he left Nuenen: to make himself more professional by submitting to the kind of academic discipline he once despised. "You talk about the clever fellows at Cormon's studio," he wrote with exaggerated confidence. "Precisely because I damned well want to be one of them, I'm setting myself in advance, out of my own conviction, the requirement of spending at least a year in Paris mainly drawing from the nude and plaster casts."[3]

Framing his Parisian ambitions around this independent studio was Van Gogh's own version of the *juste-milieu*, halfway between the strict discipline of the academy and the solitary journey of the autodidact. His experiences at the Royal Academy in Antwerp had been decidedly mixed. On the one hand he took heart from the faint praise he received from his teachers; a few kind words were enough to convince him he was on the right track. On February 2, for instance, he happily reported a conversation with one of his teachers. "Verlat

[the director of the Academy] has trained many able pupils," his drawing instructor told him, "and we make a point of training those who will do us credit—and I urge you very strongly to stay."[4] At the same time he bridled at any criticism and rebelled against their hidebound methods:

> That Siberdt, the teacher of the antique, who spoke to me at first as I told you, definitely *tried* to pick a quarrel with me today, perhaps with a view to getting rid of me. Which didn't work inasmuch as I said—Why are you trying to pick a quarrel with me? I have no wish to quarrel, and in any case I have absolutely no desire to contradict you, but you deliberately try to pick a quarrel with me.
>
> He evidently hadn't expected that and couldn't say much to refute it this time, but—next time, of course, he'll be able to start something.
>
> The issue behind it is that the fellows in the class are talking about things in my work among themselves, and I've said, not to Siberdt but outside the class to some of the fellows, that their drawings were completely wrong.[5]

Opinionated as always, Van Gogh challenged his more accomplished classmates. And they repaid him in kind, calling him "a wild man" and treating him "as if he were a rare specimen from the 'human wonders' collection in a traveling circus."

Paris would be different, he insisted. There they didn't try to put you in a straitjacket, force you to conform to a set of narrow rules. "They say that one is relatively freer in Paris and, for instance, that one can decide for oneself what one wants to do, more than here, but that the correction is indifferent."[6] But he was also realistic. He knew he'd

had difficulties toeing the line before, but now he was willing to take things in stride:

> Bear in mind that if I go to Cormon and run into trouble sooner or later either with the master or the pupils, *I wouldn't let it worry me.* If need be, even if I didn't have a master, I could also go through the antique course by going to draw in the Louvre or somewhere. And so I'd do that if I had to—although I'd far rather have correction—as long as it doesn't become DELIBERATE *provocation*; that correction without one giving any cause other than a certain singularity in one's manner of working which is different from the others. If he starts on me again, I'll say out loud in the class, I'm happy to do mechanically everything that you tell me to do, because I'm determined to pay you back what is your due, if need be, if you insist on it, but—as far as mechanizing me as you mechanize the others is concerned, that has not, I assure you, the slightest hold over me.[7]

For all his brave talk, Vincent was understandably nervous about taking on a new master. Past attempts to submit to instruction had all ended badly. No matter how hard he tried, he couldn't accept someone else's judgments on his work, bristling at even the slightest criticisms. And though Cormon's name had become a kind of shibboleth, a token of the seriousness with which he intended to pursue his art, he still hoped to put it off for a few months so that, as he put it, "I'll be more accustomed to Paris again by the time I go to Cormon's."[8*]

* For more on Van Gogh's plans, see Appendix A.

Andries Bonger confirms the key role this training was meant to play in Van Gogh's professional development, writing shortly after his arrival in Paris: "It now appears that Theo's brother has come to stay; for the next three years at the least he is going to work in the painter Cormon's studio."[9]

Cormon's Studio, c. 1885

Cormon's studio was one of many similar establishments scattered about Paris, mostly in bohemian neighborhoods like the Latin Quarter (near the École de Beaux-Arts), Batignolles, or Montmartre, where rents were low and ample space available. They were a strange hybrid, with one foot in the official art world—most of the teachers showed regularly

at the Salon, and many were members of the Academy—and another in the rebellious counterculture. One of the earliest and most successful of these independent studios was the Académie Julian, founded in 1873 with a mission to train students to pass the demanding entrance exams for the École des Beaux-Arts. Teachers there included such stalwarts of the academic system as Gustave Boulanger and William-Adolphe Bouguereau, but this did not prevent it from launching the careers of some of the greatest of the avant-garde pioneers, including Henri Matisse, André Derain, and Pierre Bonnard.

Tension between conservative teachers and radical students was a feature of the age—a dynamic that went back at least as far as 1861, when a contingent from the École des Beaux-Arts walked out to learn at the feet of their hero Gustave Courbet. Monet, Renoir, and Sisley all met at the studio of the reactionary painter Charles Gleyre, while Manet studied under (and fought with) his teacher Thomas Couture. It was a system at cross-purposes with itself, caught between the old academic regime and the new commercial market.

The studios, even those run by archconservatives like Gérôme or Cabanel, were attractive in part because they offered more freedom than the École itself. Supervision was less strict, the examination process less rigorous. A good teacher, preferably with a recognized name, could still launch your career, if, that is, you caught his eye and followed his lead.

By 1886 Cormon's own reputation as a painter had peaked. His exotic scenes of ice-age brutes, or the violent passions of a sultan's harem, had begun to seem kitschy even by the vulgar standards of the late–19th century beaux arts tradition. He remained a popular teacher, though, known as a permissive and rather absent-minded master who let his students do their own thing, within reason. Most days students worked on their own, under the supervision of the two *massiers*, with

Cormon stopping by twice a week to check on their progress and make corrections where needed.

For all Cormon's professional attainments, the students tended to make fun of the master behind his back. One dubbed him "the ugliest and thinnest man in Paris," a skin-and-bones specimen also known to his students as *Père la Rotule* (Daddy Kneebones)—a dig at both his appearance and his penchant for painting prehistoric tableaux. Another, only slightly more charitably, described him as "a sharp-featured little man, dark-haired, with the quick movements of a small bird, which he somehow resembled." Still, this pupil continued, Cormon was not without his virtues: "I should say that he had excellent brains, was an admirable teacher, more sympathetic to novelties than most of his kind. No doubt he was particular about drawing, and especially construction, as a true Frenchman and member of the Institute. . . . The crown of his reputation in the studio, however, was that he kept three mistresses at one time!"[10]

It was his flair, as much as anything, that drew top students to the Boulevard de Clichy. The flamboyant son of a theatrical stage manager, Cormon encouraged a lighthearted atmosphere that appealed to the young men who gathered there to learn their trade. Like most ateliers, the drafty hall was the site of serious work but also the usual sophomoric hijinks. Students were referred to as *rapins* (pillagers). Hazing rituals were common for the *nouveaux*, the newcomers, who were sometimes forced to strip naked and duel with paintbrushes and subjected to various other indignities. The English painter Archibald Standish Hartrick, who entered the atelier shortly after Van Gogh departed, recalled his own initiation: "Thanks to the kind offices of [John Peter] Russell, who had been popular, I got on very well after the first few days, during which I was put through the ritual of induction by paying for drinks, singing a song, etc. . . . my chief duty as a 'nouveau' was to see that the stove was lit and properly stoked."[11] He knew he'd gotten

off easy. His predecessor was "put '*à la brosse*,'" the Englishman recalled. "This means he was trussed like a fowl, with a long pole run through the back of his knees and his hands tied in front of them. He was then placed on the throne, or some place raised from the floor, from which he was bound to fall if he tried to move." After more torments, "he was half insensible with hysteria and rage."[12] Models were subjected to even worse abuse. "Inspections" by the massiers were little more than excuses to grope them, and the young women who were paid to disrobe in front of these young men were expected to serve them in other ways.

Easygoing when it came to supervising the thirty or so students under his care, Cormon was also more open-minded than many of his competitors when it came to aesthetic matters, urging them to go out into the world and paint what they saw. "Nothing can remain stationary in this world," he observed, showing a theoretical sympathy to the Impressionist ethic, however much his work diverged in practice. "Everything changes and must change. A school [of art], therefore, cannot stand still. It must be subject to transformation if it is to endure."[13]

If rules were lax inside the studio, all hell tended to break loose in the afternoons when class was dismissed for the day. Cormon "wants us to have as much fun as we can painting outside the studio,"[14] one budding painter reported, pedagogic advice he and his companions took to heart. In between sessions of plein-air painting, they descended en masse on one of the many bars that had sprung up at the base of the Butte—La Grande Pointe, Le Plus Grand Bock, or L'Auberge du Clou—consuming wine and beer in large quantities. As night fell they moved on to harder stuff, indulging in a ritual known as *etouffer un perroquet* (to choke a parrot), Montmartre slang for downing a glass of the toxic green liquor, absinthe (*perroquet*).

In the studio itself, Cormon's approach to teaching was minimalist, consisting of mumbling "only a few well-chosen words of instruction as

he paused beside each easel."[15] When he did offer criticism, it tended to be mild. "He looked at everything with a solicitude that surprised us,"[16] one of them remembered. Though he permitted liberties outside the classroom, inside, his teaching followed traditional models: copying heads from old masters—building up the volumes from dark to light—studies of live models, and finally full-scale figures from live models known as *academies*. It was the kind of conservative program, stressing precision over inspiration, that would already have been familiar to Van Gogh from the time spent in the academies in Brussels and Antwerp—an approach he'd rejected more than once in the past.

These aspiring painters were young men, most of them possessing a good deal of skill, a few showing flashes of real genius. The vast majority were French, with a few foreigners sprinkled into the mix. As was typical of aspiring artists of their generation, they were deeply conflicted, forced to choose between the safe route of academic painting and the more exciting but riskier possibilities opened up by the Impressionists and their successors.

Presiding over this unruly gang were the two student supervisors (massiers), Louis Anquetin (1861–1932) and his inseparable companion, Henri de Toulouse-Lautrec (1864–1901). Another student, François Gauzi, penned a sardonic portrait of his friend: "Lautrec is seen only as a midget—a miniscule being, a gnome, one of Ribera's dwarfs, a drunken, vice-ridden court-jester whose friends are pimps and girls from brothels. He has an appalling reputation which, in part, he deserves."[17]*

* Lautrec's dwarfism seemed to derive from the excessive inbreeding of his blue
 blood forebears, as well as a series of riding accidents in his youth that stunted
 his development.

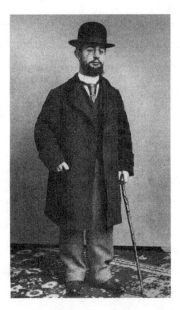

Henri de Toulouse-Lautrec

Lautrec joined Cormon's in 1882 after leaving his first teacher, the well-connected portrait painter Léon Bonnat. Known as "the favorite painter of millionaires,"[18] Bonnat was a notoriously harsh master who disliked all the new tendencies in art, dismissing the Impressionists as "humbugs and revolutionaries."[19] When Bonnat closed his studio, Lautrec was happy to find someplace where he didn't have to slavishly follow the master's instructions.

At first Lautrec thrived under his new master's indulgent tutelage. "I have just accepted an easel in the atelier of Cormon," he reported, "a young and already celebrated painter, the one who did the famous *Cain Fleeing with his Family* at the Luxembourg. A powerful, austere, and original talent."[20] After a few years, however, he began to tire of his teacher's lax methods: "Cormon's comments are far milder than those of Bonnat. Whatever you show him he warmly approves. It will surprise you, but I like this reaction less. Indeed the lashes of my old

master's whip put ginger into me and I didn't spare myself. Here, on the other hand, I feel a little too relaxed, and have to make an effort to produce a conscientious drawing when something not quite as good would do just as well in Cormon's eyes."[21]

Unlike Van Gogh, Lautrec was already a skilled draftsman, a quality that earned him the respect of, first, Bonnat and later Cormon. But for all his technical mastery, he was restless. For him, as well as for many of the talented young men on the Boulevard de Clichy unwilling to submit to rules laid down centuries earlier, Cormon's methods seemed increasingly irrelevant. Lautrec's views had expanded since he left Bonnat's studio, as had his doubts; the winds of change were blowing, and he found the fresh air bracing. A fellow student recalled how he began to move away from the academic tradition in which he'd been trained: "[Lautrec] often accompanied me to the Louvre, Notre-Dame, Saint-Séverin, but, much as he continued to admire gothic art, he had already begun to show a marked preference for that of Degas, Monet, and the Impressionists in general, so that even while he was working at the atelier, his horizon was not bounded by it."[22]

Lautrec was not alone. With his friend Anquetin, he joined forces with a brash young newcomer to the studio to form a "triumvirate" of rebels pushing against the old-fashioned methods of their master. Émile Bernard, though the youngest of the three—he was only sixteen when he arrived in 1885—was also the boldest, or at least the most impatient. A young man on the make, he encouraged his friends to cut class with him and pore through the stacks of Impressionist paintings at Durand-Ruel's gallery. There they trained their eyes to see anew, their minds to embrace fresh points of view.

All three were young, ambitious, anxious to seize the future. In the spring of 1886, that future belonged to Seurat and his colleagues, and the triumvirate embraced the mission of preaching the new gospel of

color to their classmates. Anquetin had turned "intransigent," Hartrick recounted,

> that is, he went over to the advanced section of the "poin-tellists" [*sic*] led by Signac and Seurat and carried most of the studio with him. Among those working in the studio was a young man called Bernard, about eighteen years of age, in whom Cormon took an interest. Cormon came round one morning, as usual, to find Bernard painting the old brown sail that served for a background to the model, in alternate streaks of vermilion and vert veronese. On asking the youth what he was doing, Bernard replied, "that he saw it that way." Thereupon Cormon announced that if that was the case he had better go and see things that way somewhere else.[23]

After expelling Bernard, Cormon closed up shop for the summer, refusing to open his doors until the students saw the error of their ways.

While Bernard set out on a walking tour of northern France, ending up in the Breton village of Pont-Aven, where he would forge a friendship with Paul Gauguin, Van Gogh concentrated on depicting the sights of Montmartre and painting still lifes he set up on the table by his window. These summer exercises, he believed, would prepare him for the challenge ahead "Anyone who wants to go to those fellows for advice must take with them as much prior knowledge as possible," he explained to Theo. "And it's definitely to be expected that almost all of them who are in his studio will have gone through a great many plaster casts, and that (no matter how free, how liberal the studio may be otherwise) one relies on that quite heavily. . . . At Cormon's I'll have to paint some test or other of a nude figure from life—probably—and

the more I have the structure fixed in my mind in advance the better, and the more he'll be able and willing to tell me."[24]

Still, for all the work he'd put in, it's unlikely Van Gogh would have been accepted into Cormon's exclusive atelier—which reopened early in the fall—on his own merits. Hartrick, a painter of greater technical competence, was quite pleased to be admitted. "Russell had kindly offered to sponsor my entry into the Atelier Cormon," he recalled. "I had taken some of my work to show the great man at his private studio; he had been interested and accepted me as a pupil—quite a feather in my cap, I thought, because Cormon's studio at the time was small and select, not more than thirty to thirty-five pupils all told, of whom few were foreigners."[25]

It's almost certain that Theo used his position as the manager of a prominent gallery to push Vincent to the front of the line, ahead of more qualified applicants. Both teacher and students knew that Theo could help their careers and treated his brother accordingly. "I think the French generally rather tolerated him on account of his brother, Theodore's position in Goupil's,"[26] Hartrick recalled. However eccentric Vincent appeared, however clumsy, quarrelsome, or unhinged, his connections spared him the worst of their abuse.

This runs against the grain of the Van Gogh legend that positions him as the classic outsider, spurned by society, unable to conform to social norms and unwelcome in polite company. In important ways he was the consummate insider, someone who benefited from a family that could provide him entrée into privileged realms from which he would otherwise have been excluded. This was neither the first nor the last time that Theo used his position to help Vincent. A few years earlier he'd found him a job working for an illustrated magazine in Paris (which he turned down) and had prevailed upon his colleagues to critique his brother's clumsy efforts, eliciting comments that were far

more constructive than they would have been had they not felt obliged to pull their punches. More generally, he used his knowledge of the art world to keep his brother up to date on the latest trends and alert him to commercial possibilities.

This tension between his insider and outsider status is key to understanding the nature of Van Gogh's achievement. It was singular, the product of his distinctive gifts, pathologies, and obsessions; at the same time it emerged from the particular conditions and contradictions of the art world in which he found himself between 1886 and 1888, and to which Theo provided him his initial introduction. Without Theo—and without his Uncles Cent and Cor, both of them very much art world insiders—Vincent's would have remained a voice in the wilderness. Or not even a voice, for the language of art was very much part of the family business, without which he would have remained mute. While he came to despise his uncles, Theo was Vincent's savior, his guardian angel, presiding—not always happily, never easily—over every aspect of his career, shaping it in ways he couldn't possibly have foreseen.

Securing him a spot in Cormon's studio was by far the most substantial contribution he'd made thus far to Vincent's career, placing him in the company of skilled practitioners, most of whom would soon join the ranks of the city's professional artists. Of course it was not a completely selfless act on Theo's part. Getting Vincent out of the house and back onto some productive path was essential to his peace of mind as well.

From the beginning Van Gogh was a fish out of water. At thirty-three he was older than his classmates: Lautrec had not yet turned twenty-two; Louis Anquetin was twenty-five; and Bernard, the former *wunderkind* of the atelier, just eighteen. Only the Australian John Peter

Russell,* age twenty-eight, came close, perhaps one reason why he and Van Gogh struck up a friendship.

Van Gogh and Russell were also brought together as part of the small foreign contingent, an inferior species according to the young Frenchmen who prided themselves on their sophisticated Parisian ways. They tolerated Russell because he was rich, and Hartrick because he was a genial fellow, happy to go along with their antics. They had no idea what to make of the intense, ill-humored Dutchman in their midst. He had none of the easy manners, sense of irony, and taste for sophomoric humor that his classmates reveled in. They sneered (though not when he could hear them), calling him "a man of the North [who] didn't appreciate the Parisian spirit."[27] He refused to participate in their silly pranks and met their offhand banter with diatribes delivered in his heavily accented French. According to Lautrec's friend François Gauzi, he only wanted to be left alone, a demand the others readily complied with since they were all a bit afraid of him. "If, when we were talking about 'art'," he recounted, "anyone insisted on disagreeing with him, he lost his temper in a disconcerting way."[28]

Even Hartrick, who considered himself his friend, penned a somewhat unnerving picture: "I can affirm that in my eyes Van Gogh was a weedy little man with pinched features, red hair and a beard and a light blue eye. He had an extraordinary way of pouring out sentences in Dutch, English, and French, then glancing back over his shoulder and hissing through his teeth. In fact when thus excited he looked more than a little mad; at other times he was apt to be morose, as if suspicious."[29]

* Russell, though a second-tier painter—sometimes he's referred to as "the Australian Impressionist"—had an important role in the development of modernism. He was the first to introduce Henri Matisse to the work of Van Gogh, a revelatory moment that led to the birth of Fauvism.

Van Gogh's intensity turned people off. No one who took life too seriously was taken seriously by the young men gathered at Cormon's studio. This was partly just the natural irreverence of youth, but it was also very much in the spirit of the times. While some sensitive souls—like Huysmans's antihero des Eissentes—responded to the anxieties of the fin de siècle by retreating into vaporous dreamlands, others coped by using humor and provocation. In 1882, the publisher Jules Levey founded a movement he called *Les Arts Incohérents*,* staging guerilla-like shows meant both to amuse and infuriate. Deploying a subversive humor known as *fumisme*,** the members attacked piety and offended propriety. Some saw nothing in their jests but nihilism, while others detected a more constructive message. An opinion piece in *Gil Blas* insisted these *Incohérents* rejected "the decaying, the depressing, the morose, the Symbolists and the Anarchists," while another in *Le Figaro* approved of those they claimed were "tweaking the nose of pessimism."[30] They often congregated at the nearby Le Chat Noir, the *cabaret artistique* run by Rodolphe Salis, who had discovered how to turn mockery into good business. Lautrec—a habitué of the cabaret and already casting a bleary, jaded eye on the world—was a precocious participant. On one occasion he submitted an impeccably academic portrait of a camembert cheese to the Salon jury (it was rejected); on another, he offered up a parody of one of his teacher's prehistoric tableaux titled *Les Batignolles—3½ B.C.*, including an inscription that informed viewers it had been painted by "Tolav-Segroeg, a Hungarian

* The Incohérents were descended from an even less organized group known at the *Hydropathes*. Both groups were forerunners of, and inspirations for, the 20th-century movement known as Dada.

** The word derives from the French for smoke, but *fumisme* has no literal translation. It stood for a spirit of irreverence, meant to expose the ridiculousness of contemporary life.

from Montmartre, [who] has visited Cairo and lives with one of his friends, has some talent and proves it."[31]

Van Gogh lacked this lighthearted spirit. Irony was an unaffordable luxury for someone who felt himself teetering on the brink. He'd lost his religion, but not his conviction that life had a moral dimension, and he knew from his own struggles that the forces of chaos were too dangerous to toy with. He was out of step with his younger colleagues for whom life was merely a game, to be played to the hilt—at least until old age and dissipation took too high a toll. One look into those intense, almost fanatical blue eyes would have been enough to dissuade any attempt at making him the butt of their jokes. "What laughter behind his back,"[32] one student recalled, though he admitted that there were few with the courage to mock him to his face.

Whatever Van Gogh's flaws, no one could fault him for a lack of effort. On the contrary, he was known for an almost punitive work ethic, which flew in the face of their Parisian insouciance. If mastery were to be praised, it had to be effortless, or at least appear to be. Van Gogh, by contrast, was all effort, usually unrewarded. Rather than drawing with the flair they all prized—and that Lautrec possessed in spades—he wrestled the image into submission, destroying it if it refused to yield to his efforts. While his classmates were sampling the pleasures of the tavern, he would return to the studio after hours. Not that he was abstemious; when it came to the consumption of tobacco or alcohol, he could keep up with the best of them, but he tended to drink alone, surrounded only by a thick cloud of smoke from his pipe.

For Hartrick—like Anthon van Rappard a good-natured soul willing to put up with behavior that others found off-putting—Vincent seemed odd but also a bit endearing: "In some aspects Van Gogh was

Figure 19. Georges Seurat, *A Sunday Afternoon on the Island of La Grande Jatte*, 1886

Figure 20. *Self-Portrait with Glass*, 1887

Figure 21. *Prawns and Mussels*, 1886

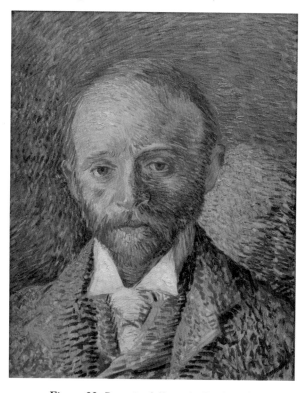

Figure 22. *Portrait of Alexander Reid*, 1887

Figure 23. *Pair of Shoes*, 1887

Figure 24. *Flower Pot with Garlic Chives*, 1887

Figure 25. Henri de Toulouse-Lautrec, *Portrait of Vincent van Gogh*, (pastel on paper), 1887

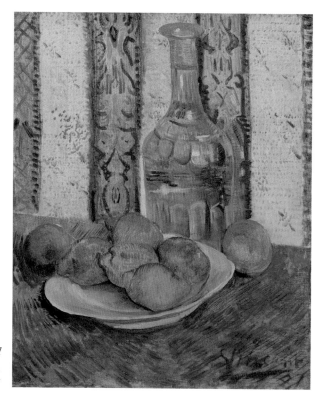

Figure 26. *Carafe and Dish with Citrus Fruit*, 1887

Figure 27. Paul Signac, *Bridge at Asnieres*, 1886

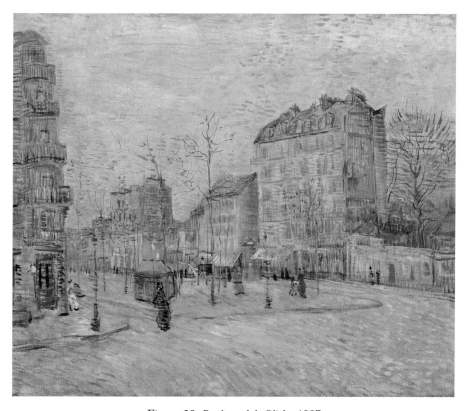

Figure 28. *Boulevard de Clichy*, 1887

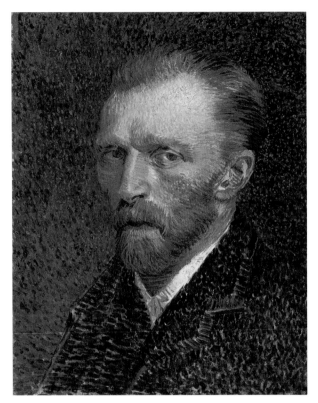

Figure 29. *Self-Portrait*, 1887

Figure 30. *Courting Couples*, 1887

Figure 31. *Spring Fishing, the Pont de Clichy,* 1887

Figure 32. *Restaurant la Sirene,* 1887

Figure 33. *Trees and Undergrowth,* 1887

Figure 34. *Kitchen Gardens Montmartre,* 1887

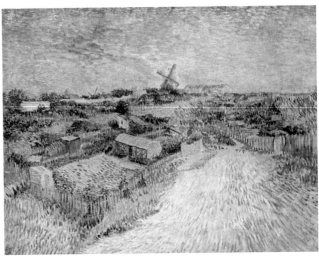

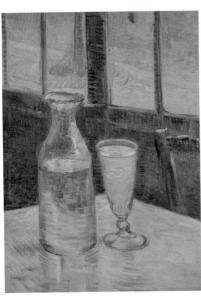

Figure 35. *Café Table with Absinthe* (detail), 1887

personally as simple as a child, expressing pleasure and pain loudly in a childlike manner. The direct way he showed his likes and dislikes was sometimes very disconcerting, but without malice or conscious knowledge that he was giving offence."[33] Most of his classmates, however, could not get past the bristling exterior. One of them remembered entering what he thought was an empty studio, only to be startled by a ghostly apparition. There in the shadows was Van Gogh, all alone, brooding "like a prisoner in his cell."[34]

If his classmates were perplexed by his strange personality, they were equally put off by his work, which, at least by the high standards of the atelier, seemed both labored and clumsy. Indeed, after his death, when he'd become a legend and historians were hoping to dig up nuggets from those who'd known him before his apotheosis, the general response was one of amazement. "I frankly confess," wrote Hartrick, "that neither myself, nor any of those I remember of his friends, foresaw that Van Gogh would be talked of specially and considered a great genius in the future. We thought him 'cracked' but harmless, perhaps not interesting enough to bother much about. Though he was always an artist in temperament, we considered his work too unskillful in handling to make an appeal to the student mind; for there were many who could surpass him from that point of view."[35]

He was also argumentative, taking up arms against anyone with the temerity to offer up his own opinions. His dogmatism clashed with their drollery, his book learning with their practical know-how. He took his frustrations out on his classmates, bristling defensively and heaping scorn on their competent but timid efforts. Lacking their facility, he took refuge in theories he only half understood and that, in any case, were not matched by anything he actually produced.

Van Gogh hoped that the summer spent wrestling with the plaster casts in his collection would improve his skills, but the exercises fell far short of what was needed. He continued to be frustrated in his efforts to reproduce what he saw in front of him. On one occasion, when Cormon stopped by to correct his students' works, they all gathered around Vincent's easel, expecting the master would lose his temper over his amateurish efforts. In the end they were disappointed as Cormon contented himself with a few bland observations. Like his students, Cormon seemed to think discretion was the best policy to adopt when dealing with the brother of an influential dealer.[36]

The yield from his months at Cormon's studio was indeed meager: a few painted studies of the nude and a couple dozen works on paper, some from the nude model and others made from the plaster casts with which any decent atelier was amply stocked.* While these student exercises demonstrate Van Gogh's increasing competence in rendering the human form, they remain heavy-handed and often awkward. In a drawing like *Standing Female Nude Seen from the Back* or *Standing Male Nude Seen from the Front*, we can see his tendency to exaggerate. Smooth contours devolve into jagged relief maps, and he treats each bump and hollow like a rocky cliff face. As always with Van Gogh, he sees too much, he feels too much, reading more into a form than is actually there.

* One of these, a rapidly brushed oil sketch of a seated young girl, is significant mostly for what lies below the surface: an earlier flower still life that helps pinpoint the period he studied with Cormon, that is *after* the summer of 1886. We know that Cormon used models as young as seven to pose for the students; drawings from both Cormon and Lautrec seem to depict the same girl. See Appendix A for further discussion of the timing of Van Gogh's residence.

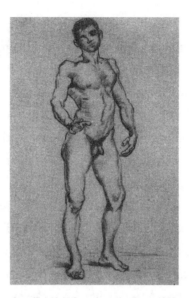

Standing Male Seen from the Front, 1886

From the distance of Antwerp, he pitched Cormon's studio as the solution to all his problems. Of course past experience had taught him to tread cautiously, but he believed he was now wise enough "that if I go to Cormon and run into trouble sooner or later either with the master or the pupils, *I wouldn't let it worry me.*" But once there he found the instruction lacking and his classmates hostile; all his deficits were exposed and none of his talents rewarded. In some ways it was a relief to return to the human figure, which he always placed at the center of his artistic mission. But, perhaps because it meant so much to him, it was the area where he struggled the most.

The few paintings attributable to his stint at Cormon's display the same somber palette brought over from his Nuenen days, though with an occasional glimpse of brighter color that hints at a new dawn about to break through. After what he called his "gymnastics" of the

summer—those vases overflowing with red poppies, blue corn flowers, yellow chrysanthemums—these works seem like something of a retreat. But it was one thing to render bouquets of flowers in vibrant hues, quite another to render a convincing nude without resorting to the tonal palette he'd hoped to leave behind. He had yet to figure out how to combine the brighter palette and broken brushwork of Impressionism with more solid, more monumental forms, a dilemma, in truth, that afflicted many of his contemporaries as well.

But this doesn't mean he'd forgotten the experiments of the summer. Contemporary accounts confirm that color was still very much on his mind, though it was not the Divisionists he sought as his guide to the chromatic mysteries but an earlier master. "Delacroix was his god," one of them remembered, and "when he spoke of this painter, his lips would quiver with emotion."[37]

Of course Delacroix was not exactly considered cutting-edge at this time, but his technique of stippling his canvases with dots of pure color had important affinities with the new art. By the time Van Gogh arrived in Cormon's studio, most of the rebels had been purged, Bernard unceremoniously, while Lautrec and Anquetin both had one foot out the door. But the echoes of that springtime revolt still reverberated. The innovations of Seurat & co. were still very much in the air, whispered out of earshot of the *maître*, who continued to fume over the abortive coup. Van Gogh, who had thus far ignored the Divisionist revolution, must have realized how closely their ideas mirrored his own, but also how far his actual practice lagged behind.

If Van Gogh was intrigued by Seurat's theories, he could never emulate his supreme control: "He worked in a chaotic fury, throwing all the colors on the canvas in feverish haste," wrote a startled eyewitness. "He picked color up as if by the shovelful and the paint ran back along

the brush and made his fingers sticky."[38] No wonder his figure studies lacked the accuracy demanded by their master! They were equally far from the cool, static paintings of the Divisionists. "The violence of his study surprised the studio," his classmate continued. "The classical artists were horrified by it."[39]

After only a few weeks, Van Gogh was no longer even pretending to follow his teacher's instructions. He was openly defiant, doubling down on those traits the master despised. By the time fall was turning into another cold, dreary Parisian winter, Vincent had had enough. "I have been in Cormon's studio for three or four months but did not find that as useful as I had expected it to be," he wrote to the painter Horace Mann Livens, offering a rather laconic postmortem on a course in which he'd invested so many hopes. "It may be my fault however," he offered in a rare moment of insight, "any how I left there too as I left Antwerp and since I worked alone, and fancy that since I feel my own self more."[40]

He doesn't elaborate on what this might mean, though he reveals some of his frustration, telling Livens, "I am struggling for life and progress in art."[41] His break with Cormon repeated his difficulties with Mauve, his struggles in Brussels and in Antwerp. Perhaps the pattern went even deeper. Anyone offering advice or trying to nudge him in a more productive direction reminded him of his father or, worse, his uncles. Even Theo drew his wrath when he adopted a paternal tone. The truth is that Vincent had an instinctive aversion to authority and lashed out at anyone who tried to tell him what to do.

Van Gogh rarely talked about his time at Cormon's. When he did, it was only to dismiss what he learned there. "I hardly measure," he later boasted to Theo, "and in that I'm quite categorically opposed to

Cormon, who says that if he didn't measure he would draw like a pig."[42] Cormon, for all his reputation as a man with liberal views on art, turned out to be just another academic hack. If nothing else, Van Gogh's unhappy experience at his atelier cured him of his mania for accuracy, which in any case was beyond his capacity. Even when he deployed his beloved perspective frame, his lines strayed; in fact he required this crutch simply to moor his canvases in reality, taming his compulsion to distort in light of his obsessions. His time at Cormon's had the paradoxical effect of encouraging him to rely on his own instinct more, to embrace expressive exaggeration—in short to be "my own self more." It was a negative lesson, but an invaluable one.

He took away something less tangible but perhaps even more important from his time on the Boulevard de Clichy. For all his difficulties with both his teacher and fellow classmates, this was his real entrée into the Parisian art world, the place where he first met other aspiring artists on equal terms, many of them men of real ability. It's not clear how well he knew Louis Anquetin at this stage; the massier had grown disillusioned with his teacher and was spending less time at the studio and more time pursuing his own experimental modes, often in the company of that other renegade, Émile Bernard. Even so, their paths must have crossed in the atelier, an introduction that would shortly pay dividends.

The other massier, Henri de Toulouse-Lautrec, was also moving away from his master, ridiculing him behind his back and seeking out new means of expression that went beyond the academic formulas taught in the studio. His taste for lowlife dives, an increasing part of his daily routine, now began to seep into his art. He applied the skills he learned in the studio to commercial work, publishing drawings in the popular newspaper *Le Courrier Français*, including one called *Gin*

Cocktail. Unlike many of his contemporaries, he didn't regard such work as merely the means to support a career in the more exalted "fine arts." Instead, he recognized that the production of eye-catching designs for posters and illustrations was a valid (and distinctly modern) form of expression, demanding its own aesthetic innovations.

In the more traditional arena of oil painting, Lautrec, like so many of his colleagues, continued to explore the innovations of the Divisionists, juxtaposing dots of pure color that blended in the eye. The impulse to develop his own distinctive style accelerated in the spring of 1887, when Cormon closed his studio for good, leaving Lautrec free to explore more offbeat directions. Even before he departed, he developed a distinctive technique that had little to do with Cormon's methods, using thinned-out paint that allowed the support (canvas or cardboard) to show through.* This gave his paintings a matte finish that distinguished them from the slick products of a Salon entry, gleaming with coats of varnish. Hartrick, for one, was intrigued by this new approach: "I can still remember vividly how novel and interesting his work looked to me among those of others in the studio. He was painting in turpentine on cardboard, using a very liney method of drawing . . . No one else attempted this method at the time, though many copied it later."[43]

Before he left the studio, Vincent established some kind of relationship with Lautrec, though the worldly Frenchman always seemed to regard him with wry amusement rather than deep affection. Even after his departure, Lautrec made a point of staying in touch. In December he invited Vincent to Le Mirliton, Aristide Bruant's popular cabaret artistique, where a number of his works had been put on permanent

* The method was known as *à l'essence*, with spirits, a reference to the turpentine used to thin out the paint into an almost watercolor-like wash.

display. And soon he was inviting Vincent to his weekly soirées on the Rue Tourlaque, where he cut a decidedly odd figure. Suzanne Valadon, Lautrec's friend and sometime lover, has left a memorable picture of Van Gogh on one such occasion: "He arrived, carrying a heavy canvas which he stood in a corner where it got a good light and then waited for some attention to be shown. But no one bothered. He sat opposite his picture, scrutinizing the others' glances, taking little part in the conversation, and finally he left wearied, taking his last work with him."[44]

The truth is that Van Gogh had none of the wit and antic spirit to succeed in such circles. No doubt Lautrec included Vincent in his life, and then only peripherally, in order to cultivate his well-connected brother. His career was just beginning to take off, and Theo was exactly the sort of dealer who might take an interest in an up-and-comer like himself. But perhaps there was something more. Another misfit, he might have seen in the awkward Dutchman a fellow outcast, doomed through an unfortunate trick of nature to remain apart from the normal run of men. In any case, as he would soon show in his art, Lautrec was a collector of oddities, fascinated by transgression, attracted to excess. Standing all alone in a corner, glowering at the revelers, who repaid his truculence with indifference, Van Gogh must have struck Lautrec as just another fascinating specimen of the human comedy, welcome in his charmed circle not despite his peculiarities but because of them.

It's no coincidence that it was during these months that Van Gogh first portrayed himself as an artist. *Self-Portrait as a Painter* reveals that, despite his struggles at Cormon's, rubbing shoulders with his colleagues gave him permission to count himself a member of that select

brotherhood. The blue workman's smock and round bohemian hat reveal he considers himself—at least on this occasion—as less a gentleman portraitist than an artisan, a man who works with his hands and whose lifestyle marks him as a member of the laboring class. He seems to have based this image on Rembrandt's self-portrait in the Louvre, deploying the Dutch master's distinctive chiaroscuro to give the image a psychological depth. Clearly, he had still not taken up the challenge of Seurat and co., retreating instead to more familiar turf. The colors he shows on the palette he's holding are the same as those he used for the painting: red-orange and yellow ochre, a bit of blue, yellow, green, and brown. This is not the prismatic palette of the Pointillists, nor even the bright hues of the Impressionists. The shades of Nuenen still cast a pall over this Parisian self-portrait, a moody, introspective image of the artist sunk deep in twilight revery.

Of course it's misleading to read too much into a single image. Van Gogh used the process of painting his own features to try on various guises, to explore an identity that was fluid, subject to violent mood swings. They were as much a disguise as a confession, often more aspirational than based in reality. In *Self-Portrait with a Pipe* he once again dons the waistcoat and vest of a bourgeois, reclaiming his spot in respectable society. Rapidly painted in bold strokes, this work demonstrates a newfound confidence in his handling of the brush. It builds on those Antwerp portraits, made under the spell of Frans Hals, in which he attempted to capture an image "in one go." Unlike the *Self-Portrait as a Painter* or the contemporaneous *Self-Portrait with Gray Felt Hat*—both of which seem to collapse in on themselves—this work is outward facing. Despite its still subdued palette, the drama of the brushwork gives this image an assertive presence that points the way toward his mature work.

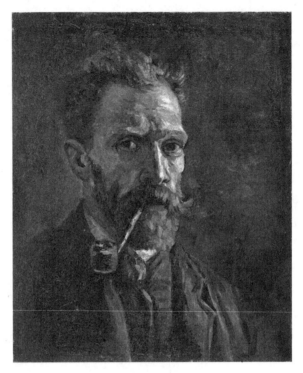

Self-Portrait with a Pipe, 1886

In a final self-portrait from this fall he's left the apartment on the Rue Lepic and seated himself at the local bar, a full glass by his elbow, ubiquitous pipe clamped firmly in his mouth. [see color plate 20] It's an unusual setting, implying a certain amount of make-believe since it's unlikely he actually painted it on site. The countertop and glass of alcohol—beer or wine?—are props, there to set the scene. He may well have had in mind one of those paintings by Manet or Degas depicting Parisian café life, portraits of drinkers alone or in company that hovered somewhere between reportage and social commentary. Van Gogh's purpose here is not simply to record his features but to record his daily round, a kind of visual diary memorializing a typical activity on a typical day.

Once again Van Gogh adopts an overall dark palette, but now strange glimmers begin to penetrate the murk. After first laying down the basic composition, he then adds dots of and crosshatchings in vivid color—complementary reds and greens—that swarm about like fireflies in a dusky sky. Here for the first time we see unmistakable signs that he's taking up the Pointillist challenge. The effort is tentative, the results incongruous—a tonal composition enlivened by a spattering of prismatic hues. But it's a beginning, a sign that the heated debates among his Cormon classmates are finally beginning to register.

As long as the weather permitted, he also continued to paint outdoors. Gray autumnal skies were hardly conducive to experimenting with a brighter color scheme, and most of the cityscapes like *Café Terrace in Montmartre (La Guinguette)* retain a somber palette, with only a few splashes of bright local color to relieve the gloom. He's bolder in still lifes like *Mackerels, Tomatoes and Lemons* and *Prawns and Mussels* [see color plate 21] where, as in his flower still lifes from the summer, he chooses the objects with an eye for vivid contrasts. All of these efforts are characterized by a slapdash approach, recalling "the chaotic fury" his classmates observed, in which he threw colors on the canvas "in feverish haste." After the frustrating drudgery of Cormon, Van Gogh reveled in his independence, throwing off the restraints of the classroom in a brazen show of defiance.

For Theo, Vincent's decision to quit Cormon's was a disaster. Once more his brother had dashed any hope that he was on the road to conventional success. After all the positive signs he'd seen that summer, it was a bitter setback.

Vincent's latest show of fecklessness was all the more disturbing coming as it did at a time when his own career had stalled. By the fall of 1886 he'd been serving as manager of the satellite branch of Boussod

& Valadon on the Boulevard Montmartre for more than five years. Initially he'd been pleased by the appointment, seeing it as a sign that management was grooming him for better things. Supervising his own gallery, he also enjoyed a certain degree of autonomy, though never as much as he wanted or as much as he felt he'd earned. In 1883, a year when the business was particularly slow, he'd been raked over the coals for his poor sales record. He was so distressed by the unfair criticism that he thought about quitting and moving to America. And while he eventually reconciled with his bosses, he continued to wonder if he might not do better elsewhere.

In 1884, old Goupil—the man who'd once partnered with their Uncle Cent to create the juggernaut Goupil & Cie—retired, placing the firm in the hands of his business partner, Léon Boussod, and Boussod's son-in-law, René Valadon. Soon, much of the day-to-day management fell to Boussod's sons, Jean and Etienne. The new regime lacked any relationship or loyalty to the van Gogh family, and Theo felt they had little respect for his judgment and failed to reward him sufficiently for his hard work. They were skeptical as well of his efforts to break into the market for Impressionist work, despite the fact that by 1886 demand for artists like Degas, Monet, Renoir, & co. was robust. Messieurs Boussod and Valadon were reluctant to involve the firm in this more speculative area, placing the bulk of their resources into blue-chip Salon stars. While Theo was able to make an occasional purchase—including his first Monet in 1885 for 680 francs—his budget was never adequate to his ambitions.

He'd been contemplating a change for a while now, and in the summer of 1886 he decided to take the plunge. "I had several artists in mind whose work I admired and with whom I was sure I could do business," he later recounted to Jo Bonger. "André [Dries] shared my views and we arranged that I would approach my uncle, who had once

promised to help me, to get the money we needed to carry out our plan and start a business together."[45]

Vincent, of course, was all in. "I think that it's very good that you've already raised the matter—and broken the ice in so far as you've spoken to the Dutch gentlemen about it &c."[46] He urged him not to proceed with caution but to go "full steam ahead."[47] Such a move, he thought, would not only be good for Theo's soul but for him as well. In Theo's bid for independence, he saw a possible revival of his dream of a true artistic partnership. As long as Theo worked for the eminently respectable Boussod & Valadon, there was no chance he would show the work of his less than respectable brother. Setting up on his own, however, he'd not only find himself on the right side of the barricade but would have an opportunity to take a stand for unknown artists like himself who still struggled for recognition.

Theo raised the matter on multiple occasions during his August trip to Holland, but his uncles remained unmoved. "For a while I was bitterly disappointed," Theo admitted, "so much so that I fell ill."[48] Vincent didn't help matters, nagging him to push on and scolding him when he showed what he regarded as excessive timidity. Full steam ahead was the only speed Vincent knew, a go-for-broke approach that usually ended in crash-and-burn. Theo was reminded of that time three years earlier when he'd urged him to quit his job and come join him on the heath. Now, as then, he was full of advice on how Theo should conduct his life, urging him to risk it all while taking no practical steps himself to help his cause.

In fact, by quitting the studio, Vincent was forcing Theo to retreat. His only hope of earning an income from his art had been to acquire technical skills that would allow him to crank out ingratiating portraits and pleasant landscapes—exactly the kind of discipline Cormon and his colleagues promised to drum into their students. Vincent's inability

to stick with the program meant he'd be unable to support himself for the foreseeable future, ensuring all the burden remained on Theo's reluctant shoulders.

Vincent, too, was frustrated, though he refused to admit responsibility for the predicament he was in. "What regards my chances of sale, look here, they are certainly not much but still *I do have* a beginning,"[49] he wrote to Livens. He grumbled about having to do business with "second class dealers" and complained of the "low prices" they offered, while admitting: "If I asked more I would do nothing, I fancy."[50]* Hartrick recalled even more pointed conversations: "He used to rage from time to time that, though he was closely connected with the picture trade, no one would buy anything he had done. He actually told me that he had never more than 10 francs for a picture."[51]

This last complaint was clearly aimed at Theo. After a honeymoon period in which Vincent's gratitude toward his brother was sufficient to overcome his natural quarrelsomeness, the old resentments were beginning to flare again. His sense of grievance toward his family had built up over the years as he clashed with his rich uncles, particularly Cor and Cent, both of whom had grown wealthy in the picture trade and who, at least to Vincent's way of thinking, had never lifted a finger to help. In fact Uncle Cent had driven him out of the family business altogether, a humiliation from which he'd still not recovered.

Now he placed Theo in the same camp. Living together, the contrast between the paths they'd chosen was made starkly evident. Each morning he felt his gorge rise as he watched his brother don an elegant

* There's no contradiction between Theo's admission that he'd not sold anything and Vincent's complaint about low prices. Many dealers, including Theo himself, took works on consignment, meaning they held the work until they could find a buyer, at which time they split the money with the artist. This is likely the arrangement Vincent had with Portier. But even at these pitiably low prices, no buyers were found.

suit, straighten his silk tie, and head out to the gallery, where he would spend the day serving the same firm that had once treated him so shabbily. There, Theo waited on the very same ladies and gentlemen who once looked at him with such scorn, flattering and cajoling them until they purchased something to decorate their well-appointed apartments. Many of these works, Vincent knew, were by inferior hacks whose only recommendation was a bit of technical finesse. And yet these nonentities still commanded prices he could never dream of. As his frustrations mounted, so did his contempt for the world Theo inhabited. He no longer thanked him for his efforts to keep them both afloat. Instead he despised him for the drudgery he endured to earn his living, and the compromises he made to please his bosses. Once more the barricades went up. Once more Theo found himself on the wrong side.

In December the situation reached a crisis. Dries Bonger reported to his parents: "I've had little time to read because of [Theo] Van Gogh's indisposition. He has had severe fits of nerves, so much so that he was quite unable to move. Yesterday I was astonished to find him entirely back to normal; he still felt stiff, as if he had fallen over, but otherwise no after-effects. He will now finally start to look after his health. He needs to."[52]

Dries followed this up with a startling bit of news: "He has now decided to part from Vincent; living together is not possible." He ended his letter by committing his family to silence: "As I said, you must say nothing to Mrs. [Van Gogh], should you see her, she knows nothing."[53]

Though Dries doesn't explicitly name Vincent as the cause of Theo's collapse, the implication is clear. Indeed, he'd never been a fan, noting the "strange life" he'd led even before arriving in Paris. Shortly after the brothers moved in together, he commented on how Vincent bullied his younger brother, "accus[ing] him of all sorts of things of which he's

completely blameless." Dries had warmed to Vincent a bit during the weeks they'd lived together while Theo was in Holland but continued to view him with a skeptical eye. To the prim Monsieur Bonger, Vincent's slovenly ways and contempt for bourgeois decorum were signs of a disturbed personality. It concerned him that he observed some of the same traits in Theo, qualities he normally hid out of a sense of responsibility and beneath a veneer of good breeding. Dries feared that having his older brother around would bring out the worst.

He also knew the toll that stress took on Theo's fragile constitution. His temporary paralysis may have been largely psychosomatic, but it was serious enough to leave Theo shaken, even months later. "Now I can tell you that last winter I thought I would never celebrate my thirtieth birthday," he told his sister Lies after the worst had passed, adding: "No one knows, and it's better that way, because it would worry the family."[54]

The situation went rapidly downhill after Vincent quit Cormon's. "He was certainly troublesome when he came here last year," Theo confided to Uncle Cor, "but one could see some improvement, I thought. But now he's back to his old self again, and it's impossible to reason with him."[55] Money was, as always, a sore spot, not only for the obvious practical reasons, but because of what it represented. For Theo, condemned to slave away at a career that was increasingly unrewarding, Vincent's lack of appreciation was galling. He didn't hate every aspect of his job: he loved art and was pleased to be surrounded by things of beauty. But he was naturally shy, and he found the strain of glad-handing and sweet-talking all day long exhausting. Gustave Kahn's description of the "pale blond" gallerist, "so melancholy that he seemed to carry canvases as beggars hold their wooden bowls," reveals someone not entirely at ease in the role he'd been forced to assume. But Theo persevered, knowing how many were depending on him.

In his calmer moments Vincent recognized how much Theo had done for him and the rest of the family. Occasionally he even acknowledged his sacrifice. "I really believe that all our lives were, as it were, literally *saved* by you," he'd written Theo from Drenthe. "Ruin averted by the support and protection that we got from you—for me, in particular, it was critical."[56] But just as often he accused him of stinginess, of even wanting to see him fail. He proclaimed his own moral superiority, heaping scorn on Theo's work ethic, rarely acknowledging that his brother's sense of duty was the only thing that allowed him to pursue a higher calling. He was particularly enraged when he discovered, in the apartment, the ledgers Theo kept totting up every franc he'd been forced to expend on Vincent's upkeep over the years.

In these battles, Theo knew he always had an ally in his sensible mother. That February he complained about Vincent's complete indifference to money: "He has painted a couple of portraits that turned out well, but he always does it for nothing. It's a shame that he doesn't have any desire to start earning, because if he wanted to he could do it here; but one can't change a person."[57]

But Vincent's carelessness with money was only a small part of a larger problem: his combativeness and lack of consideration shattered the carefully constructed routine he'd built himself over his years of bachelor living. "My home life is almost unbearable," he confided to Wil: "no one wants to come to see me any more because it always ends in quarrels; besides he is so untidy that the place looks far from attractive."[58] The spacious apartment, with its gleaming floors and marble mantelpieces, had become a pigsty as the chaos from Vincent's studio spilled out into the common spaces. Filthy rags, brushes, and jars of turpentine covered every flat surface, and canvases in various stages of completion piled up in the corners. One guest complained of getting out of bed at night and stepping into a paint pot!

For Vincent, slovenliness was a form of protest—a rejection of Theo's bourgeois lifestyle. When he first came to the city, determined to make himself a painter of modern life, Theo served as his model—"a Parisian through and through," *steely, shrewd.* He was not only anxious to *please* his brother, but to *be* like him. But as long summer days gave way to creeping night, as he beat his head against the limitations of his own abilities and the limited imaginations of his colleagues, he took his frustrations out on the person he loved best, punishing him in order to punish himself. He was compelled to gnaw at the hand that fed him until that hand, raw and bleeding, was withdrawn.

"I wish he would go away and live by himself," Theo cried: "he sometimes speaks about it, but if I were to tell him to go away, it would be just a reason for him to stay. Since I can do nothing right for him, I only ask him for one thing: that he does not cause me any trouble. But by staying with me he does just that, for I can hardly bear it." Theo follows this with a piercing observation: "It is as if there were two persons in him—one marvelously gifted, delicate, and tender, the other egotistical and hard-hearted! They present themselves in turn, so that one hears him talk first in one way, then in the other, and this always with arguments which are now all for, now all against the same point. It is a pity that he is his own enemy, for he makes life hard not only for others but also for himself."[59]

Still, Theo couldn't quite bring himself to throw Vincent out. The thought of banishing him dredged up distressing memories of his brother's epic clashes with their father, of desperate flights to the Borinage or Drenthe, where he'd pushed himself to the brink. Whether close by or in some distant exile, Vincent had an uncanny ability to inflict pain, never sparing his loved ones the agony he felt himself. In any case, where would he go? What would he do with his life? Fear that

his brother might harm himself discouraged Theo from pronouncing the ultimate sentence.

Instead of pushing Vincent out, in December Theo invited a colleague to move into the Rue Lepic apartment. Alexander Reid was a Scotsman working for Boussod's in his native Glasgow. There, he'd had success selling works by members of the Hague School. A stint in Paris, learning from the Dutch *gérant* known to be something of an expert in this field, was just what he needed to burnish his credentials in this area.

Theo pitched this arrangement as a cost-saving measure; Vincent regarded it as a betrayal of their fraternal bond. At the very least it was a not-so-subtle dig at his reckless spending and complete disregard for financial realities. Vincent, for his part, accepted the situation with as much grace as he could muster; for a time he even befriended the Scotsman. "I was very much taken in by him during the first six weeks or two months," he recalled, "but after that period he was in pecuniary difficulties and in the same acted in a way that made on me the impression that he had lost his wits."[60] This is a typical instance of Vincent projecting his own psychological crises onto others. Reid himself recalled a particularly disturbing incident from this period. Confiding in Vincent after a painful breakup with his mistress, Van Gogh "gallantly suggested a suicide pact. This appeared to [him] as altogether too drastic a solution and, as Vincent continued with his gruesome preparations, he decided to make himself scarce."[61]

With Reid gone there was no longer any buffer between the two brothers, who now squared off each night across the dinner table. Long periods of silence were followed by short bursts of anger. Both felt they'd reached a low point in their lives, and neither was in a conciliatory mood.

For Vincent, failure at Cormon's was part of a wider malaise. His darker mood owed something to the change of season; the longer nights and cold weather always left him depressed. But there were more substantive reasons for his discontent. After the better part of a year in Paris, he was no closer to discovering what kind of an artist he wanted to be. His expectation that he'd make more progress at an independent studio than at the hidebound academy had proved illusory. He'd resisted Cormon's instruction as forcefully as he had Verlat's or Siberdt's in Antwerp, meeting their strict discipline with ever more aggressive displays of rebellion.

And while he was struggling to master traditional skills, he was not yet committed to the modernist cause. He'd come to Paris in part to study up close the works of the Impressionists who, Theo told him, represented the vital future of art. But initial encounters with the new painting left him cold. Yes, he tried to meet them halfway, painting street scenes and suburban vistas rapidly, on the fly, lightening his palette to capture the shifting quality of light. But Impressionism was fundamentally foreign to his nature. It was an art of surfaces—brilliant surfaces, to be sure, shimmering, incandescent, dynamic, but surfaces nonetheless. This was never Van Gogh's strong suit. He needed depth, something that spoke to his heart, that relieved his loneliness and reassured him he was still part of the human community.

Nor was it simply a matter of latching onto the appropriate style. For someone as opinionated as Van Gogh, who infuriated friends and family with his dogmatic pronouncements and met any attempt to correct him with defiance, he was surprisingly receptive to even casual social interactions, treasuring a kind word or a sympathetic ear. A small courtesy or polite acknowledgment—all the more precious for being so rare—could cause him to suddenly reverse course as he spun dreams of kindred spirits setting out on a shared pilgrimage.

These dreams of communion almost always ended in disaster, but while they lasted they could have a profound impact not only on his life but on his art.

Thus far Van Gogh had found no one in Paris to talk to, no relationship sufficiently congenial to alter his thinking or his approach to art. But as his relationship with Theo devolved into mutual recrimination and life in the apartment became unbearable for both occupants, Vincent had no choice but to seek companionship elsewhere.

8

The Shop Around the Corner

*"There is no doubt that this plunge into pure color
stimulated him violently, and he piled the oil paint
on in a way that was astonishing and decidedly
shocking to the innocent eye as well as to that of the
more sophisticated."*
—A. S. Hartrick on Van Gogh

*"The great hurricane that renewed French art around
1890 originated in the shop of Père Tanguy, color-
merchant, Rue Clauzel, and in the Gloanec Inn at
Pont-Aven."*
—Maurice Denis

I n Paris, as in The Hague, Nuenen, and Antwerp, Van Gogh had
difficulty finding willing models. After the first few months,
when he managed to coax a couple of women to sit for their
portraits, he'd been forced to paint his own features if he wished
to hone his skills in an area he considered a vital part of an artist's
repertoire. While at Cormon's he'd had a reliable supply of nudes

to paint and draw, though, unsurprisingly, none of his classmates was willing to sit for him.*

But at the turn of the year, Van Gogh finally found a sympathetic subject: a middle-aged man with ruddy cheeks, a close-cropped beard, and a bristling hedgerow of gray hair above a high forehead.** The sitter doesn't look directly at the artist. Instead, he turns his head slightly away, a half-smile playing on his lips. Clearly Van Gogh knows the man well and likes him. Perhaps the warmth he conveys owes something to his relief in having found a willing subject, sparing him the psychologically fraught task of plumbing once more the depths of his own afflicted soul.

Pere Tanguy, 1887

* By contrast, John Peter Russell painted his portrait, a striking image that provides perhaps the most accurate likeness of Vincent van Gogh.

** This is one of the few paintings that can be precisely dated. Van Gogh has helpfully provided the inscription in red paint *janvier '87* (January '87).

In terms of technique, *The Portrait of Julien Tanguy* builds on the slightly earlier *Self-Portrait with Glass*. The overall effect is still somewhat muddled, but now Van Gogh is bolder in deploying contrasting colors to enliven an otherwise muted palette. He uses thinner paint—an almost gouache-like application—which allows the canvas support to show through, providing more light and air around the figure. He applies his brushstrokes calligraphically; they gather about Tanguy's head like flocking birds, as if he's generating his own attractive field. Those "gymnastics" of the summer when he painted "nothing but flowers" are beginning to pay off. "I lately did two heads which I dare say are better in light and colour than those I did before," Van Gogh reported to Livens. "So as we said at the time in COLOUR seeking LIFE, the true drawing is modelling with colour."[1]

The task Van Gogh has set himself in this portrait is far more difficult than merely reproducing the local color of flowers arranged in a vase, "seeking oppositions of blue with orange, red and green, yellow and violet." Now he's conjuring colors where there are none—orange highlights and purple shadows, green flecks to balance the two—creating an independent reality on the canvas that can evoke space and form and generate light without having to resort to chiaroscuro.

This tendency is even more pronounced in another painting from around the same time, the unfinished *Portrait of a Woman*—likely Madame Tanguy—where he surrounds his subject with an aureole of red strokes, for no other reason than to set up a contrast with her green blouse. In the contemporaneous portrait of his roommate Alexander Reid, painted on cheap cardboard, [see color plate 22] he goes even further, rendering flesh and fabric in separate dabs of pure color. Every inch of the surface is filled with nervous marks, like swarms of gnats or motes of dust. The figure is no more substantial than the space around him, emerging or coalescing out of dynamic vortexes. Color is no

longer merely descriptive but exists for its own sake, as do the marks of the brush, which never entirely lose their assertive presence even as they suggest form. Van Gogh traces his evolution in a letter he wrote to Wil later the following autumn: "Last year I painted almost nothing but flowers to accustom myself to a colour other than grey, that's to say pink, soft or bright green, light blue, violet, yellow, orange, fine red. And when I painted landscapes in Asnières this summer I saw more colour in it than before. I'm studying this now in portraits."[2] Seeing more color, his paintings become increasingly luminous—they start to glow. For now, the experiment is not entirely successful. The *Portrait of Julien Tanguy*, like its two companions, is still a hybrid, retaining elements of tonal painting but with hints of the chromatic explosions to come.[*]

The innovations visible in these portraits emerged from his experiences at Cormon's: not the formal lessons, which were depressingly academic, but the urgent debates among his classmates regarding the inventions of Seurat and co. Hartrick was on hand to witness his conversion to the new gospel of pure color: "At this time, Van Gogh was making his first pictures with the division of tones, painting still life, flowers, and landscapes of Montmartre," he recalled. "There is no doubt that this plunge into pure color stimulated him violently, and he piled the oil paint on in a way that was astonishing and decidedly shocking to the innocent eye as well as to that of the more sophisticated, but he had not yet mastered his materials in the way that came to him soon after his arrival in Arles."[3]

Of course this "plunge into pure color" was not completely new, but followed logically from his earliest days as a painter, when he discovered

[*] As is often the case, the present state of the painting only hints at its original appearance. Van Gogh often employed cheap materials in Paris, and the portrait is described as "severely discolored." [See *Van Gogh Paintings*, vol. 3, 44]

the theories of Charles Blanc and, through him, the paintings of Eugène Delacroix. Even so, he's clearly had an epiphany. Part of this is a recognition of the importance of "divided" rather than "broken" tones, that is of contrasting hues that mix in the *eye* of the viewer rather than pigments blended on the palette—a process that yields vivid prismatic colors rather than the murky browns so evident in his earlier work. More importantly, Van Gogh demonstrated a willingness to step outside the bounds of strict realism, to allow color to create its own independent reality on the canvas. It's something he'd talked about for years but rarely achieved. "*True painters are the ones who don't do it in the local colour*," he explained to Theo in a letter in October 1885, quoting from Blanc's *Les Artistes de mon temps*:

> that was what Blanc and Delacroix discussed once. May I not simply understand by it that a painter does well if he starts from the colors on his palette instead of starting from the colors in nature.
>
> I mean, when one wants to paint a head, say, and one looks closely at the nature one has before one, then one might think, this head is a harmony of reddish brown, violet, yellow, all broken—I'll put a violet and a yellow and a reddish brown on my palette, and break them into each other.[4]

Van Gogh's earlier understanding of Blanc's theories allowed him to cling to his tonal approach, "breaking" those complementary hues by mixing them on his palette, where they devolved into different shades of mud. Now for the first time, in January 1887, practice has finally caught up to theory, and even moved beyond. Conversations with his Cormon classmates, as well as opportunities to study the work of Seurat, Signac, and Pissarro up close, forced Van Gogh

to shift the way he conceived his paintings, allowing the play of complementaries rather than shades of light and dark to provide the necessary visual structure.

This small change was crucial, weaning Van Gogh from the art of the past and urging him on to something entirely new. Recognizing that color had a life of its own—providing a vital pictorial armature as well as new expressive possibilities—was the first step on a road that led to abstraction. Maurice Denis, a follower of Gauguin's, admonished his fellow artists: "It is well to remember that a picture—before being a battle horse, a nude woman or some anecdote—is essentially a plane surface coated with colors assembled in a certain order."[5] Taken to its logical extreme, ideas like this would eventually give rise to art that abandoned representation altogether. But decades before the advent of pure abstraction, artists like Van Gogh and Gauguin were beginning to liberate themselves from a slavish adherence to observed reality. The insight that color was an end in itself, not simply a means of reproducing reality, was the crucial breakthrough whose birth is chronicled by works like the *Portrait of Julien Tanguy*. It was a long, hard struggle for Van Gogh to rid himself of the last vestiges of the old master style, but once he threw off the shackles of the past, he reveled in his newfound freedom.

This epochal shift in Van Gogh's art coincided with significant changes in the circumstances of his life. At the very moment his relationship with his brother was imploding, and as his time at Cormon's was coming to an ignominious end—closing off what both he and Theo had believed was his most promising road to success—he was beginning to make friends in the bohemian community of Montmartre and the surrounding neighborhoods. These new acquaintances provided the vital stimulus he needed to take his art in new directions.

Van Gogh first met Julien Tanguy in the fall of 1886. Père Tanguy, as he was affectionately known, was the proprietor of a small shop selling art supplies. His main stock consisted of paints, both commercially produced tubes and a line of inexpensive pigments he ground himself on the premises. The apron he wears in Van Gogh's portrait suggests the hands-on nature of his operation.

Located at 14 Rue Clauzel, a few blocks south of the Boulevard de Clichy, Tanguy's store was a fifteen-minute walk from the Rue Lepic apartment, which helps explain why it took Van Gogh more than six months to make his acquaintance since there were plenty of more convenient establishments where he could purchase his supplies.[*]

Tanguy was sixty-one at the time they met. He had started out as a *broyeur de couleurs* (color grinder) and traveling salesman for the firm of Maison Edouard. One of the places he hawked his wares was the village of Barbizon, near the forest of Fontainebleau. There he befriended many of the "peasant painters" who congregated in the rustic hamlet and became a passionate convert to the new art. His enthusiasm may have been as much political as aesthetic. Tanguy was an old-time socialist, and these humble artisans with their callused hands, unwashed linen, and muddy clogs must have struck him (as indeed they struck some of the more respectable members of society) as radical subversives, fighting, as he was, the good fight against the powers that be.

[*] There were at least two shops more close by where Van Gogh could (and did) purchase his supplies: Rey et Perrod, next door to his first Paris address at 24 rue Laval, and Pignel-Dupont, on the Rue Lepic. Van Gogh continued to receive shipments from both Tanguy and the small firm of Tasset et L'Hôte while he was in Arles. Tanguy's prices were low. He charged, on average, at least 10 percent less for most items than a more established firm like Bourgeois Aîne and Lefranc et Cie.

Naturally, Tanguy got caught up in the events of 1870–71. He fought on the side of the Paris Commune and found himself, like so many of his comrades, imprisoned following the *semaine sanglante*. Returning to Paris in 1873, he set up his own business on the site of his former employers, selling materials at cut-rate prices to the artists who lived and worked on either side of the Boulevard de Clichy.

The bond between Van Gogh and the shopkeeper was as much political as aesthetic. Vincent was not a doctrinaire socialist like the old color merchant; much as he liked to talk about barricades, he'd never actually fought on one. But like Tanguy, Van Gogh had an instinctive sympathy for the downtrodden and shared his contempt for the bourgeoisie. Encountering Vincent in his workman's blue smock, battered bohemian hat, and generally disheveled look, Tanguy must have pegged him instantly as a fellow traveler. And Vincent felt very much the same way about Tanguy. In Arles, when Van Gogh met the postmaster Roulin, he compared him to his Parisian friend, with his "big, bearded face, very Socratic. A raging republican, like *père* Tanguy. A more interesting man than many people."[6]

Now too old to take up arms himself, Tanguy satisfied his impulse to *épater le bourgeoisie*[*] by championing the work of marginal artists, anyone whose style was rough and approach irreverent—anyone, that is, willing to thumb his nose at the establishment. Often he acquired work in exchange for supplies, an arrangement that allowed him to amass a small collection of masterpieces by some of the greatest artists of the age. Among the treasures squirreled away in his back room at the time of his death in 1894 were paintings by Van Gogh, Camille Pissarro,

[*] Literally "to shock the bourgeoisie," the phrase was popular among "decadent" poets like Baudelaire and Rimbaud. Much of modern art and literature can be traced to this simple motive.

Auguste Renoir, Paul Gauguin, Paul Signac, Armand Guillaumin, and Toulouse-Lautrec.

Tanguy's particular favorite, the artist with whom—besides Van Gogh himself—he's most closely associated, was Paul Cézanne. One of the original members of the Impressionist movement, Cézanne had largely abandoned Paris for his native Aix-en-Provence, a rustic city in the south of France.[*] In 1886 he broke with his childhood friend Émile Zola after the publication of *L'Oeuvre*, in which he saw his life ridiculed, his achievements belittled. The death of his father, a successful banker, that October left him financially independent. Now he was free to pursue his increasingly subtle art without the need to earn a living or consider the whims of the fickle crowd. Truculent, solitary, and eccentric, he preferred to work on the pictorial problems he'd set himself far from the screeching critics and ignorant public.

Cézanne's indifference to making sales or even exhibiting his work was one reason he consigned so many of his paintings to the color merchant. Anyone wishing to see what the recluse of Aix was up to—an increasing number in these years as Cézanne's work grew legendary in inverse proportion to its visibility on the Paris scene—had to make a pilgrimage to the little shop on the Rue Clauzel. Then, if the proprietor was in a good mood and had taken a liking to you, he might grant your wish. "He would disappear into a dark room," Émile Bernard recalled,

> behind a brick partition, to return an instant later, carrying a carefully tied packet of restricted dimensions; on his thick lips there would play a mysterious smile, his eyes

[*] Though one of the founding members of the Société Anonyme, Cézanne showed only twice, at the first exhibition in 1874 and at the third, in 1877.

would shine moist with emotion. He would feverishly untie the strings, after using the back of a chair as an easel, and he would then exhibit the works, one after the other, in a religious silence. His visitors would linger behind, making remarks, pointing at sections with their fingers, waxing ecstatic about tones, the matter of style and then, when they had finished, Tanguy would pick up the conversation again and speak of the artist. "Papa Cézanne," he said, "is never content with what he's done. He always gives up before finishing . . . Cézanne works very slowly, the slightest thing costs him a great deal of effort."[7]

On those rare occasions when Cézanne was in the capital, he would usually stop by Père Tanguy's shop. There's no record he and Van Gogh ever met there, or anywhere else for that matter. He apparently once saw some of Vincent's paintings at Tanguy's store, prompting him to comment: "Surely, that painter is crazy!"[8] As for any influence running the other way, Van Gogh never really grasped what Cézanne was up to.[*] Their temperaments, as well as their notions of what art should be, were simply too divergent for mutual comprehension.

Of course the same could be said for Seurat and the other Neo-impressionists. But while their innovations would soon shift the trajectory of Van Gogh's art, no such transformation was effected by his encounter with the art of Cézanne. This may have something to do with the nature of his art, which was far too cerebral for the passionate Dutchman who preferred directness to subtlety, art that pierced

[*] One of Van Gogh's few comments on Cézanne comes from his time in Arles, when he compares the local landscape to that of the master of Aix: "I must say that the few landscapes by Cezanne that I know render it very, very well, and I regret not having seen more of them." [Letter 610, May 14, 1888]

the soul rather than art that nourished the brain. Equally important, while Cézanne was notoriously secretive about his aims and methods, Van Gogh would soon encounter an able proselytizer of the Divisionist gospel, one armed with certainty and easily applicable formulas, as well as the patience to impart them to an eager listener.

The appeal of Tanguy's shop had nothing to do with its amenities. It was dingy and cluttered with his stock of inexpensive canvases, paints, and other paraphernalia of the artist's trade. Van Gogh called it "a poor run-down hole,"[9] while a Danish painter, Johan Rohde, remembered seeing the proprietor grinding colors "in his kitchen [behind a] paltry little shop poorer than the most miserable secondhand dealers."[10]

The atmosphere wasn't improved by the looming presence of Tanguy's wife, Renée Julienne, who stayed close at hand to make sure her kindhearted husband didn't give everything away for free to the artists he admired. Van Gogh was one of the chief beneficiaries of Tanguy's generosity and, thus, felt the lash of her sharp tongue. He paid her back in kind, writing to Theo:

> Xantippe,* *mère* Tanguy and some other ladies have, by some strange freak of nature, brains of flintstone or gunflint. Certainly these ladies are much more harmful in the civilized society in which they move than the citizens bitten by rabid dogs who live at the Institut Pasteur. So *père* Tanguy would be right a thousand times over if he killed his lady . . . but he doesn't do it, any more than Socrates. . . .
>
> And for that reason *père* Tanguy is more closely connected—in terms of resignation and long patience—with

* Xantippe was the famously shrewish wife of the Greek philosopher Socrates.

the early Christian martyrs and slaves than with present-day Paris pimps.[11]

Despite Madame Tanguy's efforts to expel the riffraff, Père Tanguy attracted a loyal clientele, many of them artists of genius who found the company at the Rue Clauzel stimulating. Part of the attraction was the proprietor's generosity, his willingness to extend credit to struggling artists in exchange for their work. One might even get a little useful exposure since he would place his favorites in the window where they might draw the attention of a passerby or even a well-known critic. (Albert Aurier's own introduction to Van Gogh's work came through catching a glimpse of his *Sunflowers* blazing like the noontime sun on the shaded street.) More than that, it was his generous spirit that drew people to him, his zeal for art and his eagerness to discuss it with anyone who shared his passion.

For all his geniality, Tanguy could be stubborn and opinionated, much like Van Gogh himself, which guaranteed they'd clash from time to time. On one occasion a customer saw someone burst out of Tanguy's back room looking as if "he would erupt into flames."[12] It was Vincent van Gogh, provoked by some minor disagreement. Perhaps the fight had been sparked by Mère Tanguy, who'd taken a particular dislike to him. Of all the pitiful artists who wandered into their shop, she contended, he was the least willing to pay. Not only that, but he used paint by the gallon and canvas by the roll, in exchange for which he consigned works that, to her eye, were little better than childish scrawls. As his friendship with her husband deepened so did her dislike, particularly after Van Gogh began inviting Père Tanguy to accompany him on his various unsavory escapades.

By the time Vincent began stopping by, in the fall of 1886, the shop on the Rue Clauzel was more than a place of business: it had become

an artists' hangout, somewhere you could drop by not only to pick up a few tubes of cobalt blue, carmine, or dark madder (pigments Vincent was known to purchase from Tanguy)[13] but to catch up on art world gossip or vent about the latest offerings at the Salon.

It was also a place where you could make connections, as Émile Bernard recalled: "Going back to Tanguy's, still in front of my paintings, I met a gentleman by the name of [Charles] Angrand, also an Impressionist and very well known since the last exhibition of the Artistes Indépendants. He also congratulated me."[14] It had become one of those vital, but informal, sites typical of Paris—far removed from the official circles of the Academy and the École des Beaux-Arts—where all the most interesting ideas were born. Like the Café Nouvelle Athènes or Café Guerbois, where the Impressionists had plotted their own revolution more than a decade earlier, Tanguy's shop became a meeting place for progressive artists and a clearing-house of radical notions. Maurice Denis, a future disciple of Paul Gauguin, recalled the significance of Tanguy's modest establishment in its heyday:

> The great hurricane that renewed French art around 1890 originated in the shop of Père Tanguy, color-merchant, Rue Clauzel, and in the Gloanec Inn at Pont-Aven.* . . . At Tanguy's—he was a former member of the Commune, a gentle anarchistic dreamer—there were spread out for the edification of the young, the revolutionary produc-tions of Van Gogh, Gauguin, Émile Bernard, and their emulators. They hung in disarray next to the canvases of

* Pont-Aven was the name of the village in Brittany where, in the summer of 1888, Gauguin and Bernard invented the movement known as Synthetism.

the uncontested master, the initiator of the new movement, Paul Cézanne.[15]

Denis's recollection is perhaps exaggerated, a case of an older man pining for the glory days of his youth, but there's no doubt that, at least for a few years, Tanguy surrounded himself with a constellation of talented artists, some of whom were in the process of laying the foundations of modern art. It was heady company for Van Gogh, the first time he was exposed to, even embraced by, that creative fraternity known as the avant-garde. No wonder then that, according to Bernard, during these months Vincent "practically lived there."[16]

As Vincent pulled away from Theo, he plunged further into the marginal existence of an avant-garde artist, adopting a lifestyle that included not only wine, but also plenty of women and perhaps even the occasional song—all of which Vincent sampled whenever Lautrec included him in his nightly rounds of Le Mirliton and other nightclubs. Estrangement from his brother propelled him into the arms of scruffy radicals as he taunted him by rejecting his bourgeois upbringing and indulging his taste for bohemia.

The two brothers now lived largely separate lives, inhabiting separate worlds even as they shared the same apartment. The gap between the high-end art dealer and the scruffy artist widened. As Theo set off each morning for the gallery on the Boulevard Montmartre, dapper in the suit and top hat that constituted the uniform of the good bourgeois, Vincent donned his stained smock and loaded up his paint box, easel, and perspective frame and set out once more to capture the sights of the Butte. He returned to the locales he'd painted in the spring and summer, like the *Impasse des Deux Frères* that ran beside the windmills of the Moulin de la Galette, extracting what color he could from the

dull winter landscape. When the weather turned too cold to paint out-
doors, he shut himself in his room, setting up still lifes on his tabletop
that allowed him to continue his chromatic investigations. Whether
working outdoors or in, he usually finished the day at a café, where he
drank heavily, returning home in a belligerent mood.

Van Gogh's discovery of Tanguy's cozy little shop came at a crucial
time. It provided a refuge in stormy seas, an alternative to domestic
turbulence. In Cormon's atelier he'd been mocked by the students,
younger, more sophisticated, more technically adept, and, above all,
more comfortable in their own skins. At Tanguy's, by contrast, he was
a valued customer, welcomed by the proprietor always on the lookout
for rebels like himself, and accepted by the other painters milling about.
Of course even within this bohemian enclave, Van Gogh was regarded
as something of an oddity: opinionated, quarrelsome, a bit of a rube.
But, for the first time in his life, he was part of a community where he
didn't stand out as a misfit at war with the world.

Père Tanguy was a paternal figure who came into Vincent's life just
as the final ties to his real family seemed to be unraveling. Unlike his
other ersatz father, he didn't scold or hold his eccentricities against
him. Fleeing the poisonous atmosphere on the Rue Lepic, Van Gogh
found conviviality, a sense of belonging. There he could linger after a
morning spent painting on the Butte—as long, that is, as Mère Tanguy
wasn't on the warpath—puffing away on his pipe as he engaged in
heated debate with the proprietor. There he could feel he was part of a
club of interesting fellows, colleagues all, exploring the far reaches of
the aesthetic universe. Surrounded by Tanguy's band of radical artists,
Van Gogh didn't come off as inept. Cézanne in particular was someone
who'd managed to create a profound body of work despite his ham-
fisted drawing. Like Van Gogh, he'd been laughed at all his career.
On those occasions when he exhibited with his fellow Impressionists,

the critics tended to single him out as the worst of the worst. Tanguy, for whom such awkwardness was a positive recommendation, accepted Van Gogh in much the same way, showing an appreciation for those qualities that others missed.

Here, then, was a place where he could feel a part of something larger than himself. Tanguy and his cohort were just the company Van Gogh needed on his quest to find his own true voice, an environment where his odd appearance and odder behavior were not immediately disqualifying, but chalked up to the eccentricities that were the mark of an original artist.

In many ways, Tanguy was the opposite of Van Gogh's brother: a man of the working class while Theo strived to present himself the perfect urban flaneur; bohemian rather than prim and proper; generous, even feckless, where Theo counted up every expense in neat ledgers. In a telling letter, written the following summer while Theo was away in Holland, Vincent wrote to complain he only had forty francs left to live on. In praising Tanguy's liberality, there's an implicit rebuke of Theo's penny-pinching ways: "When I started working at Asnières I had lots of canvases and Tanguy was very good to me. He still is, when it comes down to it, but his old witch of a wife noticed what was going on and objected to it."[17]

At this time of fraternal strife, Tanguy represented the father he never had, the one he felt he deserved: unconventional, liberal, and, above all, supportive. Disappointed in Theo, who seemed ever more determined to channel the spirit of the departed Dorus, Vincent sought out the company of the old Communard, making himself at home in the informal community that gathered at the shop on the Rue Clauzel.

For Van Gogh, painting could be an act of defiance as well as a means of forging connections. Or perhaps both should be thought of as two faces

of a single coin, since Vincent's contrarian nature required that committing to a cause meant openly, even violently, rejecting the opposition. Life threw up barricades, and it was important to determine which side you were on. Thus when he decided to become a peasant painter in Nuenen, it was as much about punishing his parents as expressing solidarity with the town's most impoverished residents. Personal rage and humanitarian love often went hand in hand, a scenario that played out in his relationship with Sien Hoornik, in which tenderness and spite seemed equally mixed.

It's no coincidence, then, that just when Vincent's relationship with his brother had reached its nadir, he moved away from the Impressionist style he'd been pursuing since he'd come to Paris. Impressionism was always Theo's thing. For years he'd been urging Vincent to learn from it, to remake his art in their image. And for a while Vincent had done his best to comply.

This dynamic, in which the younger brother took the lead and the older did his best to catch up, was inherently unstable. Ever since Theo had begun to climb the ladder at Goupil & Cie, while Vincent had been unceremoniously sacked, the younger brother, at least when it came to questions of aesthetic judgment, had the advantage. That gap only widened when Theo moved to Paris. His taste was more refined, his views more advanced. Even Vincent had to admit that Theo was more up to date on the latest trends, a deficit that could never be closed by the magazines he received in the mail. Playing second fiddle was not a role that suited Vincent well. He tried to compensate with bluster, making bold pronouncements on matters he knew little about, but he only succeeded in making himself appear naïve in Theo's eyes. The lack of conviction and false starts of his early Parisian works reflect his confusion as he tried to make up lost ground.

Now all that changed. Taking up the challenge of Seurat and his disciples, Vincent leap-frogged his more cautious brother, latching on to the most radical, disruptive movement in Paris to jump-start his flagging career. If this didn't reflect the same kind of belligerence he exhibited toward his parents in The Hague or in Nuenen, it was still an assertion of independence. At the very least it involved a recognition that he could no longer rely on Theo's guidance, but instead had to strike out on his own. The paintings he made over the next few months owe little to Theo's more conservative taste, which had been formed inside the elegant showrooms of Goupil & Cie and the Hôtel Drouot. Instead, they grew out of the new connections Vincent forged both at Cormon's studio and on the Rue Clauzel, the kind of marginal spaces where, at least in Paris, the real creative work was done. They embodied an edgier, more down-market aesthetic, hinting at subversion and carrying a faint whiff of revolution. This was not a world with which the fastidious Theo was particularly well acquainted, or in which he was particularly comfortable. During these months, on either side of the New Year, Vincent began to emerge from the shadow of his younger brother, embarking on a course that would force Theo to scramble to catch up and would lift him onto the stage of history.

Van Gogh's bolder approach is on full display in a pair of still lifes he painted shortly after the portrait of Père Tanguy. He returned to a subject that had obsessed him a few months earlier, painting old work shoes in various configurations. But what a difference a few months make! While the earlier versions show little advance on the chthonic palette of *The Potato Eaters*, the new ones are bursting with color. The version at the Van Gogh Museum, painted on cardboard, is built around an improbable clash of green shoes against a warm, pinkish-brown background, while the composition from the

Baltimore Museum of Art involves a standoff between the purple
cloth and the earth-and-rust-toned leather. [see color plate 23] The
real subject of these paintings is not the footwear itself, but rather
the abstract play of color, animated by a newly energized brushwork.

He continued these experiments in a number of still lifes: one
featuring a basket of crocus bulbs, another a pot of chives, and still
another a basket filled with hyacinth bulbs; there's also a table with
three novels casually strewn on top.* Van Gogh's return to still life
was an indication he was getting back to basics, investigating the
elements of a new artistic vocabulary. Working in a genre in which
he was able to control every element of the composition allowed
him—as it had in the floral arrangements and plaster casts of the
summer—to concentrate almost exclusively on technical problems.
Varying his brushstroke and his palette, he tried out different effects,
putting his newfound command of color harmonies and dissonances
to the test. This is most evident in his *Flower Pot with Garlic Chives*
[see color plate 24], organized around the dominant theme of red
and green complementaries, along with secondary notes of violet and
yellow, orange and blue. As is often the case, these apparently neu-
tral subjects carry a hidden psychological or emotional subtext. The
young chives and baskets of bulbs point to the hope of a seasonal
renewal, while the novels—a *Roman Parisien* by Jean Richepin, a
novel by Edmond de Goncourt, and another by Émile Zola—signal
his ongoing commitment to the Naturalist cause. Lighter in tone
and lighter in touch than his previous efforts, these still lifes reveal
a bounce in his step as he sets off in new directions.

By now Monticelli's influence has waned. Those corrugated sur-
faces built up from dollops of thick pigment are set aside in favor of

* The last two, both in an unusual oval format, form a matching pair.

translucent washes that allow the cardboard or canvas support to show through. This technique, known as *peinture a l'essence,* imparts luminosity to these works, giving life to the brighter colors he now favors. As Hartick pointed out, it was Toulouse-Lautrec who pioneered this novel technique, which soon found many imitators among their classmates. In fact, Lautrec's fingerprints are all over Van Gogh's work from these transformative months. If Julien Tanguy's paternal presence encouraged his artistic rebirth, Lautrec seems to have played the role of midwife. Van Gogh was clearly enthralled with this decadent Frenchman who seemed to know everyone and everything about Paris, particularly the seamier side to which he himself was instinctively drawn. Van Gogh strengthened their bond by introducing him to Tanguy's store, where his former classmate was soon included in the cast of colorful characters who gathered on the Rue Clauzel. Lautrec reciprocated, including Vincent in his posse as he prowled the various nightclubs in the vicinity, including Aristide Bruant's famous Le Mirliton, where they visited together the permanent exhibition of his works on the walls.

Soon enough, other artists will take up the role of Vincent's mentor, but Lautrec deserves credit as the first to induct him into the ranks of the avant-garde. It was under the influence of the senior massier from Cormon's studio that Van Gogh first began to grapple seriously with the movement that in 1886 defined the cutting edge. Like many of his classmates—especially the fellow members of "the triumvirate"—Lautrec had been captivated by the innovations of Seurat and his

* Hartrick's comments that at this time he "piled the oil paint on" are in fact a
 bit misleading. As is often the case in his memoirs, written many years after
 the fact, his chronology tends to be a bit confused. Some of this confusion is
 understandable since at the time Hartrick knew him Van Gogh was cycling
 rapidly through many different modes of painting.

followers after seeing their work at the Eighth Impressionist Exhibition in May, and again later that August at the Salon des Indépendants. But Lautrec, a strong personality with an already highly developed sense of his own style, refused to become just another slavish imitator. Instead, he adapted their innovations to his own specific needs.

Toulouse-Lautrec, *Aristide Bruant*, 1892

Lautrec's great gift was his mastery of line, of the whiplash contour that possessed its own inner life, a talent he used to such brilliant effect in posters he designed for the performers at the Moulin Rouge and Divan Japonais. In Lautrec's hands Divisionism was no longer

synonymous with Pointillism. Rather than amassing a uniform array of identical dots—a technique that, as its critics pointed out, reduced Pointillist paintings to frozen tableaux, each square inch of canvas exactly like every other—Lautrec animated his with tiny darts that flow and swoop, imparting a sense of dynamic movement. His short calligraphic marks better suited his essentially draftsmanlike approach. A slice of Parisian café life like *Poudre de Riz* (*Rice Powder*), depicting a young lady seated alone at a table, could never be mistaken for a work by Seurat or Signac. Swarms of needlelike dashes cause the whole scene to vibrate with hidden potentialities.

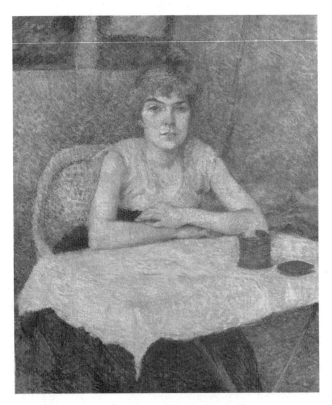

Toulouse-Lautrec, *Rice Powder*, 1887

This approach was more congenial to someone with Van Gogh's forceful personality than Seurat's monastic discipline. It's impossible to imagine Vincent spending untold hours in the studio applying tiny dots of color with the soulless precision of an automaton. Lautrec's technique, by contrast, could accommodate his own more muscular approach and express his own passionate nature. It's significant that Theo eventually purchased *Poudre de Riz* for his own collection—almost certainly on Vincent's recommendation. In the summer of 1888, Vincent compared his own portrait of the peasant Patience Escalier to Lautrec's scene of urban ennui: "I don't believe that my peasant will do any harm, for example, to the Lautrec that you have, and I dare even believe that the Lautrec will, by simultaneous contrast, become even more distinguished, and mine will gain from the strange juxtaposition, because the sunlit and burnt, weather-beaten quality of the strong sun and strong air will show up more clearly beside the face powder and stylish outfit."[18] Now, a year and a half and 500 miles removed from Lautrec's Parisian dives, Van Gogh reaffirms his connection to his former classmate while acknowledging the distance he's traveled. Reclaiming once more the role of a painter of country life that he'd embraced in Nuenen, he cedes the urban landscape to artists like Lautrec whose natural habitat is the heart of the city.

It's Lautrec's unorthodox version of Divisionism that catalyzes Van Gogh's breakthrough in the winter of 1887. Lautrec, in fact, was Van Gogh's first artistic infatuation, someone whose social ease he envied and whose artistic style he admired. Of course he'd had his crushes before. Anton Mauve comes to mind, before, that is, he rebelled against his rigid pedagogical methods. For a time Van Gogh also claimed Anton von Rappard as an artistic soulmate, but Rappard was too unformed himself to leave much of a mark on his friend's

development. In the end, it was Lautrec's tolerant attitude as much as his evident skill that allowed him to play such a vital role in Van Gogh's artistic development.

Their relationship set the pattern for Van Gogh's remaining time in Paris. Before, he'd generally found it easier to attach himself to masters who were either far away or long deceased: Millet, Delacroix, Rembrandt, Hals, Rubens, and Monticelli—artists he revered from afar, raising each one on a pedestal for a time before replacing him with a new god. Flesh-and-blood idols were more problematic since they inevitably turned out to have feet of clay.

Lautrec was the first artist who managed to navigate the choppy waters churned up in Van Gogh's wake. He was a powerful presence in his own right, a charismatic figure who possessed charm and wit, who was popular without being insufferable, magnetic in his own peculiar way. As a friend from Cormon's described him: "His most striking characteristics, it seemed to me, were his outstanding intelligence and constant alertness, his abundant goodwill toward his devoted friends, and his profound understanding of his fellow men."[19]

Most of all, he didn't look down on Van Gogh, more intrigued than repelled by his peculiarities. That winter, in a token of their friendship, he drew his portrait in sparkling blues and gold—"a good likeness,"[20] according to Hartrick. [see color plate 25] Admittedly, it's not an image that conveys much intimacy. The pastel shows Vincent in profile, seated at a café table with only an alcoholic beverage for company, like one of those "fallen" women who form his usual subject. Lost in his own world, he's apparently unaware he's being sketched. Nothing in the portrait suggests a real human connection. Instead, Lautrec treats Vincent as another interesting

specimen, no different from the dozens of strangers whose paths crossed his in the course of an eventful day.*

Still, even such a casual regard was enough to buoy Vincent's spirits, particularly during a period when home life was so painful. His relationship with Lautrec is typical of the one-sided friendships he tended to make. The temperature was always hotter on his side as he took any courtesy as a sign of profound meeting of minds, and any slight as proof of irreconcilable differences—a dynamic that would play out most violently with Paul Gauguin. Hartrick was aware of their friendship but never actually saw them together, indicating a relationship that was more casual than Vincent imagined.[21] Vincent met Lautrec's ironic detachment with ardor. As usual he was all in, while the louche, dissipated aristocrat looked on with wry amusement. He invited him to his soirées but then ignored him, preferring to spend his time with more entertaining company. As always, one shouldn't discount the possibility that he was simply using Vincent. The hope that Theo might take an interest in his art hovered somewhere in the background.

But however illusory, these friendships were crucial to Vincent's development. After struggling alone for so many years, he finally felt he was part of a community, even if he remained something of an odd man out. The scene Suzanne Valadon described where Van Gogh sat alone at the party, waiting in vain for someone to express an interest in his painting, reflects the sad reality that even in this tolerant crowd Vincent stood apart, incapable of making small talk or exchanging the

* This pastel ended up in the Van Gogh brothers' collection. Lautrec may have exchanged it for one of Vincent's paintings, a view from the window of his rue Lepic studio. If the exchange actually happened in early 1887, it's one more indication of Van Gogh's rising stature in the Paris art world.

normal courtesies. But to some extent that didn't matter. The same inability to read social cues that made it difficult to form relationships meant that he was often oblivious to the fact that his feelings weren't reciprocated. (This was even more pronounced when it came to his romantic entanglements!) He may well have read Lautrec's lack of overt cruelty as a sign of warmth that wasn't actually there. But at least Lautrec didn't actively push him away, which distinguished him from most of his colleagues at Cormon's.

Surprisingly in an artist famous for his fierce independence, Van Gogh was remarkably impressionable when anyone actually extended the hand of friendship (real or imagined). Throughout his second year in Paris, we can see his art shift back and forth depending on the company he kept. This produced some unfortunate results as he changed directions with the ease of someone changing his clothes, altering his aesthetic wardrobe to fit in with whomever he was trying to impress. But ultimately this chameleon-like flexibility worked to his advantage, as he cycled through every *ism* playing out on the Paris scene before arriving at a brilliant synthesis of his own. In two short years he got a crash course in modernism that for others took a lifetime. His eagerness to belong allowed him to grow more rapidly than if he'd taken a more dogmatic approach.

Even at the height of his "Lautrec Period," in the winter and early spring of 1887, Van Gogh never lost his distinctive personality. The work of the younger man served as a catalyst, but there's a vigor to Vincent's work, a sense of perpetual motion, that distinguishes it from its more controlled model. *Carafe and Dish with Citrus Fruit* [see color plate 26] is characteristic. Built around an opposition of complementaries—yellow fruit casting lilac shadows, the apparently arbitrary blue-green surface of the table forming a striking contrast

with the red stripes of the wallpaper—it demonstrates his continuing interest in color theory. Unlike Lautrec, for whom the human, social element is always paramount, Van Gogh, at least in these works, seems intent on exploring purely abstract pictorial values.

Having abandoned the use of dark shadows, Van Gogh needed other methods to organize space. Parallel lines—derived from the hatchings used in etchings and pen-and-ink drawings—now carry the burden of suggesting three-dimensional form, allowing color to blaze forth in its full intensity. Works like *Carafe and Dish with Citrus Fruit* and the contemporaneous *Dish with Citrus Fruit* look as if they could have been done in pastel or colored chalk, media favored by not only Lautrec but Edgar Degas, whose work he knew and admired. Line, like color itself, has largely emancipated itself from any descriptive role. The swirling marks of cerulean and cobalt blue that form the tabletop bear no resemblance to anything he could possibly have observed. They follow their own aesthetic logic; they create their own autonomous reality.

Van Gogh puts these new discoveries through their paces in a series of paintings that reprise the studies of plaster casts he painted the summer before. This time he concentrates his efforts on a headless, armless torso of an ancient Venus, perhaps relieved to replace the flesh-and-blood versions from Cormon's with a less disconcerting simulacrum. There's an unexpected elegance to these works, as if freed from the erotic charge of an actual human body he was able to appreciate the beauty of pure form. These paintings reveal a startling advance on those earlier efforts, a lightness of touch, a surehanded control, that make those other efforts seem crude in comparison. Above all, Van Gogh deploys his newfound understanding of Divisionist color—layering pastel-like strokes of warm and cool hues—to model his forms in light and space, providing a far more nuanced and richly satisfying experience.

Plaster Cast, *Venus*, 1887

With chiaroscuro banished, Van Gogh defines his masses through bold outlines. Once again Lautrec shows him the way. Contours confidently set down with the tip of the brush recall Lautrec's command of the sinuous profile. He no longer labors to reproduce exactly what's in front of him. Instead, while never straying too far from reality, he seeks out purely pictorial values: striking contrasts of hue, arabesques that have their own dynamic flow and are only loosely based the objects they define. In retrospect one can detect a decisive tilt toward abstraction, a willingness to take leave of mundane fact and alight in territory governed by the imagination.

Sometime that winter a fresh new face appeared at Tanguy's shop on the Rue Clauzel. It belonged to the boyish, willowy Émile Bernard, former enfant terrible of Cormon's classroom. "A breath of revolt had blown through the theories of the place as soon as I entered the studio,"[22] he boasted, using his expulsion to punch his ticket into the avant-garde. Lautrec's portrait of his nineteen-year-old friend captures some of that youthful bravado. Sporting an adolescent's hopeful moustache and an artfully tousled mop of light brown hair, he appears both cocky and vulnerable, with a hint of that impish streak that caused him to provoke his teacher.

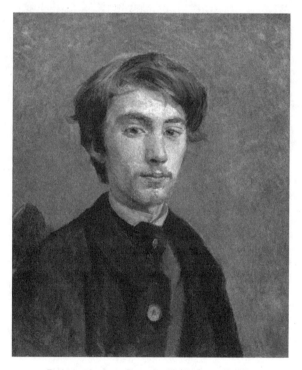

Toulouse-Lautrec, *Portrait of Emile Bernard*, 1886

Like many artists, Bernard came from a thoroughly middle-class background and had to battle the prejudices of his parents in order to

pursue his vocation. Bernard's father, a well-to-do merchant, had only reluctantly allowed his son to pursue his dreams. When Émile betrayed his trust by getting himself expelled, Bernard senior tossed his brushes and paint box into the fire and demanded he join the family business. Émile had other ideas. In April 1886 he set out on a *"voyage à pied"*[23] through northern France, where he lived a vagabond life and painted the rugged, picturesque landscapes of Normandy and Brittany.

In August he arrived in Pont-Aven, a rustic Breton village popular with artists and other bohemian types. "There is . . . an impressionist named Gauguin," he wrote to his folks back home, "a very strong fellow; he draws and paints very well."[24] The meeting did not kindle an immediate friendship, but Bernard was sufficiently impressed with both Gauguin and the artist's colony of Pont-Aven to make the journey the following two summers.

Bernard returned from his travels in October, stopping by his old studio to catch up with his former classmates. "It was there that I first saw Vincent van Gogh, who was painting,"[25] he recalled. He apparently stopped by a second time, late one afternoon when all the other students had gone home, and observed him alone, hard at work: "Seated before a plaster cast of a classical sculpture, he copies the beautiful forms with the patience of a saint. He wants to seize hold of those contours, those masses, those reliefs. He corrects himself, passionately starts afresh, erases, until finally he wears a hole in the paper with the vigorous rubbing of his eraser."[26]

Bernard didn't attempt to engage him on either occasion: Van Gogh's intense focus and generally off-putting demeanor would have discouraged any attempt at small talk. But the Dutchman evidently made a strong enough impression that Bernard recalled these encounters decades later. It was only when he bumped into him again, this time in the friendly confines of Tanguy's paint shop, that the two

actually spoke. By then, they were both Cormon dropouts, which undoubtedly helped to launch their improbable friendship.

Vincent van Gogh and Émile Bernard certainly made an odd couple. In the first place there was the large age gap; Van Gogh was fifteen years older than the Frenchman. More than that, he was a veteran of life's hard knocks, scarred in both body and soul by the struggles he'd endured, while Bernard was still a teenager unacquainted with tragedy, or much of anything at all. Equally striking were differences in temperament. For Vincent, art was a matter of life and death, a lifeline desperately reached for by a drowning man, while Émile regarded life in bohemia as something of a lark. Van Gogh was forced into the avant-garde because he had nowhere else to go. Bernard, while he liked to cast himself as a rebel, always knew just how far to push things, and was sure to pull back whenever it looked like life might become really uncomfortable. By the time he set out on his backpacking tour, he'd reconciled with his father and was assured he had a comfortable home to return to whenever he wanted. Of course Theo provided Vincent a similar safety net, but while Van Gogh wrestled with his inner demons, lashing out at those closest to him in a rage of self-loathing, Bernard's rebelliousness was little more than a fashionable pose.* When Vincent met him in the winter of 1886–1887, he was a young man thirsting for fame, articulate, full of himself, happy to provoke, and eager to impress. He was also on the lookout for anyone who might boost his budding career as an artistic provocateur. Like many of his colleagues, he attached himself to Van Gogh in part because he knew that through him he might establish a useful connection to his art-dealer brother.

* Like other founding members of modernism—André Derain comes immediately to mind—Bernard abandoned his earlier radicalism, becoming later in life a defender of traditional values.

Vincent, for his part, was delighted with his new companion. His latest friendship added to his sense that he was a member of the club. Always on the lookout for sympathetic understanding, he was flattered by the attention of this charming and charismatic youth. Indeed, Bernard's reputation had preceded him. Though he was no longer a student at Cormon's by the time Van Gogh showed up on the Boulevard de Clichy, he was already something of a legend, his revolt and subsequent expulsion having made him a hero to the more progressive elements at the atelier.

While Bernard was off on his travels, his parents had moved to Asnières, just beyond the northern slopes of the Butte de Montmartre. This pleasant suburb along the Seine had long been a destination for plein-air painters, with numerous inns and outdoor cafés catering to bathers, boaters and sun worshippers. Close by is the Island of La Grande Jatte, where Seurat set his most famous masterpiece, and a little further north the town of Argenteuil, which Monet and other Impressionists had discovered in the early 1870s.

It was the perfect spot for a budding artist to set up shop, a short walk from the heart of Montmartre but rich in the kind of sights that appealed to the contemporary landscape painter. Happily for Bernard, his doting grandmother—overcoming his father's objections—had built him a little studio where he could work. "Vincent often came to see me in the wooden atelier constructed in the garden of my parents at Asnières," Bernard recalled. "It was there that we made together the portrait of Tanguy;* he also commenced one of me."[27] These joint painting sessions chez Bernard came to an abrupt end when Vincent

* This is apparently a different version from the one currently in the Ny Carlsberg Glyptotek in Copenhagen. Bernard says Van Gogh never completed it. Bernard painted his own portrait of Julien Tanguy in 1887, and Van Gogh another in 1888, this one a true masterpiece. (See below)

quarreled with Bernard's overbearing, overly bourgeois father. After storming out in a rage, Vincent was permanently barred from the premises. Their friendship endured, but instead of meeting in the backyard of his parents' house in Asnières, Bernard now made periodic visits to the apartment on the Rue Lepic.

Bernard not only offered Van Gogh much needed companionship. He possessed a level of slick competence that gave the still rough-and-ready artist some useful pointers. Unlike the ironical Lautrec or the rigid Cormon, Bernard provided just the right amount of gentle nudging, along with plenty of encouragement, to allow Vincent to flourish.

Bernard was also a good talker, which was crucial for someone starved, as Vincent was, for intellectual give-and-take. Since his decision to become an artist more than six year earlier, he'd worked diligently and largely on his own to master the rudiments of art: first on a practical level, plowing through the exercises of Charles Bargue; and later by delving into the theories of Charles Blanc and Michel-Eugène Chevreul. Before coming to Paris, most of what he knew came from books and, on those rare occasions when he had the opportunity to study actual masterpieces in museums, he looked at them through eyes conditioned by what he'd read. His letters to Theo are filled with bold pronouncements, the dogmatic certainty with which he presents them masking his deep insecurity. "*The ancients didn't start from the line but from the centres*," he lectured Theo in a typical passage. "That is, beginning with the circular or elliptical bases of the masses instead of the outline. I found the right words for the latter in Gigoux's* book, but the thing itself had already occupied me for a long time."[28] Even after arriving in the City of Light, he'd toiled mostly on his own, excluded

* Jean-François Gigoux (1806–1894) was a French artist and writer.

from those vital conversations over the café table that were the labora-
tories of avant-garde practice. Bernard fed his hunger for conversation
about art, providing the vital intellectual underpinning for discoveries
he was making on his own.

Van Gogh's friendship with Bernard didn't immediately alter the
trajectory of his art. Rather, it reinforced tendencies already building
under the influence of Lautrec. Bernard, like his former classmate,
was (at least in the winter of 1886–1887) firmly in the camp of Seurat
and co. "Almost all of us were forced by theory into Pointillism,"[29]
he recalled of this particular period of his life. Their conversations at
Tanguy's or in Asnières revolved around the laws of "simultaneous con-
trast," optical vibrations, the impact of placing complementaries side by
side and allowing them to mix in the eye, and other pet concerns of the
Divisionists. It was at this time that Van Gogh fashioned for himself a
box filled with balls of colored yarn, which he could twist together to
explore how one color affected the perception of a contrasting hue—a
process recommended by Chevreul. "He was particularly pleased with
a theory that the eye carried a portion of the last sensation it had
enjoyed into the next," Hartrick recalled, "so that something of both
must be included in every picture made."[30]

If Bernard's enthusiasm for Pointillism would soon wane, the same
could not be said for the latest matriculant on the Tanguy campus.
"Yes, I knew Van Gogh from Père Tanguy's,"[31] Paul Signac recalled
years later, long after he'd become a grand old man of French art
and Van Gogh had become legend. Born in the year of the Salon des
Refusés, Signac was only twenty-two when Van Gogh first encoun-
tered him browsing the cluttered shelves of the Rue Clauzel. Like
Bernard, he was the son of a prosperous merchant from Asnières,
but unlike the cocky adolescent he was already a force to be reckoned
with on the avant-garde scene. Not only was he Seurat's most able

and articulate spokesman, but his formidable intellect and outgoing, if somewhat overbearing, personality meant he was eager to take on the hard missionary work that his friend considered beneath his dignity.* He was a prolific writer and proselytizer, someone for whom a theoretical armature was as necessary a part of making a painting as canvas and stretcher bars. His professorial manner comes through in his essay "From Delacroix to Neoimpressionism":

> The role of dotting [Pointillage] is more humble: it simply makes the surface of the paintings more lively, but it does not guarantee luminosity, intensity of color, or harmony. For the complementary colors, which are allies and enhance each other when juxtaposed, are enemies, and destroy each other if mixed, even optically. A red and a green surface, if juxtaposed, enliven each other, but red dots mingled with green dots make an aggregation which is gray and colorless.[32]

Signac's paintings can appear somewhat arid and programmatic, a consequence of his reliance on rules rather than intuition, but they were impeccably crafted and accessible, demonstrating how Divisionist principles could be applied successfully to a wide range of subjects. [see color plate 27] If Seurat played the role of Jesus in the new movement, Signac was Saint Paul, indefatigable preacher to the gentiles, spreading the good word wherever he went.

* Signac cast a long shadow over modern French art. In the first years of the new century, Henri Matisse fell under his spell and for a few years was in thrall to the Divisionist gospel. Matisse finally broke free of his influence in 1905 with his early masterpiece *Joy of Life*. Upon seeing it, Signac commented: "Matisse . . . seems to have gone to the dogs." [See Unger, *Picasso and the Painting that Shocked the World*, 227]

Seurat, *Portrait of Paul Signac*, 1890

Signac's influence in the Parisian avant-garde extended beyond his role as apostle of Divisionism: As a cofounder of the Salon des Indépendants, he was one of the most effective promoters of new art, a central figure in the city's progressive art scene. The friendship of this formidable figure was quite a feather in Vincent's cap, a sign he was on his way. A painter with an established reputation, well respected and well connected, Signac was someone who could vouch for him in the face of all the doubters (including Theo) and affirm his status as a card-carrying member of the Parisian avant-garde.

The results of these new friendships were apparent as soon as the weather thawed sufficiently for Van Gogh to venture outdoors. By March 1887 he was ready to set aside his tabletop experiments, shoulder his portable easel and perspective frame, and tackle once more the distinctive features of the local landscape. But now, rather than warmed-over versions of Barbizon paintings or secondhand attempts at Impressionism, he viewed his suburban subjects through eyes conditioned by the Pointillist revolution. "[Van Gogh] tried out a free form of Divisionism on Signac's advice,"[33] Bernard recalled, "free form" being the operative phrase. As the damp spring air filled his lungs, a new light emerged, a sparkle of noonday sun. It's as if the cataracts had been surgically removed and he saw the world for the first time in its true colors. Characteristic of this period is *Montmartre: Windmills and Allotments*. Since the branches are still bare and the gardeners have just begun to sow, it must have been painted sometime in March or early April. Compared to his paintings of the same hill from the previous summer, this version is bursting with vivid prismatic hues: dots and dashes of orange, purple, green, and blue. Van Gogh continued to deploy the *à l'essence* technique favored by Lautrec, thinning out his paints and allowing the blue-gray underpainting to show through, capturing the effect of watery early spring light. Typically, Van Gogh applied the Divisionist dot haphazardly, with none of the programmatic rigidity of Seurat or Signac. No matter how closely he clung to Pointillist doctrine over the next few months, he could never maintain the strict discipline necessary to marshal those thousands of uniform dots necessary to fashion a Neo-Impressionist masterpiece.

In retrospect, Van Gogh's involvement with Pointillism was only a bridge, a vital stage on a journey to a still unknown destination. It could hardly have been otherwise: The frozen majesty of Seurat's great

masterpieces, the icy perfection of Signac's landscapes, are antithetical to Van Gogh's volcanic, erratic personality. He himself recognized this. "What's Seurat doing?" he inquired of Theo six months after leaving Paris. "I often think about his system, and yet I won't follow it at all, but he's an original colourist, and it's the same thing for Signac, but to a different degree; the Pointillists have found something new, and I like them very much all the same."[34] He then goes on to make a crucial distinction: "But I—I say so frankly—I'm returning more to what I was looking for before coming to Paris, and I don't know if anyone before me has talked about suggestive colour. But Delacroix and Monticelli, while not talking about it, did it."[35] Divisionism liberated him once and for all from those "broken" tones he'd derived from his own eccentric interpretation of Charles Blanc's theories, encouraging him to discard the last vestiges of tonal painting he'd adopted during his early years as an artist when he worked almost exclusively in black and white.

Montmartre: Windmills and Allotments, 1887

Still, one final ingredient was lacking to make him into an artist of powerful originality. He hints at this when he tells Theo his idea of "suggestive color"—color not merely as a means to reproduce the quality of light or to create pleasing patterns on the surface of the canvas; but rather color as the vehicle to convey emotional states or deeper symbolic meanings, color as a purely *expressive* quality, independent of all optical phenomena.

That revelation had not yet come to him in the early spring of 1887, but there's no doubt that the brilliant chromatic experiments of those months laid the groundwork for that final breakthrough. Throughout this period, Signac rather than Bernard was the dominant influence. More experienced and more sure of himself than the teenager, Signac was happy to take the Dutchman's education in hand. These lessons were both theoretical and practical, conducted not only in discussions at Tanguy's store but out in the field.

Van Gogh proved himself an eager, perhaps too eager, student, his enthusiasm often getting the better of him. The reserved Signac was both amused and a bit unnerved. "Van Gogh, dressed in a blue workman's blouse, had painted little dots of color on his sleeves," Signac recalled. "Sticking close to me, he shouted and gesticulated, brandishing his large, freshly covered canvas, and with it he polychromed himself as well as passersby."[36] From a novitiate, he soon made himself pope. As always, he embraced his latest fling as if it was the love of his life. This new, brighter palette was not merely a useful tool but the answer to all his problems. He now saw the world through the prism, scattering rainbow hues wherever he went.

He applied the principles of simultaneous contrast not only to the natural but also the urban landscape. In March or April, around the same time as he painted the garden plots on the rear-facing slopes of

Montmartre, he tackled the busy corner of the Boulevard de Clichy.*
[see color plate 28] As he did in the *Portrait of Julien Tanguy,* Van Gogh
discovers colors where none exist, rendering the dull pavements and
neutral facades in strokes of violet and orange, finding tints of blue
and green in the shadows.

He takes a similar approach in a pair of paintings rendering the
view out the living room window of the Rue Lepic apartment. It was
the same vista described by Theo in a letter to a Dutch friend: "A
magnificent view across the city with the hills of Meudon, St. Cloud,
etc. on the horizon, and a piece of sky above it that is almost as big as
when one stands on the dunes." He added: "With the different effects
created by the variations in the sky it is a subject for I don't know how
many paintings."[37] Pencil lines still faintly visible beneath the thin paint
reveal that Vincent placed his trusty perspective frame into the window
itself, using as a focal point the distant Palais du Trocadero. In both
the version at the Van Gogh Museum and a final version in a private
collection, Van Gogh frames the distant view with the buildings in the
foreground. In June, he rendered the view out the window in slabs of
green and gray, thick brushstrokes adding to the architectural solidity
of the forms. Now, the following April, he's dissolved everything in
light. Here, the Neo-Impressionist technique comes to his aid, the
shimmering dots and dashes of pure color lightening these hulking
masses, as if both masonry and distant sky are made from the same
gossamer material sparkling in rainbow hues.

This was in many ways a season of returns, in which Van Gogh
revisited many of the subjects he'd tackled earlier as if to document how
far he'd come. In the early spring he went back to a subject that had

* The site of Cormon's studio can be seen on the far right of the painting. Both
 Seurat and Signac lived farther up the street.

occupied him in the early months of his stay in Paris, rendering his own features in numerous self-portraits. Again, the choice of subject seems more a matter of convenience than psychology, as he took advantage of what was near at hand to investigate issues that were largely technical. In his letter to Horace Mann Livens, he refers to "heads" rather than portraits, noting with satisfaction that they "are better in light and color than those I did before."[38]

It's not surprising that he tried to tackle this subject in the new mode he'd learned from Lautrec, Bernard, and Signac. Portraiture played a larger role in Van Gogh's oeuvre than in that of most of his contemporaries—one more instance of a conservative streak in which he attached himself to genres others considered outmoded—so it was understandable that he wished to explore it through a Neo-Impressionist lens. In most of the self-portraits from this time, he portrays himself not as an artist or a member of the urban proletariat, but in the jacket and starch-collared shirt of a respectable bourgeois gentleman. Each of these shows an advance in terms of color on his portraits of Julien Tanguy, as he abandons neutral tones in favor of juxtaposed slashes or dots of bright color that blend in the eye. In the self-portrait at the Art Institute of Chicago [see color plate 29], he takes advantage of his red hair and beard to build the painting around the red/green complementaries, but, following orthodox Neo-Impressionist doctrine, introducing secondary and tertiary variations within passages dominated by a contrasting hue. Another self-portrait in the Rijksmuseum showing him in a gray felt hat is a study in blues and pinks, with strokes of vivid purple and orange to define the contours of his cravat and collar. These minor elements provide early hints of what's to come: purely arbitrary color accents that make pictorial sense but bear little or no resemblance to reality.

Van Gogh's self-portraits from the spring of 1887 reveal that Divisionist technique could be applied to almost any subject, but it really came into its own in landscape painting, rendering the natural world in natural light. Here the principles of simultaneous contrast captured the varied play of sunlight and dappled shade, of leaf and lawn, sky and water. As the weather warmed, Van Gogh spent more time outdoors painting the local scenery.

In mid-May, he decided to sum up all he'd learned with an ambitious canvas depicting amorous couples in a nearby park. *Garden with Courting Couples: Square Saint-Pierre* [see color plate 30] is unusually large, nearly thirty inches tall by forty-four inches wide, on tightly woven canvas of unusually fine quality.* Unlike many of his landscape sketches, completed in a single morning or afternoon, this one demanded multiple sessions and forced him to apply the finishing touches in the studio. All of this suggests he regarded it as a finished work of art meant for public consumption, a fact confirmed when he exhibited the painting at the Théâtre Libre later that year.

Van Gogh had greater ambitions for *Garden with Courting Couples: Square Saint-Pierre* than simply documenting a picturesque corner of Paris.** Strictly speaking, this is not even a landscape painting, though the parklike setting—trees, lawn, winding gravel paths—occupies most of the acreage. Vincent himself regarded the three couples as the main

* *Garden with Courting Couples: Square Saint-Pierre*, like many paintings from this time, was actually painted over another unfinished work (two actually). For all Theo's generosity, Vincent was often short of money for supplies and reused his canvases. This points out the contingent, experimental nature of much of this work.

** Long thought to represent the Voyer d'Argenson park in Asnières, it actually depicts a spot closer to home, the Saint-Pierre square at the foot of the Butte. An 1890 inventory of Theo's collection refers to it as a *Petit Jardin à Montmartre* (A Little Montmartre Garden).

subject, referring to it as the "painting of the garden with lovers."[*][39] It is, in fact, a modern reimagining of the traditional *fête champêtre*, a scene of young lovers in nature popularized by 18th-century masters like Antoine Watteau and Jean-Honoré Fragonard, and revived by the eccentric Provençal artist Adolphe Monticelli.

It's unlikely, however, that Van Gogh had these models in mind. Instead, he looked to more contemporary variations on that hallowed theme: Manet's *Déjeuner sur L'Herbe*, which had given the subject such a pugnaciously modernist twist, and Seurat's *Sunday Afternoon on the Isle of La Grande Jatte*, which prominently features a couple walking arm in arm in the foreground. Indeed, in *Garden with Courting Couples* Van Gogh gets as close to the Pointillist master as he will ever come, submitting himself to the drudgery of applying tiny dots and dashes of color across a broad canvas in service of a creating a decorative tableau, static and timeless. His brushwork is never as regimented as Seurat's, Signac's, or Pissarro's at his Neo-Impressionist best. It's a little haphazard by their standards, varying in response to the forms he's rendering: bold strokes for the figures, more delicate for the leaves, and densely woven for the underbrush. Van Gogh is too invested in what he paints to ever achieve Seurat's Apollonian serenity or Signac's clinical precision. His version of a *tableau vivant* is less *tableau*, more *vivant*, than theirs, an attempt at a stately pantomime in which the players never quite follow the script. Still, lush and lovely as it is, this painting can't quite avoid the faults of its model, a stale whiff of the studio, the faint chill of a painting that's been too carefully plotted and too painstakingly executed.

[*] The two standing couples are immediately obvious. The third, reclining, couple is less immediately apparent.

Indeed, Van Gogh would soon move beyond Divisionism, acknowledging its revolutionary impact while admitting how easily it could devolve into empty formula. "Painting as it is now promises to become more subtle—more music and less sculpture—in fact, it promises *colour*," he wrote to Theo in the summer of 1888. "As long as it keeps this promise. . . . As for stippling, making halos, or other things, I find that a real discovery, but it can already be foreseen that this technique won't become a universal dogma any more than another. Another reason why Seurat's *La Grande Jatte*, Signac's landscapes with coarse stippling, Anquetin's boat, will in time become even more personal, even more original."[40]

That was what he was seeking—something more personal, more original. The relationships he forged at Tanguy's little shop on the Rue Clauzel, and the new language of color he learned at the side of Henri Toulouse-Lautrec, Émile Bernard, and Paul Signac did not turn him into an artistic genius overnight, but they pointed him in the right direction.

9

Outcasts

"Being exiled, a social outcast, as artists like you and I surely are 'outcasts' too."

—Van Gogh to Émile Bernard

I t was in the spring of 1887 that Vincent van Gogh finally threw off the shackles of the past and dared to imagine an art of the future. Having haunted for years the twilight halls of the museum, steeping himself in the chiaroscuro of the old masters, he now emerged, blinking and perhaps a bit disoriented, into the blazing sun of a new day.

It wasn't an easy transition. The passage from caterpillar to butterfly involved sacrifices. For the rest of his life Van Gogh viewed his rebirth as a modern artist with deep ambivalence, wondering whether he might not have lost a bit of his soul in the process. He mused about the road not taken in a letter to Theo from the summer of 1888: "It's just that I find that what I learned in Paris *is fading*, and that I'm returning to my ideas that came to me in the country before I knew the Impressionists."[1] And the following year: "I sometimes regret not having simply kept the Dutch palette of grey tones, and brushed landscapes in Montmartre without pressing the point."[2]

The journey involved a change not only in palette but in self-conception. Van Gogh was not one of those artists (like Bernard) always on the lookout for the next new thing. He was in many ways a traditionalist. Embracing the avant-garde offered the possibility of spectacular growth but also required him to abandon old certainties and set aside old loves.*

The truth is he had little choice. His inability to master traditional modes had forced him to seek alternatives, to discover an idiom in which his faults would not define him and in which his natural gifts could flourish. This is one of the most important insights budding artists can have—to find an approach that suits their particular talents and in which they can express their own distinctive vision.** For Van Gogh, the Parisian avant-garde provided just such an opportunity. Valuing expression over correctness, originality over the ability to adhere to tired formulas, it freed him from the bind in which he found himself, offering tantalizing possibilities he was only beginning to explore.

The change was as much practical as aspirational. After more than a year in the French capital, Van Gogh was determined to make himself *au courant*. In Nuenen he'd voiced his skepticism of the Impressionists and their ilk, predicting that the future belonged to artists who made paintings in the traditional way, building them around strong contrasts of light and dark. "It has bothered me FOR A LONG TIME, Theo," he wrote, "that some of the painters nowadays are taking from us the bistre and the bitumen with which, after all,

* He returned to many of them during his months at the asylum in Saint-Rémy. Unable to paint landscapes, he made copies of Delacroix and Millet, though reinterpreted in the light of his own distinct genius.

** Georges Braque once said of Cubism, the movement he helped found with Picasso, that it "put painting within range of my own gifts." [See Unger, *Picasso and the Painting that Shocked the World*, 354]

so many magnificent things were painted, which—properly used, make the coloration lush and tender and generous, and at the same time so dignified."[3]

Now he realized that color was the key to his artistic renewal, which meant hitching his wagon to Neo-Impressionism, the most radical movement currently on the Parisian scene. It's no coincidence that this epiphany came at a low point in relations with his brother and that it involved his simultaneous adoption, or at least acceptance, by the bohemian crowd at Père Tanguy's. Validation by his peers released him from his humiliating subservience to Theo. Never again would the younger brother dictate to the older in matters of taste, or use his superior knowledge of contemporary art to lecture him on his aesthetic lapses. Vincent had not only caught up to Theo but had shot past him. One of the attractions of Divisionism as far as Vincent was concerned was that it was not something he'd been led to by his brother, but rather a discovery he could call his own—one, moreover that led him into territory where Theo was reluctant to go. As a card-carrying member of the Parisian avant-garde, a resident of Paris, and a denizen of bohemian Montmartre, Vincent no longer had to defer to Theo's greater wisdom. In some ways they had returned to an earlier time when they were both teenagers and it was Vincent introducing Theo to the exciting world of paintings. The dynamic of recent years would now be reversed, with Theo seeking insight from his older brother and guidance in the arcane mysteries of the latest thing.

None of this would be possible, of course, unless and until the two of them repaired their relationship. Both wanted it; both needed it. For better or worse, their lives were so entwined that neither could really imagine an existence independent of the other. By the spring, relations, which had reached a nadir around the New Year, began to improve. Theo recovered physically from the paralysis that had floored him in

the first weeks of January, and as he recovered his health, he sought a truce with Vincent.

While the worst was averted, much of the old intimacy was gone as hot anger congealed into exhausted acceptance. Theo continued to grumble about the way Vincent had treated him, repaying his generosity with contempt and turning his well-ordered life upside down. Vincent had no respect for boundaries; he was too wrapped up in his own obsessions to ever consider his brother's needs. "When [Theo] came home tired out in the evening," his wife Jo recalled, "he found no rest . . . the impetuous, violent Vincent would begin to expound his own theories about art and art dealing . . . This lasted till far into the night; indeed, sometimes he sat down on a chair beside Theo's bed to spin out his last arguments."[4]

For Theo, at least at first, it was more a case of resignation than forgiveness, a realization that Vincent would never, could never, change. "It's such a strange situation here," he wrote to his sister Wil in March. "Were he someone in a different line of business I would have done what you advise long ago, and I've often asked myself whether it wasn't perhaps wrong to help him all the time, and I've often been on the point of letting him muddle along on his own. I thought about it seriously again after getting your letter, and I believe that in the given situation I can't do anything other than carry on."[5]

Theo's stoicism in the face of repeated provocations reflected the fundamental truth that no matter how difficult Vincent was he could never abandon him. He not only cared deeply about his brother, but believed he was touched by genius. The disappointments of recent years had tested that faith but not broken it. "It's absolutely certain that he is an artist," he assured Wil, "and what he's making now may sometimes not be beautiful but will definitely stand him in good stead later, and then it may be sublime, and it would be disgraceful to keep him

from his regular study. However unpractical he may be, if he will just be skillful there will definitely come a day when he starts to sell." The price he had to pay, he acknowledged, was high, almost unbearable:

> Nor should you think that the money business weighs the heaviest on me. It's above all the idea that we have so little affection for each other any more. There was a time when I loved Vincent very much and he was my best friend, but that's over now. It seems to be even worse as far as he is concerned, for he loses no opportunity to let me see that he despises me and that I inspire aversion in him. This makes it almost intolerable for me at home. . . . What I just hope is that he'll go and live on his own, he's spoken about that for a long time, because if I told him that he had to go it would be the very reason for him to stay. Since I can't do any good for him I ask just one thing, and that is that he do me no harm and he does that by staying, because it's heavy going. . . I've decided to carry on as I've been doing up until now, but I hope that he'll change homes somehow, and I'll do my best to bring it about. Now little sister, you'll say: what a moanful letter. Don't talk about it much.[6]

Slowly, however, each pulled back from the brink. As Theo's health recovered, Vincent began to see a way forward in his art. After the gloomy self-portraits of the fall and winter of 1886, the paintings he made in the New Year have a new brightness that suggests hope for the future.

Perhaps the explanation was as simple as a change of weather. Van Gogh was always susceptible to bouts of depression in the cold, dark days of winter and projected his sufferings onto his brother. After

he'd moved to Arles he looked back on Parisian winters and shuddered. "That's my reason for loving this part of the world," he wrote to Bernard from a sunnier clime, "not having to dread the cold so much, which by preventing my blood from circulating prevents me from thinking, from doing anything at all."[7] His mood, which improved in the spring sunshine, relieved some of the tension with Theo. It helped that Vincent had found his own posse, people with whom he could share his thoughts on art and who treated him as a colleague. The less dependent he was on Theo for emotional support, the less resentful he felt and the more his natural affection could shine through.

In April, a month after his "moanful" letter, Theo reached out to the family again: "A great deal has changed since I wrote to you all last. We have made peace, because it served no good to carry on in that way. I hope that it will last. So for the time being there'll be no change, and I'm glad of that. I would find it odd living on my own again, and he wouldn't have gained anything by it either. I've asked him to stay. It will strike you as odd after what I wrote to you recently, but it isn't weakness on my part, and since I feel much stronger than I did last winter, I have high hopes that I'll be able to bring about an improvement in our relations. We're already far enough apart that it would have served no good purpose to rend relations even further."[8]

As soon as harmony was restored on the Rue Lepic, Theo recognized an analogous improvement in his brother's art. "Vincent is still working hard and is making progress," he wrote to his sister Elisabeth on May 15. "His paintings are becoming lighter, and his great quest is to get sunlight into them. He's an odd fellow, but what a head he has on him, it's enviable."[9]

When it came to the radical young artists Vincent was now consorting with, Theo wasn't quite ready to jump on board—at least not to the extent of showing them in his gallery. But he did appreciate the

salubrious effect they were having on Vincent's work. The changes he'd been urging for years, to concentrate on landscape and to bring more light and color to his painting—changes he believed would come through a close study of Impressionism—were now being effected in association with their more radical heirs. He noted the change with relief, taking signs of progress where he could find them.

This was typical of Theo's generous spirit. While Vincent lived only for himself and for his mission, Theo tended to live through others—no life meaning more to him than his older brother's. And while not prone to those abrupt about-faces that characterized Vincent's life, he was always willing to learn and to grow. Cautious by nature, he had a keen eye and a sensitive soul. He wouldn't plunge ahead recklessly, but he was open to new ideas, new ways of seeing. If he now followed Vincent from a safe distance, he was more than willing to see where he and his new companions might lead him.

In terms of his actual day-to-day practice, Van Gogh's epochal transformation was largely a matter of which colors he chose to pull from the drawers in Tanguy's shop—brighter pigments like cobalt blue, zinc yellow, and Veronese green—and how he chose to apply them, either at full intensity, straight from the tube, or modified with a bit of white.* He no longer felt the need to "break" these colors by mixing them on the palette until they were reduced to various shades of brown.

Vincent was now committed, if in his own eccentric way, to the Divisionist cause. He'd learned a good deal from the casual, hands-off tutelage of Toulouse-Lautrec, but the former *massier* at Cormon's studio

* These colors, as well as cadmium yellow and white lead are found on the palette he depicted in his *Self-Portrait as a Painter* from early 1888, perhaps the last painting he completed in Paris.

was not officially a member of the movement and would soon move on to other things. Van Gogh also had opportunities in late March to early April to study the works of Seurat, Signac and the Pissarros, father and son, on view at the latest exhibition of Les Indépendants. Even better, starting in March he was able to work side by side with Signac himself as he painted along the banks of the Seine. "[Van Gogh] tried out a free form of *divisionism* on Signac's advice,"[10] Bernard recalled, downplaying his own role in his friend's conversion.

Van Gogh proclaimed his new allegiance not only by how he painted, but where. He spent much of the spring and summer on the Divisionists' home turf, in Bougival, Asnières, Saint-Ouen, and the Isle of La Grande Jatte, about four miles northwest of the Rue Lepic apartment. When the weather was fine, he would set out along the Rue Tourlaque (where Lautrec had his studio), skirting the base of the Butte, and head toward the river where it looped around and brushed the northern suburbs. His friend Hartrick often observed Vincent hauling his gear back from an outing on the river "and usually covering himself and others with paint from his canvas when his work was complete!"[11] Bernard, too, recalled the scene:

> With a large canvas slung on his back, he set off on his journey. He then split it up into so many compartments, depending on the subjects.* When evening came, he brought it back, filled up, like a little mobile museum, in which all the emotions of his day were captured. Stretches

* He would lay out multiple scenes along a single roll of canvas, like panels of a comic strip, and later cut them into separate paintings. While it is possible to determine which paintings were cut from the same strip—as in the three paintings of the riverbank at Asnières and another three he painted of the riverbank at Clichy—it's unlikely Van Gogh conceived of them as unified series. [See *Along the Seine*, 85ff]

of the Seine full of boats, islands with blue swings, smart
restaurants with multicolored awnings, oleanders, corners
of abandoned parks, and properties for sale.[12]

When Van Gogh arrived at his destination, he would often run
into Signac. "I met him on other occasions at Asnières and Saint-
Ouen," Signac remembered: "we painted on the banks of the river,
lunched at the *guinguette*, and returned to Paris on foot, along the
avenues of Saint-Ouen and Clichy."[13]

They made an odd couple: Signac reserved, controlled, cerebral;
Van Gogh vehement, volatile, and prone to erratic outbursts. But
Signac proved, at least in Vincent's case, a patient guide. Under
his influence Van Gogh abandoned the *à l'essence* technique he'd
learned from Lautrec in favor of a more full-bodied application
of pigment. His color became more assertive, his brushwork more
vigorous. Writing to his sister that October, he claimed, "When I
painted landscape in Asnières this summer I saw more colour in it
than before."[14]

The subjects that caught Vincent's eye were the very ones that had
piqued the interest of plein-air painters decades earlier, when Monet,
Renoir, and Pissarro first set their easels up along these same shores in
the early 1870s. Here in the outskirts of Paris, he found an intriguing
mix of natural and man-made features, of bathing cabins and iron
bridges, sparkling water and grassy banks; fashionable dandies out for
a stroll, and long-muscled rowers plying their oars.

These were the sites where hardworking city folk liked to spend their
leisure hours, boating, sunning themselves, or sipping cool drinks on
a veranda overlooking the water. For working-class visitors there were
numerous *guinguettes*, inexpensive cafés named for the cheap, bitter
wine (*guinguet*) they served, but the establishments along the water

catered to all tastes and income levels. "There are numerous villas," the Baedeker guide of 1889 informed English-speaking tourists, "and the banks of the Seine are very popular with young people as a place of amusement in summer."[15] This was the landscape not only of leisure but of modernity itself, since leisure time was a product of modern technological society as surely as the steam engine or the stock exchange. The drudgery of rote labor demanded the consolation of recreation, whose rituals played out in the dance halls of Montmartre and along the banks of the Seine. Here day-trippers might imbibe the intoxicating scent of freedom, even if it was only a mirage. Here the classes mingled on terms of near equality, the natural setting providing an illusion of democratic harmony as the banker and the laborer shared a single stretch of greenery. Along the river the landscape was thoroughly tamed, even commodified, manicured to maximize comfort, and thoughtfully provided with boats for rent and restaurants where the price of the food was determined by the quality of the view.

Suburbs like Asnières represented an extension of Haussmann's rationalizing impulse into the countryside. It was this controlled version of nature, rather than the majestic mountains and stormy seas of the Romantics or the rustic hamlets of Millet and the other Barbizon painters, that appealed to the Impressionists and their Neo-Impressionist heirs. This was a landscape reconfigured for human use, in which man-made and natural elements formed a single hybrid organism. Contemplating a similar vista, Claude Lantier, the doomed hero of *L'Oeuvre*, has an epiphany. "Look, this is it," he exclaimed, seeing his masterpiece come to life in front of him: "I stand under the bridge with all the porters busy unloading them, in the foreground, see? That's Paris at work, understand: hefty laborers, bare arms and chests and plenty of muscle! . . . Now on the other side, there's the swimming

bath, Paris at play this time. There'll be an odd boat or something there, to fill the centre, but I'm not too sure about that. I shall have to work it out a bit first. . . . There'll be the Seine, of course, between the two, a good broad stretch."[16]

In the early months of 1887, Van Gogh went in search of similar, distinctly modern, vistas. Signac proved an ideal guide to this less familiar territory. In the past, Van Gogh had bridled at any attempt to tell him what to do, but he was surprisingly open to Signac's gentle suggestions. Despite a well-earned reputation for dogmatic certainty, the younger man apparently handled him with a combination of tact and encouragement, and Vincent responded with a rare show of appreciation. "I find Signac very calm," he told Theo, "whereas people say he's so violent, he gives me the impression of someone who has his self-confidence and balance, that's all. Rarely or never have I had a conversation with an Impressionist that was so free of disagreements or annoying shocks on either side."[17]

Ultimately, however, Vincent's receptiveness had less to do with Signac's winning personality than with the fact that he could see exciting new possibilities opening up in the direction he was pointing. Signac offered both hope and affirmation. To achieve something as an avant-garde artist it was not necessary to draw like Raphael, or conjure a convincing illusion à la Meissonnier or Gérôme.* Signac was a preacher of color, something Van Gogh felt instinctively. "I know for sure that I have a feeling for color that will develop more and more," he'd insisted at the outset of his career, "that painting is in my very marrow."[18] But after years of struggling to master the tools of his trade, this aspect of his art continued to elude him: "It has sometimes surprised me that I'm

* In fact many avant-garde artists, like Seurat and Toulouse-Lautrec, *could* draw like Raphael. But others—Cézanne comes immediately to mind—achieved greatness without mastering the traditional skills.

not more of a colourist, because my temperament would certainly lead one to expect that, and yet up to now that has hardly developed at all."[19] The truth is that an instinct for pure color had necessarily taken a back seat as he attempted to make himself either into a peasant painter or a chronicler of modern life. Divisionism liberated that suppressed affinity, allowing him to indulge to the fullest his love of vibrant hues without having to worry about accurately transcribing what was in front of him.

Liberation, indeed, was the promise of the new artistic world in which he now found himself, a world in which originality rather than technical proficiency was the currency of the realm and in which unconventional choices in life as well as art were celebrated as the mark of genius. For years, his ambition to say something important through his art had been frustrated by his clumsy efforts to reproduce what he saw. Under the tutelage of Lautrec, Signac, and even Bernard, he began to realize that there was another way, one that played to his strengths rather than exposed his weaknesses.

Van Gogh's association with Signac lasted only a couple of months—from late March to late May in 1887, when the Pointillist master left Paris, seeking relief like so many residents from the city's oppressive heat.* Throughout that period Vincent tried to toe the Divisionist line, or at least as closely as his impetuous nature would allow, applying his prismatic colors with a directional dash that gave his canvases a chaotic energy lacking in their model. One need only compare Van Gogh's painting *The Bridge at Courbevoie* with Seurat's version of the same subject to see the difference. While Seurat creates a scene of classical order and repose—playing off repeating verticals and

* They met once more in March of 1889, when Signac came to visit him in Arles. Signac provided Theo a long report on Vincent's mental and physical health.

horizontals against the diagonal of the riverbank—Van Gogh stresses the motion of the current through parallel brushstrokes vigorously applied. Where Seurat takes us into the realm of the ideal—suburban Paris reimagined by a divine geometer—Van Gogh's scene is of the here and now, both more kinetic and more matter-of-fact.

Seurat, *Bridge at Courbevoie*, 1887

There remains a yawning gap as well in terms of the artists' ability to realize their visions. While Seurat's painting succeeds brilliantly on its own terms, Van Gogh continues to struggle on both the conceptual and technical levels. In truth, this painting is a pretty slapdash affair. Despite the fact that he deployed his trusty perspective frame, he's unable to render convincingly the piers and arches as they recede into

depth. Everywhere we can feel his impatience. While Seurat completed his painting in the studio after making plein-air studies, Van Gogh polished *his* off in a single session, on the spot. Every square inch of Seurat's canvas is filled with uniform dots of pure color that kindle optical vibrations, not only in the lighter areas but (especially) in the shadows, where purple and blue jostle with specks of complementary orange. At a distance, these vibrant colors tend to cancel each other out, creating an almost neutral tonality. Van Gogh marshals similar complementaries in his painting, but in a far less systematic way. Near or far, his color never loses its intensity. Ultimately, he has little interest in optical phenomena. Divisionism played a crucial catalyzing role, allowing him to see in rainbow hues, but once he mastered this new chromatic vocabulary, he deployed it for very different ends.

Bridge at Courbevoie, 1887

It used to be assumed that Van Gogh's development followed roughly the evolution of French modernism as a whole: that he first tackled Impressionism before applying the lessons of its Divisionist successor. But a close examination of his Parisian oeuvre reveals something quite different. Van Gogh had not really been able to assimilate the innovations of Monet, Renoir, & co. before the spring of 1887. Without a personal chaperone, he approached it timidly, as an outsider not quite fluent in the language. This wasn't surprising since, as he told his sister, he still found their work sloppy, superficial, and unappealing. It was only after he began associating with the young crowd at Tanguy's that he was able to appreciate fully Impressionist color and brushwork, smuggling their innovations in through the back door, so to speak. Paintings like *Spring Fishing, the Pont de Clichy* [see color plate 31] are far closer to Monet in spirit than those paintings he made in and around Montmartre in the summer of 1886, which still depend on the muted palette of the Barbizon school.

Even so, one would never mistake this work for a painting by Renoir or Monet. Compared to Monet's *Red Boats at Argenteuil*, for instance, Van Gogh's *Fishing in Spring* is far less effective in evoking light and atmosphere. His colors are more schematic, applied with such assertive strokes of the brush that they never quite cohere: blue and purple slashes to render the shaded underside of the arch, green striations to define the boat, and blots of ochre and jade for the foliage—all of these are applied with typical vehemence and bundled in masses like sheaves of grain clutched in the fist. Once again his hand is not obedient to his eye, overemphasizing, exaggerating.

But now these exaggerations seem more purposeful, more strategic; he's beginning to understand how to turn his vices into virtues. Since he can't suppress his intense nature, he leans into it.

"I always have an animal's coarse appetites," he admitted. "I forget everything for the external beauty of things, *which I'm unable to render* because I make it ugly in my painting, and coarse, whereas nature seems perfect to me."[20] He's slowly learning to harness this coarseness, the very quality that once disqualified him in the eyes of his academic colleagues. Among his radical associates, for whom expression counted for more than finesse, his tendency to push things to the limit and beyond could seem like genius. If he's not formally linked to the so-called Decadents or Incohérents, his work has many affinities with those literary provocateurs. He revels in excess, can live nowhere but on the edge. Like Rimbaud or Verlaine, who reshaped language in novel ways, Van Gogh can't help but use the tools of art for purposes other than the exact reproduction of the visible world. Line and color misbehave, refusing to play their assigned roles, becoming more expressive as they detach themselves from mere description.

Monet, *Red Boat, Argenteuil,* 1875]

In retrospect it's clear that the approach of the Neo-Impressionists was hardly more congenial than the time-worn formulas of academic training. Divisionism freed up Van Gogh's use of color, but even in these months, working shoulder to shoulder with Signac, he was never an *optical* painter, intent on reproducing the precise vibration of light in the retina. He worked with a heavy hand and an eye for purely pictorial relationships, so that color never lost its independent identity. Monet and Signac used vivid hues to conjure the intensity of light but, having starved himself for years, once Van Gogh discovered color it became an end in itself, too precious to waste on mere description.

Nor did Van Gogh ever entirely succumb to the Neo-Impressionist *pointillé*. In a painting by Seurat, Signac, or Pissarro, the same dot is used to describe sunlight reflecting off the water or a blade of grass; near and far are given the same neutral, almost mind-numbing treatment. The canvas becomes a "decorative tapestry," everywhere the same and always viewed from a distance that is both spatial and emotional; a cloud-flecked sky and a bather's naked flesh seem to be made of the same intangible stuff, more energy than matter. Van Gogh, by contrast, deploys slashing, parallel brushstrokes to define his forms in the crudest possible manner, almost as if he's carving them with a chisel. Thus in *Spring Fishing*, each separate form—boat, trees, bridge, and water—is a universe unto itself, determining the direction of the marks from which it's sculpted; even the most immaterial elements have a robust presence never seen in a true Pointillist work. In a painting by Seurat everything dissolves into an insubstantial mist.* In a painting by Van Gogh materiality aggressively reasserts itself, as if in a bas-relief.

* This is less true of his preparatory studies than his finished paintings. Seurat's oil sketches are thoroughly satisfying works in their own right, perhaps more beautiful than the final product.

A canvas by Seurat, no matter how monumental, speaks in whispers, even silences, while Vincent's blurt in raucous tones.

This technique of rendering forms with parallel lines is often described as *calligraphic*. And, indeed, in works like *Restaurant de la Sirène*, depicting a popular inn at Asnières [see color plate 32], Van Gogh uses the tip of the brush almost like the nib of a pen to describe the details of the terraced building. There are no broad swathes of color, only individual strokes of warm and cool hues, vivid reds and greens (brick wall and foliage) in the foreground, echoed in a minor key in pale pinks and blues in the distance. This essentially draftsmanlike approach will ultimately find its way back into his drawings, including the obsessively detailed works on paper he made in Arles and Saint-Remy in which every square inch is overrun with hypnotic marks.

There was never anything like a formal relationship between Van Gogh and Signac even during the two or three months they both worked in the same suburban locales. They were peers, colleagues in the avant-garde, and Vincent could listen to the younger man's musings without feeling like he was in any way obliged to follow his lead. This was just as well, for Signac must have realized early on that Vincent was incapable of the discipline necessary to be a real Divisionist. In any case, he was gone by the end of May, leaving Van Gogh to develop in his own way.

Throughout the late spring and summer, Van Gogh continued to explore the territory Signac had opened up, but without his friend looking over his shoulder he veered off in wayward tangents. One lesson Van Gogh did take to heart was to embrace subjects that more traditional painters might find ugly or trivial. The suburban landscapes he favored were by no means pristine idylls. A guidebook of 1856 described the "chimneys poking up like obelisks" and village streets "covered with their black smoke."[21] Van Gogh didn't avert his

eyes from this industrial blight. In addition to painting pleasant parks and watering holes, he set his easel up in front of factories, which he rendered in the same blaring-out-of-the-tube colors. In many of these works, Van Gogh deployed the calligraphic mark-making he developed from Lautrec's delicate peinture à l'essence, only now using thicker paint and vigorous brushstrokes. He rarely took his canvases back to the studio but preferred to complete them in front of the motif, retaining the freshness of his original vision. This was his comfort zone, the manner of painting in which he felt most himself. A year later he wrote Theo from Arles to explain his approach, offering a description that applies equally well to these paintings from the summer of 1887: "The present studies actually consist of a single *flow of impasto.* The brushstroke isn't greatly divided, and the tones are often broken." And as he reclaims this stylistic territory, he reclaims an artist whose painful journey mirrored his own: "In the end, without intending to, I'm forced to lay the paint on thickly, à la Monticelli. Sometimes I really believe I'm continuing that man's work."[22]

Factories Asnieres, 1887

Many of the landscapes he painted are built around a duality of warm and cool tones that ultimately derives from the theories of Charles Blanc. In a painting like *Wheatfield with Partridge*—a work that eerily foreshadows the famous *Wheatfield with Crows* painted a few days before his death—and *Factories at Asnières*, the canvas is divided horizontally into two zones, with cool colors defining the sky above, while warm greens and ochers define the terrestrial realm below. Despite their stark simplicity, Van Gogh manages to hold the viewer's interest through the liveliness of his brushwork. In paintings like these he seems intent on reducing his compositions to a few basic forms, presenting us with an elemental yin-yang duality: warm-cool, earth-sky. Here we can detect that impulse toward abstraction, an urge to increase visual impact by eliminating distracting details, that characterizes the masterpieces still to come.

This drive to simplify is apparent in a series of works from the summer of 1887 depicting areas of dense undergrowth on a forest floor or a path through the woods. Each was painted in a single session, the pigment worked wet into wet; they are microcosms of the natural world bursting with irrepressible, overflowing life. Here he seems to follow through with an idea he had in Nuenen while first grappling with the theories of Charles Blanc, that is to explore the "infinite variety of tone of one same family."[23] With everything pressed close to the picture plane, with the foliage devouring every square inch of canvas, these works border on abstraction, as if his intent was to provide a flat, wallpaper-like pattern on the surface rather than attempting an illusion of a third dimension.

In these works Van Gogh approaches most closely the "all-over" effect of a Pointillist painting, though, as always, he handles the brush with his own distinctive aggression. The mark-making is both obsessive and hypnotic. Consciously or not, Van Gogh has achieved in these

works a quality much sought after by advanced artists and critics at this time and associated with the word *decorative.** Used approvingly, particularly among those who identified themselves as Symbolists, the term "decorative" did not mean trivial or superficial. Quite the opposite. Rejecting beaux-arts illusionism, emphasizing the flat, two-dimensional surfaces favored by the so-called *primitives*—also a term of praise in the avant-garde—the artist embracing decoration restored painting to its true nature. The term was often applied to Monet's late series, from the *Poplars* and *Rouen Cathedral*, to the final great series of *Water Lilies*. In the words of Albert Aurier: "Decorative painting, in its proper sense, as the Egyptians and, very probably, the Greeks and the Primitives understood it, is nothing other than a manifestation of art at once subjective, synthetic, Symbolist, and Ideist. . . . decorative painting, is strictly speaking, the true art of painting. Painting can only have been created to *decorate* with thoughts, dreams, and ideals the banal walls of human edifices."[24]

Decorative art was also inherently abstract, as Maurice Denis pointed out when he defined a painting as "essentially a plane surface coated with colors assembled in a certain order." In *Trees and Undergrowth* [see color plate 33] Van Gogh has created an almost a musical effect, playing the undulating rhythms of the purple tree trunks off starbursts of green foliage.** While he manages to evoke the dappled

* These paintings also foreshadow the work of Gustav Klimt, who usually favored the same kind of all-over, two-dimensional pattern.

** Symbolists often used the musical analogy to explain visual art. According to the writer Charles Morice (who collaborated with Gauguin on his book *Noa Noa*): "[Music] is at the same time more distant and more intimate, nearer both to the origin and the resolution of feeling and sensation . . . Line and color arrest and defy time: sound yields at the very moment it is born; it lives to die, it is a profound symbol . . . Painting is a witness. Music is a yearning. Through music the soul soars of its own accord, then recaptures its self-awareness in the solid silence of painting." [Quoted in Goldwater, *Symbolism*, 181]

shade of the deep woods, the real subject of this painting is the formal play of complementaries, of sinuous line and shimmering dot.

We've come a long way from Nuenen, less than two years behind him, when the meaning of a painting depended on the story it told, on its uplifting message of toil and redemption. In these woodland sketches it's the forms themselves that must carry the burden of meaning. Van Gogh has abandoned not only narrative but the realism of his early Parisian works. There's no intention of recording the passing scene, or a particular site. These could be anywhere, and almost any time: they have an iconic, almost universal appeal. In these claustrophobic works, the world is shut out and we find ourselves marooned in the realm of pure painting.

Van Gogh does not pursue this direction for long—the world always meant too much for him to lose himself in midsummer dreams. Like much of his art during these years, these paintings are experimental. He wanted to see how far he could go in a certain direction, to isolate particular elements of his art—to pare some down and discard others entirely, to build up those that seemed most fruitful and to refine them—in order to develop his distinctive voice.

After painting most of the spring by the river, that July Van Gogh once more set up his easel closer to home. He'd already depicted the undeveloped northern flanks of Butte de Montmartre a year earlier, but now he revisited this rustic neighborhood armed with his Divisionist brushstroke and Neo-Impressionist palette. Peering through his perspective frame, he used a graphite pencil to sketch in the paths, lean-tos, and kitchen gardens that clustered on the slopes that climbed to the windmills of the Moulin de la Galette on the crest. After laying out the basic composition, he began to fill in the outlines with dabs of yellow and red, blue, and purple that represented the rhubarb stalks, sunflowers,

and other plantings tended by the residents of the area.* It was here that a Dutch visitor used to see him hard at work. "Montmartre was still an El Dorado then," Arnold Koning recalled, "and Vincent was always sitting out there somewhere in the sun, with his work and his pipe, at the brickyard, or painting a woman in a vegetable stall, with all the reflections in purple, blue and orange which the sunny environment conjured up in it."[25]

Montmartre: Behind the Moulin de la Galette and *Kitchen Gardens, Montmartre* [see color plate 34] are both large canvases, as large or even slightly larger than the *Garden with Courting Couples: Square Saint-Pierre* he'd completed in May.** He probably chose this spot, rather than Asnières or Saint-Ouen, simply because it would have been too difficult to lug the oversized canvases three or four miles to the river. Like the comparably scaled *Potato Eaters*, these landscapes were intended as "statement" pieces, summations of all he'd learned and a declaration of where he stood.

One thing was certain: these were not made with an eye toward sales. "I'm well aware that these big, long canvases are hard to sell," he warned Theo.[26] But earning a living wasn't uppermost in his mind right now. After finding a niche on the radical fringes of the Parisian art world, he was aiming for visibility and validation. The first glimmer of recognition came from his friend Julien Tanguy. "I saw Tanguy

* Like many works from this period, these paintings are badly discolored. He used inexpensive pigments, probably purchased at Tanguy's, which haven't stood the test of time. The zinc yellow has darkened to a mustard hue, and the cochineal pink has turned brown. [See *Van Gogh Paintings*, vol. 2, 423 ff for further discussion of these technical issues]

** *Montmartre: Behind the Moulin de la Galette* measures 31 x almost 40 inches; *Montmartre: Windmills and Allotments* about 38 x 47 inches. *Garden with Courting Couples: Square Saint-Pierre* measures 30 x 44 inches. *Potato Eaters* is his only comparable work, measuring about 32 x 45 inches.

yesterday and he put a canvas I had just done in his window,"[27] he wrote with evident pride. Admittedly, this was a modest achievement, but hanging alongside works by Cézanne and other masters of the new painting, it was one more sign that he'd arrived.

At the same time he was seeking other outlets to get his work in front of the buying public, though even at cut-rate prices he couldn't manage to sell anything. "At this present moment I have found four dealers who have exhibited studies of mine," he told Livens.* "And I have exchanged studies with several artists.** Now the prices are 50 francs. Certainly not much but—as far as I can see one must sell cheap to rise, and even at costing price."[28] These "second class" dealers, as he called them, did not manage storefront galleries on the major boulevards as Theo did, but dealt mostly from their own apartments, taking work on consignment rather than purchasing it outright. Even at the bottom end of the market, however, Van Gogh made little headway. "We've hardly ever exhibited, have we?" he noted wistfully the following year. "There were a few canvases at Tanguy's place first of all, at Thomas's and then at Martin's."***[29]

Van Gogh made these larger views of Montmartre for the express purpose of exhibiting at one or more of those alternative spaces where

* Again, the exact date of this letter remains controversial. But, since it was written
 sometime after he'd left Cormon's studio, it makes most sense to assign it to the
 fall of 1887.

** These exchanges, which Theo also mentioned in his letter of June–July 1886,
 got off to a slow start, with initially only third-tier artists willing to participate.
 [See chapter 8] It was only near the end of his stay in Paris that more substantial
 artists, like Lucien Pissarro, agreed to swap works with Van Gogh. The most
 important exchanges, with Bernard and Gauguin, would have to wait until he
 moved to Arles.

*** These so-called *courtier* dealers were Georges Thomas and Pierre Firmin Martin.
 Alphonse Portier, who dealt out of his apartment downstairs at 54 Rue Lepic,
 also carried some of Van Gogh's stock.

progressive artists introduced themselves to a sympathetic audience. In fact, if one excludes the shop window on Rue Clauzel, they were among the first works he put before the Parisian public. In late 1887 and again in early 1888, Van Gogh displayed *Courting Couples* in the lobby of the Théâtre Libre, where it kept company with works by Seurat, Signac, and Lautrec. This venue, founded in 1887 by André Antoine to stage experimental dramas, was popular with Naturalists, Symbolists, and other cutting-edge literary types, the very people a progressive artist needed to reach if he was to make a name for himself. In the spring of 1888, Theo submitted *Kitchen Gardens, Montmartre* to the Salon des Indépendants. Émile Bernard attended the show. "All I remember of his canvases is a large Montmartre landscape, like this," he wrote years later: "sheds surrounded by large, very yellow sunflowers rise in tiers on the little hill, from the top of which the Moulin de la Galette summons into its arms the so depraved young apprentices of the capital. A leaden sky presses down on the landscape flooded by a torrid sun."[30]

These large-scale Neo-Impressionist landscapes were Van Gogh's bid for credibility on the avant-garde scene. They were public affirmations that he'd thrown in his lot with the radicals, and demonstrations of his proficiency in the latest aesthetic language. He felt sure they would please the public. . . eventually. "In time people will see that there's open air and good cheer in them,"[31] he assured Theo. They even elicited his first review, a couple of dismissive lines in the *Chronique de la Littérature et de l'art* by the Symbolist poet Gustave Kahn, who wrote in the spring of 1888: "Mr. Van Gogh paints large landscapes with a vigorous brush, paying little attention to the value and precision of his tones."[32]

The fact that the paintings through which Van Gogh chose to present himself on the public stage were among the most orthodox

Neo-Impressionist works he ever made reveals his thinking at this point of his career. No matter how often he veered off course in his smaller, more experimental works, he wished to be mentioned in the same breath as Seurat, Signac, and the other provocateurs on the dangerous fringes of the art world. Even after he'd moved on, both geographically and conceptually, he continued to view the work he made in the spring and summer of 1887 as marking his crucial entrée into the avant-garde.

Despite the fact that Van Gogh was no closer to actually earning a living from his art, this was the moment of his professional break-through. For the first time he could think of himself as a real artist. And for the first time other serious artists began to regard him in the same light. If no one yet considered him the leader of the new school, he was at least one of the foot soldiers engaged in the slogging work of advancing the aesthetic frontiers. After years of isolation he was part of a community of like-minded strivers whose respect he'd gained and from whom he could learn. Engaged in spirited conversations with Lautrec, Signac, Bernard, and others at Tanguy's shop, investigating both the technical and theoretical aspects of painting with these accomplished practitioners, he used his formidable intellect to help shape the discourse. Passionate, articulate, and well-versed in both the history and current practice of art, his was a voice to be reckoned with. And if he still didn't know exactly where he was going, he now had reason to believe he'd get there someday.

Domestically, too, things continued to improve. Theo was pleased to note that his brother seemed less aggressive, less inclined to find fault or pick fights. His art was showing promise as well, gaining in light, as he reported to his family in Holland, a brightening that seemed to reflect a lifting of Vincent's spirits. No longer oppressed by the long night

of winter, no longer confined to the stuffy back room of his studio, Vincent put his restless body in motion as he set out each morning for a day of painting on the banks of the Seine. Walking had always been a form of therapy, a way to relieve the pressures in his head by allowing that excess energy to flow through his limbs. Vincent and Theo both profited from the change of season. The brothers hadn't fully recovered their former intimacy, but at least they could spend time in each other's company without tearing each other apart.

For all these positive signs, Vincent was feeling the pressure of life in the city. He had difficulty adjusting to the noise and hectic pace, as well as to those human interactions that placed an almost unbearable strain on his fragile equilibrium. His need for companionship, for a sense of belonging, competed with an equally strong desire to flee in the opposite direction. "I don't enjoy company," he once admitted, "and dealing with people, talking to them, is often painful and difficult for me. But do you know where a great deal if not all of this comes from? Simply from nervousness—I who am terribly sensitive, both physically and morally."[33] One gets the sense that he was holding it together, but just barely. He self-medicated, trying to soothe his jangled nerves by puffing steadily on his pipe and overindulging in alcohol. Returning from his outings in Asnières, Signac often observed him ducking into some café along the avenue Saint-Ouen or Boulevard de Clichy where, surrounded by his paint-spattered gear, he downed copious amounts of absinthe.

For better or worse, he was no longer an isolated figure. His circle of friends now included the Englishman A. S. Hartrick, the Australian John Peter Russell, and Toulouse-Lautrec—all three from Cormon's studio—along with Bernard, Signac, and the proprietor himself from Tanguy's shop, and a number of casual relationships with other important figures in the avant-garde, including Louis Anquetin and Charles

Angrand. Of course Van Gogh's were friendships of a peculiar sort: volatile and volcanic on one side, wary and bemused on the other. In every case these connections meant more to Vincent than to his companion, his neediness and volatility often driving the object of his affection away. "I'm often terribly and cantankerously melancholic, irritable," he wrote in a moment of clarity, "yearning for sympathy as if with a kind of hunger and thirst—I become indifferent, sharp, and sometimes even pour oil on the flames if I don't get sympathy."[34] Typical of these unequal partnerships was his friendship with John Peter Russell. The wealthy son of an arms manufacturer, Russell was handsome, debonair, fond of sailing and vigorous outdoor activities. He was famous for owning his own horse and carriage—a rarity among the bohemian students of Montmartre—which he drove at breakneck speed around the Bois de Boulogne. Adding to his glamour was his blond mistress, an Italian model named Marianna, whom Rodin himself dubbed "the most beautiful woman in Paris."[35]

As in the case of Rappard before him, Van Gogh attached himself to this charming lightweight, mistaking his geniality for something deeper. Russell, for his part, found his odd friend sufficiently intriguing to paint his portrait, providing us with the most accurate likeness we have of Van Gogh as a mature man.* Russell managed to describe not only Vincent's features—the close-set eyes, prominent brow, and stiff brush of reddish hair—but also a certain frantic undercurrent as he casts a nervous, sidelong glance at us. Russell appears to have caught him in the act of drawing, but Vincent wields the pencil almost like a weapon, presenting a challenge rather than inviting intimacy.

* There is one known photograph of Vincent van Gogh, taken when he was nineteen years old.

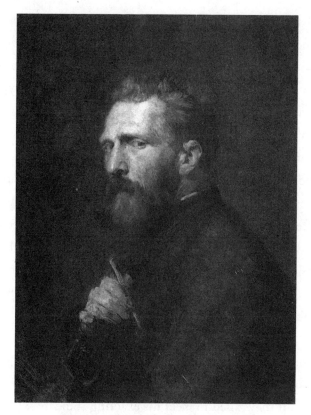

John Peter Russell, *Portrait of Van Gogh*, 1886

A. S. Hartrick, the other foreigner from Cormon's studio he befriended, provides us with an equally vivid written portrait of Van Gogh during these years. Describing him as "a weedy little man with pinched features, red hair, and a beard and a light blue eye," he also thought him "'cracked' but harmless." They were comfortable enough in each other's company that from time to time Hartrick would stop by the Rue Lepic apartment, which he described as "quite a comfortable one, even rather cluttered up with all sort of furniture and works of art."[36] More often, however, Vincent would simply show up uninvited at his studio:

All through the early part of 1887, Vincent frequently
came to see me in the Impasse Helene, to the horror of
[my roommate] poor Ryland, who, having hung up a set
of water-colours of the "La belle dame sans merci" type,
found himself mercilessly attacked by the free tongue
of Van Gogh, who promptly told him that they were
anemic and useless reflections of Pre-Raphaelites—a
kind of artist that he mostly despised. I would return,
from going up and down in Paris, to find Ryland, who
suffered from sick headaches, with his head wrapped in
a towel soaked in vinegar and looking a sickly yellow,
while he wailed: "Where have you been? That terrible
man has been here for two hours waiting for you and I
can't stand it any more."[37]

Anyone spending time in Van Gogh's company learned to expect
the occasional outburst. Even people he admired felt the sting of
his disdain if they failed to meet his exacting standards. Despite his
own thin skin, he never seemed to realize that his criticisms could
wound, assuming that any opinion honestly held and forthrightly
delivered would be welcomed by those on the receiving end of his
verbal barrage. Once when visiting the studio of the Impressionist
painter Armand Guillaumin he took exception to the way he was
depicting a scene of workers unloading sand from a barge. "Suddenly
he went wild," Guillaumin recalled, "shouting that the movements
were all wrong, and he began jumping about the studio, wielding an
imaginary spade, waving his arms, making what he considered the
appropriate gestures."[38]

Those willing to look past his odd tics appreciated his keen intel-
ligence and dedication to his craft. If he lacked any sense of proportion

or decorum, this was due to the intensity of his feelings rather than any desire to inflict pain. Lucien Pissarro recalled one occasion when he and his father bumped into Van Gogh on a busy street corner. Rather than exchanging the usual pleasantries and moving on, Vincent, "to the great amazement of passersby,"[39] dropped his painting gear where he stood, propped up his still-wet paintings against the nearest wall, and proceeded to deliver a lengthy harangue on his latest theories. Incidents like this weren't unusual. "He was forbidden to sit and work in the street and because of his volatile disposition this repeatedly led to scenes," Theo recalled, "which upset him *so* much that he became completely unapproachable."[40]

Still, for all his peculiarities, Van Gogh seemed to have found a home in Paris among the bohemians of Montmartre. Here was a community that would accept him as he was and to which he might make a meaningful contribution. After all, they were accustomed to dealing with eccentrics, many of whom were celebrated as geniuses in their own right. Despite his continued difficulties adjusting to life in the city, there was every reason to hope he might yet prosper.

Indeed, Theo had already anticipated a Parisian conquest long before he had any evidence to support his claims, writing to his mother in the summer of 1886: "To give you an example, hardly a day passes without him being invited to visit the studios of painters of repute, or people come to him. He also has acquaintances from whom he receives a beautiful delivery of flowers every week which can serve him as a model. If we can keep this up then I think that his difficult period will be behind him and that he will go on to find his feet."[41] At the time, this was largely a fabrication, but by the spring of 1887 this rosy scenario had been partly fulfilled, though not in the way Anna Cornelia van Gogh might have wished. Vincent was now able to exchange his works with a better class of painter, including not only Toulouse-Lautrec but

Russell, Bernard, and Lucien Pissarro.* This, along with the fact that a number of small-time gallerists were willing to stock his work, pointed to his rising status in the Parisian art world.

On the other hand, the company he was keeping now consisted of alcoholics (Lautrec), communists (Tanguy), and even anarchists (Signac), the kind of dangerous revolutionaries the older generation of Van Goghs regarded with horror. Theo himself was far more open-minded than his parents, but he, too, had reason to worry. Vincent was mixed up with what Anna would have considered "the wrong crowd," dissipated fellows inclined to feed his worst instincts.

Paris, as Theo had reason to know, offered unmatched opportunities not only for growth but to lose oneself, invitations to excess that had ruined many with more discipline than Vincent ever possessed. In fact, as Dries Bonger sniffed, Theo himself too often succumbed to temptation in the big city. Behind the respectable façade there were aspects of his life that would have disappointed his mother had she known, including serial mistresses and, in between the longer-term liaisons, visits to the bordello, which he made with a Parisian's lack of scruple and a bourgeois gentleman's discretion.

Of course this behavior in no way distinguished him from his neighbors. According to one study, female sex workers—known in popular jargon as *pierreuses, lorettes, grisettes, gigolettes, apperitives*—serviced three-quarters of the city's adult male residents. The lucky ones, known as *filles soumises* (supervised girls), practiced their profession in regulated establishments and received periodic medical checkups, while their freelance sisters, the *filles insoumises*, prowled the streets,

* Van Gogh's Neo-Impressionist *Still Life with Basket of Apples* is inscribed *à l'ami Lucien Pissarro—Vincent."*

flocking thickly in the neighborhoods where Vincent sought his nightly entertainments.

Given his own habits, Theo saw no reason why Vincent shouldn't avail himself of the same opportunities, within reason. But "within reason" wasn't a phrase he'd ever have associated with his brother. It was in his nature to carry things too far. "I, for one, am a man of passions," he confessed, "capable of and liable to do rather foolish things for which I sometimes feel rather sorry."[42] When he'd recklessly taken the pregnant Sien Hoornik into his home, supporting her and her children on the income he received from Theo, it had almost caused a permanent breach. Over the years Vincent had shown no signs of having learned his lesson.

In fact one of the attractions of Paris for Vincent was that it was far more permissive than his native Holland. In Antwerp he'd gotten a taste for city life, and he regarded the prospect of returning to Nuenen as bitter exile. Pursuing *la vie bohème*, he could simultaneously indulge his appetites while proclaiming his independence from the hypocritical, suffocating world of his parents. Like his friend Lautrec, he was in many ways addicted to a life pursued "outside the law."[43]

Traces of his dissolute Parisian existence occasionally find their way into his art, usually on the margins, in works never intended to be shown to the public. In one pencil drawing he shows a woman squatting over a basin cleaning her private parts, in another a couple having sex. Both are a far cry from the idealized classical torsos he was painting at the same time, reflecting a conceptual distinction between *low* life and *high* art. Van Gogh usually maintained this separation, long after Zola and his Naturalist colleagues had demonstrated that smashing through those barriers could yield powerful artistic results.

On at least one occasion Van Gogh even engaged in a bit of scatological humor. "I recall the set-out of one such [drawing]," Hartrick

recorded, "depicting the scene in a restaurant he favored at that time. It was a long narrow room, with a narrow table, and seats against the wall, a tall window filling the end.* In the foreground he showed some overcoats hanging up, then a line of eaters in perspective. Through the window, as he eagerly informed me, was a dung-heap and on it *'un petit bonhomme qui pisse'* [a little gentleman pissing]. 'Voilà!' he said."** [44]

Had Van Gogh followed through on his ambition to become a painter of modern life, this kind of gritty slice-of-life reportage might have served as source material. But Zola's unsparing realism never came naturally to him. He rarely focused on the seamier side of life, at least not in works he meant for exhibition, and never really succeeded in turning the stuff of his daily existence into art. Other artists not only lived in bohemia but made it the subject of their paintings: Manet, Degas, and particularly Toulouse-Lautrec all found inspiration in seedy dives and bars of the Batignolles or Montmartre; even Seurat made the popular Cirque Medrano he frequented a subject for two famous paintings, one focusing on the actions beneath the high tent, the other on the street outside.*** But Van Gogh, despite his initial enthusiasm for this kind of naturalism when first arriving in Paris, lacked the dispassionate journalistic eye for this sort of work. He included the popular dance hall the Moulin de la Galette in many paintings, but never as more than a picturesque prop, usually in the distant background. Unlike Renoir, who painted the dancers spinning on the floor, or Lautrec, who was fascinated by the pathologies of addiction and sexual commerce, Van Gogh rarely found a way to transform life in the city

* Hartrick is describing Madame Bataille's restaurant.

** This exact drawing or one very like it survives in the collection of the Van Gogh Museum.

*** These are *Le Cirque* (1891) and *La Parade* (1888). He also painted *Le Chahut* (1890), which features can-can dancers and musicians at a nightclub.

into vivid imagery. Baudelaire had tasked the painter of modern life with depicting "the manners of the present,"[45] urging him to cast his discerning eye on "bourgeois life and the pageant of fashion."[46] This was never really where Van Gogh's heart lay. He preferred the universal to the particular, the timeless to the here and now. For him, even the most humble subjects—a weaver at his loom, a bird's nest, or even an old pair of boots—were fraught with deeper significance. When he finally came into his own as an artist, it's as a far different kind of painter than the chronicler Baudelaire conceived. The manners of the present ultimately meant less to him than a glimpse of the eternal, the fashions of the moment discarded in favor of those truths that clothes and manners only conceal.

We can see the difference when Van Gogh tackled one of the modern-ist's favorite subjects. Baudelaire had called the prostitute "the perfect image of the savagery that lurks in the midst of civilization."[47] Manet, Degas, Lautrec, and countless other modern artists had taken up the challenge, depicting prostitutes as the emblematic figure of modernity. In Manet's *Olympia,* to take one famous example, the unsentimental transaction between prostitute and client gives this work its distinctly modern feel. But when Vincent used a prostitute as his model, he couldn't help but mythologize her, either as a woman of sorrows or the embodiment of animal sexuality.

The reclining nude Van Gogh painted in Paris was almost certainly a prostitute, perhaps even the same one he met one day while in the company of Émile Bernard, who witnessed a "tuppenny tart" *picked up* by Vincent, and who was very willing to agree to pose for him."[48] Unlike Sien, whom he turns into a universal emblem of misery, Sorrow Herself, this plain-featured woman who exposes herself to the artist's gaze represents Woman as Beast, fleshy, shameless, carnal in every sense of the word.

Reclining Nude, 1887

Not conventionally beautiful, she's explicitly, even confrontationally, sexual. With her rolled-down stockings and immodest pose, she signals her availability. As always, Van Gogh was attracted to women who bore the scars of a difficult life. Once, when asked by his Uncle Cor whether he wished to settle down with a beautiful girl, he responded: "I would have more feeling for and would prefer to be involved with one who was ugly or old or impoverished or in some way unhappy, who had acquired understanding and a soul through experience of life and trial and error, or sorrow."[49] Like an old, battered pair of shoes, the woman beaten down by life was more alluring in her vulnerability than a fashionable beauty with her proud disdain.

In this painting Van Gogh doesn't romanticize or idealize; in fact he veers in the opposite direction, toward caricature—mythologizing of another sort. Rendering her features with the exaggerations he'd deployed in his depictions of the de Groot family, he emphasized the

brutish nature that he associated with raw sexuality. She's less an individual than an archetype, a projection of his own appetites, his need to control and possess. Van Gogh's coarseness comes through in a letter from 1885, where he quoted a long passage from Zola's *Germinal* in which the manager of the mine, Monsieur Hennebeau, expresses his envy of the simple workers he employs:

> He would gladly have made them a gift of his high salary, in order to have, like them, a thick skin, an easy way of mating, with no regrets. Why could he not sit them down at his table, fatten them on his pheasant while he went off to fornicate behind hedges, tumbling lasses while jeering at those who had tumbled them before him! He would have given everything, his up-bringing, his comforts, his wealth, the power of his position as manager, if one day he could have been the lowest of the wretches who obeyed his orders, free in his fleshly existence, enough of a boor to slap his wife and take his pleasure with the neighbour-women.[50]

Like Hennebeau, or like the rogue Octave Mouret in *Au Bonheur des Dames*, Vincent longed to be "free in his fleshy existence," to throw off the shackles of his bourgeois existence and simply take what he wanted. In this image of the sexually uninhibited woman, this fantasy comes true.

In bohemian Montmartre, Van Gogh could finally live the life he'd always dreamed of, liberated from the narrow, soul-crushing morality of his parents, a life dedicated to his art and to what the poet Arthur Rimbaud called "the derangement of all the senses." However

productive this was in the short term, however gratifying, it was unsustainable over the long haul.

Looking back on his time in the capital from a safe distance, he regretted his excesses, feeling he'd squandered his energies in pursuit of empty distractions and his health through overindulgence. By the time he left for Arles, he was already something of an expert on the prostitutes of Paris. Responding to a poem Émile Bernard sent him on the theme of prostitution, Vincent criticized its moralizing tone:*

> It's not characteristic, because the women of our boulevard—*le petit*—usually sleep *alone* at night because they screw 5 or 6 times during the day or the evening and—late at night it's that honorable carnivore, their pimp, who comes to collect them and take them home, yes, but he doesn't sleep with them (only rarely). The worn-out and haggard woman usually goes to bed alone, and sleeps a leaden sleep. But with two or 3 lines redone, it'll be there.[51]

If over the two years he spent in Paris he familiarized himself with the prostitutes of the city, in Arles, by contrast, he congratulated himself on the abstemious lifestyle he adopted. "Personally, I find continence is quite good for me," he says, advising Bernard to follow his example: "Don't fuck too hard; if you don't fuck too hard, your painting will be all the spunkier for it," observing that Delacroix "fucked only a little, and had only casual love affairs so as not to filch from the time

* Van Gogh and Bernard engaged in something of a running dialogue on prostitution. In addition to his poem, Bernard dedicated "to my friend Vincent/these stupid sketches," an album of eleven sketches he made in a bordello. [See letter 697, Oct. 5, 1888, note 10]

devoted to his work."[52] And when Theo fell ill, he warned him not to follow in his footsteps. "Do without women and eat well," he advised:

> It's true that does you good, and if you spend your brains and your marrow working with your mind, it's very logical not to spend yourself making love any more than necessary.
>
> But that's easier to do in the country than in Paris.
>
> Is the desire for women that one picks up in Paris not in part the effect of the malady of nervous exhaustion?[53]

There's a certain coarseness, even callousness, to the way Van Gogh approached the sexual encounters he actually consummated, as opposed to those impossible, idealized relationships that existed only in his imagination. But he also identified with the exploited women who gratified his needs, expressing a gruff admiration for their willingness to defy convention. Unlike the respectable women who spurned his advances, at least they lived honestly. "The whore in question has my sympathy more than my compassion," he remarked to Bernard. "Being exiled, a social outcast, as artists like you and I surely are, 'outcasts' too, she is surely therefore our friend and sister. And finding—in this position—of outcast—the same as us—an independence that isn't without its advantages—all things considered—let's not adopt a false position by believing we're serving her through social rehabilitation, which is in any case impractical and would be fatal for her."[54]

He'd discovered his kinship with these marginalized women as a teenager in The Hague when it first began to dawn on him that he'd never be able to conform to the expectations of his family. "Whenever I walked down the street," he recalled, "often all alone and at loose ends, half sick and destitute, with no money in my pocket—I looked at them and envied the people who could go off with her, and I felt as

though those poor girls were my sisters, as far as our circumstances and experience of life were concerned. And, you see, that feeling is old and deeply rooted in me. Even as a boy I sometimes looked up with endless sympathy and respect into a half-withered female face on which it was written, as it were: life and reality have given me a drubbing."[55]

The difference is that now, rather than a lonely wanderer, he was part of an entire community defined by its outsider status. Like the hippies of Haight-Ashbury a century later, the bohemians of Montmartre believed in "letting it all hang out," practicing free love and expanding their consciousness by consuming large quantities of intoxicants. If they were outlaws, as Lautrec defined himself, they were outlaws together. The prostitute and the avant-garde artist both live beyond the pale, brought together by their shared marginality. Van Gogh's eccentricities no longer excluded him from society, his libido a connective rather than a disruptive force. The avant-garde's heroes were those like the poet Paul Verlaine, who had spent time in prison for shooting his lover (Rimbaud) and then proceeded to drink himself to death; Toulouse-Lautrec, who joined him on a similar downward spiral; and Adolphe Monticelli, a painter who addled his brain with absinthe and whom Van Gogh admitted was "a little, even very, cracked."[56] Among these misfits he finally fit in—or nearly so.

The worldly Lautrec appears to have been Van Gogh's companion on at least some of his jaunts to the lowlife dives of Montmartre and the surrounding neighborhoods. Cormon's former massier was leading a thoroughly dissipated life, more and more with each passing year. Vincent's eagerness to keep up forced him to stay out late and share the vices to which the Frenchman was addicted. They made the rounds together, dropping in at Le Chat Noir, Le Mirliton, and the Folies Bergères, uniquely Parisian establishments where the risqué nature of

the entertainment tended to loosen the inhibitions of the audience. Guy de Maupassant provided a description of the Folies in his *Bel-Ami*, a novel Van Gogh admired, that followed the rise of an engaging scoundrel named Georges Duroy:

> Look at the stalls; nothing but middle-class folk with their wives and children, good noodlepates who come to see the show. In the boxes, men about town, some artistes, some girls, good second-raters; and behind us, the strangest mixture in Paris. . . . There is something of everything, of every profession, and every caste; but blackguardism predominates. There are clerks of all kinds—bankers' clerks, government clerks, shopmen, reporters, ponces, officers in plain clothes, swells in evening dress, who have dined out, and have dropped in here on their way from the Opéra to the Théâtre des Italiens; and then again, too, quite a crowd of suspicious folk who defy analysis. As to the women, only one type, the girl who sups at the American café, the girl at one or two louis who looks out for foreigners at five louis, and lets her regular customers know when she is disengaged.[57]

Duroy, like Mouret from Zola's *Au Bonheur des Dames*, is a womanizer, a sexual predator, someone who looks at life cynically and takes what he wants without compunction—the very kind of man Van Gogh longed to be.

He recorded some of these late nights in a series of drawings he made in colored chalk. As Hartrick recalled, "Vincent had a habit of carrying a thick stick of red and one of blue chalk in each pocket of his coat. With these he used to illustrate his latest impressions or theories of art. As he would start work on the wall or anything that was handy,

I immediately placed a newspaper or two on the table, where he would at once begin to set out his latest 'motif' in lines a quarter to a half an inch thick."[58]

Each of these drawings, made on site, features a musician: a cellist, a violinist, a clarinet player, or a cigar-smoking pianist. Vigorously rendered and acutely observed, these works hint at another possible direction in Van Gogh's work, one that would have completed his mission to become a painter of modern life à la Manet or a behind-the-scenes observer of Paris's decadent entertainment industry à la Degas. Above all they show the influence of Lautrec, a man who not only made his home among these disreputable performers but turned his vices into brilliant art. For Van Gogh, however, while these vignettes throw a fascinating light on his daily (or nightly) life in Paris, they remain one-offs, a fascinating glimpse of a road not taken.

Clarinetist, Piccolo Player, 1887

Squandering his time and his allowance on prostitutes certainly took a toll, but excessive use of alcohol proved even more debilitating. He blamed his dependence on the psychological stress of

a profession "in which one's mind is extremely stretched, like an actor on the stage in a difficult role—where you have to think of a thousand things at the same time in a single half hour . . . [and] the only thing that comforts and distracts—in my case—as in others, is to stun oneself by taking a stiff drink or smoking very heavily."[59] It wasn't a new problem. In Nuenen he carried around a flask of brandy when he went out painting, and in Antwerp he dulled the pain of his rotting teeth with alcohol and tobacco.[*] But, as he admitted, the nerve-jangling noise and frenetic pace of the French capital exacerbated his addiction.

Café Table with Absinthe, [see color plate 35] is a scene straight out of Lautrec's repertoire of seedy cafés, but one that reflects his own particular brand of dissipation. Since Van Gogh doesn't actually show us the drinker, the painting reads as a still life, like the contemporaneous *Basket of Crocuses* or *Flowerpot with Chives.* But while the figure has stepped outside the frame, he—the artist himself—hovers in the background, an absent presence infusing these objects with autobiographical poignance. This is no random assortment of items chosen merely for their visual impact. The painting has the diary-like quality of *Self-Portrait with Glass* from a few months earlier, now rendered in his more linear style and with a vivid, Divisionist-inspired palette. By removing himself from the picture, Van Gogh puts the viewer in *his* place, the full glass of poison-green liquid ready to numb our mind, the scene outside the window ready to distract.

To 21st-century viewers this image appears innocent enough, even cheerful. But to Van Gogh's contemporaries such a scene was fraught with social and even moral significance. By the late 19th century

[*] Wil's discovery of his secret flask "agitated her greatly," according to Dorus. [Letter 464, note 1, Oct. 2, 1884]

absinthe had acquired an unsavory reputation as a poor person's drink, the drug of choice for those on the road to ruin.* Manet, Degas, and Lautrec all depicted absinthe drinkers as embodiments of urban despair, modern ennui, and wrecked lives. The beverage was associated above all with Montmartre, the neighborhood synonymous with the dangers and illicit pleasures of bohemia. As the English writer H. P. Hugh observed: "The 'absinthe' hour of the Boulevards begins vaguely at half-past five, and it ends just as vaguely at half-past seven; but on the hill [of Montmartre] it never ends. Not that it is a home of the drunkard in any way; but the deadly opal drink lasts longer than anything else, and it is the aim of Montmartre to stop as long as possible on the terrasse of a café and watch the world go by."[60]

Café Table with Absinthe captures the feelings of loneliness that continued to plague Van Gogh even in the heart of the big city. A gentle melancholy pervades the scene; the artist, alone at a table nursing his drink, watches the world outside the window as it passes him by. He has nowhere to go. No one makes a claim on his time or attention. This was not simply an artistic conceit, but reflected the realities of his daily existence. No matter how much he invested in his new friendships, he couldn't entirely overcome the feeling that he was a man apart. The yearning for community and the raw-nerved sensitivity to human contact—centripetal and centrifugal forces—existed in dynamic tension, an unstable equilibrium he tried to manage through artificial means. His colleagues were well aware of Vincent's predilections. Often after a day painting outdoors, Signac recalled, Vincent would stop by the nearest café where "the absinthes and brandies

* It was not only its high alcohol content that made absinthe dangerous, but also the addition of the hallucinogenic wormwood. It had some of the connotations that "crack" cocaine would take on in another century.

would follow each other in quick succession."[61] Lautrec observed similar scenes, one of which he recorded in his pastel portrait—a third-person narrative for which Van Gogh himself now supplies the first-person confession.

Sometime that summer he decided to take the lessons he'd learned painting outdoors and apply them to what he could see in the mirror. In the earlier group of self-portraits from Paris, he tended to depict himself as a boulevardier, a man about town in collared jacket and silk cravat. In the summer of 1887, by contrast, he generally presents himself in the garb of the landscape painter, complete with blue workman's smock and straw hat to protect him from the sun.* This is how he would have appeared while painting on the banks of the Seine or among the allotments on the lower slopes of Montmartre. He's no longer the painter, in Baudelaire's formulation, concerned for "the depiction of bourgeois life and the pageant of fashion,"[62] for whom "the crowd is his domain, as air is for the bird and water for the fish."[63] Instead, he's reinvented himself once more as a plein-air painter in the tradition of Millet, Monet, and Signac. The man who stares out at us from these works is grizzled, weather-beaten, someone who spends his time under the hot summer sun or braving the wind and rain. He's not quite the peasant painter he was before coming to Paris—he would have encountered far more sunbathers in Asnières and Saint-Ouen than actual peasants—but he's clearly relieved to jettison the pose of the flaneur, which never really suited him.

* Of the approximately ten extant self-portraits from the summer of 1887 (he would return to the theme in the fall), a majority depict him in this garb. In a couple he reprises his role of the gentleman painter. There's also a portrait from this time generally thought to be of Theo.

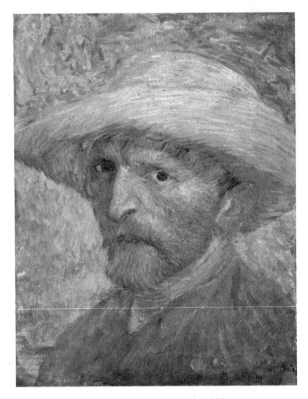

Self-Portrait with Straw Hat, 1887

Along with a new persona, these portraits register enormous artistic growth as Van Gogh begins to deploy the techniques he's learned from his avant-garde colleagues for his own aesthetic ends. While his earlier Parisian work feels tentative, experimental, he's now hit his stride. His palette is bolder, built around bold contrasts of bright hues, and his brush-work has a new authority, a new purposefulness. In Van Gogh's hands, the prismatic colors that, according to Divisionist theory, were essential for capturing the true quality of light now possess a life of their own. Color is used less to describe than for its own sake; it is more abstract, more expressive. Here we begin to see Van Gogh groping toward a new kind of truth, emotional and spiritual rather than optical.

In these self-portraits, as in the contemporaneous landscapes, he's replaced the *peinture à l'essence* he learned from Toulouse-Lautrec with a more vigorous attack, one that demonstrated the "manly strength, truth, loyalty, honesty"[64] he always prized in art, as in life. He applied the pigment in thick, buttery strokes, often in parallel arrays that recall the hatching technique he'd deployed in his drawings of the garden in Nuenen—among the most accomplished and aesthetically satisfying of his early works. He's uninterested in mere effects, his brushstrokes not so much *depicting* the world as *embodying* it, offering a material rather than a merely visual equivalent.

We saw hints of this in paintings like *Spring Fishing in Asnières* or *Restaurant de la Sirène*, where Van Gogh's dynamic, directional brushstrokes tend to follow the contours of the things represented, giving each element a greater solidity than in a typical Impressionist or Neo-Impressionist work. Instead of atomized particles of pure color that dissolve form, his more muscular marks offer a robust, tactile equivalent of matter itself. If Seurat's and Signac's paintings are cerebral, analytical, poised, Van Gogh (using many of the same ingredients) makes paintings that are expressive, passionate, dynamic. A work by Van Gogh has *oomph* rather than finesse, crude vigor rather than elegance.

His growing power as an artist is apparent in the *Self-Portrait with Straw Hat* from the Metropolitan Museum. [see color plate 36] Van Gogh has stretched and repurposed the Pointillist dot to convey not only his physical presence but the cosmic vortex that surrounds him, as if in the process of studying his own features he's generating a gravitational field or electric charge. The brim and crown of his hat, the planes of his face, the red and ochre bristles of his beard, are each described by parallel hatchings that translate three-dimensional volumes onto the two-dimensional surface. These marks are no longer ad hoc, laid down haphazardly, as in the earlier *Portrait of Alexander*

Reid. They resolve into hypnotic patterns that lift the quotidian into the realm of the miraculous. They cluster like iron filings in a magnetic field, they whirl and shimmy like schools of sardines or flocks of birds, responding in unison to hidden vibrations. Here in embryo are those hypnotic arabesques made famous in works like *The Sower* or *The Starry Night*, works that proclaim a pantheistic vision in which all of nature is suffused with divine radiance.

Van Gogh was mastering his art even as the rest of his life was spinning out of control. After years of struggle, he'd finally acquired the technical means to express the passions that had always driven his art. He'd found a home in bohemian Paris, a strange land where misfits and rebels of all stripes were welcomed, a land of freedom where he could indulge his appetites without fear that people would be looking over his shoulders and wagging their fingers. Unofficial admission into the ranks of the avant-garde offered crucial validation in his chosen profession, transforming him in profound ways, both as a man and as an artist. He was painting with a frantic exuberance that reflected his growing powers of invention and lifted him to dizzying heights from which he could only climb down by dulling his senses.

But his creative triumphs couldn't bring him stability or peace of mind. Art and life were simply incompatible, at least for him, and success in one area meant failure in the other. "The love of art makes us lose real love," he mourned: "I find that terribly true, but on the other hand real love puts you right off art."[65] For the first time in his adult life he was part of a vital community, connecting with colleagues, friends, and even sexual partners, but it was, almost literally, driving him crazy. Looking back on this period, Van Gogh could see he'd strayed into dangerous territory. "Moral standards seem to me less inhuman and contrary to nature [in Arles] than in Paris," he reflected. For a while he

was able to keep up the pace and even thrive in the eye of the storm, but ultimately the strain proved too much.

Van Gogh's last six months in Paris would be marked by spectacular artistic growth and marred by disaster in almost every other area. Ultimately, his excesses caught up with him. He rendered his final verdict eight months after his departure, confessing that when he left he was "almost ill and almost an alcoholic as a result of overdoing it."[66]

It was typical of the high-wire act that characterized his entire life that even as he was making his great breakthrough, reinventing himself as one of the most original and visionary artists of the age, he was breaking as a man.

10

Japonaiserie Forever

"All my work is based to some extent on Japanese art."
—Vincent van Gogh

"I see the possibility glimmering through of making paintings in which there's some youth and freshness, although my own youth is one of those things I've lost."
—Vincent to Willemina van Gogh

n October 1887, Vincent wrote a letter to the twenty-five-year-old Willemina van Gogh. He was in a reflective mood, by turns wistful and melancholy, as he looked back on a life filled with wrong turns, attempting to distill the lessons he'd learned along the way for the sake of a sister just starting out on her own journey.

To the ears of a proper young lady his letter must have seemed both worldly and even a bit dangerous. Wil had revealed her wish to become a writer, and he offers in return what wisdom he can, both as an older, more experienced brother and as a fellow artist. Vincent warns her not to cling to tradition, insisting an artist must embrace the times she lives

in. Perhaps most shocking to a minister's daughter, Vincent takes aim at their father's religion:

> Is the Bible enough for us? Nowadays I believe Jesus himself would again say to those who just sit melancholy, *it is not here, it is risen. Why seek ye the living among the dead?*
>
> If the spoken or written word is to remain the light of the world, it's our right and our duty to acknowledge that we live in an age in which it's written in such a way, spoken in such a way that in order to find something as great and as good and as original, and just as capable of overturning the whole old society as in the past, we can safely compare it with the old upheaval by the Christians.[1]

He continues to push back against the bourgeois pieties instilled in him as a child, though without the harshness that caused those vicious quarrels with Dorus or to demand which side of the barricade Theo was on. Instead of scripture, he recommends she delve into modern novels, particularly the Naturalists, "if one wants truth, life as it is." As a cure for "the diseases from which we civilized people suffer . . . melancholia and pessimism," he offers as an antidote the novels of the contemporary satirist de Maupassant.

When he talks about himself he's filled with regret, contemplating the "many years in my life when I completely lost all inclination to laugh." These tribulations have taken a toll not only on his mind but on his body. He's prematurely aged, "a little old man, you know, with wrinkles, with a bristly beard, with a number of false teeth &c."

But as his life frays, he notes almost with surprise, his work prospers: "I see the possibility glimmering through of making paintings in which there's some youth and freshness, although my own youth

is one of those things I've lost."[2] It's a poor bargain, he admits, but he clings to his art as the one good thing he's been able to salvage from the wreckage. Worst of all, the intimacy he craves continues to elude him. He warns his sister not to make the same mistakes. To create art, he insists, requires living as well as study. "No, my dear little sister, learn to dance or fall in love," he urges, saying it's the best preparation for a creative life. His own bungled efforts serve as a cautionary tale:

> For my part, I still continually have the most impossible and highly unsuitable love affairs from which, as a rule, I emerge only with shame and disgrace.
>
> And in this I'm absolutely right, in my own view, because I tell myself that in earlier years, when I should have been in love, I immersed myself in religious and socialist affairs and considered art more sacred, more than now. Why are religion or law or art so sacred? People who do nothing other than be in love are perhaps more serious and holier than those who sacrifice their love and their heart to an idea. Be this as it may, to write a book, to perform a deed, to make a painting with life in it, one must be a living person oneself. And so for you, unless you never want to progress, studying is very much a side issue. Enjoy yourself as much as you can and have as many distractions as you can, and be aware that what people want in art nowadays has to be very lively, with strong colour, very intense. So intensify your own health and strength and life a little, that's the best study.[3]

Of course Vincent was incapable of following his own advice. His efforts to live "as a person" always ended in disaster, his hunger for human contact unsatisfied. The difficulty of striking a balance between life and

work, proclaiming the need for love to nourish the creative soul while at the same time acknowledging his own difficulties making connections—these reflections not only emerged from a lifetime of disappointments, but also reveal the unbearable stress he was under at the time. In late October 1887, three months before his final departure, he'd already concluded he'd had enough. "It's my plan to go to the south for a while," he told Wil, "as soon as I can, where there's even more colour and even more sun."[4]

What he was seeking, in addition to the warm Mediterranean climate, was peace, relief from the clamor and emotional turmoil that engulfed him in Paris. A few months later he wrote to Theo, explaining the trade-off he'd been forced to make: "With my temperament, to lead a wild life and to work are no longer compatible at all, and in the given circumstances I'll have to content myself with making paintings. That's not happiness and not real life, but what can you say, even this artistic life, which we know isn't *the* real one, seems so alive to me, and it would be ungrateful not to be content with it."[5]

But however intolerable Paris had become, for the remainder of his days he looked back on his time in Montmartre with nostalgia, recalling not only the turmoil but also the camaraderie he'd found among the radical painters there. Life in the city was too frenetic, too assaultive, but he recognized it was the crucible in which his distinctive genius was forged. "To be back among painters and immersed again in all the conflict and discussion and above all work in the painters' little world of their own,"[6] he sighed wistfully barely a month before he died.

Van Gogh's life during those final months in Paris lifted him to soaring highs and plunged him into tawdry lows, nourished unprecedented creative growth but also provoked a disorienting cycle of emotional upheaval, inappropriate liaisons, and sudden explosions—all fueled by unsustainable excess. Usually when Vincent's life was spinning out of

control he could count on Theo to pull him out of the maelstrom. But
in the summer of 1887, Theo was suffering from his own emotional
crisis, a coincidence of misery that threatened to drag both brothers
down together.

The sometimes farcical chaos of Van Gogh's Parisian sojourn are
encapsulated in his stormy relationship with Agostina Segatori—"the
most impossible and highly unsuitable love affair" to which he obliquely
referred in his letter to Wil.*

Agostina Segatori, 1887

* In the spring of 1887, he was also apparently on friendly terms with a mysterious
woman known as La Comtesse de la Boissière from Asnières. Almost nothing
is known of her or of her relationship with Van Gogh, except for the fact that
he gave her two paintings as a gesture of friendship.

Miss Segatori, as he called her, was the manager of a gypsy-themed restaurant named Le Tambourin (the Tambourine) on the Boulevard de Clichy, a bustling establishment popular with artists and other bohemians. Located at the foot of the Butte de Montmartre, Le Tambourin was a neighborhood eatery an easy five-minute walk from Vincent's apartment. Providing inexpensive food and a lively atmosphere that helped distract him from his troubles, it soon became one of his favorite hangouts. He often dined there in the company of Julien Tanguy, provoking the wrath of his wife, who regarded the establishment as little better than a brothel.

In fact Le Tambourin and its proprietress had both earned a somewhat unsavory reputation. Before opening the restaurant in 1885, the Italian-born Agostina made her living in the suspect profession of artist's model, having posed for such luminaries as Jean-Léon Gérôme and Camille Corot. As her youthful good looks began to fade—she was thirty-five when Van Gogh first met her—she took up a new profession as a restauranteur, trading on her dark, exotic beauty to suggest an even more exotic gypsy allure. With waitresses in provocative Roma-themed costumes, tables shaped like tambourines, and the occasional performance by garishly clad musicians, Le Tambourin prospered for a time, attracting the same boisterous crowds that flocked to nearby cafés like L'Enfer and Le Mirliton.

After a promising start, by late 1886 business at Le Tambourin had begun to suffer. A rising nationalist tide, ginned up in the right-wing press, targeted the city's immigrants, many of them Italians or other "undesirable" ethnicities. The restaurant's reputation suffered in other ways as well. Like many bohemian establishments, Le Tambourin (as Madame Tanguy suspected) also served as a front for prostitution, with some of the waitresses pulling second shifts after hours. Pimping out the waitresses wasn't considered beyond the pale

in permissive Montmartre, but the nature of the business tended to draw rougher patrons. Many of the men Miss Segatori surrounded herself with were also foreigners, tough guys whose threatening manner offered her a degree of protection from the rowdier elements but also put off some of her more timid customers. When a few violent brawls broke out on the premises, patrons began to seek alternatives. And when one of the regulars—reputed to be Miss Segatori's lover—was convicted of murder (and later executed), Le Tambourin's fortunes went into precipitous decline.

None of this discouraged Vincent. One of the attractions, in addition to the charming manager herself, was the fact that Agostina liked to fill the walls of the restaurant with art supplied by her customers, and she was not too picky about quality as long as the work added a bit of color. In January 1887, she agreed to let Van Gogh hang some of his own paintings. Though not in any sense a formal exhibition, he leapt at the chance to put some of his work before the public and perhaps even make a few sales. (Needless to say, these never materialized.)

Van Gogh also traded paintings for hot meals, a not insignificant consideration since he was once again short of money. Despite Theo's generous allowance (and the additional savings that came from not having to pay his own rent), he continued to live beyond his means. Had it not been for soft touches like Père Tanguy and Agostina Segatori, willing to participate in a barter economy, he wouldn't have been able to manage. Even so, throughout these months he was forced to recycle old canvases by painting over, or on the backs of, older works.* His finances reached a crisis in the summer of 1887 while Theo was in

* This was a common practice for Van Gogh and was usually a sign that he was in financial straits. A number of the self-portraits from the summer of 1887, for instance, were painted on the backs of works from Nuenen.

Holland for his annual visit, after Madame Tanguy put a stop to her husband's overly generous policies.

In the case of Miss Segatori, Van Gogh also exchanged paintings for other favors, plying her with flower still lifes "instead of real flowers, which wither"[7] as part of a program of seduction. Of the three flower paintings he made in the spring of 1887, one, at least, was specifically associated with Agostina and Le Tambourin. *Basket of Pansies* was not only made for the restaurant but *in* the restaurant, since the basket is sitting on one of its distinctive low, tambourine-shaped tables. Painted quickly in thick, buttery strokes, it is less indebted to the Divisionist technique than the contemporaneous paintings he was making outdoors. Indeed, it's a bit of a throwback to the Manet-inspired still lifes he'd painted the previous summer, as though he'd not yet figured out a way to paint a familiar subject in the new manner.

Basket of Pansies, 1887

For Van Gogh, female models were always potential lovers, and it's reasonable to conclude that the two portraits he made of Agostina in the winter and spring of 1887 were maneuvers in his erotic campaign. The first, probably painted shortly after their initial meeting in January, is a small canvas (approximately 10.5 by 8.5 inches) showing the proprietress nearly in profile. Though many of the original brighter tints have faded, including the red of her lips and pink cheeks, the subdued tonality is not merely an artifact of poor preservation.* Like his *Self-Portrait as a Painter* from the fall, the somber earth tones probably reflect the lingering influence of the Baroque masters Frans Hals and, especially, Rembrandt.

This small portrait was likely a study for the more ambitious *In the Café: Agostina Segatori in Le Tambourin* that followed. [see color plate 37] Though the sitter is clearly Agostina Segatori, the painting is not so much a portrait as it is a slice of Parisian life, a page plucked out of a novel by Zola or the Goncourt brothers. The subject—a woman sitting alone in a café with a drink in front of her—was a stock theme for the modern artist, including Degas, whose *In a Café (L'absinthe)* from 1876 was a pioneering image of urban ennui that Van Gogh now made his own.

The sex of the sitter is significant here. Even in permissive Paris, a woman drinking and, just as bad, smoking alone was a cause for comment. For some it was a sign of feminist emancipation, for others a mark of a society in decline. The exploited young lady—often an ingenue turned prostitute—was a feature of many novels of modern Paris, from Victor Hugo to Guy de Maupassant. While Hugo makes us shed a tear for the tragic Fantine, Zola's Nana is more equivocal,

* He applied inexpensive organic pigments in thin glazes, which have not withstood the test of time.

not only exploited but exploiter, an emblematic figure of the modern age in which every human interaction is a monetary transaction. With this painting, Van Gogh clearly intends to engage this wider dialogue, reinforcing the connection between the unattended woman and the sex trade through the faint image of a Japanese print on the wall depicting a pair of geishas.

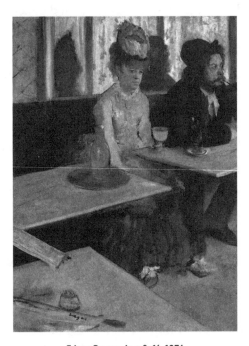

Edgar Degas, *In a Café*, 1876

When Van Gogh made this painting, he was still very much under the spell of Lautrec. His influence can be felt both in terms of its technique (separate strokes of thinned-out pigment) and its mood of weary dissipation. Given the intimate nature of the image, and the fact that Miss Segatori must have come to his studio on more than one occasion to complete the sitting, it seems likely that Vincent painted it to commemorate the consummation of an intimate relationship.

The exact nature of that relationship has been a subject of debate, with some assuming merely a platonic friendship, while others imagine a full-blown affair. The truth probably lies somewhere in between. Gauguin, who returned to Paris shortly after the relationship collapsed, claimed that Van Gogh had been "very much in love with La Segatori,"[8] an observation backed up by Bernard, who *was* there and remembered him bringing her frequent gifts of his own art in an effort to woo her. As for how Agostina felt about Vincent, it doesn't seem as if she was deeply committed to him, or to any other man for that matter. Like many women in the bohemian circles in which she traveled, she had multiple lovers and perhaps even did a little business on the side, selling her body for cash or other favors.

For the psychologically vulnerable Van Gogh, misunderstandings were inevitable. Though he wasn't a particularly jealous type, he tended to invest more in sexual relationships—as he did in every other kind—than his partner, and to have a harder time letting go.* While the details of their relationship, its consummation, and its abrupt collapse have been lost to history, what is certain is that by the summer of 1887 *her* feelings, at least, had changed dramatically.

Agostina's change of heart coincided with the acceleration of her financial difficulties. After a series of disturbances on the premises brought the unwelcome attention of the police, customers began to seek out more peaceful dining options. And as Le Tambourin teetered on the brink of bankruptcy, Agostina began to rethink her former generosity. In mid-July, seeing the way things were headed, Van Gogh attempted to retrieve his paintings: "I've been to the Tambourin, because if I didn't go there people would have thought I didn't dare,"[9] he told

* The great exception to this pattern was Margot Begemann, who was far more devastated by their abortive relationship than he was.

his brother. As he was trying to remove his work from the walls, he was attacked by one of Agostina's goons and forced to flee the premises, bloodied and ashamed. In the account he wrote to Theo, who was in Holland at the time, Vincent tried not only to excuse himself but to absolve his former lover. "As far as Miss Segatori is concerned, that's another matter altogether, I still feel affection for her and I hope she still feels some for me. But now she's in an awkward position, she's neither free nor mistress in her own house, and most of all, she's sick and ill."[10]

There's a defensive tone to everything Vincent wrote about this sordid affair that suggests he was worried how Theo would react:

> So I told Miss Segatori that I wouldn't pass judgement on her over this affair, but that it was up to her to judge herself.
>
> That I'd torn up the receipt for the paintings—but that she had to give *everything* back.
>
> That if she hadn't had something to do with what happened to me she would have come to see me the next day.
>
> That as she didn't come to see me I would take it that she knew people were trying to pick a fight with me, but that she'd tried to warn me by saying—go away—which I didn't understand, and besides would perhaps not have wanted to understand.
>
> To which she replied that the paintings and all the rest were at my disposal.
>
> She claimed that I'd tried to pick a fight—which doesn't surprise me—knowing that appalling things would be done to her if she took my side.[11]

Untangling Van Gogh's convoluted syntax and the equally convoluted story that lies behind it is difficult, but even in this implausible

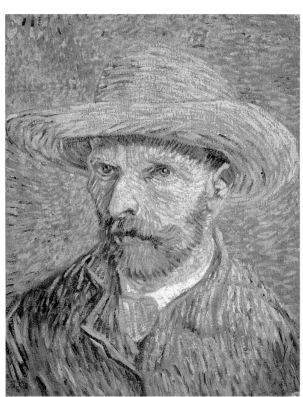

Figure 36. *Self-Portrait in a Straw Hat*, 1887

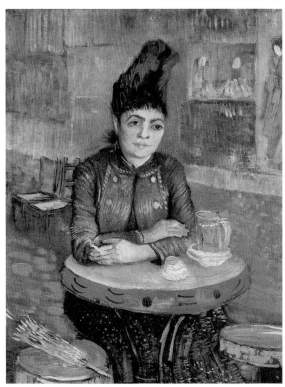

Figure 37. *In the Café: Agostina Segatori in Le Tambourin*, 1887

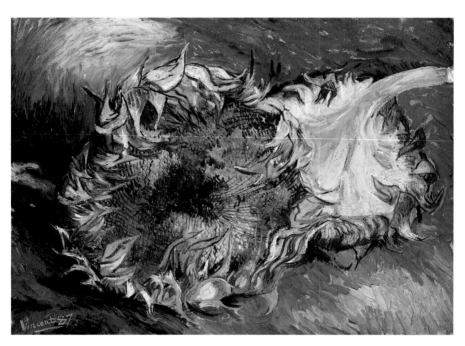

Figure 38. *Sunflowers*, 1887

Figure 39. *Still Life with Quinces*, 1887

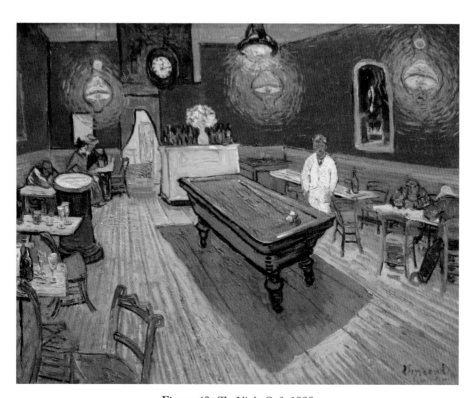

Figure 40. *The Night Cafe*, 1888

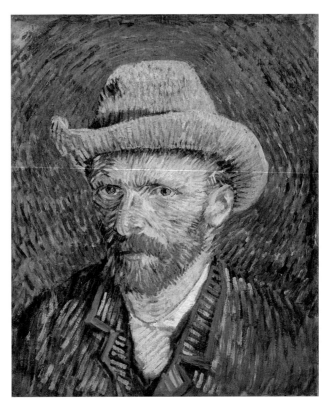

Figure 41. *Self-Portrait with Gray Felt Hat*, 1887

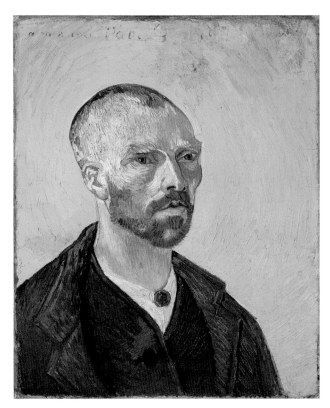

Figure 42. *Self-Portrait for Gauguin*, 1888

Figure 43. *Courtesan (after Eisen)*, 1887

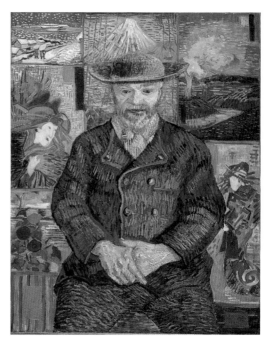

Figure 44. *Père Tanguy*, 1887

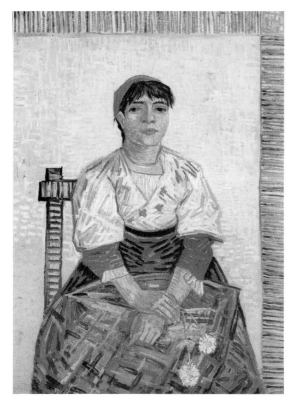

Figure 45. *The Italian Woman*, 1887

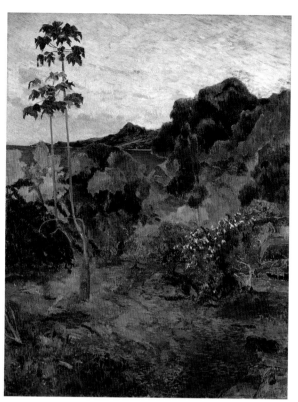

Figure 46. Paul Gauguin, *Martinique Landscape*, 1887

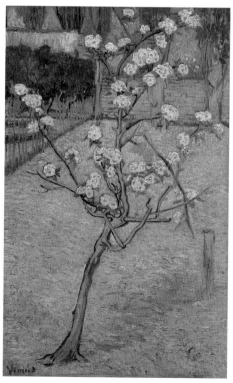

Figure 47. *Flowering Pear Tree*, 1888

Figure 48. *Flowering Peach Tree,* 1888

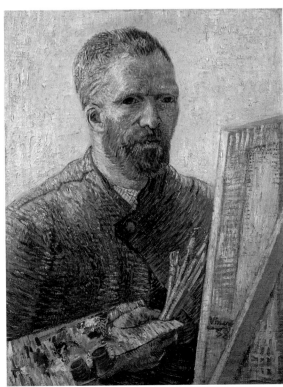

Figure 49. *Self-portrait as a Painter,* 1888

account he doesn't cover himself in glory. He'd come to the restaurant looking for a fight, Segatori says, an accusation, he claims, coerced from her by sinister forces. Her apparent hostility is all an act, he insists; her true feelings toward him she revealed only through an unspoken code. Of course none of this rings true, though it's unclear whether Vincent believed it himself or was merely spinning a tale for Theo's sake. In the end it was easier to conjure secret cabals than to face the fact that his former lover had turned on him.

Given Van Gogh's own volatile temper, his paranoia heightened by excessive consumption of alcohol, there's no doubt he played a role in the eruption of violence. Miss Segatori's business partners must have regarded the art on the walls as collateral, perhaps payment for the large tab he'd run up. Van Gogh, for his part, tended to regard any act of kindness as nothing less than his due, repaying generosity with ingratitude. He showed up at Le Tambourin in a belligerent mood, refusing to admit the creditors might have a legitimate claim on his belongings.

His simultaneous battles with Madame Tanguy help shed light on his self-serving psychology. Like Segatori, Tanguy often gave Van Gogh stuff for free, and when his wife berated him, Vincent dubbed her an "old witch." He couldn't see that the old man was taking a loss, believing instead that *he* was doing *him* a favor by patronizing the store. "Now I gave Tanguy's wife a piece of my mind and said it was her fault if I wouldn't buy anything else from them," he told Theo. "*Père* Tanguy's wise enough to keep quiet, and he'll do what I ask of him all the same."[12] We don't have Theo's response but, given his own experience with Vincent's ingratitude, he likely felt some sympathy for Père Tanguy and his much maligned wife.

The final act of his affair with Agostina Segatori brought still more humiliation. Van Gogh never did manage to retrieve his work. "The

business collapsed and was sold," Bernard remembered, "and all these paintings, piled up in a heap, were auctioned for a derisory sum."*[13]

It was in the wake of this disaster that he began to plan for major changes in his life. "Sometimes I already feel old and broken," he confided to Theo,

> but still sufficiently in love to stop me being enthusiastic about painting.
>
> To succeed you have to have ambition, and ambition seems absurd to me. I don't know what will come of it. Most of all, I'd like to be less of a burden to you—and that's not impossible from now on. Because I hope to make progress in such a way that you'll be able to show what I'm doing, with confidence, without compromising yourself.
>
> And then I'm going to retreat to somewhere in the south so as not to see so many painters who repel me as men.[14]

The pathetic end of his affair with Agostina Segatori sheds a melancholy light on these final months in Paris. Those centripetal and centrifugal forces—the hunger for human warmth frustrated by his awkward, ill-conceived efforts to forge those connections—were subjecting him to unbearable stresses, from which he could escape only by drinking too much and by plunging heedlessly into his work. Trying to have it all, he risked losing everything.

Even as Vincent was struggling with his broken heart and battling the goons at Le Tambourin, Theo was suffering through a crisis of his own.

* On another occasion Bernard elaborated that "many flower canvases, done up in batches of ten, were auctioned off for between 50 centimes and 1 franc per batch." [See *Paintings 2*, 378, note 13]

In many ways Theo's life was on a more solid footing than it had been a year earlier. After the collapse of his plans to go into business on his own, he'd returned to Paris in a depressed mood and instantly fallen ill. But, knowing how many depended on him, he soon pulled himself together. Over the following months, as sales began to pick up on the Boulevard Montmartre, his bosses rewarded him by giving him more responsibility.

Despite increased satisfaction at work, however, Theo was unhappy. The stormy winter with Vincent had left scars, and while by the spring the brothers had managed to patch things up, there was a wariness, a lack of trust, that cast a pall over the household. In April Theo wrote to his sister Elisabeth complaining of "great loneliness." "I've been ill, particularly in my spirit, and have had a great struggle with myself," he confessed, before adding: "I now feel much stronger again and hope that I'm back on my feet again."[15] Then he dropped a startling bit of news: "I plan to propose to Jo Bonger some time. It's true that I don't know her well enough to be able to tell you much about her. As you know, I've only seen her a few times, but what I know of her pleases me. She gave me the impression that I can place my trust in her completely unreservedly, as I wouldn't with anyone else. I would be able to speak to her about *everything*, and I believe that if she wanted to she could mean oh so much to me. Now the question is whether she, for her part, has the same idea, and whether it isn't a completely egotistical business I'm embarking on."[16]

He'd met Dries's younger sister the previous summer during his vacation in Holland, the one bright spot in an otherwise disappointing trip. The image of her kind face and sweet, intelligent manner sustained him through the long, bitter winter, growing into something of an obsession. Like his older brother, Theo was prone to inappropriate romantic attachments. Less violent in his passions, and certainly more

ingratiating in his manners, his love life, nonetheless, had been marked by numerous missteps. At the age of twenty, he almost threw his career away by marrying a completely unsuitable woman; more recently he'd been involved in a stormy liaison with the unstable "S." Proposing to a young woman he hardly knew, and who hardly knew him, suggests a kind of impulsiveness we normally associate with Vincent.

On the other hand, Jo Bonger was neither unsuitable nor unstable. At twenty-four, she was intelligent, well-educated, and from a respectable family of the same background as Theo himself—exactly the kind of woman his parents would have chosen for him. Even Vincent was supportive, noting: "It would please our mother greatly if your marriage came off, and for your health and business affairs you shouldn't remain single anyway."[17] In Jo, Theo would be getting not only a domestic partner but an intellectual companion. Unlike many young ladies of her class, her interests extended beyond the domestic realm. Fluent in English, she worked as a teacher and translated novels, and had a broad range of cultural interests. She was also, Theo's sister confirmed, "smart and tender, not knowing anything about the everyday, narrow-minded, annoying, prosaic world full of worries and misery."[18]

When Theo planned his annual trip to Holland in July 1887, he added a stop at the Bonger household to his usual summer itinerary. Once again he set out with high hopes. And once again his hopes were dashed. Confronted by a proposal from a virtual stranger, Jo reacted very much as one might expect. "Friday a day full of emotion," she recorded in her diary:

> At two in the afternoon the doorbell rang: Van Gogh from Paris. I was pleased he'd come, I imagined I'd be talking to him about art and literature. I received him pleasantly and then he suddenly began to make me a declaration. It

would sound improbable in a novel, and yet it is the case
that having known me for no more than 3 days he wants
to spend his whole life with me, he wants . . . to put all
his happiness in my hands. And I'm so terribly sorry that
I've had to cause him pain. He's been looking forward to
coming here all year and pictured so much to himself, and
now it ends like this. What a sad mood he will be in as he
goes back to Paris.[19]

Theo was bitterly disappointed. "Oh Jo!," he wrote as soon as he
got home: "My actions have so often been the result of the frame of
mind I was in at the time, and my life would certainly have been very
different, and of course much better, if I had come across the love and
support my heart so longed for, but I roamed alone for years, thought
I had found the right person, but it seems I was mistaken. It is not
surprising that my heart, which has been hurt so often, has become
hardened, and that for a long time art was the only thing in which I
took an interest—it has filled my entire life."[20]

He returned to the Rue Lepic apartment in a melancholy mood,
drowning his sorrows in the usual way. "[Theo] is ruining his health,"
Dries Bonger fretted, "and has adopted the kind of extreme lifestyle he
is bound to regret later on."[21] Theo continued to write to Jo, hoping to
convince her she'd made a mistake. But when he promised her "a rich
life full of variation, full of intellectual stimulation, [and] a circle of
friends who are working for a good cause, who want to do something
for the world," Jo simply responded: *I don't know you.*"[22]

Still he persevered, posting an occasional letter in the hope that she
would change her mind; or, at least, that if she wouldn't have him as
a wife, she would consent to have him as a friend. Like Vincent in his
frantic courtship of Kee Voss, Theo wouldn't take no for an answer.

Unlike his brother, however, he couched his passion in gentler terms, hoping to persuade rather than bully. Eventually, his persistence paid off. The following year, around Christmas 1888, Jo paid a visit to her brother in Paris. "Guess who I bumped into here a couple of days ago," Theo wrote to his mother:

> Jo Bonger, whatever was I to do? . . . First she wanted to know whether it was her fault that I no longer socialized with André. One thought I could treat her amicably, and I became good friends with her & her brother once again. But mother, that was impossible, I loved her too much, & now that we have seen one another a great deal these last few days, she has told me she loves me too & that she will take me the way I am. I am actually worried that she is making a mistake & that she will be disappointed in me, but I am so very happy, & I shall try my best to make her happy, if I can. If I am perhaps giving you the idea that ours was a chance meeting, then that is wrong of me, for it was she who arranged the meeting with a great deal of tact, & noble feeling, otherwise it never would have happened. I do believe that she knew that I still loved her beforehand. And now dear Mother I ask you to take her into your loving mother's heart. . . . O Mother I am so inexpressibly happy. Can it really be true?"[23]

They were married the following April.

In the meantime, Vincent, though he commiserated with Theo's heartache, wasn't too upset. Had Theo's initial proposal been successful, it would have disrupted their household arrangements, introducing a

competitor for his attention and another claimant on his resources, adding as well an unpredictable element into an already volatile mix. (It's no coincidence that his first psychotic break came on December 23, 1888, the very day he learned of Theo's engagement to Jo!) The fact that they were both apparently unlucky in love actually drew them closer together. Vincent was always at his best around those who were wounded, as when his mother broke her hip and he transformed in an instant from a prodigal into a devoted son. For him, suffering was redemptive. Experience had already taught him that nothing in life worth having came without its share of pain. "Love is the best and most noble thing in the human heart," he opined, "especially when it has been tried and tested in life like gold in the fire."[24] The differences of the past year faded to insignificance when measured against their shared misfortunes.

Both brothers responded to heartbreak by throwing themselves into their work, Theo by doubling down on the purchases of new art that he'd begun in the spring, and Vincent by pursuing his experiments on the more distant fringes of the avant-garde. For once they seemed to be moving in the same direction, even if at different speeds. While Vincent had always been constitutionally predisposed to rebel, his younger brother was more diffident. But now, with nothing to lose, Theo began to take greater risks. Their lives, as well as their views on art, were converging, which may explain the pair of small paintings Vincent made around this time: one a self-portrait, the other (a rarity) a portrait of his brother.*

* The identification of the portrait in the straw hat as Theo, rather than Vincent himself, rests on a few telling details. Perhaps the most definitive is the fact that his cheeks are clean shaven, with perhaps a hint of facial hair along the jawline, a look evident in photographs of Theo from this period. Vincent almost always depicts himself with a full red beard.

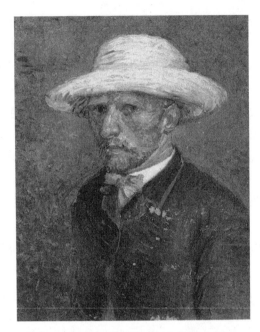

Portrait of Theo van Gogh, 1887

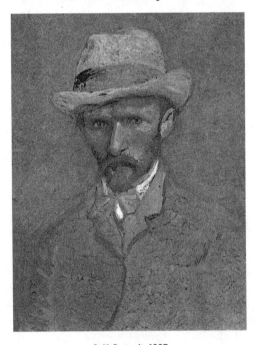

Self-Portrait, 1887

Not only are the portraits a matched set—each is on cardboard, about 7.5 x 5.5 inches square, among the smallest works he ever painted—but Vincent seems to be engaged in a playful game of trading places. While he depicts Theo in the straw hat of a plein-air painter, he shows himself in the fedora, jacket, and bow tie of a boulevardier. Theo isn't actually attired in the blue workman's smock Vincent donned while painting along the Seine, but his blue coat and yellow hat recall the palette he favored in many of his self-portraits. This mix-and-match approach is meant to commemorate their deepening bond, as if they are finally partners in a joint effort in which their separate identities have been subsumed in a common cause.

In the fall of 1887, Van Gogh painted for the first time a subject that has become almost synonymous with his name: sunflowers.* [see color plate 38] On one level, these modest works are simply a continuation of the color "gymnastics" of his previous floral still lifes, using the blossoms most closely associated with the season. But they also represent a fundamental departure from those earlier exercises. Strewing the plants casually across a tabletop rather than placing them in a vase gives these compositions a greater informality. Many have already gone to seed; they sprawl exhausted or tumble like acrobats, their twisted branches and withered petals reaching out longingly. He's discarded the Divisionist *pointille* entirely, sculpting with gestures that both capture the twisted forms and take on an expressive life of their own. Unlike the famous series he painted the following year in anticipation of Gauguin's imminent arrival, the four versions he made in Paris are not symbols of "gratitude,"[25] as he explained to Albert Aurier in 1890. Instead they wallow in the

* Earlier that summer he'd painted a view of the Butte de Montmartre with a single sunflower stalk in the foreground. But this is a landscape rather than a still life.

beauty of decay, gnarled witnesses to endings, to the encroaching death of winter.

As the weather cooled, Van Gogh moved back indoors and rededicated himself to still life painting. Working that spring and summer in bright sunlight had liberated his instinct for color. "This light . . . soon awakened like a nascent dawn in views of Asnières, La Grande Jatte, and the banks of the Seine which were already joyfully pleasant," Bernard observed. "This was Van Gogh's prelude to the symphonies of his future palette, he was trying out his instruments. . . . Gray canvases suddenly gave way to 'stippled' studies."[26] Now he applied those lessons to subjects that granted him even greater chromatic license.

Depicting bunches of purple and yellow grapes against a yellow background, golden quinces against cool blue, red apples against green, and various other combinations, he exults in striking contrasts. [see color plate 39] On occasion, he sets himself the opposite problem, exploring the possibilities contained within on a single dominant hue. Like all still lifes, these works are artificial constructs in which the artist arranges his forms in order to investigate certain pictorial problems. They are tabletop experiments, complete with controls to isolate particular variables, which, in turn, are arranged in various combinations in order to test the interactions among them.

But these works seem more than usually programmatic, pure arrangements of form and color. They can't exactly be called *abstract*—the objects are still immediately recognizable—but they are surely moving in that direction. Of course artists are always forced to balance the need to represent what's in front of them with the need to consider the formal structure of the work itself, but in these still lifes, the weight has shifted decisively toward the latter. Color in particular is handled arbitrarily, as a purely pictorial element that bears only the most tenuous

relation to reality. "I believe in the absolute necessity of a new art of colour, of drawing and—of the artistic life," he told Theo. "And if we work in that faith, it seems to me that there's a chance that our hopes won't be in vain."[27]

There's no sense of place in these works, of space, no indication of a time of day or a distinctive quality of light or atmosphere. Van Gogh selects the fruit he wishes to paint based on the particular relationships he's interested in exploring—the complementary contrast of purple and yellow grapes, for example. He then lays down a background hue that offers further permutations on the initial premise. Compared to the landscapes from the spring and summer, these still lifes are pared down to a few essential elements. There's not a lot of close looking going on, few passages that show him making keen observations from life—a telling bit of shadow or surprising discovery made on the spot that shows him responding in the moment to what's in front of him. Instead, he seems to be following his preordained scheme, with just enough detail to keep it rooted in the here and now. Sometimes, as in *Quinces, Lemons, Pears and Grapes,* the painting consists of variations of a single hue (yellow); others, like *Apples,* are built around a basic complementary contrast (red/green). Devoid of picturesque incident or narrative association, almost schematic in their presentation, they are far bolder in conception and more assertive in their presence than the landscapes that preceded them.

These are not perhaps the most compelling paintings Van Gogh ever made, but they mark a crucial breakthrough nonetheless. They register a profound shift in the nature of his art, one that will lead directly to the masterpieces of the coming months and years. Up to this point, Van Gogh was always more or less a *realist.* However much the images he conjured on his canvases deviated from the scene that was actually in front of him—often against his will, and much to his

frustration—his main purpose was to reproduce the visible world. His methods shifted over the course of the years, from the chiaroscuro of his Nuenen peasants to the bright, Divisionist landscapes painted in Asnières and Saint-Ouen, but in every case they adhere fairly closely to the view through the perspective frame. Now in these works idea takes precedence over transcription, the purely abstract, formal elements of the painting over the naturalist impulse to describe what he sees.

A side-by-side reading of three letters from three different stages of his career shows how far he's traveled. "I've also fallen in love like that, madly in love with a Dame Nature or Reality," he wrote to Anthon van Rappard in 1881, "and have felt so happy ever since, even though she's still resisting me strenuously and doesn't want me yet, and often raps my knuckles if I dare over-hastily to think of her as mine. So I'm far from saying that I've already got her, but I'm courting her and seeking the key to her heart despite the painful knuckle-rapping."[28] In the second, written shortly before he moved to Paris and under the influence of Charles Blanc and Eugène Delacroix, we can see the ground begin to shift. "COLOR EXPRESSES SOMETHING IN ITSELF," he proclaimed. "One can't do without it; one must make use of it."[29] And finally, his description from September 1888 of his famous *Night Café*:

> I've tried to express the terrible human passions with the red and the green. The room is blood-red and dull yellow, a green billiard table in the center, 4 lemon yellow lamps with an orange and green glow. Everywhere it's a battle and an antithesis of the most different greens and reds; in the characters of the sleeping ruffians, small in the empty, high room, some purple and blue. The blood-red and the yellow-green of the billiard table, for example, contrast

with the little bit of delicate Louis XV green of the counter, where there's a pink bouquet.

The white clothes of the owner, watching over things from a corner in this furnace, become lemon yellow, pale luminous green. . . . The night café is a continuation of the sower, as is the head of the old peasant and of the poet, if I manage to do the latter painting. It's a colour, then, that isn't locally true from the realist point of view of trompe l'oeil, but a colour suggesting some emotion, an ardent temperament.[30] [see color plate 40]

In the still lifes from the fall of 1887 he's not quite there. He continues to deploy color prescriptively but not symbolically, thinking in terms of formal relationships rather than expressive possibilities. But by cranking up the chromatic volume, by treating color as an end in itself, he's already made the crucial break from his realist roots.

Van Gogh did not embark on this journey alone, but arm in arm with his adventurous young colleagues. And this time he's not following, but has muscled his way to the front, a position he will continue to occupy for the remainder of his short life.

In September, Émile Bernard returned to Paris after an extended stay in the Breton village of Pont-Aven.* The previous spring, the young man had been instrumental in pushing Van Gogh to adopt the innovations of Seurat & co., introducing him not only to Signac but to the picturesque scenery of Asnières.** In fact he'd been among

* The exact date of Bernard's return in 1887 is not known, but his summer travels usually ended in late September or early October.
** It's difficult to assess Bernard's Neo-Impressionist work since he later destroyed most of his paintings from this early period.

the first to jump on the Divisionist bandwagon, earning the wrath of Cormon, who accused him of "creating disorder"[31] in the classroom. Before his expulsion he'd managed to infect a number of his fellow students with the new ideas. Among the stricken were the atelier's two massiers, Louis Anquetin and his close friend Henry de Toulouse-Lautrec, both of whom were soon using the divided brushstrokes and vivid color promoted by the radical faction.

But by now Bernard had moved on. He'd largely abandoned land-scape, which was the Neo-Impressionist's favored genre, having come to the conclusion that "working outdoors was the opposite of art because of its realistic tendencies."[32] In fact Bernard returned to Paris an apostate to the Divisionist creed.

The truth is Bernard was temperamentally incapable of sitting at the feet of any master for long, much less someone as pompous and domineering as the Pointillist prophet, Paul Signac. Bernard him-self traced his disillusionment to a visit he made to Signac's studio in April 1887 in the company of his friend from Cormon's, Louis Anquetin. There he remembered seeing "large and very luminous, but lifeless landscapes; interiors where all human figures seemed quite wooden."[33] The overall effect was monotonous. He realized that while Pointillism "was good for the vibrant production of light, it stripped out color," adding: "I immediately threw myself into the opposite theory."[34]

No doubt Bernard's epiphany was more gradual than he was willing to admit. Frustrated with Neo-Impressionism's rigid formulas and lack of emotional depth, he experimented with the "simplification of color using full tones harmonized in accordance with a system of almost flat tints."[35] The truth is that many sensitive artists at the time were engaged in a similar soul-searching, groping for something beyond the narrow horizons prescribed by Seurat and Signac, something that

did not reduce the art of painting to clinical analysis but that gave nourishment to the soul.

In formulating his new approach, Bernard initially partnered with Anquetin rather than Van Gogh, deploying the innovations of the Neo-Impressionists for purposes never intended by their inventors. The Neo-Impressionists reduced their palette to the primary and secondary colors in order to capture the true quality of light; Bernard, too, stripped his palette down to bare essentials, limiting himself to "the seven colors that make up white light." But rather than using these prismatic hues for the sake of optical precision, he used them for expressive and symbolic purposes, to develop "a style free from any realistic imitation."[36]

While Divisionism tends to operate in the no-man's-land between Impressionist naturalism and Symbolist artifice, there was no question on which side of the border Bernard and Anquetin had taken up residence. "To see a style and not an object," was the function of art, Bernard insisted: "To highlight the abstract sense and not the objective."[37] The fundamental building blocks of art, he concluded, were not tools for recreating the world apprehended by the senses but ends in themselves: "The preoccupations with space, planes and effect being rigorously banished in order to make way for color and line, which for me embodied the meaning of my work."[38] He discards the optical component of Divisionism while exaggerating its latent conceptual dimension. His paintings break free of sense experience, their forms as weightless as construction paper cutouts arranged on a flat surface.

The critic Édouard Dujardin, reviewing the work of Louis Anquetin in the Salon des Indépendants of 1888, coined the term *cloisonnisme*, naming this latest *ism* in the Parisian avant-garde for the craft in which pieces of colored glass or enamel are held in place by metal strips as

in a Tiffany lamp or the rose window of Notre-Dame. Writing in the pages of *La Revue Indépendante*, Dujardin explained:

> At first glance these works give the idea of a wholly decora-
> tive painting—a traced outline, a violent and limited color-
> ation, inevitably recalling popular imagery and Japanese art;
> then, beneath the general hieratic character of the drawing
> and the color, one perceives a sensational truth emerging
> from the passion, the romanticism; and beyond all else, little
> by little, it is the voluntary, the reasoned, the intellectual
> and systematic construction, which requires analysis.[39]

Then he makes the critical observation: "The point of departure is a symbolic conception of art. . . . Primitive art and popular art, which is the contemporary continuation of primitive art, are symbolic in this fashion. . . . In their perfection of craft, the ancient painters had this technique. And Japanese art is still like that. . . . And the work of the painter will be something like a painting *by compartments*, analogous to cloisonné work, and his technique will be a kind of cloisonnisme."[40] In describing the work of Bernard and Anquetin, Dujardin uses many of the terms and rehearses many of the concepts already familiar from Symbolism: *decorative, primitive*, references to popular or folk art, as well as sources in non-Western traditions like the art of Japan.

The *cloisonnist*, Dujardin explains, attempts to evoke "the *feeling* of things . . . not the image but the character."[41] Drastically reducing his means, the artist is able "to grasp the intimate reality, the essence of the object to which he applies himself with the least possible number of characteristic lines and colors."[42] As Jean Moréas proclaimed in his "Manifesto of Symbolism," the goal was to "clothe the idea in sensible form." These artists reject realism altogether, not only the exhausted

realist tradition of the Salon and the socially engaged realism of Courbet, but the optical realism of Impressionism. Instead of mere appearance, the true artist searches for a deeper, eternal truth. This search can involve summoning a demonic force or, more often, getting in touch with one's inner child. In each case the goal is to lift the veil of appearance and gaze upon the face of the eternal.

Bernard in particular was, perhaps, a better theoretician than painter, programmatic rather than instinctive.* But beginning in the summer of 1887 there's no doubt that he and Anquetin had conjured something fresh and exciting. *Cloisonnisme* fulfilled the Symbolist ambition to "to objectify the subjective," as Gustave Kahn put it. They managed to achieve this with an economy of means, by simplifying, by returning to basics. The paintings of Bernard and Anquetin (and soon Gauguin, as well) evoke medieval icons and primitive folk art without imitating them. They rarely deploy classical props like Puvis de Chavannes, or indulge in neurotic fantasies like Gustave Moreau or Odilon Redon. In adopting their deliberately naïve approach, they hope to recover essential truths that the materialistic, complacent civilization of the late 19th century had lost.**

Vincent was dazzled by his self-confident young friend, attracted by his brilliant, if facile, mind, and intrigued by the possibilities of the

* The potential of the new movement will be realized the following summer, during Bernard's stay in Pont-Aven, when Bernard and Paul Gauguin will develop a new variant they styled *Synthetism*. Quarrels over priority ultimately caused a rift between the two men. While Bernard probably had a case for claiming to be the originator, Gauguin ultimately used these innovations to create a far more compelling body of work.

** One of the sources Dujardin cites is the popular art form known as *images d'Epinal*, brightly colored prints of traditional subjects rendered with a certain charming naïveté.

new approach he'd developed over the course of the summer. Bernard's motives in renewing their friendship were certainly more mixed. He was ambitious, impatient to make his mark in avant-garde circles, hitting his stride just as Theo was making it known he was on the lookout for young talent. And Vincent, unworldly as he was in so many ways, was not above using that connection to draw people to him.

But it's clear that Bernard also respected Van Gogh as both an artist and an original thinker. Their correspondence, begun shortly before Van Gogh left for Arles in February 1888, reveals a mutual admiration, and even a deference on the part of the younger man.* However rough Vincent's manners or volatile his temper, Bernard appreciated his willingness to join him in exploring far-flung aesthetic horizons. For the remainder of Van Gogh's life, Bernard would remain his closest friend in the avant-garde, the conduit through which he learned of the latest subversive notions percolating in the cafés of Montmartre and a sounding board for his own ideas. And it was not only ideas that flowed back and forth: In a sign of mutual admiration, they exchanged paintings at least four times. After learning of Van Gogh's psychotic break at Christmastime in 1888, Bernard wrote a despairing letter to Albert Aurier: "My best friend, my dear friend Vincent is mad. Since I have found out, I am almost mad myself. . . . My dear friend is lost and it will probably be only a question of time until his approaching death!"[43]

Later on, when Bernard reinvented himself as a devout Christian and upholder of traditional values, he distanced himself from not only Van Gogh but all his friends in the avant-garde. But in the fall of 1887,

* Van Gogh's first letter to Bernard is dated December 1887, two months before his departure.

he developed a fruitful partnership with the older man, one that would transform the art of both in profound ways.

At first Van Gogh played the role of student to the younger man. Under Bernard's influence he adopted a more stylized approach, simplifying his compositions and emphasizing the formal, abstract values of the painting rather attempting to reproduce exactly what was in front of him. "Some advice," Bernard offered, "do not paint too much from nature. Art is an abstraction; derive it from nature while dreaming in front of it and think more of the creation than of the result."[44] It was advice Van Gogh was willing to follow only up to a point. He still needed to see what he was painting, to have the motif right in front of him, if only as a jumping-off point. And no matter how closely Van Gogh followed Bernard's lead, he remained distinctly his own man, infusing his work with dynamic energy lacking in the younger man's work.

A comparison between a still life like *Grapes, Lemons, Pears and Apples* and Bernard's *Earthenware Pot with Apples* is instructive. While Bernard clinically follows his formula—the "simplification of color using full tones harmonized in accordance with a system of almost flat tints"—Van Gogh's still seems somewhat ad hoc, even chaotic, discovered in the process of painting rather than carefully plotted beforehand. Bernard's painting is static, iconic, while Van Gogh's positively crackles with electricity; the younger man's painting is chilly to the point of frostbite, the older man's radiating warmth and life. Despite the fact that Bernard was the first to adopt Divisionist techniques, he has moved further from his source, preferring flat planes of unmodulated color, each neatly delineated by solid contours, to the broken brushwork and complementary contrasts of his predecessors. Van Gogh, initially slower off the mark, salvages more from his Neo-Impressionist infatuation, exploiting painterly effects to create a dynamic, kaleidoscopic surface.

Grapes, Lemons . . . , 1887

Émile Bernard, *Still Life with Earthenware Pot and Apples*, 1887

Van Gogh's newfound power is on full display in the contemporaneous *Self-Portrait with Gray Felt Hat.* [see color plate 41] As in the slightly earlier *Self-Portrait with Straw Hat,* he creates a swirling vortex whose ground zero centers on his hypnotic green eyes. The dominant contrast between the warm yellows, reds, and oranges of his face and the surrounding cool blues and purples makes him appear as a blazing sun in the firmament, a celestial body generating its own distorting field. But within this macrocosmic clash of warm and cool are microcosmic skirmishes between adjacent streaks of pigment: pink next to yellow next to green, in varied proportions, form the lighted and shaded portions of his face; green strokes hide within the red bristles of his beard; and lurking in the purple depths that surround him are firefly sparks as if the figure at the center is shedding some of his own radiance into the void. When he exhibited this and a pair of related self-portraits a few months later, Bernard referred to them as his "fiery faces," an apt description of these images that discharge such potent energies.*

Van Gogh had long been interested in these optical vibrations, at least in theory, but never before now had he gained such mastery, either technical or conceptual, over the process. He referred to the technique as *aureoler,* to halo, a term he borrowed from Charles Blanc, who wrote in his *Grammaire des Arts du Dessin:* "Putting a particular colour on a canvas, said Mr Chevreul, doesn't just tint everything that the brush touches with this colour, but also provides complementary colour to the surrounding area, so a red circle is surrounded by a slight green halo which becomes fainter as it spreads out; an orange circle is surrounded by a blue halo; a yellow circle is surrounded by a violet halo . . . and vice versa."[45]

* Among the "fiery faces" he may have exhibited are this one, the closely related *Self-Portrait* from the Musée d'Orsay, and the *Self Portrait with Straw Hat* from the Metropolitan Museum.

Sometimes Van Gogh hewed closely to this more technical meaning, as when he described for Theo a painting of sunflowers "on a royal blue background [which] has a 'halo,' that's to say, each object is surrounded by a line of the colour complementary to the background against which it stands out."[46] But what began as an optical device, discovered through scientific investigations of the refraction of light, ultimately possesses metaphysical connotations. As Van Gogh learns how to control these effects, he no longer regards them simply as a means of describing the world—or even as an abstract, autonomous pictorial element—but as something that allowed him to unlock the hidden spiritual dimension. Just as in a medieval icon the halo signals we've entered sacred territory. "In a painting I'd like to say something consoling, like a piece of music," he wrote in 1888. "I'd like to paint men or women with that *je ne sais quoi* of the eternal, of which the halo used to be the symbol, and which we try to achieve through the radiance itself, through the vibrancy of our colorations."[47]

Van Gogh doesn't intend this as a specifically Christian reference—he long ago put organized religion behind him—but rather something universal, as he reveals in his description of the famous self-portrait he dedicated to Paul Gauguin: "I had conceived this portrait as being that of a bonze, a simple worshipper of the eternal Buddha."[48] [see color plate 42] In this work, as in the earlier *Self-Portrait with Gray Felt Hat,* the entire background—which provides no context or illusion of three-dimensional space—acts as a halo, swirling around the artist's head like a cosmic whirlpool, pointing to his role as the prophet of the new age. Having failed to follow Dorus into the ministry, Vincent has found his calling as an avatar of a new pantheism in which all of nature is holy ground. The cool, cerebral canvases of Bernard and Anquetin, where each colored plane sits placidly within its contour like a pane of stained glass,

invite serene contemplation. By contrast, it's not possible to remain detached, or even relaxed, before one of Van Gogh's paintings. They pulse, they quiver, they writhe, and seem on the verge of disintegration as if every element of the world he depicts is touched by sparks of the divine. They invite ecstasy, even as they threaten to overwhelm.

In casting himself as "a worshipper of the eternal Buddha," the minister's son has traveled far since the days when, as a pious young man, he bombarded his family with passages from scripture or trudged the muddy lanes of the Borinage to bring the Good Word to the miners and their families. Turning his back on the dour religion of his ancestors, Van Gogh conjures an image that reaches across cultures, that speaks to a universal revelation. His mission has not really changed, but now instead of the New Testament he preaches the gospel of pure color, a creed that bridges the narrow sectarian divide to touch the spirit that animates us all.

His artistic pilgrimage followed a similar trajectory to the spiritual, beginning in the academic tradition and landing him on the far fringes of the avant-garde. Starting out, his heroes were painters like Rembrandt and Millet, artists, he believed, possessed of both heart and soul. "There's something of Rembrandt in the Gospels or of the Gospels in Rembrandt," he said to Theo in 1880. "Try to understand the last word of what the great artists, the serious masters, say in their masterpieces; there will be God in it."[49] Eight years later he's finding entirely new sources of inspiration, ones that would have appalled and perplexed his straitlaced father.

"All my work is based to some extent on Japanese art,"[50] Van Gogh now proclaimed. But just because he worships other gods and his artistic heroes inhabit the far side of the globe doesn't mean he's abandoned his original calling. Depicting himself as a bonze, Van Gogh announces a new faith in which the sacred and the aesthetic are one.

His belief in the healing power of art waxed as his belief in that old-time religion waned. But that faith was also evolving, away from traditional forms and in search of new modes of expression. Spiritual and artistic growth went hand in hand, each of them leading him toward lands unknown. Indeed, it's the archetypal journey of the sensitive soul in a crassly material world, from Bohemian Paris in the late 19th century to Haight-Ashbury in the late 1960s. Freeing themselves from the repressive world of their fathers, these rebellious sons and daughters hoped to find self-fulfillment in drugs, in alternative lifestyles, and by opening themselves up to other cultures. This embrace of non-Western forms will become one of the essential drivers of modernist innovation.

Van Gogh painted himself as a bonze not to signal that he'd adopted a new religion to replace the one he left behind. Instead, he meant to signal his rebirth into a new *artistic* faith, a conversion effected in large part through his discovery of Japanese woodblock prints.[*]

Over the course of his career Van Gogh had relied on prints to keep him company and to serve as a source of pictorial ideas.[**] He was an obsessive hoarder of images, covering the walls of his rooms with inexpensive multiples and even cheaper reproductions from which he derived both solace and inspiration. Early on, he'd leaned heavily images torn from English illustrated magazines like *The Graphic* and *The Illustrated London News*.

[*] He also participated in the craze for all things Japanese through the books he read, like Pierre Loti's *Madame Chrysanthème*, the basis for Puccini's opera *Madama Butterfly*, and Edmond de Goncourt's *Chérie*.

[**] This was particularly true during his time in The Hague. Drawings of day laborers as well as a series of studies for a never completed painting of a soup kitchen were based on models from British magazines. For his obsession with these illustrated magazines see, for instance, his letter to Anthon van Rappard from Sept. 23, 1882.

These Dickensian scenes featuring ragged children, sorrowing mothers, and stoic beggars, which paralleled his reading of the time, conformed to his notion that art should convey a morally uplifting message.

As long as Van Gogh was conjuring images of salt-of-the-earth peasants and downtrodden laborers, such images provided a suitable model. But once he began to conceive of himself as a modernist, an urban flaneur, he was forced to look elsewhere for inspiration. It's telling that he purchased his first Japanese prints in Antwerp, just as he was reinventing himself as a "painter of modern life." Arriving in the Belgian seaport, he wrote Theo an excited letter, quoting a favorite Parisian writer: "One of [Jules] De Goncourt's sayings was *'Japonaiserie for ever.'* Well, these docks are one huge *Japonaiserie*, fantastic, singular, strange."[51]

Moving to Paris, he began buying Japanese prints with the same manic fervor he'd once devoted to the English engravings. These brightly colored images, known as *ukiyo-e* (pictures of the floating world), depicted geishas, famous actors, erotica, and idyllic views of the countryside. Crafted with an exquisite feel for abstract pictorial values, they also offered a window into an exotic culture, a land of mystery onto which jaded Europeans could project their own fantasies of a world uncorrupted by Western materialism. By the time Van Gogh began to amass his own collection, the craze for all things Japanese had already reached a saturation point. According to one exhausted observer, "[Japanese] bronzes, ceramics, boxes, colored paper, even toys, were in thousands of shop windows in Paris. The vogue was such that even the decorations on everyday pastries were borrowed from Japan."[52]

While the commercial market trafficked in superficial exoticism, modern artists discovered something more compelling—an artistic tradition as sophisticated as that of Europe but based on very different premises. Manet, Degas, and the rest of the Impressionists pored over works by masters like Hiroshige, Hokusai, and Utamaro, borrowing

their radical cropping, elegant linear style, and unusual perspectives to breathe new life into the stale conventions of their own tradition.* In Manet's *Portrait of Émile Zola,* Japanese prints adorn the background along with reproductions of a painting by Velázquez and his own *Olympia*—a concise summary of his own artistic lineage. Degas's art was perhaps even more profoundly shaped by these woodblock prints, his dramatic telescoping of near and far, his preference for birds-eye viewpoints, the sinewy quality of his contours, all ultimately derived from *ukiyo-e* models.

Edgar Degas, *The Orchestra of the Opera,* 1870

Van Gogh, somewhat late to the game, made up for lost time. "There's an attic at Bing's, and in it there's a heap of 10 thousand Japanese

* This was as true in London as in Paris, where the American James Whistler made brilliant use of Japanese compositional strategies in works like *Nocturne: Blue and Gold—Old Battersea Bridge.*

prints, landscapes, figures, old Japanese prints too," he enthused.* He spent countless hours at the gallery on the Rue Chauchat, rummaging through the portfolios, buying these flimsy, brightly tinted images by the ream, and sticking Theo with the bill.** He went not only to buy but to educate his eye. "I recommend Bing's attic to you," he told Theo after he'd moved to Arles. "I learned there myself, and I got Anquetin and Bernard to learn with me."[53]

He justified his extravagance to Theo on the grounds that he'd be able to sell his collection at a profit. Of course anticipated sales never materialized, though he did manage to exchange treasures from his vast stock to acquire original works of art by his friends, including one trade involving "a good many"[54] prints for a single painting by Émile Bernard. He also tried (unsuccessfully) to hawk his prints at Le Tambourin, where he hung them alongside his own floral still lifes; a couple of them are visible in the background of the painting *In the Café.****

Though he began collecting Japanese prints in 1885, it was only in the winter of 1886–87, just as he was coming under the influence

* Vincent usually paid five *sous* per print. [See letter 642, July 15, 1888] But even at these low prices, he purchased so many that he owed more than he could pay. Siegfried Bing's gallery at 19 Rue Chauchat maintained a large stock of Chinese and Japanese art. In July 1888, Vincent admitted he still owed Bing ninety francs, but, typically, insisted that it was the owner who should be thanking *him*, rather than the other way around: "If we take into account that I've often sent people directly to Bing, it would be better that Bing leave us that, and if I was still there to deal with it, I'd wish to increase the stock so as to be able to do slightly more important business in them." [Letter 637, July 9, 1888] A few years later, Bing became one of the chief promoters of the Art Nouveau movement.

** "Theo and I have hundreds of these prints," he told Willemien. [Letter 590, March 30, 1888]

*** Though barely sketched in, one can recognize the right-hand image as a depiction of a pair of geishas. Curiously, the prints are implausibly large. Van Gogh has actually rendered them life-size, perhaps because he was relying on his perspective frame to block them in.

of Toulouse-Lautrec, that he began to assimilate the compositional devices of the *ukiyo-e* masters into his own work. And even then, paintings like *Glass of Absinthe* and *In the Café* are so heavily indebted to Lautrec's scenes of Parisian café life that it's difficult to say where his friend's influence leaves off and Hokusai's begins.

By the fall of 1887, however, the influence is direct and unmistakable. In his still lifes from this period he adopts what he calls the "simplification of colour in the Japanese manner," and the Asian master's technique of "placing his solid tints one beside the other— characteristic lines naïvely marking off movements or shapes playing one broad area of vivid hue against another."[55] One effect in particular captured Van Gogh's fancy: the crinkly texture of the paper, whose tactile surface he attempted to translate into the very different medium of oil paint. This allowed him to impart a liveliness to his own canvases that, also under the influence of the *ukiyo-e* prints, he was reducing to a few broad areas of bright color, sharply delineated. A. S. Hartrick recalled a visit to VG's studio in Paris where the artist "drew my attention specially to a number of what he called 'crepes,' i.e., Japanese prints printed on crinkled paper like crepe. It was clear they interested him greatly, and . . . what he was aiming at in his own painting was to get a similar effect of little cast shadows in oil paint from roughness of surface."[56] Bernard, too, noted the phenomenon, referring to his portraits of this time as *à zebrures*, that is zebra-style or "striped."[*][57]

This painterliness overcame the chief deficit of the new art, particularly *Cloisonnism*, which was that by restricting themselves to a few primary

[*] Perhaps the most striking example of this "zebra" style is his self-portrait from the Kunstmuseum in Basel. Here the strokes are widely divided, retaining their independent identity. The Japanese print in the background helpfully suggests the source of this technique.

and secondary colors, each contained within a well-defined outline, these artists created works with dead surfaces, as if the creative process was merely a rote execution of a plan conceived in advance. Compared to a contemporaneous work by Bernard or Anquetin, a painting by Van Gogh is dynamic, recording the movements of the artist's hand in brushstrokes that skitter across the surface of the canvas. If Van Gogh feels present in his work, it's because his clumsy, aggressive mark-making never allows us to forget the image is the product of a man wrestling with the tools of his trade. His colleagues, by contrast, are far more self-effacing, preferring to retreat into the realm of pure idea.

To the extent that Van Gogh's approach resembles strategies adopted by Bernard and Anquetin, it's as much a case of drawing on the same sources as of borrowing from his young colleagues. "Look, we love Japanese painting," he insisted. "We've experienced its influence—all the Impressionists have that in common."[58] Indeed, the three of them seem to be engaged in that archetypal avant-garde game of one-upmanship, seeing who can push the latest innovation to its logical extreme, who can offer the most original variation on a shared theme. It's a sign of his growing self-confidence, as well as his growing prominence, that for once Van Gogh insists on taking the credit for the new direction. He pointed out that he was actually the one to turn his junior partners on to Japanese art. Not only did he drag his friends to the attic of Bing's gallery, but he cited his exhibition at Le Tambourin in the winter of 1887 as a crucial turning point. "The exhibition of Japanese prints that I had at the Tambourin had quite an influence on Anquetin and Bernard,"[59] he recalled with evident pride.

Less important than the question of priority is what this competition points to: that Van Gogh was now a central player on the progressive wing of the Parisian art world, adding his powerful voice to the most up-to-date aesthetic discourse. The truth is that all the most

innovative artists had fallen under the spell of Japanese graphic art, making their work more abstract, more decorative, weaning themselves from the Naturalist tradition, rejecting even the optical realism of the Impressionists and pushing beyond the experiments of their Neo-Impressionist heirs. The limitations of the woodblock printing technique, which could only accommodate a few well-defined hues, becomes in their hands a positive virtue, demanding, in Bernard's words, "simplification of color using full tones harmonized in accordance with a system of almost flat tint." Not to be outdone, Van Gogh offered his own variation on the "Japanese" technique in a letter to Bernard:

> While always working directly on the spot, I try to capture the essence in the drawing—then I fill the spaces demarcated by the outlines (expressed or not) but felt in every case, likewise with simplified tints, in the sense that everything that will be earth will share the same purplish tint, that the whole sky will have a blue tonality, that the greenery will either be blue greens or yellow greens, deliberately exaggerating the yellow or blue values in that case. Anyway, my dear pal, no trompe l'oeil in any case.[60]

Simplifying, exaggerating, composing in broad areas of color chosen more for their pictorial or expressive qualities than for any descriptive function—all these tendencies were already present in the Japanese originals. "You can get an idea of the change in painting," he told his sister, attempting to describe what he and his colleagues were up to in Paris, "if you think, say, of the colourful Japanese pictures that one sees everywhere, landscapes and figures."[61] Their European admirers in the avant-garde were all praying at the same altar, seeking forms that, as

Bernard put it, were "freed from any realistic imitation," synchronized with deeper spiritual currents.

Van Gogh paid tribute to, and learned lessons from, his new masters in a series of three paintings in which he copied *ukiyo-e* originals: *Flowering Plum Orchard (After Hiroshige)*, *Bridge in the Rain (After Hiroshige)*, and *Courtesan (After Eisen).** [see color plate 43] While each of them closely follows its model, he brings his uniquely perceptive eye and expressive hand to bear so that they are thoroughly satisfying artworks in their own right.

Bridge in the Rain (After Hiroshige), 1887

* The two Hiroshige landscapes come from his series, *100 Famous Views of Edo.* Van Gogh owned seven prints from this series. Gauguin borrowed the motif of the tree trunk in the foreground for his famous *Vision after the Sermon* from 1888; Van Gogh will reuse it in his *Sower* from the same year.

It's typical of Van Gogh's insecurities that even now, as he was coming into his own as a master in his own right, he took a methodical, even plodding, approach to his source material, as if he was still unsure of his ability to "get it right." For all his talk of rejecting realism and a trompe l'oeil approach, he carefully duplicated the smaller prints by making a tracing and then using a proportional grid system to scale up to the larger canvas. This process functioned very much like his perspective frame, allowing him to accurately transcribe the scene in front of him onto the canvas. In this case, however, the diligent approach led to problems: the narrower format of the original left empty spaces on either side of the wider canvas, which Van Gogh filled in with borders adorned with Japanese characters.* In *Flowering Plum Orchard (After Hiroshige)* and *Bridge in the Rain (After Hiroshige)*, the addition of a border allows him to tease out secondary changes on the main complementary dualities. For the larger *Courtesan (After Eisen)*, he finds a more imaginative solution, applying a landscape border featuring a riverbank with bamboo stalks, two figures in a boat, a crane, a frog, and lily pads—elements borrowed freely from multiple Japanese sources as well as his own imagination.** Whether or not Van Gogh intended it, the contrast between the natural scene and the elegant, cosmopolitan courtesan provides a wonderfully playful and discordant counterpoint.

More than any particular detail, however, what Van Gogh contributes is his own irrepressible personality. No matter how closely he

* He borrowed them from different sources, and with no apparent understanding
 of (or interest in) their meaning.
** For the courtesan, Van Gogh's source was not an actual print, but the cover of
 an issue of *Paris Illustré* from May 1886 devoted to Japan. The fauna he used for
 the borders may actually comment on the woman's profession. The French word
 for crane, *grue*, is slang for a prostitute, while a loose woman was often referred
 to as a *grenouille*, a frog, and a whorehouse was a *grenouillère*. Thus, despite the
 incongruity, Van Gogh's addition added a sly level of meaning.

follows their broad outlines, his copies could never be confused with the Japanese models. They are less refined than the originals, more bumptious than elegant, lively, assertive, and full of dynamic tension. Translating images made with ink on paper into oil paint on canvas, he combines the bold linear designs of the print with an aggressive painterliness that will define all his later work. Here the meeting of East and West creates a strange new hybrid, neither completely one nor the other, but an entirely new life-form that will burst forth and make its own claims on the world.

Armed with his new conception, filled with his new sense of possibilities and an almost messianic fervor, Van Gogh returns to a subject he painted before, one very near to his heart: the kindly proprietor of the shop on the Rue Clauzel, Père Tanguy. Three portraits of Père Tanguy date from these months: a pencil drawing and two paintings, the smaller painting a preliminary study for the more finished portrait now in the Musée Rodin in Paris [see color plate 44] In the drawing he depicts Tanguy, bust length, in front of a Japanese landscape cobbled together from two separate prints by Hiroshige. Placed centrally on the page—actually the back of a menu from an eatery Van Gogh frequented—his eyes half closed, a beatific smile on his face, the kindly shopkeeper has become an iconic figure, a cross between a medieval Saint Francis and a Japanese Buddha. Centered, in every sense of the word, the nurturing father, Père Tanguy, inhabits an oasis of calm in a turbulent world, offering a safe harbor for the storm-tossed boat.

Van Gogh carries the sacral theme even further in the paintings. He's stepped back a few feet from his subject so that he can include Tanguy's clasped hands, heightening the sense of prayerful reverence. Surrounding the shopkeeper with works of art—not only Japanese prints, but at least one of his own floral still lifes—he emphasizes

the two-dimensional surface of the canvas, recalling the flatness of a Byzantine icon, while the jewellike colors evoke the brilliance of a Gothic stained-glass window. There are no shadows, no chiaroscuro to dull the brilliance of the prismatic hues. The sitter's enigmatic smile suggests that he's looked beyond the chaos of this world and found the one still point that lies within. It's no more surprising that Van Gogh conceived his friend as Buddha than that he painted himself in the guise of a *bonze*. Japan, for him, was not so much a geographic construct as a mythical realm, a place where even the most humble peasant lived in harmony with nature. He'd left Nuenen with few illusions about the character of the European peasant, but he could still imagine his Asian counterpart as touched by the divine spirit. As for the old Communard Tanguy, he was another "Socrates . . . more closely connected—in terms of resignation and long patience—with the early Christian martyrs and slaves than with present-day Paris pimps."[62]

Van Gogh had come to Paris determined to chronicle the passing scene in the world's most cosmopolitan city. He'd agreed with Baudelaire and Zola that depicting his own times was the task of the true artist. Now he reversed course. The here and now had vanished. Like a martyr from a medieval altarpiece, Tanguy is depicted with his sacred attributes rather than in his natural environment; the reality he inhabits is not defined by his material existence but by spiritual and aesthetic values. Surrounding Père Tanguy with Japanese prints—he placed over his head a view of the sacred Mount Fuji—he transported him to a distant Shangri-La, a Japan of his own imagining in which art, nature, and spirit are one. Even as Paris launched daily assaults on his frazzled nerves, Van Gogh was inventing an imaginary world where he could find peace. If he could not transport himself to that

blessed land, it was some consolation that he could recreate it in the 9th arrondissement.

Around the same time he returned to another subject with deep personal meaning: his former lover Agostina Segatori. [see color plate 45] As he did with his portrait of Tanguy, he removes her from her natural habitat in present-day Paris, surrounding her in a field of gold, again evoking the sacred space of a Byzantine icon. To relieve the strict symmetry, he places a border of red and green stripes on two sides that has no basis in reality but serves a purely pictorial function. While the earlier *In the Café* presents Segatori as a modern woman, a liberated resident of Montmartre who drinks and smokes—a portrait of a recognizable contemporary type, as much as an individual—in this portrait, titled *The Italian Woman*, he dresses her in traditional "gypsy garb," removing her from here and now and placing her in a space without depth, in a moment without end. There's no context, no setting. Much as Saint Catherine might carry her wheel or Saint Lawrence his griddle, she holds a daisy and a yellow carnation, attributes pointing to a deeper symbolic meaning.

Do the flowers signify innocence? Purity? Romantic love? The obscurity is not a flaw but rather a feature of Van Gogh's new artistic language. The signs are fluid, open-ended. Likewise, his spirituality is pantheistic, capable of finding meaning in all Creation. It can conflate an Eastern divinity with the attributes of Christian martyrology while belonging fully to neither tradition. Van Gogh was keenly aware of the danger that this embrace of symbolic language could easily slide into facile allegory and banal illustration. He hadn't rejected the Protestantism of his father simply to adopt another orthodoxy. Indeed

many of his contemporaries were joining cults where they burned incense and chanted in ancient tongues, like the followers of Sâr Péladan's mystic Rose + Croix, or the members of the artistic brotherhood known as the Nabis.* "When reading your many quotations from Moses, from St Luke, &c.," he chided Bernard, "I can't help saying to myself—well, well—that's all he needed. There it is now, full-blown . . . the artist's neurosis. Because the study of Christ inevitably brings it on, especially in my case."[63] The following year, when his young friend sent him photographs of some paintings he'd been working on depicting religious subjects, he was appalled:

> No, you can do better than that . . . An annunciation of what . . . there's an enormous amount of air, of clarity in it . . . but in the end, once this first impression is past, I wonder if it's a mystification . . . I would long to see things of yours again, like the painting of yours that Gauguin has, those Breton women walking in a meadow, the arrangement of which is so beautiful, the colour so naïvely distinguished. Ah, you're exchanging that for something—must one say the word—something artificial—something affected.[64]

Instead of illustrating Bible stories, or filling his paintings with occult references, Van Gogh fought for a language in which form and color convey meanings beyond the senses. Color in particular is capable of conveying states of mind, of altering the viewer's state of consciousness. "COLOR EXPRESSES SOMETHING IN ITSELF,"

* The Nabis, or prophets, were founded in 1888 by students at the Académie Julian. Among its members were Paul Sérusier, a follower of Gauguin, Pierre Bonnard, and Édouard Vuillard. Both Bernard and Gauguin were associated with the group for a time.

he proclaimed. "One can't do without it; one must make use of it." In *The Italian Woman* we have little else to go on, since he removed almost all the narrative elements. But that's enough. The red/green duality he introduces in the border, and which (more surprisingly) he uses in the flesh tones of Segatori's face, can convey deeper meanings without having to consult a glossary of runic signs. We know the emotions Van Gogh hoped to evoke by his description the *Night Café*, which depends on an almost identical palette. Armed with this knowledge, we can infer Van Gogh's conflicted feelings about his former lover, the "terrible human passions" evoked by a clash of complementaries. Of course it's more in keeping with his intention to avoid such literal interpretations. These chromatic messages are meant to operate on a subconscious level, accessing a universal language that dispenses with words altogether.

11

Artists of the *Petit Boulevard*

"You can, if you wish, do something for me, that's to con-
tinue as in the past and create for us a circle of artists and
friends, something which I'm utterly incapable of doing
by myself and which you, however, have more or less cre-
ated since you've been in France."

—Theo to Vincent van Gogh

J ust as Vincent was achieving his creative breakthrough, Theo's
career was also moving in an exciting new direction. The two devel-
opments were related. Following a year of unhappy cohabitation,
the brothers were drawing closer, and as their professional and personal
lives began to converge they each discovered intriguing possibilities in
what the other was doing. For the first time, the partnership Vincent
had always dreamed of now seemed within reach.

This renewed spirit of collaboration was all the more surprising
after the long period in which circumstances conspired to drive them
apart. The year 1886 had been difficult for both of them but par-
ticularly for Theo, who'd suffered personal and professional setbacks.

It started with Vincent's arrival in town, which had thrown his well-ordered life into chaos. Then, his uncles' refusal to provide him with the funds he needed put an end to his plans to set up on his own. Nor had the first half of 1887 seen much of an improvement. A winter made miserable by bouts of illness was followed by another summer of disappointment, as Jo's rejection left him feeling lonely and frustrated.

Fortunately, glimmers of a new dawn had begun to appear at the gallery on the Boulevard Montmartre. Perhaps realizing how close they'd come to losing his services, Theo's bosses at Boussod, Valadon & Cie decided to meet him halfway. Their change of heart was prompted in part by the improved bottom line. Following a multiyear slump, sales had picked up again, both at the main branch and at the satellite Theo managed. Perhaps even more significant was the fact that the company was now in the hands of younger, more open-minded men: the thirty-eight-year-old René Valadon, and twentysomethings Étienne and Jean Boussod, sons of Goupil's old business partner. The sons' tastes were slightly more adventurous than their father's and, in any case, they'd taken note of the rising market for new and innovative art and suspected there might be money to be made. In 1887 they decided to revamp the business model that had been so successful for decades, unloading much of their inventory of blue-chip Salon stars and expanding the firm's print and photography divisions.* Though hardly radicals—they were businessmen, not patrons of the arts—they were now open, in a small way, to Theo pursuing his interest in alternatives to the usual Salon fare.

In fact he'd already been dipping a toe into the market, having sold a painting by Camille Pissarro in 1884 for the modest sum of 150 francs

* Among the many good deeds Theo did on behalf of the Pissarro family was to find Camille's son Lucien a position in the printworks division of Boussod's.

and, the following year, single works by other Impressionist stal-
warts, including Monet, Renoir, and Sisley. But these were one-offs,
likely made on consignment so as not to risk company money. In the
spring of 1887, his bosses authorized Theo to open up the *entresol* in
the Boulevard Montmartre gallery to show new, more experimental
art. Here in this small, ill-lit mezzanine, segregated from the main
space, Theo could promote more innovative work without worrying
that he'd turn off his more conservative clients. Even now he didn't
jump in with both feet. It was not in his nature to take unnecessary
risks, and it was not in the nature of messieurs Boussod and Valadon
to sail uncharted waters. But the shift was real, and the Parisian art
world took notice.

In May 1887, Monet passed on the latest news from Paris to Paul
Durand-Ruel, who at the time was in America trying to build on the
interest he'd stoked the previous year. "We are more popular with
the buying public, no question," Monet wrote to his longtime dealer.
"What will convey the idea better to you than anything I could say is
that Boussod now carries some Degases and some Monets, and that it
will carry some Sisleys and Renoirs as well."[1] While Monet was clearly
hoping to play one dealer off another in order to jack up his own prices,
his account accurately reflected the new reality on the Paris scene. A
powerful force had entered this market, one with far greater resources
than Durand-Ruel could command and possessed of an impeccable
pedigree that could lend credibility to paintings that, until now, had
carried the stigma of subversive radicalism.

Durand-Ruel wasn't pleased. After all the sacrifices he'd made
over the years, sticking with these artists when no one else would,
he was understandably upset that they abandoned him just as the
market was picking up. Camille Pissarro recounted an uncomfort-
able conversation with his longtime dealer:

Durand took me aside and asked me if I had taken any
paintings to Theo van Gogh. "Yes," I replied. "You
shouldn't," he said to me, "take paintings to that devil of a
man! . . . Bring them to me, and especially don't do business
with Theo van Gogh, because as long as he has paintings of
yours, that'll hurt my business and make it impossible for me
to sell any." . . . So I told him very frankly that since Theo
van Gogh had sold some of my new canvases, and thought
they were very good, and represented them intelligently, I
couldn't take back what I had left with him.[2]

Durand-Ruel complained, but he couldn't do much except appeal to
the artists' sense of loyalty, which, after years of having to fight for every
scrap, could only go so far. Shelling out 4,000 francs for a painting by
Degas, Theo indicated he was willing and able to outbid the original
impresario of Impressionism.

Theo was particularly keen to add Claude Monet to his stable. He
often visited him at his home in Giverny, sometimes accompanied
by Vincent who, whatever his reservations about the work of his col-
leagues, had always admired this master's work. Over the course of
1887, Theo bought fourteen paintings from Monet for a total of 20,000
francs. The following summer he purchased ten brand-new landscapes
painted on his trip to the Mediterranean coastal resort of Antibes for
another 11,900 francs, promising the artist a 50 percent cut of every
work sold. When Durand-Ruel grumbled, Monet shot back: "You say
that it is regrettable that I have accepted this commitment, but my dear
M. Durand, what would have become of me these last four years had
it not been, first, for M. Petit, and without the house of Goupil."[3]

Thus far Theo was on solid ground. He'd long praised the work
of the Impressionists, even as his brother held back. Now, buoyed by

his success in unloading his Monets, Sisleys, and Degases, Theo was ready to venture into more dangerous territory. His initial foray into Divisionism came when he agreed to show the recent work of Camille Pissarro, the only one of the original Impressionists to convert to the Pointillist creed. Pissarro himself was thrilled to have the eminent firm behind him, since while his older works were beginning to fetch higher prices his Neo-Impressionist canvases had failed to win over the public. "I think Theo van Gogh, who is very astute, will be able to give me good advice,"[4] he told his son. But his optimism was premature. For all his efforts on the painter's behalf, Theo found it tough going. "I sell almost nothing of what seems fine to me," he griped. "When will we emerge from this period of indifference; it's certainly not the artists' fault."[5]

Still, Theo was gaining confidence in the model he'd developed. And as he felt more sure of himself—and as his bosses saw he was making a profit from his new venture on the *entresol*—he was willing to take more chances. In the emerging market for avant-garde art, where even a modest sale was big news, Theo's purchases had an outsized impact. Such was the prestige of Boussod & Valadon that when Theo became the first dealer to take on Toulouse-Lautrec this vote of confidence went a long way toward reconciling the artist's aristocratic family to his chosen profession. "Henri is doing Impressionist paintings," his uncle Odon reported, "four specimens of which are on exhibition at the big art dealer, Goupil's . . . Perhaps he will forge his way in this style, but it's an ugly style. I call that stuff the Zola of painting. I would like beauty better."[6]

The gallery on the Boulevard Montmartre soon became *the* place to see the latest art. One of those stopping by was a painter just returned from a monthslong trip to Panama and Martinique. "You know the gallery of Goupil, the editor and art dealer," Paul Gauguin told his

friend Émile Schuffenecker, "at the moment his gallery has become the center for the Impressionists. Little by little he's going to make his clientele swallow us; here is yet another hope and I am sure that in a short time I will be launched."[7]

The thirty-nine-year-old Paul Gauguin was already a veteran of the Parisian art scene. A former stockbroker turned Sunday painter, he'd been initiated into the mysteries of Impressionism by Camille Pissarro, who helped turn his hobby into an abiding passion. Gauguin gave up his comfortable life as a man of business to devote himself full time to painting, participating in every Impressionist exhibition from 1879 onward, where he showed solid, but not particularly distinctive, works in the manner of his master.

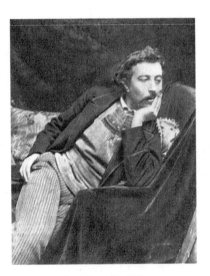

Paul Gauguin, 1891

Gauguin had yet to demonstrate his latent genius—like Van Gogh, he was a late bloomer—but he was already a remarkable personality. With his exotic good looks and unusual history—including a two-year stint in the French navy—he radiated a dangerous charisma. Trading

bourgeois respectability for picturesque bohemianism, he demonstrated a showman's flair and a single-minded purpose that drew others to him. Among those sacrificed on the altar of his art were his wife and children, whom he abandoned with scant regard for their needs. Boastful, opinionated, egotistical, he burned with an ambition to make his mark on the world. Even before the final breakup of the Impressionists, he was looking beyond their essentially earthbound vision, to conceive an art that would soar above what he scornfully referred to as the movement's *low-vaulted ceiling*. "I am convinced there is no such thing as *exaggerated art*," he told Pissarro: "I even believe that salvation lies only in the extreme; any middle road leads to mediocrity."[8]

And there *was* something extreme about him, a ruthlessness that many found unnerving. He compared himself to the outlaw Jean Valjean, hero of Victor Hugo's *Les Misérables*, and seemed to think he had no obligation to anything but his art. The savage manner he adopted may not have been entirely authentic, but he was willing to pursue it to the limit if only to add to his growing legend. A. S. Hartrick, who first met him in 1889, left a detailed description:

> Tall, dark-haired and swarthy of skin, heavy of eyelid and with handsome features, all combined with a powerful figure, Gauguin at this time was indeed a fine figure of a man. Later on, his low forehead, with its suggestion of a *crétin*, was a source of grave disappointment for Van Gogh, to Gauguin's vast amusement! He dressed like a Breton fisherman in a blue jersey, and wore a beret jauntily on the side of his head. His general appearance, walk and all, was rather that of a well-to-do Biscayan skipper of a coasting schooner; nothing could be farther from madness or decadence.

In a manner he was self-contained and confident, silent and almost dour, though he could unbend and be quite charming when he liked.

I can well believe what his son writes of him: "All his life my father shocked smugly respectable people deliberately, and for the same impish reason that impelled him to hang on his wall that obscene picture he tells about in these journals." Most people were rather afraid of him, and the most reckless took no liberties with his person.[9]

Émile Bernard first met Gauguin during his vagabond summer of 1886, in the Breton village of Pont-Aven, and immediately fell under his spell. Like many of his colleagues, Gauguin had traveled to that rustic corner of France to enjoy the picturesque scenery, the low cost of living, and the charms of the simple peasant folk. "I love Brittany," he told Schuffenecker. "I find a wildness and primitiveness there. When my wooden shoes ring on the granite, I hear the muffled, dull, powerful tone I seek in my painting."[10]

These were not the sentiments of an Impressionist. Those artists were far more comfortable in urban or suburban settings; they embraced modernity and considered the romanticizing of peasant life as so much claptrap, the stuff of Salon painters trafficking in sentimental fairy tales. Artists and writers of the new generation, by contrast, were engaged in something of a return (at least rhetorically) to the land. In rustic villages and timeless landscapes, they found refuge from the crass, get-ahead materialism of the city and proclaimed their authenticity by disguising their sophisticated art in primitive garb.

By the time Bernard met him, Gauguin was already attracting a circle of devoted admirers. "Gauguin was the chief," one of them recalled: "He had followers whom he prodded unmercifully, whom

he encouraged, and to whom he showed the road to be followed, as a friend. He also demonstrated what work really was and set the example, he who could never remain idle for a single moment. . . . Some envious people have said that he pontificated, but wouldn't he have the right to do so, even if this had been the case? Yet he was without pretension when he showed his most recent experiments, though, like every great artist, he was well aware of his own worth. . . . He opened new horizons to those who followed him. Everybody can see the influence he exerted."[11]

But while Gauguin had plenty of acolytes, he also made plenty of enemies. Before heading off to Brittany in 1886 he managed to pick a fight with that other prickly customer, Georges Seurat. The cause was petty, but the breach was to have significant art-historical consequences.* Like Bernard and Anquetin, who also quarreled with the leaders of the Divisionist school, Gauguin's personal grudge led him to reject Neo-Impressionism. Breaking with his master Pissarro, who found a cure for Impressionist vagueness in Pointillist precision, Gauguin sought a mode of painting that relied less on optical phenomena and more on the inventive powers of an unfettered imagination.

Such an approach reflected his personality, which was indulgent, drawn to violent experiences and intense sensations, contemptuous of social norms. He shared the prevailing aesthetic mood in which, much to Zola's dismay, "hearts are tortured with pessimism and brains clouded with mysticism." His quest for a more spiritual mode of expression drove him out of Paris in search of a more authentic way of life, one not corrupted by civilization or weighed down by its discontents. For a time he found what he was looking for among the peasants of

* It seems to have originated in a dispute over Gauguin's use of Signac's apartment while the latter was away in the south of France.

Brittany. These simple folk with their old-fashioned clothes and even more old-fashioned superstitions appealed to the jaded urbanite in him. But his restless soul yearned for frontiers even further removed from the boulevards of Paris. In the spring of 1887, Gauguin and his friend Charles Laval set out for Central America. For a time he served on a crew digging the Panama Canal, where the hard labor and mosquitos nearly killed him. After a couple of desperate months, the two artists escaped to the French colony of Martinique. In the tropics Gauguin's art began to change. He began to slough off the layers of civilized life and recast himself as a "noble savage." Here for the first time he began to abstract form, and use color as an expressive rather than a descriptive element [see color plate 46].

Of course Gauguin's flight from civilization didn't mean he was out of sync with his colleagues in Paris. In fact he was very much in step with the Symbolist poets and Cloisonnist painters, sharing the same anti-naturalist impulse and relying on the same sources in Japanese, primitive, and popular art to reinvent his own. In any case, he returned to the French capital in November of 1887, his health and his finances shattered by his misadventures.

Gauguin and Van Gogh first met sometime that month. Though their stormy relationship is among the most famous pairings in the history of art, it was relatively short-lived and typically one-sided. There's no evidence the two knew each other before Gauguin's return from Martinique, which was only three months before Van Gogh picked up stakes and moved to Arles.

Before Gauguin joined Van Gogh in the south of France the following year (October 1888), the two men couldn't be considered close friends—at least not as far as Gauguin was concerned. Characteristically, however, Vincent latched onto the older man,

building him up in his imagination and reading more into their relationship than was actually there. Gauguin was born to lead, and Van Gogh had a deep-seated need to follow, until, that is, admiration inevitably turned into disillusionment. The abrupt, violent end to their relationship can be attributed in large part to this dysfunctional dynamic, a clash between two outsized personalities, one domineering and exploitive, the other rash and unstable.

As was the case with so many of Van Gogh's friendships at this time, it began at Tanguy's shop, where Gauguin came to pore over the proprietor's incomparable collection of Cézannes. Van Gogh already knew him by reputation, through Bernard and other artists of their mutual acquaintance. Gauguin, too, almost certainly knew of Vincent, if only because of the van Gogh name. Theo had become the most important patron of avant-garde artists in Paris, and the ambitious (and broke) Gauguin would never have passed up an opportunity to ingratiate himself with his older brother.

In truth, many of Gauguin's friendships had a mercenary quality; there was no one he wouldn't step on to get ahead, no relationship he wouldn't exploit if he thought that would help him achieve his goals. These goals weren't material for the most part—though he wasn't indifferent to money, which he needed to survive—but intended to serve a higher purpose. "Gauguin would never allow that he owed anything in art," Hartrick observed, "or anything at all for that matter, to anybody but himself. Self-determination was his god. This spirit in later years led to much bitterness and recrimination with his early friends—Bernard especially, but there were others—as to who should be called the founder of the New School."[12]

Whatever his true feelings for Vincent, the connection soon paid dividends. Theo sold a painting of Gauguin's for 450 francs, which, though modest enough compared to the prices some of his Impressionist

colleagues now commanded, was welcome news after his recent strug-gles.* "I'm not angered if Claude Monet's have become expensive," he told Schuffenecker. "That'll be yet another example for the speculator who compares yesterday's prices with today's. And from that point of view it's not too much to ask 400 francs for a Gauguin in comparison with 3,000 for a Monet."[13]

Theo, for his part, was sympathetic to these struggling artists and did as much as he could for those he believed in. "Those poor painters, people like Pissarro & Gauguin," he wrote to Jo, "who put the very best of themselves into their work & cannot possibly support their families is unjust."[14] Over the next couple of years, Theo handled a number of painters now regarded as major figures in the modernist movement, as well as a host of secondary players, balancing those he considered safe bets (Monet, Degas) against those that, while riskier, had perhaps a greater potential upside (Lautrec, Anquetin, Gauguin).** Still, no matter how much sympathy he felt for the artists' plight, he was in the business of buying and selling, caught between an idealistic faith in art "which the general public consider ugly" but that "touch[es] our very soul,"[15] and the need to earn his yearly bonus. His relationship with the Impressionist master Alfred Sisley is instructive: after purchasing three of his landscapes in 1887, he dropped him when these failed to sell. He knew that both he and his pet project were on probation, his success measured on the bottom line, and he still had to tread carefully.

The moment Theo crossed over into this uncharted territory, Vincent became his indispensable guide. Theo had no need of his

* At that time, Vincent was unable to unload any of his works even for the pitiful sum of 100 francs.

** Among the living artists whose artwork appeared on the entresol of the Boule-vard Montmartre gallery were Monet, Degas, Sisley, Pissarro, Toulouse-Lautrec, Gauguin, Guillaumin, Anquetin, and Bernard.

advice when it came to artists like Monet and Degas who, after years of struggle, were finally coming into their own. But in the case of artists who'd yet to secure their reputations—the same ones who hung around Père Tanguy's shop plotting the next aesthetic revolution—Vincent provided crucial contacts and even more crucial insights. Of those artists whose work Theo displayed on the entresol, Vincent was probably responsible for introducing Lautrec, Bernard, Anquetin, and Gauguin, artists who represented the future of art, rather than its past.

The truth is that Theo never found these radical types entirely congenial and needed someone more in sympathy with their approach who could make sense of it all. He paid tribute to his brother's vital role some months later, after Vincent had moved to Arles. "You can, if you wish, do something for me," Theo asked, "that's to continue as in the past and create for us a circle of artists and friends, something which I'm utterly incapable of doing by myself and which you, however, have more or less created since you've been in France."[16] What a change from his earlier view that Vincent was simply a cross he had to bear! Where before he'd scoffed at Vincent's impracticality, now he came to rely on his judgment. If Theo really wanted to develop the market for this more experimental art, he would need someone on the inside he could trust, someone who spoke the new language, which he only half understood, and could point him in the right direction. Vincent, only recently arrived himself, helped orient Theo in this strange world where all the familiar signposts were lacking.

In the fall of 1887, the two brothers were finally ready to join together in a project worthy of their efforts, a true partnership that played to their very different strengths. Acting as a team—each bringing his own particular outlook to the venture—they might build a business

together that would not only prove profitable to themselves but that would serve the wider community of struggling artists.

Up to now the dream had existed largely in the mind of Vincent. Theo sometimes humored his brother; at other times he pushed back on his unrealistic schemes. He was not only scornful of Vincent's tenuous grasp of fiscal realities but often resentful that while his older brother pursued mirages he was forced to toil away to save them both from disaster. But for Vincent this had always represented the fraternal ideal. "Patience until it's good," he'd urged Theo as far back as 1883, "not letting go until it's good, not doubting, is what I would like you and I to have together and to hold on to. If we hold onto that, I don't know *to what extent* we'll benefit financially, but I do believe that—*on condition of collaboration and solidarity, however*—we'll be able to persevere for our whole lives, sometimes selling nothing and finding life hard, then at times selling and having it easier . . . Persevering depends on our will to stay together. As long as that will exists, it is possible."[17]

This longstanding dream challenges Aurier's characterization of Van Gogh as an isolé. He was, in fact, a fanatical connection builder. The more he found himself cut off from society the more he yearned for community, imagining partnerships, brotherhoods, sodalities, associations—any group effort or common cause that might relieve him of his unbearable loneliness. His need for acceptance applied to the world in general but was even more urgent when it came to his brother. Theo was his most loyal friend, the only one who stuck with him after he'd burned every other bridge behind him, extending a hand when he was drowning. Though Vincent often bit that same hand as it reached out to help, deep down he always knew what he owed Theo. "I don't really have any friends except for you," he wrote in 1883. "I gain everything, for without you I wouldn't have been able to carry on to where we are now; you gain nothing except for the feeling of giving a career

to someone who would have had no career otherwise."[18] He could only justify his continued dependence by insisting that this career was not his alone, but part of a joint effort. "And later," he continued in that same letter, "who knows what we can produce together in this way? A period of some struggling on will be required to get the painting right, but when you see the studies I believe you'll see that it isn't foolishness."[19]

It was no coincidence that at the very moment their relationship hit rock bottom, Vincent discovered the informal community of avant-garde artists at Père Tanguy's shop. Crucially, the degree of acceptance he found outside the home took some of the pressure off, opening an emotional space between the brothers that allowed the process of healing to begin. And to the extent that Vincent's belligerence was fueled by frustration over his lack of progress, his artistic growth over these months encouraged a more benevolent attitude.

Witnessing Vincent's transformation in turn transformed the way Theo regarded his own profession. Vincent's more bohemian lifestyle inevitably penetrated his more upscale world. The older brother's success among the radicals encouraged the younger to expand his horizons. Theo began to look at Vincent differently, not as a brilliant but erratic and hopelessly impractical figure, but as an accomplished artist who was earning the respect of people he respected. They were still very different—Theo conservative, prim, diffident; Vincent reckless, disheveled, volatile—but their personalities, like the pigments the older brother now favored in his paintings, could be seen as complementary.

Creating a real partnership—a mutually supporting, financially viable, community of avant-garde artists—was a goal worthy of their talents, an ambition long deferred and now close to fulfillment. "I think it is far more important, knowing that we are what we are, to extend a hand to one another &, in the faith that we are stronger together than alone," said Theo, echoing words that Vincent had used for years: "to

hope and strive, by living together, to reach a point where we see each other's faults & forgive them & try to nurture whatever is good and noble in one another."[20]

What Vincent had in mind was an association like the Société Anonyme, through which the Impressionists had launched their revolution, or the Pre-Raphaelite Brotherhood in England, a group of artists combining their talents and their resources for mutual support: "Artists won't find a better way," he explained, "than—to join together, give their pictures to the association, and share the sale price in such a way that at least the society will be able to guarantee the possibility of existence and work for its members."[21] Instead of "every man for himself," Vincent promoted a collective ethic in which the more successful painters lent a hand to those who'd not yet made their breakthrough. It's unclear to what extent Theo endorsed the specifics of Vincent's plan, but he was on board at least in principle, eager to build on his work on the entresol, perhaps with a view to reviving his old dream of setting up on his own. With Vincent's contacts in the rising avant-garde and *his* in the international art trade, he saw an opportunity to create a new vehicle for bringing the most exciting and innovative work before the public.

No doubt Theo's willingness to pursue Vincent's speculative schemes was prompted, at least in part, by his disappointment in another area of his life. With his private life in shambles, he threw himself into his work. His amorous troubles also allowed him to empathize with Vincent's misadventures. In 1881, during the Kee Voss saga, Vincent had tried to enlist Theo as an ally: "For I'm right in thinking, am I not, brother, that we aren't just brothers but also friends and kindred spirits, especially with respect to Love on?"[22] Then, Theo resisted Vincent's efforts to enlist him in his quarrels. Now, he was able to see things from his point of view.

Pulling as a team, the brothers spent more time in each other's company. They went out in the evenings after Theo closed the gallery, dining in one of the inexpensive *restaurants populaires* in the neighborhood, following the evening meal with visits to local *caf' conc's*, where they enjoyed the rough *montmartrois* humor provided by singers like Aristide Bruant or risqué performances in one of the many local cabarets. When they were in the mood for something more highbrow, they attended the famous shadow puppets at Le Chat Noir or a night at the Opéra. Both of them succumbed to the latest sensation from the Teutonic north. "Before Vincent left I went to a couple of Wagner concerts with him and we both enjoyed them very much,"[23] Theo reported to Willemina in March 1888, proof that both brothers were attentive to the latest fashions in music as well as art.*

Cultural venues were not their only source of distraction. Unable to sustain more fulfilling relationships, they satisfied their needs with the prostitutes swarming the streets at the foot of the Butte de Montmartre. In an era before antibiotics, the costs of such indiscretions could be high. Both brothers placed themselves under the care of a certain David Gruby—a "psychological doctor" as he was euphemistically called—with an office on the Rue Saint-Lazare. Vincent recorded the physician's prescription, which included the injunction to "eat well, live well, see few women, in a word live in anticipation just as though one already had a brain disease and a disease of the marrow, not to mention neurosis, which really does exist."[24] Reading between the lines, one can surmise that Theo had already contracted syphilis, a disease that

* There was a veritable Wagner cult among the Symbolists and avant-garde artists. The critic Édouard Dujardin, who coined the term *Cloisonnisme*, was coeditor of the *Revue Wagnerienne*. Vincent jumped on the bandwagon: "I feel the connections there are between our colour and Wagner's music," he wrote to Theo. [Letter 693, Sept. 18, 1888] This obsession eventually provoked a reaction against Germanic art, and a return to classical "Mediterranean" forms.

can ultimately attack the brain. This was one more thing they had in common, an affliction that drew them together in communal suffering.*

Vincent no longer drank alone; he drank with Theo sitting across the table. Rather than moderate their bad habits, each fed the other's vices, as one attempted to drown out his romantic disappointment, the other the clamor of the city that assaulted his overly sensitive nerves. As they made their nightly rounds, they often bumped into that other lush, Toulouse-Lautrec, all of them skirting the edge of the precipice, all of them in danger of tipping over. During Vincent's first year in Paris, there had been tensions on the Rue Lepic as his increasingly chaotic habits clashed with Theo's more sedate lifestyle. Now they were bohemians together, living on the dangerous margins, their vices no longer out of step but synchronized, marching in lockstep and headed toward disaster.

Vincent's final months in Paris were lived at an unsustainable pace. He drank too much, whored too much, and stayed out to all hours of the night, stumbling home to bed in a stupor that left him shattered the next day. Theo, too, was overdoing it. But these months were also enormously creative—for both brothers, each of them now making a name for himself in avant-garde circles. Masterpieces were starting to flow from Vincent's brush, and Theo's foray into the market for new art made him a figure to be reckoned with on the Parisian cultural scene.

Les Freres van Gogh were profiting more directly as well. While Theo's modest means didn't allow him to purchase work by Salon stars, or even by well-known Impressionists like Monet and Degas, paintings

* See letter 611, May 20, 1888, note 1 for a further discussion of Dr. Gruby and his likely treatment for syphilis. Vincent had already been treated in Antwerp. Theo would eventually die from the disease, which had gone to his brain, in January 1891.

and drawings by the less established artists of Vincent's acquaintance remained affordable. The brothers took advantage of their position not only to stage exhibitions on the entresol but to add to their own private collection. They acquired work by Seurat, Gauguin, Bernard, Toulouse-Lautrec, Monticelli, Pissarro, and many others—some of it purchased with Theo's money, some exchanged for Vincent's paintings.

The arrangement proved beneficial all around. Artists, eager to sell their work at a discount on the understanding that the van Goghs would advance their careers, now beat a path to 54 Rue Lepic: Bernard, Gauguin, Anquetin, Guillaumin, the Pissarros, father and son, all paid court. Vincent might be "a bit cracked," but Theo knew what he was doing. His purchases of edgier work held out the prospect that one might have one's avant-garde cake and still be able to eat. While Bouguereau and other Salon stalwarts were being shown the door, scruffier types were being ushered inside—if only at the satellite branch and then only through the side entrance. In any case, the Boussod & Valadon imprimatur did not relieve their worries all at once. Gauguin, for one, continued to struggle, badgering his latest benefactor to do more. "I don't want to put pressure on your brother," the artist wrote Vincent in February 1888, "but a brief word from you on this subject would set my mind at rest, or at least enable me to hold on. My God, how terrible these money matters are for an artist!"[25]

Gauguin wasn't the only one trying to get to Theo through Vincent. And for the most part Vincent was happy to oblige. "I've sent your drawing of the brothel to my brother," he informed Bernard, "and I've asked him to buy something of yours. If my brother *can*, he'll do it, because he knows very well that I must want to have you sell something."[26] But Theo's goodwill could only go so far. His resources were limited and the higher-ups at Boussod's continued to regard his latest venture with mixed feelings.

Unable to satisfy the artists' increasingly desperate demands, Vincent came up with a novel solution. That November he decided to organize an exhibition of his friends, convinced, as always, that all problems could be overcome with shared effort. "I believe that the first condition for success is to put aside petty jealousies," he urged on his fellow aesthetic pioneers. "It's only unity that makes strength. It's well worth sacrificing selfishness, the 'each man for himself,' in the common interest."[27] Putting the works of these still little-known figures—including himself—before the public, he hoped to give them a collective identity.* And, like any good marketer, he coined a name for this ragtag group: He dubbed them the artists of the "Petit Boulevard."[28]

The phrase is telling. In contrast to those he called "the Impressionists of the Grand Boulevard"[29]—acknowledged masters like Monet, Degas, and Renoir, whose works were beginning to fetch high prices—the denizens of the Petit Boulevard were mostly young, rebellious, and poor. These "sons of Impressionism" rejected the slick confections of the Salon, but they'd also moved beyond the eye-pleasing techniques of their own artistic fathers. In Vincent's mind, at least, they didn't constitute one school with a signature style or well-defined ideology, but rather a group united by a common need and a common commitment.

The venue he chose was an eatery he frequented called the Grand Bouillon-Restaurant du Chalet, at 43 Boulevard de Clichy. Vincent selected the working-class establishment largely because the owner, Etienne-Lucien Martin, needed something colorful to hang on the

* This was less a matter of age than of standing within the art world. Pissarro, 57, was the only one from the original group of Impressionists. Among those Van Gogh considered artists of the Petit Boulevard: Guillaumin, 46; Gauguin, 39; Van Gogh, 34; Seurat, 28; Anquetin, 26; Lucien Pissarro, 24; Toulouse-Lautrec, 23; Signac, 25; and Bernard, 19.

walls.* One participant described the space as "a kind of hall with a big glass roof like the central station, where it was good and cheap, and the walls were extremely suitable for exhibiting."[30] Another compared it to a Methodist chapel.[31] Vincent painted a view of the interior, showing waitresses in aprons and bonnets, long communal tables covered in white linen, and vases filled with flowers. At one of these tables is the proprietor sampling his own fare, and behind him some of the paintings adorning the walls.

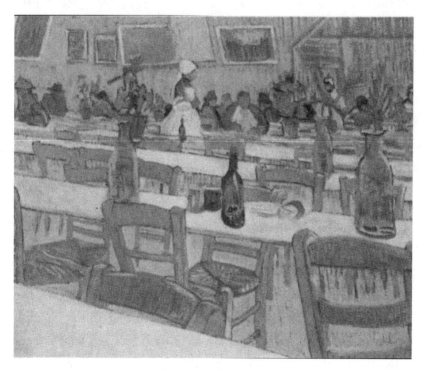

Restaurant du Chalet, 1887

* A long unidentified portrait from this period appears to be of Etienne-Lucien Martin. He can be identified by the characteristic skull cap that also appears in *Portrait of Etienne-Lucien Martin.*

Even in the world of bohemian Montmartre, where informal, ad hoc exhibition spaces were the norm, it was hardly an ideal setting in which to display such radical art. Unlike his earlier effort at the Tambourin—"What a disaster that was!"[32] Van Gogh admitted—this time he could call on a circle of friends and colleagues whose respect he'd earned. He also had reason to expect a positive response from those who simply wanted to cultivate his brother's goodwill.

In the end, however, the exhibition was a bit of a fiasco, "an endeavor," as Bernard ruefully described it, "on Van Gogh's part alone."[33] His biggest mistake was he failed to account for the factionalism that plagued the Parisian avant-garde. Like all idealists, he couldn't grasp the vanity and petty feuds that undermined any sense of unity. He grew frustrated by what he called "their disastrous civil wars, in which people on both sides try to get at each others' throats with a zeal worthy of a better destination and final goal."[34] Instead of joining together, these revolutionaries acted like Mensheviks and Bolsheviks, more eager to tear each other down than band together against their common enemy.

Indeed, most radical artistic movements, like their political counterparts, devour their own. In the Salon system, the competition revolved around honors and the government commissions that would inevitably flow from winning a gold or silver medal. Among the radicals, the prize was different but no less sought after: to be first off the mark, to be known as the inventor of the latest thing. And given their greater vulnerability, the struggle for recognition was perhaps even fiercer, claims and counterclaims of priority fostering an atmosphere of mutual recrimination. In the race to come up with something never before seen, a new movement could only rise from the grave of the old.

Two factions vied for leadership of the Parisian avant-garde in the fall of 1887. One was associated with Seurat, Signac, and the

Neo-Impressionists, the other with Bernard, Anquetin, and the Cloisonnists. If the Salon des Indépendants of 1886 and 1887 belonged to Seurat and his crew, that of 1888 would see the rise of the Cloisonnists. Focusing on the works of Louis Anquetin in *La Revue Indépendante*, the critic Édouard Dujardin praised "the first appearance of a rather new and special manner,"[35] an indication that Divisionism could no longer claim to be *le dernier cris*. When Anquetin and Émile Bernard broke publicly with the Neo-Impressionists in the summer of 1887, they did more than part company with their former comrades-in-arms—they tried to bury them. Bernard in particular made no secret of his ambition to leave his former mentor in the dust. In fact he was so determined to deny his Pointillist roots that he destroyed any paintings he could lay his hands on that he'd made in that technique.

Van Gogh labored without success to bridge the divide. He was particularly disappointed with Bernard. "If you've fallen out with a painter," he scolded his friend, "with Signac, for example, and if as a result you say: if Signac exhibits where I exhibit, I'll withdraw my canvases—and if you run him down, then it seems to me that you're not behaving as well as you could behave:

> Because it's better to take a long look at it before judging so categorically, and to reflect, reflection making us see in ourselves, when there's a falling out, as many faults on our own side as in our adversary, and in him as many justifications as we might desire for ourselves.
>
> If, therefore, you've already considered that Signac and the others who are doing Pointillism often make very beautiful things with it—Instead of running those things down, one should respect them and speak of them sympathetically, especially when there's a falling out.

Otherwise one becomes a narrow sectarian oneself, and the equivalent of those who think nothing of others and believe themselves to be the only righteous ones.[36]

Unfortunately, Van Gogh's brotherhood of artists bore no relationship to the realities of the Parisian avant-garde. Bernard refused to show with Signac, and Signac with Bernard, while Gauguin feuded first with one and then the other. Both Pissarros boycotted the exhibition when they heard that Seurat and Signac were to be excluded. Indeed, Van Gogh himself wasn't entirely blameless, refusing to exhibit Symbolists like Odilon Redon, whose work he found too precious and literary.

The exhibition finally went up in November, but it was far from the show of unity Van Gogh had hoped for. As Bernard recalled, it included some of Lautrec's "prostitutes," Anquetin's "Japanese abstractions," what he called his own "geometric syntheses," and fifty to one hundred works by Van Gogh himself, which he described as "violent" still lifes and "flaming visages."[37] Also included was a young Dutch artist named Arnold Koning, who'd moved into the Lepic apartment in September. Not only did he serve to make up the numbers, but he made himself useful by helping Vincent transport his own works the half mile down the hill to the restaurant and assisting him in hanging the show.

Ignoring Van Gogh's pleas, the Neo-Impressionists stayed away and the rest made only a token showing. They might have been more willing to bury their differences had the whole effort not seemed so amateurish and so ill-suited to their needs. Unlike the lobby of the Théâtre Libre, where Van Gogh exhibited his work alongside that of Seurat and Signac, or the offices of *La Revue Indépendante*—much smaller venues but ones frequented by the cognoscenti—the Grand Bouillon-Restaurant du Chalet was not on anyone's cultural itinerary.

The diners were perplexed—one visitor noting they were "a little dis-
concerted by the forbidding aspect of the paintings"[38]—and the owner
disrespectful, hanging up his own collection of patriotic shields to fill
in the gaps. A few notable artists did stop by—the Pissarros, Seurat,
and Gauguin among them—but not a single critic bothered to write
it up. All in all, the whole thing reflected the naïveté of its organizer.

In December Van Gogh abruptly took it down. "Unfortunately,"
Bernard recounted, "this socialist exhibition of our inflammatory
canvases came to a rather sorry end. There was a violent altercation
between the owner and Vincent, which made Vincent decide to take a
handbarrow without delay and cart the whole exhibition to his studio
in Rue Lepic. Obviously, the art of the Petite Boulevard had not been
understood by its Barnum."[39]

For all its farcical elements, the Du Chalet show was a milestone in
the history of modern art. It anticipated the Salon des Indépendants the
following spring, which marked a decisive shift away from Divisionism
and toward the Cloisonnist, Synthetist, and Symbolist modes that
would define the most exciting art over the coming decade. It also
served as the model for the exhibition the following year at the Café
Volpini, where Bernard and Gauguin introduced their latest innovation,
which they termed *Synthetism.*[*] Bernard acknowledged the impor-
tance of its predecessor. "It really looked quite new," he recalled, "by
far the most advanced thing in Paris."[40] Van Gogh was also pleased
with the results, though his claims were more modest: "For the 2nd

[*] Gauguin invited Van Gogh to participate in the Café Volpini exhibition, but
 after discussing it with Theo he decided against it, not wanting to become
 embroiled in the latest art world feuds. *Synthetism* was formed jointly by Bernard
 and Gauguin after spending the summer of 1888 painting side by side in Pont-
 Aven. They later quarreled over credit for inventing the new movement, which,
 in truth, owed a great deal to Cloisonnism. In the end, however, Gauguin made
 far more compelling use of the innovations than Bernard.

exhibition at the showroom on boul. de Clichy, I have fewer regrets about the time and effort. Bernard having sold his first painting there, Anquetin having sold a study there, and I having made the exchange with Gauguin, we all got something."[41]

In any case, he refused to be discouraged, believing enlightened self-interest would ultimately prevail. He continued to pursue his dream of joining the artists of the Petit and Grand Boulevard long after the show came down. His motives were not merely aesthetic, but political and economic. It was a question of barricades once more, of which side you were on. As Bernard suggested, the exhibition itself was not so much Symbolist or Synthetist but rather "socialist," built around the notion that those who had already made it would generously reach back to help their struggling comrades.

The project embodied Van Gogh's instinctive sympathy for the underdog, himself included, as well as his touching faith that the haves would be eager to lend a hand to the have-nots. Vincent was so taken with his idea that he not only roped in Theo but tried to enlist his old enemy in the effort:

I think about this association of artists every day, and the plan has developed further in my mind, but Tersteeg would have to be involved, and a lot depends on that.

Nowadays, the artists would probably allow themselves to be persuaded by us, but we can't go ahead before we have Tersteeg's help. Without that we'd be on our own, listening to everybody moaning from morning till night, and each of them individually would be constantly coming to ask for explanations—axioms—&c. Shouldn't be surprised if Tersteeg took the view that we can't do without the Grand Boulevard artists—and if he advised you to persuade them

to take the initiative in an association by giving paintings that would become common property and cease to belong to them individually. It seems to me that the Petit Boulevard would be morally obliged to join in response to a proposal from that side. And those Grand Boulevard gentlemen will only retain their current prestige by forestalling the partly justified criticism of the minor Impressionists, who'll say: "you're putting everything in your pocket." They can easily reply to that: not at all, on the contrary, we're the first to say: our paintings belong to the artists.

If Degas, Monet, Renoir, and Pissarro say that—even leaving plenty of room for their individual ideas about putting it into practice—they could—say worse, unless—they say nothing and let things ride.[42]

Unfortunately, Van Gogh's analysis was completely untethered to reality. There wasn't the slightest chance that the old-guard Impressionists would be willing to tie their reputations to the more marginal painters, or that the younger generation would be willing to put aside their petty quarrels in order to all rise together. Ultimately, the feuds that agitated the Parisian avant-garde were too deeply ingrained.

At first, Theo was inclined to indulge his brother's wild scheme, allowing himself to be carried away by Vincent's enthusiasm. Tersteeg happened to be in Paris in June 1888, at the very moment he was showing ten landscapes by Monet on the entresol. Theo hoped the success of that show would convince his old colleague to join his new venture. But his old boss was unimpressed. "Tersteeg's visit isn't at all what I'd dared hope," Vincent sighed after Theo reported the results of his visit, "and I make no secret of it to myself that I miscalculated the odds on his cooperating."[43] Without the backing of Tersteeg, or

indeed any other figure of standing in the art world, the scheme quickly fell apart. In the end Vincent, all alone in Arles, was far more invested in the notion of community than his colleagues who remained in Montmartre, if only to be able to strike their enemies at close quarters.

Even after Tersteeg's rejection, Vincent returned to the notion from time to time, writing to Bernard that July:

> And then there's the fact that the material difficulties of the painter's life make collaboration, union among painters, desirable . . . By safeguarding their material life, by liking each other as pals instead of getting at each others' throats, painters would be happier and anyway less ridiculous, less foolish, and less guilty.
>
> However, I don't insist, knowing that life carries us along so fast that we don't have the time to discuss and act simultaneously. That's why at present, while the union exists only very incompletely, we're sailing on the high seas in our small and wretched boats, isolated on the great waves of our time.[44]

If Van Gogh's collaborative ethic failed to gain traction in the real world, it was reflected in the paintings themselves, which belong fully to neither of the two camps currently duking it out on the front lines of the Parisian avant-garde. Instead of accepting their zero-sum logic, he staked out a position halfway between the Neo-Impressionists and their Cloisonnist rivals. Even as he was hanging his works next to those of Bernard and Anquetin at the Grand Bouillon-Restaurant du Chalet, he was showing one of his Pointillist landscapes alongside works by Seurat and Signac in the lobby of the Théâtre Libre. In a formulation that surely would have irritated all his associates had they heard it, he told Theo, "but after all—the leader of the Petit Boulevard is without any doubt

Seurat, and young Bernard has perhaps gone further than Anquetin in the Japanese style."[45] Van Gogh was determined not to take sides but to learn from each movement and forge a powerful new synthesis.

Even after he'd landed in Arles, he continued to move back and forth between these two poles, preferring a position somewhere near the scorching equator to the chilly antipodes. Under the influence of *ukiyo-e* prints and in conversation with his younger Cloisonnist colleagues, he adopted simplified contours, bold asymmetries, solid blocks of vivid color, and a tendency to abstract his forms. At the same time he continued to enliven this technique with dynamic divided brushwork that owes more to their Divisionist predecessors and that allowed him to give expression to his own vehement nature.

This was not a case of indecision but rather a conscious choice. In the spring of 1888 he made a pair of paintings of flowering pear and peach trees in which he explored the potential of each approach. He described his process in a letter to Bernard, defiantly insisting on his right to take what he needed as the mood struck him. In the first he adopts the Cloisonnist technique of "fill[ing] the spaces demarcated by the outlines." [see color plate 47] But in the second he returns to the broken brushwork of the Divisionists and Impressionists [see color plate 48]: "I follow no system of brushwork at all; I hit the canvas with irregular strokes which I leave as they are, impastos, uncovered spots of canvas—corners here and there left inevitably unfinished—reworkings, roughnesses; well, I'm inclined to think that the result is sufficiently worrying and annoying not to please people with preconceived ideas about technique."[46]

Once again he showed himself incapable of following the rules, as reflexively rebellious with his friends in the avant-garde as he was with Mauve or any of his instructors at the Royal Academy. To his way of thinking, Bernard and his colleagues were as much slaves to theory, as unwilling to put brush to canvas without a predetermined recipe

to guide them, as any student at the École des Beaux-Arts. Such an adherence to orthodoxy threatened to sink into sterility or arid intellectualism. Van Gogh was saved from this peril by his capacity to be moved by the world around him. He was guided by instinct rather than theory, propelled by his immediate emotional response to the subject in front of him rather than a rigid formula. For all the debt he owed to Japanese prints or to the conceptual innovations of his colleagues, his responses to his environment were so vivid, so overwhelming, as to overcome any formula, even to threaten reason itself.

This distinction was the source of a good deal of debate over the coming years. Unlike Bernard—or even Gauguin, who joined them in a lively three-way dialogue over the early months of 1888— Van Gogh almost never invented an image out of whole cloth. The one major exception was a painting he described to Theo as a "reminiscence of our garden at Etten." Significantly it was made under the immediate supervision of Paul Gauguin while the two were rooming together in the Yellow House at Arles. "Gaugin gives me courage to imagine," he told Theo at the time, "and the things of the imagination do indeed take on a more mysterious character."[47] But he didn't feel inclined to repeat the experiment. There's an artifice to the painting of a kind that so often undermines Bernard's efforts, and occasionally Gauguin's as well. Unlike his colleagues in the Symbolist movement, Van Gogh required a hard nugget of fact to stimulate him, perhaps because he knew his grip on reality was already tenuous. "I never work from memory," he confessed to Bernard, as if this were a failing of his:

> And I can't work without a model. I'm not saying that I
> don't flatly turn my back on reality to turn a study into
> a painting—by arranging the colour, by enlarging, by

simplifying—but I have such a fear of separating myself from what's possible and what's right as far as form is concerned.

Later, after another ten years of studies, all right, but in very truth I have so much curiosity for what's possible and what really exists that I have so little desire or courage to search for the ideal, in so far as it could result from *my* abstract studies.

Others may have more clarity of mind than I for abstract studies—and you might certainly be among them, as well as Gauguin and perhaps myself when I'm old.

But in the meantime I'm still living off the real world. I exaggerate, I sometimes make changes to the subject, but still I don't invent the whole of the painting; on the contrary, I find it ready-made—but to be untangled—in the real world.[48]

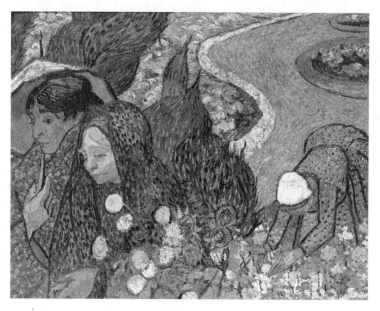

Memory of the Garden in Etten, 1888

Living off the real world even as he exaggerates, turning his back on reality even as he draws nourishment from it—this tension is at the heart of Van Gogh's singular genius, a dialectic that powers his greatest masterpieces. Compare this approach to Bernard's admonition: "Do not paint too much from nature. Art is an abstraction . . ." Bernard lives in his head, while Van Gogh is all raw nerves, experiencing the world too powerfully for comfort. And while the more conventional Bernard tries to steal a little sacred fire from folk art or medieval icons to enliven his rather banal conceptions, Van Gogh already inhabited a haunted world; even the most mundane vistas were fraught, capable of inducing ecstasy or plunging him into darkest despair. For one of them art is an intellectual exercise, for the other an emotional necessity.

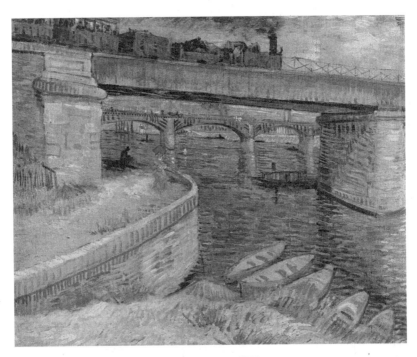

Bridge at Asnieres, 1887

These differences will become glaringly obvious over the next couple of years, but they were present even before Vincent left for Arles. At different times in 1887, both Bernard and Van Gogh painted almost identical scenes of the railroad bridge crossing the Seine at Asnières, providing a kind of controlled experiment isolating their distinctive qualities. Van Gogh's painting, built around strong contrasts of cool blues and purples against warm yellows and oranges, seethes with nervous energy. Everywhere his brush is active, creating contrasting zones of movement: the ripples of the water playing off the sweeping curve of the embankment; calligraphic touches that pick out the foliage in the foreground or the figures along the path.

The topography Bernard depicts is nearly the same—the same two bridges, the same pathway, even the same locomotive belching smoke—but the paintings (and, by implication, the painters) seem to inhabit different worlds. While Van Gogh's image is almost incandescent, Bernard's is cool, clinical; while Van Gogh seems to be enveloped in, or consumed by, the environment he inhabits, Bernard is removed. Part of this has to do with the change of seasons: Van Gogh has set out to capture the burning heat of summer, while Bernard evokes an autumnal chill, complete with two rather ominous figures bundled against the wind.* But there's more to it than that. Bernard's approach is supremely controlled. Each flat area of color is carefully circumscribed, creating a beautiful decorative pattern as in a Japanese print or medieval stained-glass window. In Van Gogh's painting the eye has nowhere to rest. Every element—water, air, masonry, iron—seems in the process of disintegrating or coalescing, made up of packets of energy forever

* These are likely rag-pickers, poor peddlers who plied their trade along the riverbanks. Many of Bernard's paintings reflect a degree of social commentary.

reconfiguring. While neither painting is particularly realistic, one gets the sense that Bernard knew what he wanted to achieve beforehand and went in search of a suitable motif to illustrate his ideas, while Van Gogh set up his easel with no preconceived notion and responded to what he found in real time.

Emile Bernard, *Iron Bridge at Asnieres*, 1887

Van Gogh painted the railroad bridge at Asnières sometime in the late spring or early summer of 1887. By July, perhaps discouraged by the midsummer heat, he no longer bothered to haul his gear the three or four miles to the river. Rather than depicting the watering holes so popular with day-trippers and Neo-Impressionists, he set his easel up at the base of the Butte of Montmartre. The two large paintings he made in the Divisionist manner depicting the garden plots hugging its northwest slopes are the last views he ever made of the city.*

* This is not strictly true if one counts interiors like the *Interior of the Restaurant of Etienne-Lucien Martin.*

In the final works he made in Paris, Paris disappears. He retreats inside the studio. His art becomes unmoored from place and time, hermetic, self-referential. He lives in dialogue with other works of art, rather than the environment he inhabits; far-off Japan seems more present than the street outside his apartment. He paints self-portraits and still lifes, works that make no reference to the outside world. When he does venture beyond the studio, it's to depict those closest to him, as if his circle is tightening to a precious few. And even then he plunks them down in a never-never land: Père Tanguy is transported to an artificial Japan, Agostina Segatori to a golden realm even less anchored in the here and now.

His art begins to soar as his immediate surroundings vanish. Fantasy takes over as reality recedes, leaving a gap between the world he inhabited and the one he dreamed of. For someone like Van Gogh for whom even the greatest flight of fancy must take off from a solid ground of observed fact, the dissonance was unsustainable. He was alienated from his immediate environment, longing for someplace better. He found himself an idealist in a fallen world that continually threatened to drag him down.

As the New Year began, with the prospect of another long, dreary winter ahead of him, Van Gogh decided he'd had enough. He detected a "poison in the Paris atmosphere," a toxic brew that "seeps insidiously into your pores."[49] His affair with Agostina Segatori had descended into tawdry farce, and the exhibition at the Grand Bouillon-Restaurant du Chalet ended hardly any better. Exhausted and depressed, he realized he'd already hung on too long. "I really couldn't stand it anymore,"[50] he told Theo. "In Paris one is always suffering, like a cab-horse."[51] The longer he stayed the worse his symptoms: "I was certainly well on the way to catching a paralysis when I left Paris. It caught up with me afterward, right enough! When I stopped drinking, when I

stopped smoking so much, when I started reflecting on things again instead of trying not to think—my God, what melancholias and what dejection."[52]

Before leaving the city he made one final painting in which he summed up the state of both the man and the artist, a painting that measures the impact of the two transformative years he lived in the world's most creative and nerve-racking city. It's a split screen work, pulling simultaneously in opposite directions: a powerful image of someone fulfilling his genius even as he was coming apart at the seams.

Van Gogh's *Self-Portrait as a Painter* [see color plate 49] is all the more haunting for being the product of careful deliberation and meticulous craftsmanship. He displays here none of his habitual impetuosity, wishing to present a more sober, more objective self-assessment, like a scientist describing a particularly interesting specimen. Unusually for him, he both signed *and* dated the painting, scrawling VINCENT/88 in red paint as if commemorating an important milestone in his life. He chose a particularly fine linen and worked on it over multiple sessions, adding to and subtracting from, correcting and improving. There is nothing off the cuff or spontaneous here; everything is carefully calibrated. Like *The Potato Eaters*, it is a statement piece, not only a compelling image in its own right, but a manifesto.

Above all, Van Gogh wishes to present himself as a *modern* artist, what he called, with his usual carelessness about labels, an *Impressionist*. The only colors on his palette are the primaries—red, yellow, and blue—and the secondaries, green, purple, and orange, along with a generous dollop of lead white. In other words, it's the palette of an orthodox Divisionist. Gone are the days when, in an idiosyncratic take on the theories of Charles Blanc, he would "break" one color with its opposite, producing an endless variety of earthen

tones. After two years in Paris he's kicked off the mud of Drenthe and Nuenen and cloaked himself in the rainbow.

The composition draws on devices employed to such powerful effect in works by Hokusai, Hiroshige, and other Japanese masters, especially the bold asymmetry of the composition as he shoves the image of the canvas stretcher and palette right up against the picture plane. His debt to Seurat, Signac, & co. is also clear throughout, from the blue smock flecked with complementary strokes of orange, to the pink and green streaks that allow for subtle variations in the flesh tones. The effect is more subdued than in his *Self-Portrait with Gray Felt Hat* from a few months earlier, the contrasts less jarring, and the brushwork more restrained. One senses his newfound mastery, but also a resignation, as if, having been caught up in the creative vortex, he now returns to earth, a sadder and a wiser man.

In every sense, this is a more reserved work, marked by Apollonian balance rather than Dionysian frenzy. The face in the mirror no longer generates its own reality; the neutral background is only a setting, not a projection. But there's a sense of brooding melancholy, a crimping about the eyes that suggests exhaustion, disillusionment. He's physically robust, having put on weight while under Theo's roof, but there's something haunted and hounded in his expression. That the effect was deliberate is clear from the description he offered to Wil a few months later:

> Here's an impression of mine, which is the result of a portrait that I painted in the mirror, and which Theo has: a pink-gray face with green eyes, ash-coloured hair, wrinkles in forehead and around the mouth, stiffly wooden, a very red beard, quite unkempt and sad, but the lips are full, a blue smock of coarse linen, and a palette with lemon

yellow, vermilion, Veronese green, cobalt blue, in short all
the colours, except of the orange beard, on the palette, the
only whole colours, though. The figure against a grey-white
wall. You'll say that this is something like, say, the face of—
death—in Van Eeden's book or some such thing*—very
well, but anyway isn't a figure like this—and it isn't easy
to paint oneself—in any event *something different* from a
photograph? And you see—this is what Impressionism
has—to my mind—over the rest, it isn't banal, and one
seeks a deeper likeness than that of the photographer.[53]

The specter of death, mental and physical paralysis, humiliating
sexual escapades, alcoholism brought on by stress, and the daily sensory
overload—it's no wonder he felt he had to leave!

This self-portrait is a farewell. Van Gogh no longer doubted that
for the sake of both his health and peace of mind, he had to remove
himself physically from the city, but his fate and artistic identity were
now so bound up with the bohemian community to which he now
belonged that he couldn't possibly extricate himself. Nor did he want
to! The self-portrait proclaimed his allegiance to the Parisian avant-
garde; it was a testament of faith. Dressed in the blue smock worn by
the city's proletarian laborers, his palette laid out as in a Divisionist
primer, Van Gogh reaffirmed his commitment to the modernist cause.
This was the identity he would cling to for the rest of his life.**

* In Frederik van Eeden's *Little Johannes*, the character Hein represents death.

** He did occasionally express regret about the course he'd taken but stuck to it
until the end. (See, for example, letter 574, October 1887, to Willemien.) Had he
lived longer, he might have turned his back on modernism like Bernard, Derain,
de Chirico, and others.

Even as he packed up his belongings—the suits he'd acquired when he first came to city (now stained and weathered), his precious books, and as much of his painting gear as he could carry with him (Theo would mail the rest as soon as he found a permanent address)—he continued to promote his pet project of an artist's association based on socialist principles and held together by a spirit of mutual goodwill. As part of this campaign, the two brothers paid a visit to the studio of Georges Seurat on the Boulevard de Clichy. Vincent was anxious to recruit the man he considered "the leader of the Petit Boulevard,"* knowing his prestige would encourage others to join. In a letter to Gauguin he penned some months later, he summarized his thinking at the time:

> When you left Paris,** my brother and I spent more time there together that will always remain unforgettable to me. Our discussions took on a broader scope—with Guillaumin, with Pissarro, father and son, with Seurat, whom I didn't know (I visited his studio just a few hours before my departure). In these discussions, it was often a matter of the thing that's so dear to our hearts, both my brother's and mine, the steps to be taken in order to preserve the financial existence of painters, and to preserve the means of production (colours, canvases), and to preserve directly to them their share in the price that their paintings at present fetch only when they have long ceased to be the property of the artists.[54]

* This somewhat surprising fact emerges in a letter Van Gogh wrote to Gauguin in October 1888. [See below.]

** Gauguin had left Paris for Pont-Aven on January 26.

Seurat was noncommittal that day, though future discussions reveal he never had any real interest in lending his name or his prestige to their project.* Indeed, it's hard to imagine anyone less likely to join in such an endeavor than the aloof father of Divisionism. And in any case his participation would certainly have caused Gauguin, Bernard, and Anquetin to withdraw. Vincent's inability to resolve these differences doomed his project from the start.

Later that night—February 19, 1888—Theo and Vincent made their way to the Gare de Lyon where, after a tearful goodbye, Vincent boarded the Paris à Lyon et à la Méditerranée express train bound for Marseilles.[55]

Theo broke the news to Wil. "I need to tell you that I'm alone again," he wrote his sister. "Vincent left for the south last Sunday, first to Arles to get his bearings and then probably on to Marseille."**[56] One can sense him struggling to make sense of Vincent's decision. "The new school of painters tries above all to get light and sun into paintings," he continued, "and you can well understand that the grey days lately have supplied little material for subjects. Moreover, the cold was making him ill. The years of so much worry and adversity hadn't made him any stronger, and he felt a definite need for rather milder air. A day and a night's travel and one is there, so the temptation was great and he

* Even if they were unsuccessful in getting the great man to sign on, Theo at least managed to profit from the association. He purchased a small drawing of a cabaret singer for his own collection, paying a meager sixteen francs. According to Lucien Pissarro, who was at the auction, he picked it up cheaply by sending Émile Bernard in his place, fearing they'd jack up the price if they knew the buyer was a dealer from Boussod's. Vincent's attempts to exchange paintings with Seurat also came to nothing.

** It's not clear how seriously Vincent considered continuing on to Marseilles. It was related to a scheme to corner the market on the work of the Provençal artist Adolphe Monticelli, which also came to nothing.

accordingly decided swiftly to go there. I believe that it will definitely do him good, both physically and for his work."[57]

The separation was wrenching for both brothers. They'd grown increasingly close that fall, shared disappointment encouraging them to pool their emotional resources: "When he came here two years ago I never thought that we'd become so attached to each other," Theo mused, "for there's definitely an emptiness now that I'm alone in the apartment again. If I find someone I will live with him, but it's not easy to replace someone like Vincent."[58]

Theo's admiration had grown along with his affection: "It's incredible how much he knows and what a clear view he has of the world. So I'm sure that if he has a certain number of years yet to live he'll make a name for himself." He emphasized the fact that Vincent was no longer simply a drain on his resources, but was making a real contribution. "It was through him that I came into contact with many painters who regarded him very highly. He's one of the champions of new ideas, that's to say there's nothing new under the sun and it would therefore be more correct to speak of the regeneration of old ideas that have been corrupted and diminished by the daily grind. In addition, he has such a big heart that he's always looking to do something for others, unfortunately for those who cannot or will not understand him."[59]

Over the remaining two and a half years of his life, Vincent offered shifting explanations for his decision to leave Paris. First of all there was the climate. "You see that I've gone somewhat further to the south," he wrote to his sister a few days after he arrived in Arles: "I've seen only too clearly that I cannot prosper with either my work or my health in the winter."[60] It was not only a question of comfort but of perfecting his art. The kind of painting he now had in mind was not compatible with the famously muted light of Paris: "Nowadays people are demanding colour contrasts and highly intense and variegated colours

in paintings rather than a subdued grey colour. So I thought for one reason and another that I wouldn't do anyone any harm if I just went to what attracted me."[61]

Equally compelling were the bad habits he'd picked up in the city, the excessive drinking, smoking, and generally unhealthy lifestyle. Perhaps his most revealing, if not his most honest, explanation for the move came in a letter he wrote to his mother in December of 1889: "And when Pa was no longer with us and I went to [Theo] in Paris, then the poor chap attached himself so much to me that I came to understand how much he had loved Pa. And now, I say this to you and to Wil and not to him, it's a good thing I didn't stay in Paris because we should, he and I, have become all too much bound up in each other."[62]

There's a good deal of self-delusion here. His suggestion that he moved to Paris to provide Theo with emotional support is pure projection, a fiction he concocted to cover up his own humiliation at having come as a beggar to his door. The one grain of truth comes in his description of how it all ended. By the time he left, the two of them were in fact caught in a downward spiral, locked in a codependent relationship that threatened to drag them both into the abyss. No matter how painful the separation, they both realized they needed a break from each other.

Loneliness set in almost as soon as the train pulled out of the Gare de Lyon. "During the journey I thought at least as much about you as about the new country I was seeing," he wrote to Theo in a wistful vein. "But I tell myself that you'll perhaps come here often yourself later on. It seems to me almost impossible to be able to work in Paris unless you have a refuge in which to recover and regain your peace of mind and self-composure. Without that, you'd be bound to get utterly numbed."[63]

Much had changed since the last time he'd set out to make a new home in a new city. Two years earlier he'd arrived on the overnight train from Antwerp in poor health and poorer spirits. When Theo had first spotted him across the Salon Carré of the Louvre, he'd seemed an object of pity, a heartbreaking picture of neglect: haggard, ragged, nearly shattered by the disasters of the previous months. The sudden move to Paris had been an act of desperation, a final roll of the dice after a nearly fatal run of misfortune. But Vincent had grown over the months they'd lived together, physically as he put some extra pounds on his lean frame, and even more as an artist. Now, rather than an object of pity, Theo viewed him with respect, perhaps even a bit of awe.

As for Vincent himself, though his daily existence was still in shambles—he was incapable of living anywhere or any way but on the brink of disaster—he was actually in a far better place than he'd been when he moved in with his brother. His farewell self-portrait shows a man tested but not broken, carrying the weight of the world but bearing up under the strain. Above all, it reveals a painter in full command of his craft, needing only "a refuge," an oasis of calm for his genius to catch fire.

The truth is that his decision was fully in character, perhaps the only surprise being how long it took him to arrive at it. Van Gogh had always been a restless voyager, never content with where he was, always imagining someplace better just beyond the horizon. He idealized places, as he did people, only to grow disillusioned when reality failed to live up to his expectations. Whenever his troubles piled too high he picked up stakes and set out for virgin territory, someplace without painful entanglements or memories. In boarding the train for Arles, he once more tried to outwit his problems by giving them the slip.

All the next day as the train chugged south toward the Mediterranean coast, Van Gogh imagined a different landscape from the one

unspooling outside his window. "I still have in my memory the feelings that the journey from Paris to Arles gave me this past winter," he wrote to Gauguin. "How I watched out to see 'if it was like Japan yet!'"[64]

He arrived in the ancient city early on the evening of the following day. But instead of the golden land he'd dreamed of, he found two feet of snow beneath his feet.* After a good night's sleep in the room he'd rented above Restaurant Carrel on the Rue Cavalerie, he set out to explore the surrounding countryside. He wasn't discouraged by the weather, noting vivid hues that caught his painter's eye. "So far I've taken no more than a little walk round the town, as I was more or less completely done in last night,"[65] he reported. "I noticed some magnificent plots of red earth planted with vines, with mountains in the background of the most delicate lilac. And the landscape under the snow with the white peaks against a sky as bright as the snow was just like the winter landscapes the Japanese did."[66]

In this new land, Van Gogh was both a keen observer of his environment and a latter-day Don Quixote reimagining mundane facts as something magical—an alchemy far easier to perform in the fields of Provence than in the suburbs of Paris. With only a little readjustment, he could turn the rocky soil of southern France into the exotic East, a land where, he believed, everyone was an artist and Man and Nature were one.

Though he'd put almost 500 miles between himself and Paris, he had no intention of turning his back on the city that had transformed him into an artist of genius. Far from it. "The first time I saw [Paris],"

* He boarded the train at 9:40 P.M. on February 19, arriving around 4:45 P.M. the next evening. Arles was a city before the Romans conquered it in the 2nd century B.C.E. It still boasts a well-preserved amphitheater from the imperial age. In 1888, Arles had a population of 13,300. Another 10,000 inhabited the surrounding countryside.

he recalled, "I felt above all the miseries that one cannot wave away, any more than the smell of sickness in the hospital, however clean it may be kept." But there was another dimension to the city, one that made up for all its flaws: "Later I gained an understanding of how it's a hotbed of ideas, and how the people try to get everything out of life that could possibly be in it. Other cities shrink by comparison, and it seems as big as the sea."[67] It was this Paris, the city of ideas, that continued its hold on him. He'd arrived in the French capital a provincial rube, with firm opinions about but scant knowledge of the latest innovations in modern art. By the time he left, he was a prominent member in that exclusive club known as the avant-garde, one of the most daring and radical painters in a community that prized originality above all.

Landscape in the Snow, 1888

He maintained that role even after saying goodbye to the taverns of the Boulevard de Clichy. Two weeks after arriving in Arles, he agreed to allow Theo to exhibit three of his paintings at the fourth exhibition of the Société des Artistes Indépendants, the city's premier venue for avant-garde art.* "He himself doesn't attach much importance to this exhibition," Theo noted, "but here, where there are so many painters, it's essential to make himself known and the exhibition is the best means of doing it."[68] Van Gogh was no more isolated than Gauguin and Bernard were by their westward jaunt to the rustic hamlet of Pont-Aven. Each of these journeys traced the spoke of a wheel in which Paris formed the hub.** It remained the focus of their interest, the locus of their potential market—the place where, they hoped, they would soon enjoy recognition and robust sales—and where they'd be welcomed by their former comrades with open arms, their weather-beaten faces and calloused hands signs that they were more serious, more authentic, than those they'd left behind. Adopting a simpler way of life was, in fact, a quintessentially urban maneuver, the geographic counterpart to the deliberately "primitivizing" features of their work.

Van Gogh never envisioned his new home as a place of exile—much less of solitary confinement—but as an outpost of Montmartre, a retreat where his friends from the Rue Clauzel might take a break from the rigors of Paris and work in harmony with nature and in

* Two of the paintings were views of the Butte de Montmartre, the third a still life of "Parisian novels." He would also exhibit in the Indépendants the following year.
** Another spoke tied Paris and Aix-en-Provence, where Cézanne was building a remarkable body of work. Gauguin would ultimately strain this metaphor past the breaking point when he sailed for the South Seas. Even so, his work was meant for the Parisian market and made sense in a European, specifically Parisian, context.

companionship with each other. No sooner had he arrived than he began urging them to come join him. To Gauguin he wrote: "And that it seems to me that if I find another painter who feels like getting the most out of the south, and who like me was sufficiently absorbed in his work to be able to resign himself to living like a monk who'd go to the brothel once a fortnight—apart from that, bound up in his work and not inclined to waste his time—then the thing would be good. On my own, I suffer a bit from this isolation. So I've very often thought about talking to you about it straight out."[69] Knowing he needed to sweeten the pot, he added: "You know that my brother and I have a high regard for your painting and that we'd very much wish to know you were a little at your ease. But all the same, my brother can't send money to you in Brittany and at the same time money to me in Provence. But would you like to share with me here? Then by joining forces, there would perhaps be enough for two; I'm sure of it, even."[70]

He began to work on Bernard as well. "Do you know that we've been very foolish, Gauguin, you and I, in not all going to the same place?" he wrote in June 1888. "If we'd all left for here together it wouldn't have been so foolish, because the three of us would have done our own housekeeping. And now that I've found my bearings a little more, I'm beginning to see the advantages here. For myself, I'm in better health here than in the north—I even work in the wheatfields at midday, in the full heat of the sun, without any shade whatever, and there you are, I revel in it like a cicada. My God, if only I'd known this country at 25, instead of coming here at 35—in those days I was enthusiastic about grey, or rather, absence of colour."[71]

Van Gogh conceived of his would-be hostel not simply as a refuge but as a school for the new art, a Studio of the South inspired by the

East: "Look, we love Japanese painting, we've experienced its influence," he insisted: "all the Impressionists have that in common—and we wouldn't go to Japan, in other words, to what is the equivalent of Japan, the south? So I believe that the future of the new art still lies in the south after all."[72] Working collaboratively, they'd make far more progress than on their own: "I've always thought it ridiculous for painters to live alone &c. You always lose when you're isolated. . . . For my part, it worries me to spend so much on myself alone, but to find a remedy for that there's none other than that of finding a wife with money or pals who associate with one another for paintings. Now I don't see the wife, but I do see the pals."[73]

Despite Albert Aurier's depiction of Van Gogh as a holy hermit, he really had the heart of a monk—not an anchorite brooding alone in his cave but one of the cenobitic variety who works the fields and shares his meals with his housemates. The ideal he hoped to realize in Arles was to live alongside his fellow strivers in an ascetic brotherhood devoted to a common cause. "I must tell you that even while working I never cease to think about this enterprise of setting up a studio with yourself and me as permanent residents," he wrote to Gauguin a month before the latter finally succumbed to Vincent's nagging, "but which we'd both wish to make into a shelter and a refuge for our pals at moments when they find themselves at an impasse in their struggle."[74]

If Arles was a southern outpost of Montmartre, providing a peaceful environment in which he could build on the artistic achievements he'd made over his two years in Paris, it also represented a return to the moral landscape of Brabant. In Nuenen he'd proclaimed, "Painting the peasants means that once and for all the *countryside,*

not the city is my place of work."[75] A few months later he'd completely reversed course, moving to Antwerp and then on to Paris in an effort to recast himself as a painter of modern life. What he discovered in the French capital was that to be a modern artist (as opposed to a painter of modern life) he didn't have to abandon his former ideals. The most compelling artists he encountered had already turned away from the model proposed by Baudelaire and turned their sights inward, on the realm of the human spirit that was Van Gogh's natural habitat.

Though Paris made Van Gogh into an artist, it's doubtful that he would have achieved greatness had he been there at any other time in history. Crucially, his residence coincided with the anti-naturalist backlash of the fin de siècle: Mystical symbolism had replaced rationalist materialism among progressive thinkers; Zola's journalism made way for Huysmans's decadence; Manet's objectivity for Odilon Redon's neurotic allegories. Even Seurat's supposedly "scientific" approach undercut the Naturalist aesthetic as he transformed suburban Paris into frozen tableaux every bit as artificial as Puvis de Chavannes's mythical never-never lands. This radical transformation led Van Gogh back to the art that always spoke most deeply to him, an art of passion, of spirit, of heart rather than eye, one still grounded in the real world but pointing to the one beyond.

Most of all, this new mode of understanding allowed Van Gogh to stitch together the divided halves of his artistic persona: the sentimental peasant painter in the tradition of Millet, committed to social justice and searching for spiritual transcendence, and the modernist pioneer in dialogue with his avant-garde colleagues. The conceptual tools he acquired in Paris enabled what one might call the *resacralization* of his art. Years earlier he'd turned his back on the faith in which he'd been raised. But even after rejecting any recognizable form of Christianity,

the Gospels' message of suffering and redemption remained close to his heart, its cadences never far from his lips.

Van Gogh continued to regard art as a sacred calling, but the work he now envisioned was a religious art without religion. This inevitably embroiled him in arguments with his colleagues Gauguin and Bernard, who were attempting to summon spirituality by more traditional means. "They'd driven me mad with their Christs in the garden, in which nothing is observed," he grumbled to Theo. "Of course there's no question of me doing anything from the Bible—and I've written to Bernard, and also to Gauguin, that I believed that thinking and not dreaming was our duty, that I was therefore astonished when looking at their work by the fact that they give way to that. . . . So this doesn't leave me cold, but it gives me an uncomfortable feeling of a tumble rather than progress."[76] Van Gogh, it turns out, was the hard-headed realist among the bunch, resisting his colleagues' urge to lose themselves in sterile fantasies.

Of course he didn't object to them addressing the spiritual dimension of life—after all he was going down a similar path! What he objected to was that they relied on hackneyed symbols, rather than seeking the extraordinary in the ordinary. His mature approach involved a kind of pantheism in which he discovered something holy in every blade of grass and birdsong, an innocent faith he ascribed above all to the Japanese artists. "Just think of that," he exalted: "isn't it almost a new religion that these Japanese teach us, who are so simple and live in nature as if they themselves were flowers? And we wouldn't be able to study Japanese art, it seems to me, without becoming much happier and more cheerful, and it makes us return to nature, despite our education and our work in a world of convention."[77]

One needn't travel to some exotic locale or plumb the distant past to discover evidence of God's handiwork. "If I remain here," he told Theo

during the months he was confined in the asylum at Saint-Remy, "I wouldn't try to paint a Christ in the Garden of Olives, but in fact the olive picking as it's still seen today, and then giving the correct proportions of the human figure in it, that would perhaps make people think of it all the same."[78] All the world, in other words, was Gethsemane, a place where the great drama of suffering and redemption was enacted. There was no need to sail to Jerusalem, or to Japan for that matter, for holy ground was all around you, revealed in the stoop of a peasant's back as he tilled the soil, in the gnarled branches of an ancient olive tree. The more acutely he observed such scenes, the more closely he hewed to mundane details, the more he'd be able to reveal the divine operating in daily life.

Van Gogh was less susceptible than many of his colleagues to the supernatural mumbo jumbo fashionable among Symbolists and other cultural radicals. These were the years that saw the rise of groups like Sâr Péladan's Salon de la Rose + Croix and The Nabis, both of which resembled religious cults as much as art movements. Despite, or perhaps because of, his early and intense involvement with organized religion, this flight into mysticism left him cold. Even as he embraced the spiritual dimension of his art, he stubbornly clung to facts. He'd not spent all those years copying from Charles Bargue's *Exercices au Fusain*, endured repeated attempts to put his nose to the academic grindstone, applied himself to the drudgery of copying plaster casts, and lugged about his perspective frame—in short, all those frustrated efforts to "get it right"—just to invent fantasies out of whole cloth.

He still had a deep-seated need to ground his art in something real. But now he approached the facts of the world in an entirely new manner, steeped in the modernist gospel of color and liberated from a slavish devotion to plain fact. "Instead of trying to render exactly what I have before my eyes, I use colour more arbitrarily in order to express

myself forcefully,"[79] he now insisted. Reality, he realized, was not an end in itself but a door through which he needed to walk to reach a deeper truth, one that could be made manifest through the magical properties of line and (above all) color.

"I believe in the absolute necessity of a new art of colour, of drawing and—of the artistic life," Van Gogh wrote less than a month after arriving in Arles. "And if we work in that faith, it seems to me that there's a chance that our hopes won't be in vain."[80] The almost messianic language was deliberate. Color was the means through which he could reconcile the material and sacred elements of his art: not the "scientific" color of Seurat and his colleagues, but the expressive, exaggerated color of the Cloisonnists and *ukiyo-e* prints. As he wrote of his painting *The Night Café*, his intent was to use color "that isn't locally true from the realist point of view of trompe l'oeil, but a colour suggesting some emotion, an ardent temperament."

Indeed, the new school he imagines arising in the south is based on that new understanding:

> I foresee that other artists will wish to see colour under a stronger sun and in a more Japanese clarity. Now if I set up a studio-refuge right at the entrance to the south, that's not so silly.
>
> And precisely that means that we can work calmly. Ah, if others say, it's too far from Paris &c.? Let them, too bad for them. Why did the greatest colourist of all, Eugene Delacroix, judge it indispensable to go to the south, and as far as Africa? Obviously because not only in Africa but even from Arles onward you'll naturally find fine contrasts between reds and greens, blues and oranges, sulphur and

lilac. And all true colourists will have to come to admit that there exists another coloration than that of the north. And I don't doubt that if Gauguin came, he would love this part of the country; if Gauguin didn't come, it's because he has already had this experience of more colourful countries, and he'd still be one of our friends and in agreement in principle. And another one of them would come in his place.[81]

Van Gogh had already begun to compose chromatic tone poems along the banks of the Seine in the company of Signac; he then turned up the volume under the spell of the Cloisonnists and *ukiyo-e* prints. As he neared the Mediterranean coast, the spectrum he perceived in his *mind's* eye now corresponded more closely to the environment he inhabited, an important factor for an artist who never felt comfortable relying solely on his own imagination. "The south will delight you and make you a great artist,"[82] he assured Bernard. To Theo he gushed: "I believe that a new *colourist* school will take root in the south, seeing increasingly that those from the north rely more on skill with the brush and the so-called picturesque effect than on the desire to express something through colour itself."[83]

For Vincent, this new approach did not simply transform a painting's appearance: It transformed its soul, operating on an emotional, perhaps even metaphysical, plane. "To express the love of two lovers through a marriage of two complementary colours," he proclaimed as the ultimate goal of his art, "their mixture and their contrasts, the mysterious vibrations of adjacent tones."[84]

As the snow melted and the first blossoms began to poke through the brown mud in splashes of yellow and purple, Van Gogh felt his winter of discontent give way to a hopeful spring. Each morning he

set out in search of motifs to paint: peach trees with their pink petals, a picturesque drawbridge over a canal leading to the sea, a stone farmhouse rising above a field of wheat. Nature was beginning to stir, and everywhere he saw color bursting forth: "I have 6 paintings of blossoming fruit trees," he informed his sister Wil at the end of March. "And the one I brought home today would possibly appeal to you—it's a dug-over patch of ground in an orchard, a wicker fence and two peach trees in full bloom, pink against a sparkling blue sky with white clouds and in sunshine."[85]

He no longer has to shut out the too-clamorous world, to retreat to the safety of his studio to find subjects that speak to his heart—they are all around him. The noise and hectic pace of the city fades, and he loses himself in the timeless rhythms of rustic labor, comforting rituals in which Man and Nature move in sympathy with one another. Though he draws inspiration from what he observes, he now dares to go beyond what he finds in the grid of his perspective frame. "I'm trying now to exaggerate the essence of things," he explained, "and to deliberately leave vague what's commonplace."[86] He refines, he abstracts, building on the ideas he batted around with Lautrec, Bernard, and Signac: taking expressive license by simplifying and exaggerating his contours, discovering different emotional keys in each complementary contrast. He conjures soothing harmonies and orchestrates jarring dissonances. "I don't know if you'll understand that one can speak poetry just by arranging colours well," he explained to his sister, "just as one can say comforting things in music."[87]

The fog that clouded his brain—a mix of tobacco smoke and alcohol fumes—begins to lift in the bracing country air. He can't look back on the past two years without shuddering. "For all through the year I've forced myself to forget Paris as much as I could from the point of view of the disturbance and excitement a prolonged

stay causes," he confided to Wil. "No matter what people say; we painters work better in the country, everything there speaks more clearly, everything holds firm, everything explains itself, now in a city when one is tired one no longer understands anything and feels as if one is lost."[88]

Still, he didn't regret the time he spent there. How could he? By now he was a Parisian artist through and through—a Parisian even in his horror of the city he'd left behind. "Suffice it to say that I don't believe that even when apparently cutting yourself off from Paris you will cease to feel that you're in fairly direct contact with Paris," he told Gauguin, as much to convince himself as his friend. For the two years of life remaining to him, he would continue to ring the changes on what he'd learned there, replaying, as he told Gauguin, "those strange days of discussions in the poor studios and the cafés of the *Petit* Boulevard."[89]

When Vincent first embarked on his artistic journey in the summer of 1880 he unburdened himself to Theo:

> You feel emptiness where there could be friendship and high
> and serious affections, and you feel a terrible discouragement
> gnawing at your psychic energy itself, and fate seems able
> to put a barrier against the instincts for affection, or a tide
> of revulsion that overcomes you. And then you say, How
> long, O Lord! Well, then, what can I say; does what goes
> on inside show on the outside? Someone has a great fire in
> his soul and nobody ever comes to warm themselves at it,
> and passersby see nothing but a little smoke at the top of
> the chimney and then go on their way. So now what are
> we to do, keep this fire alive inside.[90]

For years it felt as if the fire was slowly dying; the great world passed him by, cold and indifferent. But no longer. "At present," he confided to Gauguin, "dimly on the horizon, here it comes to me nevertheless—hope."[91] That hope came from the knowledge that he was no longer alone. He'd found a way to pry the door ajar, to invite in a few companions who now warmed themselves at the communal hearth. A few acts of kindness, a few signs of sympathy, were invaluable to someone who had lived so long without either. Both as an artist and as a man, he now lived in dialogue with his friends, responding to their latest efforts and they to his. However difficult the struggles that lay ahead, Van Gogh knew he was bound up in something larger than himself, participating in the wider cultural discourse that was shifting the trajectory of modern art.

That artistic conversation reached its peak, in the fall of 1888, when Van Gogh convinced Gauguin and Bernard to engage in a three-way exchange of self-portraits.

Emile Bernard, *Self-Portrait*, 1888

Bernard's contribution was the tamest of the three. Drawn with the stripped-down, almost childlike contours typical of the Cloisonnist

style and dominated by cool blues relieved by hints of complementary orange, it demonstrates both his virtues and limitations as an artist: a certain decorative gift, but also a rather paint-by-numbers handling of the brush that doesn't allow the painting to rise above its initial premise. In a tribute to his friend, he included a drawing of Gauguin on the wall behind him. Charming as it is, this work reveals some of its maker's superficiality.

Gauguin's self-portrait, inscribed "*à l'ami Vincent*" (to my friend Vincent), also reveals the nature of its maker. With a characteristic combination of literary conceit, bluster, and boundless egotism, Gauguin offers up an image that is both pugnacious and strangely compelling. Titling the work *Les Misérables*, he casts himself in the role of Victor Hugo's classic antihero. "The mask of a thief, badly dressed and powerful like Jean Valjean, who has his nobility and inner gentleness," he explains. "The rutting blood floods the face, and the tones of a fiery smithy, which surround the eyes, suggest the red-hot lava that sets our painters' souls ablaze. The drawing of the eyes and the nose, like the flowers in Persian carpets, epitomizes an abstract and symbolic art. That girlish little background, with its childish flowers, is there to testify to our artistic virginity. And that Jean Valjean, whom society oppresses, outlawed; with his love, his strength, isn't he too the image of an Impressionist today? By doing him with my features, you have my individual image, as well as a portrait of us all, poor victims of society, taking our revenge on it by doing good."[92]

While Gauguin depicts himself as an outlaw, Van Gogh adopts the guise of a religious pilgrim, "a bonze, a simple worshipper of the eternal Buddha." [see color plate 42] With his shaved skull and far-off eyes, he seems to see beyond this earthly realm to far horizons of the spirit. It's a deeply moving work, showing an artist in full possession of his powers even as it exposes his fragility as a man. He seems at once

ecstatic and undone, filled with wonder at the beauty of the world and on the verge of madness, both fierce and fiercely vulnerable. Unlike the self-portrait he painted right before he left Paris, he is no longer weighed down. In fact he seems almost unmoored, perhaps even a bit unhinged. In the process of meeting his destiny, he has both found and lost himself.

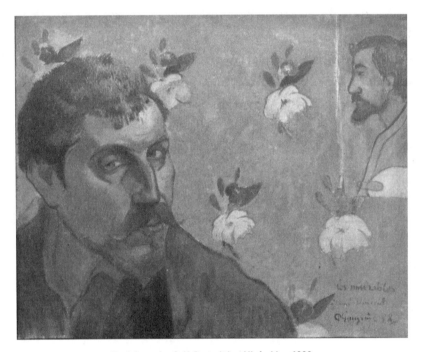

Paul Gauguin, *Self-Portrait Les Misérables*, 1888

The truth is that Vincent van Gogh had always been a pilgrim, trudging through wind and rain as he had in the Borinage and on the moors in Drenthe, searching for something he could never find in this life. At another time, and in a very different place—physically and spiritually—he was fond of quoting a particular Biblical passage: "Between that moment and today are years of pilgrimage. There are

words that accompany us and grow up with us, as it were—which are, 'sorrowful, yet always rejoicing.'"*93 Sorrowful, yet always rejoicing! These words pointing simultaneously in opposite directions—toward both tragedy and triumph, from darkness into light—encapsulate his life's journey.

He'd traveled far since he first quoted that passage, finding at long last the path he would follow, if not his final destination. As always he plunged forward recklessly, impelled by an insatiable yearning for someplace better. "It always seems to me that I'm a traveler who's going somewhere and to a destination," he confessed. "If I say to myself, the somewhere, the destination don't exist at all, that seems well argued and truthful to me."94

Like all true seekers he'd find no rest, no oasis of calm from which he could look back and take satisfaction in a job well done, a life well lived, and be content. "Ah well, I risk my life for my own work and my reason has half foundered in it,"95 he wrote less than a week before he died.** By that time, having passed through the purgatory of madness and despair, he was well on his way to immortality.

* 2 Corinthians, 6:10.
** The letter was never sent. Theo found it in his clothes after he shot himself.

Epilogue

Four Days

"I wanted it to end like this' & so it was for a few moments & it was over & he found the peace he could not find on earth."

—Theo to Jo on Vincent's death

When Van Gogh left for Arles in February of 1888 he had a little more than two and a half years to live. During that time he visited Paris only twice, spending a total of four days in the city that continued to seduce and repel him. The first came in May of 1890 after his release from the asylum of Saint-Paul de Mausole in Saint-Rémy. Then, he stayed with his brother for three days before heading to Auvers, an hour's train ride from the city, where Theo had arranged for him to be under the care of "a specialist in nervous disorders"[1] by the name of Dr. Paul-Ferdinand Gachet.*

On that first occasion Vincent had compelling reasons to make the trip since it was his first opportunity to meet not only his sister-in-law Jo, but also his nephew and namesake, the four-month-old Vincent

* Dr. Gachet was also recommended by the fact that he was an amateur painter and longtime friend of Pissarro, Cézanne, and Guillaumin.

Willem. "How pleased I am to have seen Jo and the little one,"[2] he wrote a few days later. At the same time, he admitted how difficult he'd found it: "I really felt in Paris that all the noise there wasn't what I need."[3]

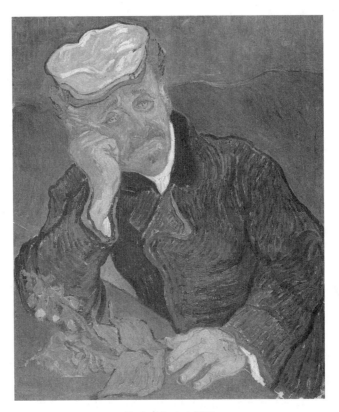

Dr. Paul Gachet, 1890

As for Jo, she was pleasantly surprised by her brother-in-law's appearance. "I had expected a sick person," she recalled, "but here was a sturdy, broad-shouldered man, with a healthy colour, a smile on his face, and a very resolute appearance . . . 'He seems perfectly well; he looks much stronger than Theo,' was my first thought . . . He stayed with us three days and was lively and cheerful all the time."[4]

Vincent's final visit to Paris came in early July, a few weeks before his death, and lasted less than a day. Unlike the pleasant reunion in May, this one proved fraught. "Vincent came again to see us in Paris," Jo remembered. It was a stressful time for the new parents, and Vincent was sensitive to any perceived slight. "We were worn out by the child's serious indisposition," Jo admitted. "Theo had again conceived the plan to leave Goupil in order to start a business of his own, Vincent was not satisfied with the room the paintings are stored in, so we talked about moving to a larger apartment, so they were days of worry and tension."[5] A few weeks later, when she learned that Vincent had shot himself, she was overcome with guilt, thinking she might have been partly responsible. "If only I'd been a bit kinder to him when he was with us!" she cried out. "How sorry I was for being impatient with him the last time."[6]

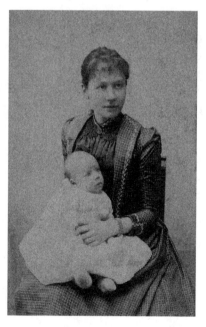

Jo Bonger van Gogh and Vincent Willem van Gogh, 1890

Despite Jo's understandable remorse, the depression that led to Vincent's suicide had nothing to do with her. In fact they'd quickly smoothed things over. Soon after he left, Jo had written to apologize, explaining the pressures she and Theo were under. Vincent was relieved. "Dear brother and sister," he replied, "Jo's letter was really like a gospel for me, a deliverance from anguish which I was caused by the rather difficult and laborious hours for us all that I shared with you."[7]

Still, though he easily forgave his sister-in-law, he couldn't shake a feeling of imminent doom. Hanging over everything like a black cloud was the fear that his madness would return: "Once back here I too still felt very saddened, and had continued to feel the storm that threatens you also weighing upon me. What can be done—you see I usually try to be quite good-humoured, but my life, too, is attacked at the very root, my step also is faltering. I feared—not completely—but a little nonetheless—that I was a danger to you, living at your expense—but Jo's letter clearly proves to me that you really feel that for my part I am working and suffering like you.[8]

Van Gogh's depression came despite his rising prospects and dawning fame. After years of struggle he was finally receiving the recognition he deserved. Aurier's article from January had boosted his profile, at least among the avant-garde circles that really mattered. His fellow artists, most of whom continued to regard him as a bit of an odd duck, now no longer doubted his talent.

Equally important, he had every reason to believe that material rewards would soon follow. In a sign of things to come, he sold his first painting in February.* Not that he cared about money. But earning a living from his art would relieve him of a burden that continued

* The painting was *The Red Vineyard*, sold to the Belgian painter Anna Boch for 400 francs.

to weigh on him to the end: his continued dependence on Theo—a dependence made all the more painful now that he had a wife and young son to care for. In the near future, Vincent knew, he'd be able to repay him for his years of steadfast devotion.

His two brief visits to Paris revealed how much had changed in the years he'd been away. During his May stopover the city was still abuzz over his contributions to the exhibition of the Société des Artistes Indépendants held the month before. Theo had selected ten paintings from his vast store, some recent and "a choice from those that are at Père Tanguy's,"[9] including a number of landscapes from Saint-Remy and at least one of his sunflowers. These were hung alongside works by Seurat, Signac, Lautrec, Pissarro, Anquetin, and Guillaumin, but even in this exalted company Van Gogh managed to stand out. Even Monet—not given to effusive praise of his rivals, particularly when they were engaged in an Oedipal battle to supplant their aesthetic fathers—called his contribution "the best of all in the exhibition."[10] Gauguin, too—a man with every reason to resent him after their violent quarrel—was impressed. "I offer you my sincere compliments," he wrote, "and for many artists you are the most remarkable in the exhibition. With things from nature you're the *only one there who thinks*."[11] Theo was deeply moved by all the praise being heaped on his brother. "Many other artists have spoken to me about them,"[12] he gushed, hoping to lift Vincent's spirits and reassure him all would be well.

Van Gogh's Parisian success hadn't come as a total surprise. A few months earlier, when his work was shown at the seventh Exposition des Vingt in Brussels, his paintings had generated most of the commentary and most of the controversy.* Not everyone was on board, but as progressive artists over the last quarter century had learned, the trick was

* Les Vingt (The Twenty) was a Belgian organization dedicated to promoting new art. Usually, the most advanced art on exhibit came straight from Paris.

to be talked about, not necessarily loved. Most gratifying to Vincent was the eagerness of his Montmartre colleagues to leap to his defense. When the Belgian painter Henry de Groux threatened to withdraw his work rather than be seen in the company of the "abominable Pot of Sunflowers by Monsieur Vincent or any other agent provocateur,"[13] Lautrec challenged him to a duel. Signac quickly volunteered to take his place were he to be killed in the confrontation.

A more reliable measure of Van Gogh's stature in avant-garde circles came in an article from *L'Art Moderne: Revue Critique des Arts et de la Littérature*: "In particular, we might mention among the canvases destined to excite artistic curiosity, Paul Cézanne's engaging open-air studies, Vincent van Gogh's vivid symphonies, Sisley's landscapes, Renoir's new compositions, and the entries of the Neo-Impressionist group, whose technique is becoming ever more sure."[14]

This show of support should have been particularly welcome after a troubled year in which mental illness threatened to destroy him. When Van Gogh's crises were at their worst, he was unable to paint, but between psychotic episodes he remained extremely productive, turning out work at a feverish pace. His final trip to Paris, painful as it was, offered a preview of what might have been. "There were also constant visitors for Vincent," Jo noted, "including Aurier, who had written his famous article about Vincent shortly before this, and now looked at all the work again with the painter himself, and Toulouse-Lautrec, who stayed to have lunch with us and had the biggest laugh with Vincent about an undertaker's assistant, whom they met on the stairs."[15]

But this outpouring of good cheer and goodwill failed to keep the demons at bay. Van Gogh canceled a planned meeting with Guillaumin "and went back to Auvers in great haste; overfatigued and overwrought."[16] His mood hardly improved in Auvers, though at least he was able to paint. "There—once back here I set to work again—the

brush however almost falling from my hands and—knowing clearly what I wanted I've painted another three large canvases since then. They're immense stretches of wheatfields under turbulent skies, and I made a point of trying to express sadness, extreme loneliness."[17]

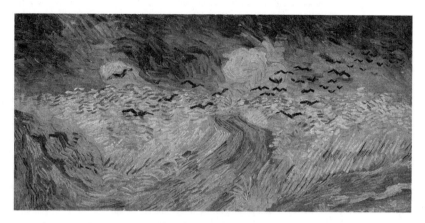

Wheatfield with Crows, 1890

The countryside offered little consolation. Rather than lift his spirits it now seemed to mirror his despair. Still, despite his unhappiness, he gave no indication he planned to kill himself. Indeed, he remained hard at work, these final paintings confirming his undimmed powers. But having finally achieved mastery over his craft and the means to channel the deepest longing of his heart into his painting, he found it wasn't enough. He'd once written to his sister Wil: "In earlier years, when I should have been in love, I immersed myself in religious and socialist affairs and considered art more sacred, more than now." He returned to this theme at the end of his life. "I often think of the little one," he told Theo and Jo, "I believe that certainly it's better to bring up children than to expend all one's nervous energy in making paintings, but what can you do, I myself am now, at least I feel I am, too old to

retrace my steps or to desire something else. This desire has left me, although the moral pain of it remains."[18]

If Vincent had learned anything over the course of his thirty-seven years, it was that life and art were antithetical, inimical. At least for him. "I risk my life for my own work and my reason has half foundered in it." These were almost the last words he ever wrote, the closest thing we have to a suicide note. Art could not save him because art consumed him. Perhaps his professional success actually hastened his death, allowing him to take leave of this world without regret.

On the morning of July 28, Theo received a note from Dr. Gachet: "It is with the utmost regret that I intrude on your privacy, however I regard it as my duty to write to you immediately, today, Sunday, at nine o'clock in the evening I was sent for by your brother Vincent, who wanted to see me at once. I went there and found him very ill. He has wounded himself."[19]

Theo rushed to be with him, taking the next train to Auvers. It was an anguishing vigil at his bedside as he watched his brother slowly fade, his sense of helplessness deepened by the fact that Vincent didn't seem to struggle against his fate. His final hours were marked by a serenity he'd rarely known before. His journey was over, and he'd finally found a place where he could rest.

Theo relayed the sad news to Jo the same day: "One of his last words was 'I wanted it to end like this' & so it was for a few moments & it was over & he found the peace he could not find on earth."[20]

When Was Van Gogh at Cormon's Studio?

T he main piece of evidence regarding the period Van Gogh spent in Cormon's studio comes from the letter he wrote to Horace Mann Livens: "I have been in Cormon's studio for three or four months but did not find that as useful as I had expected it to be. It may be my fault however, any how I left there too as I left Antwerp and since I worked alone, and fancy that since I feel my own self more."[1] The scholars of the Van Gogh Museum who have compiled his letters date it to the summer or fall of 1886, implying he'd already left Cormon's by that time. But there is no real evidence for this, other than the assumption that Van Gogh would not have written to Livens more than a year after they had known each other in Antwerp. This version of events is seconded by Jo Bonger. But Jo did not meet Vincent until two years later. Her account is based on what Theo told her, as recalled years after his death.

More definitive testimony comes from Émile Bernard, who places his time there firmly in the fall. Bernard had been a student at Cormon's studio before being expelled in April 1886. He spent the summer of 1886 in Pont-Aven, where he first met Paul Gauguin, returning to Paris in the fall. It was only then, upon paying a visit to his

old classroom, that he first met Van Gogh. "'It was there that I first saw Vincent van Gogh, who was painting."[2] Given the importance Bernard always attached to his friendship with Van Gogh, it's impossible that he wouldn't have remembered meeting him earlier as a fellow student.

Also decisive is a small painting Van Gogh did of a nude seated girl, a subject Vincent could only have painted in Cormon's studio, where such exercises were commonplace. X-rays of the painting reveal it was painted over a flower still life that closely resembles those he was churning out in the summer of 1886, proof that he was at Cormon's sometime after the summer of 1886.[3]

The rest of the evidence, while less precise, is equally compelling. Theo's letter to his mother, written in June or July of 1886, makes no mention of Vincent studying with Cormon, something he would surely have included in his list of accomplishments. His silence on the matter speaks volumes.

In their discussions about the possibility of studying with Cormon, begun while the older brother was still in Antwerp, Vincent insists he needs time to prepare before enrolling. "If I take a garret in Paris, bring my painting box and drawing materials with me—then as far as the work's concerned I can finish the most pressing things at once—those studies of plaster casts that will certainly help me when I go to Cormon's. I can go and draw either in the Louvre or in L'École des Beaux-Arts."[4] He also stresses the importance of getting "more accustomed to Paris again by the time I go to Cormon's."[5] Specifically, he needs to put in more work before he'll be ready to pass the entrance exam:* "And I'm quite sure that it will help me at Cormon's if I spend the interim doing nothing but drawing. . . . At Cormon's I'll have to

* This is further proof that Vincent knew little about Cormon's, since there was almost certainly no entrance exam.

paint some test or other of a nude figure from life—probably—and the more I have the structure fixed in my mind in advance the better, and the more he'll be able and willing to tell me."[6] In his final letter from Antwerp, written four days before he left for Paris, he argues again for delay: "I still continue to urge you rather to go ahead with the Cormon plan and what, for my part, I would so much like to precede it—a further period continuing to draw plaster casts."[7] The plaster casts he painted that summer were doubtless made in preparation for his course of study in the fall. It's unclear whether Theo agreed with Vincent about the need for more time, but given the fact that he showed up in Paris unannounced, it's unlikely that Theo could have arranged for his immediate matriculation.

In the spring of 1886 Van Gogh was primarily engaged in painting *en plein air*, acquainting himself with his new surroundings by hauling his easel around the Butte de Montmartre. Being cooped up in a studio as the first buds were appearing on the trees would hardly have appealed to him. It's also clear that he remained an isolated figure during these first months. It was only in the fall that we see him making those first tentative connections to his fellow artists, building the relationships that would ultimately set him on a radical new course.

Acknowledgments

Writing is often a solitary pursuit, but always a collaborative effort. Whatever interpretations I've made, whatever conclusions I've drawn from the vast body of material available, they are built on the work of others who've come before: the scholars, the archivists, the curators and conservators, as well as the countless art aficionados whose enduring love for the art and fascination with the life of Vincent van Gogh are the foundation upon which all else rests.

I am particularly grateful to the staff of the Van Gogh Museum in Amsterdam who have made it their mission not only to place his work before the public, but to preserve, protect, elucidate, and interpret his legacy. Without their help and cooperation this book would not have been possible. Their impeccable scholarship in arranging, translating, and annotating Vincent's vast correspondence is the essential building block upon which any narrative of his life must rest. As the repository of the world's largest collection of his paintings, drawings, and ephemera, the Museum's curators and conservators continue to do essential work, which they generously make available to interested scholars.

In addition, I'd like to thank my editor at Pegasus Books, Claiborne Hancock, who believed in this project from the start and nurtured it from beginning to end, as well as the capable, hardworking production staff who have made up for many of my mistakes. Credit goes as well to my agent Alexander Hoyt who was the first to see the potential of this topic and made sure it saw the light of day.

And, as always, I have to thank my friends and family who have put up with the eccentricities and occasional misanthropy of a writer's life with unfailing generosity and support.

Bibliography

Primary

Vincent van Gogh, The Letters, Van Gogh Museum, https://vangoghletters.org /vg/letters.html.

Aurier, Gabriel-Albert. "The Isolated Ones." In Nochlin, Linda, *Impressionism and Post-Impressionism 1874–1904: Sources and Documents in the History of Art*, 135–139. Englewood Cliffs, N.J.: Prentice-Hall, 1966.

Ibid., *"Le Symbolisme en Peinture: Paul Gauguin."* In Herschel B. Chipp. *Theories of Modern Art*. Berkeley: University of California Press, 1979, 89–93.

Baedeker, Karl. *Paris and Its Environs: With Routes from London to Paris: Handbook for Travelers.* London: Baedeker, 1899.

Balzac, Honoré de. *The Unknown Masterpiece.* Scotts Valley, Calif.: CreateSpace Independent Publishing Platform, 2015.

Bargue, Charles. *Excercices au fusain pour preparer a l'étude de l'académie d'après nature.* Paris: Goupil & Cie, 1871. Van Gogh Museum Digital Archive. https://archive.org/details/vangoghmuseumlibrary.

Baudelaire, Charles. *Flowers of Evil.* Oxford, UK: Oxford University Press, 2008.

Ibid., *The Painter of Modern Life and Other Essays.* London: Phaidon, 2001.

Bell, Clive. *Since Cézanne.* Memphis, Tenn.: General Books, 2010.

Bernard, Émile. "Julien Tanguy Dit Le Père Tanguy." *Mercure de France,* Dec. 16, 1908 [pdf].

Ibid., *Les Lettres d'un Artiste.* Dijon, France: Presses du Réel, 2012.

Ibid., "On Cézanne." In Nochlin, *Impressionism and Post-Impressionism,* 98–102.

Ibid., *Les Peintres Impressionistes: Vincent Van Gogh.* In *Émile Bernard 1868–1941: A Pioneer of Modern Art,* Amsterdam: Waanders Publishers, 1990.

Blanc, Charles. *Grammaire des Arts du Dessin: Architecture, Sculpture, Peinture.* Paris: Jules Renouard, 1870.

Ibid., *The Grammar of Painting and Engraving.* Trans. Kate Newell Doggett. New York: Hurd and Houghton, 1874.

Bonger, Jo. *A Memoir of Vincent van Gogh.* Los Angeles: J. Paul Getty Museum, 2018.

Carco, Francis. *The Last Bohemia: From Montmartre to the Latin Quarter.* New York: Henry Holt and Co., 1928.

Cassagne, Armand. *Guide de l'alphabet du dessin ou l'art d'apprendre et d'enseinger les principes rationnels du dessin après nature.* Paris: Librarie Classique Internationale, 1895.

Cézanne, Paul. "Cézanne's Letters." In Nochlin, *Impressionism and Post-Impressionism,* 83–96.

Ibid., "Letters to Émile Bernard [1904–1906]." In Charles Harrison and Paul Wood. *Art in Theory.* Cambridge, UK: Blackwell, 1993.

Chevreul, Michel. *On the Law of the Simultaneous Contrast of Colours.* London: Longman, Brown, Green, and Longmans, 1855.

Ibid., *The Principles of Harmony and Contrast of Colours.* London: Henry G. Bohn, 1860.

Croce, Benedetto. "What is Art? [1913]." In Harrison and Wood, *Art in Theory.*

Delacroix, Eugène. *Journal: 1823–1850.* Sanary-sur-Mer, France: Livio Editions, 2018.

Ibid., *Journal: 1850–1854.* Sanary-sur-Mer, France: Livio Editions, 2018.

Denis, Maurice. "Cézanne." In Harrison and Wood, *Art in Theory.*

Ibid., "A Definition of Neo-Traditionalism." In Nochlin, *Impressionism and Post-Impressionism,* 191–192.

Ibid., "From Gauguin and van Gogh to Neo-Classicism." In Chipp, *Theories of Modern Art: A Sourcebook by Artists and Critics.*

Douglas, Charles. *Artist Quarter: Reminiscences of Montmartre and Montparnasse in the First Two Decades of the Twentieth Century.* London: Faber and Faber, 1941.

Durand-Ruel, Paul. *Memoirs of the First Impressionist Art Dealer (1831–1922).* Paris: Flammarion, 2014.

Duranty, Edmond. "The New Painting: Concerning the Group of Artists Exhibiting at the Durand-Ruel Galleries (1876)." In Nochlin, *Impressionism and Post-Impressionism,* 3–7.

Duret, Theodore. "The Impressionist Painters (1878)." In Nochlin, *Impressionism and Post-Impressionism,* 7–10.

Ibid., "Monet." In Nochlin, *Impressionism and Post-Impressionism,* 29–30.

Émile-Bayard, Jean. *Montmartre Past and Present.* New York: Brentano's, 1929.

Fénéon, Félix. "The Impressionists in 1886." In Nochlin, *Impressionism and Post-Impressionism,* 108–110.

Ibid., "Neo-Impressionism." In Nochlin, *Impressionism and Post-Impressionism,* 110–112.

Ibid., *Novels in Three Lines.* New York: New York Review of Books Classics, 1997.

Gauguin, Paul. *Avant et après.* London: Hodder & Stoughton, 1926.

Ibid., *The Intimate Journals of Paul Gauguin.* London: Heinemann, 1952.

Ibid., "Letter to Émile Bernard." In Nochlin, *Impressionism and Post-Impressionism*, 160–162.

Ibid., "Letter to Emile Schuffenecker." In Nochlin, *Impressionism and Post-Impressionism*, 157–160.

Ibid., "Notes on Painting." In Nochlin, *Impressionism and Post-Impressionism*, 162–166.

Ibid., "Notes Synthetiques (1888)." In Chipp, *Theories of Modern Art*.

Geffroy, Gustave. "On Paul Cézanne." In Nochlin, *Impressionism and Post-Impressionism*, 102–107.

Gilot, Françoise, and Carlton Lake. *Life with Picasso*. New York: McGraw-Hill, 1964.

Goncourt, Edmond de. *Chérie*. Paris: G. Charpentier et Cie, 1884.

Ibid., *La Maison d'un Artiste*. Paris: Charpentier, 1881.

Goncourt, Edmond and Jules. *Pages from the Goncourt Journals*. New York: New York Review of Books, 2007.

Hartrick, Archibald Standish. *A Painter's Pilgrimage through Fifty Years*. Cambridge, UK: Cambridge University Press, 1939.

Herbert, Robert L., ed. and trans. *Modern Artists on Art*. Mineola, N.Y.: Dover Publications, 1964.

Huysmans, J. K. *A Rebours (Against Nature)*, Overland Park, Kan.: Digireads.com Publishing, 2016

Ibid., "On the Art of Gustave Moreau." In Nochlin, *Impressionism and Post-Impressionism*, 199–203.

Kandinsky, Wassily. "From *Concerning the Spiritual in Art*." In Harrison and Wood, *Art in Theory*.

Laforgue, Jules. "Impressionism." In Nochlin, *Impressionism and Post-Impressionism*, 14–21.

Leroy, Louis. "A Satiric Review of the First Impressionist Exhibition." In Nochlin, *Impressionism and Post-Impressionism*, 10–14.

Maupassant, Guy de. *Bel-Ami*. Oxford, UK: Oxford University Press, 2008.

Michel, Louise. *The Red Virgin: Memoirs of Louise Michel*. Tuscaloosa: University of Alabama Press, 1981.

Monet, Claude. "Letters to Bazille." In Nochlin, *Impressionism and Post-Impressionism*, 30–33.

Ibid., "Letters to Gustave Geffroy." In Nochlin, *Impressionism and Post-Impressionism*, 33–35.

Moore, George. *Confessions of a Young Man*. New York: Barnes & Noble Digital Library, 2011.

Ibid., *Reminiscences of the Impressionist Painters*. Dublin: Maunsel & Co., 1906.

Moreau, Gustave. "Statements on Art." In Nochlin, *Impressionism and Post-Impressionism*, 198–199.

Pickvance, Ronald, ed. *A Great Artist Is Dead: Letters of Condolence on Vincent van Gogh's Death*. Amsterdam: Waanders Publishers, 1992. Van Gogh Museum Digital Archives, https://archive.org/details/vangoghmuseumlibrary.

Pissarro, Camille. "Abandonment of Divisionism." In Nochlin, *Impressionism and Post-Impressionism,* 59.

Ibid., "Letter to Durand-Ruel." In Nochlin, *Impressionism and Post-Impressionism,* 54–55.

Ibid., "Two Letters to Lucien [Pissarro]." In Nochlin, *Impressionism and Post-Impressionism,* 55–59.

Redon, Odilon. "To Myself: Journal (1867–1915)." In Nochlin, *Impressionism and Post-Impressionism,* 192–198.

Renoir, Jean. *Renoir, My Father.* Boston: Little, Brown and Company, 1958.

Renoir, Pierre-Auguste. "Letters to Durand-Ruel." In Nochlin, *Impressionism and Post-Impressionism,* 52–54.

Ibid., "The Society of Irregularists (1884)." In Nochlin, *Impressionism and Post-Impressionism,* 45–47.

Rimbaud, Arthur. *Complete Works.* New York: Harper Perennial Modern Classics, 2008.

Rothenstein, William. *Men and Memories: Recollections of William Rothenstein.* New York: Coward-McCann, Inc., 1935.

Ruskin, John. *Lectures on Art.* New York: Allworth Press, 1996.

Sensier, Alfred. *La Vie et L'Oeuvre de J-F Millet.* Paris: A. Quantin, 1881.

Sérusier, Paul. "The ABC of Painting." In Nochlin, *Impressionism and Post-Impressionism,* 184–186.

Ibid., "A Letter to Maurice Denis from Le Pouldu (1889)." In Nochlin, *Impressionism and Post-Impressionism*, 182–184.

Seurat, Georges. "Letter to Maurice Beaubourg (1890)." In Nochlin *Impressionism and Post-Impressionism,* 112.

Ibid., "Transcription of a Passage from Chevreul's 'De la loi du contraste simultané des couleurs'." In Nochlin, *Impressionism and Post-Impressionism,* 114–116.

Signac, Paul. "Excerpts from Paul Signac's Journal: 1894–1899." In Nochlin, *Impressionism and Post-Impressionism*, 125–135.

Ibid., "From Eugène Delacroix to Neo-Impressionism." In Nochlin, *Impressionism and Post-Impressionism*, 116–125.

Ibid., *Le Neo-Impressionisme.* Madrid: Casimiro, 2015.

Symons, Arthur. *The Symbolist Movement in Literature.* Chicago: Carcanet Press, 2014.

Toulouse-Lautrec, Henri de. *The Letters of Henri de Toulouse-Lautrec.* Oxford, UK: Oxford University Press, 1991.

Van Gogh, Elisabeth Huberta du Quesne. *Personal Recollections of Vincent van Gogh.* Mineola, N.Y.: Dover Publications, 2017.

Van Gogh, Theo and Jo Bonger. *The Account Book of Theo van Gogh and Jo van Gogh-Bonger.* Amsterdam: Van Gogh Museum, 2002.

Ibid., *A Brief Happiness: The Correspondence of Theo van Gogh and Jo Bonger.* Amsterdam: Van Gogh Museum, 1999.

Van Gogh, Vincent. *Van Gogh on Art and Artists: Letters to Émile Bernard.* Mineola, N.Y.: Dover Publications, 2003.

Verlaine, Paul. *A Bilingual Selection of His Verse.* University Park: Penn State University Press, 2021.

Vlaminck, Maurice de. *Dangerous Corner.* New York: Abelard-Schuman, 1967.

Whiteing, Richard. *Paris of To-day.* New York: Century Company, 1900.

Wyzewa, Téodor de. "Wagnerian Painting (1897)." In Harrison and Wood, *Art in Theory, 1900–1990,* 20–23.

Zola, Émile. *Au Bonheur des Dames.* Boston: Addison-Wesley, 2002.

Ibid., *Germinal.* New York: Penguin Classics, 2004.

Ibid., *The Masterpiece.* Oxford, UK: Oxford University Press. 2016.

Ibid., *Mes Haines Causeries Littéraires et Artistiques.* Paris: Charpentier, 1923.

Ibid., *Mon Salon.* Paris: Librarie Centrale, 1866.

Ibid., "Mon Salon: Dedication to Cézanne (1866)." In Nochlin, *Impressionism and Post-Impressionism,* 96–98.

Ibid., *Nana.* Oxford, UK: Oxford University Press, 2020.

Ibid., *Pot Luck.* Oxford, UK: Oxford University Press, 2009.

Secondary

Allwood, John. *The Great Exhibitions.* London: Studio Vista, 1977.

Anderson, R. D. *France 1870–1914: Politics and Society.* London, Routledge & Kegan, 1977.

Arnason, Hjorvadur Harvard. *History of Modern Art: Painting, Sculpture, Architecture, Photography.* Englewood Cliffs, N.J.: Prentice-Hall, 1966.

Bailey, Martin. *Van Gogh's Finale: Auvers and the Artist's Rise to Fame.* Beverly, Mass.: Francis Lincoln, 2021.

Barasch, Moshe. *Theories of Art: From Plato to Winckelmann.* New York: New York University Press, 1985.

Barr, Alfred. *Defining Modern Art: Selected Writings of Alfred H. Barr Jr.* New York: Harry N. Abrams, 1986.

Ibid., *Matisse and His Public.* New York: Museum of Modern Art, 1951.

Ibid., *Painting and Sculpture in the Museum of Modern Art, 1929–1967.* New York: Museum of Modern Art, 1977.

Benson, Gertrude R. "Exploding the van Gogh Myth," *American Magazine of Art,* January 1936, 29, no. 1.

Bernier, Georges. *Paris Cafés: Their Role in the Birth of Modern Art.* New York: Wildenstein, 1985.

Boggs, Jean Sutherland. *Degas.* New York: Metropolitan Museum of Art, 1988.

Boime, Albert. *The Academy and French Painting in the Nineteenth Century.* New Haven, Conn.: Yale University Press, 1986.

Ibid., *Art and the French Commune: Imagining Paris after War and Revolution.* Princeton, N.J.: Princeton University Press, 1995.

Ibid., *Art in the Age of Bonapartism, 1800–1815.* Chicago: University of Chicago Press, 1990.

Ibid., *Art in the Age of Revolution: 1750–1800*. Chicago: University of Chicago Press, 1987.

Ibid., *Revelation of Modernism: Responses to Cultural Crises in Fin-de-Siècle Paris*. Columbia: University of Missouri Press, 2008.

Brookner, Anita. *The Genius of the Future: Essays in French Art Criticism*. Ithaca, N.Y.: Cornell University Press, 1971.

Cachin, Françoise. *Gauguin: The Quest for Paradise*. New York: Harry N. Abrams, 1989.

Canaday, John. *Mainstreams of Modern Art*. New York: Holt, Rinehart and Winston, 1981.

Carvalho, Fleur Rosa de. "A Painting by Louis Anquetin Acquired by the Van Gogh Museum, Amsterdam." *Burlington Magazine*, 152, no. 1293 (December 2010).

Castleman, Riva, and Wolfgang Wittrock. *Henri de Toulouse-Lautrec: Images of the 1890s*. New York: Museum of Modern Art, 1985.

Cate, Phillip Dennis. *The Circle of Toulouse-Lautrec: An Exhibition of the Work of the Artist and His Close Associates*. New Brunswick, N.J.: Jane Voorhees Zimmerli Art Museum, 1985.

Chapman, Guy. *The Third Republic of France*. London: Macmillan, 1962.

Childs, Elizabeth. *Vincent Van Gogh and the Painters of the Petit Boulevard*. Saint Louis: Saint Louis Art Museum, 2001.

Chipp, Herschel B. *Theories of Modern Art*, Berkley, 1979.

Clark, T. J. *Farewell to an Idea: Episodes from the History of Modernism*. New Haven, Conn.: Yale University Press, 1999.

Ibid., *The Painting of Modern Life: Paris in the Art of Manet and his Followers*. Princeton, N.J.: Princeton University Press, 1984.

Clayson, Hollis, "The Family and the Father: The 'Grande Jatte' and Its Absences." Art Institute of Chicago Museum Studies, 14, no. 2 (1989).

Conrad, Barnaby. *Absinthe: History in a Bottle*. San Francisco: Chronicle Books, 1988.

Cooke, Cristina Scassellati. "The Ideal of History Painting: George Rouault and Other Students of Gustave Moreau at the École des Beaux-Arts, Paris, 1892–98." *Burlington Magazine*, May 2006, cxlviii.

Crespelle, Jean. *The Fauves*. Greenwich, Conn.: New York Graphic Society, 1962.

Ibid., *La vie Quotidienne à Montmartre*. Paris: Hachette, 1978.

Crow, Thomas E. *Modern Art in the Common Culture*. New Haven, Conn.: Yale University Press, 1996.

Ibid., *Painters and Public Life in Eighteenth-Century Paris*. New Haven, Conn.: Yale University Press, 1985.

Crow, Thomas E., and Stephen Eisenman. *Nineteenth-Century Art: A Critical History*. London: Thames and Hudson, 1994.

Danchev, Alex. *Cézanne: A Life*. London: Profile Books, 2013.

Dejean, Joan. *How Paris Became Paris: The Invention of the Modern City*. New York: Bloomsbury, 2014.

Dorn, Ronald, George S. Keyes, Joseph J. Rishel, Katherine Sachs, George T. M. Shackelford, Judy Sund. *Van Gogh Face to Face: The Portraits.* Detroit: Detroit Institute of Art, 2000.

Dorrs, Henri. "Van Gogh and Cloisonism." *Art Journal,* 41, no. 3 (Autumn 1981).

Faille, J. B. de la. *The Works of Vincent van Gogh: His Paintings and Drawings.* New York: Morrow, 1970.

Ferrier, Jean-Louis. *The Fauves: The Reign of Color.* Paris: Terrail, 2001.

Figura, Starr, Isabelle Cahn, and Phillipe Peltier. *Félix Fénéon: Aesthete and Anarchist in Fin-de-Siècle Paris.* New York: Museum of Modern Art, 2020.

Flam, Jack. "Matisse and the Fauves." In Rubin William, *Primitivism in 20th Century Art: Affinity of the Tribal and the Modern,* vol. 1. New York Museum of Modern Art, 1984.

Flam, Jack, ed. *Matisse: A Retrospective.* New York: Park Lane, 1988.

Franck, Dan. *Bohemian Paris: Picasso, Modigliani, Matisse, and the Birth of Modern Art.* New York: Grove Press, 2001.

Frey, Julia. *Toulouse-Lautrec: A Life.* London: Orion Books, 2007.

Friedlander, Walter. *David to Delacroix.* Cambridge, Mass.: Harvard University Press, 1980.

Gerritse, Bregje, and Jacquelyn Coutre. *Van Gogh and the Avant-Garde: Along the Seine.* New Haven, Conn.: Yale University Press, 2003.

Goldwater, Robert. *Symbolism.* New York: Harper & Row, 1979.

Gordon, Donald E. "Kirchner in Dresden." *Art Bulletin,* 48 (1966).

Ibid., *Modern Art Exhibitions, 1900–1916.* Munich: Prestel, 1974.

Gould, Cecil. *Seurat's 'Bathers, Asnieres' and the Crisis of Impressionism.* London: National Gallery Press, 1976.

Green, Christopher. *Art in France, 1900–1940.* New Haven, Conn.: Yale University Press, 2000.

Green, Nicholas. "Circuits of Production, Circuits of Consumption: The Case of Mid-Nineteenth Century French Art Dealing." *Art Journal* (Spring 1989).

Greenhalgh, Paul. *Ephemeral Vistas: The Expositions Universelles, Great Exhibitions, and World's Fairs.* Manchester, UK: Manchester University Press, 1988.

Hamilton, George Heard. *Painting and Sculpture in Europe: 1880–1940.* Englewood Cliffs, N.J.: Prentice-Hall, 1972.

Harrison, Charles, and Paul Wood, eds. *Art in Theory, 1900–1990.* Oxford, UK: Blackwell, 1993.

Heugten, Sjraar van. *The Graphic Work of Vincent van Gogh.* Amsterdam: Van Gogh Museum, 1995.

Ibid., *Vincent van Gogh Drawings,* vol. 1: *The Early Years, 1880–1883.* Amsterdam: Van Gogh Museum, 1996.

Ibid., *Vincent van Gogh Drawings,* vol. 2: *Nuenen, 1883–1885.* Amsterdam: Van Gogh Museum, 1997.

Higonnet, Patrice. *Paris: Capital of the World.* Cambridge, Mass.: Belknap Press of Harvard University Press, 2002.

Hirsh, Sharon. "Symbolist Art and Literature." *Art Journal* 45, no. 2 (Summer 1985): 95–97.

Holstijn, A. Westerman, and Hans P. Winzen. "The Psychological Development of Vincent Van Gogh." *American Imago* 8, no. 3 (September 1951)

Holt, Elizabeth Gilmore. *The Triumph of Art for the Public, 1785–1848: The Emerging Role of Exhibitions and Critics*. Princeton, N.J.: Princeton University Press, 1983.

Houchin, John. "Origins of the Cabaret Artistique." *Drama Review* 28, no. 1 (Spring, 1984).

House, John. *Impressions of France: Monet, Renoir, Pissarro, and Their Rivals*. Boston: Museum of Fine Arts, 1995.

House, John, et al. *Faces of Impressionism: Portraits from American Collections*. Baltimore: Baltimore Museum of Art, 2000.

Howard, Michael. *Encyclopedia of Impressionism*. Glasgow: Carlton Books, 1997.

Hughes, Robert. *The Shock of the New*. New York: Knopf, 1980.

Hyslop, Lois Boe. *Baudelaire, Man of His Time*. New Haven, Conn.: Yale University Press, 1980.

Jampoller, Lili, and Theo Van Gogh. "Theo van Gogh and Camille Pissarro: Correspondence and an Exhibition." *Simiolus: Netherlands Quarterly for the History of Art* 16, no. 1 (1986).

Jobert, Barthelemy. *Delacroix*. Princeton, N.J.: Princeton University Press, 2018.

Jullian, Philippe. *Montmartre*. Oxford: Phaidon, 1977.

Ibid., *The Triumph of Art Nouveau: The Paris Exhibition, 1900*. New York: Carousse, 1974.

King, Ross. *The Judgment of Paris: The Revolutionary Decade That Gave the World Impressionism*. New York: Walker Books, 2009.

Krauss, Rosalind. *The Originality of the Avant-Garde and Other Modernist Myths*. Cambridge, Mass.: MIT Press, 2010.

Lambourne, Lionel. *Victorian Painting*. London: Phaidon, 1999.

Leiris, Alan de. "Charles Morice and His Times." *Comparative Literature Studies* 4 (1967): 371–395.

Levin, Miriam. "The Eiffel Tower Revisited." *French Review* 62, no. 6 (May 1989): 1052–1064.

Lovgren, Sven. *The Genesis of Modernism: Seurat, Van Gogh, and French Symbolism in the 1880s*. New York: Hacker Art Books, 1983.

Lubin, Albert J. *Stranger on the Earth: A Psychological Biography of Vincent van Gogh*. New York: Holt, 1972.

Luijten, Hans, and Lynne Richards. *Jo van Gogh-Bonger: The Woman Who Made Vincent Famous*. London: Bloomsbury Visual Arts, 2023.

McAuliffe, Mary. *Dawn of the Belle Epoque: The Paris of Monet, Zola, Bernhardt, Eiffel, Debussy, Clemenceau, and Their Friends*. Lanham, Md.: Rowman and Littlefield, 2011.

Ibid., *Paris, City of Dreams: Napoleon III, Baron Haussmann, and the Creation of Paris*. Lanham, Md.: Rowman and Littlefield, 2020.

Ibid., *Twilight of the Belle Epoque: The Paris of Picasso, Stravinsky, Proust, Renault, Marie Curie, Gertrude Stein, and Their Friends Through the Great War*. Lanham, Md.: Rowman and Littlefield, 2014.

McCullough, David. *The Greater Journey: Americans in Paris*. New York: Simon & Schuster, 2011.

Milner, John. *The Studios of Paris: The Capital of Art in the Late Nineteenth Century*. New Haven, Conn.: Yale University Press, 1988.

Moffett, Charles S. *The New Painting: Impressionism 1874–1886*. Geneva: Richard Burton SA, Publishers, 1986.

Mucha, Jiri. *Alphonse Maria Mucha: His Life and Art*. London: Academy, 1989.

Murphy, Alexandra R., Susan Fleming, and Chantal Mahy-Park. *Jean-François Millet*. Boston: Museum of Fine Arts, 1984.

Myers, Nicole. "The Lure of Montmartre." In *Heilbrunn Timeline of Art History*. New York: Metropolitan Museum of Art, 2000. [http://www.metmuseum.org/toah/hd/mont/hd_mont.htm] (October 2007).

Naifeh, Steven. *Van Gogh and the Artists He Loved*. New York: Random House, 2021.

Naifeh, Steven, and Gregory White Smith. *Van Gogh: The Life*. New York: Random House, 2011.

Newhall, Beaumont. *The History of Photography*. New York: Museum of Modern Art, 1982.

Nochlin, Linda. *Impressionism and Post-Impressionism, 1874–1904*. Englewood Cliffs, N.J.: Prentice-Hall, 1966.

Ibid., *The Politics of Vision: Essays on Nineteenth-Century Art and Society*. New York: Harper & Row, 1989.

Nordenfalk, C. "Van Gogh and Literature." *Journal of the Warburg and Courtauld Institutes* 10, 1948.

Oberthur, Mariel. *Cafés and Cabarets of Montmartre*. Salt Lake City: Gibbs M. Smith, 1984.

Orwicz, Michael R., ed. *Art Criticism and Its Institutions in Nineteenth Century France*. Manchester, UK: Manchester University Press, 1994.

Ozanne, Marie-Angelique, and Frederique de Jode. *Theo: The Other Van Gogh*. New York: Vendome Press, 2004.

Patry, Sylvie, ed. *Inventing Impressionism: Paul Durand-Ruel and the Modern Art Market*. London: National Gallery Company, 2015.

Penot, Agnes. "The Goupil & Cie Stockbooks: A Lesson in Gaining Prosperity through Networking." *Getty Research Journal*, no. 2, 177–182.

Peres, Cornelia. *A Closer Look: Technical and Art-Historical Studies on Works by Van Gogh and Gauguin*. Amsterdam: Van Gogh Museum, 1991.

Perruchot, Henri. "Van Gogh à Paris." *Hommes et Mondes*, no. 103 (February 1955): 307–326.

Pickvance, Ronald. *Gauguin and the School of Pont-Aven*. London: Apollo, 1994.

Poggioli, Renato. *The Theory of the Avant-Garde.* Cambridge, UK: Belknap Press, 1968.

Pollock, Griselda. *Avant-Garde Gambits: Gender and Colour of Art History.* London: Thames & Hudson, 1992.

Pool, Phoebe. *Impressionism.* London: Thames & Hudson, 1974.

Rathbone, Eliza E., and George T. M. Shackleford. *Impressionist Still Life.* New York: Harry N. Abrams, 2002.

Read, Herbert. *A Concise History of Modern Painting.* London: Thames & Hudson, 1974.

Ibid., *The Philosophy of Modern Art.* London: Faber & Faber, 1964.

Reff, Theodore, and William Rubin. *Cézanne: The Late Works: Essays.* New York: Museum of Modern Art, 1977.

Rewald, John. *Cézanne: A Biography.* London: Thames & Hudson, 1986.

Ibid., *History of Impressionism.* New York: Museum of Modern Art, 1973.

Ibid., *Post-Impressionism: From Van Gogh to Gauguin.* New York: Museum of Modern Art, 1956.

Robbins, Daniel. "From Symbolism to Cubism: The Abbaye of Creteil." *Art Journal* 23, no.2 (Winter 1963–64): 111–116.

Robinson, William. "Puvis de Chavannes's 'Summer' and the Symbolist Avant-Garde." *Bulletin of the Cleveland Museum of Art* 78, no. 1 (January 1991).

Roe, Sue. *In Montmartre: Picasso, Matisse and Modernism in Paris, 1900–1910.* London: Fig Tree, 2014.

Ibid., *The Private Lives of the Impressionists.* New York: HarperCollins, 2006.

Rose, June. *Suzanne Valadon: Mistress of Montmartre.* New York: St. Martin's Press, 1999.

Rosenblum, Robert. *Transformations in Late Eighteenth Century Art.* Princeton, N.J.: Princeton University Press, 1967.

Rosenblum, Robert, and H. W. Janson. *Nineteenth Century Art.* Upper Saddle River, N.J.: Prentice-Hall, 2005.

Roskill, Mark. *Van Gogh, Gauguin and the Impressionist Circle.* Greenwich, Conn.: New York Graphic Society, 1970.

Rubin, William. *Primitivism in 20th Century Art: Affinity of the Tribal and the Modern* (2 vols). New York: Museum of Modern Art, 1984.

Rudorff, Raymond, *Belle Epoque, Paris in the Nineties.* New York: Saturday Review Press, 1973.

Schama, Simon. *Rembrandt's Eyes.* New York: Knopf, 1999.

Schapiro, Meyer. *Modern Art: 19th and 20th Centuries.* New York: Braziller, 2011.

Schwartz, Vanessa. *Spectacular Realities: Early Mass Culture in Fin-de-Siècle Paris.* Berkeley: University of California Press, 1998.

Segel, Harold B. *Turn-of-the-Century Cabaret: Paris, Barcelona, Berlin, Munich, Vienna, Cracow, Moscow, St. Petersburg, Zurich.* New York: Columbia University Press, 1987.

Seigel, Jerrold. *Bohemian Paris: Culture, Politics, and the Boundaries of Bourgeois Life, 1830–1930.* New York: Viking Press, 1986.

Shattuck, Roger. *The Banquet Years: The Origins of the Avant-Garde in France, 1885 to World War I.* London: Faber & Faber, 1959.

Shiff, Richard. *Cézanne and the End of Impressionism: A Study of the Theory, Technique, and Critical Evaluation of Modern Art.* Chicago: University of Chicago Press, 1984.

Shorto, Russell. "The Woman Who Made Van Gogh." *New York Times,* April 14, 2021.

Sloane, Joseph C. *French Painting: Artists, Critics, and Traditions from 1848 to 1870.* Princeton, N.J.: Princeton University Press, 1973.

Smee, Sebastian. *The Art of Rivalry: Four Friendships, Betrayals, and Breakthroughs in Modern Art.* New York: Random House, 2016.

Spurling, Hilary. *Matisse: The Life.* London: Hamish Hamilton, 2009.

Ibid., *The Unknown Matisse: A Life of Henri Matisse, The Early Years, 1869–1908.* New York: Alfred A. Knopf, 1998.

Stevens, Mary Anne. *Émile Bernard, 1868–1941: A Pioneer of Modern Art.* Amsterdam: Van Gogh Museum, 1990

Ibid., *Vincent's Choice: The Musée Imaginaire of Van Gogh.* Amsterdam: Van Gogh Museum, 2003.

Stolwijk, Chris, and Richard Thomson. *Theo van Gogh, 1857–1891: Art Dealer, Collector and Brother of Vincent.* Amsterdam: Van Gogh Museum, 1999.

Stone, Irving. *Lust for Life: The Novel of Vincent van Gogh.* Garden City, N.Y.: Doubleday, 1937.

Suleiman Susan. *Subversive Intent: Gender, Politics and the Avant-Garde.* Cambridge, Mass.: Harvard University Press, 2012.

Sutton, Peter C. *The Age of Rubens.* Boston: Museum of Fine Arts, 1993.

Thomson, Belinda. *Visions: Gauguin and His Time.* Zwolle: Waanders, 2010.

Tilborgh, Louis van. *The Potato Eaters by Vincent van Gogh.* Amsterdam: Van Gogh Museum, 1993.

Ibid., *Van Gogh: New Findings.* Amsterdam: Van Gogh Museum, 2012.

Tilborgh, Louis van. *Vincent van Gogh Paintings*, vol. 1: *The Dutch Period, 1881–1885.* Amsterdam: Van Gogh Museum, 1999.

Ibid., *Vincent van Gogh Paintings*, vol. 2: *Antwerp and Paris, 1885–1888.* Amsterdam: Van Gogh Museum, 2011.

Tuchman, Barbara. *The Proud Tower: A Portrait of the World Before the War, 1890–1914.* New York: Random House, 1966.

Tuchman, Maurice, Judi Freeman, and Carel Blotkamp. *The Spiritual in Art: Abstract Painting, 1890–1985.* New York: Abbeville Press, 1986.

Tucker, Paul Hayes. *Monet in the '90s: The Series Paintings.* New Haven, Conn.: Yale University Press, 1989.

Tunnicliffe, Wayne. *John Russell, Australia's French Impressionist.* Sydney: Art Gallery of New South Wales, 2018.

Uitert, Evert van. "Van Gogh's Concept of His Oeuvre." *Netherlands Quarterly for the History of Art* 12 (1981–1982).

Ibid., "Vincent van Gogh and Paul Gauguin: A Creative Competition." In *Simiolus: Netherlands Quarterly for the History of Art* 9, no. 3 (1977).

Unger, Miles J. *Picasso and the Painting That Shocked the World*. New York: Simon & Schuster, 2018.

Varnedoe, Kirk. *A Fine Disregard*. New York: H.N. Abrams, 1989.

Ibid., "Gauguin." In Rubin, *'Primitivism' in 20th Century Art*, vol. 1.

Varnedoe, Kirk, and Adam Gopnik. *High and Low: Modern Art, Popular Culture*. New York: Museum of Modern Art, 1991.

Veen, Wouter van der. *Van Gogh: A Literary Mind*. Amsterdam: Van Gogh Museum, 2009.

Vellekoop, Marije. *Vincent van Gogh Drawings*, vol. 3: *Antwerp & Paris, 1885–1888*. Amsterdam: Van Gogh Museum, 2001.

Ibid., *Vincent van Gogh Drawings*, vol. 4: *Arles, Saint-Remy & Auvers-sur-Oise: 1888–1890*. Amsterdam: Van Gogh Museum, 2007.

Venturi, Lionello. *History of Art Criticism*. New York: E.P. Dutton & Co., 1964.

Walker, Janet A. "Van Gogh, Collector of 'Japan'." *The Comparatist* 32, 82–114.

Walther, Inigo F., and Rainer Metzger. *Van Gogh: The Complete Paintings*. Cologne, Germany: Taschen, 2021.

Ibid., *Vincent van Gogh: 1853–1890, Vision and Reality*. Cologne, Germany: Taschen, 2016.

Ward, Martha. *Pissarro, Neo-Impressionism, and the Spaces of the Avant-Garde*. Chicago: University of Chicago Press, 1996.

Welsh-Ovcharov, Bogomila. *Vincent van Gogh and the Birth of Cloisonism*. Toronto: Art Gallery of Ontario, 1981.

Ibid., *Vincent Van Gogh: His Paris Period 1886–1888*. Utrecht: Editions Victorine, 1976.

White, Harrison C., and Cynthia A. White. *Canvases and Careers: Institutional Change in the French Painting World*. Chicago: University of Chicago Press, 1993.

Wildenstein, Daniel. *Monet: The Triumph of Impressionism*. Cologne, Germany: Taschen, 2014.

Wissman, Fronia E., and George T. M. Shackelford. *Impressions of Light: The French Landscape from Corot to Monet*. Boston: Museum of Fine Arts, 2002.

Zemel, Carol M. *The Formation of a Legend: Van Gogh Criticism, 1890–1920*. Ann Arbor: University of Michigan Research Press, 1980.

Websites and Electronic Media

Baltimore Museum of Art, The Cone Collection: https: //artbma.org/collections /cone.html.

The Barnes Foundation, Philadelphia, Art Collection: http: //www.barnes foundation.org/collections/.

The Metropolitan Museum of Art, New York, Collection: http://www.met museum.org/art/collection.

The Museum of Modern Art, New York, The Collection: http://www.moma.org /collection/.

The Van Gogh Museum https://www.vangoghmuseum.nl/en.

Endnotes

Introduction. The Isolated One
1 Van Gogh Letter 853, to Albert Aurier, Feb. 10, 1890.
2 Letter 853, Feb. 10, 1890.
3 Letter 155, June 24, 1880.
4 Aurier, "Les Isolees," *Mercure de France*, Jan. 1890; reprinted in Nochlin, *Impressionism and Post-Impressionism*, 136.
5 Letter 855, to Anna Van Gogh, Feb. 19, 1890.
6 Aurier, "Les Isolees," *Mercure de France*, Jan. 1890; reprinted in Nochlin, *Impressionism and Post-Impressionism*, 136.
7 Letter 670, to Wil, Aug. 26, 1888.
8 Aurier, "Les Isolees," *Mercure de France*, Jan. 1890; reprinted in Nochlin, *Impressionism and Post-Impressionism*, 139.
9 Zemel, *The Formation of a Legend*, 19.
10 Bonger, *A Memoir of Vincent van Gogh*, 69.
11 Letter 626, to Wil, June 20, 1888.
12 Ibid.
13 Ibid.
14 Letter 249, July 21, 1882.
15 Letter 155, June 24, 1880.
16 Letter 490, April 6, 1885.

1. Two Brothers
1 Letter 567, on or around Feb. 28, 1886.
2 Letter 563, Feb. 16 or 17, 1886.
3 See letter 164, Apr. 2, 1881.
4 Letter 561, on or about Feb. 11, 1886.
5 Letter 552, Jan. 16, 1886.
6 Letter 564, Feb. 18, 1886.
7 Letter 552, Jan. 16, 1886.
8 Letter 564, Feb. 18, 1886.

9 Letter 556, Jan. 19, 1886.

10 See, for example, letter 541, Nov. 14, 1885.

11 Letter 524, Aug. 6, 1885.

12 Ozanne and de Jode, *Theo: The Other Van Gogh*, 100.

13 Letter 559, Feb. 6, 1886.

14 Letter 551, Jan. 2, 1886.

15 Naifeh and Smith, *Van Gogh*, 453.

16 Bonger, *A Memoir of Vincent van Gogh*, 36.

17 Ibid., 16.

18 Naifeh and Smith, *Van Gogh*, 31.

19 Ibid., 58.

20 Letter 155, June 24, 1880.

21 Naifeh and Smith, *Van Gogh*, 32.

22 Bonger, *A Memoir of Vincent van Gogh*, 38–39.

23 Letter 102, Feb. 8, 1877.

24 Elisabeth Dusquesne Van Gogh, *Personal Recollections of Vincent van Gogh*, 4.

25 Ibid., 5.

26 Ibid., 6.

27 Ibid., 18.

28 Naifeh and Smith, *Van Gogh*, 18.

29 Ibid., 37.

30 Letter 90, Sept. 8, 1876.

31 Naifeh and Smith, *Van Gogh*, 41.

32 Van Gogh and Bonger, *A Brief Happiness*, 64.

33 Ibid.

34 Elisabeth Duquesne Van Gogh, *Personal Recollections of Vincent van Gogh*, 9.

35 Naifeh and Smith, *Van Gogh*, 183.

36 Ibid., 18.

37 Letter 155, June 24, 1880.

38 Letter 312, Feb. 11, 1883.

39 Naifeh and Smith, *Van Gogh*, 74.

40 Ibid., 71.

41 Letter 2, Dec. 13, 1872.

42 Letter 3, mid-Jan. 1873.

43 Ibid.

44 Naifeh and Smith, *Van Gogh*, 79.

45 Ibid., 78–79.

46 Letter 247, July 18, 1882.

47 Hartrick, *A Painter's Pilgrimage*, 41.

48 Letter 5, March 17, 1873.

49 Naifeh and Smith, *Van Gogh*, 83.

50 Bonger, *A Memoir of Vincent van Gogh*, 51.

51 Letter 33, Aug. 1874, note 4.

52 Bonger, *A Memoir of Vincent van Gogh*, 51.

53 Letter 33, May 8, 1875, note 4.

54 Naifeh and Smith, *Van Gogh*, 104.

55 Letter 33, May 8, 1875.

56 Letter 46, Sept. 9, 1875.
57 Bonger, *A Memoir of Vincent van Gogh*, 56.
58 Letter 50, Sept. 25, 1875.
59 Letter 46, Sept. 9, 1875.
60 Bonger, *A Memoir of Vincent van Gogh*, 53.
61 Letter 377, Aug. 20, 1883.
62 Letter 65, Jan. 3, 1876, note 2.
63 Bonger, *A Memoir of Vincent van Gogh*, 54.
64 Letter 405, Nov. 11, 1883.
65 Elisabeth Duquesne Van Gogh, *Personal Recollections of Vincent van Gogh*, 13.
66 Letter 76, Apr. 7, 1876.
67 Letter 90, Sept. 8, 1876.
68 Letter 96, Nov. 3, 1876.
69 Letter 106, Mar. 8, 1877.
70 Elisabeth Duquesne Van Gogh, *Personal Recollections of Vincent van Gogh*, 20.
71 Lubin, *Stranger on the Earth*, 198.
72 Naifeh and Smith, *Van Gogh*, 189–190.
73 Ibid., 182.
74 Ibid.
75 Ibid., 147.
76 Letter 117, May 21, 1877, note 1.
77 Ibid.
78 Letter 117, May 30, 1877.
79 Letter 145, July 22, 1878.
80 Naifeh and Smith, *Van Gogh*, 188.
81 Letter 148, Nov. 16, 1878.
82 Letter 150, Jan. 19, 1879, note 2.
83 Naifeh and Smith, *Van Gogh*, 194.
84 Letter 151, Apr. 1879.
85 Letter 152, note 16.
86 Naifeh and Smith, *Van Gogh*, 200.
87 Ibid.
88 Ozanne and de Jode, *Theo: The Other Van Gogh*, 74.
89 Ibid., 71.
90 Letter 154, Aug. 11, 1879.
91 Ibid.

2. The Country of Paintings

1 Letter 155, June 24, 1880.
2 Ibid.
3 Ibid.
4 Letter 160, Nov. 1, 1880.
5 Naifeh and Smith, *Van Gogh*, 208.
6 Letter 185, Nov. 18, 1881.
7 Letter 186, Nov. 18, 1881.
8 Letter 158, Sept. 24 1880.

9 Letter 97, Nov. 10, 1876.
10 Letter 155, June 24, 1880.
11 Naifeh and Smith, *Van Gogh*, 172.
12 Letter 155, June 24, 1880.
13 Ibid.
14 Ibid.
15 Ibid.
16 Ibid.
17 Letter 156, Aug. 20, 1880.
18 Letter 214, Apr. 2, 1882.
19 Letters 158, Sept. 24, 1880.
20 Letter 214, Apr. 2, 1882.
21 Bonger, *A Memoir of Vincent van Gogh*, 68.
22 Letter 36, June 29, 1875.
23 Letter 155, June 24, 1880.
24 Letter 163, Feb. 16, 1881.
25 Ibid.
26 Letter 160, Nov. 1, 1880.
27 Letter 195, to Rappard, Dec. 30, 1881.
28 Bonger, *A Memoir of Vincent van Gogh*, 73–74.
29 Naifeh and Smith, *Van Gogh*, 164.
30 See, for instance, letter 179, Nov. 3, 1881.
31 See, for instance, letter 181, Nov. 9, 1881.
32 Letter 179, Nov. 3, 1881.
33 Letter 185, Nov. 18, 1881.
34 Letter 228, May 16, 1882.
35 Letter 220, Apr. 23, 1882.
36 Letter 194, Dec. 28, 1881.
37 Naifeh and Smith, *Van Gogh*, 253.
38 Letter 181, Nov. 9, 1881.
39 Letter 189, Nov. 23, 1881.
40 Letter 196, Jan. 3, 1882.
41 Naifeh and Smith, *Van Gogh*, 257.
42 Letter 483, Feb. 26, 1885.
43 Letter 205, Feb. 18, 1882.
44 Letter 209, Mar. 9, 1882.
45 Letter 224, May 7, 1882.
46 Naifeh and Smith, *Van Gogh*, 269.
47 Letter 219, Apr. 21, 1882.
48 Quoted in van Heugten, *Van Gogh Drawings*, vol. 1, 31–32.
49 Naifeh and Smith, *Van Gogh*, 275.
50 Ibid., 276.
51 Letter 207, Mar. 3, 1882.
52 Letter 245, July 7, 1882.
53 Letter 225, May 10, 1882.
54 Letter 232, May 28, 1882.
55 Letter 237, June 8, 1882.

56 Letter 224, May 7, 1882.
57 Letter 207, Mar. 3, 1882.
58 Letter 294.
59 Letter 234, June 2, 1882.
60 Ibid.
61 Letter 227, May 15, 1882.
62 Ozanne and de Jode, *Theo: The Other Van Gogh*, 88.
63 Naifeh and Smith, *Van Gogh*, 303.
64 Letter 252, July 31, 1882.
65 Letter 255, Aug. 11, 1882.
66 Quoted in van Heugten, *Van Gogh Drawings*, vol. 1, 165.
67 Letter 259, Aug. 26, 1882.
68 Letter 222, May 1, 1882.
69 Letter 375, Aug. 18, 1883.
70 Letter 383, Sept. 8, 1883.
71 Letter 407, Nov. 26, 1883.
72 Letter 256, Aug. 13, 1882.
73 Letter 378, Aug. 21, 1883.
74 Letter 386, Sept.14, 1883.
75 Letter 390, Sept. 26, 1883.
76 Letter 394, Oct. 12, 1883
77 Letter 408, Dec. 1, 1883.
78 Letter 394, Oct. 12, 1883.
79 Letter 396, Oct. 15, 1883.
80 Ibid.
81 Letter 407, Nov. 26, 1883.
82 Ibid.
83 Welsh-Ovcharov, *Vincent Van Gogh: His Paris Period 1886–1888*, 4.
84 Letter 407, Nov. 26, 1883.
85 Letter 406, Nov. 13, 1883.
86 Ibid.
87 Letter 408, Dec. 1, 1883.
88 Ibid.
89 Letter 409, Dec. 6, 1883.
90 Naifeh and Smith, *Van Gogh*, 374.
91 Letter 410, Dec. 7, 1883.
92 Ibid.
93 Letter 411, Dec. 8, 1883.
94 Letter 422, Jan. 15, 1884.
95 Letter 432, Mar. 2, 1884.
96 Naifeh and Smith, *Van Gogh*, 388.
97 Letter 479, Jan. 23, 1885.
98 Letter 428, Feb. 3, 1884.
99 Naifeh and Smith, *Van Gogh*, 382.
100 Ibid., 402.
101 Ibid.
102 Letter 456, Sept. 16, 1884.

103 Naifeh and Smith, *Van Gogh*, 414–415.

104 Bonger, *Memoir of Vincent van Gogh*, 96.

105 Naifeh and Smith, *Van Gogh*, 406.

106 Ibid., 394.

107 Ibid., 432.

108 Kerssemakers, "Letter to De Groene," Apr. 14, 1912.

109 Ibid.

110 Ibid.

111 Letter 473, Dec. 6, 1884.

112 Ibid.

113 Letter 474, Dec. 10, 1884.

114 Letter 455, Aug. 23, 1884.

115 Letter 432, Mar. 2, 1884.

116 Letter 472, Nov. 28, 1884.

117 Letter 469, Nov. 14, 1884.

118 Letter 474, Dec. 12, 1884.

119 Letter 472, Nov. 28, 1884.

120 Letter 473, Dec.6, 1884.

121 Ibid.

122 Ibid.

3. The Lure of Paris

1 Bonger, *A Memoir of Vincent van Gogh*, 53.

2 Letter 396, Oct. 15, 1883.

3 Letter 473, Dec. 6, 1884.

4 McAuliffe, *Dawn of the Belle Epoque*, 8 [Zola, *L'assommoir*, 21].

5 Letter 189, Nov. 23, 1881.

6 Letter 562, Feb. 14, 1886.

7 Letter 463, Sept. 30, 1884.

8 Letter 461, Sept. 28, 1884.

9 Letter 464, Oct. 2, 1884.

10 Letter 560, Feb. 9, 1886.

11 Letter 490, Apr. 6, 1885.

12 Letter 464, Oct. 2, 1884.

13 Ibid.

14 Ibid. The quotation comes from *Au Bonheur des Dames,* chapter 11, 317.

15 Ibid.

16 Letter 473, Dec. 6, 1884.

17 Letter 465, Oct. 9, 1885.

18 Letter 472, Nov. 28, 1884.

19 Letter 473, Dec. 6, 1884.

20 Letter 428, Feb. 3, 1884.

21 Letter 280, Nov. 5, 1882.

22 Letter 495, Apr. 21, 1885.

23 Letter 499, May 2, 1885.

24 Letter 526, Aug. 15, 1885.

25 Letter 494, Apr. 18, 1885.

26 Blanc, *Grammar of Painting and Engraving*, 157.
27 Letter 485, Mar. 9, 1885.
28 Letter 450, mid-June 1884.
29 Letter 464, note 1.
30 Letter 473, Dec. 6, 1884.
31 Letter 472, note 9.
32 Letter 199, Jan. 9, 1882.
33 Letter 484, Apr. 6, 1885, note 9.
34 Letter 486, Mar. 27, 1885.
35 Letter 487, Mar. 27, 1885.
36 Letter 486, note 1.
37 Ibid.
38 Ozanne and de Jode, *Theo: The Other Van Gogh*, 105.
39 Letter 489, note 2.
40 Bonger, *A Memoir of Vincent van Gogh*, 101.
41 Letter 507, June 9, 1885.
42 Letter 506, June 2, 1885.
43 Letter 497, note 3.
44 Letter 494, Apr. 18, 1885.
45 Anton Kerssemakers, Letter to De Groene, written April 14, 1912.
46 Letter 436, Mar. 10, 1884.
47 Letter 484, Mar. 2, 1885.
48 Letter 500, May 5, 1885.
49 Welsh-Ovcharov, *Vincent Van Gogh: His Paris Period 1886–1888*, 138.
50 Letter 497, Apr. 30, 1885.
51 Ibid.
52 Ibid.
53 Tilborgh, Louis van et. al. *Vincent van Gogh Paintings, vol. 1*, 140.
54 Letter 501, note 3.
55 Letter 505, note 5.
56 Ibid.
57 Tilborgh, Louis van et. al. *Vincent van Gogh Paintings, vol. 1*, 141.
58 Letter 510, June 28, 1885.
59 Letter 552, Jan. 16, 1886.
60 Letter 505, May 28, 1885.
61 Letter 506, June 2, 1885.
62 Ibid.
63 Letter 506, June 2, 1885.
64 Ibid.
65 Ibid.
66 Letter 503, Rappard to Vincent, May 24, 1885.
67 Letter 528, Aug. 18, 1885.
68 Anton Kerssemakers. Letter to De Groene, written April 14, 1912.
69 Letter 531, Sept. 2, 1885.
70 Letter 499, May 2, 1885.
71 Anton Kerssemakers. Letter to De Groene, written April 14, 1912.
72 Ibid.

73 Letter 249, July 21, 1882.

74 Letter 542, Nov. 17, 1885.

75 Letter 543, Nov. 20, 1885.

76 Welsh-Ovcharov, *Vincent Van Gogh: His Paris Period 1886–1888*, 7.

77 Ibid., 6.

78 Letter 551, Jan. 2, 1886.

79 Letter 545, Nov. 28, 1885.

80 Letter 535, Oct. 13, 1885.

81 Letter 547, Dec. 14, 1885.

82 Letter 550, Dec. 28, 1885.

83 Naifeh and Smith, *Van Gogh*, 479.

84 Letter 550, Dec. 28, 1885.

85 Tilborgh, Louis van et. al. *Vincent Van Gogh Paintings, Vol. 2*, 92.

86 Welsh-Ovcharov, *Vincent Van Gogh: His Paris Period 1886–1888*, 6.

87 Letter 551, Jan. 2, 1886.

88 de la Faille, *The Works of Vincent van Gogh*, 108.

89 Tilborgh, Louis van et. al. *Vincent Van Gogh Paintings, Vol. 2*, 56.

90 Ibid., 67.

91 Naifeh and Smith, *Van Gogh*, 559.

92 Letter 537, Oct. 28, 1885.

93 Tilborgh, Louis van, *Vincent Van Gogh Paintings, Vol. 2*, 67.

94 Letter 553, note 3.

95 Letter 553, Jan. 20, 1886.

96 Letter 555, Jan. 28, 1886.

97 Letter 551, Jan. 2, 1886.

98 Ibid.

99 Ibid.

100 Letter 552, Jan. 16, 1886.

101 Letter 559, Feb. 6, 1886.

102 Letter 558, Feb. 4, 1886.

103 Naifeh and Smith, *Van Gogh*, 486.

104 Letter 561, Feb. 11, 1886.

105 Letter 557, Feb. 2, 1886.

106 Ibid.

107 Letter 556, Jan. 29, 1886.

108 Ibid.

109 Naifeh and Smith, *Van Gogh*, 503.

110 Letter 559, Feb. 6, 1886.

111 Letter 556, Jan. 29, 1886.

112 Letter 557, Feb. 2, 1886.

113 Letter 564, Feb. 18, 1886.

114 Letter 565, Feb. 22, 1886.

4. *L'Oeuvre*

1 Letter 552, Jan. 16, 1886.

2 Schwartz, *Spectacular Realities*, 40–41.

3 Zola, *The Masterpiece*, 190-191.

4 Schwartz, *Spectacular Realities*, 53.
5 Zola, *The Masterpiece*, 37.
6 Rewald, *History of Impressionism*, 458.
7 Zola, *The Masterpiece*, 153.
8 Ibid., 154.
9 Welsh-Ovcharov, *Vincent Van Gogh: His Paris Period 1886–1888*, 48.
10 Zola, *The Masterpiece*, 116.
11 Rose, *Suzanne Valadon: Mistress of Montmartre*, 90.
12 White and White, *Canvases and Careers*, 79.
13 Crow, *Painters and Public Life*, 6.
14 Ibid., 18.
15 Canaday *Mainstreams of Modern Art*, 147.
16 Ibid., 150.
17 Baedeker, Karl. *Paris and Its Environs: With Routes from London to Paris: Handbook for Travelers*. London: Baedeker, 1899.
18 Canaday, *Mainstreams*, 109.
19 King, *The Judgment of Paris*, 69.
20 Gerritse and Coutré, *Along the Seine*, 34–35.
21 Ibid.
22 Baudelaire, "Le Cygne," *Fleurs du mal*, 119.
23 McAuliffe, *Paris, City of Dreams*, 60–61.
24 Siegel, *Bohemian Paris*, 225.
25 Zola, *Au Bonheur des Dames*, 4.
26 King, *The Judgment of Paris*, 70.
27 Hyslop, *Baudelaire: Man of his Time*, 55.
28 White and White, *Canvases and Careers*, 140.
29 Zola, *The Masterpiece*, 123.
30 Canaday, *Mainstreams of Modern Art*, 200.
31 Zola, *The Masterpiece*, 118.
32 Milner, *The Studios of Paris*, 102.
33 Zola, *Mes Haines; causeries litteraires et artistiques*, "M. Manet," 297.
34 Durand-Ruel, *Memoirs of the First Impressionist Art Dealer*, 50.
35 White and White, *Canvases and Careers*, 124.
36 Naifeh and Smith, *Van Gogh*, 546.
37 White and White, *Canvases and Careers*, 123.
38 Ibid.
39 Franck, *Bohemian Paris: Picasso, Modigliani, Matisse, and the Birth of Modern Art*, 13.
40 White and White, *Canvases and Careers*, 140.
41 Zola, *L'Oeuvre*, 180.
42 Durand-Ruel, *Memoirs of the First Impressionist Art Dealer*, introduction, ix.
43 See Letter 73, March 28, 1876.
44 King, *Judgment of Paris*, 287.
45 McCauliffe, *Dawn of the Belle Epoque*, 15.
46 Durand-Ruel, *Memoirs of the First Impressionist Art Dealer*, 103.
47 Zola, *The Masterpiece*, 197.
48 Durand-Ruel, *Memoirs of the First Impressionist Art Dealer*, 116.

49 Milner, *The Studios of Paris*, 102.
50 Canaday, *Mainstreams of Modern Art*, 223.
51 McCauliffe, *Dawn of the Belle Epoque*, 47.
52 Zola, quoted in *The Masterpiece*, introduction, xii.
53 McCauliffe, *Dawn of the Belle Epoque*, 68.
54 Ibid.
55 Durand-Ruel, *Memoirs of the First Impressionist Art Dealer*, 129.
56 Ibid., 156.
57 Ibid., 158.
58 Letter 528, to Rappard, Aug. 18, 1885, note 9.
59 Zola, *The Masterpiece*, 240.
60 Ibid., 359.
61 Ibid., 243.
62 Letters 361, July 11, 1883, note 9.
63 Letter 371, Aug. 7, 1883.
64 Letter 651, July 30, 1888.
65 Letter 805, Sept. 20, 1889.
66 Letter 854, Feb. 12, 1890.
67 Letter 394, Oct. 12, 1883.

5. The Painter of Modern Life
1 Letter 144, May 13, 1878.
2 Letter 569, to Horace Mann Livens, Fall 1886.
3 Letters, Concordance—Documentation. Theo to Elisabeth van Gogh, April 17, 1887.
4 Ibid.
5 Ozanne and de Jode, *Theo: The Other Van Gogh*, 56.
6 Ozanne and de Jode, *Theo: The Other Van Gogh*,128.
7 See Letter 568, Aug. 18, 1886, footnote 1: Andries Bonger to his parents.
8 Bonger, *A Memoir of Vincent van Gogh*, 39.
9 Ibid., 23.
10 Letter 508, June 15, 1885, note 7.
11 Stolwijk, Chris and Richard Thomson, *Theo van Gogh*, 39.
12 Ibid.
13 Letter 508, June 15, 1885, note 7.
14 Letter 561, Feb. 11, 1886.
15 Letter 377, Aug. 20, 1883.
16 See Letter 163, to Dorus and Anna, Feb. 16, 1881.
17 Letter 553, Jan. 20, 1886.
18 Letter 481, Jan. 30, 1885.
19 Letter 569, to Horace Mann Livens, undated.
20 Hartrick, *A Painter's Pilgrimage through Fifty Years*, 41–42.
21 Baudelaire, *Painter of Modern Life*, 4–5.
22 Ibid., 9.
23 Ibid., 4.
24 Bonger, *A Memoir of Vincent van Gogh*, 115–118.
25 Ibid.

26 Van Gogh and Bonger, *A Brief Happiness*, 15.
27 Letters Concordance, Andries Bonger to Hendrik Christiaan Bonger and Hermine Louise Bonger-Weissman, June 23, 1886.
28 Welsh-Ovcharov, *Vincent Van Gogh: His Paris Period 1886–1888*, 9.
29 Bonger, *A Memoir of Vincent van Gogh*, 118.
30 Letter 193, Dec. 23, 1881.
31 Letter 307, to Rappard, Feb. 4, 1883.
32 Siegel, *Bohemian Paris*, 17.
33 Letter 307, to Rappard, Feb. 4, 1883.
34 Letter 193, Dec. 23, 1881.
35 Letter 558, Feb. 4, 1886.
36 Letter 492, Apr. 9, 1885.
37 Vellekoop, *Van Gogh Drawings*, vol. 3, 107.
38 Zola, Emile, *L'Oeuvre*, 75.
39 See Tilborgh, Louis van, *Vincent van Gogh Paintings* vol. 2, 196.
40 Quoted in Tilborgh, Louis van, *Vincent van Gogh Paintings* vol. 2, 264, note 6.
41 Letter 626 to Wil, June 20, 1888.
42 Ibid.
43 Ibid.
44 Letters Concordance, Andries Bonger to Hendrik Christiaan Bonger and Hermine Louise Bonger-Weissman, June 23, 1886.
45 Naifeh and Smith, *Van Gogh*, 503.
46 Naifeh and Smith, *Van Gogh*, 504.
47 Bonger, *A Memoir of Vincent van Gogh*, 110–115.
48 Meedendorp, Teio "One Floor Up: Van Gogh's Apartment at 54 Rue Lepic" in *Van Gogh: New Findings*, Van Gogh Studies 4, p. 99.
49 Quoted in Nicole Myers, "The Lure of Montmartre, 1880–1900," 1.
50 Baedeker, Karl, *Paris and its Environs: With Routes from London to Paris: Handbook for Travelers*, London, 1899.
51 Quoted in Naifeh and Smith, *Van Gogh*, 501.
52 Houchin, "Origins of the Cabaret Artistique," *The Drama Review* 28, no. 1, French Theatre (Spring, 1984): 12.
53 Letter 549, Dec. 19, 1885.
54 Bonger, *A Memoir of Vincent van Gogh*, 110–115.
55 Letter 898, Feb. 12, 1890.
56 Tilborgh, Louis van, *Vincent van Gogh Paintings*, vol. 3, 230.
57 Letter 235, June 3, 1882.
58 Letter 280, Nov. 5, 1882.
59 Letter 526, Aug. 15, 1885.
60 Letter 553, Jan. 20, 1886.
61 Letter 555, Jan. 28, 1886.
62 Letter 332, to Rappard, March 21, 1883.
63 Rewald, *History of Impressionism*, 456.
64 Letter 550, Dec. 28, 1885.
65 See Tilborgh, Louis van, *Vincent van Gogh Paintings*, vol. 3, 217.
66 Theo to Anna van Gogh-Carbentus, June–July 1886, in Concordance "Documentation."

67 Letter 535, Oct. 13, 1885.
68 Letter 569, to Livens Fall, 1887.
69 Letters 537, Oct. 28, 1885.
70 Letter 634, June 28, 1888.
71 Letter 569, to Livens, Fall 1887.
72 Ibid.
73 Ibid.
74 Letter 568, Vincent and Dries Bonger to Theo, Aug. 18, 1886.
75 Letter 574, to Wil, late Oct. 1887.
76 Letter 569, to Livens, Fall 1887.
77 Bonger, *A Memoir of Vincent van Gogh,* 110–115.
78 Rewald, *The History of Impressionism,* 458.
79 Letter 853, Feb. 10, 1890.
80 Letter 670, to Wil, Aug. 26, 1888.
81 Letter 741, Jan. 22, 1889, and Theo to Jo, doc. Feb. 14, 1889.
82 Letter 371, Aug. 7, 1883.
83 Theo van Gogh to Anna Cornelia van Gogh-Carbentus, June–July 1886, in Letters, Concordance: Documentation.
84 Ibid.
85 Welsh-Ovcharov, *Vincent Van Gogh: His Paris Period 1886–1888,* 216.
86 Ibid.
87 Theo van Gogh to Anna Cornelia Van Gogh-Carbentus, June-July, 1886, in Letters, Concordance: Documentation.

6. Messiah of a New Art

1 Zola, *L'Oeuvre,* 359.
2 Ibid.
3 Stevens, et al., *Emile Bernard, 1868–1941: A Pioneer of Modern Art,* 16.
4 Rewald, *History of Impressionism,* 465.
5 Loevgren, *The Genesis of Modernism,* 11.
6 Ibid., 12.
7 McCauliffe *Dawn of the Belle Epoque,* 171.
8 Howard, *Encyclopaedia of Impressionism,* 105.
9 McCauliffe, *Dawn of the Belle Epoque,* 171.
10 Tucker, *Monet in the '90s,* 18.
11 Durand-Ruel, *Memoirs of the First Impressionist Art Dealer,* 152.
12 McCauliffe, *Dawn of the Belle Epoque,* 171.
13 Naifeh and Smith, *Van Gogh,* 547.
14 McCauliffe *Dawn of the Belle Epoque,* 170.
15 Ibid., 170-171.
16 Gerritse and Coutré, *Along the Seine,* 121.
17 Letter 556, Jan. 29, 1886.
18 Ibid.
19 Letter 123, July 7, 1877.
20 Letter 556, Jan. 29, 1886.
21 Ibid.
22 Letter 569, to Horace Mann Livens, Fall 1887.

23 Letter 626, to Willimien, June 20, 1888.
24 Letter 574, to Wil, late October 1887.
25 Goldwater, *Symbolism*, 1.
26 Stevens, et al., *Emile Bernard, 1868–1941: A Pioneer of Modern Art*, 15.
27 Rewald, *Post-Impressionism*, 112–114.
28 Loevgren, *The Genesis of Modernism*, 159.
29 Rewald, *Post-Impressionism: From Van Gogh to Gauguin*, 83.
30 Félix Fénéon, "MM. Camille Pissarro, Georges Seurat, Paul Signac, Lucien Pissarro," *Les Impressionistes en 1886*, 23.
31 Rewald, *Post-Impressionism: From Van Gogh to Gauguin*, 99.
32 Goldwater, *Symbolism*, 78.
33 Rewald, *Post-Impressionism*, 86.
34 Ibid., 101.
35 Ibid.
36 Loevgren, *The Genesis of Modernism*, 71.
37 Ibid., 78–79.
38 Ibid., 89.
39 Loevgren, *The Genesis of Modernism*, 56.
40 Ibid., 159.
41 Félix Fénéon, "MM. Camille Pissarro, Georges Seurat, Paul Signac, Lucien Pissarro," *Les Impressionistes en 1886*, 43.
42 Letter 875, to Jo Bonger, May 25, 1890.
43 Letter 669, Aug. 26, 1888.
44 Goldwater, *Symbolism*, 156.
45 Rudorff, *Belle Epoque, Paris in the Nineties*, 155.
46 Goldwater, *Symbolism*, 71.
47 Hirsh, "Symbolist Art and Literature," 95.
48 Loevgren, *The Genesis of Modernism*, 83.
49 Ibid.
50 Goldwater, *Symbolism*, 118.
51 Ibid., 95.
52 Loevgren, *The Genesis of Modernism*, 83.
53 Goldwater, *Symbolism*, 179.
54 Ibid.
55 Hirsh, "Symbolist Art and Literature," 95.
56 Aurier, *Les Isolees, Mercure de France*, Jan. 1890; reproduced in Nochlin, *Impressionism and Post-Impressionism*, 137.
57 Ibid.
58 Zola, *L'Oeuvre*, 359.
59 Loevgren, *The Genesis of Modernism*, 16.
60 Huysmans, *A Rebours* (Kindle edition), loc. 122.
61 Ibid., loc. 139.
62 Loevgren, *The Genesis of Modernism*, 22–23.
63 Ibid., 99.
64 Symons, *The Symbolist Movement in Literature* (Kindle edition), loc. 1314.
65 Huysmans, *A Rebours* (Kindle edition), loc. 782.
66 Ibid., loc. 903.

67 Baudelaire, "Le Cygne," *Fleurs du mal,* II.

68 Rudorff, *Belle Epoque, Paris in the Nineties,* 207–208.

69 Goldwater, *Symbolism,* 186–187.

70 Ibid., 186.

71 Tucker, *Monet in the '90s,* 215–216.

72 Letter 568, note 1.

73 Letter 568, Aug. 18, 1886.

74 Ibid.

75 Ibid.

76 Hendricks, et al., *Vincent van Gogh Paintings: Volume 2,* 257.

77 Welsh-Ovcharov, *Vincent Van Gogh: His Paris Period 1886–1888,* 138–139.

78 Letter 493, Apr. 13, 1885.

7. The Student

1 Letter 556, Jan. 29, 1886.

2 Letter 557, Feb. 2, 1886.

3 Letter 558, Feb.4, 1886.

4 Letter 557, Feb. 2, 1886.

5 Letter 559, Feb. 6, 1886.

6 Letter 557, Feb. 2, 1886.

7 Letter 559, Feb. 2, 1886.

8 Letter 561, Feb. 11, 1886.

9 Welsh-Ovcharov, *Vincent Van Gogh: His Paris Period 1886–1888,* 211.

10 Hartrick, *A Painter's Pilgrimage through Fifty Years,* 48.

11 Ibid., 49.

12 Ibid., 50.

13 Frey, *Toulouse-Lautrec: A Life,* 144.

14 Ibid., 142.

15 Naifeh and Smith, *Van Gogh,* 509.

16 Ibid.

17 Frey, *Toulouse-Lautrec: A Life,* 241.

18 Ibid., 125.

19 Ibid., 126.

20 Ibid., 140.

21 Ibid., 143.

22 Ibid., 144.

23 Hartrick, *A Painter's Pilgrimage through Fifty Years,* 42.

24 Letter 564, Feb. 18, 1886.

25 Hartrick, *A Painter's Pilgrimage through Fifty Years,* 47–48.

26 Ibid., 47.

27 Naifeh and Smith, *Van Gogh,* 512.

28 Frey, *Toulouse-Lautrec: A Life,* 205.

29 Lubin, *Stranger on the Earth,* 151.

30 Frey *Toulouse-Lautrec: A Life,* 213.

31 Ibid.

32 Naifeh and Smith, *Van Gogh,* 512.

33 Hartrick, *A Painter's Pilgrimage through Fifty Years,* 45–46.

34 Naifeh and Smith, *Van Gogh*, 514.
35 Hartrick, *A Painter's Pilgrimage through Fifty Years*, 47.
36 Naifeh and Smith, *Van Gogh*, 514.
37 Ibid., 520.
38 Ibid., 514.
39 Ibid.
40 Letter 569, to Horace Mann Livens, undated.
41 Ibid.
42 Letter 683, Sept. 18, 1888.
43 Frey, *Toulouse-Lautrec: A Life*, 207.
44 Ozanne and de Jode, *Theo: The Other Van Gogh*, 119.
45 Letter 568, Aug. 18, 1886.
46 Ibid.
47 Ibid.
48 Theo to Jo, in Letter 568, note 2.
49 Letter 569, to Livens, undated.
50 Ibid.
51 Hartrick, *A Painter's Pilgrimage through Fifty Years*, 47.
52 Andries Bonger to Hendrik Christiaan Bonger and Hermine Louise Bonger-Weissman, Dec. 31, 1886, in Letters Concordance: Documentation.
53 Andries Bonger to Hendrik Christiaan Bonger and Hermine Louise Bonger-Weissman, Dec. 31, 1886, in Letters Concordance: Documentation.
54 Ozanne and de Jode, *Theo: The Other Van Gogh*, 118.
55 Theo to Cornelius van Gogh, Mar. 11, 1887, in Letters, Concordance: Documentation.
56 Letter 406, Nov. 13, 1883.
57 Quoted in Hendriks, *Vincent van Gogh Paintings, vol. 2*, 73.
58 Bonger, *A Memoir of Vincent van Gogh*, 118–120.
59 Ibid.,118.
60 Rewald, *Post-Impressionism*, 25.
61 Ibid., 26.

8. The Shop Around the Corner

1 Letter 569, to Horace Mann Livens, undated.
2 Letter 574, to Willemien, late Oct. 1887.
3 Hartrick, *A Painter's Pilgrimage through Fifty Years*, 43–44.
4 Letter 537, Oct. 28, 1885.
5 Maurice Denis, "Definition du Neo-Traditionisme" in Chipp, *Theories of Modern Art*, 94–97.
6 Letter 652, July 31, 1888.
7 Rudorff, *Belle Epoque, Paris in the Nineties*, 266.
8 Hartrick, *A Painter's Pilgrimage through Fifty Years*, 52.
9 Letter 634, June 28, 1888.
10 Hendriks, *Vincent van Gogh Paintings*: Vol. 2, 96.
11 Letter 638, July 10, 1888.
12 Naifeh and Smith, *Van Gogh*, 521.
13 Letter 634, June 28, 1888.

14 Gerritse and Coutré, *Along the Seine*, 162.
15 Denis, "From Gauguin and van Gogh to Neo-Classicism" in Harrison and Wood, *Art in Theory*, 47.
16 Gerritse and Coutré, *Along the Seine*, 68.
17 Letter 571, July 19, 1887.
18 Letter 663, Aug. 18, 1888.
19 Castleman and Wittrock, *Henri de Toulouse-Lautrec*, 30.
20 Hartrick, *A Painter's Pilgrimage through Fifty Years*, 50.
21 See Hendriks, *Van Gogh Paintings*, vol. 2, 75, note 107.
22 Naifeh and Smith, *Van Gogh*, 548.
23 *Van Gogh on Art and Artists: Letters to Émile Bernard*, 12.
24 Stevens, et al., *Émile Bernard, 1868–1941: A Pioneer of Modern Art*, 49.
25 Vellekoop, *Van Gogh Drawings*, vol. 3, 22.
26 Hendriks, *Van Gogh Paintings*, vol. 2, 141.
27 Welsh-Ovcharov, *Vincent Van Gogh: His Paris Period 1886–1888*, 33.
28 Letter 494, Apr. 18, 1885.
29 Stevens, Mary Anne et. al. *Emile Bernard, 1868–1941: A Pioneer of Modern Art*. Amsterdam: Van Gogh Museum, 1990.
30 Hendriks, *Van Gogh Paintings*, vol. 2, 74.
31 Ibid.
32 Signac, "From Delacroix to Neoimpressionism" quoted in John Gage, "The Technique of Seurat: A Reappraisal," 452.
33 Hendriks, *Van Gogh Paintings*, vol. 2, 74.
34 Letters 683, Sept. 18, 1888.
35 Ibid.
36 Rewald, *Post-Impressionism*, 55.
37 Hendriks, *Van Gogh Paintings*, vol. 2, 345.
38 Letter 569, undated.
39 Letter 592, Apr. 3, 1888.
40 Letter 669, Aug. 26, 1888.

9. Outcasts

1 Letter 663, Aug. 18, 1888.
2 Letter 768, May 3, 1889.
3 Letter 450, mid-June 1884.
4 Naifeh and Smith, *Van Gogh*, 528.
5 Theo to Wilhemien, Mar. 14, 1887, in Concordance, Documents.
6 Ibid.
7 Letter 628, to Bernard, June 19, 1888.
8 Theo to Wil, Apr. 25, 1887 in Concordance, Documents.
9 Theo van Gogh to Elisabeth Paris, May 15, 1887, in Concordance, Documents.
10 *Paintings 2*, 74.
11 Hartrick, *A Painter's Pilgrimage through Fifty Years*, 52.
12 Gerritse and Coutré, *Along the Seine*, 91.
13 Hendriks, *Van Gogh Paintings*, vol. 2, 74.
14 Letter 574, October 1887.

15 Hendriks, *Van Gogh Paintings*, vol. 2, 387.
16 Zola, *L'Oeuvre*, 210–211.
17 Hendriks, *Van Gogh Paintings*, vol. 2, 75, note 100.
18 Letter 260, Sept. 3, 1882.
19 Letter 371, Aug. 7, 1883.
20 Letter 695, Oct. 3, 1888.
21 Gerritse and Coutré, *Along the Seine*, 20.
22 Letter 689, Sept. 26, 1888.
23 Welsh-Ovcharov, *Vincent Van Gogh: His Paris Period 1886–1888*, 97.
24 Goldwater, *Symbolism*, 183–184.
25 Arnold Hendrik Koning to Albert Plasschaert, May 8, 1912, in Letters, Documentation.
26 Letter 572, July 25, 1887.
27 Ibid.
28 Letter 569, to Horace Mann Livens, undated.
29 Letter 718, Nov. 10, 1888.
30 Hendriks, *Van Gogh Paintings*, vol. 2, 426–427.
31 Letter 572, July 25, 1887.
32 Letter 594, Apr. 9, 1888, note 15.
33 Letter 244, July 6, 1882.
34 Letter 244, July 6, 1882.
35 Naifeh and Smith, *Van Gogh*, 512.
36 Hartrick, *A Painter's Pilgrimage through Fifty Years*, 45–46.
37 Ibid.
38 Naifeh and Smith, *Van Gogh*, 550.
39 Ibid.
40 Letters, Documents, Theo to Jo Bonger, Feb. 14, 1889.
41 Concordance, Documentation, Theo to Anna Cornelia van Gogh, June–July 1886.
42 Letter 155, June 24, 1880.
43 Castleman and Wittrock, *Henri de Toulouse-Lautrec*, 28.
44 Hartrick, *A Painter's Pilgrimage through Fifty Years*, 51.
45 Baudelaire, "The Painter of Modern Life," 1.
46 Ibid., 4.
47 Baudelaire, *The Painter of Modern Life and Other Essays*, 36–38.
48 Hendriks, *Van Gogh Paintings*, vol. 2, 274.
49 Letter 139, Jan. 10, 1878.
50 Letter 506, June 2, 1885.
51 Letters 612, May 22, 1888, to Émile Bernard.
52 Letter 655, to Émile Bernard, Aug. 5, 1888.
53 Letter 658, Aug. 9, 1888.
54 Letter 655, to Émile Bernard, Aug. 5, 1888.
55 Letter 193, Dec. 23, 1881.
56 Letter 670, to Wil, Aug. 26, 1888.
57 Maupassant, *Bel-Ami*, 99.
58 Hartrick, *A Painter's Pilgrimage through Fifty Years*, 51.
59 Letter 635, July 1, 1888.
60 Hendriks, *Van Gogh Paintings*, vol. 2, 319.

61 Ibid.

62 Baudelaire, "The Painter of Modern Life," 4.

63 Ibid., 1.

64 Letter 332, to Rappard, March 21, 1883.

65 Letter 572, July 25, 1887.

66 Letter 694, Oct. 3, 1888.

10. *Japonaiserie* **Forever**

1 Letter 574, late Oct. 1887.

2 Ibid.

3 Ibid.

4 Ibid.

5 Letter 602, May 1, 1888.

6 Letter 878, to Anna Carbentus van Gogh, June 5, 1890.

7 See Hendriks, *Vincent van Gogh Paintings*, 377, note 9.

8 Gauguin, *Avant et Après*, 177, also quoted Hendriks, *Paintings*, 296, note 12.

9 Letter 571, July 19, 1887.

10 Letter 572, July 25, 1887.

11 Letter 571, July 19, 1887.

12 Ibid.

13 Bernard letter 571, note 3.

14 Letter 572, July 25, 1887.

15 Letters, documentation, Theo to Elisabeth, Apr. 19, 1887.

16 Ibid.

17 Letter 572, July 25, 1887.

18 Naifeh and Smith, *Van Gogh*, 526–527.

19 Letter 572, note 1.

20 Stolwijk and Thomson, *Theo van Gogh*, 44.

21 Naifeh and Smith, *Van Gogh*, 562.

22 Ibid., 540.

23 Ozanne and de Jode, *Theo: The Other Van Gogh*, 139–140.

24 Letter 143, Apr. 3, 1878.

25 Letter 853, to Albert Aurier, Feb. 10, 1890.

26 Gerritse and Coutré, *Along the Seine*, 93.

27 Letter 585, Mar. 16, 1888.

28 Letter 184, Nov. 12, 1881.

29 Letter 537, Oct. 28, 1885.

30 Letters 676, Sept. 8, 1888.

31 "Letters to Emile Bernard [1904–6]." In Harrison and Wood, *Art in Theory*. Cambridge, UK: Blackwell, 1993. .

32 Van Tilborgh. *Vincent van Gogh Paintings: Volume 2, Antwerp and Paris, 1885–1888*. Amsterdam: Van Gogh Museum, 2011.

33 Stevens, *Émile Bernard, 1868–1941: A Pioneer of Modern Art*, 34.

34 Hendriks, *Van Gogh Paintings*, vol. 2, 82.

35 Ibid.

36 Ibid.

37 Ibid., 66.

38 Ibid., 82.
39 Lovgren, *The Genesis of Modernism*, 132.
40 Ibid.
41 Stevens, *Émile Bernard, 1868–1941: A Pioneer of Modern Art*, 60.
42 Ibid., 36.
43 Ozanne and de Jode, *Theo: The Other Van Gogh*, 151.
44 Stevens, *Émile Bernard, 1868–1941: A Pioneer of Modern Art*, 51.
45 Letter 668, Aug. 24, 1888, note 7.
46 Letter 668, Aug. 24, 1888.
47 Letters 673, Sept. 3, 1888.
48 Letters 697, Oct. 5, 1888.
49 Letter 155, June 24, 1880.
50 Letter 640, July 15, 1888.
51 Letter 545, Nov. 28, 1885.
52 Ernest Chesnau, quoted in Tucker, *Monet in the '90s*, 124.
53 Letter 642, July 15, 1888.
54 Letter 640, July 15, 1888.
55 Letter 622, to Bernard, June 7, 1888.
56 *Vincent van Gogh and the Painters of the Petit Boulevard*, note 25, 149.
57 Welsh-Ovcharov, *Vincent Van Gogh: His Paris Period 1886–1888*, 168.
58 Letter 620, June 5, 1888.
59 Letter 640, July 15, 1888.
60 Letter 596, Apr. 12, 1888.
61 Letter 590, to Willemien, March 30, 1888.
62 Letter 638, July 10, 1888.
63 Letter 632, June 26, 1888.
64 Letter 822, Nov. 26, 1889.

11. Artists of the *Petit Boulevard*

1 Ozanne and de Jode, *Theo: The Other Van Gogh*, 128.
2 Ibid., 131.
3 Ibid.
4 Ibid., 129.
5 Ibid.
6 Frey, *Toulouse-Lautrec: A Life*, 231.
7 Lovgren, *The Genesis of Modernism: Seurat, Van Gogh, and French Symbolism in the 1880s*, 120.
8 Rewald, *Impressionism*, 496.
9 Hartrick, *A Painter's Pilgrimage through Fifty Years*, 31.
10 Goldwater, *Symbolism*, 82.
11 *Gauguin and the School of Pont-Aven*, 27.
12 Hartrick, *A Painter's Pilgrimage through Fifty Years*, 33–34.
13 Ozanne and de Jode, *Theo: The Other Van Gogh*, 75.
14 Van Gogh and Bonger, *A Brief Happiness*, 138.
15 Ibid., 131, 133.
16 Letters 713, Theo to Vincent, Oct. 27, 1888.
17 Letter 377, Aug. 20, 1883.

18 Letter 364, July 22, 1883.

19 Ibid.

20 Naifeh and Smith, *Van Gogh*, 541.

21 Letter 584, Mar. 10, 1888.

22 Letter 181, Nov. 9, 1881.

23 Letter 590, Theo to Wil, note 9.

24 Letter 603, May 4, 1888.

25 Letter 581, Gauguin to VG, Feb. 29, 1888.

26 Letter 633, to Bernard, June 27, 1888.

27 Letter 575, to Bernard, Dec. 1887.

28 Letter 584, Mar. 10, 1888.

29 Ibid.

30 Hendriks, *Vincent van Gogh Paintings*, vol. 2, 513.

31 Naifeh and Smith, *Van Gogh*, 552.

32 Welsh-Ovcharov, *Vincent Van Gogh: His Paris Period 1886–1888*, 36–37.

33 Letter 575, note 9.

34 Letter 643, July 20, 1888.

35 Dujardin 'Aux XX et aux Indépendants. Le cloisonnisme,' *La Revue Indépendante* 6 (March 1888), quoted in Letter 620, note 12.

36 Letter 575, 12/87 to Émile Bernard.

37 Émile Bernard, quoted in Welsh-Ovcharov, *Vincent Van Gogh: His Paris Period 1886–1888*, 38.

38 Naifeh and Smith, *Van Gogh*, 553.

39 Letter 575, note 9.

40 Stevens, et al., *Émile Bernard, 1868–1941: A Pioneer of Modern Art*, 33.

41 Letters 640, July 15, 1888.

42 Letter 584, Mar. 10, 1888.

43 Letter 625, June 16, 1888.

44 Letter 643, July 20, 1888.

45 Letter 620, June 5, 1888.

46 Letter 596, Apr. 12, 1888.

47 Letter 719, Nov. 12, 1888.

48 Letter 698, to Bernard, Oct. 5, 1888.

49 Letter 407, Nov. 26, 1883.

50 Theo to Wil, Feb. 24 and Feb. 26, 1888 in Letters, Documentation.

51 Letter 582, Mar. 2, 1888.

52 Letter 603, May 4, 1888.

53 Letter 626, to Wil, June 20, 1888.

54 Letter 695, to Gauguin, Oct. 3, 1888.

55 See letter 577, note 3.

56 Theo to Wil, Feb. 24 and Feb. 26, 1888 in Letters, Documentation.

57 Ibid.

58 Ibid.

59 Ibid.

60 Letter 579, to Wil, Feb. 24, 1888.

61 Ibid.

62 Letter 831, to Anna, Dec. 23, 1889.

63 Letter 577, Feb. 21, 1888.
64 Letters 706, Oct. 17, 1888.
65 Letter 577, Feb. 21, 1888.
66 Ibid.
67 Letter 626, to Wil, June 20, 1888.
68 Quoted in letter 582, Mar. 2, 1888, note 9.
69 Letter 616, enclosed draft letter to Gauguin, May 29, 1888.
70 Ibid.
71 Letter 628, June 29, 1888.
72 Letter 707, Oct. 17, 1888.
73 Letter 616, May 29, 1888.
74 Letter 695, to Gauguin, Oct. 3, 1888.
75 Letter 527, Aug. 17, 1885.
76 Letter 823, Nov. 26, 1889.
77 Letter 686, Sept. 24, 1888.
78 Letter 820 Nov. 19, 1889.
79 Letter 663, Aug. 18, 1888.
80 Letter 585, Mar. 16, 1888.
81 Letter 682, Sept. 18, 1888.
82 Letter 684, to Bernard, Sept. 25, 1888.
83 Letter 707, Oct. 17, 1888.
84 Letter 673, Sept. 3, 1888.
85 Letter 590, Mar. 30, 1888.
86 Letter 613, May 26, 1888.
87 Letter 720, Nov. 12, 1888.
88 Letter 841, Jan. 20, 1890.
89 Letter 695, to Gauguin, Oct. 3, 1888.
90 Letters 155, June 24, 1880.
91 Letter 695, to Gauguin, Oct. 3, 1888.
92 Letter 692, Gauguin to Van Gogh, Oct. 1, 1888.
93 Letter 90, Sept. 8, 1876.
94 Letter 656, Aug. 6, 1888.
95 Letter RM25, July 23, 1890.

Epilogue; Four Days
1 Letter 807, note 6.
2 Letter 873, May 20, 1890.
3 Ibid.
4 Letter 872, note 1.
5 Letter 898, note 3.
6 Ibid.
7 Letter 898, July 10, 1890.
8 Ibid.
9 Letter 854, Feb. 12, 1890.
10 Pickvance, *A Great Artist is Dead,* 149.
11 Letter 859, Gauguin to Vincent, Mar. 20, 1890.
12 Letter 862, Theo to Vincent, Apr. 23, 1890.

13 Frey, *Toulouse-Lautrec: A Life,* 60.
14 Quoted Letter 843, Theo to Van Gogh, Jan. 22, 1890.
15 Letter 898, July 10, 1890, note 3.
16 Ibid.
17 Letter 898, July 10, 1890.
18 Ibid.
19 Pickvance, *A Great Artist is Dead,* 17.
20 Ibid.

Appendix

1 Letters, 569.
2 See *Drawings vol. 3*, 22.
3 See Vellekoop, *Van Gogh Drawings*, vol. 3, 23, fig. 13.
4 Letter 561, Feb. 11, 1886.
5 Ibid.
6 Letter 564, Feb. 18, 1886.
7 Letter 566, Feb. 24, 1886.

Index

A

absinthe, 349, 451, 464, 467–469

abstraction, 315, 386, 407, 408, 496, 505, 555–556, 44406

Académie de peinture et de sculpture, 174

Académie Julian, 347, 522

Académie Royale des Beaux-Arts, 61–64, 106, 111, 166, 168–172, 174, 186, 198, 216

academies, 350

Adam, Paul, 323

adolescence, 21–22

aesthetic progress, xx, 29, 131, 195–196, 322, 365, 450, 544

aesthetics, 35, 114, 162, 166, 170, 172, 244, 295, 398, 427, 509

After Dinner at Ornans (Courbet), 176

Against the Grain (Huysmans), 219

Agostina Segatori (Van Gogh), 479

Aix-en-Provence, 570

alcohol use, 235, 349, 358, 451, 466–469, 488, 542, 566, 578

alienation, xiv, 31, 109, 330

alla prima technique, 142, 240, 280

America, 214–216, 370, 527

Amsterdam, 37, 38, 68, 71, 138, 139

anarchists, 203, 297, 298, 321, 357, 393

Angrand, Charles, 288, 451–452

Anquetin, Louis, 350, 352–353, 355, 362, 364, 451, 500–503, 515, 543, 547–548, 553

Antoine, André, 449

Antonio, Cristóbal de, 288

Antwerp, 2, 139–142, 144, 147, 150–151, 154, 222, 237, 244, 249, 272, 342–344, 573

anxiety, 184, 291, 329

Apples (Van Gogh), 497

Argenteuil, 412

Aristide Bruant (Toulouse-Lautrec), 401

Arles, 317, 388, 462, 553, 565, 567–568, 570–572, 577–578, 585

art: commercialization of, 28–29, 75, 92–93, 111, 196–197, 209; depressed prices for, 295–297; emotions in, 71–72; family involvement in, 54; initial attempts at, 57, 59, 67; as investment, 195–196; Japanese, 502, 509–521, 553–554, 561, 572, 574; modern, xix–xx, xxiii, 115–116, 159–160, 216, 247, 252, 278–279, 319–320, 394, 411, 580; objective rules for, 311; official, 166–172, 176–177, 180–181, 185–190, 196–198, 206, 296, 313, 319–320, 334, 346–347; periodicals devoted to, 162; popular taste in, 82, 185; principles, 307–308; public consumption of, 191; public discourse and, 170–174; spiritual view of, 54; storytelling through, 67

art collectors, 199–200, 205–206, 208, 215, 296

art community: in Paris, xviii–xxv, 27–28, 62, 63, 105–106, 161–164, 198–199, 260, 333, 455–456; Van Gogh's attitude toward, 111; Van Gogh's place in, 450, 464, 515–516

art critics, 27, 160, 170, 172, 191, 194, 195, 214, 307, 501–502. *See also specific critics*

art dealers, 54, 122, 144, 195–202, 205, 288, 301, 372, 448. *See also specific dealers*

art education, 59; at Cormon's studio, 341–366, 371–372, 378; at École des Beaux-Arts, 106, 167–170, 173–174, 177–178, 181, 186, 198, 206, 306, 347; with Mauve, 73–74; in Paris, 106, 248, 301–302; at Royal Academy, 61–63, 147–148, 271–272, 343–344

art galleries, 30, 65–66, 114, 122, 296–297, 301, 319, 334, 448

Art Institute of Chicago, 421

Les Artistes de mon temps (Blanc), 385

artistic development, xxi–xxii, 5–6, 278–279, 304, 318, 403–408, 435–440, 496–499, 505–510, 516–517, 539, 553–554, 573–579

artistic identity, 145, 147, 148, 256, 295, 367, 562

artistic progress, 195–196

artistic reinvention, 248–249

artistic techniques, 507, 557–558; *à l'essence*, 365, 400–403, 417, 433; *alla prima*, 142, 240; *aureoler*, 507–508; calligraphic, 442; Impressionist, 295, 303; plen-air painting, 178, 204, 206, 211–212, 216–217, 264, 282, 292, 302, 433, 595; Pointillist, 307–312, 362, 402, 420, 424, 441–442, 505, 547; of Toulouse-Lautrec, 365, 400–403; of Van Gogh, 274–277, 285–286, 302–303, 383–386, 420–422, 441–442, 470–472, 482, 484, 505, 507–508, 514–515, 553–556; woodblock printing, 515–516

artists: avant-garde, xviii, xxi, 29, 110–111, 158, 160, 163–167, 195, 216, 219, 244–245, 301, 319, 400–401, 416, 426, 435, 449–450, 464, 472, 562, 569, 590; community of, 333, 395–396, 405–406, 550–553, 563; cooperation among, 540, 544, 550–551, 571–572; enclaves

of, 260; Grand Boulevard, xx, 544, 550–551; Parisian, in *L'Oeuvre*, 157–160; perception of, 211; Petit Boulevard, xix–xx, 320, 332, 544–553, 563. *See also specific artists*
artists' cooperative, 208, 301, 319
The Artists of My Time (Blanc), 115–116
art market, 197–200, 209, 214–215, 296–298, 526–529. *See also* art dealers; art galleries
L'Art Moderne, 291, 311–312
Art Nouveau, 250, 513
art reproductions, 23, 27, 57, 197
Arts and Crafts movement, 330
Les Arts Incohérents, xxii, 357, 440
art supplies, 2, 95, 102, 150, 235–236, 263–264, 387
Asnières, 412, 414, 433–434
L'Assommoir (Zola), 109
Astruc, Zacharie, 188, 199
asylum, 51, 221, 426, 575, 585
Au Bonheur des Dames (*The Ladies' Delight*) (Zola), 112, 185, 244–245, 247, 461, 465
aureoler technique, 507
Aurier, Albert, xi–xvii, xx, xxiv, 17, 86, 221–222, 283, 299, 323, 324, 332, 392, 445, 495, 504, 538, 572, 588
authority, aversion to, 363
Autumn Landscape with Four Trees (Van Gogh), 146
Auvers, 317, 585, 590–591
avant-garde, xviii, 163–167, 192–193, 195–196, 216, 244, 301, 319, 416, 435, 562; art market and, 529–530; evolution of, 177; factionalism in, 546–548, 551; heroes of the, 464; literary, 332; Paris Commune and, 203; Van Gogh's place among, xxi, 29, 110–111, 245, 270, 318, 394, 400–401, 411, 426, 449–452, 472, 539–540, 569, 590; Zola and, 158, 160, 165, 219. *See also* Impressionism

B

Baltimore Museum of Art, 399
Balzac, Honoré de, 221
Barbizon School, 27–28, 33–34, 96, 114, 178–179, 201, 204–205, 212, 266, 387, 434, 439
Bargue, Charles, 59, 413, 575
Baroque religious imagery, 126
barter economy, 481
Basket of Crocuses (Van Gogh), 467
Basket of Pansies (Van Gogh), 482
Basket with Apples (Van Gogh), 137
Bataille's restaurant, 242–244, 250, 264, 334, 458
Bateau Lavoir, 262
Bathers at Asnières (Seurat), 319
Batignolles, 246, 346

Battle of Sedan, 202
Baudelaire, Charles, 184, 188, 225, 239, 249, 326, 328, 332, 459, 573
The Bearers of Burden (Van Gogh), 67, 68
Begemann, Margot, 98–99, 108, 112, 136, 246, 485
Bel-Ami (Maupassant), 245, 465
Belgian Evangelization Committee, 41
belonging: need for, xii, 451; sense of, at Tanguy's, 395
Berlin, 161
Bernard, Émile, xxii, 221, 239, 270, 280, 329, 355, 364, 389–390, 393, 417, 424, 425, 449–451, 459, 462, 463, 485, 488, 513, 515–517, 522, 543, 546, 553, 554, 556, 571, 574; contrasted with Van Gogh, 555–558; Cormon's studio and, 314–315, 352, 353, 362, 499–500, 593–594; on Du Chalet exhibition, 550; friendship with, 409–414, 503–505, 593–594; Gauguin and, 532; innovations by, 500–502; letters to, 25; Neo-Impressionism and, 500, 547–548; self-portrait by, 580–581; on Symbolism, 323; Synthetism and, 393, 503; on van Gogh, 126, 146, 432, 514, 549
Bible, 36, 247, 476, 574, 582–583
Bible teacher, 38
Bing, Siegfried, 513, 515
The Birth of Venus (Cabanel), 191
Bismarck, Otto con, 202
"black country," 41–43, 46, 50–53, 55
Blanc, Charles, 115–116, 129, 147, 266, 278, 280–281, 307, 308, 331, 385, 413, 418, 444, 498, 507, 560
boarding school, 19–20
Boch, Anna, 588
Boch, Eugène, 318
Boggs, Frank, 287, 288
bohemians, 246, 386, 395, 396, 410, 427, 455, 464, 468, 531, 562
Boissière, La Comtesse de la, 479
Bonger, Andries (Dries), 6, 119, 231–232, 241–242, 281, 334, 335, 336, 346, 370–371, 373–374, 456
Bonger, Jo. *See* Van Gogh, Jo Bonger
Bon Marché, 185
Bonnard, Pierre, 347, 522
Bonnat, Léon, 351–352
Borinage, Belgium, 41–43, 50–53, 55, 61, 67
Bottle with Peonies and Forget- Me-Nots (Van Gogh), 282, 285
Boucher, François, 170
Bouguereau, William-Adolphe, 27, 192, 197, 273–274, 277, 297, 347

Boulanger, Ernest, 298

Boulanger, Gustave, 347

Boulevard des Capucines, 208–209

Boulevard Haussmann (Marville), 183

Boulevard Montmartre (Pissaro), 213

Boulevard Montmartre gallery, 1, 65–66, 88, 227, 234, 279, 369–370, 489, 526–527, 529–530, 536

bourgeoisie, 197, 388

bourgeois values, 40–41, 72, 93, 98, 240, 245, 476

Boussod, Etienne, 370, 526

Boussod, Jean, 370, 526

Boussod, Léon, 88, 227, 370

Boussod & Valadon, 88, 243, 279, 369–371, 526, 527, 529–530, 543

Brabant, 4, 14, 15, 132–133, 236, 572

Braque, Georges, 426

Brasserie des Martyrs, 162

Brasserie Gambrinus, 163

Breitner, George, 342

Breton, Jules, 33, 51, 53, 61, 79, 112, 114, 131

Bridge at Asnieres (Van Gogh), 556–558

Bridge at Courbevoie (Seurat), 437–438

The Bridge at Courbevoie (Van Gogh), 436–438

Bridge in the Rain (After Hiroshige) (Van Gogh), 517, 518

Brittany, 533–534

"broken colors," 129, 266, 308

Brouwer, Adriaen, 126

Bruant, Aristide, 250, 260–261, 365, 400, 541

Bruegel, Pieter, 126

brushwork, 190, 210, 216–217, 280, 282, 286, 296, 312, 362, 367, 399, 423, 433, 439, 444–445, 470–472, 505, 515, 553

Brussels, 60–64, 66, 237, 244, 589

bureaucracy, 180

A Burial at Ornans (Courbet), 176, 177

business of art, 196–197

Butte de Montmartre, 227, 259, 260, 261, 267, 412, 446, 495, 558, 595. *See also* Montmartre

C

Cabanel, Alexandre, 191, 192

cabarets, 226, 260–261, 357, 541

Caberet des Assassis, 261

In a Café (L'absinthe) (Degas), 483, 484

In the Café (Van Gogh), 513, 514, 521

Café de la Nouvelle Athènes, 162

Café Guerbois, 162, 206, 208, 393

Café Nouvelle Athènes, 393

cafes, 514

Café Table with Absinthe (Van Gogh), 467–468

Café Terminus bombing, 298

Café Terrace in Montmartre (La Guinguette) (Van Gogh), 369

Café Volpini exhibition, 549

Caillebotte, Gustave, 216

Cain Fleeing with his Family (Cormon), 342, 351

calligraphic technique, 442, 443

Calvinism, 13, 59, 245

capitalism, 111, 329

Carafe and Dish with Citrus Fruit (Van Gogh), 406–407

Caravaggio, 126, 286

Carbentus, Anna. *See* Van Gogh, Anna Carbentus

Carbentus, Wilhelmina. *See* Stricker, Wilhelmina

Carbentus, Willem, 13–14

Cassagne, Armand, 59

Cassatt, Mary, 296

Catholicism, 330

Cavenaille, Amadeus, 150

Central America, 534

Cézanne, Paul, xx, 157–158, 218, 284, 318, 389–391, 394–396, 435, 590

Le Chahut (Seurat), 458

Champsaur, Félicien, 259

Chaplin, Charles Joshua, 254

Le Charivari, 210

Le Chat Noir, 260–261, 357, 464, 541

Le Chat Noir, 249

Chérie (Goncourt), 510

Chevreul, Michel Eugène, 116, 307, 308, 413, 414

chiaroscuro, 74, 117, 128–129, 135, 152, 274, 287, 300, 367, 383, 408, 425, 498

Christ Asleep during a Tempest (Delacroix), 280

Christianity, 32–33, 38, 573–574

chromoluminism, 308

The Circus (Seurat), 310

circuses, 261

Le Cirque (Seurat), 458

Cirque Fernando, 261

Cirque Medrano, 261, 458

city life, 111, 112–113, 115, 139, 238, 240, 457; paintings of, 239–240

Civil War (Manet), 203

Classicism, 174, 175

Cloisonnism, 501–503, 514–515, 534, 541, 547, 549, 553, 576, 577

clothing, 236–238, 338–339

coal mines/miners, 41–42, 52–53, 67

coarseness, 440, 461

collaboration, 299, 301, 550–553, 571–572

color palette, 369, 383–386, 399, 407, 425, 431, 501, 560–561

colors, 142, 206, 276–279, 285–286, 331–332, 361, 367, 435–436, 441, 470, 496–499, 505, 509, 522–523, 565–566, 576–577; broken, 129, 266, 308; complementary, 147, 219, 252–253, 266, 277, 308, 386, 414, 446, 523; in Japanese prints, 516–517; monochromatic, 74–75, 277; suggestive, 418–420

color theory, 115–117, 129, 147, 266, 278, 280–281, 307–309, 331, 384–385, 407, 414, 418, 444

commercialization, of art, 28–29, 75, 92–93, 111, 196–197, 209

commercial success, lack of, xxv, 369, 513

commercial work, 249–250, 364–365

Communards, 203

communion, 378–379

companionship, xxiii, 29, 45–46, 65, 78, 86, 113, 143, 150, 229, 379, 413, 451, 571

complementaries, 147, 219, 252–253, 266, 277, 308, 386, 414, 446, 523

conformity, xviii, 13–14, 147

connection, 299–300, 396–397; need for, xxiii–xxiv, 151, 300, 340, 452, 538; between Van Gogh brothers, 28

Constable, John, 201, 210

controversy, as route to fame, 192–193

cool tones, 444

Cormon, Fernand, 296, 314–315, 500; art students of, 347–349, 350, 355–356; studio of, 341–366, 371–372, 378, 381–382, 384, 395, 400, 420, 593–595; teaching approach of, 349–352, 360

Corot, Jean-Baptiste-Camille, 27, 33, 96, 178, 204, 266, 480

counterculture, 259, 510. See also avant-garde; bohemians

"country of paintings," 49, 56, 72, 139, 331

countryside, 114, 434, 591; in Drenthe, 85–88; paintings of, 126, 176, 178–180, 266–267, 403, 532, 534, 572–573, 578–579

Courbet, Gustave, 175–178, 186, 194, 195, 209, 292, 326, 347, 503

Courrières, France, 51

Le Courrier Français, 164, 364–365

Courtesan (After Eisen) (Van Gogh), 517, 518

courtier dealers, 448

Couture, Thomas, 347

creative innovation, 311, 320

critics. See art critics

Cubism, 426

Cuesmes, 55, 60

cults, 522, 575

cultural change, 318, 320–322

Cuyp, Aelbert, 266

D

Dada movement, 357

Daubigny, Charles-François, 27, 96, 114, 178, 179, 205, 266

Daumier, Honoré, 197, 198, 251

David, Jacques-Louis, 173–174, 181, 273, 314

Decadents, xxii, 440

decorative art, 445–446, 502

Decrucq, Charles, 52

Degas, Edgar, 206, 211, 217, 293–295, 302–303, 407, 458, 466, 483, 512, 528, 544

De Groot, Gordina, 136–137, 246

De Groot–Van Rooijen clan, 126

Le Déjeuner sur L'Herbe (Luncheon on the Grass) (Manet), 187, 190–192, 212, 284, 314, 423

Delacroix, Eugène, 116, 142, 174, 177, 201, 273, 277, 278, 280, 306, 311, 362, 385, 404, 418, 462, 498

"From Delacroix to Neoimpressionism" (Signac), 415

Delarebeyrette, Joseph, 283

Delvau, Alfred, 184

democracy, 172

Denis, Maurice, 381, 386, 393–394, 445

department stores, 185

depression, 17, 230–231, 378, 429–430, 559–560, 588, 590–591

Derain, André, 347, 411

Desfossés, Victor, 280

Díaz, Narcisse Virgilio, 96, 178, 205

Dickens, Charles, 22, 38, 53, 67, 109, 164, 332

Diderot, Denis, 172

The Digger (Van Gogh), 83

Dish with Citrus Fruit (Van Gogh), 407

Divan Japonais, 401

Divisionism, 308, 323, 331–332, 401–404, 407, 415–417, 422, 424, 427, 431–446, 470, 500, 501, 529, 547, 549, 564. See also Neo-Impressionism; Pointillism

Divisionists, xii, 362–363, 365, 391, 414. See also specific artists

dogmatism, 117, 164, 272, 331, 359, 378, 406, 413, 435

Drenthe, 85–88, 107

Dreyfus, Alfred, 325

Dr. Paul Gachet (Van Gogh), 586

Du Chalet exhibition, 544–550, 559

Dujardin, Édouard, 501–502, 541, 547

Dupré, Jules, 87

Durand-Ruel, Paul, 122, 200–209, 214–215, 294–297, 527–528
Dürer, Albrecht, 269
Duret, Theodore, 195
Dutch Club, 231
Dutch masters, 141–142

E

ear, cutting off of, 71
École des Beaux-Arts, 106, 167–170, 173–174, 177–178, 181, 186, 198, 206, 306, 347
École romane, 330
economic crises, 301, 328–329
economy, 297–299
education: as evangelist, 40; in ministry, 37–38. *See also* art education
Eiffel Tower, 177
Eighth Impressionist Exhibition, 217, 294–295, 307, 311–313, 401
Eliot, George, 38, 53, 67, 332
emotional connection. *See* connection
emotional responses, 71–72, 245–246, 554
employment: at Goupil & Cie, 22–24, 26–31, 34–35; as teaching assistant, 36
Engels, Friedrich, 203
England, 36
ennui, 329
ethics, 170, 238
Etten, 51, 66, 70, 72
evangelism, 62
evangelist, van Gogh as, 40–43, 53–54
Exercices au Fusain (Bargue), 575
Exposition des Vingt, 589
Exposition Universelle of 1855, 61, 177, 180, 201
Expressionists, 311

F

Factories at Asnières (Van Gogh), 443, 444
fame, xv
family dynamics, 12–14, 19–21, 35, 38–39, 96–99, 110, 149, 245, 300–301
faulty judgement, about people, 32
Fauvism, 356
Fénéon, Félix, 298, 308–309, 312–313, 315, 317, 321, 322
Le Figaro, 162, 194
figure studies, 84, 130–131, 179, 273, 360–361, 363
financial issues, 24, 36, 102, 262, 374, 481–482, 588–589
financial success, 588–589

financial support: by parents, 95; by Theo, 2, 6–8, 49–50, 58, 72–73, 76–77, 84–85, 90–91, 100–102, 143–144, 149–150, 227–228, 371–375, 396, 589
fin de siècle, 219, 291, 328–329, 357, 573
Les Fleurs du Mal (Baudelaire), 328
Flowering Plum Orchard (After Hiroshige) (Van Gogh), 517, 518
flower paintings, 276–278, 281–282, 285–286, 336, 361–362, 369, 383–384, 482, 495–496
Flower Pot With Garlic Chives (Van Gogh), 399, 467
Folies Bergères, 464–465
Fragonard, Jean-Honoré, 170, 171, 284, 423
France: political upheavals in, 172–174, 180, 182–183, 202–203, 259, 267, 321, 388; societal changes in, 184–186. *See also* Paris
Francesca, Piero della, 315
Francq, Edouard Joseph, 44
French Revolution, 110, 172–174
French ultramarine, 276
Frère, Pierre Edouard, 227
The Friends (Breton), 114
friendships, 451–452, 454–455, 468; with Bernard, 409–414, 503–505, 593–594; with Gauguin, 353, 405, 534–536, 580; with Hartrick, 358–359, 451, 453–454; in Paris art community, 386–394, 453–456, 472; with Rappard, 63–66, 133–135, 498; with Russell, 452; with Signac, 414–416, 419, 435–436, 442; with Toulouse-Lautrec, 365–366, 400–406, 451, 464–465
Fromentin, Eugène, 115
The Frugal Meal (Israëls), 126, 127
fumisme, 357

G

Gachet, Paul-Ferdinand, 585, 592
galleries, 301, 334
Gallic nationalism, 298
Garden with Courting Couples: Square Saint-Pierre (Van Gogh), 422–423, 447, 449
Gauguin, Paul, xii, xx, xxii, 270, 310, 316–319, 330–331, 386, 389, 485, 508, 522, 529–536, 543, 548–549, 554, 563, 570–574, 579–580, 589, 593; Bernard and, 410; on Degas, 293; Impressionism and, 304, 305; letters to, 25; quarrel with, 71; self-portrait by, 580–582; Synthetism and, 393, 503; Theo and, 79, 535–536; van Gogh's friendship with, 353, 405, 534–536, 580
Gauzi, François, 350, 356
Georges Petit Gallery, 301

Géricault, Théodore, 201, 273
Germinal (Zola), 461
Gérôme, Jean-Léon, 27, 63, 192, 197, 277, 480
Gigoux, Jean-François, 413
Gin Cocktail (Toulouse-Lautrec), 364–365
Gladwell, Harry, 106–107, 300
Glass of Absinthe (Van Gogh), 514
Glass with Yellow Roses (Van Gogh), 285
Gleyre, Charles, 347
Goncourt, Edmond de, 221, 399, 510
Goncourt, Jules de, 511
Goncourt brothers, 109, 246, 332
gonorrhea, 150
Goupil, Adolphe, 23, 27, 88, 197, 370
Goupil & Cie, 23, 26–31, 34–35, 44, 65–66, 88,
 114, 122, 163, 197, 216, 227, 234, 370, 397, 398
Goupil School, 27
Government of National Defense, 202
Grammar of Painting and Engraving (Blanc),
 115–116
Grand Bouillon-Restaurant du Chalet, 544–546,
 548–549, 552, 559
Grand Boulevard artists, xx, 544, 550–551
Grande Odalisque (Ingres), 175
Grapes, Lemons, Pears, and Apples (Van Gogh),
 505, 506
The Graphic, 67
"gray school," 27–28
Greffulhe, Comtesse de, 297
Gros, Antoine-Jean, 273
group exhibitions, 165–167, 186–187, 208–210,
 214, 217, 294–295, 297, 301, 305, 311, 319–
 320, 544–546
Groux, Henry de, 590
Gruby, David, 541
Guillaumin, Armand, 389, 454, 543
The Gypsy Girl (Hals), 143

H
The Hague, 22–24, 26–30, 35, 72–73, 76, 77, 84,
 244, 246, 510
Hague School, 27–28, 54, 73, 216, 377
Haight-Ashbury, 464, 510
halos, 507, 508
Hals, Frans, 142, 143, 145, 189, 240, 274, 277,
 280, 367, 404, 483
Hartrick, Archibald Standish, 365, 372, 381,
 384, 400, 405, 414, 457–458, 465–466, 514;
 at Cormon's studio, 348–349, 353–354, 356;
 friendship with van Gogh by, 358–359, 451,
 453–454; on Gauguin, 531–532, 535
Haussmann, Georges-Eugène, 182–183

Head of a Peasant Woman (Van Gogh), 254
health issues: of Theo, 231, 373–374, 427–428; of
 Vincent, 2, 150–152, 154, 235–236, 240, 248
hedonism, 112
Henry, Charles, 309–311, 323
Henry, Émile, 298
Heyerdahl, Hans, 233
"high culture," 185
hippies, 464, 510
history painting, 169, 181–182, 215
Holy Family (Rembrandt), 7
homesickness, 15, 18, 29, 30, 56, 138
Hoogeveen, 86
Hoornik, Clasina Maria (Sien), 78–80, 85, 150,
 246, 254, 303, 337, 397, 457
Hoornik, Willem, 78–79
hopefulness, 580
Hoschedé, Alice, 297
Hôtel de Ville, 203
Hôtel Drouot auction, 279–280
Hugh, H. P., 468
Hugo, Victor, 22, 72, 109, 184, 483, 531, 581
human connection. See connection
human form, 125, 271–272, 361. See also figure
 studies
human progress, 247
Huysmans, Joris-Karl, 219, 325–329, 332, 573
Hydropathes, 357

I
idealism, 316
Illustrated London News, 67
illustrated magazines, 163–164, 249, 510–511
illustrations, 249–251, 364–365
images d'Epinal, 503
imagination, 67, 220, 270–271, 408, 533, 554,
 577
immorality, 245
Impression, Sunrise (Monet), 210
Impressionism, 210–213, 503; collapse of, 291–
 293, 295–296, 307, 318, 320; discontent with,
 304, 305, 307; modernism and, 319; rejection
 of, 330–333; Van Gogh and, 29, 115–116, 130–
 131, 248, 267–269, 287, 302–303, 318–320,
 362, 439
Impressionists, xx–xxiii, 62, 117, 162, 287; art
 sales by, 200–202, 204–206, 526–530, 535–
 537, 543; breakup of, 160, 217–219, 291–293,
 295–296, 531; conflicts among, 217–218,
 291–297, 302, 304–305; Durand-Ruel and,
 200–202, 204–209, 214–215; exhibitions
 by, 107, 208, 214–218, 293–295, 301–302,

305–307, 311–313, 401; female, 296; financial struggles for, 296–298; Goupil's and, 27; of Grand Boulevard, xx, 544, 550–551; influences on, 179, 511–512; lack of support for, 207–210; reception in America of, 215–216; subject matter for the, 212–213, 267, 434–435, 532; success of, 217; Symbolism and, 323–324; techniques used by, 73, 75, 126, 129, 142, 211–213, 252, 274, 295, 302–303, 367; Theo and, 117, 163, 528–530, 535–536, 543, 551–552; Van Gogh and, 216–217, 378, 397, 426–427. *See also* *specific artists*

In the Café: Agostina Segatori in Le Tambourin (Van Gogh), 483

ingratitude, 8, 487

Ingres, Jean-Auguste-Dominique, 174, 175, 273, 274, 306

inner transformation, 247

insanity, certificate of, 51–52

Institute de France, 216

Institut Nationale des Sciences et des Arts, 166, 198

Interior of the Restaurant of Etienne-Lucien Martin (Van Gogh), 558

investment opportunities, 195–197

Iron Bridge at Asnieres (Bernard), 558

irony, 358

Isaacson, Joseph, xiii

Island of La Grande Jatte, 412

isolation, xi, xiv, xx–xxi, xxv, 31, 235, 450, 571

"Les Isolés" (Aurier), xi–xiv, xvi–xvii, xxiv

Israëls, Jozef, 126, 127, 131

The Italian Woman (Van Gogh), 521, 523

J

Jacobin Club, 174

Japanese art, 502, 509–521

The Jewish Bride (Rembrandt), 138–139

Joie de Vivre (Zola), 325–326

journalists, 172

Joy of Life (Matisse), 415

jury system, 170, 172, 186–187, 209

juste-milieu, 296, 342, 343

K

Kahn, Gustave, 231, 307, 315, 322–324, 326, 374, 449, 503

Kerkstraat: De Groot cottage in, 136; studio in, 99–100, 120

Kerssemakers, Anton, 100, 123, 129–130, 136, 138, 140

Kitchen Gardens, Montmartre (Van Gogh), 449

Klimt, Gustav, 445

Koning, Arnold, 447, 548

L

laborers, 76, 82–83, 251, 265, 510, 511

Lafargue, Paul, 267

La Font de Saint-Yenne, Étienne, 170, 172, 191

Landscape in the Snow (Van Gogh), 569

landscapes, 74, 84–87, 178, 206, 210–212, 215, 265–267, 384, 417, 422–423, 432–433, 444, 447–449, 500

Landscape with Bog (Van Gogh), 87

Lapin Agile, 261

Latin Quarter, 246, 346

Lautrec. *See* Toulouse-Lautrec, Henri de

Laval, Charles, 534

lay preacher, 41–43, 53–54

Le Brun, Charles, 167, 169, 180, 185

leisure activities, 267, 433–434

Leroy, Louis, 210

letter writing, xxiii–xxvi, 24–26

Levey, Jules, 357

Lhermitte, Léon Augustin, 131–132

liberal society, 246

Liberty Leading the People (Delacroix), 174

light, 74, 118, 129–130, 178, 210–212, 217, 274, 295, 307, 308, 422, 441, 501, 508

line(s), 303, 309, 315, 407, 440, 441, 442, 576

literature, 21, 108–109, 112, 159, 161, 162, 247, 322, 324–328, 332–333, 440

"Literature: Manifesto of Symbolism" (Moréas), 322, 326

lithography, 197, 250

Little Johannes (van Eeden), 562

live models, 76–80, 136, 145, 254, 272, 274, 349, 381–382, 476

Livens, Horace Mann, 228, 277, 363, 372, 421, 593

London, 30–32, 161, 202–204, 215, 512

loneliness, 31, 45–46, 77, 87–88, 92, 106, 118, 152, 230, 300, 468, 566

Loti, Pierre, 510

Louis Napoleon. *See* Napoleon III

Louis Philippe (king), 110

Louis XIV (king), 167, 180

Louvre, 6, 7, 334

Louvre Palace, 169

love affairs. *See* romantic relationships

Loyer, Eugenie, 31–32

lunatic asylum, 51, 221, 426, 575, 585

Luxembourg Museum, 216, 334

luxury goods market, 196

M

Mackerels, Tomatoes and Lemons (Van Gogh), 369
Madama Butterfly (Puccini), 510
Madame Chrysanthème (Loti), 510
Maison Dorée, 217, 295, 301, 306, 311, 313, 320, 323, 331
malerisch, 142
Mallarmé, Stéphane, 326, 332
Manet, Édouard, 107, 115, 158–160, 162, 187–196, 199, 203, 206–208, 211, 213, 280, 282, 284, 287, 304, 314, 347, 423, 458–459, 512, 573
Manet, Eugène, 296, 297
"Manifesto of Symbolism" (Moréas), 502
Marriage at Cana (Veronese), 7
Marseilles, 564
Marsh with Water Lilies (Van Gogh), 66
Martin, Etienne-Lucien, 544–545
Martin, Pierre Firmin, 448
Martinet, Louis, 199
Martinique, 534
Marville, Charles, 183
Marx, Karl, 203
mass production, 185
materialism, 329, 532, 573
mathematical laws, 309–310
Matisse, Henri, 347, 356, 415
Maupassant, Guy de, 109, 245, 332, 465, 476, 483
Mauve, Anton, 54, 73–76, 79, 84, 137, 216, 244, 266, 403
Mazarin, Cardinal, 167–169, 172, 180, 185, 209
McLean, Don, xvi
medieval guild system, 168
Meissonier, Ernest, xix, 182, 203
Memory of the Garden at Etten (Van Gogh), 220, 555
Mendes da Costa, Maurits, 37–38, 43
mental illness, xiii–xiv, xv, 33, 219–222, 324, 378, 493, 504, 588, 590–591
Mercure de France, xi–xii, xv–xvii, xxiii
mercury, 150–151, 235
Metropolitan Tabernacle, 32
Meurent, Victorine, 190–191, 213
Michel, André, 293
Michel, Georges, 86
Michelet, Jules, 34, 72
middlebrow culture, 124, 197, 206
middle class, 180, 184–185, 197, 209
Millet, Jean-François, 27, 33, 53, 57, 61–62, 79, 87, 96, 105, 112–115, 126, 128, 179, 266, 338, 404, 434, 509
Miners in the Snow (Van Gogh), 53
minister, training as, 37–38

ministry, 40
Le Mirliton, 261, 365–366, 394, 400, 464
Les Misérables (Hugo), 531
misery: attraction to, 42, 96. *See also* suffering
mistresses, 78–80, 85, 98, 112, 136–137, 143, 234, 246, 456
modeling by drawing, 273–274
models, 76–80, 136, 142–143, 145, 254, 272, 274, 349, 381–382, 480, 483
modern art, xix–xx, xxiii, 115–116, 159–160, 216, 247, 252, 278–279, 319–320, 394, 411, 580
Modern Chromatics (Rood), 308
modern economy, 195–196
modernism, 161–162, 165–167, 195, 199, 318, 319, 320, 406, 439, 562
modernity, 110, 111, 247, 434, 458–459, 532
modern life: alienation of, 330; art based on, 131, 142, 218, 225, 239, 247–249, 265, 267, 338, 458–459, 465–466, 466, 511, 573; superficiality of, 110
modern vistas, 433–435
Mona Lisa (da Vinci), 7
Monet, Claude, 158, 200, 204, 210–212, 217–218, 262, 280, 294–297, 305, 315, 323, 326, 347, 370, 412, 439, 441, 445, 527, 528, 536, 544, 589
money economy, 184–185, 195–196
money issues, 6–8, 24, 36, 102, 143–144, 262, 374, 481–482, 588–589
Le Moniteur Universel, 92
monochrome colors, 74–75, 277
Montesquiou, Robert de, 297
Monticelli, Adolphe, xix, 283–287, 304, 399, 404, 418, 423, 443, 464, 564
Montmartre, xxi, 112, 202, 225–227, 243, 246, 258–271, 346, 353, 412, 446–447, 468
Montmartre: Behind the Moulin de la Galette (Van Gogh), 447
Montmartre: Windmills and Allotments (Van Gogh), 417, 418
mood swings, 3, 21, 68, 84
moral decline, 329
moral geography, 238
morality, 112, 245, 246, 461
morality tales, 181
Moréas, Jean, 322, 326, 330, 502
Moreau, Gustave, 327, 503
Morice, Charles, 445
Morisot, Berthe, 206, 214, 215, 295–298
Moulin de La Galette, 261, 267, 458
Le Moulin Rouge, 261, 401
Mucha, Alphonse, 250

museums, 138–139, 141–142, 189, 276, 334, 413, 421
music, 445, 541
mysticism, 575

N

Nabis, 522, 575
Nadar (Gaspard-Félix Tournachon), 208, 214
Napoleon III (Louis Napoleon), 176, 180, 182–184, 186–187, 202
narrative, 131, 135, 169, 327, 446, 497
National Assembly of the French Republic, 202–203
Naturalism, 160, 220–222, 246, 292, 322, 399
Le Naturalisme au Salon (Zola), 304
Naturalists, 449, 476
nature, love of, 19
Neo-Classicists, 174, 273, 274, 326
Neo-Impressionism, 116, 308, 311–318, 331, 390, 415–421, 427, 441, 449–450, 500, 501, 533, 546–547, 590. *See also* Divisionism; Pointillism; *specific artists*
New York, 161, 215
Nieuwekerke, Count de, 181, 186
Night Café (Van Gogh), 498–499, 523, 576
nightclubs, 394, 400, 458, 464–466, 541
nihilism, 357
Nocturne: Blue and Gold—Old Battersea Bridge (Whistler), 512
nonconformity, 61–62, 147
Nordau, Max, 329
notoriety, 209–210, 215
Nouvelle Athènes, 206
novels, 22, 34, 38, 57, 67, 109, 112, 246, 325, 399, 440, 476, 483–484
Nuenen, 4, 6, 92–102, 108, 111, 147, 154, 238, 246, 367, 426, 572

O

Oath of the Horatii (David), 173–174, 314
objectivity, 282, 292, 323, 324, 573
L'Oeuvre (Zola), 157–161, 165, 192, 193, 199–200, 207, 217–220, 251, 292–293, 296, 305, 320, 389, 434
oil painting, 74–75, 84, 95–96, 365
The Old Church Tower at Nuenen (The Peasants' Churchyard) (Van Gogh), 121
Old Paris, 184
Olympia (Manet), 193–194, 212, 459, 512
100 Famous Views of Edo (Hiroshige), 517
optics, 307
optimism, 152

The Orchestra of the Opera (Degas), 512
originality, xiv, 135, 194, 195, 419, 426, 436, 569
orthodoxy, 192, 521, 553–554
outcasts, xv, 41, 96, 99, 109, 246, 366, 425, 463–464

P

"The Painter of Modern Life" (Baudelaire), 225, 239
painting supplies. *See* art supplies
Pair of Shoes (Van Gogh), 337
Palais de l'Industrie, 180, 206, 334
Palais des Champs-Élysées, 180, 187
Panama Canal, 534
panoramas, 267–269
pantheism, 574
La Parade (Seurat), 458
Parade de Cirque (Seurat), 310
parallel lines, 303, 407, 441, 442
parents, 13–15, 17, 20–22, 35–39; disappointment of, in Vincent, 40–41; financial support by, 95; relationship between Vincent and, 51–52, 66, 70, 72–73, 92–94, 96–99, 108, 118; Theo and, 39–40, 43–44
Paris, xviii; art community in, xvii–xxv, 27–28, 62, 63, 105–106, 161–164, 198–199, 333, 455–456; avant-garde in, xviii, xxi, 29, 110–111, 158, 160, 163–167, 195, 216, 244–245, 301, 319, 400–401, 416, 426, 435, 449–450, 464, 472, 546–548, 562, 569, 590; cafe culture in, 162–163; culture of, 161, 180, 244, 318, 320–322; expense of, 227–228; leaving of, by Van Gogh, 562–572; move to, by Vincent, 1–7, 58–59, 92–93, 102–103, 107–108, 140, 150, 153, 154–155, 232–239, 342–343, 566, 567, 573; permissiveness of, 456–457; political upheavals in, 202–203, 259, 267, 321, 388; prostitutes in, 456–457; Theo's life in, 225–232, 241–243; urban renewal project in, 182–184; Van Gogh in, 33, 106–107, 163–164, 222–223, 225–228, 238–282, 330–344, 372–382, 404, 425–473, 478–488, 520–521, 542–543; Van Gogh's artistic output in, 248–249, 251–256, 263–282, 336–340, 367–369, 398–399, 419–424, 441–447, 556–559; Van Gogh's attitude toward, 106–108, 111–112, 131, 495–498, 568–569; visits to, by Vincent from Arles, 585–587, 589
Paris Commune, 203, 259, 267, 321, 388
Paris Salon, 131–132, 163, 165–172, 177, 546; of 1863, 186–191; cultural influence of, 180, 181, 196; jury system, 170, 172, 186–187, 209;

Van Gogh's attitude toward, 111, 124; Van Gogh's submission to, 123–124; Van Gogh's sum, 131–132

Path in Montmartre (Van Gogh), 265–266

The Pavilion of Realism, 177, 209

peasant life, 532–534; Japanese, 520; living the, 132–133, 139, 236; paintings of, xxvi, 61, 87, 96, 105, 108, 111–112, 114, 115, 121, 123–128, 131–132, 140, 176, 247, 511, 572–573

peers, xix–xxii. *See also* art community

peinture a l'essence technique, 365, 400–403, 417, 433, 443, 471

Péladan, Sâr, 329–330, 575

people, misreading of, 71

Pere Tanguy (Van Gogh), 382

periodicals, 163–164

personality, of Van Gogh, xviii–xix, 26, 68, 84, 123, 130, 147, 148, 244, 271, 273, 356–359, 366, 374, 403, 406–407, 418, 454, 518–519

perspective frame, 269–271, 364, 420, 437, 513, 518, 578

Petit, Georges, 297, 334

Petit Boulevard artists, xix–xx, 320, 332, 544–553, 563

"Phenomena of Vision" (Henry), 311

photogravure, 197

physical appearance, 8–10, 235–238, 243, 247, 338–339

physical health: of Theo, 231, 373–374, 427–428; of Vincent, 2, 150–152, 154, 235–236, 240, 248

physical suffering, 92, 99–100

physics, 292

Picasso, Pablo, 177, 196, 261, 262, 426

pilgrimages, 51, 86

Pissarro, Camille, 161, 206, 279, 305, 307, 388, 432, 526–530, 533, 543, 548; as anarchists, 298; Degas on, 294; financial hardships of, 217, 262, 297–298; Neo-Impressionism and, 312–315, 441; Paris Commune and, 203; techniques used by, 212–213, 274

Pissarro, Lucien, 243, 308, 312, 314, 432, 448, 455, 526, 543, 548, 564

Plaster Cast (Van Gogh), 275

plaster casts: drawing, 5, 61, 63, 76, 147, 152, 169, 248, 271–272, 274, 343; paintings of, 275, 302–303, 407–408

plein-air painting, 178, 204, 206, 211–212, 216–217, 264, 282, 292, 302, 433, 595

poetry, 326, 332

Pointillism, 308, 311–318, 323, 333, 367, 402, 414–418, 423, 441, 500, 529, 533, 547. *See also* Divisionism; Neo-Impressionism

political upheavals, 180, 182–183, 202–203

Pollard Birches (Van Gogh), 97

Pont-Aven, 410, 532, 570, 593

poor: depiction of, in art, 95–96; sympathy with the, 79–80, 82–83, 126; work as lay preacher among, 38, 40–43. *See also* laborers; peasant life

Poplars (Monet), 445

popular taste, 82, 126, 182

Portier, Alphonse, 448

Portier, Arsène, 122–123, 130, 288

Portrait of a Lady with a Hat (Van Gogh), 253

Portrait of Alexander Reid (Van Gogh), 471–472

Portrait of a Woman (Van Gogh), 383

Portrait of Emile Bernard (Toulouse-Lautrec), 409

Portrait of Émile Zola (Manet), 512

Portrait of Julien Tanguy (Van Gogh), 383, 384, 386, 420

Portrait of Paul Durand-Ruel (Renoir), 201

Portrait of Paul Signac (Seurat), 416

Portrait of Theo van Gogh (Van Gogh), 494, 495

Portrait of Van Gogh (Russell), 453

portrait painting, 142–145, 152, 240, 252–256, 382–384, 404–405, 421

positivism, 292

poster design, 249–250, 364–365, 401–402

The Potato Eaters (Van Gogh), 67, 123–126, 128–136, 138, 142, 145, 176, 252, 265, 287, 338, 398, 447, 560

Poudre de Riz (*Rice Powder*) (Toulouse-Lautrec), 402, 403

Poussin, Nicolas, 170, 212, 316

poverty, 50–51, 73, 99–100, 136, 150

Prawns and Mussels (Van Gogh), 369

preacher, Van Gogh as, 36–37, 40–43

Pre-Raphaelite Brotherhood, 330, 540

press coverage, 162, 164, 174, 192, 215, 296

primitives, 445, 502

The Print Collector (Daumier), 198

Prix de Rome, 173

progress, 328–329

promiscuity, 112–113

prostitutes, 29, 76, 78, 112, 185, 240, 246, 253, 303, 337, 456–457, 459–464, 466, 480–481, 483, 541–542

Protestantism, 13, 14, 521

provocateurs, 172

Prussia, 202

Prussian blue, 276

psychotic breakdowns, 221, 493, 504, 590–591

public recognition, for Van Gogh, xiii–xiv, 447–448, 588–590

puritanism, 112

Puvis de Chavannes, Pierre, 205, 315–317, 320, 329, 330, 503, 573
Pyat, Felix, 246

Q

Quinces, Lemons, Pears and Grapes (Van Gogh), 497

R

radicalism, 298, 320, 411
Raffaëlli, Jean-François, 293
Rappard, Anthon van, 63–67, 73, 85, 93, 99, 133–135, 244, 272–273, 358, 403–404, 498
rationalism, 310
Raynaud, Ernest, 321, 322
realism, 211, 221–222, 316, 322, 330, 385, 446, 458, 497–498, 502–503, 516, 518
Realists, 162, 175–178, 326
A Rebours (*Against the Grain*) (Huysmans), 219, 325, 326–329
Reclining Nude (Van Gogh), 459–461
recognition, xiii–xiv, 447–448, 588–590
Red Boats at Argenteuil (Monet), 439, 440
redemption, 574, 575
Redon, Odilon, 323, 327–329, 503, 548, 573
The Red Vineyard (Van Gogh), 588
Reformed Dutch Church, 14, 37
Reid, Alexander, 377, 383
Reign of Terror, 174
religion, xxiv, 32–38, 53–54, 247, 330, 358, 476, 477, 508–510, 573–575
religious cults, 522, 575
religious imagery, 126, 127
Rembrandt, 7, 126, 127, 138, 142, 286, 367, 404, 483, 509
Renoir, Pierre-Auguste, 167, 201, 217, 267, 280, 294, 305, 315, 347, 389, 439, 458, 527, 544, 590
respectability, 13, 237
Restaurant de la Sirèn (Van Gogh), 442, 471
Restaurant du Chalet (Van Gogh), 545
retail industry, 185
revolution, 322, 398
Revolution of 1830, 174, 180
Revolution of 1848, 110, 180, 183
La Revue Indépendante, 548
Richepin, Jean, 399
"The Right to Laziness" (Lafargue), 267
Rijksmuseum, 138–139, 141–142, 146, 189, 276, 421
Rimbaud, Arthur, 332, 440, 461
Robespierre, Maximilien, 174
Rochedieu, Reverend, 43

Roelofs, Willem, 61
Rohde, Johan, 391
Roman Parisien (Richepin), 399
Romanticism, 175, 322
romantic relationships: of Theo, 81–82, 90, 229–230, 234, 334–335, 456, 489–492, 540; of Vincent, 98–99, 136–137, 245, 335–336, 406, 477, 479–488
Romantics, 174, 273, 311, 326, 434
Rood, Ogden, 307, 308
Roos, Dina, 23
Roos, Willem, 23
Rouen Cathedral (Monet), 445
Rousseau, Théodore, 96, 178
Royal Academy of Painting and Sculpture, 167
Royal Academy of Visual Arts, 147–148, 151–152, 174, 271–272, 343–344
Rubens, Peter Paul, 273, 274, 277, 404
Rue Laval, 225–226
Ruisdael, Jacob, 266
Russell, John Peter, 355–356, 382, 451, 452, 453

S

Sacred Grove (Puvis de Chavannes), 316, 317
Saint-Paul de Mausole asylum, xiv, 585
Saint-Remy asylum, 221, 426, 575
Salis, Rodolphe, 260, 357
Salon Carré, 7, 180
Salon de la Rose + Croix, 329–330, 522, 575
Salon des Indépendants, 313, 334, 401, 416, 449, 501, 547, 549
Salon des Refusés, 107, 165–167, 187–193, 199, 206, 209, 239, 319
salons, 334
Scheffer, Ary, 27
Scheveningen seascapes, 84
schooling, 17–20. *See also* art education
"school of 1830," 178
Schopenhauer, Arthur, 330
Schuffenecker, Émile, 530, 532
Schwob, Marcel, 268
science, 292, 309–311, 314, 323, 329
scientific aesthetic, 309–310
seasonal affective disorder (SAD), 264, 429–430
Seated Nude after Charles Bargue (Van Gogh), 60
Second Republic, 110
Segatori, Agostina, 479–488, 521–523, 559
self-conception, 240, 247, 426
self-doubt, 93–94
self-mutilation, 71
Self-Portrait (Bernard), 580–581
Self-Portrait (Van Gogh), 494, 495

Self-Portrait as a Painter (Van Gogh), 338–339, 366–367, 431, 483, 560–562, 567
Self-Portrait Les Misérables (Gauguin), 580–582
self-portraits, 10, 18, 122, 254–256, 338–339, 366–369, 421, 422, 429, 469–472, 493, 495, 507–508, 559–562, 567, 580–582
Self-Portrait with a Pipe (Van Gogh), 255–256, 367, 368
Self-Portrait with Glass (Van Gogh), 383, 467
Self-Portrait with Gray Felt Hat (Van Gogh), 367, 507, 508, 561
Self-Portrait with Straw Hat (Van Gogh), 470, 471–472, 507
self-punishment, 43
La Semaine Sanglante (The Bloody Week), 203
Sérusier, Paul, 522
Seurat, Georges, 116, 291, 306–320, 384, 412, 435–438, 458, 573; artists' cooperative and, 563–564; disciples of, 314–315, 414–415; Gauguin and, 533; Impressionism and, 306–307, 312–313; Neo-Impressionism and, 308–320, 323, 352–353, 362, 400–401, 441, 546–547; Petit Boulevard artists and, 552–553, 563; techniques used by, 307–308, 417–418, 441–442; Van Gogh and, 331–333, 390, 398, 423–424, 432
Seventh Impressionist Exhibition, 294
sexual freedom, 112–113, 245–247, 456–457, 461–463, 541–542
shadow puppets, 541
shadows, 129, 212, 274, 295, 407, 438, 514, 520
shoes, still lifes with, 72, 336–339, 398–399
Sien in a White Bonnet (Van Gogh), 78
Signac, Paul, xxii, 116, 298, 307, 314, 332, 389, 414–419, 424, 432–436, 441–442, 450–451, 468–469, 500, 546, 548, 590
Signol, Émile, 186
Silvestre, Théophile, 116
Sisley, Alfred, 212, 217, 262, 280, 347, 527, 536, 590
Smiling Spider (Redon), 327
smoking, 235, 358, 467, 566, 578
social awkwardness, 80, 488
social connections, 229, 333, 393, 396–398, 406, 452, 478, 488, 538, 595. *See also* friendships
social interactions, 378–379
socialism, 109–111, 176, 298, 550, 563
Socialist International, xxii
social reforms, 203
societal changes, 184–186
Société Anonyme, 389, 540
Société des Artistes Indépendants, 319–320, 570, 589
solitary genius, xi–xv, xxiii

solitude, xi, 16–17. *See also* loneliness
Sorrow (Van Gogh), 80, 81
The Sower (Van Gogh), 472
Spanish Guitar Player (Manet), 189
specimen collecting, 19
speculative bubbles, 196
spirituality, 509–510, 521–522, 574–575
Spring Fishing, the Pont de Clichy (Van Gogh), 439, 441, 471
Spurgeon, Charles Haddon, 32, 38, 54
Standing Female Nude Seen from the Back (Van Gogh), 360
Standing Male Nude Seen from the Front (Van Gogh), 360, 361
The Starry Night (Van Gogh), 472
state-sponsored art, 166–167, 176–177, 180–181, 185–190, 196–198, 206, 296, 313, 319–320, 334, 346–347
Steinlen, Théophile, 250
still lifes, 71–72, 74, 137, 190, 247, 276, 280–282, 285–287, 336–338, 353, 369, 398–400, 496–499, 505, 559
Still Life with an Earthenware Pot and Clogs (Van Gogh), 74
Still Life with Basket of Apples (Van Gogh), 456
Still Life with Bible (Van Gogh), 121–122
Still Life with Earthenware Pot and Apples (Bernard), 505, 506
The Stop at the Inn (Meissonier), 182
Stowe, Harriet Beecher, 22, 67, 109, 332
street life, 457–459
Stricker, Johannes, 68–69, 71
Stricker, Wilhelmina, 68–69
student revolt (1861), 186
The Studio: A Real Allegory of the Last Seven Years of My Life (Courbet), 177
subjectivity, 292, 322, 323, 324
suburban landscapes, 378, 417, 437, 442–443, 446–447, 532, 573
suffering, 43, 574, 575; attraction to, 79, 493; physical, 92, 99–100
suggestive color, 418–420
suicide, xiv–xv, 377, 587, 588, 591
A Sunday Afternoon on the Island of la Grande Jatte (Seurat), 308–309, 311–314, 317, 319, 423, 424
sunflowers, 495–496, 507
Supper at Emmaus (Rembrandt), 127
The Swing (Fragonard), 171
Symbolism, 80, 160, 322–332, 501–503, 549
Symbolists, xxii, 162–163, 445, 449, 534, 541, 548, 554, 575

Synthetism, xxii, 393, 503, 549
syphilis, 150–151, 235, 541–542

T

tableau vivant, 423
Le Tambourin, 480–482, 485–487, 513
Tanguy, Julien (Père), 144, 264, 382–383,
 387–396, 400, 421, 424, 427, 447–448, 451,
 480–481, 487, 519–521, 535, 539
Tanguy, Renée Julienne, 383, 391–392, 395, 482,
 487
technological progress, 292
temperament, 6–7, 19–21, 411, 454–455, 487, 504
Terrace of the Tuileries (Van Gogh), 252
terrorism, 298
Tersteeg, Hermanus Gijsbertus, 29–30, 35, 75, 79,
 111, 134, 195, 551–552
Théâtre Libre, 449, 548, 552
third estate, 110
Thomas, Georges, 448
Tintoretto, 142
Titian, 142, 193–194
tobacco use, 235, 358, 467, 566, 578
tonal painting, 130, 221, 252, 266, 286, 332, 362,
 369, 384, 385, 418
Toulouse-Lautrec, Henri de, xxii, 296, 318, 389,
 407–409, 435, 450, 458, 464, 469, 500, 542,
 548, 590; artistic technique of, 365, 400–403;
 at Cormon's studio, 243, 350–352, 355,
 357–358, 362, 364–365; friendship between
 Vincent and, 365–366, 394, 400–406, 451,
 464–465; influence of, 414, 417, 424, 431–432,
 466, 471, 484, 513–514; posters and illustra-
 tions of, 249, 250, 261; Theo and, 529, 537
Tournachon, Gaspard-Félix (Nadar), 208, 214
Trees and Undergrowth (Van Gogh), 445–446
trompe l'oeil, 518
troubadour style, 181–182
Tuileries Palace, 203

U

ukiyo-e prints, 511–514, 517, 553, 576–577
Union Générale des Banques, 297
urbanization, 184–185
urban life, 227, 238, 239–240, 248, 403, 419–420

V

Valadon, René, 88, 227, 370, 526, 527
Valadon, Suzanne, 366, 405
van Eeden, Frederik, xv, 562
Van Gogh, Anna Carbentus (mother), 13–15, 17,
 19–22, 35, 456; attitude toward art of, 111;

injury of, 96–98, 300, 493; Theo and, 39, 375;
 Vincent and, 41–43, 66, 93, 96–98
Van Gogh, Anna (sister), 15, 31–32, 118, 119, 120
Van Gogh, Cornelia, 22
Van Gogh, Cornelis (Cor), 15, 54, 94, 372
Van Gogh, Elisabeth (Lies), 15, 16, 17, 19
Van Gogh, Jo Bonger, xviii–xix, 15, 31, 60,
 120, 232, 242, 334–335, 339, 370, 489–492,
 585–588
Van Gogh, Johannes (Jan), 14, 37
Van Gogh, Theo, xii, xxii; arguments between
 Vincent and, 81–82; as art agent for Vincent,
 113, 122–123; art connections of, 354–355,
 366, 405, 411, 504, 535, 543; as art dealer,
 xx, xxv, 113–114, 227–229, 279–280, 297,
 299, 334, 369–374, 489, 526–530, 535–537,
 542–543; birth of, 15; business partnership
 between Vincent and, 525–526, 536–543;
 business success of, 35, 39, 44, 46–47, 65–66;
 career troubles of, 88–90, 369–370; character
 of, 431; depression of, 230–231; emotional
 crises for, 479, 488–492; father's death and,
 119–120; financial support provided by, 2,
 6–8, 49–50, 58, 72–73, 76–77, 84–85, 90–91,
 100–102, 143–144, 149–150, 227–228,
 371–372, 374–375, 396, 589; at Goupil & Cie,
 44, 65–66, 88–90, 216, 227–229, 234, 397; in
 The Hague, 24; health issues of, 231, 373–374,
 427–428; Impressionists and, 216–217, 370,
 397, 528–530, 535–536, 543, 551–552; let-
 ters to, xxiii–xxvi, 6, 24–26, 33; living in
 Paris with Vincent, 227, 232–244, 256–263,
 336, 339–340, 372–377, 430, 526; parents
 and, 43–44, 72; in Paris, 107, 163, 225–232,
 241–243, 456; personality of, 229; physical
 appearance of, 9–12; portrait of, 228; relation-
 ship between Vincent and, 1–12, 18–20, 35,
 44–50, 55–59, 88–95, 100–102, 149–150,
 154–155, 229–233, 279–280, 341, 369–370,
 372–377, 379, 394–395, 397–398, 427–430,
 450–451, 492–493, 525–526, 538–542,
 565–566; romantic relationships of, 81–82, 90,
 229–230, 234, 334–335, 456, 489–492, 540;
 setbacks experienced by, 525–526; on Sien, 80;
 temperament of, 18, 20; trip to Holland by,
 334–335; unconventional streak in, 39–40, 66;
 on Vincent's art, 123–124, 130, 146, 233–234,
 428–429, 430–431; Vincent's move to Paris
 and, 107–108, 153–155, 232–233
Van Gogh, Theodorus (Dorus) (father), 13–15, 17,
 20, 22; attempt to commit Vincent by, 51–52;
 death of, 119–121; as minister, 37; relationship

between Vincent and, 43, 50, 66, 70, 72–73, 92–94, 97, 99, 108, 118; religiosity of, 32–33; on Theo, 39; on Vincent, 34, 35, 38–39, 42

Van Gogh, Vincent: art community and, 111, 450, 464, 515–516; artistic development by, xxi–xxii, 5–6, 278–279, 304, 318, 403–408, 435–440, 496–499, 505–510, 516–517, 553–554, 575–579; attitudes toward women of, 136, 335–336, 460–464, 483; Aurier's article about, xi–xiv; childhood of, 15–22; death of, xiv–xv; decision to become artist by, 54–61; Divisionism and, 431–446; Du Chalet exhibition of, 544–550; Impressionism and, 29, 115–116, 130–131, 248, 263, 267–269, 287, 302–303, 318–320, 378, 397, 439; insider/outsider status of, 354–355; memory of, 554–555; move to Paris by, 1–7, 58–59, 92–93, 102–103, 107–108, 140, 150, 153–155, 232–239, 342–343, 566, 567, 573; personality of, xviii–xix, 26, 68, 84, 123, 130, 147, 148, 244, 271, 273, 356–357, 366, 374, 403, 406–407, 418, 454, 518–519; popular myth of, xiv–xvii; relationship with parents, 51–52, 66, 70, 72–73, 92–94, 96–99, 108, 118; romantic relationships of, 98–99, 136–137, 245, 335–336, 406, 477, 479–488; as student at Cormon's studio, 341–366, 371–372, 378, 381–382, 384, 395, 593–595

Van Gogh, Vincent (grandfather), 14

Van Gogh, Vincent (Uncle Cent), 14, 22–24, 27, 30, 34, 54, 75, 94, 197, 370, 372

Van Gogh, Vincent Willem (nephew), 585–586, 587

Van Gogh, Willemina (Wil), 15, 25, 118, 475–476

Van Gogh Museum, 398, 420, 593

Van Rappard, Anthon, 25

Vase of Flowers (Monticelli), 285

Vase with Peonies (Manet), 280–281

Velázquez, Diego, 189

venereal diseases, 150–151

Venus (Van Gogh), 408

Venus of Urbino (Titian), 193–194

Verlaine, Paul, 332, 440, 464

Verlat, Charles, 147

Veronese, Paolo, 7

Victorian England, 330

La Vie Populaire, 164

View from Vincent's Studio (Van Gogh), 263, 264, 266

View of Paris (Van Gogh), 268

Les Vignt, 313, 589

A La Villette, 253

Villiers de l'Isle-Adam, Auguste, 326

"Vincent" (McLean), xvi

Vincent and Theo (Pissarro), 243

Vinck, Frans, 147, 271

Vos, Cornelia (Kee), 69–71, 72, 98, 112, 247, 286, 491, 540

Vuillard, Édouard, 522

W

Wagner, Richard, 330

war, 322

warm tones, 444

Washerwomen on the Banks of the Seine (Daubigny), 179

watercolors, 84

Water Lilies (Monet), 445

Watteau, Antoine, 284, 423

Wheatfield with Crows (Van Gogh), 444, 591

Wheatfield with Partridge (Van Gogh), 444

Where Do We Come From? What Are We? Where Are We Going? (Gauguin), 317

Whistler, James, 512

Willem II school, 19

Willette, Adolphe, 250

Wolff, Albert, 162, 194, 195, 210, 214

Wölfflin, Heinrich, 142, 277

women: in art, 483–484; marginalized, 463–464; Van Gogh's attitude toward, 136, 335–336, 460–464, 483

woodblock printing, 510–514, 516, 517

work ethic, 59, 63, 358–359

working class, 267

World Exposition, 44

worldview, of Van Gogh, 108–111

wormwood, 468

Wyzewa, Téodor de, 320

Z

zebra-style, 514–515

Zevenbergen, 17–18

Zola, Émile, 109, 112, 136, 164, 184–185, 239, 246, 291, 322, 324, 328–329, 332, 399, 483–484, 533, 573; *Au Bonheur des Dames*, 112, 185, 244–245, 247, 461, 465; Cézanne and, 389; *Germinal*, 461; on Impressionism, 115, 212, 216–219, 297, 304–305; *Joie de Vivre*, 122; *L'Assommoir*, 109; *L'Oeuvre*, 157–161, 165, 192, 193, 199–200, 207, 217–220, 251, 292–293, 296, 305, 320, 389, 434; on Manet, 194, 196; realism of, 458; on the Salon, 188–190; on Symbolism, 324–326; Van Gogh and, 219–223, 248

Zunderdt, 232